THE LEGACY OF
GENGHIS KHAN

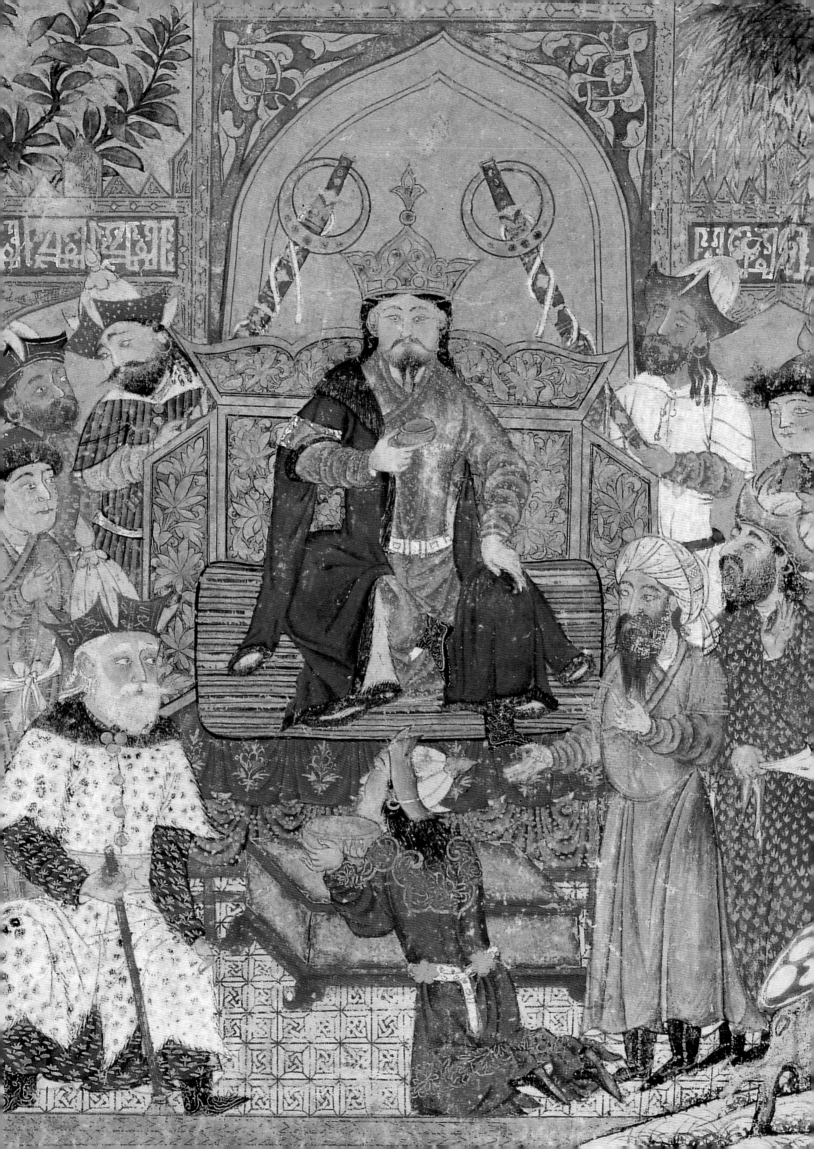

THE LEGACY OF GENGHIS KHAN

Courtly Art and Culture in Western Asia, 1256–1353

Edited by Linda Komaroff and Stefano Carboni

The Metropolitan Museum of Art, New York

Yale University Press, New Haven and London

This publication accompanies the exhibition "The Legacy of Genghis Khan: Courtly Art and Culture in Western Asia, 1256–1353," held at The Metropolitan Museum of Art from November 5, 2002, to February 16, 2003, and at the Los Angeles County Museum of Art from April 13 to July 27, 2003.

This publication is made possible by The Hagop Kevorkian Fund and The Adelaide Milton de Groot Fund, in memory of the de Groot and Hawley families.

In New York the exhibition is made possible in part by The Hagop Kevorkian Fund.

Additional support has been provided by the National Endowment for the Humanities.

The exhibition has been organized by The Metropolitan Museum of Art and the Los Angeles County Museum of Art.

An indemnity has been granted by the Federal Council on the Arts and the Humanities.

At the Los Angles County Museum of Art support is provided by the Al-Ameen Foundation and Joan Palevsky. Support for the conservation research component of the exhibition is provided in part by a grant from The Barakat Foundation. Transportation assistance was provided by Lufthansa German Airlines.

Published by The Metropolitan Museum of Art, New York

John P. O'Neill, Editor in Chief
Ruth Kozodoy, Editor
Bruce Campbell, Designer
Gwen Roginsky and Megan Arney, Production
Minjee Cho, Desktop Publishing
Jayne Kuchna, Bibliographic Editor

New photography of Metropolitan Museum objects by Anna-Marie Kellen and Mark Morosse, the Photograph Studio, The Metropolitan Museum of Art

Maps by Anandaroop Roy

Typeset in Castellar and Perpetua by Di Vincenzo Design, Dobbs Ferry, N.Y.
Color separations by Nissha Printing Co., Ltd., Kyoto
Printed and bound by Nissha Printing Co., Ltd., Kyoto

Cataloging-in-publication data is available from the Library of Congress.

ISBN 1-58839-071-3 (hc: The Metropolitan Museum of Art)
ISBN 1-58839-072-1 (pbk: The Metropolitan Museum of Art)
ISBN 0-300-09691-7 (Yale University Press)

Jacket/cover illustration: *Iskandar's Iron Cavalry* (detail), from a page of the Great Mongol *Shahnama* (Book of Kings), Iran, 1330s (cat. no. 48)

Frontispiece: *Shah Zav Enthroned* (detail), from a page of the Great Mongol *Shahnama* (Book of Kings), Iran, 1330s (cat. no. 39)

Quotation on page 1: Rashid al-Din 1998–99, pt. 1, p. 17

Contents

Directors' Foreword

The saga of Genghis Khan and the Mongols has long appealed to the Western imagination. Beginning in the late Middle Ages, firsthand travelers' accounts, such as those of Marco Polo and the Franciscan friars Giovanni da Pian del Carpine and William of Rubruck, helped create a place for the Mongols in the popular consciousness that continues to this day. Certainly part of this interest stems from their establishment of the largest contiguous land empire in history, reaching at its greatest extent from Hungary to Korea. The fact that the Mongol world empire was achieved through war and conquest has also added to its sometimes macabre fascination. But the legacy of Genghis Khan extends far beyond the battlefield. For over a century his descendants ruled an often loosely united Mongol confederacy in which the promotion of pan-Asian trade, the practice of relocating artists, and a taste for luxury goods combined to encourage a remarkable and widespread cross-fertilization of artistic ideas throughout Eurasia.

The Metropolitan Museum of Art and the Los Angeles County Museum of Art are proud to present "The Legacy of Genghis Khan: Courtly Art and Culture in Western Asia, 1256–1353." This exhibition is the first to explore the important artistic developments that occurred in the Iranian world as a result of the Mongol conquest of both western and eastern Asia. "The Legacy of Genghis Khan" focuses on the period of Ilkhanid rule—an era that witnessed extraordinary achievements within the sphere of Islamic art and culture—in an area encompassing Iran, Iraq, western Afghanistan, southern Russia, and eastern Turkey. It gathers more than two hundred outstanding works from public museums, libraries, and institutions and from private collections in Europe, Asia, the Middle East, and the United States. We are grateful to these institutions and collectors for the loan of their treasures, which include illustrated manuscripts, illuminated Korans, tilework and ceramics, jewelry, metalwork, stone and wood objects, and textiles.

These vivid paintings, sumptuous decorative arts, and splendid architectural elements help reveal the complex cultural, political, social, and religious fabric of the Iranian world in the thirteenth and fourteenth centuries. In exhibiting them we also document and explore the creation of a dynamic visual language and of a new relationship between royal patrons and the fine arts—developments that resonated throughout the eastern Islamic world for some three hundred years. Our aim is to call deserved attention to the fresh artistic identity forged in the crucible of the Mongol invasions and their aftermath, a vital aspect of Genghis Khan's legacy: a new manner of art.

We are grateful for the efforts of Linda Komaroff, Curator of Islamic Art and Department Head of Ancient and Islamic Art at the Los Angeles County Museum of Art, and Stefano Carboni, Associate Curator of Islamic Art at The Metropolitan

Museum of Art, who organized this exhibition. On behalf of both institutions we wish to express appreciation to the National Endowment for the Humanities, dedicated to expanding American understanding of history and culture, for its important contribution toward this project. The exhibition is supported by an indemnity granted by the Federal Council on the Arts and the Humanities. At the Metropolitan Museum, our profound gratitude goes to The Hagop Kevorkian Fund for its generous support of the exhibition and its accompanying catalogue. We are also indebted to The Adelaide Milton de Groot Fund, in memory of the de Groot and Hawley families, for its assistance toward the realization of the exhibition catalogue. At the Los Angeles County Museum, support for the conservation research project was provided in part by a grant from The Barakat Foundation. Transportation assistance was provided by Lufthansa German Airlines. Additional support for the Los Angeles venue came from the Al-Ameen Foundation and Joan Palevsky.

Philippe de Montebello
Director
The Metropolitan Museum of Art

Andrea L. Rich
President and Director
Los Angeles County Museum of Art

Acknowledgments

"The Legacy of Genghis Khan" is the outcome of several years of research, travel, and planning. It is an undertaking that could not have been accomplished without the generosity and cooperation of numerous institutions and individuals. We would like to acknowledge the assistance of the many organizations and colleagues who helped to bring this project to fruition.

We are greatly indebted to the forty lenders in thirteen countries who so graciously lent works to the exhibition from their collections. Of particular assistance were the following public and private institutions and their directors, curators, and key administrative staff (given in alphabetical order by country): at the Inner Mongolia Museum in Hohhot, China, Shao Qing Long, Huang Xue-Yin, and Fu Ning; at the David Collection, Copenhagen, Kjeld von Folsach and Mette Korsholm; at the Bibliothèque Nationale de France, Paris, Jean-Pierre Angrémy, Monique Cohen, Marie-Geneviève Guesdon, Thierry Grillet, and Cyril Chazal; at the Musée des Beaux-Arts, Lyon, Philippe Durey, Laurence Tilliard, Vincent Pomarède, and Muriel Le Payen; at the Musée du Louvre, Paris, Henri Loyrette and Sophie Makariou; at the Musée National de Céramique, Sèvres, Antoinette Hallé and Jacqueline Barlet; at the Deutsches Archäologisches Institut, Berlin, Helmut Kyrieleis, Antje Krug, and Dietrich Huff; at the Kunstgewerbemuseum, Berlin, Barbara Mundt and Suzanne Netzer; at the Museum für Islamische Kunst, Berlin, Volkmar Enderlein, Claus-Peter Haase, Jens Kröger, and Almut von Gladiss; at the Staatsbibliothek, Berlin, Antonius Jammers and Hartmut-Ortwin Feistel; at the Chester Beatty Library, Dublin, Michael Ryan, Elaine Wright, and Sinéad Ward; at the Miho Museum, Shigaraki, Japan, Takeshi Umehara and Hajime Inagaki; at the al-Sabah Collection, Dar al-Athar al-Islamiyyah, Kuwait National Museum, Kuwait City, Shaikh Nasser Sabah al-Ahmad al-Sabah, Shaikha Hussah Sabah al-Salim al-Sabah, Sue Kaoukji, Layla Mossawi, and Aurora Luis; at the Museum of Islamic Art, Doha, Qatar, Shaikh Saud bin Mohammed bin Ali al-Thani and Rebecca Foote; at the State Hermitage Museum, Saint Petersburg, Michael Piotrovsky, Mark Kramarovsky, Anatoli Ivanov, and Nina Michailovna Ivochkina; at the Musée d'Art et d'Histoire, Geneva, Cäsar Menz and Claude Ritschard; at the British Library, London, Graham Shaw and Beth McKillop; at the British Museum, London, Robert G. W. Anderson, Sheila Canby, Steve Drury-Thurgood, and Elizabeth Morgan; at the Edinburgh University Library, Ian R. M. Mowat and Richard Ovenden; at the Keir Collection, England, Edmund de Unger and Richard de Unger; at the Nasser D. Khalili Collection of Islamic Art, London, Nasser D. Khalili, Nahla Nassar, and Tim Stanley; at the National Museums of Scotland, Edinburgh, Dale Idiens, Ulrike al-Khamis, and Rosalyn Clancey; at the Victoria and Albert Museum, London, Mark Howat, Oliver Watson, David Wright, Rebecca Wallace, and Jody Trowbridge;

at the Art and History Trust Collection, Houston, Abolala Soudavar; at the Arthur M. Sackler Gallery, Smithsonian Institution, Washington, D.C., Milo C. Beach, Julian Raby, Vidya Dehejia, and Bruce Young, with special thanks to Massumeh Farhad; at the Asian Art Museum, San Francisco, Emily J. Sano, Forrest McGill, and Hanni Forester; at the Cleveland Museum of Art, Katharine Lee Reid, Louise Mackie, Mary Lineberger, and Mary Suzor; at the Cooper-Hewitt National Design Museum, Smithsonian Institution, New York, Paul Watkins Thompson, Lucy A. Commoner, and Cordelia Rose; at the Detroit Institute of Arts, Graham W. J. Beal, Elsie Peck, and Michelle Peplin; at the Harvard University Art Museums, Cambridge, James Cuno, Mary McWilliams, and Evelyn P. Bavier; at the Museum of Fine Arts, Boston, Malcolm Rogers, Julia Bailey, Kim Pashko, and Christopher Atkins; at the Pierpont Morgan Library, New York, Charles E. Pierce, William Voelkle, Marilyn Palmieri, and Lucy R. Eldridge; at the Textile Traces Collection, Los Angeles, Lloyd Cotsen and Miriam Y. Katz; at the Walters Art Museum, Baltimore, Gary Vikan, Marianna Shreve Simpson, and Laura Graziano; at the Worcester Art Museum, James A. Welu and Nancy L. Swallow; Oliver S. Pinchot; and Cyrus Behman and the late Mina Sadegh.

Because of the different areas of Islamic and Asian studies involved, an inter-disciplinary and international team was assembled to contribute to the catalogue: Sheila Blair, Norma Jean Calderwood Professor of Islamic and Asian Art, Boston College; Robert Hillenbrand, Professor of Islamic Art, Edinburgh University; Tomoko Masuya, Associate Professor of Islamic Art, Institute of Oriental Culture, Tokyo University; Charles Melville, University Lecturer in Middle East and Islamic Studies, Faculty of Oriental Studies, Cambridge University; Morris Rossabi, Professor of Chinese and Central Asian History, Columbia University and Queens College, City University of New York; and James C. Y. Watt, Brooke Russell Astor Senior Curator and Chairman, Department of Asian Art, The Metropolitan Museum of Art. Two important technical studies were also undertaken, one by Sarah Bertalan, former paper conservator, The Metropolitan Museum of Art, and the other by John Hirx, Marco Leona, and Pieter Meyers, Conservation Center, Los Angeles County Museum of Art. We are grateful to all the authors, not only for their very significant contributions to this volume but also for the great generosity of their time and their good-natured collegiality.

At the Metropolitan Museum, special thanks are due Mahrukh Tarapor, Associate Director for Exhibitions, and Daniel Walker, Patti Cadby Birch Curator of Islamic Art, for supporting this exhibition. This complex book would not have been possible without the efforts of the Metropolitan's Editorial Department and Photographic Studio—John P. O'Neill, Gwen Roginsky, Mary Laing (who edited

the catalogue entries), Jayne Kuchna, Margaret Donovan, Elaine Luthy, Peter Antony, Megan Arney, Minjee Cho, Anandaroop Roy, Mary Gladue, Anna-Marie Kellen, and Josephine Freeman. We are especially grateful to Ruth Kozodoy, who edited this catalogue with great skill and good humor, the latter a necessity in dealing with eight far-flung authors and almost as many languages, and to Bruce Campbell, who brought his elegant aesthetic sensibility to the catalogue's design. A special thanks goes to Qamar Adamjee, Research Assistant to Stefano Carboni in the Department of Islamic Art, for her efficiency and organizational skills and for her contribution to numerous catalogue entries. For their efforts in realizing the exhibition in New York, we would like to thank Daniel Kershaw, Exhibition Designer; Constance Norkin, Graphic Designer; Zack Zanolli, Lighting Designer; Herbert Moskowitz, Registrar; Elzbieta Myszczynski, Assistant to the Registrar; Linda Sylling, Associate Manager for Operations and Special Exhibitions; Patricia Gilkinson, Assistant Manager for Gallery Installations; Annick Des Roches, Administrative Assistant in the Department of Islamic Art; and Timothy Caster, Technician in the Department of Islamic Art. For the valuable opinions and assistance provided by colleagues in various departments, we would like to acknowledge in particular Yangming Chu in the Department of Asian Art and also Yana Van Dyke, Mike Hearn, Marilyn Jenkins-Madina, Nobuko Kajitani, Jean-François de Lapérouse, Stuart W. Phyrr, Donald J. LaRocca, Hwai-ling Yeh-Lewis, Jack Jacoby, Carol Lekarew, Martha Deese, Sian Wetherill, Rebecca Noonan, Olga Bush, and Egle Zygas.

At the Los Angeles County Museum, thanks go to Irene Martin, Assistant Director, Exhibitions, and Christine Lazzaretto and Beverley Sabo of the Exhibitions Department, and to J. Keith Wilson, Chief Curator, Asian Art. Sarah Sherman, Curatorial Administrator, Ancient and Islamic Art Department, gave unstinting help with things great and small. Interns, especially Saleema Waraich as well as Yael Rice, Ed Rothfarb, and Ladan Akbarnia, gave valuable assistance. We also thank John Hirx, Sabrina Carli, and Jean Neeman in Objects Conservation for their work on the Takht-i Sulaiman tiles, and June Li, Associate Curator of Chinese Art, for lending books and patiently answering questions. Other colleagues were most helpful: Stephanie Dyas and Karen Benson in Development-Grants; Ted Greenberg, Head Registrar, and Jennifer Garpner, Assistant Registrar; Samara Whitesides, Director's Office; Peter Brenner, Steven Oliver, and Annie Appel in Photographic Services; Art Owens in Operations; Kirsten Schmidt in Communications; Jane Burrell, Chief of Art Museum Education, and Gail Maxwell in Education; Anne Dierderick in the Research Library; Elvin Whitesides and

Megan Mellbye, in Audio Visual; J. Patrice Marandel, Chief Curator, European Art; Jeff Haskin and the Art Preparation staff; Katherine Go in Graphic Design; and Bernard Kester, designer extraordinaire.

We would also like to recognize the assistance in various capacities of Saeed Alizadeh, Marie-Hélene Bayle, Giovanna Gaeta Bertelà, Jonathan Bloom, Bernard Bohler, Alessandro Bruschettini, Isabelle Caussé, Chen Shujie, Albert E. Dien, Otgonnasan Dorzjav, Mina Eghbal, Priscilla Farnum, Gabriella di Flumeri, Maria Vittoria Fontana, ʿAbdallah Ghouchani, Frances Groen, Zari Jafar-Mohammadi, Hülya Karadeniz, Mohamed Reza Kargar, Richard Keresey, Kong Xiang Xing, Maan Madina, John Masson Smith, Donatella Mazzeo, Ralph Minasian, Elisabeth Naumann, Stacey Pierson, William Robinson, David Roxburgh, Zohreh Ruhfar, George Saliba, Marco Spallanzani, Carlo Maria Suriano, Wheeler Thackston, Paola Torre, Filippo Trevisani, Maria Grazia Vaccari, Edward Wilkinson, John Willenbecker, Joe-Hynn Yang, and Lyn Yunis.

We are deeply indebted to Thomas W. Lentz and Glenn D. Lowry, whose landmark 1989 exhibition "Timur and the Princely Vision" and its accompanying catalogue were the inspiration for the present exhibition and catalogue.

Finally, our respective directors—Philippe de Montebello and Andrea L. Rich—must be sincerely thanked for their unflagging support of, and interest in, "The Legacy of Genghis Khan."

Although our work on this exhibition took considerably less time than the journeys of Marco Polo, Ibn Battuta, and others who ventured to the Mongol empire, it seems as though we have traveled just as far and have seen sights almost as astonishing as those they witnessed.

Linda Komaroff
Curator of Islamic Art and
Department Head of Ancient and Islamic Art
Los Angeles County Museum of Art

Stefano Carboni
Associate Curator of Islamic Art
The Metropolitan Museum of Art

Lenders to the Exhibition

CHINA

Inner Mongolia Museum, Hohhot 182, 188, 189, 190, 194, 196, 200, 201, 202, 204, 205

DENMARK

The David Collection, Copenhagen 72, 73, 108, 109, 110, 128, 156, 167, 170

FRANCE

Bibliothèque Nationale de France, Paris 1, 5
Musée des Beaux-Arts, Lyon 163
Musée du Louvre, Paris 45, 46, 130, 133, 165
Musée National de Céramique, Sèvres 119, 120

GERMANY

Deutsches Archäologisches Institut, Berlin 87, 92
Staatliche Museen zu Berlin, Preussischer Kulturbesitz, Kunstgewerbemuseum 71, 75, 76
Staatliche Museen zu Berlin, Preussischer Kulturbesitz, Museum für Islamische Kunst 85, 86, 88, 89, 90, 91, 102, 103, 104, 105, 140
Staatsbibliothek zu Berlin, Preussischer Kulturbesitz, Orientabteilung 17, 18, 19, 20, 21, 22, 23, 24, 25, 26, 27, 28, 29, 30, 31, 32

IRELAND

The Trustees of the Chester Beatty Library, Dublin 33, 36, 38, 47, 60, 63, 65, 66

JAPAN

Miho Museum, Shigaraki 94

KUWAIT

The al-Sabah Collection, Dar al-Athar al-Islamiyyah, Kuwait National Museum, Kuwait City 9, 175

QATAR

Museum of Islamic Art, Doha 162

RUSSIA

State Hermitage Museum, Saint Petersburg 77, 78, 127, 138, 139, 142, 143, 144, 145, 146, 147, 149, 153, 154, 155, 157, 161, 198

Contributors to the Catalogue

Sarah Bertalan, former Associate Conservator, Sherman Fairchild Center for Works on Paper
and Photography, The Metropolitan Museum of Art

Sheila Blair, Norma Jean Calderwood Professor of Islamic and Asian Art, Boston College

Stefano Carboni, Associate Curator of Islamic Art, The Metropolitan Museum of Art

Robert Hillenbrand, Professor of Islamic Art, Edinburgh University

John Hirx, Head Objects Conservator, Los Angeles County Museum of Art Conservation Center

Linda Komaroff, Curator of Islamic Art and Department Head of Ancient and Islamic Art, Los Angeles
County Museum of Art

Marco Leona, Senior Conservation Scientist, Los Angeles County Museum of Art Conservation Center

Tomoko Masuya, Associate Professor of Islamic Art, Institute of Oriental Culture, Tokyo University

Charles Melville, University Lecturer in Middle East and Islamic Studies, Faculty of Oriental Studies,
Cambridge University

Pieter Meyers, Senior Conservation Chemist, Los Angeles County Museum of Art Conservation Center

Morris Rossabi, Professor of Chinese and Central Asian History, Columbia University and Queens
College, City University of New York

James C. Y. Watt, Brooke Russell Astor Senior Curator and Chairman, Department of Asian Art,
The Metropolitan Museum of Art

Notes to the Reader

Transliterations of Mongol, Persian, and Arabic names and terms have each been carried out according to the language of the original. Except for the *ayn* and *hamza,* most diacriticals have been eliminated, as is currently standard practice. Transliteration of Chinese follows the pinyin system.

The geographical area that is the main subject of this work has often been called Persia, but the ancient and enduring name used by its inhabitants is Iran. In this book the land is called Iran; the adjective "Persian" is frequently used to describe its culture.

Where relevant, both A.H. (Anno Hegirae, counting from 622, the year of Muhammad's hegira, or emigration, from Mecca) and A.D. dates are given.

THE LEGACY OF GENGHIS KHAN

It is not concealed from the minds of the intelligent and perspicacious or those possessed of vision and insight that history consists of recording and arranging. For every strange incident and marvelous unusual event that happens and is recorded in registers and on folios, the wise call the beginning of that event its date, and the extent and quantity of time can be known thereby. . . . And what event has ever been more magnificently appropriate for making it a date than the beginning of Genghis Khan's rule?

—Rashid al-Din, *Compendium of Chronicles*

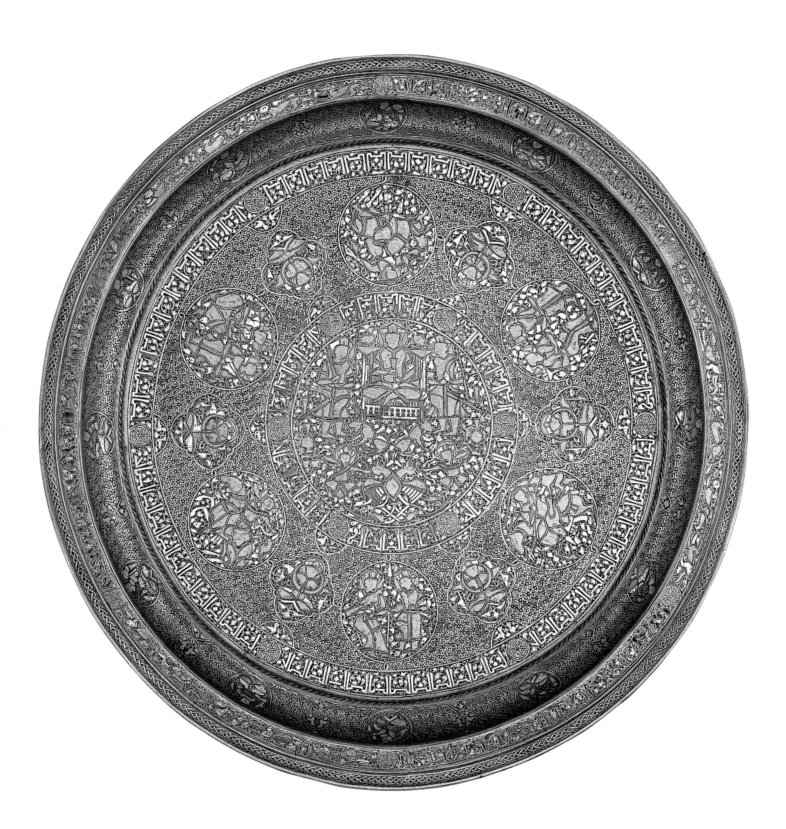

Introduction: On the Eve of the Mongol Conquest

[Genghis Khan] sallied forth, a single man, with few troops and no accoutrement, and reduced and subjugated the lords of the horizons from the East unto the West . . . and when through pride of wealth, and power, and station the greater part of the cities and countries of the world encountered him with rebellion and hatred and refused to yield allegiance (and especially the countries of Islam, from the frontiers of Turkestan to uttermost Syria), then wherever there was a king, or a ruler, or the governor of a city that offered him resistance, him he annihilated together with his family and followers, kinsmen and strangers.

— ʿAlaʾ al-Din ʿAta Malik Juvaini, *The History of the World Conqueror*[1]

The Persian historian ʿAta Malik Juvaini, who completed his history in 1260, was not an eyewitness to the initial wave of Mongol invasions led by Genghis Khan in the early thirteenth century, but he had just observed at first hand an equally devastating invasion of western Asia under the great conqueror's grandson Hülegü. Juvaini (1226–1283) belonged to a distinguished family from eastern Iran, many members of which had held high ministerial posts—most recently in the empire of the Khwarazmshahs, who were defeated by the Mongols in 1231. The young Juvaini himself rose to important offices under the Mongols, the highest being that of governor of Baghdad, southern Iraq, and western Iran; his brother, Shams al-Din Muhammad Juvaini, was appointed chief minister. Like his forefathers, Juvaini administered on behalf of princes who in turn made him wealthy.[2] But the world in which Juvaini lived was very different from that of his ancestors. It was a world transformed by massive destruction and loss of human life, tempered by new practices of governance, and invigorated by contact with such disparate cultures as those of China and (to a lesser degree) Christian Europe.

For nearly two centuries prior to the Mongol conquests of the early thirteenth century, Turkish rulers had dominated Greater Iran (the territories of modern Iran, Afghanistan, and parts of Iraq, the Caucasus, and Central Asia).[3] Foremost among these Turkish dynasts were the Seljuqs (1038–1194). Like subsequent non-Iranian rulers, they adopted indigenous practices: the administrative structure, the tax system, and, most significantly, the tradition of kingship and royal authority.[4] In the process of assimilating Persian culture they became important patrons of art and architecture.

Decorative arts flourished during the two centuries preceding the Mongol invasions.[5] Ceramic objects show the continued refinement of existing techniques and also benefited from the development of new ones. A new type of artificial ceramic

1. Juvaini 1958, vol. 1, pp. 24–25.
2. Ibid. (Introduction by John A. Boyle), pp. xxvii–xlvii; see also D. O. Morgan 1982.
3. "Persia" has long been another name for Iran (it is now somewhat outdated). In this book, while the adjective "Persian" is often used to describe the culture, the land is called Iran.
4. For this period, see Bosworth 1968.
5. See, among many works, Ettinghausen 1970; Hillenbrand 1994.

Opposite: Fig. 1 (cat. no. 159). Tray, northwestern Iran, late 13th century. Brass, inlaid with silver and gold. The Trustees of the British Museum, London (OA 1878.12-30.706)

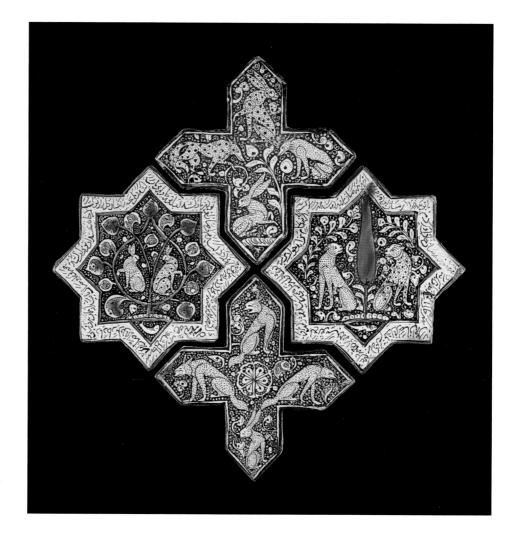

Fig. 2 (cat. no. 107). Star and cross tiles, Iran (Kashan), later 13th century. Fritware, overglaze luster-painted. The Trustees of the British Museum, London (OAG 1983.230, 231, 232a & b)

6. O. Watson 1985.

7. Melikian-Chirvani 1982, pp. 55–135; Ward 1993, pp. 71–82.

8. See, for example, Melikian-Chirvani 1986.

9. For example, Allsen 1997a, p. 96.

10. Serjeant 1972, pp. 87–96, 97–103; Mackie 1996, pp. 86–88.

11. The earliest illustrated manuscript to survive is a copy of the *Book of the Fixed Stars* by the astronomer ʿAbd al-Rahman al-Sufi (d. 986), who elaborated on the celebrated *Almagest* by Ptolemy. The book was copied and illustrated with drawings of the constellations in 1009; it is now in the Bodleian Library, Oxford (inv. Marsh 144). See Wellesz 1959.

body generally referred to as fritware came into use at this time. Combining ground quartz, glass frit (partially fused glass), and a small proportion of fine white clay, it was intended to approximate the light color and weight of Chinese porcelain. Such fritware was often decorated in one of two overglaze painting techniques, both of which were complicated and costly because they required the ware to be fired at least twice. In the first, luster-painted pottery, the decoration has a lustrous metallic color derived from silver and copper oxides. In the second and more colorful technique, so-called *minaʾi* (enamel) ware, enamel colors are applied to the previously glazed surface and then fixed in a second firing. The center for the ceramic industry was Kashan in central Iran. Luster vessels and tiles for architectural revetment continued to be made there after the Mongol invasions (figs. 2, 3),[6] but the *minaʾi* technique, mainly used to decorate vessels, did not survive the Mongol invasions. It may have evolved, however, into a related technique known as *lajvardina* after the Persian word for lapis lazuli, *lajvard*.

Beginning about the mid-twelfth century, luxury vessels and implements of bronze and brass were lavishly inlaid with silver and either copper or gold. Metalwork of this period represents a refinement and a surpassing of earlier techniques. Finely drawn wire and small, thin pieces of precious metal were inserted into designs cut in the surface of the metal object, and the precious metal was then embellished with finer details. Many of these inlaid metal wares, including buckets, candlesticks, pen cases, and inkwells, can be associated with eastern Iran; metalworkers

displaced by the Mongols may have carried their art both west and east (fig. 1).[7] Objects fashioned of precious metal from this period have not survived as well as base metalwork, but numerous references in contemporary texts provide additional information about them.[8] Vessels, jewelry, and other items of personal adornment were produced in gold and silver. Gold- and silver-smiths were among the craftsmen spared by the Mongols, a circumstance that helped keep these traditions alive in the Iranian world (fig. 4).[9]

Textiles played an essential role in the medieval Islamic world, serving not only as clothing and in all manner of furnishings but also as commodities for commercial exchange. Greater Iran was especially renowned for its luxury textiles, including elaborately patterned silks, sometimes woven with gold-wrapped thread; the most complicated and sumptuous silks were woven on drawlooms. The number of extant textiles of the eleventh to the early thirteenth century is few in comparison to the many textual references to great centers of production, especially in eastern Iran.[10] While the textile industry of eastern Iran did not survive the Mongol invasions, many of its weavers and associated textile craftsmen were transplanted to other locales and played an important part in the subsequent development of the arts under the Mongols.

The tradition of calligraphy and illumination (manuscript decoration) was perhaps the most important and best-established form of art, having begun in the seventh century, when manuscripts of the Koran were first copied in beautiful scripts and decorated with gold. Baghdad, the capital of the ʿAbbasid caliphate and for some centuries the cultural center of the Islamic world, was seminal in the development of calligraphy. This important tradition continued uninterrupted in Baghdad after the arrival of the Mongols in 1258 (fig. 5). The production of illustrated manuscripts of a scientific nature had a long-standing history in the Islamic world; it was prompted by the translation of Greek texts and their amplification with explanatory drawings.[11] Few works of literature with illustrations from before the fourteenth century survive, but those that do indicate that book painting had scarcely achieved the creative force and eloquence it would reach under the Mongols and their

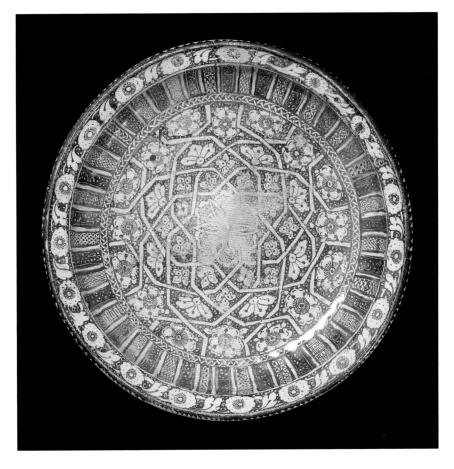

Fig. 3 (cat. no. 128). Luster-painted dish, Iran (Kashan), A.H. 667/A.D. 1268–69. Fritware, overglaze luster-painted. The David Collection, Copenhagen (Isl. 95)

Fig. 4 (cat. no. 140). Two belt ornaments, Iran or southern Russia, late 13th–14th century. Gold, pierced, chased, and worked in repoussé. Staatliche Museen zu Berlin—Preussischer Kulturbesitz, Museum für Islamische Kunst (I.889)

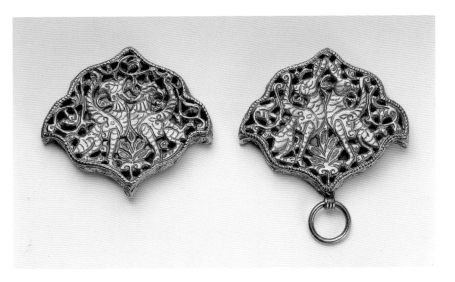

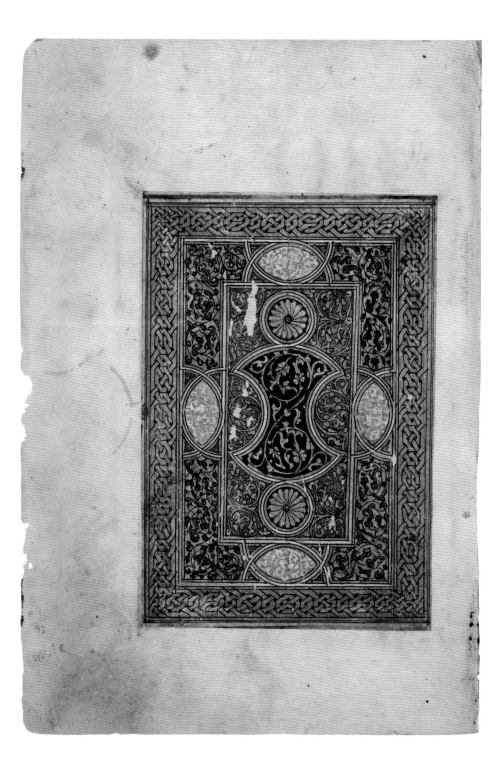

Fig. 5 (cat. no. 62). Opening page from *juz³* 15 of a thirty-part Koran, copied by Yaqut al-Mustaʿsimi, Iraq (probably Baghdad), A.H. 681/A.D. 1282–83. Fol. 1r; ink, colors, and gold on paper. The Nasser D. Khalili Collection of Islamic Art, London (QUR 29)

successors. As the extant pre-Mongol manuscripts demonstrate, a Byzantine-influenced style developed in the ʿAbbasid capital at the beginning of the thirteenth century, while a different style showing pronounced Iranian and Turkic influence was created in the Seljuq-controlled areas.[12] Artists under Mongol rule in Iran would eventually absorb both styles and combine them with the fruits of their encounter with East Asian art, creating one of the most extraordinary moments in the history of Persian painting.

The main architectural achievement of the pre-Mongol period was the development of the classic Iranian mosque type, constructed of baked brick and comprising a central courtyard with four rectangular vaulted chambers, or iwans, aligned along the axes. Fewer secular buildings than mosques have survived. Excavated palaces,

mainly from the eastern Iranian world and often lavishly decorated, incorporate a plan like that of the congregational mosques, with four iwans opening onto a rectangular courtyard.[13] The so-called four-iwan plan continued to be employed under the Mongols in both religious and secular architecture. Splendid patterns and designs, derived from the high-quality brick building material itself, were the primary means of architectural decoration in pre-Mongol Iran. Large-scale, extensive luster tilework began to be used to decorate the interior of religious monuments, especially shrine complexes, about the beginning of the thirteenth century. During the late thirteenth and fourteenth centuries, the Mongol period, the role of tile revetment as a kind of colorful decorative skin expanded considerably, extending to the exterior of buildings; at the same time a variety of new techniques and tile types were introduced.

Thus, on the eve of the Mongol conquest of the Iranian world, Persian arts, sponsored by Turkish patrons and built largely on indigenous traditions, had achieved a kind of golden age. The Mongols' devastating invasions of Central and West Asia between 1218 and 1258 brought much of this to an end. What replaced it was an original aesthetic idiom forged by the dramatic confrontation between the nomadic traditions of the Mongols and the urban Islamic culture of Greater Iran, and invigorated and refined by contact with East Asian art. An exhibition presenting the remarkable cultural achievements that followed a period of almost unfathomable destruction may seem an unlikely project. The fact is, however, that the practices of governance, patronage, conscription, and mercantile exchange adopted by the Mongols after their conquest produced a singular environment for artistic creation, and this in turn had a profound impact on the development of art and architecture throughout Eurasia and particularly in the Islamic lands of western Asia.

This exhibition and accompanying catalogue represent the first systematic investigation of the important artistic and cultural achievements that occurred in the Iranian world as a by-product of the Mongol conquest of Asia. They consider the striking new visual language, and its functions, sources, and means of transmission, that developed under the Ilkhanid dynasty (1256–1353) within a vast territory encompassing present-day Iran, Iraq, southern Russia, western Afghanistan, and eastern Turkey. Politically, the invasion of western Asia brought to a decisive end the long period of Arab-centered dominance there—as was underscored by the Mongols' termination in 1258 of the ʿAbbasid caliphate, which had ruled from Baghdad for over 500 years. Culturally, the Mongol invasions and the so-called Pax Mongolica had the effect of energizing Iranian art and infusing it with novel forms, meanings, and motifs that were further disseminated throughout the Islamic world. In uniting eastern and western Asia for over a century, the Mongols created a unique opportunity for an unrestricted cultural exchange that forever altered the face of art in Iran and made it a focal point of innovation and synthesis for the next three hundred years. This, too, was Genghis Khan's legacy.

LINDA KOMAROFF
STEFANO CARBONI

12. The best survey of pre-Mongol book illustration is still Ettinghausen 1962, esp. pp. 59–124.

13. The architecture of this period is summarized in Ettinghausen, Grabar, and M. Jenkins 2001, pp. 139–63.

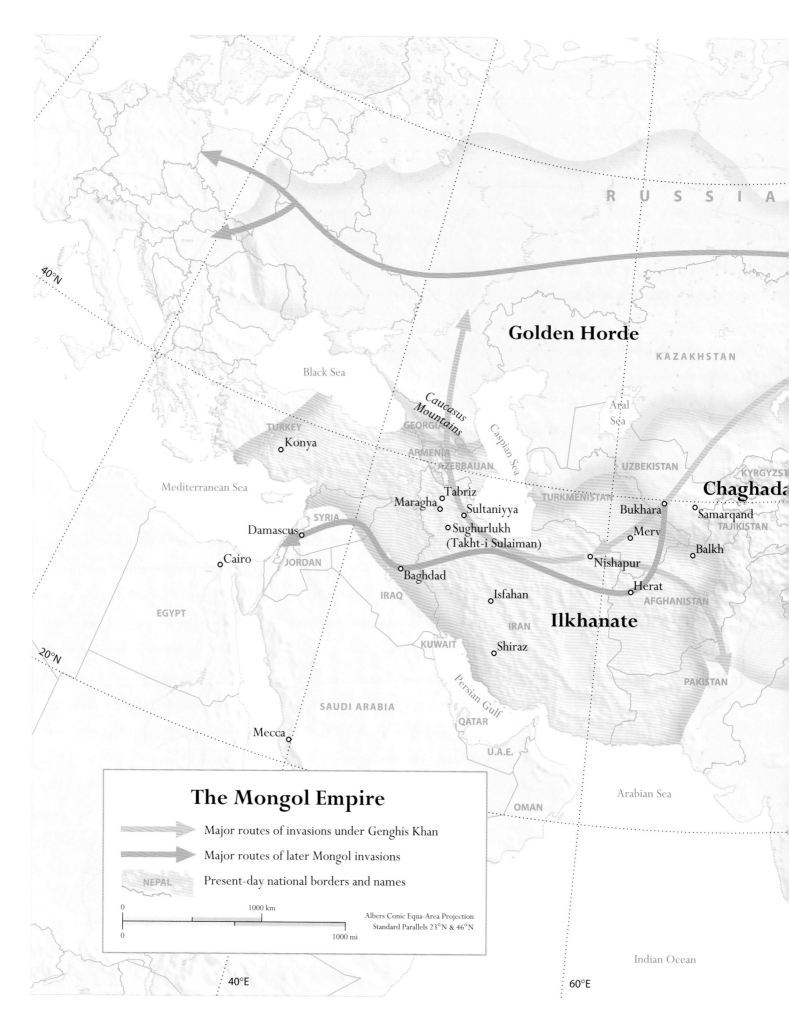

The Mongol Empire

Major routes of invasions under Genghis Khan

Major routes of later Mongol invasions

Present-day national borders and names

0 1000 km
0 1000 mi

Albers Conic Equa-Area Projection
Standard Parallels 23°N & 46°N

Golden Horde

Chaghada

Ilkhanate

RUSSIA

KAZAKHSTAN

Black Sea

Caucasus Mountains

TURKEY

Konya

Mediterranean Sea

GEORGIA

ARMENIA

AZERBAIJAN

Caspian Sea

Aral Sea

UZBEKISTAN

KYRGYZST

Tabriz

Maragha

Sultaniyya

Sughurlukh
(Takht-i Sulaiman)

TURKMENISTAN

Bukhara

Samarqand

TAJIKISTAN

Merv

Balkh

Damascus

SYRIA

Cairo

JORDAN

Baghdad

IRAQ

Isfahan

Nishapur

Herat

AFGHANISTAN

EGYPT

IRAN

KUWAIT

Shiraz

Persian Gulf

SAUDI ARABIA

QATAR

PAKISTAN

Mecca

U.A.E.

Arabian Sea

OMAN

NEPAL

Indian Ocean

40°N

20°N

40°E

60°E

8

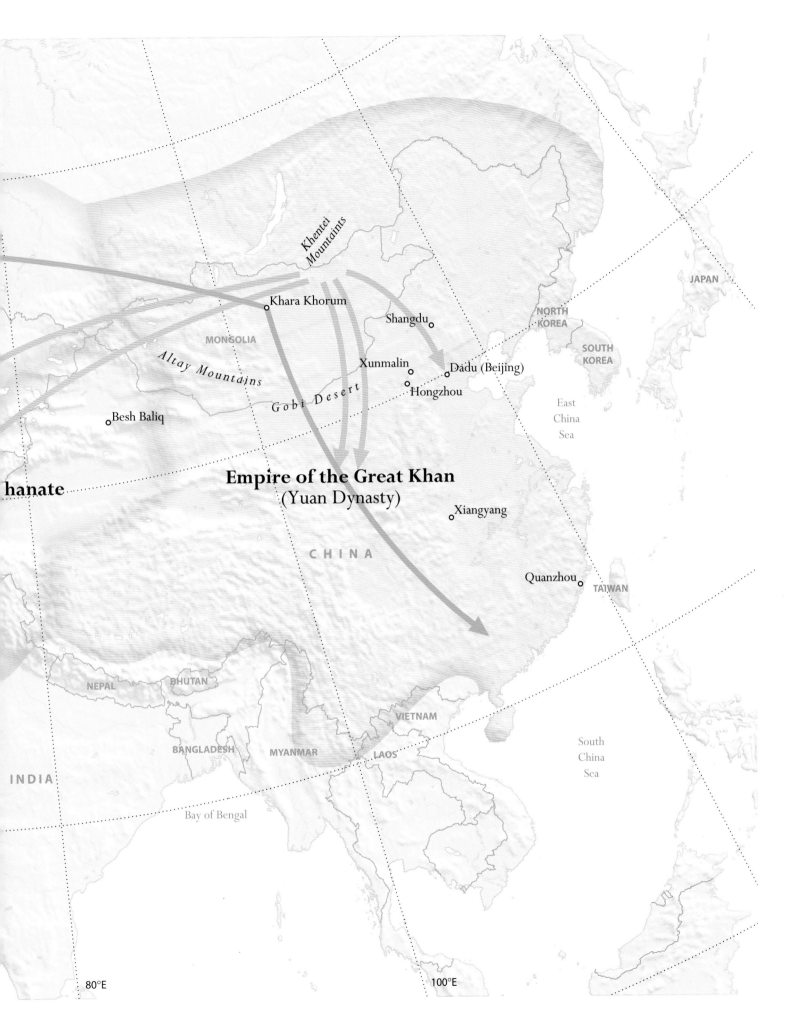

Khentei
Mountains

Khara Khorum

Shangdu

MONGOLIA

Xunmalin

Dadu (Beijing)

Altay Mountains

Hongzhou

Besh Baliq

Gobi Desert

East
China
Sea

hanate

Empire of the Great Khan
(Yuan Dynasty)

Xiangyang

CHINA

Quanzhou

TAIWAN

JAPAN

NORTH
KOREA

SOUTH
KOREA

NEPAL

BHUTAN

VIETNAM

BANGLADESH

MYANMAR

LAOS

INDIA

South
China
Sea

Bay of Bengal

80°E

100°E

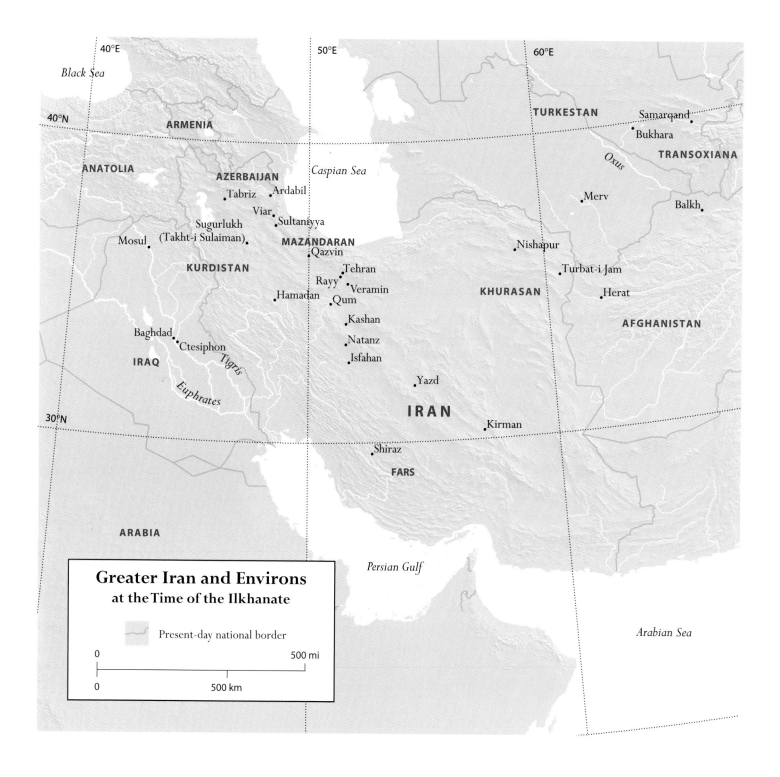

Greater Iran and Environs
at the Time of the Ilkhanate

Present-day national border

0 500 mi

0 500 km

The Mongol Khans

Great Khans shown in bold

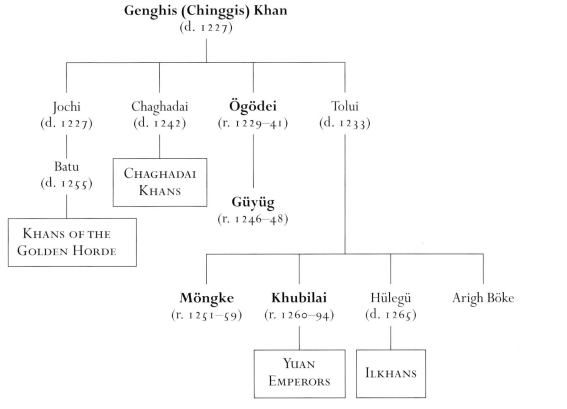

Genghis (Chinggis) Khan
(d. 1227)

Jochi
(d. 1227)

Chaghadai
(d. 1242)

Ögödei
(r. 1229–41)

Tolui
(d. 1233)

Batu
(d. 1255)

CHAGHADAI
KHANS

Güyüg
(r. 1246–48)

KHANS OF THE
GOLDEN HORDE

Möngke
(r. 1251–59)

Khubilai
(r. 1260–94)

Hülegü
(d. 1265)

Arigh Böke

YUAN
EMPERORS

ILKHANS

The Ilkhans

Ilkhans shown in bold

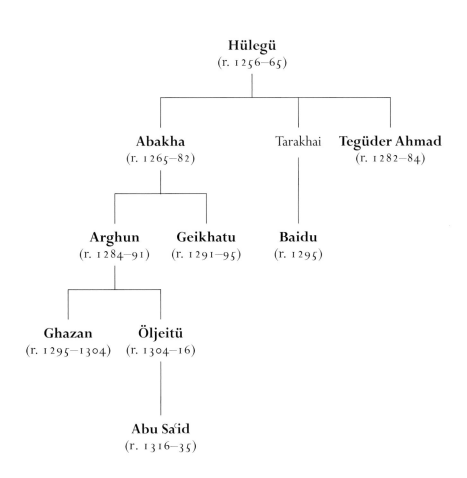

Hülegü
(r. 1256–65)

Abakha
(r. 1265–82)

Tarakhai

Tegüder Ahmad
(r. 1282–84)

Arghun
(r. 1284–91)

Geikhatu
(r. 1291–95)

Baidu
(r. 1295)

Ghazan
(r. 1295–1304)

Öljeitü
(r. 1304–16)

Abu Saʿid
(r. 1316–35)

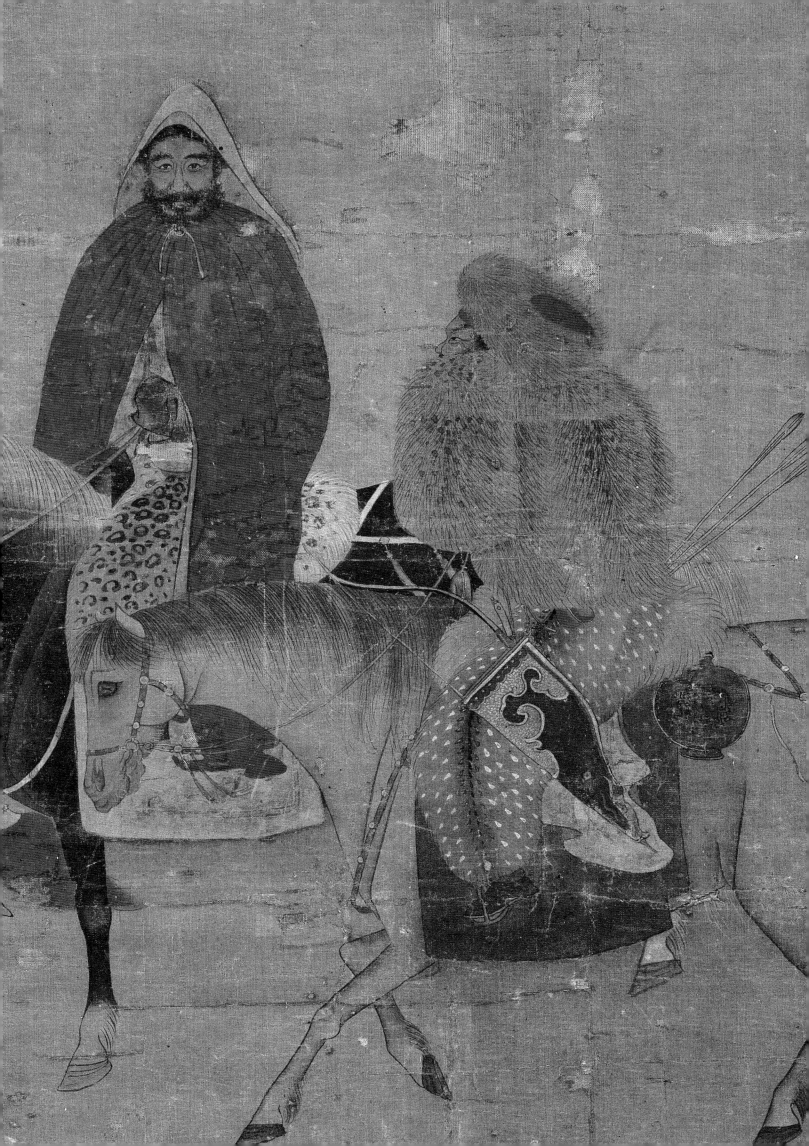

1.

The Mongols and Their Legacy *MORRIS ROSSABI*

*In these days, when, thank God, all corners of the earth are under our control and that of
Genghis Khan's illustrious family, and philosophers, astronomers, scholars, and historians
of all religions and nations—Cathay, Machin [North and South China], India, Kashmir,
Tibet, Uyghur, and other nations of Turks, Arabs, and Franks—are gathered in droves at our
glorious court, each and every one of them possesses copies of the histories, stories and beliefs
of their own people.*

—Rashid al-Din, *Compendium of Chronicles*[1]

The widely held image of the Mongols as barbaric plunderers intent on slaughter and destruction is based principally on Chinese, Persian, and Russian accounts of the thirteenth and fourteenth centuries. These contemporaneous descriptions emphasize the extraordinary speed and ruthlessness with which, under the command of their dreaded leader Temüjin (Genghis Khan, ca. 1162–1227), the Mongols carved out the largest contiguous land empire in world history. Little attention has been paid, however, to the significant contribution these steppe peoples made as patrons of the arts during the thirteenth and fourteenth centuries. Though the brutality of their military campaigns cannot be ignored, neither should their impact on Eurasian culture be overlooked.[2]

The Mongols supported cultural manifestations of great variety. Chinese theater, patronized by Temüjin's grandson Khubilai Khan and his successors during the Yuan dynasty (1271–1368), experienced a golden age.[3] Mongol rulers gave employment to Confucian scholars and Tibetan Buddhist monks, encouraging the construction of temples and monasteries.[4] In Iran, the Mongol era witnessed an outpouring of great historical writings, some of which dealt with the steppe peoples themselves.[5] Mongol khans funded medicine and astronomy throughout their domain and sponsored construction projects that promoted science and engineering. These included

1. Rashid al-Din 1998–99, pt. 1, p. 6.
2. I wish to thank Professor Charles Melville of Cambridge University, Dr. Stefano Carboni of The Metropolitan Museum of Art, Dr. Linda Komaroff of the Los Angeles County Museum of Art, and Professor Sheila Blair of Boston College for their valuable comments on drafts of this essay.
3. See Crump 1980, among other works on Yuan drama.
4. See Chan and De Bary 1982 for more on Buddhism and Confucianism in the Yuan. A recent study of some of the religious art is Jing 1994a.
5. For complete or partial translations of these histories, see Juvaini 1958; Rashid al-Din 1971; Juzjani 1970.

Opposite: Fig. 6 (cat. no. 178). *Mongol Rider
with Administrator* (detail), China, Yuan dynasty
(1271–1368). Color on silk. See fig. 15.

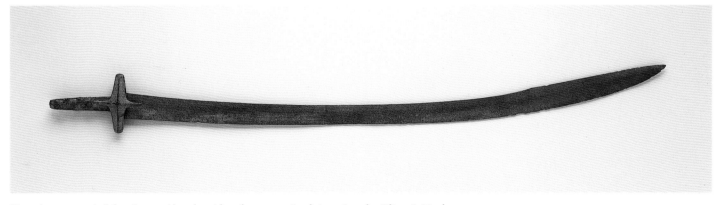

Fig. 7 (cat. no. 136). Saber, Iran, mid-13th–mid-14th century. Steel, iron. Lent by Oliver S. Pinchot

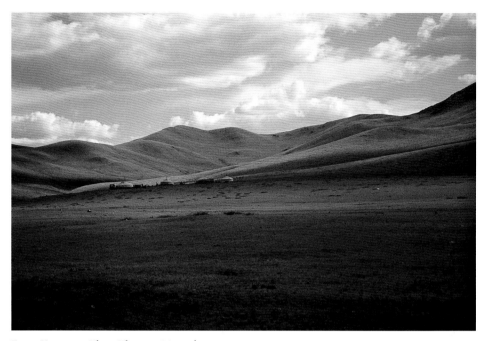

Fig. 8. View near Khara Khorum, Mongolia

the building of a capital city in Dadu (Daidu in Mongolian; present-day Beijing), summer palaces in Shangdu ("Xanadu") and Takht-i Sulaiman, and observatories in Maragha and Tabriz; the extension of China's Grand Canal; and the development of a sizable network of roads and postal stations.[6]

All of these developments stemmed from attitudes the Mongols held long before they occupied vast regions of Asia. The policy of support for trade and the crafts, for example, reflected the values and needs of a mostly pastoral nomadic lifestyle.

MONGOL CONQUESTS

Before their conquests, the Mongols were dependent largely on sheep, goats, yaks, camels, and horses for their existence and migrated several times annually to seek water and grass for the animals. The Mongols' principal unit of social and political organization was the tribe—a relatively small grouping and the optimal size for a herding economy such as theirs. Larger groups with more numerous herds would have depleted the grasslands very rapidly, necessitating even more frequent migrations. While the tribal system of organization fostered divisions and worked against the formation of a common identity, certain shared characteristics bound the tribes together. One was the Mongolian language, a member of the Uralic-Altaic group (which includes many of the languages spoken in Central and northern Asia, among them the Turkic languages). Another was their shamanistic religion, centering on belief in the shaman as an intermediary between humans and the spirit world.

The unforgiving, landlocked country inhabited by the Mongols embraced several types of terrain (fig. 8). The Altay Mountains to the west and the Khentei Mountains to the east hemmed in the northern areas of lakes and forest. The central, steppe region sustained most of the rather small and dispersed population. The south consisted of the inhospitable Gobi Desert, in which small numbers of nomads were able to eke out an existence. Mongol nomads were vulnerable to heavy snows,

6. On the debates about the extension of the Grand Canal, see Rossabi 1988b, pp. 188–90; on Dadu and Shangdu, see C.Y. Liu 1992 and Harada 1941; on the observatories, see Sayili 1960; and on the postal stations, see Olbricht 1954.

ice, and droughts (judging from contemporary trends, these last afflicted Mongolia about twice a decade), which jeopardized their herds and heightened their own sense of fragility. Beyond this demanding landscape to the south was China, with its vast population and its valuable goods. To the west were deserts and mountains, punctuated by flourishing oases, that were home to several regional powers, including the Xia dynasty and the Khwarazmian empire. They were crossed by the Silk Roads that led to Central and West Asia.

Chinese peasants could store the surplus of a bounteous harvest to tide them through some later catastrophe, but Mongol herders, despite occasional hunting and farming activity, had scant control over the conditions of their lives. Dependent on trade with China for their survival at times of natural disaster, they knew the value of commerce. Because China required few Mongol products, the economic relationship tilted in its favor. However, China was fragmented into regions controlled by three separate dynasties, the Jin and the Xia in the north and the Southern Song in the south. The Mongols, with their mobility, their powerful cavalry, and their accurate, far-reaching bows and arrows, had a decided military advantage, which induced the dynasties in northern China to consent to trade with them. Both the Jin dynasty, founded by a Tungusic people named the Jurchens, which dominated northern China from 1127 to 1234, and the Xia dynasty, ruled by a mixed Tibetan-Turkic group called the Tanguts, which controlled sections of northwestern China from about 985 to 1227, were trading partners of the Mongols.

A variety of factors help to explain the eruption of the Mongols in the thirteenth century. A drop in the mean annual temperature in the late twelfth and early thirteenth centuries drove some Mongols to leave Mongolia in order to escape the severe winters and to find food. Conditions deteriorated further when the Jin and Xia dynasties limited their trade with the Mongols.[7]

In addition, Temüjin was a man of powerful ambition. Claiming to seek conquest for the greater glory of the sky god, he proved extraordinarily adept at uniting the diverse and scattered Mongol tribes under his leadership, paving the way for military expeditions. Temüjin had been nine years old when his father was murdered, and he and his widowed mother had fended for themselves throughout his childhood and young adulthood—experiences that made clear to him the need for allies. His career in the late twelfth century consisted largely of forging blood brotherhoods, eliciting personal loyalty from tribal chiefs, and overwhelming and defeating hostile leaders.

Temüjin's unification of the Mongols, a gradual winning of dominion over all the small tribes and confederations in a territory three times the size of modern France, was probably his greatest achievement. In 1206 the title Chinggis Khan, meaning "Oceanic Ruler" or "Fierce Ruler" and in English usually written Genghis Khan, was bestowed upon him by an assemblage of the Mongol nobility.[8] His tightly disciplined army, which had helped him become ruler of all the Mongols, now acquired a new purpose. By 1215, within a decade after assuming his new title, Genghis Khan and his forces had defeated the Xia dynasty that ruled northwestern China and had routed the Jin troops, occupying the area around what is now Beijing. Shortly thereafter he moved farther west and became embroiled in a war with the

7. G. Jenkins 1974.
8. Ratchnevsky 1991 is the most important study of the Mongol ruler.

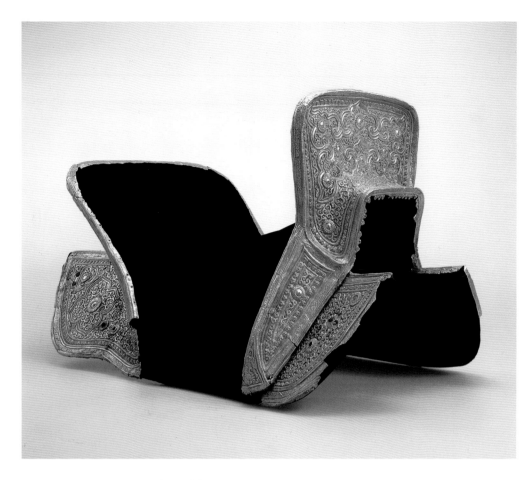

Fig. 9 (cat. no. 137). Saddle arches and fittings, Mongol empire, first half of the 13th century. Gold, worked in repoussé, remains of iron rivets. The Nasser D. Khalili Collection of Islamic Art, London (MTW 795)

Khwarazmshah, the Islamic ruler of Central Asia (in areas corresponding to modern-day Uzbekistan and Turkmenistan). During a campaign lasting from about 1219 to 1225, the Mongols conquered and occupied a vast territory that reached to Samarqand and Bukhara and northern Iran, with one military detachment dispatched all the way to the Caspian Sea.[9]

But Genghis Khan's conquests were only the beginning. After his death in 1227 his son and successor, Ögödei (1185–1241), sent troops to impose Mongol rule in Korea, northern China, Georgia, Armenia, parts of West Asia, and Russia, prevailing with astonishing speed. In 1241 there were even forays into Hungary and Poland. Genghis's grandsons enlarged the Mongol domains to include the rest of China and Iran. His grandson Khubilai Khan (1215–1294) founded the Yuan dynasty ruling northern and western China in 1271 and in 1279 finally defeated the Southern Song dynasty to gain control over all of China. Farther west, Khubilai's brother Hülegü (ca. 1217–1265) conquered the ʿAbbasid dynasty, which ruled from Baghdad and had at one time governed a huge territory extending from Spain and North Africa through West Asia to Iran (see figs. 33, 35). He also subjugated the powerful Ismaʿilis, or Order of the Assassins, a secret Shiʿite order of Islam based in the mountainous area south of the Caspian Sea. After these victories Hülegü established the Ilkhanid dynasty in Iran in 1259–60.

At the same time, and even before Khubilai's accession, the Mongol empire had started to fragment because of internal rivalries among Genghis's four principal sons and their families and supporters. By 1260 the empire was composed of four khanates: the Yuan dynasty, which ruled in China (including Mongolia); the Golden Horde, in Russia; the Chaghadai Khanate, in Central Asia; and the Ilkhanate, in Iran and other parts of West Asia.[10] These separate powers were frequently in conflict with one another. Genghis had forged unity by inspiring a direct personal loyalty to him, but thereafter unity eluded the Mongols.

Khubilai Khan and his brother Hülegü, sons of Genghis's son Tolui, dominated two of the most important of the Mongol domains, China and Iran. Their astonishing successes were due in part to military skill, characterized by tight discipline, fine cavalries, superb organization, innovative military tactics (for example, feigned retreat, which lured the advancing enemy into a trap), and the ability to recruit defeated Turkic, Chinese, and Persian commanders and soldiers into their armies.

9. The primary source on this campaign is Juvaini, as translated in Juvaini 1958.
10. For some of these conflicts, see Rashid al-Din 1971; Rossabi 1988b; Rossabi 1988c, pp. 133–83.

The spectacular victories of a few hundred thousand troops over advanced civilizations with millions of inhabitants also owed much to the political disorganization across much of Asia. As noted, three separate dynasties reigned over different parts of China; Russia was far from united; and the Islamic ʿAbbasid dynasty that ruled in West Asia and North Africa was in a state of decline. Thus it was through a combination of their own prowess and their enemies' weaknesses that the Mongols, who in the majority of conflicts were outnumbered, swiftly and decisively defeated the forces of most of the great Asian civilizations.

THE MONGOLS GOVERN IN CHINA

Unlike previous invaders from the steppes— such as the Huns and several early Turkic peoples—the Mongols wanted more than plunder from the territories they seized. To be sure, they lusted after the resplendent silks, jewelry, carvings, and other goods found in China, Iran, and Russia (figs. 4, 11, 62, 66, 207). But by the time Genghis's sons and grandsons came to power, their concern was partly to ensure a steady supply of these products, and they recognized that devastation of the native economies would be counterproductive in the long run. Rather than spread instability and chaos through systematic pillaging, they therefore opted to reestablish viable governments in the lands they had occupied. Iran and China proved to be the two principal countries that the Mongols worked to govern.

Although Hülegü's uncle Ögödei (r. 1229–41) and his older brother Möngke (r. 1251–59) had begun the process of devising institutions for governance in China, it was Genghis's grandson Khubilai, reigning from 1260 until his death in 1294, who truly effected the transition from nomadic conquest to sedentary rule (fig. 14). All of China was reunited under his sovereignty: his predecessors had taken over the territories of the Xia and the Jin, and Khubilai, by defeating the Southern Song in 1279, completed the unification of the country. His mother saw to it that he lived most of his early life in northern China and was tutored by Chinese Confucian scholars and Buddhist monks. Khubilai developed feelings of empathy with his Chinese subjects alongside the traditional Mongol attitudes and beliefs that were part of his upbringing. His introduction of the latter into China and his effort to maintain a balance between the Mongol and Chinese cultures would have a substantial impact on Chinese art and its diffusion throughout the Mongol domains. Before his confirmation as Great Khan, however, he had to withstand a major challenge to his power from his younger brother Arigh Böke, who represented the Mongol traditionalists opposed to any accommodation with Chinese culture. By

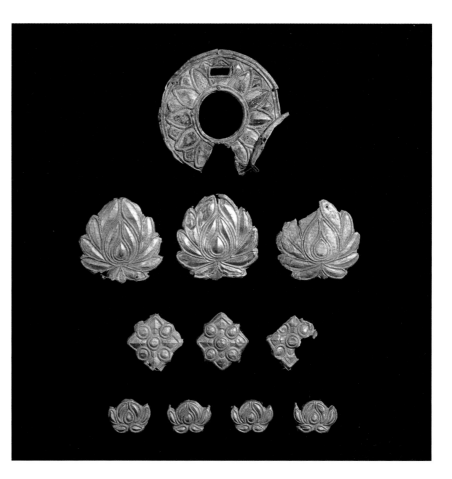

Fig. 10 (cat. no. 141). Horse trappings, probably Greater Iran, 13th–14th century. Silver gilt, worked in repoussé, chased, and incised. The Nasser D. Khalili Collection of Islamic Art, London (MTW 795)

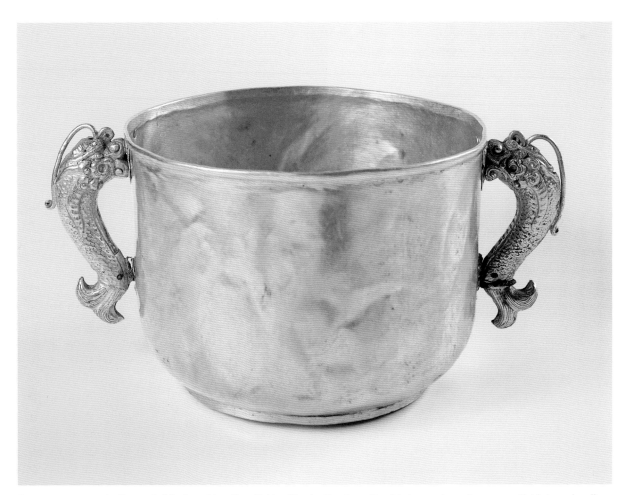

Fig. 11 (cat. no. 139). Cup with fish-shaped handles, Golden Horde (Southern Russia), late 13th–14th century. Gold sheet, handles worked in repoussé and engraved. State Hermitage Museum, Saint Petersburg (SAR-1613)

Fig. 12 (cat. no. 153). Covered goblet with bird finial, probably Iran, late 13th–early 14th century. Silver, punched, engraved, chased. State Hermitage Museum, Saint Petersburg (Kub-364)

Fig. 13 (cat. no. 149). Handled cup, Golden Horde (Southern Russia), late 13th–14th century. Gold sheet, engraved, chased, and worked in repoussé. State Hermitage Museum, Saint Petersburg (SK-589)

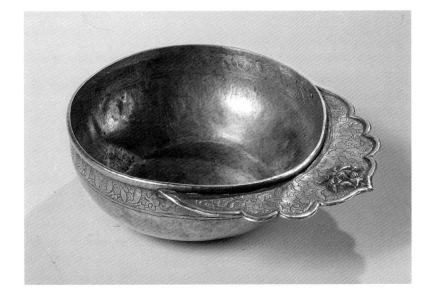

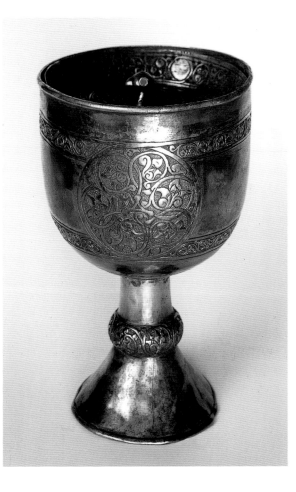

1264 Arigh Böke had been defeated, leaving Khubilai free to implement his own policies.

First he sought to ingratiate himself with his Chinese subjects by restoring familiar practices and institutions.[11] He reinstituted the traditional Confucian rituals at court, including those of music and dance; he built Altars to the Gods of the Soil and Grain, at which officials performed ceremonies to ensure good harvests. Even more telling was his construction of a great temple, signaling his acceptance of the Chinese belief in the power of ancestors to intercede in human affairs and the necessity of consulting them on questions of great importance.[12]

Confucianism taught that an emperor who ruled according to its traditional principles had a mandate from heaven to govern China. In seeking to legitimate himself as an emperor of China, Khubilai built a shrine for Confucius at his court and took other steps to gain the backing of Confucian officials and academicians. He supported the writing of dynastic histories, an activity valued by China's rulers since the Han dynasty (206 B.C.–A.D. 220). For Chinese officials, the consideration of historical events and the identification of parallels to contemporary developments often shaped the making of policy, giving enormous significance to history. Khubilai ordered archives and records of the dynastic regimes the Mongols had subjugated to be collected, in preparation for the drafting of a history. He restored the Hanlin Academy (a literary academy at which edicts were drafted for the emperor) and the National History Academy (composed of compilers, editors, and scholars) to coordinate the writing of these works. At the same time he impressed Chinese scholars by having some of the Confucian classics translated into Mongolian.[13] Offering the Mongol elite greater access to a knowledge of Chinese civilization might lead to their Sinicization, an appealing prospect for Chinese Confucians.

Khubilai had recruited Confucian advisers from his earliest days, a policy that would go on to influence the next generation of Mongols. Several of these counselors helped him devise the laws and administrative system for his dynastic rule. Others taught Khubilai and members of the Mongol elite the basic tenets of Chinese culture, lessons that were appealing because they emphasized practical knowledge that the steppe overlords could make use of in ruling China. Khubilai even chose to employ Confucian scholars as tutors for his second son, Zhenjin ("True Gold" in Chinese), an important signal to the Chinese of his growing interest in and attraction to their culture.[14] The emperor adopted a Chinese name, Yuan, for his dynasty; the general meaning of "Yuan" is "origin," but in the *Book of Changes*, a classic Chinese work, it signifies "origins of the universe" and "primal force." Thus the dynasty's name was directly linked to a major Chinese text and a central Chinese belief. Another demonstration of Khubilai's effort to please the Chinese was his commitment

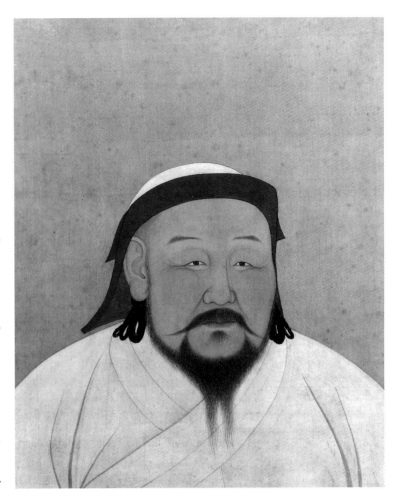

Fig. 14. *Khubilai Khan* (r. 1260–94), Yuan dynasty (1271–1368), second half of the 13th century. Album leaf; ink and color on silk. National Palace Museum, Taipei

11. See Rossabi 1988b, pp. 136–41.
12. See ibid., p. 134.
13. Fuchs 1946.
14. *Yuanshi* 1976, pp. 2888–93 (chap. 115); Tu 1962, chap. 76, pp. 1a–1b.

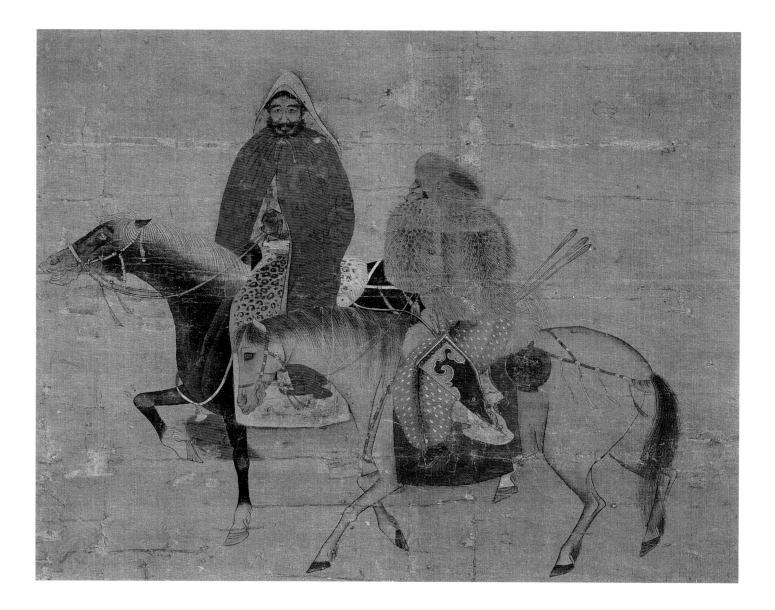

Fig. 15 (cat. no. 178). *Mongol Rider with Administrator,* China, Yuan dynasty (1271–1368). Color on silk. The Art and History Trust, Courtesy of the Arthur M. Sackler Gallery, Smithsonian Institution, Washington, D.C. (LTS 1995.2.7)

to achieving an accurate calendar, one major responsibility of a traditional emperor. Recruiting the Persian astronomer Jamal al-Din and the Chinese astronomer Guo Shoujing, he charged them to devise a new calendar more precise than any previous one.

The governmental institutions the Mongols established differed from their traditional Chinese models in only two significant respects. First, the new rulers did not restore the civil service examinations that had long been the sole means of recruiting officials. (When the tests were finally reestablished in the early fourteenth century, they were still not used as the only criterion for staffing the bureaucracy.) For the Mongols to rely on the examinations in choosing their officials would have been tantamount to turning over the government to the Chinese, who obviously were far better equipped to pass the Confucian-oriented tests. Suspending the examinations for almost the duration of the Mongol dynasty made possible the second deviation from traditional practice, the recruitment of non-Chinese for government positions. The Mongol khans appointed Muslims from Central Asia and Iran to be fiscal administrators and in one case governor of a province, Tibetans to supervise the Buddhist monasteries, and a Nepalese to serve as manager of all the artisans in China.[15]

15. Rossabi 1981; H. Franke 1981, pp. 306–10.

Otherwise, nearly all the institutions of Yuan government resembled those of the traditional Chinese dynasties. The khans fulfilled the duties of the emperors, the determination of policy and supervision of the bureaucracy; the Secretariat, as before, assisted the emperors in the formulation of policy and the drafting of edicts; and the Six Ministries—War, Justice, Public Works, Rites, Personnel, and Revenue—implemented and enforced the policies devised by the emperor and the Secretariat. The Censorate, which had been used by the Chinese emperors to spy on the bureaucracy, was granted even greater authority to inspect and report on corrupt, untrustworthy, or ineffective officials—partly because most officials were not Mongols. The Mongol system of local administration also followed that established by the Chinese dynasties.

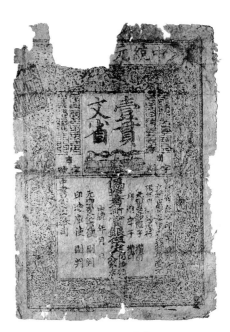

Fig. 16 (cat. no. 198). Paper bill (currency), China, Yuan dynasty (1271–1368). Ink on paper. State Hermitage Museum, Saint Petersburg (GE KH-3027)

SOCIAL AND ECONOMIC POLICIES AND THE ARTS

In their social and economic policies, however, the Mongols deviated from Chinese practice. New policies supporting trade and other dealings with foreigners had a dramatic impact on the arts and crafts and led to the diffusion of Chinese motifs and techniques westward. Chinese ambivalence about relations with foreigners had persisted since the time of the Han dynasty, a thousand years earlier. Most Chinese officials opposed any movement toward greater involvement with foreign lands, although merchants, innkeepers, and others who profited from trade were less hostile to the idea. The Mongols, on the other hand, had actively cultivated relations with foreigners. As pastoral nomads they had relied on trade, and now as they

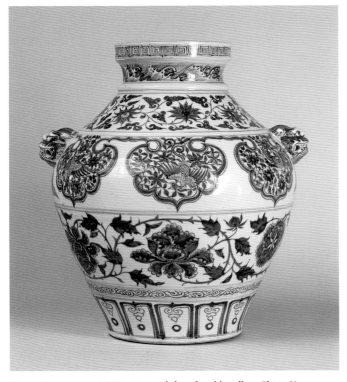

Fig. 17 (cat. no. 193). Wine jar with lion-head handles, China, Yuan dynasty (1271–1368). Porcelain, underglaze painted. The Cleveland Museum of Art, John L. Severance Fund (1962.154)

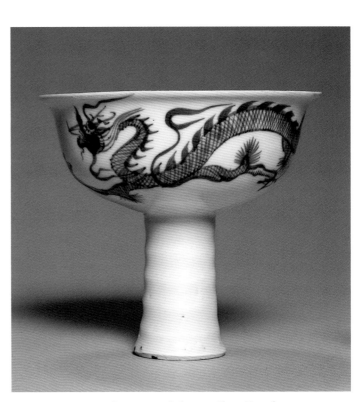

Fig. 18 (cat. no. 192). Stem cup with dragon, China, Yuan dynasty (1271–1368). Porcelain, underglaze painted. The Cleveland Museum of Art, Severance and Greta Millikin Collection (1964.169)

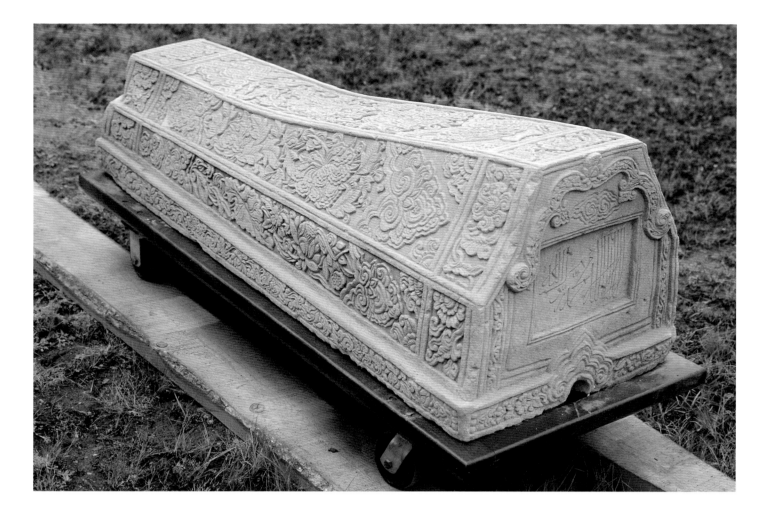

Fig. 19 (cat. no. 205). Cenotaph with inscription in Arabic, China, Yuan dynasty (1271–1368), 14th century. Stone. Inner Mongolia Museum, Hohhot

embarked on the rule of great sedentary civilizations they continued to foster commerce. In China they encouraged the increased use of paper currency (fig. 16), built roads and postal stations to facilitate transport, extended the Grand Canal almost to the new capital in Dadu, and promoted the development of *ortoghs* (merchant associations).[16] The *ortogh* benefited from government loans at low rates of interest—which, frequently used to finance the risky long-distance caravans that carried goods to Central and West Asia, reduced the economic burden on any single merchant. Support such as this paved the way for a considerable growth in commerce.

The Mongol rulers also lifted some of the earlier Chinese restrictions on travel by merchants and on the conduct of trade. In addition, the damagingly high tax on commercial exchanges was cut to a relatively modest 3⅓ percent. Unlike the Chinese dynastic rulers, they neither restricted the profit that could accrue to traders nor enacted sumptuary legislation to regulate their lifestyles. Perhaps equally important, the Mongol khans accorded merchants a higher status than they had had under the traditional Chinese dynasties. Official Chinese ideology denigrated trade and portrayed merchants as parasites who did not produce but merely exchanged goods. Chinese officials both perceived and treated merchants as a lower class in the social hierarchy. When the Mongols reversed that negative image of commerce and elevated the status of merchants, both Chinese and foreign traders benefited.

This change in perception and policy ushered in an era of unprecedented, large-scale trade throughout Eurasia. Goods flowed relatively freely from the empire of

16. On the *ortoghs*, see Endicott-West 1989.

Fig. 20 (cat. no. 182). Textile with griffins, China, Yuan dynasty (1271–1368). Lampas weave, silk. Inner Mongolia Museum, Hohhot

17. Kuwabara 1928, p. 25.
18. See Rossabi 1981, p. 275.
19. Chen Dasheng 1984, pp. 15–63. See also Leslie and Youssef 1988.
20. *Journey into China's Antiquity* 1997, pp. 34–35.
21. Allsen 1994, p. 73. See also Crowe 1991.

the Yuan dynasty to the Mongol Ilkhanate in Iran as well as to Central, South, and Southeast Asia. China received horses, camels, and spices in exchange for the copper cash (coins), silks, and porcelain it exported (fig. 17).[17] Exposure to Chinese art influenced the work of craftsmen in Iran.

It was merchants from Iran and West Asia who transported most of the goods between Yuan and Ilkhanid lands. Few Chinese traveled westward; foreigners generally came to China. Persian traders arrived overland along the caravan trails of Central Asia to northwestern China and by ship via the Indian Ocean to the southeast coast of China. After trading they returned by the same difficult routes, bearing Chinese goods. Some from the West remained in Yuan China, where they formed virtually self-governing communities, with leaders known as shaikhs al-Islam (in Chinese, *huihui taishi*) and *qadis,* or interpreters of Islam (*huijiaotu faguan*) (see fig. 19).[18]

Quanzhou in southeastern China was an important center for these foreign merchants. Their community in that city had its own bazaars and hospitals and by the middle of the fourteenth century, according to one source of the period, six or seven mosques.[19] Excavations of the front doors, the mihrabs, and stone tablets nearby have shown that several of the mosques were either built or repaired during the Yuan dynasty. A Yuan-period Muslim cemetery yields more information on the contacts between Persians and Chinese. Names and titles in the gravestone inscriptions show that many, if not most, of the buried were Persians. Though the brief memorial writings are in a mélange of Arabic, Persian, and Chinese, nearly all the cited places of origin of the dead are in Iran. Several of those buried were from Tabriz; other cities mentioned include Isfahan, Nisa, and Bukhara. At least one had been on the hajj, or pilgrimage to Mecca.

In light of the restrictions on foreign travel for Chinese merchants, the discovery in Quanzhou of a stone tablet that describes just such a mission is extraordinary. The stele commemorates a certain Chinese merchant's trip to the court of the Ilkhan Ghazan (r. 1295–1304), who had recruited him to come collect and then deliver tribute owed to the Yuan emperor, Khubilai's grandson. In 1299 the Yuan court sent the trader back to Iran as its official emissary.[20] There can scarcely be greater confirmation of the Mongols' favorable attitude toward trade than the selection of a merchant to fill the position of court envoy.

This point of view and the growing trade with West Asia that it fostered paved the way for artistic cross-fertilization. Among the Chinese goods exchanged in commercial transactions were porcelains, silks (fig. 25), and perhaps scrolls, all lightweight and easily transported products. Persian craftsmen were able to admire these works, study them, and borrow their designs. It is known that Chinese books on agriculture and medicine and at least one major Mongol work, a historical chronicle known as the *Altan Debter* (Golden Book), reached Iran via trade. Other books may well have contained patterns, motifs, and descriptions of techniques used by Chinese craftsmen.[21]

The Mongols' generally benevolent policies toward foreign religions also facilitated relations among different territories within their recently conquered domain. Their own shamanistic beliefs notwithstanding, Mongol leaders determined early on that an aggressive imposition of their native religion on newly acquired subjects would make ruling them difficult. Instead they ingratiated themselves with prominent

local clerics, who then more readily accepted Mongol government. Genghis Khan himself initiated this policy by courting a Daoist monk named Changchun, as a contemporaneous account, translated by Arthur Waley, makes clear. Learning that the Daoists had a formula for immortality, Genghis invited Changchun to accompany him on one of his campaigns and in the course of it asked for some of the concoction. The monk's response (recorded by a disciple traveling with him) was, "I have means of protecting life, but no elixir that will prolong it."[22] Genghis, despite his disappointment, continued to treat Changchun as a sage and offered him lavish inducements to remain with the Mongols. The most plausible explanation for this hospitality is that Genghis hoped to gain the confidence of the Daoist wise man and through him of his own Chinese subjects, on the assumption that a religious leader could induce his followers to acquiesce to a new overlord. Genghis prudently cultivated the Daoist and Buddhist monks and rewarded them, principally with tax exemptions, to induce them to remain loyal to the Mongols.[23]

The same policy was pursued by Genghis's son Ögödei and his grandsons Möngke and Khubilai. Khubilai was an especially generous patron of the religions in China. Buddhism was the faith favored by Chabi, his most influential wife (fig. 27), and he also supported his mother's religion, Nestorianism, a heretical Christian sect. Marco Polo, who was in China from 1275 to 1292, quoted Khubilai as saying, "There are four prophets who are worshipped and to whom everybody does reverence. The Christians say their God was Jesus Christ; the Saracens Mahomet; the Jews Moses; and the idolaters Sagamoni Burcan [the Shakyamuni Buddha], who was the first god of the idols; and I do honour and reverence to all four, that is to him who is the greatest in heaven and more true, and him I pray to help me."[24]

The Yuan dynasty's openness toward foreign religions allowed relations between China and Iran to flourish. The Mongols, who had never ruled a great sedentary empire, needed foreign assistance to govern China. Khubilai in particular recruited Persian and Central Asian Muslims, some already living in China, to help him. He needed non-Chinese to serve as officials and advisers, since it would not have been wise to rely exclusively on the Chinese, whom his uncle Ögödei and he had only recently subjugated. Although from time to time, fearful that Muslims might gain too much power, Khubilai imposed political and occasionally religious restrictions on them, in general he offered them countless opportunities. Muslims were employed as supervisors of trade, *darughachi* (commissioners), censors, and tax collectors. The skilled administrator Sayyid Ajall Shams al-Din was Khubilai's choice to become the first governor of the newly conquered province of Yunnan. Khubilai even recruited Persians and Central Asians into his military forces. In 1271, for example, his nephew ruling in Iran, the Ilkhan Abakha, dispatched two specialists who were quite helpful to the Mongol troops laying siege to the important Southern Song town of Xiangyang. The two Persians constructed a mangonel and a catapult, which hurled huge boulders, one of which crashed into the central tower at Xiangyang and did so much damage that the Chinese forces surrendered. Impressed with the Westerners' ability, Khubilai set up a special government office, the Superior Myriarchy of Muslim Trebuchet Operators and Military Artisans, to maintain and operate siege engines obtained from Iran.[25]

22. The work by the disciple, Li, is translated in Li 1931, p. 101.
23. Rachewiltz 1962, p. 198.
24. Marco Polo, *Il milione*, as translated in Polo 1938, p. 201.
25. Farquhar 1990, p. 259. See also Goodrich and Feng 1945–46, p. 118; Rossabi 1981, p. 287.

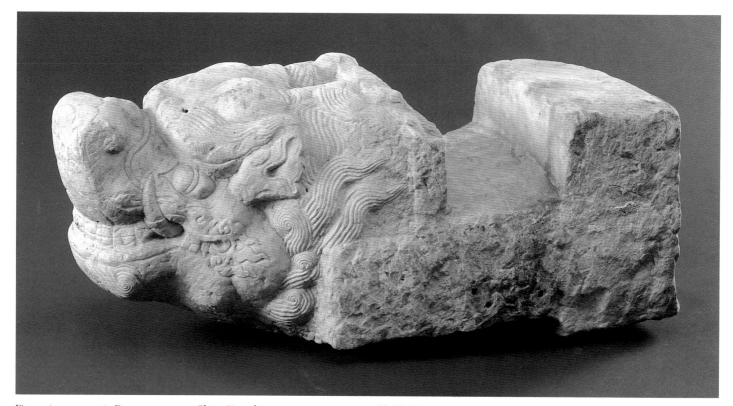

Fig. 21 (cat. no. 204). Dragon protome, China, Yuan dynasty (1271–1368), second half of the 13th century. White marble. Inner Mongolia Museum, Hohhot

In addition to playing roles in government and in the military, Muslims offered scientific and cultural expertise to Khubilai and his Yuan-dynasty successors. The Mongol rulers of China recognized that the Persians had superior astronomical instruments, and at least one Persian astronomer was invited—or perhaps compelled—to come to China. His diagrams of an armillary sphere and the actual instruments he brought with him served as models for Chinese astronomers. Guo Shoujing, the leading Chinese astronomer, developed a calendar that the Chinese used for four centuries, basing it on one previously devised by a Persian astronomer.[26] These Persian contributions prompted the court to found in 1271 the Institute of Muslim Astronomy, which subsequently supervised the Yuan government's observations and its activities concerning climate and the skies.[27]

Through their close contacts with Islam, the Mongol rulers in China also learned about the effectiveness of Persian medicine. Plagued by physical ailments, perhaps caused in part by an increasing rate of alcoholism after their successful conquests, the Mongols were interested in obtaining the most advanced therapies.[28] They imported thirty-six volumes on Persian medicine and founded Muslim pharmaceutical bureaus in Dadu and Shangdu, both eventually subsumed under the Office for Muslim Medicine.[29] These various offices supplied medicines for the imperial family and its guards and also for poor residents of the cities. Culinary dishes of Persian origin were imported along with medical know-how. Even so quintessentially Chinese a dish as *jiaozi* (dumplings) may have come to China from West Asia during the Mongol era.[30]

Exploring these interests required knowledge of the languages of West Asia, especially Persian. In 1289 the Yuan court established the Muslim National College

26. *Yuanshi* 1976, pp. 136 (chap. 7), 3845–52 (chap. 164). Guo Shoujing's home has just been turned into an excellent museum in Beijing.

27. The Institute of Muslim Astronomy persisted into Ming times. See Ho Peng-yoke 1969, p. 140.

28. Smith 2000, pp. 51–52.

29. See Rall 1960; Rall 1970.

30. Buell and Anderson 2000, pp. 159, 283, 314.

with Erudites for Teaching the Arabic Script, in which officials were trained to translate and interpret Persian. A special group of clerks, designated Muslim Scribes and Muslim Copyists, were parts of the sub-bureaucracy throughout the empire.[31] These measures ensured that anywhere in the Mongol domain there were a certain number of bureaucrats who could communicate in Persian.

Eager to encourage artisans and the practice of crafts, the Mongols instituted policies that had the additional effect of dispersing artistic motifs from one to another of the Mongol lands. Genghis recognized that the almost constant movement of his people when they were pastoral nomads had prevented their developing a sizable artisan class. Therefore he set about acquiring access to the talents of foreign craftsmen. Even in military operations he put artisans in a special category: after conquering Samarqand, for example, he spared thirty thousand craftsmen, whom he distributed among his sons and kinsmen.[32] Genghis not only saved the craftsmen but also frequently freed them from ordinary corvée labor and taxes. His son Ögödei continued the same policy, particularly after he had begun building the first Mongol capital, at Khara Khorum in Mongolia. He needed to recruit and employ numerous foreign artisans, who were mostly either Chinese or from Muslim lands. The palaces in Khara Khorum, the buildings for storage, and the sites of ordinary housing—in many cases heated by steam canals beneath the floor—offer strong evidence of Ögödei's success. One of the recruited craftsmen, a French silversmith named Guillaume Boucher captured by the Mongols in eastern Europe, constructed a remarkable fountain that dispensed a variety of liquors. Bronze mirrors, gold and silver vessels, porcelains, and lacquer cups were discovered in the 1940s by Russian archaeologists excavating the site. Although some of these may have been imported, the find in its totality testifies to the high quality of craftsmanship Ögödei could command in this relatively remote area in Mongolia.[33] Like his nomadic forebears, Ögödei cherished his mobility and built several additional seasonal residences, each of which required the efforts of large numbers of artisans.[34]

Khubilai was the master builder of the Mongols in East Asia. The summer capital he constructed in Kaiping, which he renamed Shangdu (Coleridge's Xanadu), in what is now Inner Mongolia, had a marble palace described by Marco Polo: "The halls and rooms and passages are all gilded and wonderfully painted within with

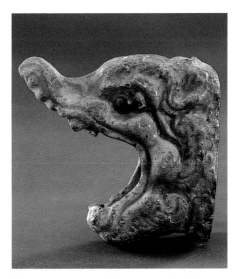

Fig. 22 (cat. no. 190). Dragon mask, China (Inner Mongolia), Yuan dynasty (1271–1368). Glazed earthenware. Inner Mongolia Museum, Hohhot

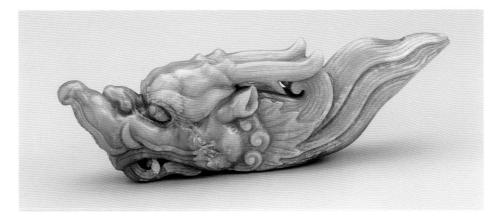

Fig. 23 (cat. no. 206). Dragon's head finial, China, Yuan dynasty (1271–1368). Jade. Arthur M. Sackler Gallery, Smithsonian Institution, Washington, D.C., Gift of Arthur M. Sackler (S1987.819)

31. *Yuanshi* 1976, p. 2127 (chap. 85).
32. Juvaini 1958, vol. 1, p. 122.
33. For a report on the work of the Russian archaeologists, see Kiselev 1965. For the French silversmith, see Olschki 1946.
34. Boyle 1972.

35. Marco Polo, *Il milione,* as translated in Polo 1938, vol. 1, p. 185.
36. C.Y. Liu 1992 downplays the role of the Muslim architect and emphasizes that the city was based on Chinese models.
37. Chu 1956, p. 245.
38. Farquhar 1990 provides a complete list of these agencies.
39. Ibid., p. 200.

pictures and images of beasts and birds and trees and flowers and many kinds of things, so well and so cunningly that it is a delight and a wonder to see."[35] Modeled in a general way on existing Chinese capital cities, Shangdu consisted of several sectors. In the Outer City lived the bulk of the population, mostly in mud or board houses. The Inner City, surrounded by a brick wall 10 to 16 feet in height, housed the khan, his retinue, and other officials. Though its grandiose palaces and offices do not survive, tiles and other objects from them have been found (figs. 21, 22, 83, 105). The city also encompassed a wild preserve retained for hunting, a traditional Mongol pursuit. The mosques and Buddhist monasteries in the Outer City required the services of foreign artisans.

Khubilai also recruited craftsmen to build the even more elaborate capital Dadu, in China. One of the principal construction supervisors was a Muslim; where specifically he came from is unclear.[36] Although most of these skilled workers were Chinese, artisans of other groups—Khitans, Jurchens, Muslims, and eventually Nepalese—also took part in the construction. The city was modeled on a traditional Chinese capital, with walls, ancestral temples, and Altars to the Gods of the Soil and Grain.

Khubilai sought to entice craftsmen for his architectural and public works projects by offering them favorable treatment. Although traditional Chinese scholar-officials had prized fine handiwork, they had accorded a relatively low status to the artisans themselves. Khubilai raised their social standing and granted them special concessions and privileges. In addition to being relieved of corvée obligations, craftsmen were often provided with food and clothing. Once they had filled their government quotas they could sell on the open market any products that remained.[37]

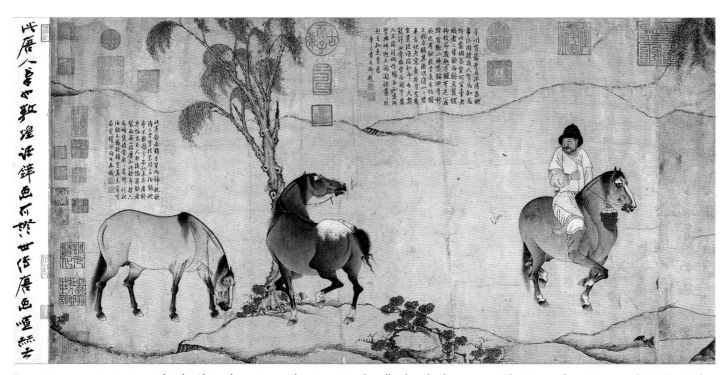

Fig. 24 (cat. no. 177). *Six Horses* (detail), China, this section 14th century. Handscroll; ink and color on paper. The Metropolitan Museum of Art, New York, Bequest of John M. Crawford Jr., 1988 (1989.363.5)

In time the Mongols acquired an astonishing number of government offices to supervise the production of craft articles, some of them traditional agencies but many newly established. Representative of this proliferation is the array of departments concerned solely with textiles. The directorate general of the Office of Rare Textiles managed Superintendencies for Brocade Weaving and Dyeing, Rare Embroideries, and Gauze, which produced silks for the court. In addition, the heir apparent had his own Offices of Brocade, Gold Brocade, and Weaving and Dyeing. The Ministry of Works supervised additional Embroidery, Gauze, and Gold Brocade Offices and a Bureau for Patterned Satins, which in turn managed government and private artisan workshops both in the capital

Fig. 25 (cat. no. 186). Textile with paired parrots, China or Mongolia, 13th–14th century. Tabby, brocaded, silk and gold thread. The Art and History Trust, Courtesy of the Arthur M. Sackler Gallery, Smithsonian Institution, Washington, D.C. (LTS 1995.2.8)

and in various silk production centers throughout the empire. About one-half of the eighty agencies in the Ministry of Works dealt with the production and collection of textiles (see fig. 20).[38]

Other agencies in the Ministry of Works oversaw other crafts. Several offices managed metal works, with separate Bronze, Silver, and Steel Bureaus. Jade Polishing and Carving had its own office (fig. 23), as did Leather and Felt Production. Though the principal tasks of the ministry were the construction and repair of government works and the supervision of artisans, the majority of its subordinate offices were actually government workshops in which luxury items were manufactured for the imperial court.[39] The imperial court also had its own, separate bureaus, including a Gold Thread Office, a Porcelain Office (fig. 18), an Ivory Office, and a Gold and Silver Utensils Superintendency.

Unlike the preceding Song dynasty, the Yuan did not have a separate government-sponsored painting academy. Instead, the Mongol rulers appointed to the Hanlin Academy those Chinese painters who were willing to serve them (see figs. 15, 24), including the most renowned painter of the Yuan dynasty, Zhao Mengfu. Many painters refused positions in an alien government. They continued to work on their own, developing an amateur painting tradition that would dominate Chinese painting henceforth.

As with astronomy and medicine, artisanship that had developed in other parts of the domain was explored by Mongol rulers, who enticed or compelled talented craftsmen to move from their original lands. For example, Ögödei and succeeding khans based in Mongolia and China admired textiles produced in Central Asia and transported several communities of weavers eastward—to northern China and what are now Xinjiang and Inner Mongolia. In particular, they sought craftsmen

Fig. 26 (cat. no. 77). Purse, Golden Horde (Southern Russia), second half of the 13th century. Silk, woven, gold-embroidered. State Hermitage Museum, Saint Petersburg (ZO-763)

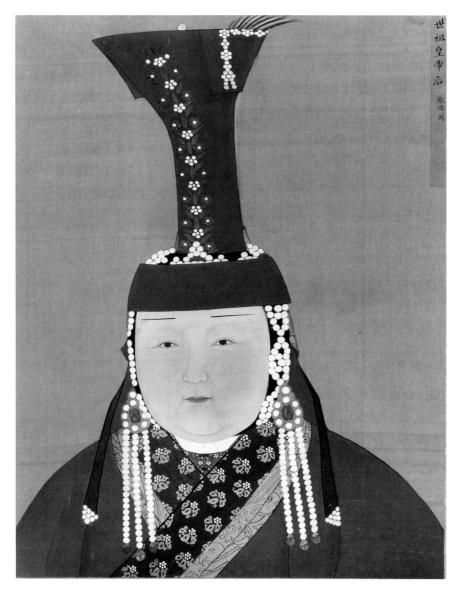

世祖皇帝后 徹伯爾

Fig. 27. *Chabi, Consort of Khubilai Khan,* Yuan dynasty (1271–1368), second half of the 13th century. Album leaf; ink and color on silk. National Palace Museum, Taipei

skilled at weaving the renowned "cloth of gold" (*nasij*) (fig. 25).[40] Because the Mongol leaders cherished these luxury products, they took pains to sustain the silk-producing communities, keeping them busy with orders for silk robes, banners, or items with Buddhist motifs. It is possible that the Mongols also moved craftsmen working in media other than textiles from Iran and Central Asia to China and vice versa, but there is no written record of any such relocations.

Many of the "craftsmen" so valued by the Mongols were women.[41] It was women who wove textiles, in particular the cloth of gold prized by the Mongol court. They and their households received the same privileges and exemptions as male artisans. Little is known of these craftswomen because the Chinese scholar-officials who wrote the historical accounts hardly mentioned women. Women received little recognition in traditional Chinese society and thus rarely appear in historical records.

Mongol society placed fewer restrictions on women, and there were notable female figures in Mongol China, Central Asia, and Iran.[42] Because women played a vital role in the pastoral economy of the Mongols, milking and caring for the livestock and making clothing as well as performing household tasks, they had considerable status and a degree of power. In addition to their usual work, they assumed the duties of the men during military campaigns, an obligation that was formalized in the legal codes.[43] Thus Mongol women led more active lives and were more valued than other East Asian women, although they did not achieve equality with men.

It is, therefore, no accident that several women among the Mongol elite enjoyed considerable authority and power. Genghis's mother, widowed by the murder of her husband, was praised in the histories for keeping her family together during difficult times. But the most influential and renowned woman among the Mongol elite was Sorghaghtani Beki, Genghis's daughter-in-law and the mother of Khubilai. The Persian historian Rashid al-Din (1247–1318) wrote that she was "extremely intelligent and able and towered above all the women in the world." The contemporary Syrian physician Bar Hebraeus (1226–1286) quoted these words of another: "If I were to see among the race of women another woman like this, I should say that the race of women was far superior to that of men."[44] Sorghaghtani Beki raised all four of her sons to be rulers, insisting that they become literate and be tutored by an international coterie of advisers and also that they adopt policies of religious toleration in their

40. See Watt and Wardwell 1997; Watt 1998.
41. Bray 1997, pp. 187–91.
42. Rossabi 1992a.
43. Riasanovsky 1965, p. 153.
44. Rashid al-Din 1971, p. 168; Bar Hebraeus 1932, vol. 1, p. 398.

domains. She governed her own lands in North China, fostering rather than exploiting the native agrarian economy and offering a model of proper rule for her sons.[45]

The most celebrated women of the next generation were Chabi and Dokhuz Khatun. Chabi, Khubilai's wife (fig. 27), substantially influenced her husband and the direction of his government. A fervent Tibetan Buddhist, she made sure that Khubilai supported the religion by funding monasteries and recruiting Tibetan monks for government positions (this was compatible with his endorsement of Confucian philosophy). She persuaded Khubilai to accord every possible consideration to the two captured empresses of the defeated Southern Song dynasty and to oppose the Mongol impulse to expropriate Chinese agricultural land and convert it to pastureland.[46] In Iran, Hülegü's wife Dokhuz Khatun, a Nestorian Christian, promoted the interests of her coreligionists at the Ilkhanid court, seeing to it that several Nestorians assumed prominent government positions. She may have played a role in negotiating, or at least fostering, a marriage between Hülegü's son Abakha and Maria, the illegitimate daughter of the Byzantine emperor Michael VIII.[47]

Because of their considerable status and the major roles they occasionally played, Mongol women of the elite were able to influence artistic developments. Women were supporters of the arts; Khubilai's great-granddaughter Sengge achieved renown as an outstanding collector of Chinese painting and also one of the great patrons of painters. Her distinctive taste in art is reflected in the unorthodox collection of bird and flower paintings she assembled.[48] Other Mongol women who

45. *Yuanshi* 1976, pp. 35 (chap. 1), 912 (chap. 43).
46. *XinYuanshi* 1962–69, p. 6837; *Yuanshi* 1976, pp. 115 (chap. 6), 2871 (chap. 114).
47. Lippard 1984, p. 197.
48. See Fu 1978 for more on this collection.

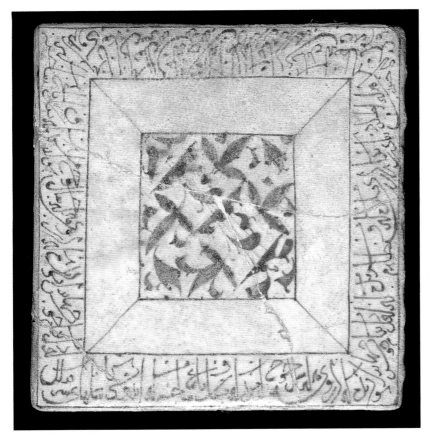

Fig. 28 (cat. no. 127). Square tile with inscription in Persian, Golden Horde (New Saray, Southern Russia), 14th century. Fritware, underglaze painted. State Hermitage Museum, Saint Petersburg (GE SAR-1491)

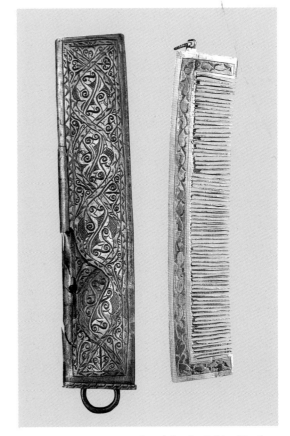

Fig. 29 (cat. no. 144). Comb and sheath, Golden Horde (Southern Russia), 14th–15th century. Silver gilt, engraved, chased, punched, and inlaid with a black compound. State Hermitage Museum, Saint Petersburg (TB-43a, b)

49. Allsen 1991, pp. 228–31.

adopted Buddhism provided funds for Buddhist ritual and artistic objects. Still others were consumers who specially ordered jades, textiles, and porcelains for themselves or their households.

PARALLELS WITH ILKHANID IRAN

This discussion of the Mongol impact on the arts has so far been focused on China. Many similar patterns prevailed in the western Mongol domains, particularly in the Ilkhanate, centered in Iran. This is not surprising, since the Ilkhanid rulers and the Mongol rulers in China maintained relatively close contact and were political allies. In 1260, when Khubilai and a younger brother, Arigh Böke, had competed for the throne, their brother Hülegü, in power in Iran, had supported the eventual winner, Khubilai. Khubilai had been opposed, however, by the Golden Horde in Russia and the Mongol khanate in Central Asia, neither of which accepted Khubilai as the Great Khan. Hülegü, in choosing the title Ilkhan (subordinate khan), acknowledged the supreme authority of the Great Khan. For some years his successors accepted this nominally subordinate status—for example, issuing coinage inscribed with such phrases as "struck by Abakha in the Khaghan's [Khan's] name"—even though the Ilkhanate was politically autonomous. Later the Ilkhan Ghazan, a convert to Islam determined to govern as a Muslim ruler, would reject this symbolic fealty to the Great Khan,[49] and his successors would turn even further away from East Asia.

Until that time, however, relations between the Ilkhanate and the Yuan remained

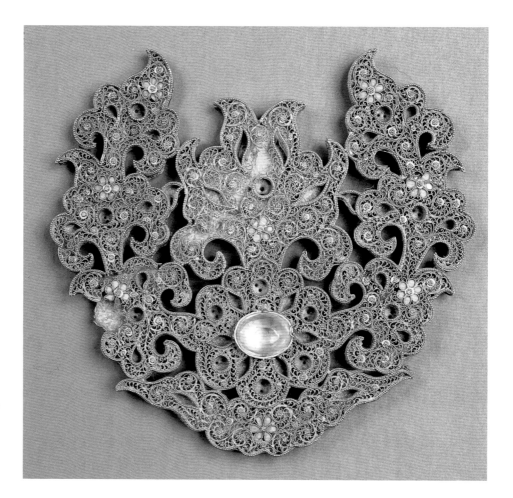

Fig. 30 (cat. no. 145). Pendant, Mongol empire, mid-13th century. Gold sheet, worked in repoussé, engraved, filigree, granulation, set with rock crystal. State Hermitage Museum, Saint Petersburg (SA-8091)

close. Marco Polo provides an account, confirmed by other sources, of Khubilai sending the Mongol princess Kökejin from China in 1291, by ship, to be the bride of the Ilkhan Arghun (r. 1284–91), in response to the Ilkhan's request for a wife. The emperor's embassy accompanying Kökejin consisted of Arghun's envoys, the Polos, and an escort of ninety men. In addition, officials privately funded the travel of seventy merchants to return to China with Persian goods, calculating that as part of an official mission they would be able to bring the merchandise in duty-free and it could then be sold at a handsome profit.[50] The episode attests to the habitual flow of goods back and forth between Iran and China, as well as to the relative ease of sea travel. Land travel was also feasible, despite Khubilai's conflict with the ruler of Central Asia. The Nestorian cleric Rabban Sauma, the first native of Dadu (Beijing) known to have reached Europe, encountered few problems when he journeyed from China to the Ilkhanate sometime between 1275 and 1279.[51] Persian ambassadors and traders continued to arrive in China, strengthening the Ilkhanate's relations with the Yuan dynasty. Even routes from as far away as Europe, via Iran, to China had become so well traveled that in the 1330s the Florentine writer Francesco Balducci Pegolotti could describe the itinerary in great detail, specifying the number of men and animals required for the caravans, the quantity of goods needed to turn a profit, and the approximate distance from one major halting place to another.[52]

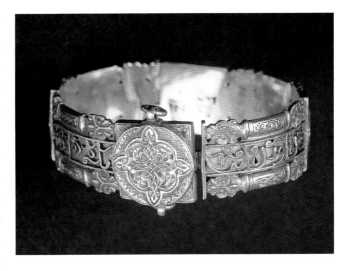

Fig. 31 (cat. no. 147). Bracelet, Golden Horde (Southern Russia), early 14th century. Gold sheet and wire, engraved, stamped, chased, and punched, with a black compound. State Hermitage Museum, Saint Petersburg (ZO-717)

Thus in the years from about 1259 to 1295, during the reigns of Hülegü and his successors, Iran was uniquely open to interchange with Central and East Asia and receptive to influences from those lands.[53] Like their Yuan cousins, the early Ilkhans actively promoted contact with foreigners, recruiting non-Persians, particularly non-Muslims, to serve in their bureaucracy. Their encouragement of commerce resulted in Persian merchants reaching west to Europe and east across Asia and in Persian becoming a lingua franca for merchants and bureaucrats in Eurasia.

The Ilkhanid rulers borrowed from the Yuan the concept of paper money and tried to introduce its use. While the policy's goal was to add to the government's coffers—the profligacy of corrupt officials had drained the state's treasury—it would also have been a boon to trade. The attempt failed, however, because the government could not persuade native merchants of the new money's efficiency and soundness; most merchants suspected that the government intended, by means of the currency, to gather up for itself all the precious metals in the country.[54] When Ghazan assumed the throne he sought to adopt policies even more favorable to merchants than those previously in effect. He reduced taxes on traders and commercial transactions, devised uniform weights and measures, and established fixed standards for the weight and value of coins, measures that resembled ones taken by the Mongols in China.

Both the Yuan dynasty and the early Ilkhanid rulers tolerated a wide variety of religions. The Ilkhans supported Buddhism, for which many temples and monasteries were established. They did not discriminate against the Nestorian Christian community in their midst, however, and permitted the continuation of a patriarchate in

50. Cleaves 1976, p. 188. See Rachewiltz 1997 for a magisterial refutation of those who doubt that Marco Polo reached China.
51. See Rossabi 1992b for an account of his travels.
52. Yule 1966, vol. 3, pp. 137–71.
53. Juvaini 1958, vol. 1, p. 608; Jahn 1970, p. 118.
54. Jahn 1970, p. 102.

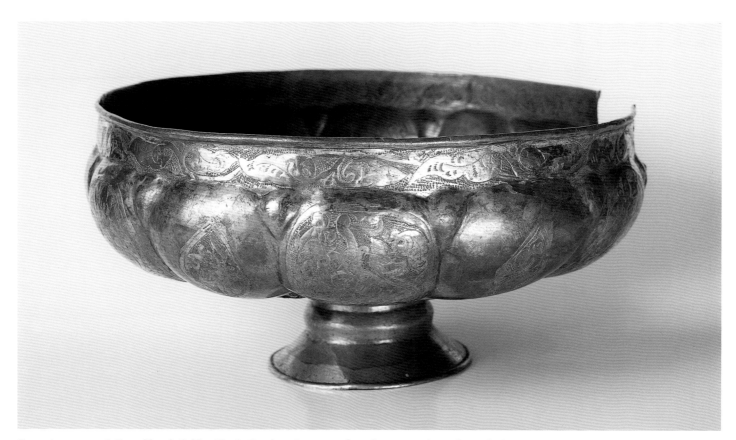

Fig. 32 (cat. no. 157). Footed bowl, Golden Horde (Southern Russia), early 14th century. Silver gilt, worked in repoussé, punched, engraved, and chased. State Hermitage Museum, Saint Petersburg (ZO-741)

Baghdad. Arghun even selected a Nestorian, Rabban Sauma, to undertake the delicate mission of forging an alliance with the European monarchies and the Papacy. In an account of his travels through Central Asia and Iran, Rabban Sauma described the hospitality he received in numerous Nestorian communities that thrived unpersecuted in towns and oases. Many Nestorians were traders, and the government's tolerance of them thus contributed to the vigor of long-distance commerce with China.[55] Jews, another group with many traders in their number, were also favored by the Ilkhanids. Several individuals recruited to be prominent government officials were Jews.

With the accession of the Muslim Ilkhan Ghazan in 1295 came an aggressive resurgence of Islam, which was particularly characterized by the growth of Shi'ism and Sufism. The policy of religious toleration underwent something of a reversal. Buddhist monasteries and temples in western Asia were closed (some damaged or destroyed), and Buddhism there would not recover from this assault.[56] The attacks adversely affected relations with the Mongols of the Yuan dynasty, some of whom had converted to Tibetan or Chinese Buddhism (see fig. 126). Although Nestorianism and Judaism did not suffer the same fate as Buddhism, their political influence gradually eroded from the time of Ghazan on, and there were some attacks on churches and synagogues. Still, this development scarcely impinged upon trade with the Yuan because Muslims in China played many of the key roles in commerce.

As with the Yuan rulers, the Ilkhans' support for crafts reflected the traditional Mongol attitudes toward artisanship. Policies were designed to foster craftsmanship and the arts and to benefit from technical or artistic innovations developed else-

55. A longer discussion may be found in Rossabi 1992b, pp. 27–31.
56. Boyle 1968b, pp. 379–80. Much of this section is based on Boyle 1968b.

57. Allsen 1994, p. 71.

where in the Mongol domains. Artisans were granted tax reductions. Those based in cities along the major Eurasian trade routes had no trouble marketing their wares and profited from the Mongol rulers' support of commerce. Others living near the residences of the Ilkhans, whether permanent or temporary, also had a substantial market for their wares: the Mongol capital at Tabriz, the city of Maragha, and the summer palace at Takht-i Sulaiman were all dense with wealthy consumers who craved luxury articles (figs. 29–32). Craftsmen were generally freemen organized in corporations or guilds. However, they were obliged to turn some of their products over to the state or to landowners, and often to work gratis on public projects.

Some artisans were slaves and could be compelled to move wherever their overlords wished. It is very likely that the Ilkhans recruited Chinese craftsmen and forced them to migrate to Iran to work in their service. Although Chinese and Persian written sources contain few references to the movement of Chinese artisans and painters into Iran, this paucity of evidence is not particularly significant. The authors of Chinese histories generally evinced little interest in foreigners and scarcely mentioned contacts with them, while Persian histories focused on political events and omitted much of social interest. In fact, Chinese of other professions were present in Iran, and it seems probable that Chinese craftsmen were as well. Chinese doctors reached Iran, along with drugs and Chinese medical texts that were subsequently translated into Persian. A Chinese chef worked for the historian Rashid al-Din. The Ilkhanids imported seeds from China, employed translations of Chinese agricultural texts, and brought in Chinese agronomists to help foster the growth of an agrarian economy in Iran.[57] Mongols played roles in transmitting to Iran technical texts and historical works, the latter of which exerted an influence on the writing of Rashid al-Din's monumental history. When Mongols from China traveled to the Ilkhanate, a few Chinese surely accompanied them. It is not unreasonable to assume that Chinese craftsmen and artists were among these escorts and that they brought with them works of art including textiles and scrolls, or at least pattern books of designs.

The policies regarding trade, religion, crafts, and the arts that the Mongols implemented in the vast Asian domains they had subjugated were ones that facilitated cultural and artistic diffusion. The Mongols themselves were not artistic creators or innovators; however, they helped transmit cultural developments from China to Iran and back again and in addition were patrons and consumers of a wide range of arts. Even after the Ilkhan Ghazan adopted the title Sultan and distanced himself from the Great Khan in East Asia, cultural and artistic relations persisted between Yuan China and Iran, enriching both civilizations. It ceased only when political and economic turbulence engulfed the two Mongol domains. It may be that the most enduring aspects of the legacy of Genghis Khan and his successors were not their military exploits but the unification of much of Asia and the cultural and artistic flowering that ensued.

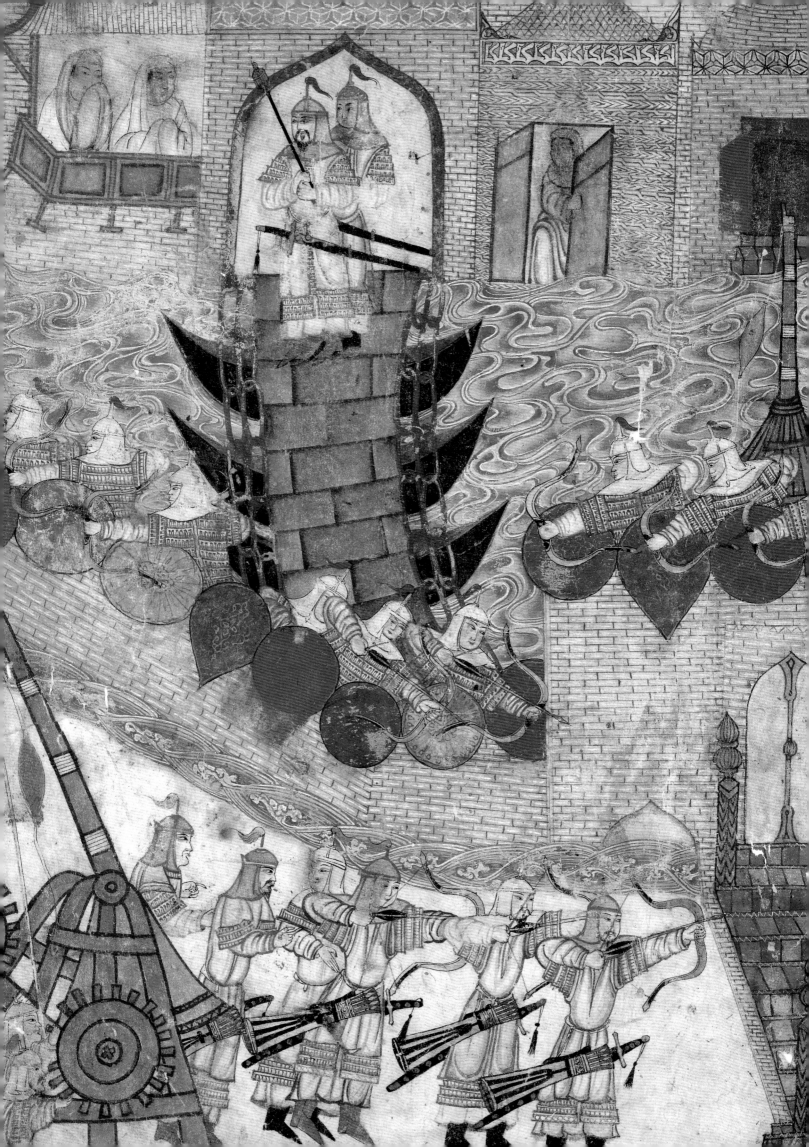

2.
The Mongols in Iran *CHARLES MELVILLE*

Hülegü Khan consulted the great men of state and his closest courtiers concerning his intention. . . . Husam al-Din the astrologer advised him not to attack the caliphal dynasty nor lead the army to Baghdad. "If the King does not listen to his servant's words, six evil consequences will quickly appear: 1, all the horses will die and the troops will fall sick; 2, the sun will not rise; 3, the rain will not fall; 4, a strong wind will rise up and the world will be destroyed by an earthquake; 5, the plants will not grow from the earth; and 6, a great king will die within the year." . . . Then Hülegü consulted Khwaja Nasir al-Din Muhammad Tusi, who said, "None of these things will occur." Hülegü asked, "Then what will happen?" He said, "Hülegü Khan will take the caliph's place." ——Rashid al-Din, *Compendium of Chronicles*[1]

Eighty years elapsed from the time Hülegü Khan's forces arrived in Baghdad, till the death of Sultan Abu Saʿid. During this period, the kingdom of Iran had a rest from the oppression of men of violence, particularly in the days of the Sultanates of Ghazan Khan, Öljeitü Khudabandah and Abu Saʿid Bahadur Khan. How can anyone describe how well the affairs of the kingdom of Iran were regulated during these three reigns? —Auliya Allah Amuli, *Tarikh-i Ruyan*[2]

On January 1, 1256, the Mongol prince Hülegü, a grandson of Genghis Khan, led his army west across the Oxus River into Iranian territory. This invasion can be seen as a new episode in the ancient cycle of confrontations between Iran and lands to the north and east. One of its main consequences, in the long term, would be the reorientation of Iran toward Central Asia and away from the Arab lands of the Fertile Crescent with which it had been so closely associated since the rise of Islam in the seventh century.

HISTORY OF THE CONQUEST

A complex chain of events, filled with warfare and family rivalries, preceded Hülegü's invasion of Iran. Almost forty years earlier, Genghis Khan had conducted his first devastating raid across Asia. In three hectic years (1219–22) the Mongol forces carried out their first objective, annihilating the Khwarazmian empire to the east of the Caspian Sea. The great conquerer himself pursued the Khwarazmshah's warlike son Jalal al-Din all the way to the banks of the Indus River, while other commanders systematically besieged and sacked the capitals of Khwarazm and Transoxiana. Hülegü's father, Tolui, presided over the destruction of Merv, Nishapur, and Herat, the great cities of Khurasan in northeastern Iran.[3] The Mongols then reduced to ruin anyone who stood in their way as they swept on across northern Iran, up through the Caucasus, and into the Crimea, before withdrawing via southern Russia.

1. Rashid al-Din 1994, vol. 2, pp. 1006–7.
2. That is, *History of Ruyan* (in the Caspian region of Iran). Auliya Allah Amuli 1969, p. 178.
3. The story of Genghis Khan's conquests has frequently been told; see, for example, Boyle 1968b, pp. 306–22; Ratchnevsky 1991, pp. 119–34. The best contemporaneous source is Juvaini 1958, vol. 1, pp. 95–178; for a good popular account, see Marshall 1993, pp. 49–57.

Opposite: Fig. 33 (cat. no. 24). *The Conquest of Baghdad,* illustration from the Diez Albums, Iran, 14th century. Ink and colors on paper. Staatsbibliothek zu Berlin—Preussischer Kulturbesitz, Orientabteilung (Diez A fol. 70, S. 7)

Fig. 34 (cat. no. 154). *Paiza* (passport), Golden Horde (Southern Russia), ca. 1362–69. Engraved silver inlaid with gold. State Hermitage Museum, Saint Petersburg (ZO-295)

The death and destruction caused by Genghis's western campaign cannot now be calculated;[4] what is certain is that those who experienced and reported the events were horrified by the unprecedented scale and violence of the attack. Alongside the urban ruin and loss of life came the destruction of many libraries and treasures and thus, perhaps, precious evidence about the nature of cultural and artistic activity on the eve of the Mongol invasions.[5] Still, the possibility of some continuity was ensured when Genghis spared artisans and craftsmen and deported them, largely to Mongolia, to serve the conquerors' needs.[6]

Genghis Khan's son and successor, Ögödei (r. 1229–41), sent his general Chormaghun to deal with the elusive prince Jalal al-Din and to extend Mongol control farther west.[7] Nevertheless, various powers remained unsubmissive to the Mongols. Most notable among them were the ʿAbbasid caliphate of Baghdad—the titular head of the Islamic world for five hundred years—and the Ismaʿilis, popularly known as the Assassins, a religious sect entrenched in mountain strongholds in eastern Iran and south of the Caspian Sea.

Hülegü's mission in 1256 was to complete and consolidate the conquests of his forebears. His forces, perhaps about two hundred thousand strong, included a significant component (possibly even a majority) of Turkic troops from Central Asia, absorbed into the Mongol armies in the course of Genghis Khan's westward expansion. Hülegü first suppressed the Assassins, capturing the key fortress of Alamut late in 1256 (see cat. no. 23, fig. 68). A year later he was encamped before Baghdad, which fell in February 1258 after a short siege (figs. 33, 35). The caliph and most of his kinsmen were executed. Previous conquerors of Baghdad had stopped short of such action, choosing instead to retain the caliphate and through it legalize their usurpation of power, but this new invader had no need of such sanctions. The method of execution was also unprecedented: the caliph was rolled up in a carpet and trampled to death so that none of his royal blood could soak into the ground. According to ancient Turko-Mongol beliefs, blood was sacred, one of the seats of the soul; by not shedding his blood, the Mongols showed respect for the nobility of the caliph and ensured that he would survive in the afterlife. Nothing could have demonstrated more clearly that these warriors from the wilds of inner Asia had their own taboos and a view of the world utterly alien to the Islamic civilization they had overwhelmed.

The sack of Baghdad effectively brought to an end the caliphate that had been Islam's principal political institution since the death of the prophet Muhammad in A.D. 632. A couple of ʿAbbasid survivors made their way to Cairo, where they became figurehead caliphs for the new Mamluk masters of Egypt and served to confer some legitimacy on their rule. The Mamluks, a regime of military slave origin who were establishing themselves in Egypt during the 1250s, were to become the most stubborn and successful opponents of the Mongols in western Asia. They maintained a well-guarded frontier along the Euphrates and resisted the Mongols' repeated efforts to penetrate into northern Syria, presenting this resistance as a holy war (jihad) against the pagans.[8]

Hülegü had more to confront than external foes such as the Mamluks. His expedition west was launched at a time of internal conflict within the Mongol empire. When Ögödei's son Güyüg (r. 1246–48) died, there had been a struggle for

4. For efforts to do so, see Smith 1975, and the discussions in D. O. Morgan 1986b, pp. 73–83, and Lambton 1988, pp. 19–27, citing previous literature. An unpublished paper delivered by the late Jean Aubin in 1992 poured scorn on the figures provided by contemporary sources.

5. For one area, see Blair 1985.

6. See, for example, Jackson 1999, p. 20, and Allsen 1997a, pp. 30–36, concerning textile workers.

7. See Boyle 1968b, pp. 333–40; Jackson 1993a; Aubin 1995, pp. 11–17.

8. For a thorough account of the early stages of this enmity, see Amitai-Preiss 1995. For the transfer of the ʿAbbasid caliphate to Cairo, see most recently Heidemann 1994.

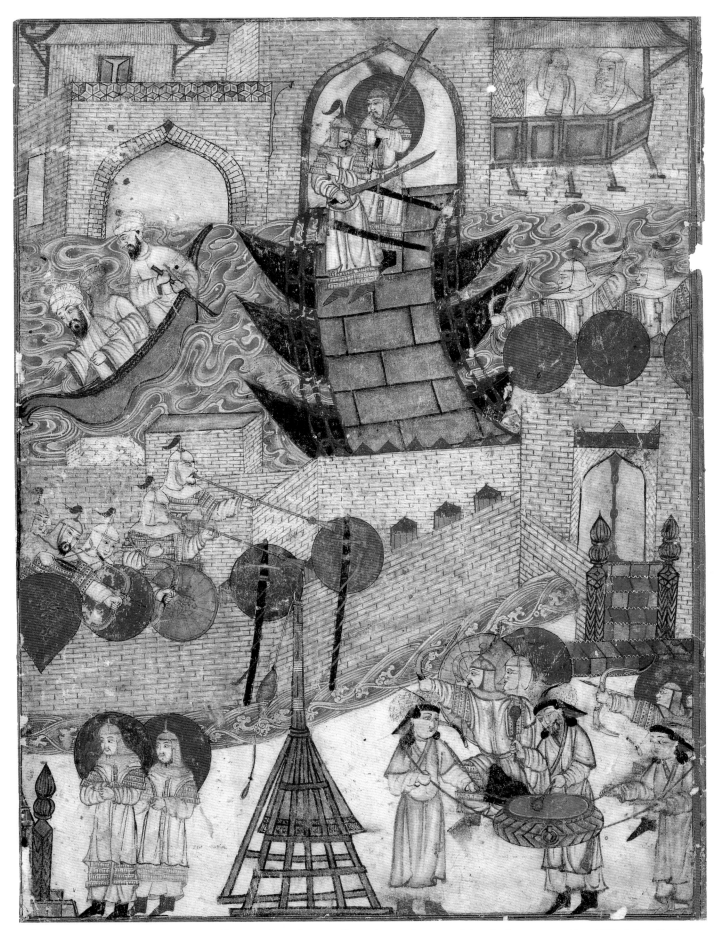

Fig. 35 (cat. no. 25). *The Conquest of Baghdad,* illustration from the Diez Albums, Iran, 14th century. Ink and colors on paper. Staatsbibliothek zu Berlin—Preussischer Kulturbesitz, Orientabteilung (Diez A fol. 70, S. 4)

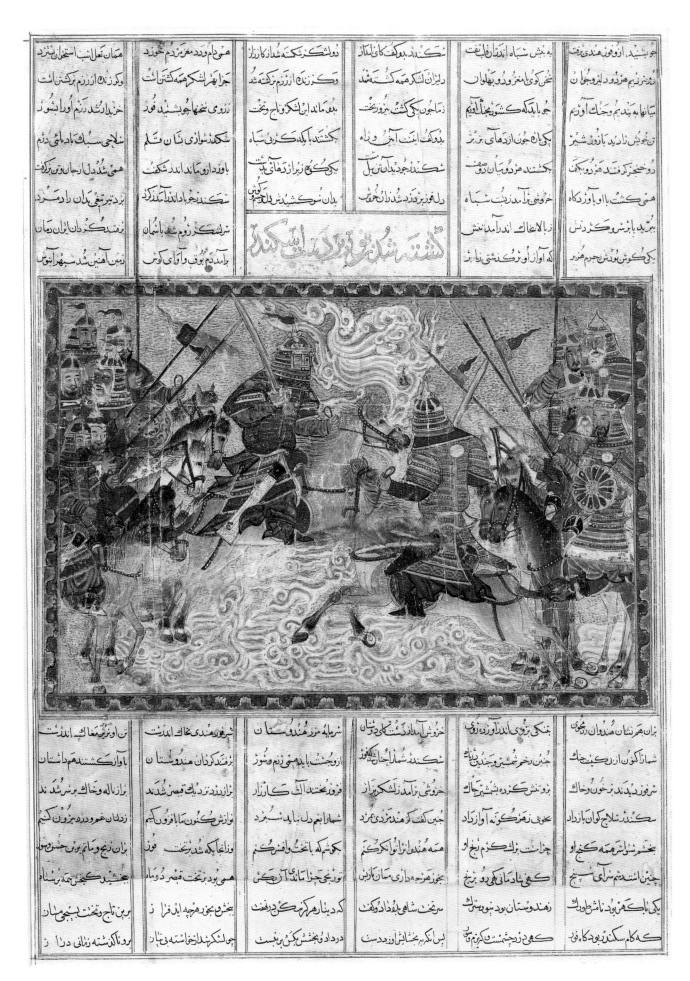

Fig. 36 (cat. no. 49). *Iskandar Killing Fur of Hind,* page from the Great Mongol *Shahnama* (Book of Kings), Iran (probably Tabriz), 1330s. Ink, colors, and gold on paper. Keir Collection, England (PP1)

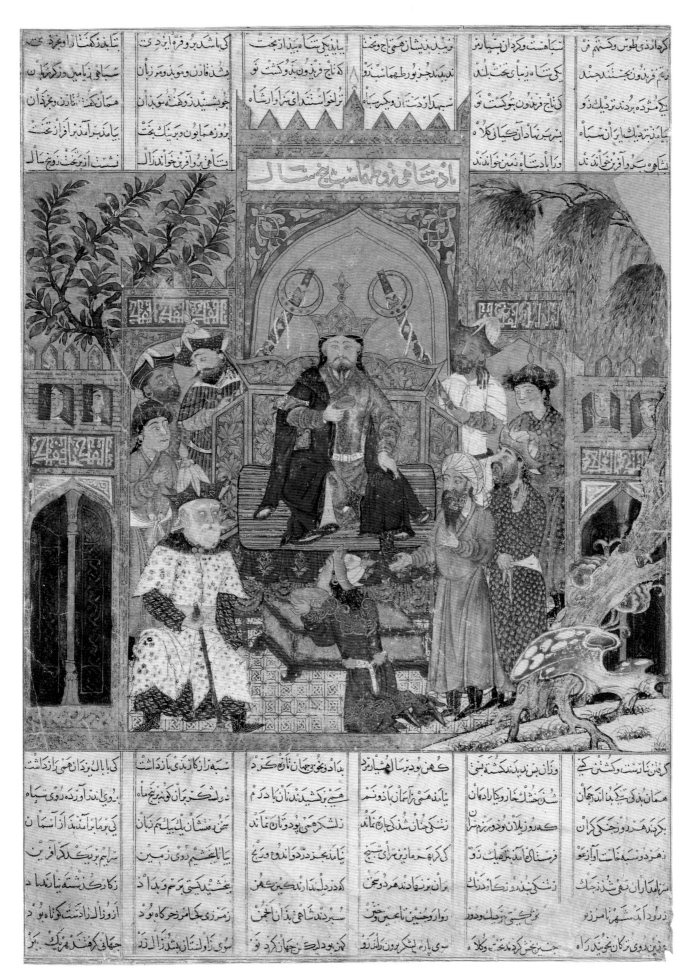

Fig. 37 (cat. no. 39). *Shah Zav Enthroned,* page from the Great Mongol *Shahnama* (Book of Kings), Iran (probably Tabriz), 1330s. Ink, colors, and gold on paper. Arthur M. Sackler Gallery, Smithsonian Institution, Washington, D.C.; Purchase, Smithsonian Unrestricted Trust Funds, Smithsonian Collections Acquisition Program, and Dr. Arthur M. Sackler (S1986.107)

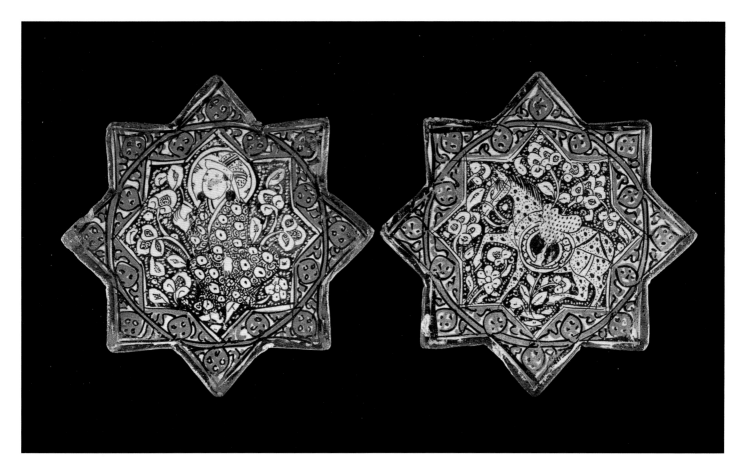

Fig. 38 (cat. no. 106). Two star tiles, Iran
(Kashan), second half of the 13th century.
Fritware, overglaze luster-painted. The
Trustees of the British Museum, London
(OA G 1983.212, 229)

succession to the throne of the Great Khan, which culminated in the election of
Hülegü's older brother Möngke in 1251. Möngke was the son of Tolui, Genghis
Khan's youngest son. The descendants of Ögödei, dispossessed of their inheritance,
were purged, together with the family of his brother Chaghadai (ruler of the
Central Asian Mongol kingdom, the Chaghadai Khanate), who supported them.
Möngke was backed, however, by the senior line of the family in the person of Batu,
who was the son of Genghis's oldest son, Jochi, and khan of the Mongols in their
westernmost territories (the so-called Golden Horde). Cousin was set against cousin
across the empire (see map of the Mongol empire, pp. 8–9; genealogical chart, p. 11).

To assert his control throughout his realms, Möngke dispatched his brothers
Khubilai to China and Hülegü to the west—that is, into territory originally granted
to Jochi. Thus seeds of rivalry were sown in the west as well, particularly in the
Caucasus. This situation was drastically altered by Möngke's death in 1259. In the
ensuing succession crisis, Hülegü supported the cause of his brother Khubilai in
China. Against him stood their youngest brother, Arigh Böke, who ruled in Khara
Khorum, the Mongol capital, and maintained that the traditional homeland in
Mongolia should remain the center of the empire. Although Khubilai eventually tri-
umphed, the cost was steep: the Mongol empire was effectively dismembered, and
his own authority was confined to China. Meanwhile Hülegü seized the opportunity
to carve out his own kingdom in the Iranian lands, where he styled himself Ilkhan,
or subject khan, subordinate to Khubilai. Flanking him were hostile Mongol
khanates—to the north, in southern Russia and the Caucasus, the Jochids of the
Golden Horde, and to the east, in Central Asia, the remnants of the Ögödeid-
Chaghadayid alliance. Born at this time of strife within the empire,[9] the Ilkhanate
would eventually be undermined and then destroyed by similar succession crises.

9. The most penetrating accounts of these develop-
ments are Jackson 1978 and Jackson 1999,
esp. p. 9, n. 11, pp. 23–32.

One of the many consequences that flowed from the establishment of Mongol rule in Persia was the revival of the concept of the land of Iran ("Iranzamin," known before the advent of Islam as "Iranshahr"). While Iranshahr had been the cradle of a succession of imperial regimes from the time of Cyrus the Great (r. ca. 558–529 B.C.), its glory had been finally, and apparently permanently, eclipsed by the Muslim Arab conquests of the seventh century A.D. With their new religion the Arabs brought a hostile attitude to secular kings and dynasts. Iran was absorbed into a new political dispensation, whose center of gravity, even after the transfer of the capital to Baghdad and the old heartlands of Iranshahr, was farther west—the so-called Fertile Crescent and beyond it the Mediterranean world of late antiquity, to which the Arabs were heirs. The great arch of the Sasanian palace of the Khusraus (Chosroes) at Ctesiphon, just across the Tigris from Baghdad, became a poetic symbol of the lost grandeur of ancient Iran, one viewed with nostalgia but, from an Arab and Islamic perspective, no serious ambition to restore (fig. 37).[10] In a way that has not been fully explored (but that we will touch on again later), the Mongols and their Persian administrators reinvigorated the idea of the political and cultural autonomy of Iran, renewed her ties with the Central Asian world that had played such a large part in her past history, and in so doing released to an extraordinary degree the creative talents of her people.[11]

The North

The Ilkhans did not exercise their authority evenly throughout Iranian territory (see map of Greater Iran, p. 10). In 1275 the scholar and historian Qadi ʿAbd

10. See Christensen 1993. On Ctesiphon, see, for example, Clinton 1976; Clinton 1977; Hillmann 1990, pp. 44–51.

11. See Fragner 1997, esp. pp. 127–29 and references cited on p. 122.

Fig. 39 (cat. no. 22). *Mongol Traveling*, illustration from the Diez Albums, Iran (possibly Tabriz), early 14th century. Ink and colors on paper. Staatsbibliothek zu Berlin—Preussischer Kulturbesitz, Orientabteilung (Diez A fol. 71, S. 53)

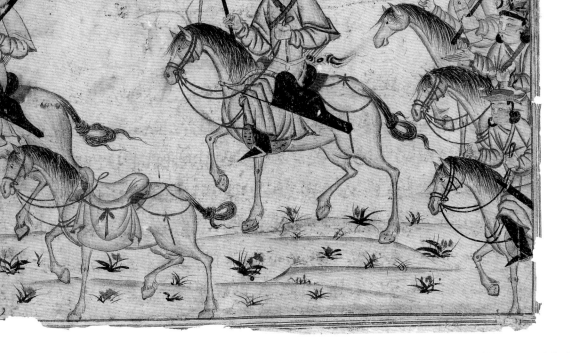

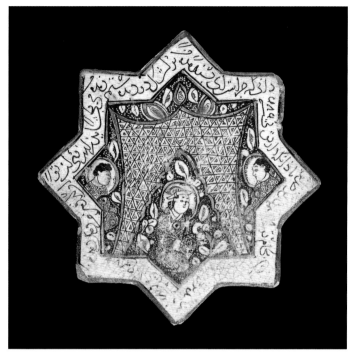

Fig. 40 (cat. no. 111). Star tile with man seated before a tent, Iran (Kashan), A.H. 689/ A.D. 1290–91. Fritware, overglaze luster-painted. Private collection

Allah al-Baidavi defined Iranzamin as extending from the Euphrates to the Oxus, that is, from the borders of the Arab lands to Khojand (in present-day Tajikistan). According to Hamd Allah Mustaufi Qazvini, a historian and geographer writing in 1340 at the end of the Ilkhanid period, Iranzamin stretched from Konya (central-west Turkey) in the west to Balkh (Afghanistan) in the east, and from Darband (in the Caucasus) in the north to Abadan (on the Persian Gulf) in the south.[12] The Mongols, numerically rather insignificant in comparison both with the Turkish elements in their armies and with those inhabitants who managed to survive their massacres, were concentrated in the north of this large area, in Khurasan and particularly Azerbaijan. Here the Mongols frequented a series of seasonal capitals and built their main palaces and principal monumental constructions. Hülegü commissioned an observatory for the astronomer and polymath Nasir al-Din Tusi (1201–1274) outside Maragha, his first capital; later rulers developed substantial complexes at Takht-i Sulaiman, Tabriz, and Sultaniyya (see below and Tomoko Masuya's chapter 4).

The reasons for this concentration in the northwest were partly military and partly ecological and economic. A nomadic people, the Mongols were at home on horseback and in tents (figs. 38, 40). When they moved, whether in war or in peace, they took the whole camp (ordu, horde) with them, together with the herds of sheep, goats, and horses on which they depended for their livelihood and mobility. Northern Iran and central Anatolia lie in a zone of high mountain valleys and steppe vegetation that provided the kind of terrain and climate the Mongols needed for summer and winter pasturing of their animals (fig. 41). The military chiefs maintained seasonal camping grounds in these areas throughout the Ilkhanid period.[13] Anatolia, the Caucasus, and Khurasan were border regions that needed defending

12. Al-Baidavi 1935, p. 2; Hamd Allah Mustaufi Qazvini 1915–19, vol. 1, pp. 20–22, vol. 2, pp. 22–23.

13. Smith 1999.

14. Al-Aqsarayi 1944, pp. 295–96; Rashid al-Din 1994, vol. 2, pp. 1303–4. See also Melville 1990a. For Ghazan's development of Ujan, see Hamd Allah Mustaufi Qazvini 1915–19, vol. 1, p. 80, vol. 2, p. 83; Ibn Fadl Allah al-'Umari 1968, pp. 86–87.

15. See Allsen 1989, esp. pp. 109–16, for the operation of these associations, which were probably tax exempt. Muslim merchants, such as the notorious 'Abd al-Rahman, rose to high rank as tax officials in China. See also Lambton 1988, pp. 123, 293–94, 333–34.

16. Hamd Allah Mustaufi Qazvini 1915–19, vol. 1, pp. 76–77, vol. 2, pp. 79–80; Ibn Battuta 1962, pp. 344–45; Polo 1903, vol. 1, pp. 74–76; Rashid al-Din 1994, vol. 2, pp. 1373–75. On the principal urban tax, called tamgha, see, for example, Remler 1985, p. 172; Lambton 1998, pp. 123–24.

17. Abu-Lughod 1989 does not bring out the importance of this route. See the work of Jean Aubin, for example, Aubin 1963.

Fig. 41. View from Takht-i Sulaiman, Iran

against the Ilkhanids' enemies—the Mamluks in the west, the Golden Horde to the north, and the Chaghadai Khanate in the east.

The seat of rule also remained peripatetic. In addition to conducting campaigns against the Mamluks and other opponents, normally over the winter or in early spring, the Ilkhans in general kept on the move. By the reign of Abu Saʿid, the last generally recognized Ilkhan (r. 1316–35), the most common pattern was for the court to migrate between Sultaniyya in the summer and Baghdad in the winter. Magnificent tents were created to reflect the rulers' imperial splendor, such as one for Ghazan Khan (r. 1295–1304) that was three years in the making and took two hundred men twenty days to erect (see fig. 42). It was completed in Tabriz in 1302 and first installed at Ghazan's favorite summer quarters at Ujan (see fig. 80).[14] This adherence to the seasonal rhythms of life was not merely nostalgic; pastoral nomadism was an important element in the Mongols' economy, particularly since their original destructiveness and subsequent methods of raising taxes had done much to reduce agricultural production, the traditional basis of Iran's economy.

Northern Iran lay astride one branch of the so-called Silk Road connecting Anatolia with China and was a natural corridor for east-west trade and the movement of goods and ideas (see fig. 34). The Mongol courts were active in the pursuit and encouragement of trade, providing capital and security for merchants to traffic on their behalf in commercial associations (*ortogh*s), which channeled wealth into the hands of the ruling circles. Princesses and royal wives (*khatun*s) played an important role in these enterprises, since they had considerable freedom to dispose of their assets.[15] The most impressive efforts to stimulate international trade and provide the urban infrastructures necessary for commerce can be seen in the development of Tabriz, which Ghazan made his capital. (First the Mongols had to overcome their antipathy to cities and recognize how they could be exploited to generate revenue, especially through taxes.) Tabriz city was greatly enlarged and furnished with baths and caravanserais to accommodate merchants from all points of the compass.[16] Azerbaijan was at the knot of a string of routes, some of which wound southeastward from the Black Sea and the Caucasus down to Hormuz on the Persian Gulf.[17]

The South

If the Mongols quickly imposed themselves across northern Iran, the situation was very different in the south. Unscathed by the invasions of Genghis Khan and offering only notional allegiance to his first successors, the southern provinces started to become more closely integrated into the Mongol realm after Hülegü's capture of Baghdad. The various established local powers

Fig. 42 (cat. no. 73). Tent hanging, eastern Iran or Central Asia, late 13th–early 14th century. Lampas weave (tabby and twill), coral and purple silk, gilded strips. The David Collection, Copenhagen (40/1997)

submitted to Hülegü and were left in place. These were small principalities, mainly in the hands of Turkish *atabegs,* who were originally guardians and advisers to young Seljuq princes but later wielded power in their own right. They included the Salghurids in Fars and other dynasties in Yazd and Luristan. There were also the indigenous Shabankara tribal chiefs in Fars, and, in Kirman, the Qara-Khitai or Qutlugh-Khanids, descended from a Khwarazmian military commander.[18]

Relations between these southern regions and the *ordu* (here, the center of government, or court) varied with changing circumstances, but as a general principle the local ruling families were tied to the *ordu* by marriage. There is no documentary evidence that any of the Ilkhans ever went in person to southern Iran. They were able to intervene in the affairs of the provinces by supporting one claimant to power against another family member or by the simple device of dividing rule between two rivals, thus reducing their local influence and making them dependent on the *ordu.* These regional princes were frequently minors, and it was often their mothers who acted as regents, wielding considerable authority. Many of these princesses were patrons of the religious classes and made extensive pious endowments, or *awqaf* (fig. 269); an outstanding example was Qutlugh Terken in the Kirman region. Indeed, the prominence of women in both economic and political affairs is one of the distinctive characteristics of the Mongol period in Iran. Their influence was personal rather than institutionalized, however, and it is not necessarily the case that such freedom existed for women outside the ruling circles.[19]

The Mongols did not have the same strategic interests in the south as in the border zones of the north, but here as elsewhere they were determined to collect taxes and tribute. Moreover, the southern lands offered access to the lucrative trade of the Persian Gulf, which, as Marco Polo recorded in the 1270s, consisted of spices and precious stones, pearls, cloths of silk and gold, ivory, and other goods from China and India, as well as an important trade in horses. The main emporia for this trade were Hormuz and the nearby island of Qais (Kish). Some of those involved in this commerce, both merchants and government officials, acquired extraordinary wealth. (One such was the Malik al-Islam Ibrahim ibn Muhammad [d. 1306], whose career spanned the reigns of four Ilkhans. His riches, partly gained from his appointment as tax farmer, made him indispensable to the court but also the object of suspicion and repeated intrigues.)[20] Even after Fars, Kirman, and Yazd came under the direct control of the *ordu,* the Mongol presence in the south remained minimal. The area was predominantly hot and dry and had little to attract permanent occupation. These contrasts between the north and south do much to explain the distinct cultural and artistic developments in the different regions of Iran, both during and after the Ilkhanid period.

Cultural Life

In the thirteenth and fourteenth centuries, as in earlier periods, the large distances between provincial centers and the strong tendency toward political fragmentation encouraged the growth of regional schools of literature at a variety of princely courts, particularly in western and eastern Iran. Fars, along with its capital,

18. For Fars and Kirman, see Lambton 1986; Fairbanks 1987; Lambton 1987; Spuler 1987a; Spuler 1987b. For the Shabankara district, see Aubin 1995, esp. pp. 69–78.

19. Lambton 1988, pp. 271–96; Lambton 1997, esp. pp. 310–13. For comparison with the situation under the Timurids, see Soucek 1998.

20. Polo 1903, vol. 1, p. 107. See also Aubin 1953, esp. pp. 90–99; Lambton 1988, esp. pp. 335–41.

21. For Injuid painting, see Adamova and Giuzal'ian 1985; Çağman, Tanindi, and Rogers 1986, p. 51; Canby 1993, pp. 34–38; Simpson 2000. For metalwork, see Giuzal'ian 1963; Melikian-Chirvani 1982, p. 148; Komaroff 1994, pp. 9–13, 21; Allan 2002, pp. 34–39.

22. Aubin 1995, pp. 22–23. See also Gilli-Elewy 2000.

23. For the poets, see Rypka 1968, pp. 610–14; on painting, Simpson 1982b; Soucek 1987, p. 609.

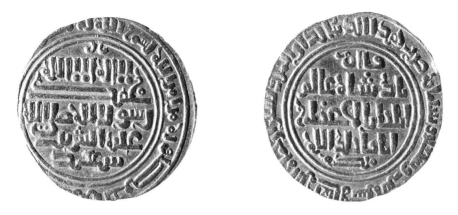

Fig. 43 (cat. no. 172). Dinar of Abesh Khatun, Iran (Shiraz), A.H. 673/A.D. 1274–75. Gold. Art and History Trust Collection

Shiraz, became something of a haven for poets and artists and was soon associated with a vigorous production of illustrated manuscripts. The poet Saʿdi (d. 1292), author of two much-loved didactic masterpieces in prose and verse, the *Gulistan* (Rose Garden) and the *Bustan* (Scented Garden), as well as a fine corpus of lyrical poems (*ghazals*), looked with a philosophical gaze on the political upheavals of the time from the relative sanctuary of the gardens of Shiraz. The Mongols attempted to administer the province directly after the death of Abesh Khatun, the last Salghurid (fig. 43), in 1287, but they can hardly be said to have controlled it closely. From about 1304 on the local ruling family of Injuids (originally, administrators of Mongol *injü,* or crown estates) enjoyed considerable independence; they were essentially autonomous from about 1325 until their eclipse in 1357 by the Muzaffarids, a family that had seized power in the Yazd region during the reign of Abu Saʿid. Miniature painting and metalwork particularly flourished under the Injuids (fig. 44), especially the last of them, Abu Ishaq (see Stefano Carboni's chapter 8).[21]

Iraq had been reduced to a border province, but it clearly recovered some cultural life; its artists set the standard, for example, in calligraphy and inlaid metalwork (figs. 5, 46). Hülegü quickly gave orders for Baghdad to be restored, and in 1260 it came under the authority of the historian ʿAlaʾ al-Din ʿAta Malik Juvaini, whose brother Shams al-Din rose under Abakha Khan (r. 1265–82) to become *sahib-i divan,* the highest official in the Ilkhanid administration. It was the usual Mongol practice for a Persian bureaucrat to work in harness with a Mongol military chief, and Juvaini was paired with Sughunjakh Akha, who was also military governor of Fars.[22] A century later, when the Ilkhanate disintegrated, Baghdad became the center for the long-lived successor regime of the Jalayirids, under whose patronage an important school of painting developed (see chapter 8) and poetry flourished.[23]

In the more northerly heartlands of Ilkhanid rule, the contrast between the situations in Anatolia and Azerbaijan offers another illustration of the interplay between cultural

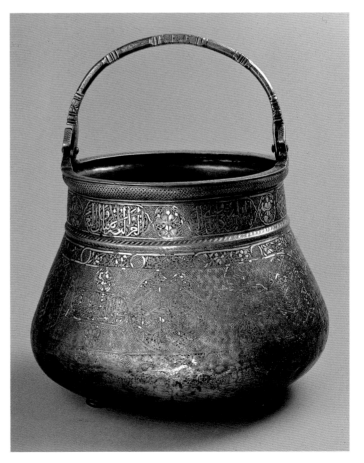

Fig. 44 (cat. no. 161). Bucket, signed by Muhammad Shah al-Shirazi, Iran (probably Shiraz), A.H. 733/A.D. 1332–33. Brass, inlaid with gold and silver. State Hermitage Museum, Saint Petersburg (IR-1484)

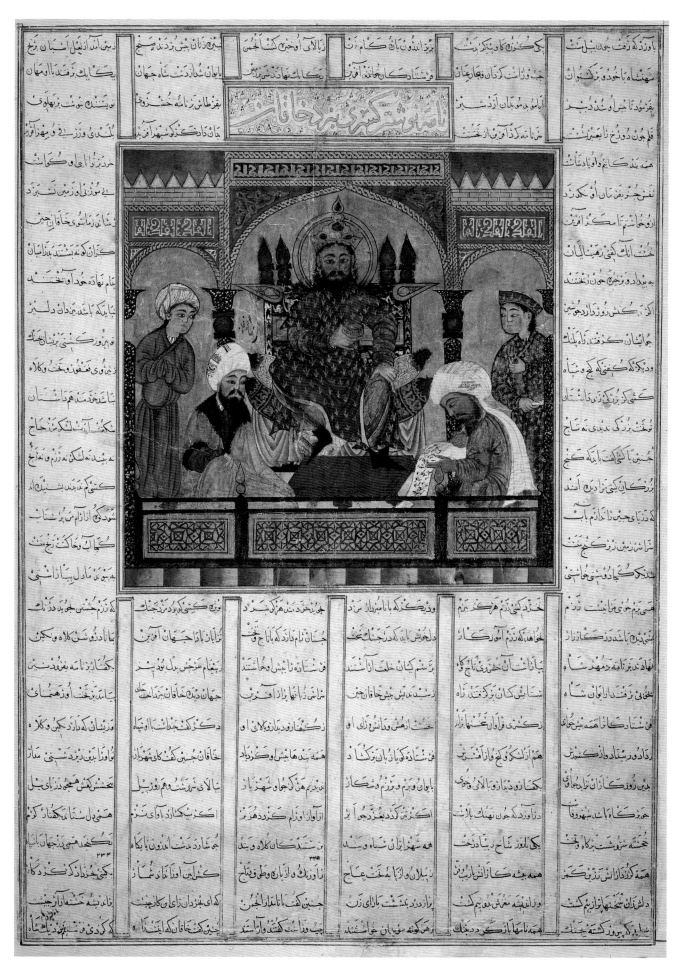

Fig. 45 (cat. no. 60). *Nushirvan Writing to the Khaqan of China*, page from the Great Mongol *Shahnama* (Book of Kings), Iran (probably Tabriz), 1330s. Ink, colors, and gold on paper. The Trustees of the Chester Beatty Library, Dublin (Per 111.7)

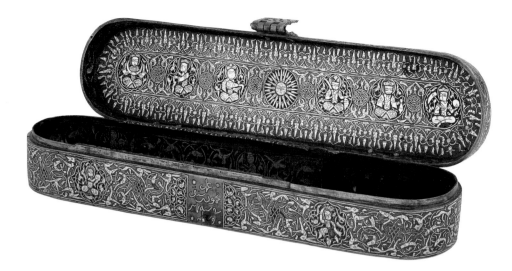

activity and political evolution. The Mongols did not extend their direct control over Anatolia until the late 1270s, and up to that time local Seljuq patrons continued to endow a number of fine madrasas (religious colleges), Sufi convents, and caravanserais across the country.[24] As in more distant peripheries of the empire, such as southern Iran and northern India, the semi-independent Seljuq regime in Konya provided a refuge for scholars, most notably the Sufi master and charismatic poet Jalal al-Din Rumi (1207–1273).[25] The image of Islamic piety that he, his descendants, and other followers presented, according to their hagiographers, deeply impressed the pagan Mongol and Turk invaders. However, once Anatolia was brought more closely under central government administration, its cultural life declined, and this decline continued after the disintegration of the Ilkhanate. In Azerbaijan, on the other hand, there was no prior cultural development comparable to that fostered by the Seljuqs in Anatolia. Yet the Mongols' acculturation to Islam in the fourteenth century (see below) encouraged the formation of an imperial center of artistic production there in the capital, Tabriz. This activity continued to be influential even in the very disturbed political climate that prevailed in the period before the region came under Jalayirid control in the 1360s.

In short, the Mongols, as non-Muslims, steppe dwellers, and pastoralists, did not settle evenly throughout the Iranian realm they conquered, and this had varying consequences in the different provinces.[26] Nor were they equipped, at first, to govern Iran in the traditional manner of previous regimes, any more than they were in China, that other great area of ancient sedentary civilization finally conquered by Khubilai Khan in 1279. The Mongols were guided by their own traditions, epitomized by the Yasa (code of practice) of Genghis Khan. The exact nature of the Yasa is still vigorously debated by scholars. It seems to have been essentially a set of unwritten norms for the regulation of military discipline, hunting (fig. 50), and social behavior at feasts and other ceremonies; it also governed the nomads' relations among themselves and with the sedentary population. The authority of the Yasa, frequently invoked throughout the Ilkhanid period and later eras, remained a potent idea, although, as has often been observed, on its own it was not sufficient to bring political stability to the areas under Turko-Mongol control.[27] One way to characterize the history of the Mongols in Iran is as the story of their willingness and ability to

Fig. 46 (cat. no. 158). Pen case, signed by Mahmud ibn Sunqur, Iran, A.H. 680/A.D. 1281–82. Brass, inlaid with silver and gold. The Trustees of the British Museum, London (OA 91.6-23.5)

24. See Rogers 1969.
25. See most recently F. D. Lewis 2000. Amir Khusrau of Delhi (1253–1328), author of the *Khamsa* (Quintet), was also a refugee from the Mongols.
26. More remote regions, such as the Caspian provinces and Sistan, remained essentially self-governing under their own rulers throughout the period. See, for example, Bosworth 1994, esp. pp. 429–44; Melville 1999b.
27. D. O. Morgan 1986a. For a recent discussion, see McChesney 1996, esp. pp. 122–23, 127–41.

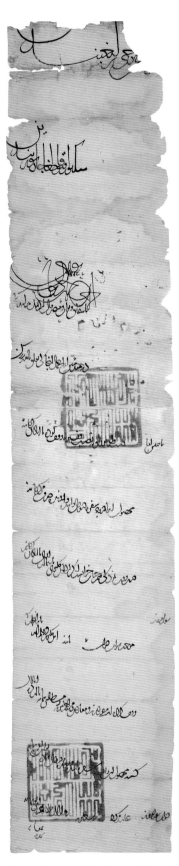

Fig. 47 (cat. no. 68). Firman (decree) of Geikhatu, northwestern Iran, A.H. early Jumada II 692 / A.D. May 1293. Ink on paper. Art and History Trust, Courtesy of the Arthur M. Sackler Gallery, Smithsonian Institution, Washington, D.C. (LTS 1995.2.9)

adjust to Persian ways in some circumstances and in others their determination to maintain their own customs within the Persian context.

THE EARLY ILKHANIDS

The successors of Genghis Khan ruled Iran directly for just under a century. The Ilkhanate is generally considered to have begun in 1258 with Hülegü's conquest of Iraq, an event that was marked by the inauguration of a new calendrical era.[28] The last Ilkhan, Togha (or Taghai) Temür, was murdered in 1353, after the collapse of the dynasty's undivided authority some twenty years earlier. Historians both contemporaneous and modern have usually divided the period between these dates into two approximately equal halves, with the separation coming at the start of the reign of Ghazan Khan in 1295.

In the early period of Iran's conquest, the full implications of the change in regime and the alien character of the new dynasty quickly became evident. This time of warfare brought economic hardship and the undermining of Islamic institutions. With one or two exceptions (mainly in peripheral areas such as Anatolia and Fars, as previously noted), cultural patronage and artistic production were almost nonexistent.

At the outset of his reign, Hülegü Khan (r. 1258–65), having conquered Baghdad, regrouped his forces and invaded Syria to further expand the empire. He captured and sacked Aleppo and then occupied Damascus in March 1260, at which time he received the news that his brother Möngke Khan had died the previous summer. Hülegü withdrew to Azerbaijan, where he would be better situated to respond to events in Khara Khorum. The small occupying force he left behind was defeated by the Egyptian sultan Qutuz at ʿAyn Jalut (Goliath's Well in present-day Israel) on September 3, 1260. This defeat proved to be a turning point, marking the western limit of Mongol military success in the Middle East and becoming a key event in the establishment of the Mamluk regime in Egypt. Later efforts to avenge ʿAyn Jalut by both Hülegü and his successor, Abakha, were in vain. The Mongols suffered further severe reverses, in eastern Anatolia in 1277 and in northern Syria in 1281. The superiority of the Mamluks' military training and equipment, their commitment to defend their territories against aggression, and the logistical difficulties faced by the Mongols all played a part in the Egyptians' success.[29]

Another factor was disunity within the Mongol empire. Confronted with the hostility of their Mongol neighbors, the Golden Horde and the Chaghadai Khanate, the Ilkhans were unable to concentrate their full strength against the Mamluks. After a series of indecisive engagements with the Golden Horde, Abakha constructed a fortified dyke along the Kur River to mark the northern boundary of the Ilkhanate. But the Golden Horde remained a threat throughout the period, maintaining close ties with the Mamluks of Egypt even after the Mamluks and the Ilkhans were officially at peace. (The alliance between the Horde's Berke Khan [r. 1257–67], a convert to Islam, and the Mamluk sultan Baibars [r. 1260–77] had turned into an enduring relationship because of common commercial interests.)[30] In the East, the

Fig. 48 (cat. no. 173). Dinar of Geikhatu, Iran (Tabriz), A.H. 691/A.D. 1291–92. Gold. Art and History Trust Collection

Chaghadai Khan Barakh (r. 1266–71) also laid claim to Ilkhanid territory. He invaded Khurasan and suffered a decisive defeat at the hands of Abakha himself at the battle of Herat, on July 22, 1270. Abakha's forces later followed up this defensive campaign with an expedition into Transoxiana, sacking Bukhara in January 1273.[31]

Hemmed in by foes, the Ilkhans had to look farther afield for friends. Support came from their Toluid relatives in China, although it was largely ideological and moral rather than material. Hülegü's nominal subjection to the Great Khan Khubilai is reflected in his coinage. Khubilai's preeminence is further demonstrated by his mandate authorizing Abakha's succession as Ilkhan; Abakha went through a second coronation ceremony when permission arrived. His son Arghun (r. 1284–91) later did the same, and retained the services of Khubilai's representative, Bolad Chingsang, throughout his reign. This anachronistic vision of a universal Mongol empire persisted under the Ilkhan Geikhatu (r. 1291–95) (figs. 47, 48). Even once their political and ideological importance had waned, contacts with China remained relatively close. Bolad's continued role as an adviser to Ghazan and Rashid al-Din (see below) provided a conduit for cultural exchanges between China and Iran.[32]

A dramatic example of these links across Asia, one that also illustrates the continuing efforts of the Ilkhans to develop diplomatic contacts with the European powers, took place during Arghun's reign. Sometime after 1275, Khubilai Khan gave permission for two Chinese Nestorian Christian monks, Bar Sauma and Markos, to make a pilgrimage to Jerusalem. Arriving in the Ilkhanate in early 1280, they became involved in the internal politics of the Christian communities in Iran and found their way to Jerusalem blocked. The following year Markos was installed as catholicos (patriarch) in Baghdad, the seat of the Nestorian church. The Ilkhans were still pagan, and the Christians retained hopes of converting them—hopes encouraged by Mongol diplomacy with the Christian West. In 1287 Arghun sent Bar (now Rabban) Sauma on a mission to the European courts, charging him to seek an alliance against the Mamluks. Rabban Sauma traveled as far as Paris and Bordeaux, where he was able to present Arghun's proposals to the French and English kings, and finally to Rome, where he met with the new pope, Nicholas IV. However, the result of his mission was the same as those of previous efforts to coordinate an anti-Muslim crusade: by Arghun's death in 1291, the promised aid from the West had failed to materialize.[33]

28. However, there is no specific evidence that the new calendar was used. See Melville 1994, p. 83 and n. 6.

29. See esp. Amitai-Preiss 1995, pp. 233–35.

30. Boyle 1968b, pp. 352–54, 356; DeWeese 1994, pp. 83–87; Amitai-Preiss 1995, pp. 79–91; Hartog 1996, pp. 60–62.

31. Biran 1997, esp. pp. 26–33.

32. Allsen 1991; Allsen 1996; Allsen 2001.

33. Rossabi 1992b; for earlier contacts, see, for example, Ruysbroeck 1990, esp. pp. 25–47; Amitai-Preiss 1995, pp. 94–105.

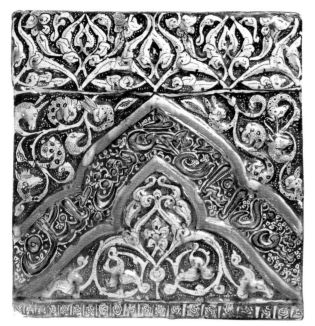

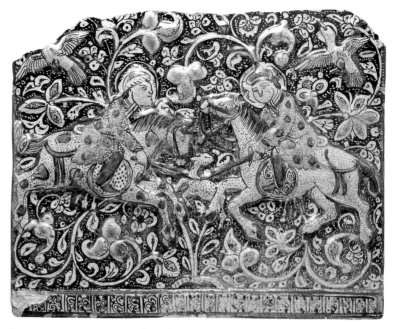

Fig. 49 (cat. no. 80). Frieze tile with inscription from the
Shahnama (Book of Kings), Iran (Takht-i Sulaiman), 1270s.
Fritware, overglaze luster-painted. The Trustees of the British
Museum, London (OA 1878.12-30.573b)

Fig. 50 (cat. no. 98). Frieze tile with two hunters, Iran (probably Takht-i Sulaiman),
ca. 1270–75. Fritware, overglaze luster-painted. The Metropolitan Museum of Art,
New York, Gift of George Blumenthal, 1910 (10.9.1)

This series of contacts reflected the high profile of the Christian communities
within Iran during the early Mongol period. Instinctive allies against the Muslims,
who had long been their oppressors, the Christian communities—Nestorian,
Monophysite, and Armenian—initially hoped to benefit from the recent destruc-
tion of the caliphate and concomitant blow to Islam. However, despite brief
moments of tranquillity and some protection from a succession of Christian royal
wives, starting with Hülegü's queen, Dokhuz Khatun, the situation of Christians
remained uneasy. Internal rivalries undermined their position, and they were the
objects of bitter hostility from their Muslim neighbors, against whom they were not
always effectively protected by the courts. Despite the Ilkhans' professed sympathy
and even supposed preference for Christianity, the church steadily lost ground to
Islam among the Mongol elite and seemingly even sooner among the Mongol rank
and file.[34]

The Jews fared little better, although at first they, like the Christians, were
exempted from the requirement to pay *jizya* (poll tax levied on non-Muslims) and
from other discriminatory measures. One of their number, Saʿd al-Daula Abhari,
achieved high office under Arghun, first as controller of the financial administration
of Iraq and then (1289–91) as *sahib-i divan* (chief minister). Despite his considerable
competence and success, his Jewish background aroused great opposition, and he
was murdered shortly before the death of Arghun. Among the projects for which he
is notorious was his effort to establish that Arghun had inherited the quality of
prophethood from Genghis Khan, and thereby to merge Mongol and Muslim
notions of legitimacy. This revelation was to be accompanied by a purge of dis-
senters and a plan to turn the Kaʿba in Mecca into an idol temple.[35] The most cele-
brated Jew in Mongol service, however, was Rashid al-Din (1247–1318), who
achieved his fame only after converting to Islam. We will meet him again later. As in
China, the Mongols in Iran needed loyal administrators to govern an essentially

34. See Fiey 1975; Spuler 1976; Ryan 1998.
 For a closer analysis, see Bundy 1996.
35. Aubin 1995, pp. 42–44. See also Fischel 1968,
 esp. pp. 90–117.

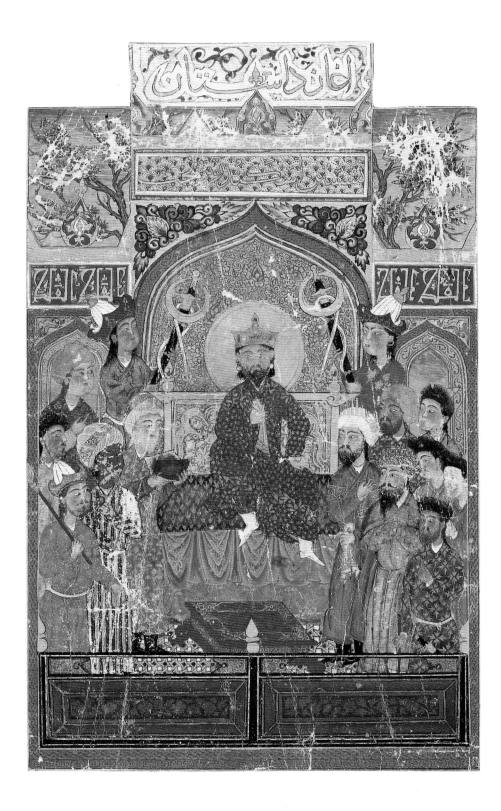

Fig. 51 (cat. no. 46). *Iskandar Enthroned*,
page from the Great Mongol *Shahnama*
(Book of Kings), Iran (probably Tabriz),
1330s. Ink, colors, and gold on paper.
Musée du Louvre, Paris (7096)

hostile subject population and naturally sought them among either outsiders or those indigenous minority groups more likely to be sympathetic to the regime. In the case of Christian and Jewish bureaucrats, their coreligionists benefited little: like their religious policy, the Ilkhans' financial oppression was evenhanded.

Meanwhile, the struggle for the salvation of the Mongols' pagan souls had quickly gotten under way. Abakha's brother Tegüder Ahmad (r. 1282–84), named after the dervishes of the Ahmadiyya sect who had converted him sometime in his childhood, was the first Muslim Ilkhan. Although his election as khan probably owed little to his religion, it is certainly true that his most influential supporter was the

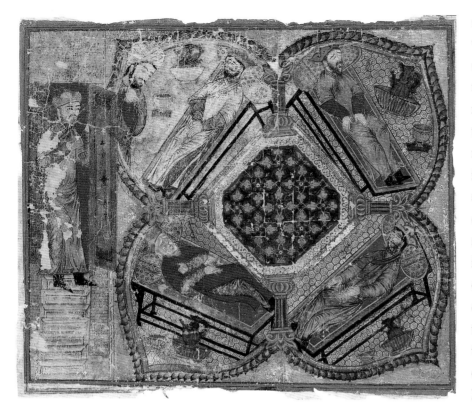

Fig. 52 (cat. no. 26). *Four Sleeping Kings*, illustration from the Diez Albums, Iran, 14th century. Ink, colors, and gold on paper. Staatsbibliothek zu Berlin—Preussischer Kulturbesitz, Orientabteilung (Diez A fol. 72, S. 29)

chief minister, Shams al-Din Juvaini. Juvaini was undoubtedly responsible for several discernible shifts in policy during Ahmad's reign, which included a new readiness to reach a truce with the Mamluks;[36] a guarantee of the inviolability of Islamic endowments, or *awqaf* (singular *waqf*); and the introduction of discriminatory policies against Christians and Jews.[37] Ahmad's own outlook was more ambiguous. Although the strife with his nephew Arghun, who successfully overthrew and executed him, is described in Persian and Arabic sources as a conflict of pro- and anti-Islamic factions, there is no real evidence for this interpretation. Essentially, this was the first of several succession disputes that rocked the Ilkhanate and was a direct consequence of the notorious inability of the Mongols to achieve a reliable system for the transfer of power. Still, religion was undoubtedly an aggravating factor as the dispute developed; clearly the Mongols were not yet ready to embrace the faith of their subjects.[38]

It is significant that Tegüder was converted by dervishes and continued to associate with them rather than with the orthodox religious scholars espoused by Juvaini and the bureaucratic establishment. When a more general conversion of the Mongols came about in the next generation, it was also at the hands of Sufi shaikhs, as we shall see.

Islamization was only one of the means employed to transform the Mongols. The Juvaini brothers and their circle also sought to fit the new rulers into the old mold of Iranian kingship. Hence the revival during the reign of Abakha of the symbolically laden site at Takht-i Sulaiman, south of Maragha, where the coronation ceremonies of the pre-Islamic kings of Iran had taken place (see also chapter 4). The palace that the Mongols built there over ruins from the Sasanian period was decorated with tiles bearing illustrations and verses from the Persian national epic the *Shahnama* (Book of Kings) by the poet Firdausi (ca. 935–ca. 1020), suggesting that the new rulers wished to present themselves as heirs both of the Sasanians, who reigned from 224 to 651, and of Iran's legendary heroes (fig. 49).[39] On a lesser scale, al-Baidavi's *History*, written in 1275 for Shams al-Din Juvaini and his colleague Sughunjakh Akha, sought to present the Ilkhans as the latest in a long sequence of Iranian dynasts, all endowed with the traditional virtues of justice and concern for cultivation. Later this idealization would be carried even further in the repackaging of Ghazan, the convert khan, as a second Alexander, a philosopher king, and a Persian emperor (figs. 36, 51).[40]

The value of such imperial propaganda was no doubt apparent to the Mongol rulers, who needed a more locally relevant image with which to impress their sub-

36. This was still conditional on the Mamluks agreeing to acknowledge Mongol suzerainty, a substantial stumbling block; see Allouche 1990.

37. For various letters written especially to Baghdad, see, for example, Baibars al-Mansuri 1998, pp. 218–19; Ibn ʿAbd al-Zahir 1961, p. 5; Ibn al-Fuwati 1997, pp. 457–59.

38. See Aubin 1995, pp. 31–32, for an inconclusive summary of the arguments; Melville 1998b, pp. 111–12. See also Amitai-Preiss 2001.

39. Melikian-Chirvani 1996; Irwin 1997, pp. 126–27; Melikian-Chirvani 1997, esp. pp. 149–67.

40. Hillenbrand 1996; Melville 2001; Melville forthcoming.

jects than the appeal to Genghisid legiti-
macy. It was the equivalent of Khubilai
Khan adopting a Chinese dynastic name,
Yuan ("the Origin"), for his regime, also on
the advice of indigenous officials. It is thus
not surprising that Firdausi's *Book of Kings*
became the vehicle par excellence for the
reassertion of Iranian identity at the Mongol
courts and the model for a number of
heroic verse chronicles of Mongol history in
the idiom of ancient Iran. Likewise, the
revival of the concept of Iranzamin and the
participation of Iran once again in a world
empire of Central Asian origins provided a
powerful impetus to literary and artistic
creativity, the most dramatic and original
expressions of which are surely the illustra-
tion of the *Shahnama* and the composition of
other historiographical texts.⁴¹

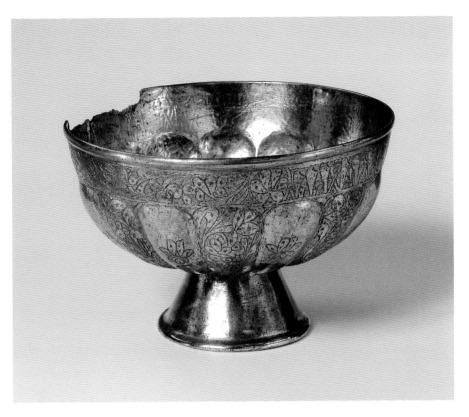

Fig. 53 (cat. no. 156). Footed cup, Greater
Iran or Golden Horde (Southern Russia),
late 13th–early 14th century. Silver gilt,
punched and incised. The David Collection,
Copenhagen (47/1979)

For the direction of the empire, Mongol values at first prevailed and deter-
mined the character of government. Arghun was a Buddhist and eliminated Juvaini
soon after seizing power in 1284. He relied on his Mongol lieutenant, Bukha, to
head the government, and after him the Jew Saʿd al-Daula, as mentioned above. Saʿd
al-Daula had as a colleague the Mongol amir Ordukhiya, just as Juvaini had been
paired with Sughunjakh Akha. The Mongols fully intended to retain control of the
administration, even when much of the practical work of the bureaucracy, as in
China, was left to indigenous officials.⁴² The Mongol characteristic of appointing
two government officials to one post fostered factionalism and rivalries at court,
however, while in the provinces the multiplicity of officials and their rapacity
brought despair to the population. An oppressive system of dual taxation also seems
to have operated, with arbitrary taxes being levied by the Mongols in addition to the
traditional ones already in force.⁴³

During Arghun's reign, outlying areas, such as Anatolia and Fars, came directly
under central government control. When Arghun died in 1291, poisoned by an elixir
intended to make him immortal, the Ilkhanate entered a short but disastrous period
in which two khans were deposed and executed in four years. Geikhatu, a son of
Abakha, succeeded his brother Arghun, but he quickly alienated supporters by his
licentiousness and lax government. His chief minister, the capable but ambitious Sadr
al-Din Zanjani, in a desperate attempt to counteract the damage done by the court's
profligacy, presided over the disastrous introduction of paper currency on the
Chinese model.⁴⁴ While drunk, Geikhatu insulted his cousin Baidu, who responded
by leading a rebellion in which Geikhatu was killed. Baidu claimed the khanate, but
his brief reign was immediately challenged by Ghazan, son of Arghun, whose tri-
umph in October 1295 ushered in the second phase of Mongol rule in Iran.

41. See Grabar and Blair 1980, pp. 13–27; Simpson
 1982a; Melikian-Chirvani 1988; Melikian-Chirvani
 1991; Blair 1995, pp. 60–88; Soudavar 1996.
42. Aubin 1995, pp. 38–43; D. O. Morgan 1996,
 esp. pp. 69–71.
43. See al-Aqsarayi 1944, pp. 149, 180–81, 228, 258,
 for Anatolia; Lambton 1987, esp. pp. 105ff., for
 Fars; Lambton 1988, esp. pp. 199–209, in general.
44. See Jackson 1992; Jackson 2001.

Fig. 54 (cat. no. 5). Left side of a double-page frontispiece from the *Kitab jami⁶ al-tasanif al-rashidi* (Collected Writings of Rashid al-Din), copied by Muhammad ibn Mahmud al-Baghdadi, illuminated by Muhammad ibn al-⁶Afif al-Kashi, Iran (Tabriz), A.H. 707–10/ A.D. ca. 1307–10. Fol. 4r; ink and colors on paper. Bibliothèque Nationale de France, Paris (MSS or. Arabe 2324)

Ghazan's success and his subsequent reputation as the greatest of the Ilkhans were due to his conversion to Islam, which brought him the support of some key Muslim Mongol commanders, such as Nauruz and Chupan. Ghazan was also fortunate to be served by the converted Jewish doctor Rashid al-Din (here too, always with another colleague in the vizierate). The renewed impetus given to courtly patronage of the arts and letters, largely inspired by the example of Rashid al-Din himself (fig. 54) but not discouraged by the Ilkhans, is what particularly distinguishes the second phase of Mongol rule from the first, rather than any significant alteration in the government of the kingdom; however, Ghazan's efforts to reform the worst aspects of the postconquest phase of Mongol rule have also contributed to his reputation.

Outside Tabriz, Ghazan developed a new city quarter, called Ghazaniyya. There he erected a spectacular mausoleum for himself (thus breaking with the practice of his predecessors) and also constructed a mosque, two madrasas, a hospice for *sayyids* (descendants of the Prophet), an observatory, and other buildings.[45] Rashid al-Din emulated his master by constructing the Rashidiyya suburb on the east side of Tabriz, establishing, among other foundations, an atelier (*kitabkhana*) for the production of illustrated manuscripts. Commissioned by Ghazan and later by his brother and heir, Öljeitü (r. 1304–16), Rashid al-Din produced his great history of the Mongol empire and the peoples with whom it came into contact. Called the *Jami' al-tavarikh* (Compendium of Chronicles), the work presents the Mongol achievement in a world context and, as importantly, in its place in Persian history, setting the Mongol chapter after a survey of the previous dynasties that ruled Iran. Rashid al-Din and later his son, Ghiyath al-Din (d. 1336), were themselves patrons of numerous writers and members of the religious classes.[46] The Ilkhan Öljeitü went on to develop an extensive complex of buildings around his mausoleum in the new capital at Sultaniyya (see Sheila Blair's chapter 5). During the reign of his son Abu Sa'id, a monumental mosque was constructed in Tabriz by the vizier Taj al-Din 'Alishah (Rashid al-Din's rival and nemesis). Its design was inspired by the arch that remained from the ancient palace of the Khusraus at Ctesiphon, which it was intended to surpass.[47]

The religious scholars, or *'ulema*, found some consolation in this revival of Islamic institutions, which included a reaffirmation of the validity of the religious law (*shari'a*), a renewed interest in the pilgrimage (hajj), and the construction of mosques and madrasas. However, the main agents and beneficiaries of the Mongols' conversion to Islam were the Muslim mystics known as Sufis. Ghazan himself was converted at the hands of Sadr al-Din Humuya, a shaikh of the Sufi order founded by Najm al-Din Kubra (d. 1221) of Khwarazm. Many Mongols had already taken this step.[48] The charisma of individual shaikhs, such as Jalal al-Din Rumi, Qutb al-Din Shirazi, 'Ala' al-Daula Simnani, and Safi al-Din of Ardabil, made them influential in the ruling circles. Moreover, the size of their popular following—not least among the Turko-Mongol tribesmen who constituted the military power of the Ilkhanate—and their increasing readiness to champion the rights of the people against the authorities made the shaikhs a potent force that it was

45. See Haneda 1997, esp. pp. 144–60.
46. There is a vast literature on Rashid al-Din. For some of the most important recent work, with reference to earlier studies, see, for example, Blair 1995; Blair 1996; Hoffmann 1997; Rajabzadah 1998.
47. O'Kane 1996, esp. pp. 506–10; Haneda 1997, pp. 160–63. See also chapter 5 in this catalogue.
48. Melville 1990b.

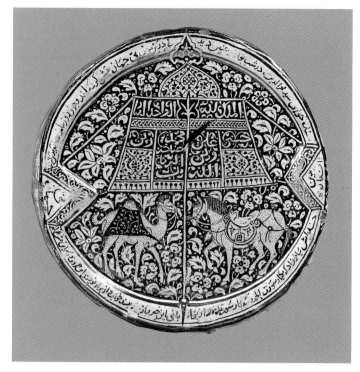

Fig. 55 (cat. no. 119). Tile with imprint of camel's hoof, from the Shrine of the Footprint of ʿAli, Iran, A.H. 711/A.D. 1311–12. Fritware, overglaze luster-painted. Musée National de Céramique, Sèvres (MNC 26903)

Fig. 56 (cat. no. 120). Tile with imprint of horse's hoof, from the Shrine of the Footprint of ʿAli, Iran, A.H. 711/A.D. 1311–12. Fritware, overglaze luster-painted. Musée National de Céramique, Sèvres (MNC 22688)

impolitic to ignore. Shaikh Safi al-Din (d. 1334), the ancestor of the Safavid dynasty that would rule Iran from 1501 to 1722, was courted by all three of the last Ilkhans and frequented the cultured circle of Rashid al-Din and his son in Tabriz. The favors he received contributed greatly to the wealth and prestige of the Safavid order in Ardabil.[49]

Popular religious sentiment embraced other, more extreme forms. Many antinomian dervishes, known as *qalandari,* were also very successful in impressing the Mongol chiefs and their coarse followers. Among the most prominent dervishes were ʿAbd al-Rahman and Baba Yaʿqubiyan in the time of Tegüder Ahmad, and Baraq Baba under Ghazan and Öljeitü.[50] The heterodox tendencies expressed by such figures remained powerful in the mainly tribal society of northwest Iran and eastern Anatolia. Particularly strong was the appeal of Shiʿite Islam, which looked to ʿAli, the son-in-law of Muhammad, and his descendants as the legitimate leaders of the Muslim polity. In the post-caliphal world of Sunni collapse, Shiʿite views found fertile soil and were elaborated by writers such as Nasir al-Din Tusi and ʿAllama al-Hilli (d. 1325). The crowning moment of this development was Öljeitü's conversion to the sect of Twelver Shiʿism in 1309, after a long career of spiritual vacillation (he had previously been baptized Nicholas in honor of the pope). Öljeitü's attempt to force Shiʿism on his subjects, symbolized in the fine mihrab added in 1310 to the Friday Mosque in Isfahan (fig. 138), was a failure. Nevertheless, in the Mongol period the seeds were sown for the close identification of Shiʿism not only with Iranian mysticism but also with popular piety and, ultimately, the national religious faith (figs. 55, 56).[51]

Though the conversion of the Mongols was an important turning point in their rule and enabled them to acquire both legitimacy and authority in Iranian and

49. See, for example, Minorsky 1954; Aubin 1976–77; Melikian-Chirvani 1984, esp. pp. 312ff.; Aubin 1989; Melikian-Chirvani 1991, pp. 52–54; Walbridge 1992; Elias 1995, esp. pp. 15–31; Aigle 1997b; Gronke 1997. Hagiographies of Safi al-Din, Jalal al-Din Rumi, and Amin al-Din Balyani are particularly rich sources for the social history of the period. Lesser saints, living and dead, were also patronized; see chapter 5.

50. See Karamustafa 1994, esp. pp. 51–63; see also Amitai-Preiss 1999; Melville 1999b, pp. 85–86, 98–104 (on the career of Baraq Baba).

51. Bausani 1968, pp. 543–49; Calmard 1997; Pfeiffer 1999.

Islamic terms, it did not on its own have many practical consequences. Rashid al-Din devoted much of his account of the rule of Ghazan, the *Padshah-i Islam* (Muslim King), to reforms that were implemented: reviving agriculture, improving the fiscal system, standardizing weights and measures, regulating the coinage, maintaining the army, and removing many of the oppressive taxes that fell on the peasantry. The enumeration of these measures serves partly to cast into greater relief the violence and disorder of the early period of Mongol rule; still, it is not clear how effective they were in the short term. The figures subsequently provided by Mustaufi Qazvini comparing the general situation under the Seljuqs with those before and after Ghazan's reforms do illustrate a dramatic decline before and a small recovery afterward, but the relationship between conditions in the country and the amount of revenue reaching the central treasury is hard to determine.[52]

The conversion of Ghazan and Öljeitü did not preempt further hostilities against the Mamluks; quite the contrary. Adding his new Islamic credentials to the previous Genghisid claims to universal rule, Ghazan demanded the submission of the Mamluk sultanate. When this was not forthcoming, he invaded Syria and captured Damascus (January 1300). However, as with their previous foray into Syria, the Mongols found that they could not operate so far from home, and they soon withdrew. A third attempt met defeat at the disastrous battle of Marj al-Suffar near Damascus (April 1303). Öljeitü's desire to expand the empire was more ambivalent, and a desultory campaign against Rahba on the Euphrates in the winter of 1312–13 was quickly abandoned. Lowered expectations paved the way for a peace treaty with the Mamluks in 1323, in the reign of Abu Sa'id, by which time rivalries were expressed more in ideological and symbolic terms than through military confrontation, although numerous sources of tension remained.[53]

Within the Ilkhanate, tensions between traditional Mongol attitudes and forces for accommodation erupted in several serious disorders, which weakened the cohesion between the army chiefs and undermined the authority of the regime. Ghazan's accession to power was followed by the execution of no less than ten royal princes. His brother Öljeitü's reign was ostensibly a more peaceful interlude, but the accession in 1316 of Öljeitü's twelve-year-old son, Abu Sa'id, soon saw the rivalries and ambitions of different factions spill over into open warfare.

One of the first casualties was the aged vizier Rashid al-Din, who was killed in 1318, a victim of the intrigues of his rival Taj al-Din 'Alishah. The Rashidiyya quarter in Tabriz was pillaged, although Ghiyath al-Din was able to revive it for a while. A revolt in 1319 against the senior amir (military commander), Chupan, was defeated, but after his fall from power in 1327 the Mongol chiefs became increasingly resentful of the influence that Ghiyath al-Din, the new vizier, exercised over the young sultan.[54] Ghiyath al-Din's attempt to administer the kingdom according to Islamic norms, and more particularly his patronage of scholars, Sufi shaikhs, poets, artists, and musicians, gave the impression that the cultivated court of Abu Sa'id was presiding over a golden age. Tabriz itself, as described by the Moroccan traveler Ibn Battuta in 1327, was visibly flourishing. However, evidences of a decline in commercial activity with the Italian city-states and of successive debasements of the coinage, together with the problems of asserting central control over the provinces, suggest that all

52. Hamd Allah Mustaufi Qazvini 1915–19, vol. 1, pp. 26–28, vol. 2, pp. 32–34. See also Petrushevsky 1968, pp. 494–500; Lambton 1969, pp. 77–99; Lambton 1998, pp. 125–26.
53. Melville 1992; Melville 1996a.
54. See Melville 1997a; Melville 1999a.

was not well.[55] Crucially, Abu Saʿid died without an heir, and in 1335 the Ilkhanate rapidly began to unravel.

Arpa Keʾün, a descendant of Hülegü's brother Arigh Böke, was the first ruler to emerge. Although he warded off an invasion by the Golden Horde, who were eager to take advantage of the disarray in the Ilkhanate, Arpa could not rally enough support to hold power, and after his elimination in May 1336, chaos erupted. During the next twenty years puppet sultans from the house of Genghis Khan were elevated to the throne in succession by rival factions, sometimes more than one being acknowledged at the same time. They found support principally in the north and northwest of Iran. The descendants of Amir Chupan put forward a number of Genghisids, including Abu Saʿid's sister Sati beg, before themselves taking control of Azerbaijan and the northwest in about 1345 in the name of a non-Genghisid sultan. Ironically, they called him Anushirvan, a name associated with the famous Sasanian king celebrated for his justice; Chupanid rule was particularly violent and oppressive. (Still, some building work continued in the capital, Tabriz.)[56]

More significant were the Jalayirids (1336–1432), based in Baghdad, who at first acknowledged the sovereignty of various claimants including Geikhatu's grandson Jahan Temür, but then from 1346 on ruled independently. Since they gained power in the north as well, the Jalayirids presided over two of the main centers of artistic production in the late fourteenth century, Baghdad and Tabriz. Under Jalayirid patronage, the courtly arts that had developed under the Ilkhanids spread to the provinces.[57]

Meanwhile in the east, in Khurasan, Togha Temür was elected Ilkhan in 1336, but all his efforts to gain control of western Iran were defeated. Finally he was murdered in his camp near Sultan Duvin in December 1353, by the Sarbadarids. This regime of local landowners was based in Sabzavar and Nishapur. Attempting to satisfy the aspirations of the rural population, they formed an uneasy alliance with a dervish movement called the Shaikhiyya and later also associated themselves with a type of messianic Shiʿism—indications of the growing importance of these trends in late Ilkhanid society. The Sarbadarids were able to restore some measure of security to western Khurasan before submitting to Timur (also known as Tamerlane) in 1381.[58]

In southern Iran, other forms of independent rule emerged under former representatives of the Ilkhanid government, notably the Injuids in Fars and Isfahan and the Muzaffarids, who ultimately replaced them, in Yazd and Kirman (see chapter 8). The celebrated poet Hafiz of Shiraz (1326–1389) lived through this transitional period; he was not alone in lamenting the passing of the Injuid rulers and their enlightened patronage.[59]

Not until Timur (r. 1370–1405) did there appear a ruler able to forge the scattered fragments of the Ilkhanid state into a new amalgam. Rising to power in the Chaghadai Khanate in Transoxiana, he revived to some extent the goals of Genghis Khan's conquests, lightly cloaked in a veneer of Islamic political propaganda. During a long career of almost ceaseless campaigning, Timur brought further waves of nomadic troops, mainly Turkish, into all corners of Iranian territory. He left it to his descendants to tackle, with some success, the enduring problems of accommodating

55. See above, note 16, on Tabriz. For Venetian debts and the apparent reduction in Genoese activity in the reign of Abu Saʿid, see, for example, Paviot 1997, pp. 75–82. For the coinage, see Blair 1983, esp. pp. 307–10. For Ghiyath al-Din, see Melville 1999a, esp. pp. 60–68; Jackson and Melville 2001.

56. Jackson 1987; Melville and Zaryab 1992; Melville 1999a, esp. pp. 44–50, 61–62.

57. Gray 1961, pp. 34–56; Titley 1983, pp. 26–32; Canby 1993, pp. 41–48.

58. Smith 1970; Aubin 1991; Melville 1997b.

59. Limbert 1985; Roemer 1986; Jackson 1993b. For the arts in southern Iran, see Gray 1961, pp. 57–64; Titley 1983, pp. 35–43; Canby 1993, pp. 34–41.

60. See Aubin 1975.

the Turko-Mongol military and ruling circles to the norms of Iranian and Islamic culture, of which they had now become a permanent ingredient.

The dichotomy between Turk and Tajik ("Persian"), nomad and settled, an alien military leadership and the urban and agrarian society it dominated was an ancient one. Indeed, the wedding of new Persian culture to Turkish military might had already begun in the eleventh century under the Ghaznavids, a dynasty of Turkish slave origin based in what is now Afghanistan, which extended its sway over eastern Iran and northern India. But the massive injection of Turkish and Central Asian elements into the Iranian world in the wake of the Mongol invasions exaggerated these distinctions and altered the balance within Persian society. The formation of vigorous new states on the Iranian plateau governed by military chiefs of Turkish background and Genghisid horizons reoriented Iran, bringing it closer once more to its traditional and historical position in the world, as celebrated in Firdausi's *Book of Kings*. The presence of new patrons to impress and to educate, combined with a new freedom of self-expression, stimulated Persian cultural creativity, resulting in remarkable original achievements. Historiography, art, and architecture, partly released from the restraints of previous conventions, now recalled more ancient glories; in the field of manuscript illustration, artists broke completely new ground (see Robert Hillenbrand's chapter 6). Meanwhile on a humbler level, away from the princely capitals and their courts, local provincial families did much to support the religious classes (the *ulema* and Sufi shaikhs) by building schools, mosques, and dervish convents. Such pious patronage helped reaffirm the values of Islamic communal life previously undermined by the shocks of the Mongol conquests.[60]

This reorientation of Iran, and the political continuities with Central Asia and northern India that were created especially by the Timurids in the fifteenth century, led to an extension of the Turko-Persian ecumene eastward across the Oxus and the Indus Rivers, to lands where it enjoyed a lasting future. In its westward gaze, this world was open to the merchants and merchant states of western Europe, glancing lightly over the intervening Arab lands of the Levant—to which it had been somewhat unnaturally joined and which also went their own way, first under the Mamluks and then as part of the Ottoman empire.

In terms of political culture, however, the new ruling classes proved to be too strongly rooted in their rather informal Turkish steppe traditions to adapt easily to Iranian notions of centralized dynastic rule. Their unwieldy and impractical concept that sovereignty resided in the whole family was compounded by the lack of any single agreed system of succession. The independent instincts and competition for leadership characteristic of tribal society further heightened the violence in political life, which was scarcely if at all modified by notions of justice or fear of religious sanctions. The dilemma for the series of secular Turko-Mongol regimes that ruled all or parts of Iran after the conquests of Genghis Khan was how to reconcile his political legacy with the very different expectations of rule, rooted in Islamic legal principles, that had evolved during the previous caliphal period. Successive Mongol and post-Ilkhanid rulers treated Iranian territory as little more than a military camping ground, despite conversion to Islam and an ostentatious acculturation to Persian courtly manners. Although the Mongol flood subsided, the course of the riverbed had changed.

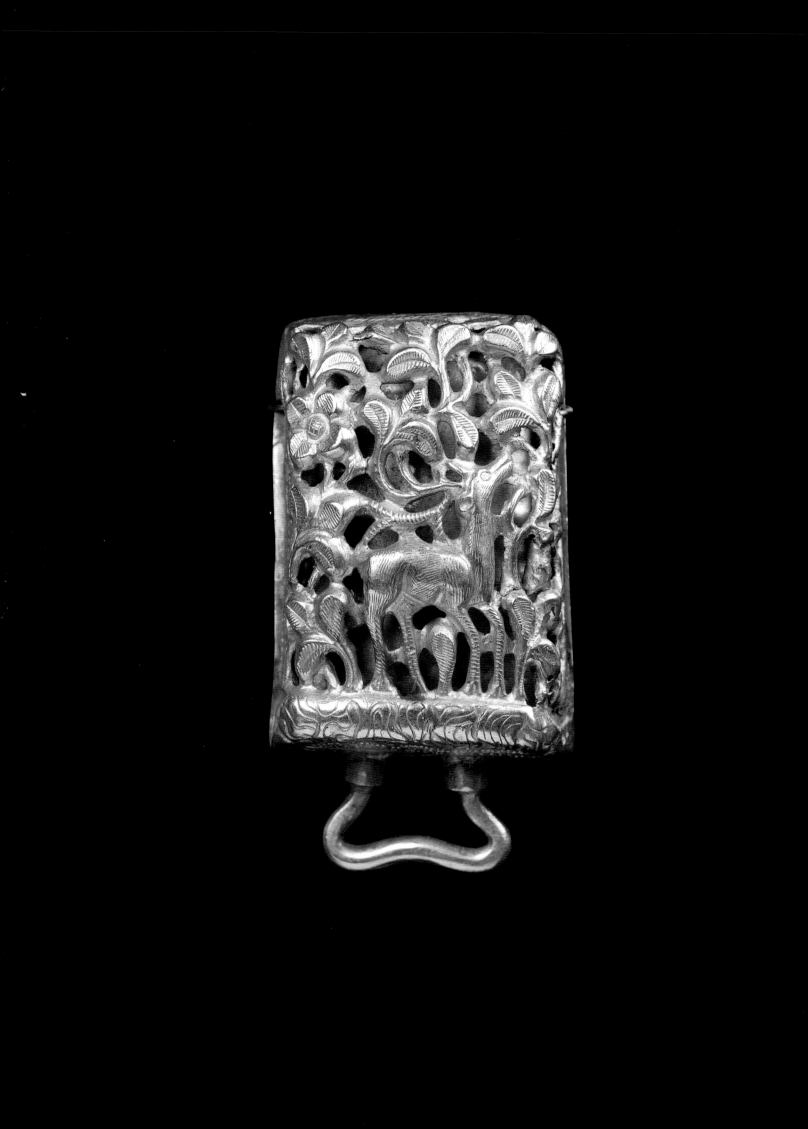

3.

A Note on Artistic Exchanges in the Mongol Empire *JAMES C. Y. WATT*

[Ögödei] commanded a hundred balish *to be given to a poor man. The Ministers of the Court said to one another: "Does he know how many dirhems there are to so many* balish?" *They took the hundred* balish *and scattered them where he would pass by. And when he passed by he asked, "What is this?" They replied that it was the hundred* balish *for the poor man. "It is a miserable amount," he said. And so they doubled it and gave it all to the poor man.*
— *'Alā' al-Dīn 'Ata Malik Juvaini,* The History of the World Conqueror[1]

THE EARLY PERIOD, 1206–CIRCA 1270

It is well known that Mongol conquerors, who ruthlessly slaughtered the inhabitants of cities resisting their military advances, nonetheless spared those with any claim to skill in a useful craft. Particularly favored were weavers and metalworkers, including armorers and gold- and silver-smiths. In the early days, during the Mongols' first sweep across Central and West Asia, captured craftsmen were sent to Khara Khorum, the capital of the empire, on the upper Orkhon River in Mongolia. Alternatively, they were dispatched to production centers located in various parts of the empire at the previous seats of government of recently conquered states and now under the nominal control of Secretariats. In the time of Ögödei (r. 1229–41), the Secretariats were located in Yanjing, the former Middle Capital of the Jin dynasty (present-day Beijing); Besh Baliq, the capital of the Uyghur kingdom, in the northern foothills of Tianshan (northeast of Urumqi in present-day Xinjiang province); and somewhere in Transoxiana, which contained the rich cities of Samarqand and Bukhara and previously had been under the control of the Khwarazmian empire.[2] The secretaries were charged with collecting revenues, "mainly in the form of precious metals and silk," within their respective administrative territories and forwarding them to the Great Khan in Khara Khorum.[3] Workshops were generally situated in places with long-established traditions of craft production, although for silk textiles new centers were established in North China, within convenient reach of Beijing but near or on the border with Mongolia.

These early workshops were staffed with craftsmen drawn from all across the newly founded empire. An example is Xunmalin, located along one of the routes between Beijing and Shangdu (the Upper Capital, Khubilai's seat of rule before he founded the Yuan dynasty and set its capital at Beijing, whose name he changed from Yanjing to Dadu); in the time of Ögödei, *nasij* (cloth of gold) was being produced in Xunmalin by a colony of three thousand households of weavers from Samarqand.[4] At the same time in Hongzhou, west of Beijing, over three hundred households of "weavers of patterned [cloths of] gold from the Western Regions" and three hundred

1. Juvaini 1958, vol. 1, pp. 218–19.
2. Xiao Qiqing 1966, p. 47.
3. Dardess 1972–73, p. 118. This article provides the historical background on which the present essay is based.
4. Pelliot 1927.

Opposite: Fig. 57 (cat. no. 143). One of a set of belt fittings, Golden Horde (Southern Russia) and China, 13th century. Gold. State Hermitage Museum, Saint Petersburg (KUB-705–721). See fig. 62.

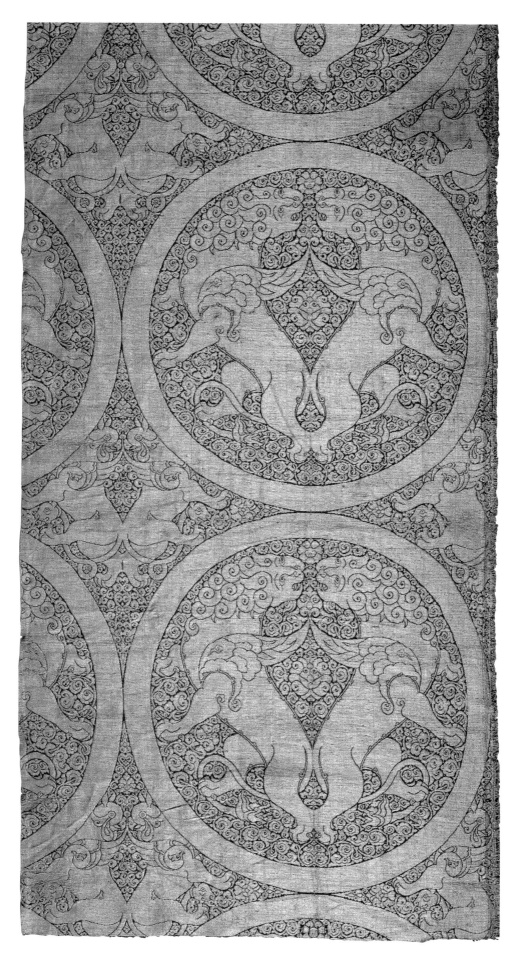

Fig. 58 (cat. no. 69). Textile with winged lions and griffins, Central Asia, mid-13th century. Lampas weave
(tabby and tabby), gold thread on silk foundation. The Cleveland Museum of Art, Purchase from the
J. H. Wade Fund (1989.50)

households of weavers from Bianjing (the former capital of the Jin dynasty, present-day Kaifeng) were added to the workshop, where young boys and girls and master craftsmen "from all over the empire" were already employed.[5] In Besh Baliq there were artisans from Herat and probably also from Nishapur[6] (although in the years 1236–39 some weavers were repatriated to Herat to revitalize the weaving industry there).[7] This massive movement of craftsmen over vast distances in the days of the early empire, particularly during the reigns of Ögödei and Möngke (r. 1251–59), would have long-lasting effects for the arts across all of Asia.

Each of the textile production centers established under the Mongols contributed to the development of new styles of patterning and weaving techniques. Although it is not possible to identify a particular textile as the product of a specific workshop, some general indications as to area of production—North China, Central Asia, Transoxiana, or Khurasan—can be gleaned from an examination of the patterns and structures of the not-very-numerous fragments of textiles that survive (fig. 58).[8] Both Chinese and Iranian elements of design and technique can be discerned in varying proportions in nearly all Mongol textiles, irrespective of their place of origin. A contribution specific to Central Asia has, however, only recently been pointed out.[9] Designs of dragons and other animals in Central Asian textiles display characteristics that are endemic in the age-old arts of

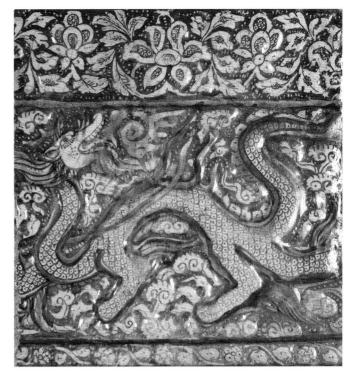

Fig. 59 (cat. no. 101). Frieze tile with dragon, Iran (probably Takht-i Sulaiman), ca. 1270s. Fritware, overglaze luster-painted. The Nasser D. Khalili Collection of Islamic Art, London (POT 790)

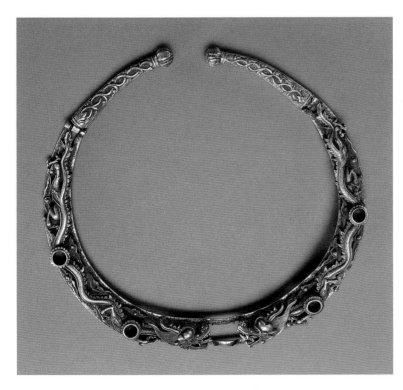

Fig. 60 (cat. no. 202). Torque, China, probably Yuan dynasty (1271–1368). Silver, worked in repoussé. Inner Mongolia Museum, Hohhot

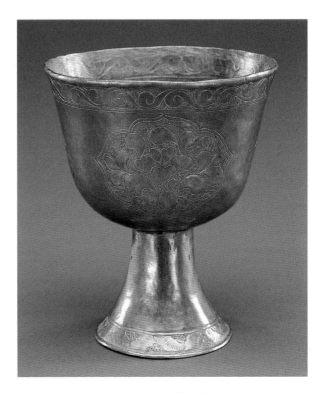

Fig. 61 (cat. no. 196). Footed cup, China, Yuan dynasty (1271–1368). Gold. Inner Mongolia Museum, Hohhot

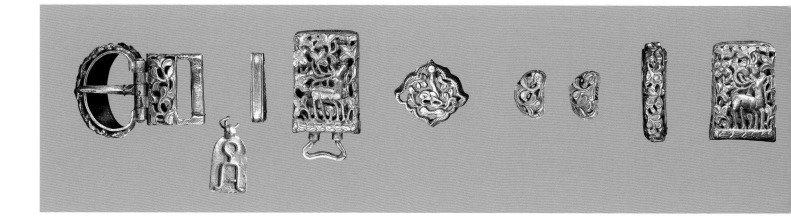

Fig. 62 (cat. no. 143). Set of belt fittings, Golden Horde (Southern Russia) and China, 13th century. Gold sheet, engraved, stamped, chased, and punched, worked in repoussé. State Hermitage Museum, Saint Petersburg (KUB-705–721). See fig. 57.

the Eurasian steppes. Although the images of dragons and phoenixes perhaps had originated in China, they were transformed when interpreted by weavers in Central Asia. The animals and birds are given twisting or writhing bodies and are imbued with a vitality not seen in Chinese models. For example, the dragons and phoenixes on the tiles of Takht-i Sulaiman (figs. 59, 97, 100, 101; on Takht-i Sulaiman, see Tomoko Masuya's chapter 4) are as often as not of the Central Asian type rather than the type derived directly from a Chinese source. Indeed, the phoenixes in Yuan China themselves took on a more rigorous, almost aggressive look compared with those from other periods of Chinese history (see fig. 210). Their distinctive quality could well be attributed to influences from Central or northern Asia.

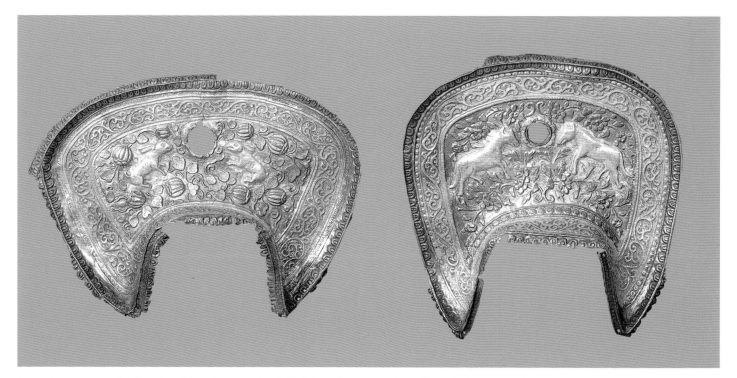

Fig. 63 (cat. no. 138). Saddle arches, Mongol empire, first half of the 13th century. Silver gilt, worked in repoussé. State Hermitage Museum, Saint Petersburg (ChM-1199, -1200)

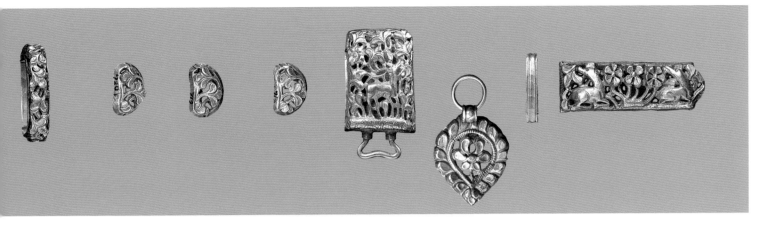

Records about the production of precious metal objects are even scantier and less specific than those for textiles. Since workers in gold and silver can ply their crafts individually and require little elaborate equipment, they can be stationed almost anywhere. There certainly were goldsmiths working in Khara Khorum itself. The Franciscan friar William of Rubruck, who had an audience with the Great Khan Möngke at his court at Khara Khorum, has left us with a detailed description of an elaborate silver fountain spouting four different kinds of wine, made for Möngke's palace by a Parisian goldsmith.[10] The iconography of this wine fountain seems from the description to be purely European; its main body was in the form of a tree, with an angel on top blowing a trumpet. In the same way, goldsmiths captured in newly conquered areas would have produced works in their native styles. A good example is the set of gold belt fittings and ornaments found at the site of Gashun Uta, North Caucasus (Russia) (fig. 62; see also fig. 65). Its technique of manufacture and its motif of deer among foliage are both typical of work done under the Jin dynasty in North China, which was overrun by the Mongols in 1115 (although the Southern Capital of Jin State did not fall until 1234).[11] Found with the set of fittings and ornaments was a small plaque bearing the heraldic crest of the house of Batu, a grandson of Genghis Khan and founder of the Golden Horde. This set must have been made for a family member of Batu by a Chinese goldsmith from the Jin State, unless it is simply war booty. Other examples of Chinese workmanship are an incomplete set of silver belt fittings found at the Crimean city of Simferopol[12] and a silver bowl from the Ob' basin in Siberia.[13] The Simferopol treasure is particularly instructive: the large horde of precious objects includes articles from Iran and Central Asia as well as a set of Italianate gold belt plaques that could have been brought from Italy.[14]

Hybrid styles are exhibited by other metal objects found within Mongol territory. A bronze bowl from Khara Khorum combines Islamic and Chinese motifs, very much in the manner of textiles known to have been produced in Central Asia.[15] It is likely that the bowl was made in Central Asia in the area of textile workshops and sent to Khara Khorum as tribute.

In connection with metalwork, mention should be made of the *paiza* (from the Chinese *paizi*), a tablet signifying official authorization (see cat. no. 23, fig. 68).

Fig. 64 (cat. no. 150). Belt plaque, Central Asia, 13th century. Silver, repoussé, chased and engraved decoration. The Nasser D. Khalili Collection of Islamic Art, London (JLY 1825)

Fig. 65 (cat. no. 151). Three belt plaques, Southern Russia or Central Asia, 13th century. Gold, repoussé, chased and engraved decoration, granulation. The Nasser D. Khalili Collection of Islamic Art, London (JLY 1012, 1836)

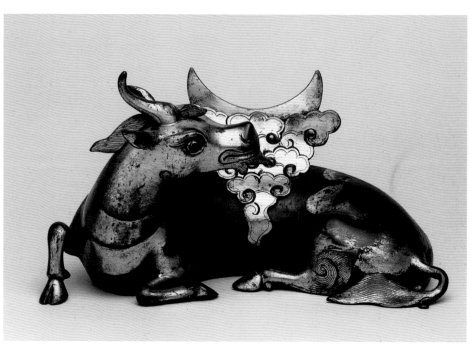

This universal instrument of Mongol administration owes its original form to that of *paizi* used by the Liao dynasty in North China (907–1125); a gold version of a Liao *paiza* with an inscription in Khitan reading "By imperial command, expedite" was recently found near Chengde in Hebei province (fig. 70). This oblong form survived through the Jin dynasty (1115–1234) and was adopted by the Mongols. A round version (fig. 69) was used in Yuan China from the time of Khubilai (r. 1260–94); the "tiger head" of its handle is in Tibetan style. Early *paizi* have inscriptions only in Phagspa—the new script for writing Mongolian devised in the 1260s by the Tibetan monk Phagspa—in gold or silver, inlaid in iron. Later versions, especially in South China, are inscribed in Phagspa, Persian, and Chinese.[16] In other areas, including Iran, *paizi* are usually, if not exclusively, inscribed in the Uyghur script.[17]

Generally speaking, the available archaeological and art historical evidence for East-West cultural exchange within the early Mongol empire can be interpreted as the result of a three-way interaction between North China, eastern Central Asia, and the Iranian world. This interpretation accords well with historical accounts of the organization and administration of craft and industrial production at the time.

AFTER CIRCA 1270

In the early Mongol period, up to the reign of Möngke, the flow of tribute in the form of luxury goods from all over the empire created a great concentration of wealth at Khara Khorum, the capital. This made possible the legendary liberality of Ögödei, described by the historian ʿAta Malik Juvaini (see quotation at head of this essay).[18] But with the succession

Fig. 66 (cat. no. 179). Textile with pattern of *djeiran* (antelope) in a landscape, China, Jin dynasty (1115–1234). Tabby, brocaded, silk and gold thread. The Cleveland Museum of Art, Purchase from the J. H. Wade Fund (1991.4)

Fig. 67 (cat. no. 195). Mirror stand representing a *djeiran* (antelope), China, Song, Jin, or Yuan dynasty, 12th–14th century. Gilt bronze. Victoria and Albert Museum, London (M.737-1910)

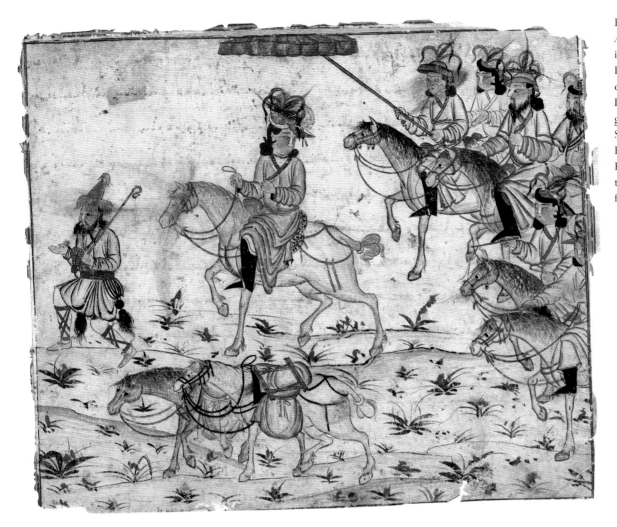

Fig. 68 (cat. no. 23).
A Royal Procession,
illustration from the
Diez Albums, Iran,
early 14th century.
Ink, colors, and
gold on paper.
Staatsbibliothek zu
Berlin—Preussischer
Kulturbesitz, Orien-
tabteilung (Diez A
fol. 71, S. 50)

Fig. 69 (cat. no. 197). *Paiza* (passport) with inscription
of Phagspa script, China, Yuan dynasty (1271–1368),
late 13th century. Cast iron, inlaid with silver. The
Metropolitan Museum of Art, New York, Purchase,
Bequest of Dorothy Graham Bennett, 1993 (1993.256)

Fig. 70. *Paiza* (passport) with Khitan
inscription, Liao dynasty (907–1125).
Gold. Found near Chengde (northeast
of Beijing), Hebei Province. Hebei
Provincial Museum, Shijiazhuang

5. *Yuanshi* 1976, pp. 2963–64 (chap. 120).
6. Watt and Wardwell 1997, pp. 134–35.
7. Allsen 1997a, p. 40.
8. To date, the key work on this subject is Wardwell 1988–89.
9. See Wardwell 2000.
10. Ruysbroeck 1990, pp. 209–10. See also Morris Rossabi's chapter 1, p. 27 and n. 33.
11. The motif of deer among foliage was the prescribed decoration on the uniforms and accoutrements of officers who accompanied the Jin emperor on the autumn hunt (*qiushan*). See Yang 1983.
12. Fedorov-Davydov 2001, no. 34, pl. 64.
13. Marshak and Kramarovsky 1996, no. 77 (English summary of Marshak's introductory article, pp. 221–22; see particularly the comments on no. 77).
14. Fedorov-Davydov 2001, pp. 58–59.
15. Kiselev 1965, pl. 143. Illustrated and discussed in Wardwell 1992.
16. Cai 1984.
17. For an Ilkhanid *paiza*, see Ghouchani 1997.
18. Juvaini 1958, vol. 1, pp. 201–36.
19. Allsen 1997a, p. 35.
20. Watt and Wardwell 1997, pp. 130–31. See also Zhou 1997.
21. *Yongle dadian* 1962, chap. 19781, leaf 17.
22. Watt and Wardwell 1997, p. 131.

crisis that ensued after Möngke's death in 1259, the great empire gradually disintegrated into basically independent khanates, each still encompassing a vast area. While the central administration of production and the collection of tributes continued, now they obtained within each separate state. Soon after his accession as Great Khan in 1260, Khubilai began to consolidate his economic base in North China and to deprive his rivals khans of the same. Craftsmen in Mongolia were relocated to China.[19] In 1275, when Turpan was under siege by Khaidu and Du'a (Mongol princes of the Ögödei and Chaghadai houses, respectively), Khubilai transferred weavers from Besh Baliq, the principal city of that area, to Dadu (Beijing), the new capital of the Yuan dynasty.[20] Khubilai's edict, which was recorded, required the Besh Baliq office in Dadu to "weave *na-shi-shi* [*nasij,* that is, cloth of gold] for collars and cuffs for imperial use."[21] This is confirmed by the thirteenth-century portrait of Chabi, Khubilai's wife (fig. 27), in which the collar of her dress is of cloth of gold patterned with heads of griffinlike birds, a design certainly imported along with weavers from Central Asia.[22]

Thus the period of large-scale movement of craftsmen over long distances and the resulting creative exchange of techniques and ideas ended with the political reorganization of the Mongol empire in the 1260s and early 1270s. If the Yuan empire in China and Mongolia is taken as a model, it can be postulated that elsewhere too under the Mongols, the populations of craftsmen stabilized, and new

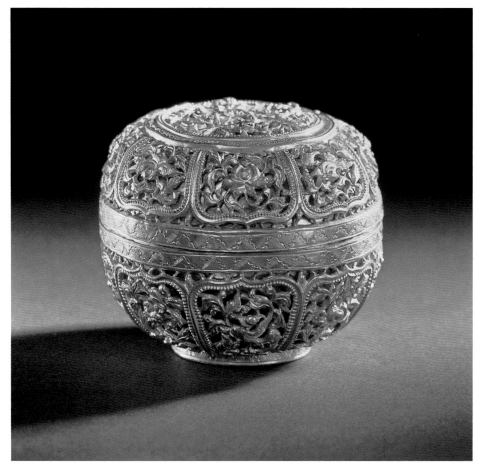

Fig. 71 (cat. no. 199). Covered box, China, Yuan dynasty (1271–1368). Gold, pierced, chased, and worked in repoussé. The Art and History Trust Collection

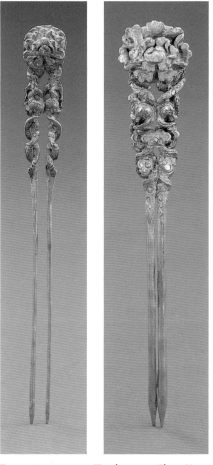

Fig. 72 (cat. no. 200). Two hairpins, China, Yuan dynasty (1271–1368). Gold, worked in repoussé and chased. Inner Mongolia Museum, Hohhot

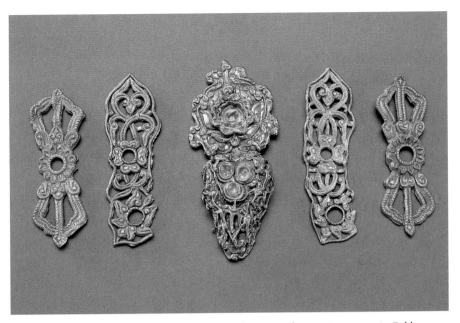

Fig. 73 (cat. no. 201). Five headdress ornaments, China, Yuan dynasty (1271–1368). Gold, worked in repoussé. Inner Mongolia Museum, Hohhot

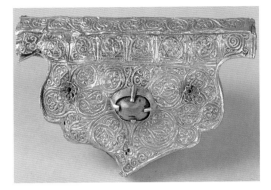

Fig. 74 (cat. no. 146). Amulet case, Golden Horde (Southern Russia), 14th century. Gold, worked in repoussé, engraved, set with jasper. State Hermitage Museum, Saint Petersburg (ChM-978)

recruits for the workshops were drawn locally. At Hongzhou and Xunmalin, workshops founded at the time of Ögödei, the number of weavers had so far dwindled by 1278 that an imperial decree went out for the enlistment of "unemployed and vagrants," who would be taught to weave. Xunmalin declined to the extent that the following year it came under the administration of the Hongzhou office, although after a period of revival it was granted a certain degree of administrative independence. The chief commissioner overseeing both offices was named Hu-san-wu-ding (perhaps Hasan-al-Din?).[23]

It seems that after the establishment of the Yuan dynasty in 1271 and particularly after the conquest of the Southern Song dynasty in 1279, exchanges within the Mongol world of motifs, patterns, and stylistic features took place mainly through trade, by both land and sea.[24] The period of technical innovation that resulted from the working together of craftsmen of different cultural backgrounds (and training) was over. The hybrid styles that had been created, a different one in each artistic center of the early empire, gradually were absorbed into local traditions.

However, artistic motifs continued to travel across the Asian continent and from one medium to another. The probable influence of Chinese and Central Asian textiles on the patterns of tiles at Takht-i Sulaiman is discussed in chapter 7 of this catalogue.[25] In the late thirteenth and fourteenth centuries, textiles from the eastern Iranian world occasionally reflect contemporary Chinese patterns developed after the establishment of the Yuan dynasty. An example is the silk and gold-thread lampas in the Kunstgewerbemuseum in Berlin (fig. 76). Its patterning and its dragons enclosed in lobed roundels display a striking similarity to those of a Yuan Chinese cloth of gold in the Cleveland Museum of Art (fig. 206).[26]

Especially intriguing and much less tractable is the question of the transmission of pictorial styles in drawings and paintings. Most writers on Persian painting have noted the Chinese influence on landscape in Ilkhanid painting, particularly in the

23. *Yongle dadian* 1962, chap. 19781, leaf 17.
24. Of all the goods traded from China to Iran in the Mongol period, only the porcelain has survived in any quantity. For an excellent account of fourteenth-century Chinese porcelain in Iran, see J. A. Pope 1956. For trade and other contacts between Yuan China and the Ilkhanate, see chapter 1 in this catalogue.
25. See also Crowe 1991, written before Central Asian textiles became generally known.
26. See Watt and Wardwell 1997, p. 153, no. 42.
27. See Hearn 1996, pp. 273–74.

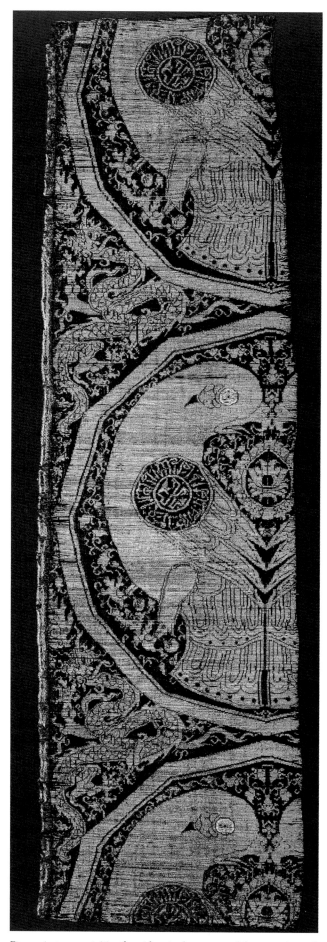

Fig. 75 (cat. no. 71). Textile with paired parrots and dragons, Central Asia, first half of the 14th century. Lampas weave (twill and tabby), silk and gold thread. Preussischer Kulturbesitz, Staatliche Museen zu Berlin, Kunstgewerbemuseum (1875.258)

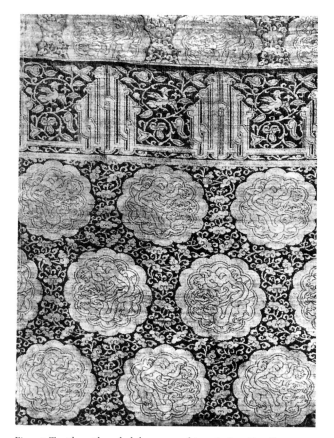

Fig. 76. Textile with coiled dragons and inscription (detail), eastern Iranian world, late 13th–mid-14th century. Lampas weave, silk and gold thread. Preussischer Kulturbesitz, Staatliche Museen zu Berlin, Kunstgewerbemuseum, Berlin (00.53)

treatment of mountains and trees. A more fundamental aspect of this inquiry concerns the treatment of space in landscape painting, a subject tackled by Linda Komaroff in chapter 7. It is important to recognize that the treatment of space in Chinese landscape painting underwent a major change in the late thirteenth century. Whereas in previous Southern Song paintings the middle distance had been shrouded in mist, at this time there appeared in paintings a continuous ground leading from the foreground to distant mountains. Although often this "ground" is water, still the lost middle distance has been replaced by a unified space. This observation holds true for most early Yuan paintings, particularly those that can be associated with painters at the court of Khubilai. The salient example in this regard is *Khubilai Khan Hunting* by the artist Liu Guandao, dated 1280 (fig. 77). The scene is that of the vast grassland of Mongolia, and the painting's continuous ground may follow from the natural landscape it depicts. However, the same treatment of the ground is evident in a painting by Zhao Mengfu, whose ostensible subject matter is the two famous mountains in

Shandong province (fig. 78). It was painted in 1296, soon after the artist had returned south after some years of unsatisfactory service in the capital, Dadu.[27] In Zhao Mengfu's painting, the flat ground is broken up by a series of spits of land extending into the water and marked by clumps of grass. Lines of grass also extend from either side of the roots of the trees. This manner of depicting the ground appears in a later Chinese textile and also in Ilkhanid painting, as discussed in chapter 7 (see p. 183 and fig. 215). Whether or not further research reveals other possible modes of transmission of pictorial styles, the parallels between Yuan and Ilkhanid pictorial art will be the starting point for further discussion on the subject.

This summary note is intended only to provide a general background for the inquiry into East-West artistic exchange in the Mongol period. Much of the detailed work remains to be done.

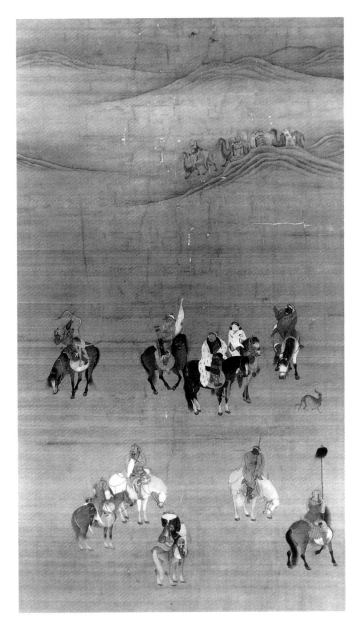

Fig. 77. Liu Guandao, *Khubilai Khan Hunting,* China, dated 1280. Hanging scroll, ink and color on silk. National Palace Museum, Taipei

Fig. 78. Zhao Mengfu, *Autumn Colors on the Qiao and Hua Mountains* (detail), China, dated 1296. Handscroll, ink and color on paper. National Palace Museum, Taipei

4.
Ilkhanid Courtly Life *TOMOKO MASUYA*

In Rabi‘ II [April–May of 1256] they pitched a tent of nasij [cloth of gold] in Jinh-al-Fuqara near Tus at the gate of a garden that had been laid out by the Emir Arghun.... That tent was one which the World-Emperor Mengü Qa’an [Möngke] had ordered the Emir Arghun to prepare for his brother [Hülegü]. In obedience to the Emperor's command the master craftsmen had been called together and consulted, and in the end it had been decided that the tent should be made of a single sheet of cloth with two surfaces. And in executing the weaving and dyeing of it they had surpassed the art of the craftsmen of San‘a [in Yemen]: the back and front were uniform and the inside and outside in the exact correspondence of the colours and designs complemented one another like the simple-hearted....That gilded cupola and heaven-like tent, the disc of the sun, lost its brightness out of jealousy of the truck of this tent, and the resplendent full moon wore a sulky expression because of its roundness. For a few days they feasted and revelled here, and the access of mirth and joy to their breasts was unrestricted.
 —‘Ala’ al-Din ‘Ata Malik Juvaini, *The History of the World Conqueror*[1]

T he Ilkhans in Iran were always conscious that their territory was part of the great Mongol empire and that they themselves were subordinate to the Great Khans in Mongolia and later China — as the title Ilkhan, meaning "subject khan," suggests. The Great Khans were absolute models to the Ilkhans, who tried to emulate the Great Khans in their courtly life, conducting many of their private and official affairs in the Mongolian fashion of their ancestral homeland. To some degree this situation changed when the seventh Ilkhan, Ghazan, converted to Islam in 1295; at that time some new Islamic features were introduced into city building and planning and into the rituals observed at weddings and burials. Nevertheless, the greatest part of Ilkhanid courtly life continued to follow Mongolian traditions.

This essay is divided into two sections. The first deals with Ilkhanid courtly life in general and treats subjects such as locations of the court, types of buildings, and the observance of Mongolian annual events. Because historical sources contain few detailed descriptions of the life of the Ilkhans, the discussion is augmented by information about the Great Khans. The subject of the second part of the essay is the only Ilkhanid palace of which some structures remain, Takht-i Sulaiman. Both archaeological evidence and written sources are examined to discover what an Ilkhanid palace looked like and how it was used, drawing on the unique testimony about Ilkhanid courtly life that Takht-i Sulaiman offers.

THE ITINERANT COURT

Seasonal Migrations

Ilkhanid courtly life did not take place in a single settled location. The court was itinerant because the Ilkhans moved among their seasonal camps in the course of the year. These movements are an essential aspect of the life of nomads, who each

1. Juvaini 1958, vol. 2, p. 616.

Opposite: Fig. 79 (cat. no. 99). Frieze tile with phoenix (detail), Iran (probably Takht-i Sulaiman), ca. 1270s. Fritware, overglaze luster-painted. See fig. 97

Box shows area of map at right.

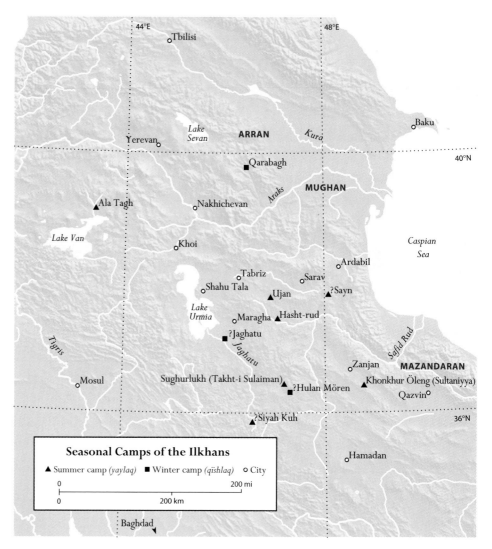

Seasonal Camps of the Ilkhans

▲ Summer camp (*yaylaq*) ■ Winter camp (*qïshlaq*) ○ City

0 _____ 200 mi

0 _____ 200 km

Fig. 80. Map of seasonal camps of the Ilkhans
(adapted from Honda 1991, p. 369)

season must bring their animals to a locale that offers good pasture, sufficient water, and mild climate. Genghis Khan, the first leader of all the Mongols, incorporated seasonal migration into the procedure of his rule in the early thirteenth century, and the practices of migration and herding were continued under his successors. On their migrations the Great Khans were accompanied by their enormous *ordu*s, or hordes. In Turkic and Mongolian, *ordu* originally meant "headquarter" or "encampment," but it sometimes acquired more specific meanings, among them "imperial camp," "palace," and "unit of horde under the management of a ruler's *khatun* (legitimate wife)."[2] Genghis Khan established four *ordu*s for his four legitimate, or principal, wives, and if one of them died, all the property of her *ordu* was transferred to another wife from the same tribe. A Great Khan's entire *ordu* could consist of the *ordu*s, or households, of his four legitimate wives; his ministers and bureaucrats; his royal guards; and thousands of army troops. The Ilkhanid rulers took similar *ordu*s with them when they moved between their seasonal camps.[3]

While the first Ilkhan, Hülegü (r. 1256–65), spent his summers and winters at certain seasonal camps within his territory, it was his successor, Abakha (r. 1265–82), who regularized the seasonal migration of the Ilkhan. These migrations are comparatively well documented. The names of many of the royal summer camps (*yaylaq*s) and winter camps (*qïshlaq*s) are given in fourteenth-century writings

2. See Doerfer 1963–75, vol. 2, pp. 32–39, no. 452.
3. Smith 1999, p. 42.

of the historians Rashid al-Din, Abu al-Qasim ʿAbd Allah Kashani, and others.[4]

*Yaylaq*s frequented by the Ilkhans (see fig. 80) were Ala Tagh (presently Ala Dau in Turkey), Siyah Kuh (somewhere northwest of Hamadan), Sughurlukh (now in ruins and called Takht-i Sulaiman), Khonkhur Öleng (later the Ilkhanid capital Sultaniyya), Ujan (southeast of Tabriz), Sayn (somewhere between Sarav and Ardabil), and Hasht-rud (east of Maragha). Ilkhanid *qïshlaq*s were at Jaghatu (possibly on the lower Jaghatu River, south of Lake Urmia), Baghdad, Hulan Mören (somewhere along the Qizil Uzun River), Qarabagh (northeast of Nakhichevan), and unspecified sites in the regions of Mazandaran, Arran, and Mughan. It seems that much of the Ilkhans' activity was in the Azerbaijan region and that they usually situated their summer camps upriver and their winter camps downriver.

Probably the early Ilkhanids did not have a capital that functioned as a governmental and economical center. While Rashid al-Din notes that Abakha selected Tabriz as his *dar al-mulk* (capital),[5] the site seems to have been used as nothing more than a seasonal camp that the Ilkhans visited only in the summer. It was during the reign of the seventh Ilkhan, Ghazan (r. 1295–1304), that Tabriz became a true Ilkhanid capital and the administrative center from which Ghazan's political reforms were implemented.

Sultaniyya, the Ilkhanid capital established at the site of the summer camp Khonkhur Öleng by Ghazan's successor, Öljeitü (r. 1304–16), was indeed a "sultan's capital." Within the city were constructed the various governmental, public, and imperial buildings necessary for capital functions, as well as the starting points of six royal highways leading to diverse regions of Iran. Nevertheless, Öljeitü and his successor, Abu Saʿid (r. 1316–35), continued the practice of seasonal migration. The Ilkhans stayed at Sultaniyya only during the summer.

Temporary Buildings and Permanent Buildings

The popular conception is that nomads live in tents — that is, temporary, portable buildings made of textiles and wooden supports — and make no use of permanent, immovable constructions. However, most of the Mongol capital cities and many of their seasonal camps contained permanent buildings of some kind. Recent archaeological research in Mongolia attests to the existence of permanent structures at Genghis Khan's seasonal camps. According to the excavator, some enclosures contained platforms that supported wooden buildings with roof tiles in a Chinese style. In others, permanent and temporary elements were combined: tents were pitched over immovable structures of stone and brick that served as foundations, supports, or space dividers (fig. 81).[6]

At the same time, strictly temporary buildings and tents continued to be used by Mongol

4. See Melville 1990a; Honda 1991; Smith 1999.
5. Rashid al-Din 1994, vol. 2, p. 1061.

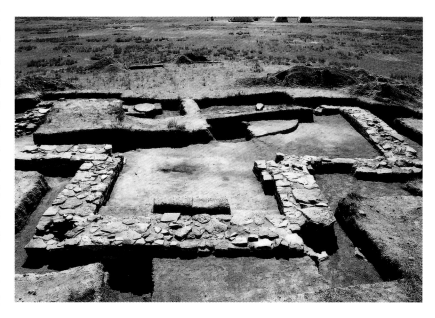

Fig. 81. Permanent structure at Genghis Khan's seasonal camp, Auragha, Mongolia, reign of Ögödei (1229–41). The structure was probably used in combination with a tent.

6. Shiraishi 2001, pp. 79–98.

7. Juvaini 1958, vol. 1, pp. 238–39; Rashid al-Din 1971, p. 63.

8. Giovanni da Pian del Carpine 1955, pp. 61–65.

9. Ye 1987, pp. 37–38. See also Steinhardt 1990, pp. 150–54.

10. Polo 1903, vol. 1, pp. 299–300.

royalty. Enormous tents often served both official and private purposes. Tents generally were kept in place for a few months, then removed and taken to the next seasonal camp or put away for use at the same camp the next year. The Great Khans Ögödei (r. 1229–41) and Güyüg (r. 1246–48) both had a huge tent called Sira Ordu (Yellow Ordu) pitched at Örmügetü, a summer camp in Mongolia.[7] The camp was visited by an emissary from the pope, Giovanni da Pian del Carpine, in 1246, when the Mongols were holding a *khuriltai,* or great meeting, to name Güyüg as Ögödei's successor. Giovanni described the tent as a large pavilion made of white velvet, "so big that more than two thousand men could have got into it," and wrote that "around it had been erected a wooden palisade, on which various designs were painted." He was then taken to another tent, Golden Ordu, pitched three to four leagues away from Sira Ordu. It rested on pillars covered with gold plates fastened with gold and wooden nails, and its top and sides were decorated with baldachins. In this tent the ceremony of Güyüg's enthronement was held. Finally Giovanni was taken to a third tent also pitched in the Örmügetü area, a wonderful tent all of red velvet, given by Chinese people; here the Mongols held feasts.[8] These three enormous tents were apparently each assigned a specific purpose: the yellow/white tent was for *khuriltai,* the golden tent for enthronements, and the red tent for feasts.

Written sources and archaeological findings make clear that tents and permanent buildings were used together in Yuan-dynasty China, at Shangdu, the summer capital of the Great Khans. The city was enclosed by three sets of surrounding walls (fig. 82). The innermost walled precinct was the Palace City; incorporated into its northern wall was the audience hall, a structure called Da'ange. Surrounding the Palace City was the Imperial City, and west and north of that, between the middle and outer walls, lay the Outer City, an area designated for the pleasure of the Great Khans. Its western section, Xinei (Western Inner Space), contained a pleasure palace called Bai Ordu (Rich Ordu) with at least five permanent buildings, but their exact location has not been determined. Official activities, such as lectures given for the Great Khans by scholars and theologians, parties to reward officers' service, feasts of *zhama* (described below), and audiences with foreign envoys were held there.[9] The city's northern area, Beiyuan (Northern Garden), contained a botanical garden, a zoo, and a pleasure palace called Sira Ordu. Sira Ordu was in a walled area in Beiyuan where excavators found no trace of a permanent structure. Khubilai's "cane palace" in Shangdu, which Marco Polo described, must be this Sira Ordu: it was a temporary building made of canes of an enormous size and supported by gilt and lacquered columns, each of which bore a dragon entirely gilt.[10] In Chinese sources this palace is called a *zongmaodian* or *zongdian,* both words meaning "palace of palm fiber." The Great Khan Yesün Temür (r. 1323–28) ordered the construction of a new *zongmaodian* in 1325, for which two carpets were prepared covering 2,343 *chis* (about 850 square yards, or one-sixth of an acre), and made from 2,344 *jins*

Fig. 82. Plan of Shangdu. Adapted from Jia 1977, figs. 1 and 6

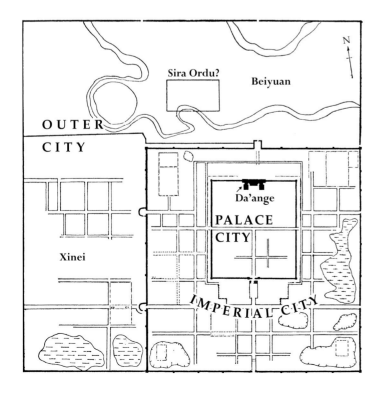

(about 3,000 pounds) of blue and white wool.[11] Khubilai's Sira Ordu in Shangdu seems to have been very similar to the one in Örmügetü. What distinguishes Shangdu, however, is the coexistence in one city of permanent buildings and temporary buildings.

Permanent buildings were constructed to be palaces for the Great Khans in Dadu (now Beijing), their main capital city. Excavations and various historical sources give evidence of a city plan based on the Confucian ideal as prescribed in the *Zhou li* of the eleventh century B.C.,[12] and of palace buildings that were purely Chinese. These were aspects of the Mongol rulers' attempt to legitimize their rule over China.[13]

Overall, the Great Khans utilized four types of palatial building: temporary buildings only, as at Örmügetü; structures that combined permanent and temporary features, as at Genghis Khan's seasonal camps; erection at the same site of both permanent and temporary buildings, as at Shangdu; and permanent buildings only, as at Dadu. There is archaeological or written evidence for Ilkhanid palatial structures in Iran of all these types except the combined form.

Hülegü (later the first Ilkhan), sent from Mongolia by the Great Khan and his brother Möngke to conduct campaigns in western Asia, rested in lavish tents prepared by Mongol amirs, or military commanders, on his way. For instance, when in the fall of 1255 Hülegü arrived at Samarqand, Mas'ud Beg, the Mongol governor of Central Asia, erected for him a tent of *nasij* (cloth of gold) with a covering of white felt. Hülegü remained there for almost forty days, enjoying revelry and merrymaking;[14] in the spring of 1256 he left for the area of Tus in Iran, where he stayed in another splendid tent, prepared for him by Arghun Akha, the Mongol governor of Khurasan, again on the order of the Great Khan (see the opening quotation of this essay). According to Rashid al-Din, the tent had a thousand gold nails and consisted of an antechamber and an audience hall.[15]

As the Great Khans did at Shangdu, the Ilkhans at their seasonal camps erected a mixture of permanent buildings and tents. In 1302 Ghazan pitched a "golden tent" that took engineers a month to set up in the midst of the garden at Ujan, a site where he had previously had a number of buildings constructed, including "kiosks, towers, baths, and lofty buildings." He celebrated the tent's completion with a feast and held a *khuriltai* there.[16]

The Ilkhans constructed permanent palace buildings at their capital cities and seasonal camps. There is no record of palaces at the early Ilkhanid capital Tabriz itself, but beginning in the late thirteenth century, Ilkhans, and in one case a vizier, built private cities just outside Tabriz. Ilkhan Arghun (r. 1284–91) founded his palatial city, Arghuniyya (Arghun's city); subsequently his son Ghazan built his own complex, Ghazaniyya (Ghazan's city), and the vizier and historian Rashid al-Din established Rashidiyya (Rashid's city), also called Raba'-i Rashidi (Rashid's quarter). Rashidiyya was basically a religious foundation, and its endowment deed, which survives, does not indicate that the vizier had a residence there.[17] Unfortunately, little is known in detail about any of the palaces built in the two Ilkhans' cities except for the mention of "lofty houses" at

Fig. 83 (cat. no. 189). Two roundels used for roof decoration, China (Inner Mongolia), Yuan dynasty (1271–1368). Glazed earthenware. Inner Mongolia Museum, Hohhot

11. *Da Yuan zhanjiwu ji* (Record of Felt and Wool of the Great Yuan Dynasty) in the *Jingshi dadian* (Canon of Practical Administration), quoted in Chen Gaohua and Shi 1988, p. 124.
12. In *Kaogong ji* (Record of Trades), a section of the classic Confucian text *Zhou li* (Rituals of the Zhou Dynasty), an ideal state capital is described: "a square nine *li* on each side; each side has three gates. Within the capital are nine north-south and nine east-west streets. The north-south streets are nine carriage tracks in width. On the [east] is the Ancestral Temple, and to the [west] are the Altars of Soil and Grain. In the front is the Hall of Audience and behind the markets." Steinhardt 1990, p. 33.
13. Steinhardt 1990, pp. 33–36, 154–60.
14. Juvaini 1958, vol. 2, p. 612; Rashid al-Din 1994, vol. 2, p. 978.
15. Rashid al-Din 1994, vol. 2, p. 980.
16. Ibid., pp. 1303–4. See also Allsen 1997a, p. 15.
17. See Blair 1984.

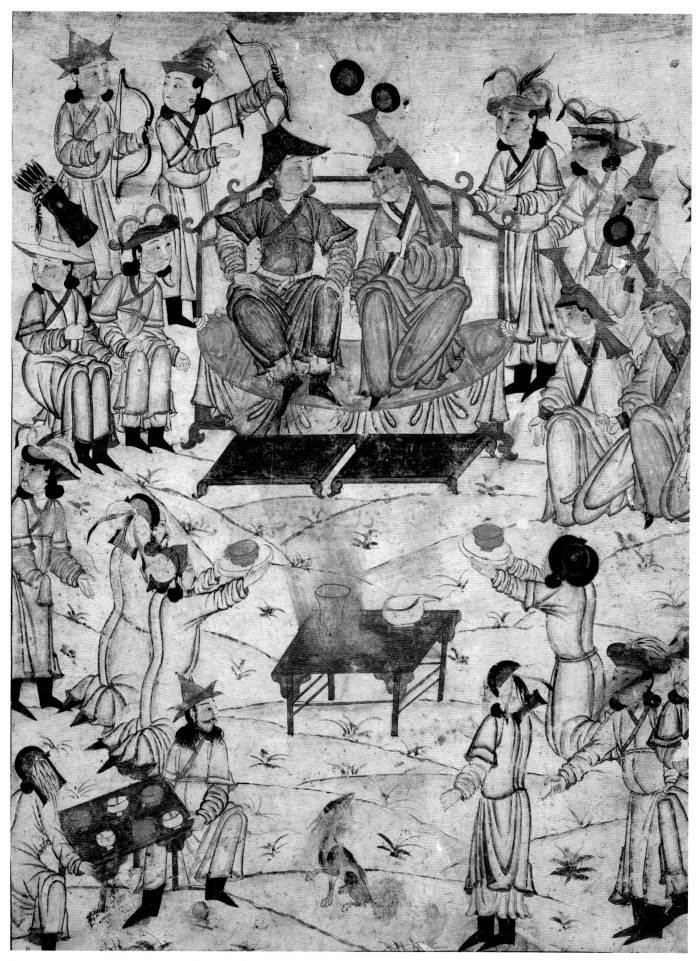

Fig. 84 (cat. no. 19). *Enthronement Scene,* illustration from the Diez Albums, Iran (possibly Tabriz), early 14th century. Ink, colors, and gold on paper. Staatsbibliothek zu Berlin—Preussischer Kulturbesitz, Orientabteilung (Diez A fol. 70, S. 22)

Arghuniyya and of Ghazan's tall-domed mausoleum and some religious foundations at Ghazaniyya.[18]

Arghun's son Öljeitü established his capital, Sultaniyya, at the Ilkhanid summer camp Khonkhur Öleng in Iranian Azerbaijan, a spot where his father had previously constructed some buildings. According to the Timurid historian Hafiz-i Abru (d. 1430), Öljeitü built an enormous palace there that had at its center a square court paved with marble. Adjacent to the court was a huge iwan, or rectangular vaulted room open on one side. Twelve small palace rooms were also ranged around the court, each with a window overlooking it. An audience hall, or *kiryas* (*kiräs* in Mongolian), accommodated two thousand people.[19] The popularity of a court with iwans in Iranian and Iraqi architecture of the pre-Islamic period is well established. Such a scheme was utilized in various secular buildings of the eleventh and twelfth centuries, including the palaces of the Ghaznavids in Afghanistan and the Seljuq palaces and caravanserais in Turkmenistan.[20] Öljeitü's palace at Sultaniyya seems to have followed the plan of a traditional Persian palace, in which a large central courtyard is surrounded by huge iwans and small rooms. A variation can be observed at Takht-i Sulaiman, the only surviving Ilkhanid palace, which is discussed in the second part of this essay. A historical source attests to the existence of a similar palace, with four iwans around an arcaded court, in Isfahan; it belonged to the family of ʿAlaʾ al-Din ʿAta Malik Juvaini, the important Ilkhanid historian and statesman.[21]

That palaces were built at the seasonal camps in Ala Tagh, Arran, and Siyah Kuh is reported in historical writings, but the structures are not described in any detail.[22]

Activities at Palaces and Tents

As far as can be determined from historical writings, the activities conducted at seasonal camps under the Ilkhans were very similar to those at pleasure palaces of the Yuan dynasty. However, the Ilkhanid court more fully retained the quality of nomadic life. Thus, while the Great Khans ruled from large capitals like Dadu and Shangdu, the Ilkhans had no such cities and conducted a larger number of state affairs, including *khuriltai*s and enthronements, at camps. At least seven Ilkhanid *khuriltai*s were held at the seasonal camps. The enthronements of some Ilkhans also took place at seasonal camps: of Abakha in 1270, at Jaghatu; of Tegüder Ahmad in 1282 and Geikhatu in 1292, both at Ala Tagh; and of Arghun in 1286, at Arran (fig. 84). In attendance at these ceremonies were official envoys from the Great Khan carrying a letter of his approval.[23] The Mongolian New Year (*keyünükemishi*) was celebrated at a camp near Qazvin in 1257. Trials, executions, appointments of officers, and audiences of foreign envoys were also carried out at camps.[24] In addition, the Ilkhans kept their imperial treasuries at seasonal camps. According to Rashid al-Din, Hülegü's treasury was located on Shahu Tala Island in Lake Urmia (now Shahi Peninsula; the level of the lake has fallen), Abakha's was at Siyah Kuh, and Arghun's was at Sughurlukh.[25] Although the treasuries were probably guarded all year long, their management and security were haphazard until Ghazan's reign, when the treasures were finally itemized and sealed for safekeeping.[26]

18. Rashid al-Din 1994, vol. 2, pp. 1179, 1282, 1374. See Haneda 1997 for the Ilkhanid establishment of Ghazaniyya and Sultaniyya as "pastoral cities" and "mausoleum cities."
19. Blair 1986c, p. 146; Blair 1993b, pp. 240–41.
20. Allen 1988–90; Bombaci 1959; Bombaci 1966; Flood 1993; Pugachenkova 1967, pp. 108–11.
21. Blair 1993b, p. 241.
22. Rashid al-Din 1994, vol. 2, pp. 1174, 1528; Hamd Allah Mustaufi Qazvini 1915–19, vol. 2, p. 83; Vassaf al-Hazrat 1852–53, pp. 1303–4.
23. Rashid al-Din 1994, vol. 2, pp. 1058–61, 1096–97, 1161–62.
24. Honda 1991, p. 375.
25. Rashid al-Din 1994, vol. 2, pp. 1022, 1126, 1349, 1350.
26. Ibid., pp. 1509–13.

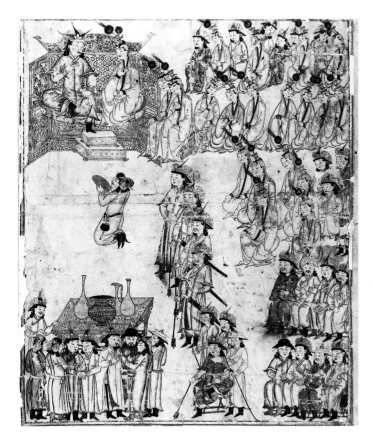

State affairs were usually accompanied by enormous feasts that lasted anywhere from a few days to a month. At a feast, a Mongol ruler gave garments and gifts to the participants. Since Ilkhanid feasts are not fully described in the sources, we can only imagine them from descriptions of those of the Great Khans in Mongolia and China. The most famous feast was the feast of *zhama* (Persian *jama,* meaning garment), called in Mongolian the feast of *jisun* (color). The celebration continued for three days, and the participants were all required to wear clothes of a different, specified color each day.[27] Before Hülegü set out for western Asia in 1253, the Mongol princes held such feasts for him in Khara Khorum: "Each in turn gave a feast, and they cast the die of desire upon the board of revelry, draining goblets (*jamha*) and donning garments (*jamaha*) of one colour, at the same time not neglecting important affairs."[28] At feasts, the ruler was seated on a platform at the northern (or north-north-western; see below) end of the tent or hall, facing south (or south-southeast). The first wife sat next to him at his left. Male royal participants were seated to his right and females

Fig. 85. Scene of an Ilkhanid court, from a lost *Jamiʿ al-tavarikh* (Compendium of Chronicles) by Rashid al-Din, Iran, ca. 1330. Ink and colors on paper. Topkapı Palace Museum, Istanbul (Hazine 2153, fol. 148v)

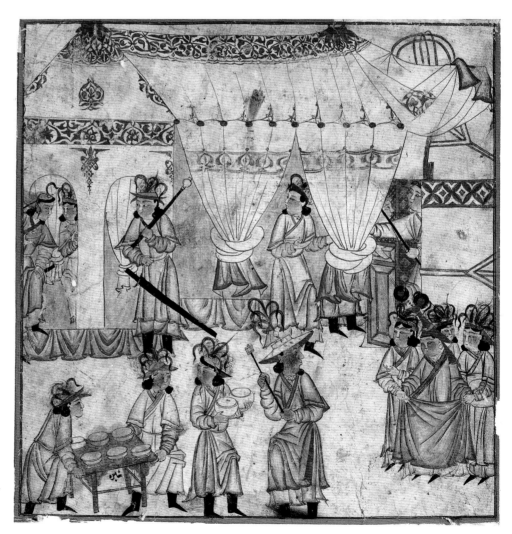

Fig. 86 (cat. no. 30). *Preparations for a Banquet,* illustration from the Diez Albums, Iran, 14th century. Ink and colors on paper. Staatsbibliothek zu Berlin—Preussischer Kulturbesitz, Orientabteilung (Diez A fol. 70, S. 18, no. 1)

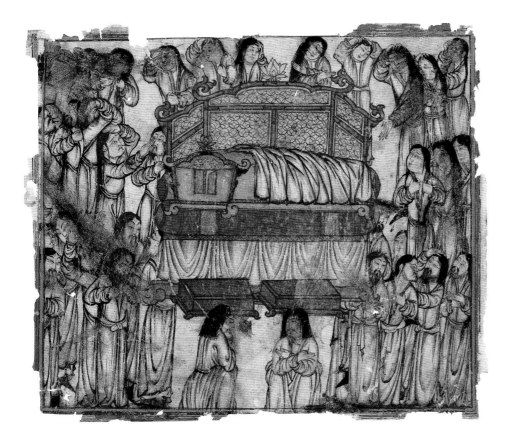

Fig. 87 (cat. no. 27). *Funeral Scene,* illustration from the Diez Albums, Iran, early 14th century. Ink and colors on paper. Staatsbibliothek zu Berlin—Preussischer Kulturbesitz, Orientabteilung (Diez A fol. 72, S. 25)

opposite them. This seating arrangement was also adopted by the Ilkhans, as can be seen in several Ilkhanid paintings (figs. 85, 86).

Hunting, including archery and falconry, was a favorite sport of Mongol rulers and constituted an important part of their private lives. Mongol rulers selected the sites for their seasonal camps based on the presence of abundant natural resources, such as water, grass, and hunting game. Chaghan Na'ur in Hebei, near Shangdu, a pleasure palace of the Great Khans built in 1280 by Khubilai, is well documented. The General Administration of Imperial Demands (Yunxu), established in 1315, was in charge of guarding Chaghan Na'ur and taking care of supplies for the pleasure palace encampment.[29] Marco Polo, who visited the complex sometime before 1290, noted the plenitude of game birds and described Khubilai's falconry.[30] A Chinese poet wrote that there was a hut to keep falcons and that many officers of the Yunxu Administration were falconers.[31]

Hunting was also an important activity for the Ilkhans in Iran (fig. 98). They were trained for it when very young; Ghazan, for example, learned to ride a horse when he was three years old and practiced archery at five. His first hunt, with his grandfather Abakha in Damghan (in northeastern Iran), took place when he was eight years old and was accompanied by a three-day celebration.[32] Professional falconers and cheetah keepers supplied hunting animals for the Ilkhans, at great expense. Indeed, it was necessary for Ghazan to regulate the practice because large sums were being siphoned off by the suppliers through abuse of their position,[33] a measure of the significance hunting held for the Ilkhanids.

Much royal life was lived at the seasonal camps of the Ilkhans: births, education, marriages, deaths, and mourning rituals (see figs. 86, 87, 122, 134).[34] The early life of Ghazan, the first Ilkhan born in Iran, is instructive. His birth in 1271 was at an unlocated winter camp named Abaskun in Mazandaran, a region on the southern coast of

27. Giovanni da Pian del Carpine 1955, p. 61; Polo 1903, vol. 1, pp. 386–88. There are a number of references by Chinese writers to the feasts of *zhama* at the *zongmaodian* in Shangdu. See Ye 1987, p. 39; Ye 1992, pp. 154–55.

28. Juvaini 1958, vol. 2, pp. 610–11.

29. *Yuanshi* 1976, vol. 3, pp. 551 (chap. 24), 677 (chap. 30).

30. Polo 1903, vol. 1, p. 296.

31. "Foreword for the Poem on Accompanying the Emperor" by Zhou Boqi, recorded in his anthology *Jinguang ji*; quoted from Chen Dezhi 1984, pp. 675–76.

32. Rashid al-Din 1994, vol. 2, pp. 1208–11.

33. Ibid., pp. 1518–23.

34. Honda 1991, pp. 375–77.

35. Rashid al-Din 1994, vol. 2, pp. 1206–11.
36. Vassaf al-Hazrat 1852–53, p. 52.
37. For religions of the Ilkhans, see Sheila Blair's chapter 5.
38. For the excavation reports on building of the Ilkhanid period at the site, see E. and R. Naumann 1969; R. and E. Naumann 1976; R. Naumann 1977.
39. Al-Qumi 1980–84, vol. 1, pp. 87, 312.
40. Hamd Allah Mustaufi Qazvini 1915–19, vol. 2, p. 69. Mustaufi Qazvini calls the town Saturiq, a corrupted version of Sughurlukh.

the Caspian Sea, and from the age of five he received his education at seasonal camps, where Chinese (*Khatayi*) tutors taught him Mongolian and Uyghur scripts and the scholarship and literature of those languages.[35] Ceremonies surrounding the death of Hülegü also typify Mongol practices. After he died at the winter camp of Jaghatu in 1265, his body was taken to Shahu Tala Island in Lake Urmia, where it was buried together with jewels and human victims.[36] Religious ceremonies probably took place in the camps as well, although a specific record of such ceremonies exists only for the court of the Great Khans.[37]

TAKHT-I SULAIMAN, THE REMAINS OF AN ILKHANID PALACE

Only one actual setting of Ilkhanid courtly life survives, the seasonal palace known as Takht-i Sulaiman (fig. 88). The archaeological site, on a mountainside at an elevation of about 7,900 feet, is in the Azerbaijan region of Iran, two hundred miles south of Tabriz and southeast of Lake Urmia. The camp was a walled town of oval shape about a third of a mile long and a quarter mile wide and contains a small lake. Its Ilkhanid structure was built over a Zoroastrian sanctuary that dates from the Sasanian period (224–651). The palace remains, excavated by the German Archaeological Institute between 1959 and 1978, provide valuable evidence about the physical nature of an Ilkhanid seasonal camp.[38] The function of its various parts can to some degree be reconstructed from the writings of Rashid al-Din.

Takht-i Sulaiman, literally meaning "Throne of Solomon," is a name given to this site long after the Ilkhanid reign, probably during the Safavid period (1501–1722), when it appears in a historical document by Qadi Ahmad al-Qumi.[39] It is likely that the name comes from "Sulaiman-makan" (one who takes Solomon's place), one of the epithets of Ismaʿil I (r. 1501–24), the first Safavid ruler, who visited the spot several times. A geographical survey written by Hamd Allah Mustaufi Qazvini in 1340 that contains a description of the site allows us to identify Takht-i Sulaiman with the Ilkhanid summer camp Sughurlukh. Writes Mustaufi Qazvini about Sughurlukh:

> It stands on the summit of a hill and it was originally founded by King Kay Khusraw the Kayanian. In this town there is a great palace, in the court of which a spring gushes forth into a large tank, that is like a small lake for size, and no boatman has been able to plumb its depth. . . . This palace was restored by Abaqa Khan the Mongol, and in the neighbourhood there are excellent pasture grounds. Its revenues amount to 25,000 dinars.[40]

Mustaufi Qazvini's attribution of the Ilkhanid palace to Abakha is in accord with the archaeological evidence at Takht-i Sulaiman. Construction of the palace there must go back at least to Abakha's reign (1265–82), because luster-painted tiles excavated at the site carry the dates 670, 671, and 674 (A.H.), that is, A.D. 1271–73 and 1275–76.

History of the Site

The Ilkhanid structure at Takht-i Sulaiman was built over a Sasanian fire temple of Adur Gushnasp that seems to have been in use from the late fifth to the early seventh

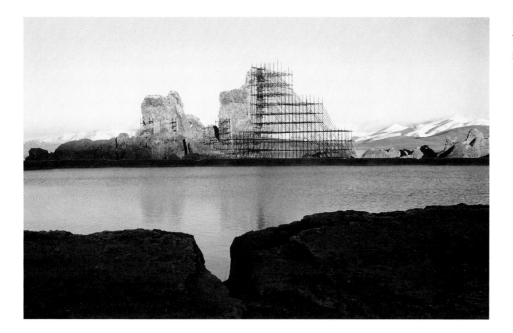

Fig. 88. View of the West Iwan of the palace at Takht-i Sulaiman, Iran, with the lake in the foreground

century. Adur Gushnasp, one of the three sacred fires of Zoroastrianism, is often associated with the legendary Iranian king Kaikhusrau the Kayanian, who founded its altar in Azerbaijan, according to a Zoroastrian tradition.[41] In Arabic sources of the ninth and tenth centuries the site was called Shiz, and it is reported that a Persian king customarily visited the temple there on foot when he was newly crowned.[42]

The Ilkhanids renamed this site Sughurlukh, in Turkic "place abounding in marmots" (Turkic toponyms were very commonly used throughout the Mongol empire). The marmot is frequently hunted in Mongolia, and its fur is highly prized. Presumably the spot was selected for an Ilkhanid summer camp because of its suitability as a hunting ground rather than because of its glorious Zoroastrian past.

In the *Jamiʿal-tavarikh* (Compendium of Chronicles) of Rashid al-Din, Sughurlukh figures in a complex family drama, although less in connection with Abakha himself than with Abakha's son Arghun, his grandson Ghazan, and his wife Bulughan Khatun the Elder.[43] Ghazan, according to Rashid al-Din, was born in Mazandaran in the year corresponding to 1271. When he was three years old he was taken by his father, Arghun, then governor of Khurasan, to see his grandfather Abakha at Khongkhur Öleng. Abakha became very fond of the boy and told Arghun that he would oversee Ghazan's education. Since Abakha's favorite wife, Bulughan Khatun, had no son, Arghun suggested that the child be entrusted to her care. Rashid al-Din writes:

> Abakha was pleased [with this idea], and Bulughan Khatun proceeded to Sughurluq. Arghun followed her bringing Ghazan's belongings, then returned to Khurasan. Bulughan Khatun was overjoyed; she called [the child] god's gift, who to her was like her own son. Arghun left [Ghazan] ten servants . . . from the tribe of Önggüt [a Turkish tribe]. Abakha said, "Ghazan should remain in this *ordu,* and this *ordu* should belong to him. And after me this *ordu* shall be his, and he shall be its head." Most of the time Prince Ghazan stayed in Bulughan Khatun's *ordu.*[44]

41. Boyce 1985, p. 475.
42. Ibn Khurdadhbih 1889, p. 91 (trans.); al-Masʿudi 1894, pp. 95–96. See also Minorsky 1964 for the identification of Takht-i Sulaiman with a number of places mentioned in historical sources.
43. In the *Jamiʿ al-tavarikh* she is called Bulughan Khatun-i Buzurg because there is another Bulughan Khatun. See Melville 1990c, p. 338.
44. Rashid al-Din 1994, vol. 2, pp. 1208–9.

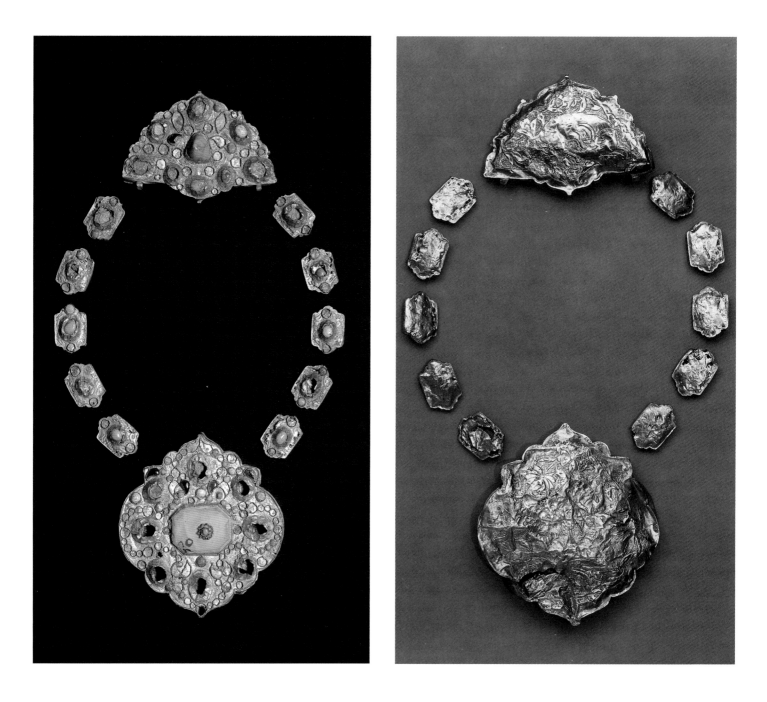

45. Ibid., p. 1056.
46. Ibid., p. 1214.

Fig. 89 (cat. no. 148). Necklace (front and back views), Iran, possibly 14th century. Gold sheet, chased and set with turquoise, gray chalcedony, and glass. The Metropolitan Museum of Art, New York, Rogers Fund, 1989 (1989.87a–l)

Bulughan Khatun (the Elder) was Abakha's tenth wife and was favored by Abakha over his other wives. The passage quoted suggests that the palace at Takht-i Sulaiman did indeed belong to Abakha and that the *ordu* led by Bulughan Khatun was based there, although it may not have been permanently located there.

Following the Mongol custom, after Abakha's death in 1282 Bulughan Khatun was married to his son Arghun. Rashid al-Din writes that she even acted as Arghun's deputy when he was absent.[45] When Bulughan Khatun died in 1286, Arghun inspected her treasury, which was filled with precious jewelry and pearls given to her by Abakha. After taking some of the robes and gold and silver ware for himself, Arghun said that, in accordance with Abakha's wishes, the rest of the treasure, the *yurt* (appanage), and the *ordu* should be sealed and kept for Ghazan.[46] Although Rashid al-Din does not specify where Bulughan Khatun's treasury was, it may have been at Sughurlukh, and Arghun's unusually long stay at Sughurlukh that year may have been in order to inspect her treasury.

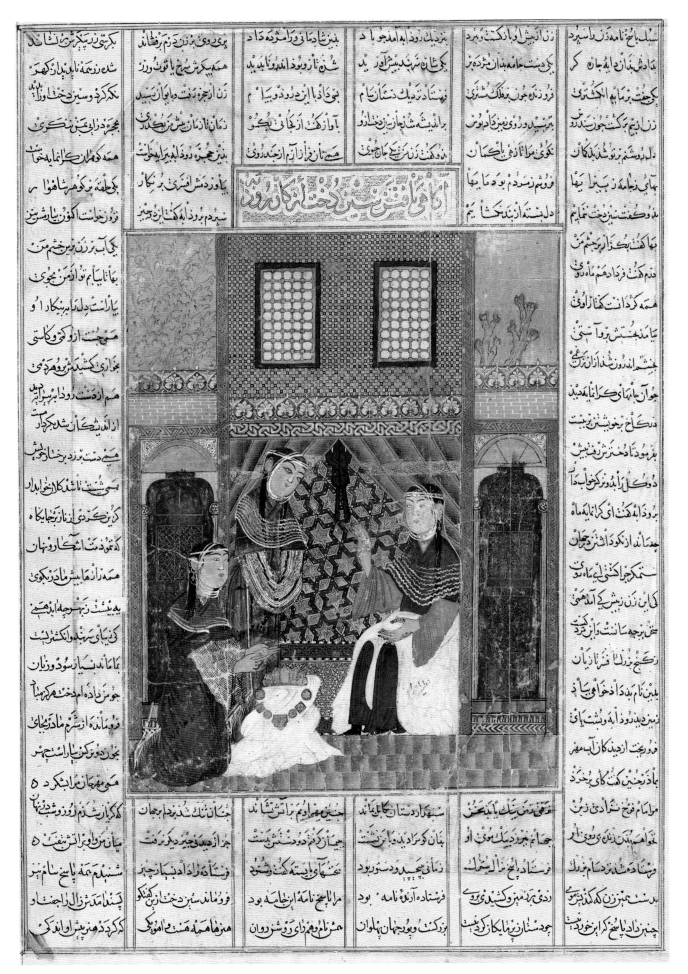

Fig. 90 (cat. no. 37). *Sindukht Becoming Aware of Rudaba's Actions*, page from the Great Mongol *Shahnama* (Book of Kings), Iran (probably Tabriz), 1330s. Ink, colors, and gold on paper. Arthur M. Sackler Gallery, Smithsonian Institution, Washington, D.C.; Purchase, Smithsonian Unrestricted Trust Funds, Smithsonian Collections Acquisition Program, and Dr. Arthur M. Sackler (S1986.102)

In 1290 Arghun married another Bulughan Khatun and granted her the *ordu* that had belonged to Bulughan Khatun the Elder.[47] Thereafter, Sughurlukh was frequently mentioned in association with the new Bulughan Khatun. After Arghun's death in 1291, a struggle for her arose among three aspirants to the throne: Arghun's son Ghazan, Arghun's brother Geikhatu, and Arghun's cousin Baidu. She was married to Geikhatu (r. 1291–95) in 1292, but later Ghazan married her, according to Islamic law, when he was enthroned in 1295. The great interest members of the royal family showed in these two Bulughan Khatuns seems to have been partly motivated by their wealth, originally given by Abakha to the Elder and then passed to the Younger, and probably kept at Sughurlukh. Arghun's own treasury was also situated at Sughurlukh, although Rashid al-Din states that after his death it was stolen or wasted by Geikhatu and Baidu (r. 1295) and that nothing remained when Ghazan came to the throne.[48]

Rashid al-Din makes frequent mention of amirs being stationed at Sughurlukh. He also records stays there of the reigning Ilkhan, usually only for a few days as a rest stop on a long journey. Sometimes an Ilkhan handled state affairs during his stay at Sughurlukh; for example, Arghun issued an edict there in 1284 appointing Bukha as his vizier and another in 1289 appointing Sa'd al-Daula vizier.[49]

Sughurlukh/Takht-i Sulaiman, a summer residence of the Ilkhans, was apparently smaller and politically less important than those in Ala Tagh and Arran, since no *khuriltai*s or enthronements were held there. However, it may have had its own particular significance as the site of the treasuries belonging to the two Bulughan Khatuns and to Arghun.

Plan of the Palace

The oval perimeter walls at Takht-i Sulaiman (fig. 91) date to the Sasanian period. Their main gate was at the north end of the oval, and the sanctuary complex within was situated north of the lake. Ilkhanid builders kept the pre-Islamic perimeter walls and also reused other Sasanian structures, incorporating them into the North Iwan, the Palace Hall, and the West Iwan of the new palace.

Building a palace over ruins was a common practice among Mongols in both eastern and western Asia. The city of Khara Khorum in Mongolia, the capital of the Mongol empire until 1266, is said to have been built on the remains of an Uyghur fortress.[50] In China, the main capital of the Yuan dynasty, Dadu, was created by Khubilai on the site of Zhongdu, one of the five capitals of the previous Jin dynasty (1115–1234). The building of Dadu began in 1264 with the reconstruction of a Jin-dynasty pleasure palace on Qionghua Island, located within the Imperial City of Zhongdu.[51] In the West, Hülegü built his palace at Ala Tagh over the much earlier summer residence of the Armenian Arshakids (53–428).[52] The reuse of older structures was less common. Da'ange, the most important official building in Shangdu (fig. 82), was constructed in 1266 out of materials taken from a building called Xichunge that had been erected in Bianjing (modern Kaifeng), the capital of the Northern Song dynasty during its reign (960–1127).[53]

At Takht-i Sulaiman, the builders of the Ilkhanid period ignored the old Sasanian main gate on the north-northwest and a secondary gate to the southeast. They

47. Ibid., p. 1176. She was the daughter of Otman, son of Abatai Noyan. The circumstances surrounding the choice of a successor to Bulughan Khatun the Elder are detailed by Marco Polo. See Polo 1903, vol. 1, pp. 31–36; Melville 1990c, p. 339.
48. Rashid al-Din 1994, vol. 2, p. 1350.
49. Ibid., pp. 1156, 1173.
50. Juvaini 1958, vol. 1, pp. 54–55, 236.
51. *Yuanshi* 1976, vol. 1, p. 96 (chap. 5).
52. Grigor of Akanc' 1954, p. 343; Honda 1991, p. 364.
53. Ye 1987, pp. 34–35; Chen Gaohua and Shi 1988, pp. 100–104.

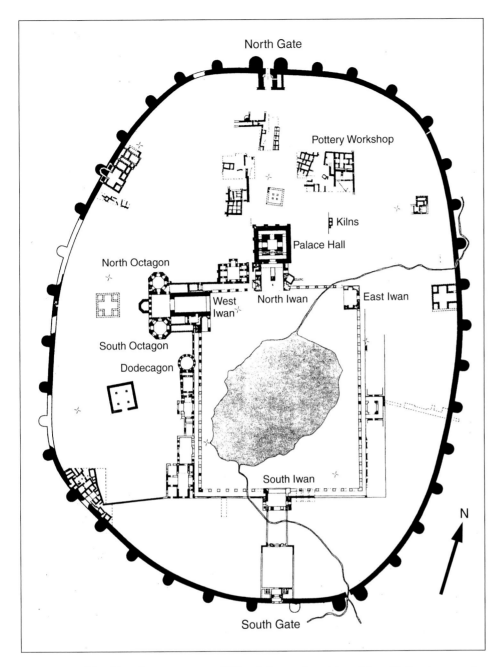

North Gate

Pottery Workshop

Kilns

Palace Hall

North Octagon

West Iwan

North Iwan

East Iwan

South Octagon

Dodecagon

South Iwan

N

South Gate

Fig. 91. Plan of the Ilkhanid summer camp at Takht-i Sulaiman, Iran. Adapted from Huff 1989–90, p. 8. Used with the kind permission of Dr. Dietrich Huff

established a new gate at the south-southeastern end; it faces the North Iwan across the lake and thus emphasizes the major role of that iwan, the main building of the complex. Another palace structure, the remarkable Dodecagon in the western arcade, has its only doorway on the south-southeastern side, contributing to the south-southeast orientation of the Ilkhanid palace.

The Mongol tendency to orient buildings to the south was noticed by contemporary observers. William of Rubruck, who traveled to the Mongol domain in 1253–55, wrote that the Mongols pitched their tents with the doorway facing south and placed the master's couch at the northern end, opposite the entrance.[54] At Khara Khorum, he reported, the palace of the Great Khan Möngke extended from north to south; there were three doors on its southern side, and at the northern end

54. Ruysbroeck 1990, pp. 74–75.

55. Ibid., pp. 210–11.

56. See Kiselev 1965, pp. 316–22; Shiraishi 2001, pp. 137–54.

57. Minert 1985, pp. 191–92. On the other hand, V. V. Barthold suggests that a cult of the South among Mongols inspired the southern orientation of Mongol tents. See Barthold and Rogers 1970, pp. 217–18.

58. Chinese sources customarily refer to polygonal, often octagonal, structures as "round." Since the exact plans of some of the buildings are uncertain, in the translations of their descriptions given here, "round" is used.

59. Tao Zongyi 1959, pp. 250–57 (chap. 21); Xiao Xun 1980, pp. 73–77.

60. Elisabeth and Rudolf Naumann suggest that the North Octagon served as the Ilkhan's dining room and the South Octagon his bedroom. This hypothesis is implausible because in a traditional Mongol dwelling the same space served different purposes at different times. Mongols dine and sleep in the same area. See E. and R. Naumann 1969, p. 56; R. and E. Naumann 1976, p. 41; R. Naumann 1977, p. 86.

61. See Wilber 1969 for the survey of Ilkhanid architecture in Iran. See also Blair 1993b for Iranian aspects of Ilkhanid palaces.

sat the Great Khan, in an elevated position.[55] Archaeological research there has determined that the main axis of Möngke's palace in fact ran north-northwest to south-southeast.[56] L. K. Minert, a Russian archaeologist, suggests that rather than resulting from miscalculation, the south-southeast (rather than south) alignment of the building was intentional.[57] His argument is supported by the south-southeast orientation found in almost all the excavated Mongol cities built during the first half of the thirteenth century. Minert quotes D. Maydar, a Mongolian archaeologist, to the effect that this south-southeast orientation was the characteristic one for Mongol tents and that it was based on the direction of sunlight, with the purpose of dividing a tent used as a residence into functional zones. The redirection of the plan's axis at Takht-i Sulaiman most probably occurred because of this Mongol preference.

The Takht-i Sulaiman palace included several polygonal structures, the North and South Octagons in the West Iwan complex and the Dodecagon in the western arcade. Their presence is unusual, for in Iran a polygonal plan was normally a feature of a mausoleum, not a residence. These buildings seem to reflect a Mongol preference for polygonal structures ultimately based on the form of the Mongol round tent, or *ger*. The *ger*, the most common and traditional Mongol type of residential tent, consists of a collapsible lattice wall of birch slats arranged in a circle, with coverings of felt. Mongol round tents are mentioned by most of the Europeans who traveled to the court of the Great Khans during the thirteenth and fourteenth centuries.

Several other Mongol palaces, most of them pleasure palaces, also contained round or polygonal structures.[58] Indeed, the Mongol enthusiasm for palatial polygonal or round buildings was remarkable. In the palace of Dadu there were at least ten polygonal or round buildings, many of them in pairs like the North and South Octagons at Takht-i Sulaiman.[59] These Octagons, which were lavishly decorated, may have been private quarters of the Ilkhans.[60] The Dodecagon, however, is a curious structure. As mentioned above, its single doorway is set at the south-southeast like that of a Mongol tent, even though the building is in the western arcade, where it would have been more natural for the doorway to face east. The difficult route of access to this building suggests that it may have been the treasury reportedly located at Takht-i Sulaiman.

Since specific Mongol features were incorporated into the architecture of the palace at Takht-i Sulaiman, the functions that individual buildings served probably also followed Mongol custom. At the same time, many aspects of the plan and the construction materials are characteristically Iranian.[61] The Ilkhanid buildings at Takht-i Sulaiman were undoubtedly built by Iranian workers and craftsmen striving to satisfy the requirements of the Mongol rulers while making use of their own Iranian techniques.

If the rectangular area enclosing the lake and surrounded by arcades is regarded as a central courtyard—and Mustaufi Qazvini calls it a "court" in the passage quoted above—the plan of the entire palace can be seen as a variation of the traditional Iranian four-iwan scheme discussed above. In a typical four-iwan plan, each barrel-vaulted iwan opens onto one side of a quadrangular courtyard, and two facing iwans usually share the same central axis. At Takht-i Sulaiman, while the North and South Iwans almost face each other along the building's central axis, the West and East

Iwans are placed at the northern ends of their arcades rather than in the center. The atypical corner location of these two iwans probably occurred because the foundations and walls of a pre-existing Sasanian structure were used as a basis for the western iwan. Öljeitü's palace at Sultaniyya also was designed with a central courtyard and a huge iwan.[62] An Ilkhanid palace with a courtyard and iwans—a version of the traditional Iranian palace—seems to be represented in Ilkhanid manuscript paintings such as *Shah Zav Enthroned* from the Great Mongol *Shahnama* (fig. 37).

The foundations of the Ilkhanid buildings at Takht-i Sulaiman were made of rubble masonry with mortar, red sandstone, and reused Sasanian ashlar masonry.[63] (Both rubble masonry and ashlars are found in other Ilkhanid buildings as well.)[64] The walls were constructed of bricks and wood, although little of the latter has survived. Architectural elements such as columns, column bases, capitals, and doorjambs were of red sandstone. Panels of limestone and marble lined the walls of certain buildings, and some floors were covered with marble slabs. The use of dressed stone is a characteristic of building in Azerbaijan. According to Hafiz-i Abru, in Sultaniyya the Ilkhanid Great Mosque was built of marble, and the courtyard of Öljeitü's palace was paved with marble.[65]

Decoration

The Ilkhanid structures at Takht-i Sulaiman, especially the North Iwan–Palace Hall complex and the West Iwan complex, were lavishly decorated with tiles and stucco. The most striking use of stucco was for *muqarnas,* a three-dimensional architectural decoration on vaults and domes composed of nichelike elements arranged in geometric patterns. Dramatic in its intricacy and play of light and shadow, *muqarnas* decoration was much employed in Islamic architecture. At Takht-i Sulaiman, some of the stucco *muqarnas* elements are decorated with animals, animal scrolls, and stylized vegetal decoration in carved and incised relief; others are painted.[66] A square gypsum plaque with an incised geometric pattern, excavated at the site, is thought to be the plan for one-quarter of a *muqarnas* dome.[67] Stucco was also used to cover walls that were then richly painted. Polychrome mural painting, one of the most popular techniques for wall decoration in Iran, was also applied to palace buildings in Mongolia; several sources report that the palaces at Khara Khorum were painted with pictures of some sort.[68] Unfortunately, the painted stucco walls at Takht-i Sulaiman are too badly damaged to compare with examples elsewhere.[69]

The large number of tile fragments found at Takht-i Sulaiman makes clear that the Ilkhanid palace there was also adorned with lavish tile decoration, both externally and, especially, internally (fig. 92). The tiles display a wide range of techniques and designs and are of different shapes and sizes (figs. 49, 93, 204). About one hundred different molded tile designs can be identified from the fragments. These finds are important because, with their certain provenance and date, they provide a firm benchmark to apply when examining various aspects of tile production during the Ilkhanid period.

The tiles at Takht-i Sulaiman display six different techniques. There are unglazed tiles, partially glazed tiles, monochrome-glazed tiles, luster-painted tiles, *lajvardina*

62. Blair 1986c, p. 146; Blair 1993b, pp. 240–41.
63. R. Naumann 1977, p. 74.
64. Wilber 1969, p. 52; Vardjavand 1975, pp. 123–24; Vardjavand 1979, p. 534.
65. Hafiz-i Abru 1971, pp. 68–69. For the stone decoration at Takht-i Sulaiman, see R. and E. Naumann 1976, figs. 23, 27, 28; R. Naumann 1977, figs. 69, 70, 84.
66. E. and R. Naumann 1969, figs. 14, 15; R. and E. Naumann 1976, figs. 24a, 26; R. Naumann 1977, figs. 71, 72, 75.
67. Harb 1978, pp. 9–11, 60–66.
68. For example, Juvaini 1958, vol. 1, pp. 236–37; Rashid al-Din 1971, pp. 61–62.
69. E. and R. Naumann 1969, fig. 13.

Fig. 92. Tiles on the wall of the West Iwan at Takht-i Sulaiman, Iran. Photograph Archive, Deutsches Archäologisches Institut, Berlin (neg. 1974-301)

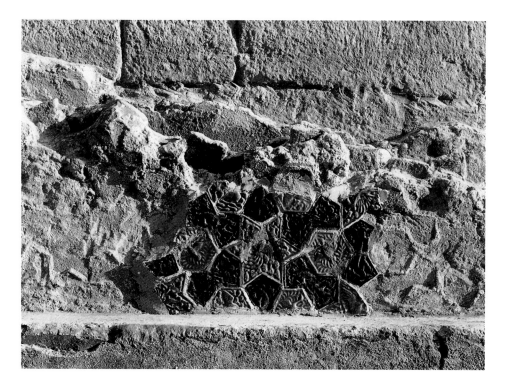

70. Kashani, in Allan 1973, p. 114. For a detailed description of the technique, see O. Watson 1985, pp. 31–36.

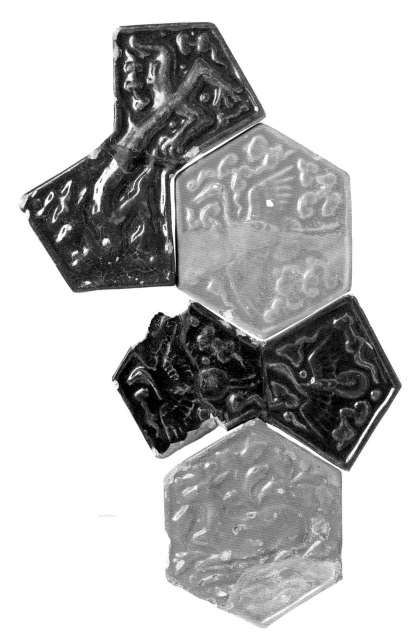

tiles, and underglaze *lajvardina* tiles. All the techniques are strongly related to those in contemporary Iranian use for the making of pottery. A potter's workshop and kilns have been excavated within the precinct of Takht-i Sulaiman, and at least some part of the tiles were manufactured at the site (see technical study 2 and fig. 279).

Luster painting was widely used for ceramic decoration in Iran between the late-twelfth and mid-fourteenth centuries. The technique is mentioned in the treatise on ceramics written in 1301 by the Persian historian Abu al-Qasim ʿAbd Allah Kashani, who came from a family of potters.[70] According to the most recent analyses by the Conservation Department of the Los Angeles County Museum of Art (see technical study 2), the ceramic received its first firing with a translucent glaze and underglaze oxides. The glazed surface was overpainted with a pigment containing oxidized silver or copper, which was reduced in a second firing, leaving a metallic sheen on the surface. A wall covered with luster-painted tile would have seemed like a wall of gold.

Fig. 93 (cat. nos. 88–91). Two hexagonal tiles and two double pentagonal tiles, Iran (Takht-i Sulaiman), 1270s. Fritware, underglaze painted. Staatliche Museen zu Berlin—Preussischer Kulturbesitz, Museum für Islamische Kunst (I. 13/69, 15h; I. 13/69, 15h; I. 13/69, 15; I. 13/69, 15e; I. 4/67, 8)

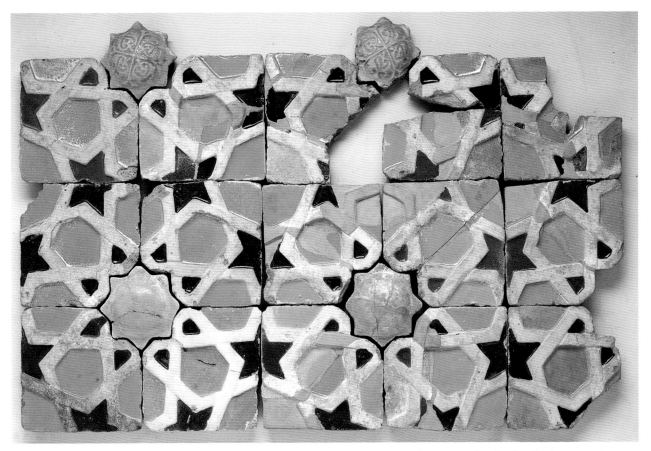

Fig. 94 (cat. no. 104). Tile panel (exterior tile), Iran (Takht-i Sulaiman), 1270s. High-clay fritware, unglazed and underglaze painted. Staatliche Museen zu Berlin—Preussischer Kulturbesitz, Museum für Islamische Kunst (I. 4/67; I. 6/71a–b)

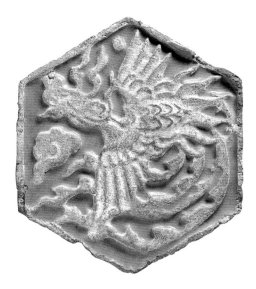

Fig. 95 (cat. no. 103). Hexagonal tile with phoenix (exterior tile), Iran (Takht-i Sulaiman), 1270s. High-clay fritware, unglazed and underglaze painted. Staatliche Museen zu Berlin—Preussischer Kulturbesitz, Museum für Islamische Kunst (I. 1988.10)

Fig. 96 (cat. no. 105). Hexagonal tile panel (exterior tile), Iran (Takht-i Sulaiman), 1270s. High-clay fritware, unglazed and underglaze painted. Staatliche Museen zu Berlin—Preussischer Kulturbesitz, Museum für Islamische Kunst (I. 13/69)

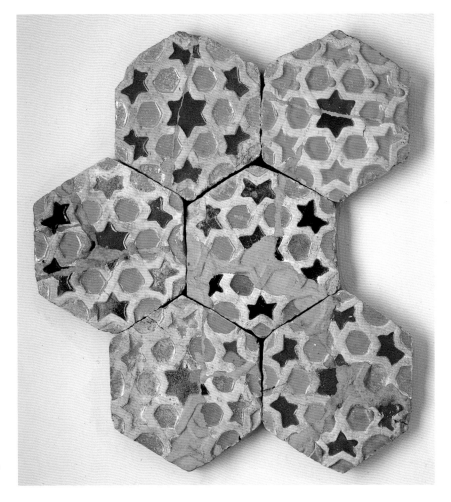

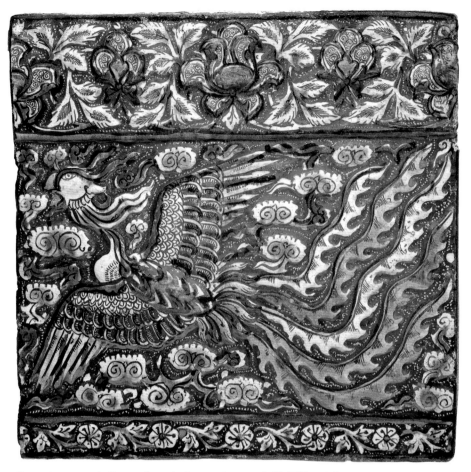

Fig. 97 (cat. no. 99). Frieze tile with phoenix, Iran (probably Takht-i Sulaiman), ca. 1270s. Fritware, overglaze luster-painted. The Metropolitan Museum of Art, New York, Rogers Fund, 1912 (12.49.4). See figure 79

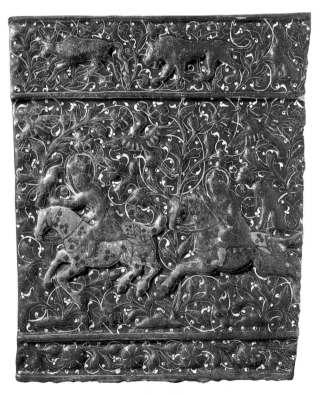

Fig. 98 (cat. no. 94). Frieze tile with hunters on horseback, Iran (probably Takht-i Sulaiman), 1270s. Fritware, overglaze painted (*lajvardina*). Miho Museum, Shigaraki, Japan (SS1480)

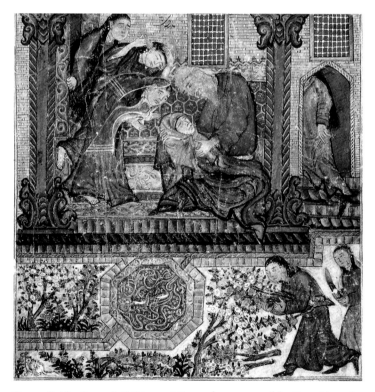

Fig. 99. *Faridun Goes to Iraj's Palace and Mourns,* from a page of the Great Mongol *Shahnama* (Book of Kings), Iran (probably Tabriz), 1330s. Ink, colors, and gold on paper. Arthur M. Sackler Gallery, Smithsonian Institution, Washington, D.C., Purchase, Smithsonian Unrestricted Trust Funds, Smithsonian Collections Acquisition Program, and Dr. Arthur M. Sackler (S1986.100a)

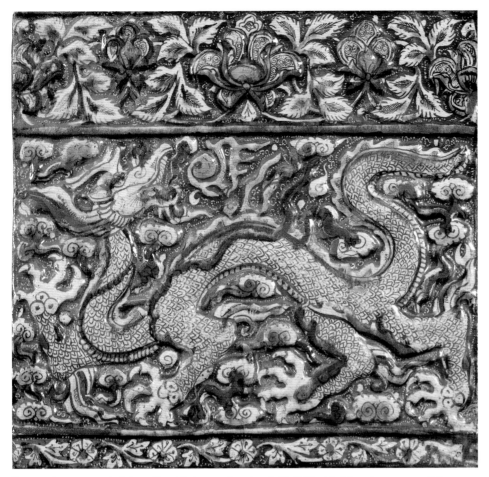

Fig. 100 (cat. no. 100). Frieze tile with dragon, Iran (probably Takht-i Sulaiman), ca. 1270s. Fritware, overglaze luster-painted. Victoria and Albert Museum, London (541-1900)

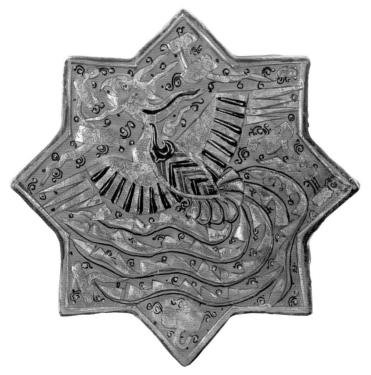

Fig. 101 (cat. no. 84). Star tile with phoenix, Iran (probably Takht-i Sulaiman), 1270s. Fritware, overglaze painted (*lajvardina*). Arthur M. Sackler Gallery, Smithsonian Institution, Washington, D.C., Gift of Osborne and Gratia Hauge (S1997.114)

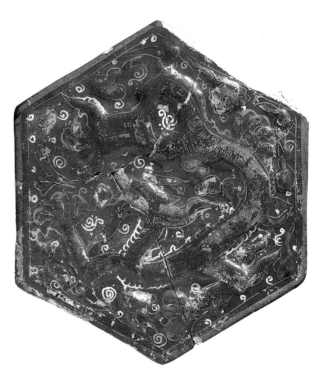

Fig. 102 (cat. no. 86). Hexagonal tile with dragon, Iran (Takht-i Sulaiman), 1270s. Fritware, overglaze painted (*lajvardina*). Staatliche Museen zu Berlin—Preussischer Kulturbesitz, Museum für Islamische Kunst (I.6/71c)

Fig. 103. Roof tile with a dragon, from Dening lu (Olon Süm), summer residence of the Önggüt chiefs, Inner Mongolia, China. Glazed earthenware. Institute of Oriental Culture, The University of Tokyo

Fig. 104. Roof tile with a phoenix, from Dening lu (Olon Süm), summer residence of the Önggüt chiefs, Inner Mongolia, China. Glazed earthenware. Institute of Oriental Culture, The University of Tokyo

Fig. 105 (cat. no. 188). Roof tile with a dragon, China (Inner Mongolia), Yuan dynasty (1271–1368). Glazed earthenware. Inner Mongolia Museum, Hohhot

Lajvardina technique, also mentioned by Kashani, was in use from the late thirteenth to the late fourteenth century.[71] On a monochrome glaze of cobalt blue, turquoise blue, or white, overglaze painting was done in black, white, and red enamel with highlights of gold (fig. 275). These are fixed by a second firing. For underglaze *lajvardina,* a hybrid technique, enamel overglaze painting and gold highlights were applied on a translucent glaze that had been underglaze-painted with turquoise blue and cobalt blue, rather than on the monochrome glaze of ordinary *lajvardina.* This hybrid technique is so far known only from Takht-i Sulaiman.

Both these techniques produce a rich, showy effect. Tiles decorating the interior at Takht-i Sulaiman consisted of floor tiling; dado tiling on the walls to a height of about six feet; and tile friezes running horizontally higher up on the walls. The same decorative scheme and the metallic and cobalt blue colors of the Ilkhanid tiles used for it are clearly depicted in a few manuscript paintings from the Great Mongol *Shahnama* (figs. 90, 99).

While some of the motifs that figure in the palace decoration display the repertoire of the Iranian craftsmen, others seem carefully chosen by the Mongol overlord. Chinese dragons and phoenixes are depicted on frieze tiles and eight-pointed star tiles, which in most cases are paired (figs. 97, 100, 101, 204). The dragon and the phoenix are considered good omens and are two of the oldest and most popular mythical animals in Chinese culture. Most importantly, both were symbols of sovereignty in China. Often forming a pair, they were used as decorative motifs on imperial belongings—buildings, palanquins, robes, and miscellaneous objects for daily use.[72] The Great Khans in China followed this Chinese tradition, and indeed, it was during the Yuan period that the imperial monopoly over these two motifs was firmly established. The code stipulating the types and colors of officers' robes that was issued in 1314 prohibits the appearance on robes of officers, vessels, plates, tents, or carts of any design using the dragon with five claws and two horns, or the phoenix.[73] The use of dragon and phoenix designs in the architectural decoration of Mongol cities in Mongolia and China is documented by both historical texts and archaeological evidence. In Dadu, historians described an audience hall surrounded by terraces of white stone sculpted with dragons and phoenixes, while behind it in a private hall of the Great Khan, the interior walls were covered in silk painted with dragons and phoenixes.[74] Glazed roof tiles carrying a relief decoration of dragon and phoenix have been found on governmental buildings or imperial palaces in many Mongol cities in Mongolia and China (figs. 103–105).

The affinity between the dragon and phoenix designs on the East Asian tiles and some of those on tiles from Takht-i Sulaiman

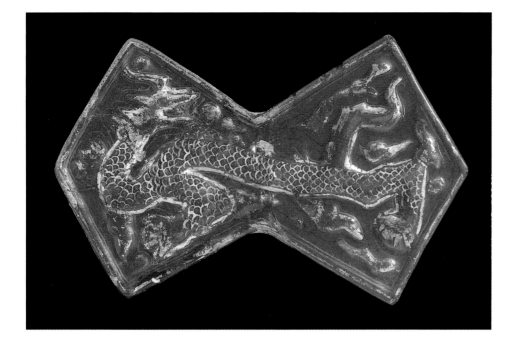

Fig. 106 (cat. no. 93). Double pentagonal tile with dragon, Iran, late 13th–early 14th century. Fritware, overglaze painted (*lajvardina*). Keir Collection, England (196)

suggests that the Iranian tile makers obtained their designs, directly or indirectly, from the Yuan court. They may have worked from Chinese models, probably from pattern books of some kind that supplied several different designs of a paired dragon and phoenix.[75] Like the Great Khans in China, the Ilkhanids used these motifs in their palaces as symbols of sovereignty. But the presence of only four claws on the dragons at Takht-i Sulaiman may have expressed the Ilkhans' respect for the suzerainty of the Great Khans, who claimed for themselves the exclusive use of the five-clawed dragon.

A lion, a deer, and a peony are the principal motifs on other tiles from Takht-i Sulaiman. The lion—with a knotted tail, holding in its mouth a tufted band with a ball and leaping amid foliage—is apparently based on a Chinese motif, the "lion playing with a ball," which is considered an auspicious emblem.[76] The deer symbolizes wealth in China. A crouching deer, like that on the Takht-i Sulaiman tiles, was used to decorate palanquins of the crown prince at the courts of the Song and Jin dynasties.[77] In China, the peony is called the king of flowers and symbolizes wealth and nobility.

The use of this group of East Asian motifs at Takht-i Sulaiman is significant evidence of the close relations between eastern and western Asia within the great Mongol empire. The introduction of the dragon and phoenix motifs into Iran was especially important. The motifs as used at Takht-i Sulaiman were almost exact copies of ones of Chinese origin, and they may have carried the same significance there as in China. However, these motifs gradually became assimilated into the Iranian artistic repertoire, acquiring new identities as the Iranian dragon and the mythical bird Simurgh.[78]

71. Kashani, in Allan 1973, pp. 114–15. The technique name *lajvardina* came from the Persian word *lajvard*, meaning lapis lazuli, because a glaze of that color was most often used for this technique.
72. Allsen 1997a, pp. 107–8.
73. *Yuanshi* 1976, vol. 7, pp. 1942–43 (chap. 78).
74. Tao Zongyi 1959, p. 252 (chap. 21); Xiao Xun 1980, p. 73.

Fig. 107 (cat. no. 95). Frieze tile with Faridun and two attendants, Iran (Takht-i Sulaiman), 1270s. Fritware, overglaze luster-painted. The Walters Art Museum, Baltimore (48.1296)

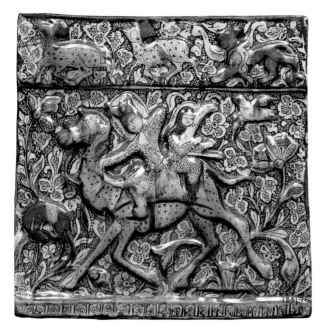

Fig. 108 (cat. no. 97).
Frieze tile with Bahram
Gur and Azada on a camel,
Iran (Takht-i Sulaiman),
ca. 1270–75. Fritware,
overglaze luster-painted.
Victoria and Albert
Museum, London
(1841-1876)

Fig. 109 (cat. no. 96). Frieze tile with elephant and
rider, Iran (probably Takht-i Sulaiman), 1270s.
Ceramic, overglaze luster-painted. Los Angeles
County Museum of Art, The Nasli M. Heeramaneck
Collection, Gift of Joan Palevsky (M.73.5.222)

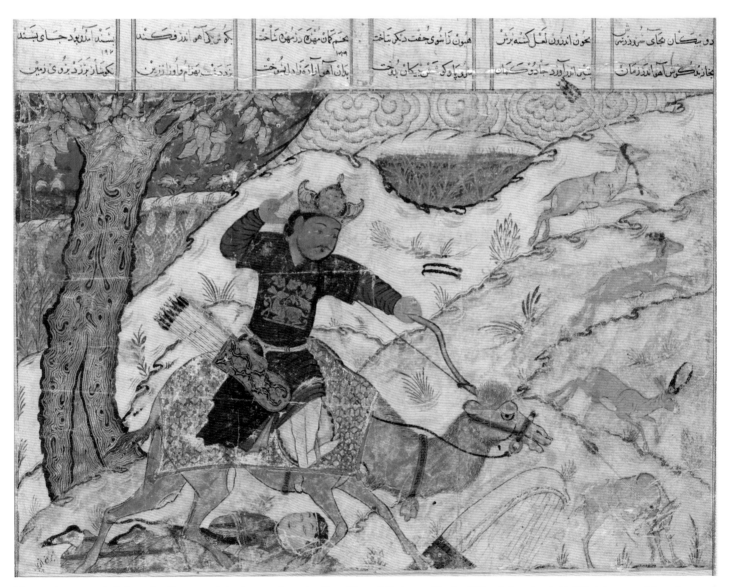

Fig. 110 (cat. no. 55). *Bahram Gur Hunting with Azada,* page from the Great Mongol *Shahnama* (Book of Kings), Iran (probably Tabriz), 1330s. Ink, colors, and gold on paper. Harvard University Art Museums, Cambridge, Mass., Gift of Edward W. Forbes (1957.193)

On the other hand, a completely different situation obtains with one group of objects. A few of the figural scenes represented in molded relief on Takht-i Sulaiman frieze tiles illustrate the national epic that celebrates Iran's ancient kings, Abul al-Qasim Firdausi's *Shahnama*. On some tiles, the story of Faridun, who overthrew the tyrant Zahhak and became the sixth king of Iran, is depicted (fig. 107). Another type of tile presents the *Shahnama* story of Bahram Gur, the fifteenth Sasanian king, hunting gazelles with his harpist slave girl Azada (fig. 108). The tiles carrying these two episodes from the *Shahnama* have differing dimensions and thus did not belong to the same frieze. The Bahram Gur tile was accompanied by another tile showing a hunting scene in which two unidentifiable horsemen are stabbing a deer with swords (fig. 50). Probably the frieze that contained these two tiles depicted various scenes of hunt, a theme particularly suitable for a pleasure palace, where hunts were frequently conducted. No tiles with dimensions matching those of the Faridun tile have been found at Takht-i Sulaiman, and it is difficult to identify the general theme of the frieze to which it belonged.

A number of tiles found at Takht-i Sulaiman carry quotations from the *Shahnama*. The texts are written in the borders of eight-pointed luster-painted star tiles and in the main fields of frieze tiles (figs. 49, 111, 112).[79] At least three long quotations are featured, each from the beginning of a story. The first comes from the opening of the Prelude at the head of the entire *Shahnama* cycle. The second is the beginning of the story of Rustam and Suhrab in the Book of Kaika'us. This telling of how Rustam killed his own son Suhrab has long been one of the best-known tales in the *Shahnama*. The third quotation is from the first part of an ode to Mahmud of Ghazna (to whom the *Shahnama* was dedicated), which introduces the popular story of Rustam and Isfandiyar in the Book of Gushtasp. The quotations contain little narrative content and apparently no specific allusions; verses referring to Kaikhusrau and Adur Gushnasp, for example, which would have had special relevance at Takht-i Sulaiman, are not quoted. Instead, by supplying the opening verses of the *Shahnama* and those of popular episodes, these passages seem to allude to the entire epic cycle,

75. See Linda Komaroff's chapter 7 for other possible sources for the designs.

76. Crowe 1991, p. 157.

77. *Jinshi* 1975, vol. 3, p. 874 (chap. 38); *Songshi* 1985, vol. 11, p. 3505 (chap. 150). For the lion and the deer, see chapter 5 and Jane Watt's chapter 3.

78. See the entries for cat. nos 83, 84, 100–102.

79. See Melikian-Chirvani 1984 and Melikian-Chirvani 1991 for an extensive study of the cataloguing and reading of the *Shahnama* verses inscribed on the frieze tiles.

Figs. 111, 112 (cat. nos. 81, 82). Frieze tiles with inscription from the *Shahnama,* Iran (Takht-i Sulaiman), 1270s. Fritware, overglaze luster-painted. Asian Art Museum of San Francisco, The Avery Brundage Collection (B60P2145, B60P2146)

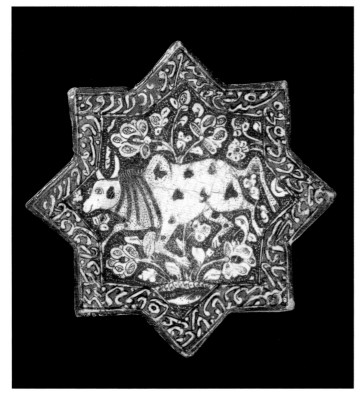

Fig. 113 (cat. no. 108). Star tile with bull, Iran (Kashan), A.H. 689/ A.D. 1290–91. Fritware, overglaze luster-painted. The David Collection, Copenhagen (13/1963)

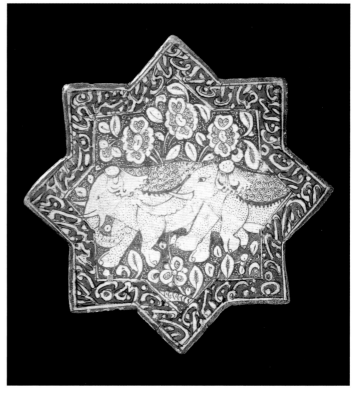

Fig. 114 (cat. no. 109). Star tile with elephants, Iran (Kashan), A.H. 689/ A.D. 1290–91. Fritware, overglaze luster-painted. The David Collection, Copenhagen (14/1963)

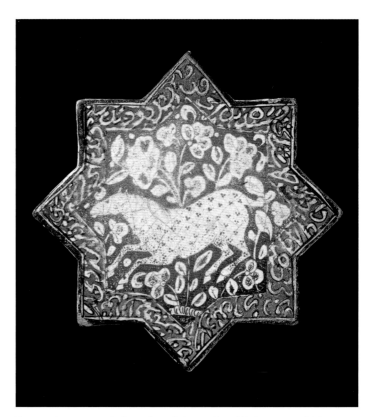

Fig. 115 (cat. no. 110). Star tile with horse, Iran (Kashan), A.H. Muharram 689/A.D. January14–February 13, 1290. Fritware, overglaze luster-painted. The David Collection, Copenhagen (12/1963)

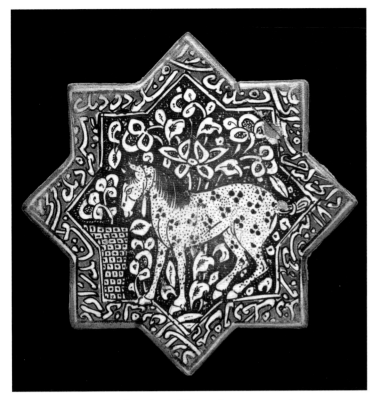

Fig. 116 (cat. no. 117). Star tile with horse, Iran, A.H. 710/A.D. 1310–11. Fritware, overglaze luster-painted. Museum of Fine Arts, Boston, Maria Antoinette Evans Fund and Gift of Edward Jackson Holmes (31.729)

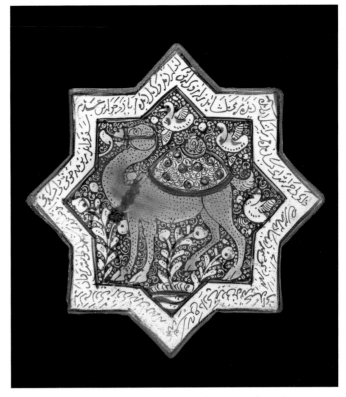

Fig. 117 (cat. no. 118). Star tile with camel, Iran, early 14th century. Fritware, overglaze luster-painted. Museum of Fine Arts, Boston, Gift of the Estate of Mrs. Martin Brimmer (06.1896)

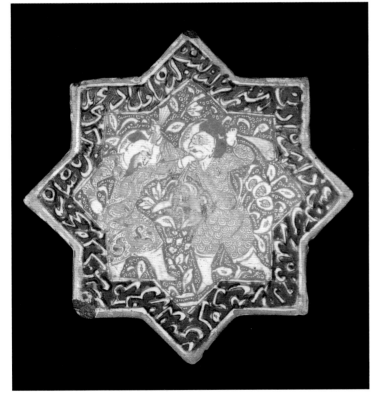

Fig. 118 (cat. no. 123). Star tile with two men fighting, Iran (Kashan), early 14th century. Fritware, overglaze luster-painted. The Walters Art Museum, Baltimore (48.1288)

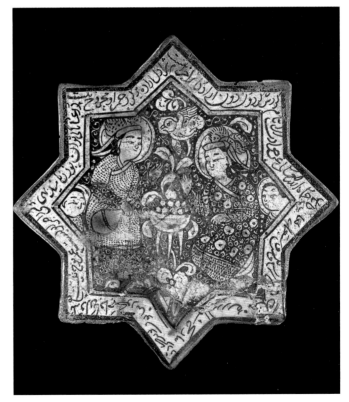

Fig. 119 (cat. no. 126). Star tile with seated man and attendant, Iran (Kashan), A.H. 739/A.D. 1338–39. Fritware, overglaze luster-painted. The Trustees of the British Museum, London (OA + 1123)

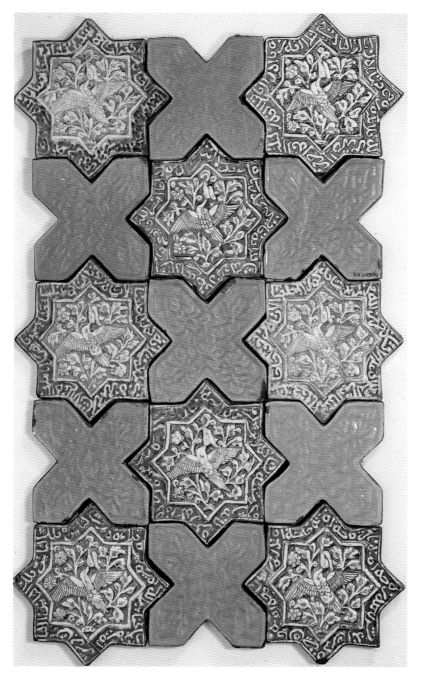

Fig. 120 (cat. nos. 112, 113). Star tiles with phoenixes and cross tiles, Iran, late 13th–early 14th century. Fritware, underglaze and overglaze luster-painted. Victoria and Albert Museum, London (1893+a-1897, 546-1900)

as if giving a cue for the recitation of all those *Shahnama* verses that Iranians would have learned by heart. In this they are palatial counterparts to the quotations from the Koran found on tiles in religious structures built in Iran between the late twelfth and mid-fourteenth centuries (figs. 151, 152).

Decoration based upon the *Shahnama* did not begin at Takht-i Sulaiman. The same Faridun who appears on its tiles is represented mounted on a humpbacked cow on large numbers of ceramic and metalwork objects dating from the twelfth to the fourteenth century.[80] Another popular motif decorating the same type of object, also drawn from the *Shahnama,* is of Bahram Gur and Azada mounted on a camel. Illustrations of these two stories adorned buildings datable to the late twelfth and early thirteenth centuries.[81] The theme of Bahram Gur and Azada in particular had long figured in palace decorations: a series of stucco panels with depictions of the story in high relief adorned a palace near Rayy (south of Tehran) attributable to the second half of the seventh century or the first half of the eighth century,[82] and an overglaze-painted tile illustrating the subject, datable to the late twelfth century, was excavated at a Seljuq palace of the sultanate of Rum in Konya, Turkey.[83] As for the *Shahnama* text, the historian Ibn Bibi (active ca. 1285) reports that in 1221 the sultan of Rum, ʿAlaʾ al-Din Kaiqubad I, had maxims from the epic inscribed on the walls of the palace in Konya and also of one in Sivas.[84] The examples cited in this paragraph demonstrate that it was an established practice, before the construction of the palace at Takht-i Sulaiman, to embellish a palatial building with tiles and other forms of decoration carrying quotations from the *Shahnama* or illustrations of its stories.

Thus, the potters crafting tiles for Takht-i Sulaiman were following an existing tradition; were they also formulating a new decorative program specifically for this palace? The *Shahnama,* the epic of Persian kings, was undoubtedly regarded as a powerful symbol of the tradition of Iranian kingship. As non-Persian rulers of Iran, the Mongol Ilkhans would have been wise to invoke this symbolism while simultaneously benefiting from a well-developed Persian tradition of palace decoration. The inclusion in the design scheme of dragons and phoenixes, Chinese symbols of rulership, was, on the other hand, a deliberate importation of foreign imagery that had special significance for the Ilkhans. At Takht-i Sulaiman, Chinese symbols of rulership were used together with Iranian symbols of rulership to decorate the palace of the Mongols. The site's architecture represented a similar blending of diverse features.

The palace at Takht-i Sulaiman must have offered an ideal setting for the amusement of the Ilkhans: rich pasture for their animals, an abundance of marmots for hunting, comfortable climate for the summer stay, and a beautiful landscape, with the lofty iwans encircling a lake. Both exterior and interior surfaces of the buildings were richly embellished. Most conspicuous were the multicolored tile revetments, with hints of glimmering gold. Dragons and phoenixes on the tiles sounded a familiar note for the Mongols, while the other, Persian designs created a setting that perhaps was experienced as exotic. A noble Mongol lady, Bulughan Khatun the Elder, once sat there far from her native land; beneath the intricate *muqarnas* vault she spoke of the glory of Genghis Khan to a small, bright boy named Ghazan.

It is probably only by chance that Takht-i Sulaiman alone has survived while all the other Ilkhanid palaces, including ones that served more important functions, were lost. At Takht-i Sulaiman, within the framework of a Persian sedentary palace, we can visualize the Mongol rulers continuing to deal with state affairs and conduct their private lives in traditional Mongol ways. This palace complex exemplifies the early stage of confrontation and accommodation between Iranian craftsmen and architects and their Mongol rulers. It was not until later in the Ilkhanid period—after the Ilkhan Ghazan converted to Islam, after Ilkhanid courtly life began to be conducted according to Islamic law and a functioning capital was built—that these conflicts were resolved, and the separate strains merged to become a truly new culture.

80. See the list of representations of Faridun and of Bahram Gur with Azada on medieval Islamic objects provided in Simpson 1985, pp. 143–46. See also Ettinghausen 1979 and Fontana 1986 for representations of Bahram Gur and Azada in Iranian art, including in the pre-Islamic period.

81. Faridun is depicted on the fragment of a polychrome-painted fresco datable to the early thirteenth century (Harvard University Art Museums, Cambridge, Mass., 1935.23). Bahram Gur and Azada are represented on two tiles probably dating from the late twelfth or early thirteenth century, a monochrome-glazed tile (Musée du Louvre, Paris, MAO 256) and a so-called *mina'i* tile (Museum of Islamic Art, Cairo, 11590).

82. They were excavated from the main palace of Chal Tarkhan ʿIshqabad near Rayy. One of the panels is in the Museum of Fine Arts, Boston (39.485).

83. Konyunoglu Collection, Konya.

84. Cited in Bombaci 1966, p. 39. See also Blair 1993b, pp. 243–44.

غَيْرَ مُسَافِحِينَ وَلَا مُتَّخِذِىٓ

أَخْدَانٍ وَمَن يَكْفُرْ بِالْإِيمَانِ

فَقَدْ حَبِطَ عَمَلُهُ وَهُوَ فِى

الْءَاخِرَةِ مِنَ الْخَاسِرِينَ يَٰٓأَيُّهَا

الَّذِينَ ءَامَنُوٓا إِذَا قُمْتُمْ إِلَى الصَّلَوٰةِ

5.

The Religious Art of the Ilkhanids

SHEILA BLAIR

Until now it has been the custom of the Mongol emperors of Genghis Khan's urugh [lineal descendants] to be buried in unmarked places far from habitation in such a way that no one would know where they were. . . . When the emperor became Muslim and elevated the customs of religion to the skies, he said, "Although such was the custom of our fathers . . . there is no benefit in it. Now that we have become Muslim we should conform to Islamic rites, particularly since Islamic customs are so much better.". . . Since he was in the capital Tabriz, he chose it as the site [of his tomb] and laid the foundation himself outside the city to the west in the place called Shamb. They have been working on it for several years now, and it is planned to be much more magnificent than the dome of Sultan Sanjar the Seljuq in Merv, which is the most magnificent building in the world.

—Rashid al-Din, *Compendium of Chronicles*[1]

In religion as in many cultural and artistic affairs, the Mongols were eclectic. Like people everywhere they adopted religion for a variety of reasons, ranging from a personal desire to understand the ineffable to broader concerns about social cohesion and political control. The Mongols were also ecumenical. Unlike many others, they had an extremely wide range of religions upon which to draw. The geographical and social changes the Mongols underwent in the course of their transformation from a nomadic regime on the Mongolian steppe to a sedentary Islamic polity on the Iranian plateau, and their pivotal position on the transcontinental trade routes connecting China and Europe, meant that they were exposed to many of the major religions practiced in Eurasia: shamanism, Buddhism, Zoroastrianism, Manichaeism, at least four types of Christianity (Nestorian, Jacobite, Armenian, and Catholic/Latin), Judaism, and several approaches to Islam (notably Sunnism, Shiʿism, and Sufism).[2] Like the Mongols in China, the Ilkhanids initially tolerated and even encouraged a variety of religions as a way of ingratiating themselves with their subjects in foreign lands;[3] and all these religions, to differing degrees, affected the arts and architecture patronized by the Ilkhanids during the period of their rule in Iran and Iraq, the mid-thirteenth to the mid-fourteenth century.

After the Ilkhan Ghazan (r. 1295–1304) officially converted to Islam in 1295, adherence to other religions was curtailed. Many non-Muslim monuments were destroyed,[4] and official chronicles written after this date trumpet orthodox Islam. Traces of other religious practices are nonetheless discernible in some surviving works of art and architecture, and these can be used to elucidate the changing religious affiliations of the Ilkhanid court and its subjects. In looking at such works, however, it is important to remember that the evidence is sometimes scanty and equivocal and can be interpreted to justify a particular position or interest. The same complex of rock-cut caves near Maragha in northwestern Iran has been identified, for example, as both a Jacobite monastery church and a Buddhist cave

1. Rashid al-Din 1998–99, pt. 3, p. 685.
2. For a general overview of religion in the Mongol period, see Bausani 1968.
3. For the Mongols' generally tolerant view of religion, specifically Khubilai's cultivation of Confucianism in China, see Morris Rossabi's chapter 1 in this catalogue.
4. The basic study of Ilkhanid architecture remains Wilber 1969.

Opposite: Fig. 121 (cat. no. 65). Page from Öljeitü's Mosul Koran, copied by ibn Zaid al-Husaini ʿAli ibn Muhammad, Iraq (Mosul), A.H. 706–11/A.D. 1306–11. Ink, colors, and gold on paper. The Trustees of the Chester Beatty Library, Dublin (Is 1613.2, fol. 1v)

5. Bowman and Thompson 1967–68; Ball 1976.

6. J. M. Rogers's identification of a Mongol shamanist in his note on iconography in Barthold and Rogers 1970 is mistaken; the figure is not a shaman but an *ilchi,* or official messenger. See Blair 2002a and cat. no. 23 (fig. 68) in this catalogue.

7. Most easily available in Rashid al-Din 1998–99.

8. Rührdanz 1997.

9. For a history of illustrated versions of the *Compendium of Chronicles,* see Blair 1995. Of those later copies, one of the first is a little-known copy probably transcribed in the fourteenth century but heavily repainted in the fifteenth century and again under the Mughal emperor Akbar, which is in the Reza library in Rampur (India); see Blair 1995, figs. 60, 61.

10. Barthold and Rogers 1970.

11. Ibid., pp. 217–19.

Fig. 122 (cat. no. 28). *Funeral Scene,* illustration from the Diez Albums, Iran, early 14th century. Ink, colors, and gold on paper. Staatsbibliothek zu Berlin—Preussischer Kulturbesitz, Orientabteilung (Diez A fol. 71, S. 55)

temple.[5] Nevertheless, carefully putting together small pieces of evidence allows us to reconstruct a multistranded tapestry in which elements from one religion were often woven into the traditions of another.

BEFORE THE ADOPTION OF ISLAM

The Mongols of the Eurasian steppe believed in shamans—leaders who could intercede between humans and powerful spirits both good and evil—and prepared for an afterlife with elaborate ceremonies. Both Genghis (d. 1227) and his son Ögödei (r. 1229–41) were shamanists, but we have little visual information about the religious customs practiced during their rule.[6] Some of the first surviving illustrations of their funeral practices are paintings in manuscripts of Rashid al-Din's *Compendium of Chronicles,* or *Jami ʿ al-tavarikh.* Rashid al-Din, vizier to the Ilkhan Ghazan, was commissioned by Ghazan to compose a history of the Mongols; under Ghazan's brother and successor Öljeitü (r. 1304–16), the work was expanded to become the earliest known history of the world. The multivolume work, including numerous appendixes, was completed in 1310, and multiple copies of it were prepared for the vizier in the years before his downfall and execution in 1318. The *Compendium*'s first volume, one of the main sources of information about the history of the Mongols,[7] contains illustrations depicting royal funerals following traditional Mongol custom. These scenes are found both on detached pages mounted in several albums in Berlin (figs. 87, 122)[8] and in later, complete copies of the *Compendium.*[9] Depictions of the ruler's coffin set on a throne surrounded by mourning courtiers match the sparse accounts of Mongol burial customs given in the sources and pieced together by the noted Orientalist V. V. Barthold.[10] According to these accounts, the body was put in a coffin bound with gold bands, which in turn was placed on a catafalque of white felts and carpets, or later, after the death of the Great Khan Möngke in 1259, on a throne.

Even after Ghazan's official conversion to Islam in 1295, the Ilkhanids seem to have maintained elements of traditional Mongol orientation practices. The Mongols had set the entrances of their tents and the gates of their encampments to the south and faced that direction during religious rites.[11] This custom apparently persisted into Islamic times. The monumental tomb of the Ilkhanid sultan Öljeitü at Sultaniyya, for example, is positioned not toward the southwest to face the qibla, as it should be according

Fig. 123 (cat. no. 42). *Isfandiyar's Funeral Procession,* page from the Great Mongol *Shahnama* (Book of Kings), Iran (probably Tabriz), 1330s. Ink, colors, and gold on paper. The Metropolitan Museum of Art, New York, Purchase, Joseph Pulitzer Bequest, 1933 (33.70)

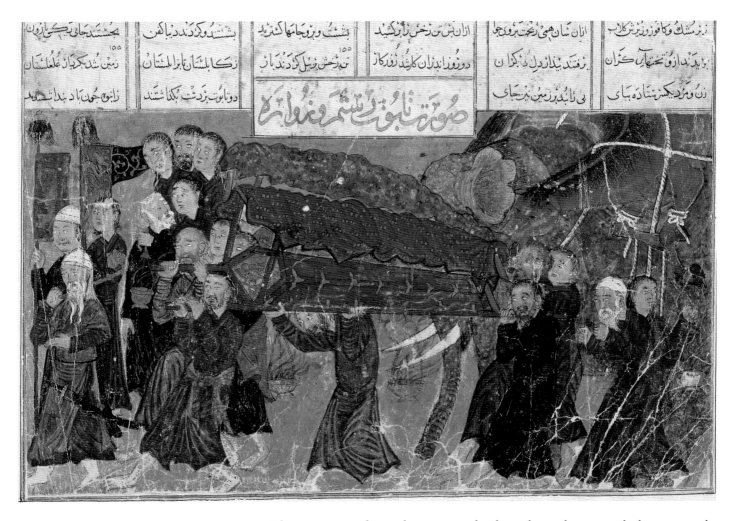

The following text appears within the illustration in Arabic/Persian script:

بجشسد جای و کرد درد باکن | بشسد و کرد دد باهن | بیژن تن زخن از بریژید | ازان نس می زخت بروژ جا | ازان شان می زخت بروژ جا | بیز مشک و کافوز بز ژیر کلاب

زمین شد بگریان غلغلستان | ز کابلستان باز آلتستان | تو زخش زنیل کرد دد باز | دوزون اندزان کاشد نفرکاز | بر بد داز و تحفا از کزان | بی رابند زمین بز جای

زابوغ جون تز دشت بگذا شد | دو تابوت بز دشت بگذا شد | صوت تابوت رستم و غوازه | بی رابند زمین بز جای | ژن و مزد کس تاده دجای

صوت تابوت رستم و غوازه

to Islamic practice, but rather on a cardinal north-south axis, with the rectangular hall situated directly south of the domed room (fig. 141).[12]

Similarly, the Mongol interest in astrology and the stars continued to be pursued under the Ilkhanids. Astrological concerns underlay one of the first Ilkhanid acts of architectural patronage, Hülegü's foundation of an observatory at Maragha, begun in 1259, the year after his conquest of Baghdad.[13] The observatory became a center for scientific discovery and innovation under Nasir al-Din Tusi, who developed there the well-known astronomical tables known as the *Zij-i ilkhani.* It was

Fig. 125. *The Yuan Emperor Togha Temür and His Brother Khoshila,* detail of fig. 126.

founded, however, because of Hülegü's desire to predict terrestrial events from configurations of the planets, stars, and astrological places.[14] Astrology remained important for the Ilkhanids and their successors, the Jalayirids, who continued to use the Chinese-Uyghur animal calendar[15] and commissioned large, heavily illustrated copies of the astrological treatise *Kitab al-bulhan.*[16]

Genghis's grandson the Great Khan Khubilai (r. 1260–94) embraced Buddhism, which had arisen in India sometime between the seventh and fourth centuries B.C. and had gradually spread into Central Asia, China, and Southeast Asia. Buddhism became the dominant religion in Yuan China under the auspices of the Tibetan monk Phagspa (see fig. 126). Khubilai's brother Hülegü (r. 1256–65), founder

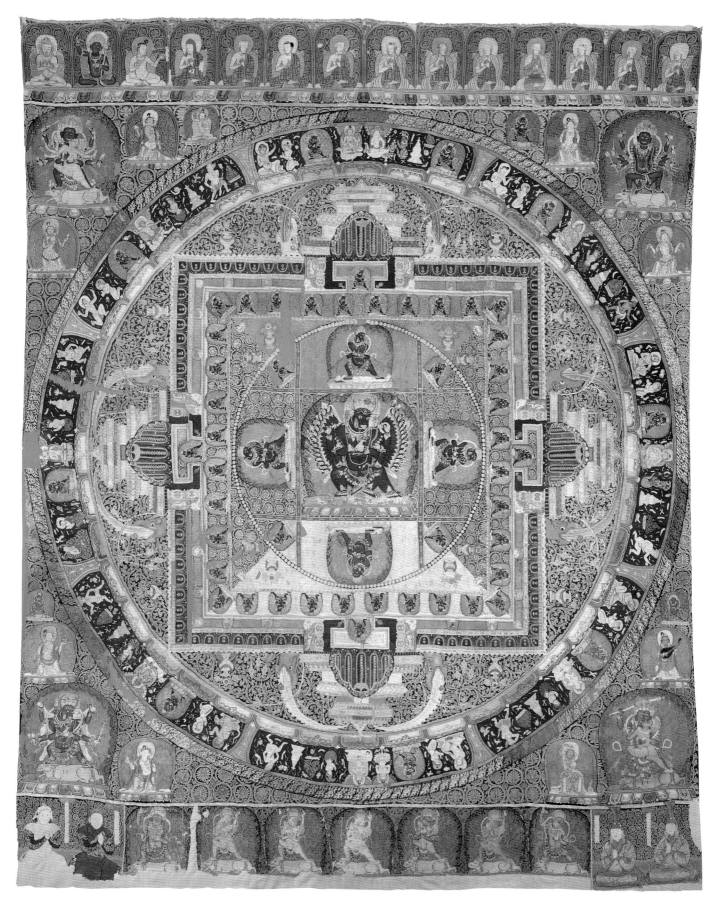

Fig. 126 (cat. no. 185). Mandala with imperial portraits, China, Yuan dynasty (1271–1368), ca. 1330–32. Silk tapestry (*kesi*). The Metropolitan Museum of Art, New York, Purchase, Lila Acheson Wallace Gift, 1992 (1992.54)

Fig. 127. Stone dragon relief, Viar, Iran, probably second half of the 13th century

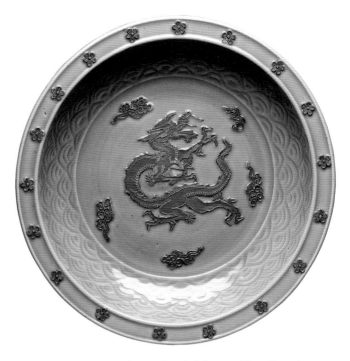

Fig. 128 (cat. no. 191). Plate with coiled dragon, China, Yuan dynasty (1271–1368), 14th century. Porcelain, with celadon glaze and biscuit. The Cleveland Museum of Art, John L. Severance Fund (1961.92)

12. Öljeitü's tomb at Sultaniyya deserves a mono-graphic study; meanwhile see Blair 1997. For the identification of the north-south orientation, see Blair 1996, p. 42.

13. For a brief survey of the excavations, see Vardjavand 1979. For the instruments used there, see Bausani 1982.

14. For the sciences in Ilkhanid Iran in general, see Kennedy 1968; on Nasir al-Din Tusi, see Daiber and Ragep 2000.

15. Melville 1994.

16. Carboni 1987; Carboni 1988.

17. Bausani 1968, esp. p. 543, with a translated description of Ghazan's destruction of the temples as given by Rashid al-Din. As Charles Melville has commented to me, more work needs to be done sorting out the various strands of Buddhism; there must have been great differences between the Tibetan, or Red, Buddhism adopted by the Yuan in China and that in Central Asia or Iran. On Ghazan's conversion, see Melville 1990b.

18. Scarcia 1975. Other possible Buddhist sites include the grotto at Bisitun in the area around Sultaniyya; see Curatola 1979. See also Ball 1976.

19. For a discussion of the dragon's iconography, see Curatola 1982; for Takht-i Sulaiman, see Tomoko Masuya's chapter 4 in this volume.

of the Ilkhanid line, may also have adopted Buddhism, which grew particularly strong in Iran under his grandson Arghun (r. 1284–91). Arghun reportedly had Buddhist priests brought from India and is even said to have died from an elixir promising eternal life prescribed by one of them. After Arghun's son Ghazan converted to Islam, the Ilkhanids grew antagonistic toward Buddhism, and most Buddhist temples were destroyed.[17]

Although various ruins in Iran have speculatively been identified as Buddhist, that for which the best case can be made is the rock-cut complex carved into the northern slopes of the Kuh-i Rustam range in northwestern Iran, south of the city of Zanjan.[18] The complex consists of several caves containing carved reliefs, traces of steps, and cavities that could have enclosed wooden elements. Its identification as a Buddhist monastery is supported by the name of the site, Viar, which may derive from *vihara,* the Sanskrit term for a Buddhist monastery. Like Öljeitü's tomb at nearby Sultaniyya, the rock-cut complex at Viar is positioned cardinally, with the principal cave, measuring about 30 feet across and 26 feet deep, on the south side. The west wall preserves some fine reliefs, notably of two large serpentine dragons, each with an unusual tuft of hair growing from the nape of its neck (fig. 127). This style of dragon, which had been popular in China under the late Song and Yuan dynasties, was adopted in Ilkhanid Iran, where it appears on objects (fig. 128) and capitals and tiles found at Takht-i Sulaiman, the Ilkhanid palace erected in the 1270s in northwestern Iran.[19]

Following Ghazan's conversion to Islam in 1295, much of the physical evidence of Buddhism in Iran was eradicated. The same thing happened with ancient indigenous systems of belief, including Zoroastrianism, a dualistic religion based on the

concept of a struggle between good and evil that traced its foundations back to the teachings of Zoroaster, and Manichaeism, a gnostic religion first preached by Mani.[20] The Ilkhanids' continued interest in the religious traditions of other eras and cultures is nonetheless evident from surviving manuscripts made for the court in the opening years of the fourteenth century. A manuscript of Muhammad ibn Ahmad Abu al-Rayhan al-Biruni's treatise on calendrical systems, *Kitab al-athar al-baqiya* copied by Ibn al-Kutbi in 1307, demonstrates this curiosity.[21] Virtually the only illustrated copy of the text ever made,[22] the manuscript has several images depicting the celebration of pre-Islamic Iranian holidays such as Mihrjan and Sa'da. Both this manuscript and the section on ancient prophets in the Arabic copy of Rashid al-Din's *Compendium of Chronicles*[23] also contain representations of legendary Iranian figures, such as the tyrant Zahhak.

Al-Biruni's original text included a section on Zoroaster, curiously missing from the Ilkhanid copy, as well as one on the life of Mani. The subject of Mani's execution seems to have captivated the Ilkhanids, for the scene is depicted both in al-Biruni's text, where the illustration follows the Christian account of Mani's death by hanging, and in the Great Mongol *Shahnama* (Book of Kings) made a generation later, where the illustration follows the traditional Muslim account of Mani's death by flaying (fig. 129).[24] Here, Mani's flayed body lies on the ground, while his stuffed skin dangles from a palm tree. At the right is the hospital mentioned in the text, with female onlookers peering out of the upstairs windows. The group of onlookers on the left wear distinctive hats, tall, pointed, and brimmed. Mongol envoys wore such hats (see fig. 68); they were depicted by European artists in a variety of settings, ranging from the scene of Mongols eating their victims in a manuscript of Matthew Paris made about 1240[25] to the representation of Mongol envoys in *Franciscan Martyrdom,* a fresco painted in the 1330s by Ambrogio Lorenzetti for the cloister of San Francesco in Siena.[26] European artists put similar tall, pointed hats on many sorts of foreigners, such as the money changers in the Temple in a Gospel book made in Verona in the late thirteenth century.[27] The hats may have evolved into the tall ones typically worn by magicians and witches in the West.

Artworks and traces of architecture also provide insights into the several types of Christianity that existed in Ilkhanid Iran. The Jacobites, or Syrian Monophysites, believed in the single divine nature of Christ. The head of the Jacobite church in the Persian territories was the historian and polymath Bar Hebraeus (d. 1286). He frequently stayed in the Ilkhanid capitals at Maragha and Tabriz, and his chronicle describes the churches there.[28] None remains, although some scholars have tried to match various rock-cut ruins with these textual accounts.[29]

The Jacobites were at odds with the Nestorians, who asserted the independence of Christ's divine and human natures. Nestorian Christianity had been denounced as a heresy by the Western church in the fifth century but had spread widely in Asia. It was

20. Charles Melville informs me that very little information on Zoroastrianism during this period survives. During the reign of Abakha, the poet Zartusht Bahram wrote a work called *Zartushtnama* (F. Rosenberg's edition, *Le Livre de Zoroastre* [Saint Petersburg, 1904], was unavailable to me) in which he alluded to contemporary events and to the just deserts the Muslims got at the hands of the Mongols. Zartusht's father, Bahram Pazdu, also wrote a verse chronicle, *Bahariyat,* praising Zoroastrianism and its founder, but the work is said to have little literary merit. See Amuzgar 1989.

21. Soucek 1975; Hillenbrand 2000.

22. The only other example (Paris, BN Ms. arabe 1489), datable to the seventeenth century and probably of Ottoman provenance, is a copy of the Ilkhanid version.

23. See D. T. Rice and Gray 1976.

24. Reza Abbasi Collection, Tehran; Grabar and Blair 1980, no. 46.

25. Cambridge, Corpus Christi College, Ms. 16, fol. 166a; illustrated in L. Arnold 1999.

26. For a Mongol emissary wearing such a hat, see Blair 2002. The Matthew Paris manuscript (Cambridge, Corpus Christi College, Ms. 16, fol. 166a) and the Lorenzetti fresco are illustrated in L. Arnold 1999, fig. I-2.

27. Vatican, Biblioteca Vaticana, MS lat. 39.

28. Teule 1998.

29. Bowman and Thompson 1967–68.

Fig. 129. *The Slaying of Mani,* page from the Great Mongol *Shahnama* (Book of Kings), probably Tabriz, 1330s. Ink and colors on paper. Reza Abbasi Collection, Tehran

Fig. 130 (cat. no. 6). *The Birth of the Prophet Muhammad,* from the *Jamiʿ al-tavarikh* (Compendium of Chronicles) by Rashid al-Din, Iran (Tabriz), ca. A.H. 714/A.D. 1314–15. Fol. 44r; ink, colors, and gold on paper. Edinburgh University Library (MS Arab 20)

popular with prominent women of the Ilkhanid line; Hülegü's wife Dokhuz Khatun was a Nestorian. The Chinese Nestorian monk Rabban Sauma, sent by Khubilai as an envoy to Pope Nicholas IV (papacy 1288–92) in Rome, traveled through the Ilkhanid realm and noted many churches there.[30] He reached Rome in 1288 and was sent back the following year with gifts and letters urging the Ilkhan Arghun to convert.[31] Arghun did not embrace Christianity, but he had his son (later the ruler Öljeitü) baptized Nicholas in the pope's honor.

Christian friars of the Franciscan order were also active in Ilkhanid Iran. Nicholas IV was the first Franciscan pontiff, and during his papacy many Franciscan monks embarked on missions to the East.[32] The friars carried religious objects for both personal devotion and proselytizing, and the merchants who accompanied them had their own devotional objects. These portable altars, diptychs, Gospel books, missals, and other treatises became sources of imagery for Ilkhanid painters.[33] The period of Ilkhanid rule saw the rise of the illustrated book in Iran,[34] with manuscript painters drawing upon ideas from both East and West. Illustrations from the Great Mongol *Shahnama,* made in the 1330s, reveal the inspiration of Italian works by the likes of Simone Martini, Lorenzetti, and their contemporaries. The borrowed features are both compositional devices—such as a circular arrangement with *repoussoir* figures in the foreground and receding planes to indicate perspective—and individual motifs, such as gold halos behind faces in profile, transparent veils, and recumbent or mourning figures. Stock compositions from Christian illustrated books were adapted for Muslim stories; for instance, the

30. See chapter 1.
31. Nicholas's letter written to Arghun in 1298 is preserved in the Vatican, reg. Vat. 44, fol. 89v, and illustrated in L. Arnold 1999, fig. 203.
32. On these connections, see L. Arnold 1999.
33. Maginnis 2001 describes in detail the many types of works produced in Siena from the mid-thirteenth to the mid-fourteenth century.
34. Blair 1993a.

Fig. 131 (cat. no. 47). *King Kayd of Hind Recounting His Dream to Mihran,* page from the Great Mongol *Shahnama* (Book of Kings), Iran (probably Tabriz), 1330s. Ink, colors, and gold on paper. The Trustees of the Chester Beatty Library, Dublin (Per 111.5)

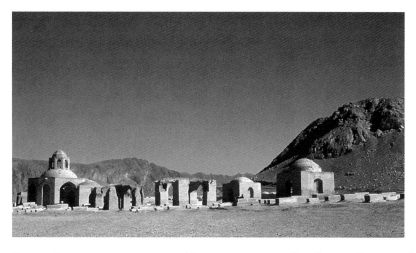

Fig. 132. Cemetery near Linjan, central Iran

Nativity of Christ provided a composition for the birth of the prophet Muhammad as illustrated in Rashid al-Din's world history (fig. 130).[35] Other subjects of Western medieval art, among them the seasons and the labors of the months, were also taken over and appear on metalwork and in manuscripts made in northern Syria and Mesopotamia during the thirteenth and fourteenth centuries.[36]

The Christianity of neighboring Armenia also played a role in Ilkhanid art, particularly in connection with the arts of the book. The most important center for the production of Armenian manuscripts was Sivnik, the mountainous area north of the Araks River. Monasteries there were exempted from taxes and flourished as major centers of learning and artistic production. The one most prominent at the end of the thirteenth century was the monastery of Gladzor. Nearly seventy of the manuscripts scribes produced there survive, including twenty with illustrations.[37] Armenian artists who trained at these monasteries were peripatetic and often worked in a number of cities, including ones within the Ilkhanid domains.

Fig. 133 (cat. no. 21). *Angel and Three Figures in a Landscape; Mongol Ruler and Consort* (six scenes), illustrations from the Diez Albums, Iran, early 14th century. Ink, colors, and gold on paper. Staatsbibliothek zu Berlin—Preussischer Kulturbesitz, Orientabteilung (Diez A fol. 71, S. 63, nos. 1–7)

For example, the painter Awag, who trained at Gladzor, practiced not only in Cilicia but also in the Ilkhanid cities of Tiflis, Tabriz, and Sultaniyya.

When working in Ilkhanid domains, Armenian painters incorporated typical Ilkhanid techniques and styles into their own art of book painting. Such adaptation may be seen in a fine Gospel book copied by the deacon T'oros at Tabriz in 1311 and now dispersed.[38] While Armenian manuscripts of the period are generally on parchment, this copy of the Gospels, like most Ilkhanid manuscripts, is written on paper. T'oros used a quite ordinary paper that is wrinkled, has tiny inclusions, and was never polished. His paintings are very dramatic, with vividly colored figures set against a highly burnished ground. Quite distinctive are the pink and blue washes employed to represent rows of receding hills in the foreground and the blue hands and faces of the figures. While the use of wash rather than opaque color may represent an adaptation to the paper support, it is also characteristic of the major illustrated manuscripts produced in Tabriz at this time, copies of Rashid al-Din's *Compendium of Chronicles.* Similarly, the receding hills and blue faces typical of T'oros's work appear in a Persian manuscript painting made in Tabriz a generation later, *King Kayd of Hind Recounting His Dream to Mihran* ((fig. 131).

Jews too were prominent in Ilkhanid Iran,[39] with significant Jewish communities in Isfahan and Hamadan. At Linjan, about 18 miles southwest of Isfahan, the tomb of the Sufi mystic Shaikh Muhammad ibn Bakran (known as Pir-i Bakran; d. 1303) is set near a large cemetery that includes Jewish tombstones from an earlier period (fig. 132).[40] This reuse of the site exemplifies the religious syncretism of the Ilkhanid period; a similar history has been posited for the tomb of Sayyid Muhammad west of Isfahan[41] and for the sanctuary at Qaydar (now Khudabanda) in the area around Sultaniyya.[42] The tomb of Pir-i Bakran took the form of a monumental iwan—that is, a rectangular, vaulted hall open on one side—decorated with tiles and some of the finest and most elaborate stucco embellishment to survive from the Ilkhanid period.[43] The superb quality of the decoration shows that the shrine was underwritten by a wealthy patron and hence that such religious syncretism occurred in the highest levels of society.

Like the art commissioned by Armenians, art made for Jews in Ilkhanid Iran partook of the milieu's characteristic styles. This is evident in the wooden cenotaph for the so-called tomb of Esther and Mordecai at Hamadan.[44] Although it includes an inscription in Hebrew, the carving otherwise resembles work done for Muslims, with geometric designs, vase-shaped capitals, and small mihrablike niches. The cenotaph is in very fine condition and may be a later replacement for an older work. The tomb itself may have been an older structure restored by the vizier Rashid al-Din, a native of Hamadan and a Jewish convert to Islam, whose interest in Judaism is well known. His *Compendium of Chronicles* contains a history of the Jews that parallels other sections devoted to histories of the Chinese, Indians, and Turks. Many depictions of Jewish prophets are found in two important manuscripts of the period, the calendrical treatise of al-Biruni copied in 1307 and the Arabic copy of Rashid al-Din's world history copied in 1314–15.

35. First noted by T. W. Arnold 1928, p. 99.
36. D. S. Rice 1954; Atil 1972; Allan 1978.
37. The finest and most profusely illustrated is the Gladzor Gospels, done by several painters in the opening years of the fourteenth century. See Mathews and Wieck 1994, no. 36; Mathews and Taylor 2001.
38. Mathews and Wieck 1994, nos. 19, 31.
39. See Charles Melville's chapter 2 in this volume.
40. Herzfeld 1926, pp. 237–39; Wilber 1969, no. 26; Paone 1981.
41. Paone 1981; Scerrato 1981.
42. Curatola 1987, p. 97 and n. 6.
43. Wilber 1969, no. 26; Grube 1981.
44. Curatola 1987; on the tomb, see Netzer 1998.

Fig. 134 (cat. no. 31). *Tent Mosque; Birth Scene,* illustrations from the Diez Albums, Iran, 14th century. Ink and colors on paper. Staatsbibliothek zu Berlin—Preussischer Kulturbesitz, Orientabteilung (Diez A fol. 70, S. 8, nos. 1, 2)

Fig. 135 (cat. no. 174). Double dinar of Öljeitü, Iran (Shiraz), A.H. 714/A.D. 1314–15. Gold. Art and History Trust Collection

ISLAM

With Ghazan's conversion to Islam, the patronage of religious art in Iran became focused on promulgating Islam. Many of Ghazan's actions as described by Rashid al-Din parallel those taken by Khubilai in China in the 1260s: commissioning dynastic chronicles, encouraging theological debates, and underwriting religious buildings. Most people in Iran at that time were Sunni Muslims, traditionalists who believed that succession to the prophet Muhammad is determined by the consensus of the community. In various pockets of the country, notably southern Iraq and the area around Kashan in central Iran, the population was made up of Shiʿites, followers of the sect according to which succession passed to the Prophet's family via his cousin and son-in-law ʿAli.[45] Both Sunnis and Shiʿites venerated ʿAli and his sons Hasan and Husayn, and this devotion to the Prophet's family may help explain why depictions of Muhammad became popular at this time. Although today conservative Muslims reject any attempt at representing his person, such was not the case in Ilkhanid times. The Prophet is depicted enthroned at the beginning of a copy of the *Marzubannama* (Book of the Margrave) transcribed in Baghdad in 1299,[46] and cycles of illustrations of Muhammad's life appear in manuscripts from the Ilkhanid period—including an undated copy of Abu al-Fadl Muhammad Balʿami's history, the 1307 copy of al-Biruni's treatise (figs. 136, 137), and several copies of Rashid al-Din's *Compendium of Chronicles* (fig. 130).[47]

Religious debates between Sunnis and Shiʿites grew vociferous under Ghazan's successor Öljeitü.[48] He is said to have had a mobile madrasa, or theological school, follow his camp, and in the evening he was entertained by Shiʿite scholars debating their learned Sunni counterparts. The Shiʿites were ultimately successful in their arguments, and Öljeitü officially converted to Shiʿism in A.H. 709 (1310).[49] The date can be verified by his coins; those issued after this date carry a differently shaped cartouche, an expanded profession of faith including the phrase ʿAli is God's friend," and blessings on the Twelve Imams (fig. 135).[50] The imposition of Shiʿism, however, was only temporary, and under Öljeitü's young son Abu Saʿid, traditional

45. Calmard 1997.
46. Simpson 1982b.
47. The Balʿami manuscript is in the Freer Gallery of Art, Washington, D.C. (30.21, 47.19, and 57.16). In general, see Soucek 1988. For the al-Biruni manuscript, see Hillenbrand 2000.
48. On Shiʿism in this period, see, most recently, Calmard 1997.
49. On Öljeitü's conversion, see Pfeiffer 1999.
50. Blair 1983. Öljeitü type B, with the new legends and cartouches, was issued between 1310 and 1313; on the latter date a new type, C (fig. 135), was struck, with similar legends but differently shaped cartouches and of a significantly different weight.

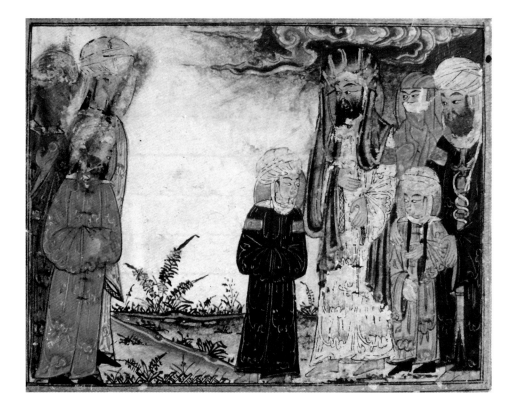

Fig. 136 (cat. no. 4). *The Day of Cursing,* from the *Kitab al-athar al-baqiya ʿan al-qurun al-khaliya* (Chronology of Ancient Nations), copied by Ibn al-Kutbi, northwestern Iran or northern Iraq, A.H. 707/ A.D. 1307–8. Fol. 161r; ink, colors, and gold on paper. Edinburgh University Library (MS Arab 161)

Sunni authority was restored by his amirs. Nonetheless, Öljeitü's conversion fore-shadowed the permanent conversion of Iran to Shiʿism two centuries later in Safavid times, when many Sufi orders rewrote their histories, transforming themselves from Sunni to Shiʿite.

The arts and architecture produced under the Ilkhanids reflect the diverse sec-tarian trends active in the early fourteenth century. The last two illustrations in al-Biruni's calendrical treatise copied in 1307 deal with major events dear to Shiʿites: the Day of Cursing, when Muhammad exchanged curses with the Christians of Najran and proclaimed Hasan and Husayn his heirs (fig. 136); and the investiture of ʿAli at Ghadir Khumm, when Muhammad instructed his followers to transfer their loyalty to ʿAli, invoking God's support for the friends of ʿAli and his vengeance on ʿAli's enemies (fig. 137). These are the finest and largest illustrations in the text; the investiture at Ghadir Khumm occupies more than three-quarters of its page. They also differ, in both style and iconography, from other illustrations in the manu-script, employing a brighter palette, larger figures, and more dramatic compositions and including detailed renditions of such elements as the Prophet's cloak and his braided hair.

Mosques

Öljeitü's conversion to Shiʿism is also documented by the finest sculptural achieve-ment of the age, the stupendous new mihrab added to the Friday Mosque at Isfahan (fig. 138). Some 20 feet high and 10 feet across, the stucco mihrab displays a set of

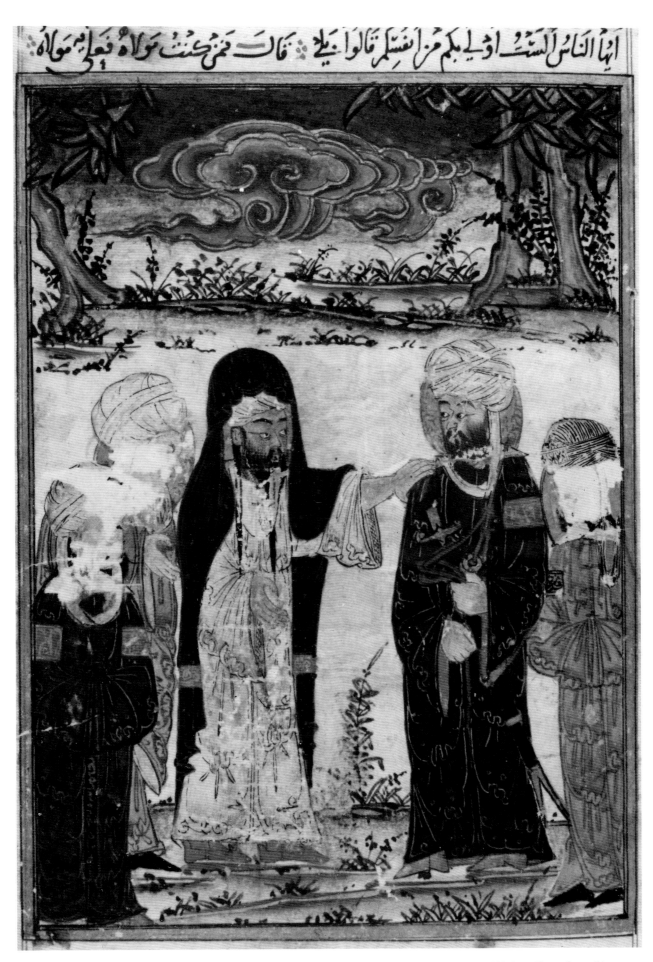

أيها الناس السنة أولى بكم من أنفسكم قالوا بلى قال فمن كنت مولاه فعلى مولاه

Fig. 137 (cat. no. 4). *The Investiture of ʿAli at Ghadir Khumm,* from the *Kitab al-athar al-baqiya ʿan al-qurun al-khaliya* (Chronology of Ancient Nations), copied by Ibn al-Kutbi, northwestern Iran or northern Iraq, A.H. 707/A.D. 1307–8. Fol. 162r; ink, colors, and gold on paper. Edinburgh University Library (MS Arab 161)

51. Berchem 1909; Hunarfar 1977.
52. Rashid al-Din 1998, p. 743.
53. Paone 1981.

concentric niches within rectangular frames. Each area is elaborately worked in a distinct pattern carved to several depths; grounds of intricate floral design support arabesque scrolls with inscriptions in different styles of angular and round script. The texts extol the virtues of Shiʿism and the traditions of ʿAli and carry the date Safar 710 (June–July 1310), just months after Öljeitü's official conversion to Shiʿism.[51] The mihrab was evidently commissioned to counter religious dissension in this traditionally Sunni city, where rioting is said to have broken out upon news of the ruler's decision to convert.

After Ghazan's conversion to Islam he had ordered the construction of baths and mosques in all towns of the realm; the profits from the bath were to be used to support the upkeep of the mosque.[52] Since most of the Iranian population was Muslim before Ghazan's conversion, major cities already had large congregational mosques that were simply restored or rebuilt under the Ilkhanids, as at Isfahan and Ardabil. New mosques were added in rural areas opened up for cultivation and colonization, such as the Isfahan oasis, where mosques were built or restored to the southeast of the city at Dashti, Kaj, Aziran, and perhaps as far down the Ziyanda River as Barsiyan.[53]

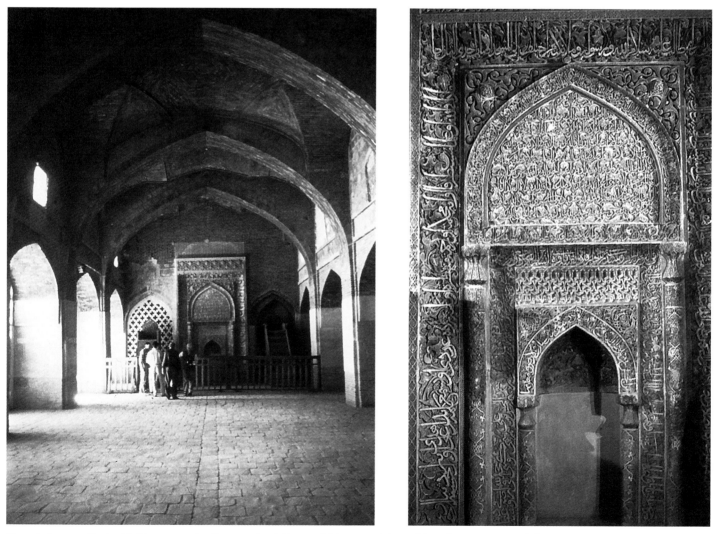

Fig. 138. Stucco mihrab added in 1310 to the Congregational Mosque, Isfahan, to celebrate Öljeitü's conversion to Shiʿism; two views

Ilkhanid congregational mosques vary in material, plan, and form.[54] Though a few in the northwest are built of stone and have horizontal beams (for example, at Asnak, 1332–33),[55] most are constructed of brick, with vaults and arches. Smaller mosques consist of a single domed chamber (Kaj, Dashti, and Aziran, all ca. 1325). Larger mosques are usually composed of iwans, ranging in number from one (mosque of ʿAlishah, Tabriz, early fourteenth century) or two (Ashtarjan, 1315–16) to four (Hafshuya, early fourteenth century; Friday Mosque at Kirman, 1349). The most stunning of them is the mammoth single-iwan mosque of ʿAlishah at Tabriz, which epitomizes the gargantuan scale of Ilkhanid architecture. The vaulted iwan was designed to outshine the great arched palace of the Sasanian kings at Ctesiphon, then still standing outside Baghdad, the Ilkhanids' winter capital.[56]

Some mosques built in the Ilkhanid period were variations of the standard four-iwan plan. This classic Iranian mosque plan, in which four iwans are arranged around a central courtyard with the largest iwan leading to a domed room containing the mihrab, is best exemplified in the Friday Mosque at Veramin just south of Tehran.[57] According to the foundation inscription around the qibla iwan (the iwan pointing toward Mecca), the mosque was commissioned in 722 (1322–23) by Muhammad ibn Muhammad ibn Mansur al-Quhadi through the efforts of his son and pious successor Hasan. Another large inscription around the dome chamber gives the date 726 (1325–26), so construction must have taken at least four years.[58] A small inscription in a side aisle identifies the building as the work of ʿAli Qazvini. The patrons were probably members of a family from the nearby village of Quhad that was prominent in the Ilkhanid administration. The amir ʿIzz al-Din Quhadi, for example, served as vizier under Öljeitü.[59]

The mosque at Veramin may have been intended for Shiʿites. In about 1340 the Ilkhanid accountant Hamd Allah Mustaufi Qazvini reported that Veramin was noted for its population of Twelver Shiʿites (the largest Shiʿite sect),[60] and several shrines to the descendants of ʿAli were built or rebuilt in the town during Ilkhanid times. One of these, the Imamzada Yahya (the tomb for a descendant of ʿAli named Yahya), was extensively decorated with luster tiles. A dado composed of star and cross tiles with geometric, floral, or arabesque designs carries the date 660–61 (1262), and a large mihrab signed by ʿAli ibn Muhammad ibn Abi Tahir is dated 663 (1264).[61] In 1307 the tomb was redecorated, and a new luster cenotaph, signed and dated 10 Muharram 705 (August 3, 1305), was added.[62] A second Shiʿite shrine in Veramin was the tomb tower for ʿAlaʾ al-Din Murtada ibn Fakhr al-Din al-Hasan al-Varamini (d. 1276), completed in 1289.[63] An additional small mosque or shrine was built in 1307.[64] Pious inscriptions on the Friday Mosque—not only the name of ʿAli on the end-plugs between the bricks, but also an invocation to his sons Hasan and Husayn, written prominently in square Kufic above the main doorway—attest to the veneration of the Prophet's family in the town.

The inscription around the dome chamber in the mosque at Veramin (fig. 139) illustrates some of the problems associated with interpreting texts during this period of religious splintering and syncretism. A large band, over 30 inches high, contains a curious Koranic text, the first seven verses of sura 62. The text opens with four verses glorifying God, who sent a messenger with signs to instruct

54. Wilber 1969. Most of the buildings mentioned in this essay are catalogued there; the notes here refer only to subsequent publications.

55. O'Kane 1979.

56. Hamd Allah Mustaufi Qazvini 1958, p. 87, mentions the enormous (250 x 200 gaz) courtyard of the mosque of ʿAlishah and states that the iwan is bigger than the arch of Khusrau at Madaʾin (Ctesiphon). See also O'Kane 1996.

57. Wilber 1969, no. 64.

58. Krachkovskaia 1931 is the most complete publication of the inscriptions; the dated ones are repeated in Combe, Sauvaget, and Wiet 1931, nos. 5478, 5536.

59. According to Kashani 1970, pp. 136, 154, 195, ʿIzz al-Din Quhadi was appointed vizier in charge of tamgha on 3 Rabiʿ I 712 (July 9, 1312), governor of Fars on 25 Shawwal 713 (February 12, 1314), and assistant to the chief vizier Taj al-Din ʿAlishah when he split the vizierate with Rashid al-Din in 715 (1315–16).

60. Hamd Allah Mustaufi Qazvini 1958, p. 59.

61. Wilber 1969, no. 11; O. Watson 1985, App. III, no. 27, has collected over 150 examples of the dado tiles from some 24 collections, including V&A 1837–1876. The mihrab, once in the Kevorkian Collection and now in the Doris Duke Collection, is App. III, no. 29.

62. The tomb redecoration was done by Abu Muhammad Hasan ibn Murtada ibn al-Hasan ibn Muhammad ibn Hasan ibn Abi Zayd; the cenotaph is signed by ʿAli ibn Ahmad ibn ʿAli al-Husayni and Yusuf ibn ʿAli ibn Muhammad. The stucco inscription is given in Combe, Sauvaget, and Wiet 1931, no. 5222; the mihrab in the Hermitage is mentioned in O. Watson 1985, App. III, no. 98. The date 10 Muharram holds special significance for Shiʿites: it marks the martyrdom of the Prophet's grandson Husayn outside Kufa in 680.

63. Combe, Sauvaget, and Wiet 1931, no. 4912; Wilber 1969, no. 21.

64. Wilber 1969, no. 42.

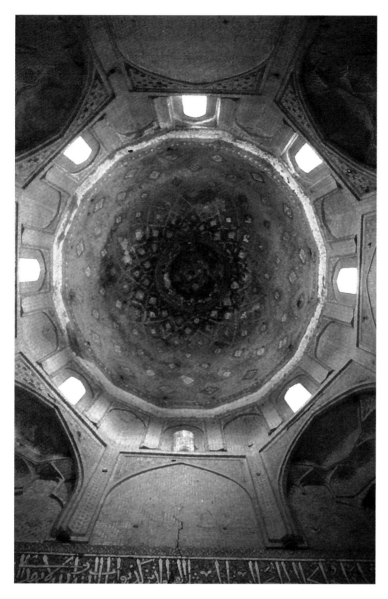

Fig. 139. View upward in the dome chamber, Congregational Mosque, Veramin, 1320s

mankind and confer benefits upon them as part of his bounty, which he bestows on whomever he wills. This relatively standard passage about God's power is followed by three more unusual verses that compare Jews loaded with the Torah to an ass (*himar*) carrying books and state that God does not guide evildoers.

It is not clear why this particular text was chosen for this location, although various explanations can be proposed. The opening verses about God's power also occur in the stucco inscription dated 707 (1307) that runs around the Imamzada Yahya, and the text there may simply have been repeated in this nearby congregational mosque, with the extra verses about Jews added to fill the space. This seems unlikely, however, as stucco carvers in the Ilkhanid period were experts at spacing their inscriptions and choosing appropriate texts. The Koranic text on the portal to the dome chamber in the Friday Mosque contains the last three verses of the sura (9–11) along with an altogether appropriate text about Friday prayer. Thus the inscriptions connected with the dome chamber might be read as together containing the whole sura, but this explanation is also insufficient because it presupposes that the stucco carver unconsciously omitted verse 8. V. Krachkovskaia (see n. 58) suggested that the reference to Jews was connected with the conversion of several Jewish doctors to Islam during Ramadan 705 (March–April 1306). But given the two-decade gap between those events and the construction of the mosque, this idea too seems unlikely. Another possibility is that the text was chosen because it contains a pun on the word *ass,* since the village of Quhad, the hometown of the mosque's patron, was sometimes called Quhad of the Asses (Quhad-i Kharran), either to distinguish it from a nearby Quhad of the Water (Quhad-i Ma'i) or because living there were many adherents of the Hanifi school of law.[65] This explanation, which depends on punning in two languages—Arabic in the Koranic text, Persian for the village names—is once again difficult to accept. Finally, the verses may simply have been chosen to please a Shi'ite audience, for they contain the phrase "friends to God" (*awliya Allah*), a term interpreted by Shi'ites to designate their special relationship through 'Ali, who was God's friend (*wali allah*).

In many ways, mosque architecture of the Ilkhanid period represents the culmination of the style formulated under the Ilkhans' precedessors, the Seljuqs, rulers of Iran and Iraq from the mid-eleventh century to the end of the twelfth. The dome chamber at Veramin, for example, repeats the classic elevation developed in Seljuq times: above the square chamber (33 feet wide) is an octagonal zone composed of four squinches alternating with four blind arches, which in turn supports a sixteen-sided zone, on which rests the hemispherical dome. The proportions of

65. The thirteenth-century geographer Yaqut gives the first explanation; the Ilkhanid accountant Hamd Allah Mustaufi Qazvini the second; Hamd Allah Mustaufi Qazvini 1958, pp. 58–59.

66. Rashid al-Din expressly mentions Sanjar's tomb as the most magnificent building in the world, which Ghazan himself had seen and used as the model for his own tomb. Rashid al-Din 1998, p. 685.

Ilkhanid architecture, however, are refined and attenuated compared with those of their Seljuq counterparts. Rooms are generally taller in relationship to their width; arches are pointed, struck from four centers, and crowned high, with a height greater than half their span. Iwans are correspondingly narrower and higher, and minarets are taller, often with several stories divided by balconies supported on *muqarnas* corbels. The courtyard, as at Veramin, is smaller in relation to the size and scale of the structure. Ilkhanid mosques also make fuller use of color, particularly in glazed tile. The portal at Veramin is covered with strapwork patterns in light and dark blue, and the dome chamber contains panels of tile mosaic worked in the same two colors. The extensive use of glazed tile and tile mosaic is what most visibly differentiates Ilkanid from Seljuq architecture.

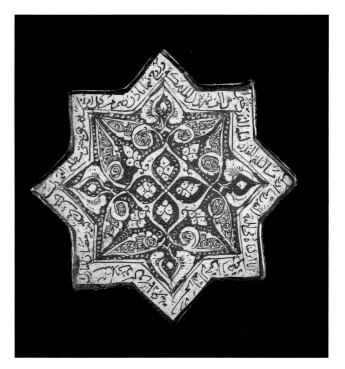

Tombs and Shrines

While Ilkhanid mosque architecture was conservative, Ilkhanid funerary architecture was innovative. Tomb chambers, large and domed, were meant to outdo the colossal tomb that the Seljuq sultan Sanjar had built for himself at Merv (see quotation at head of this chapter).[66] Tombs were integrated into complexes, which typically included a mosque, a madrasa, and other buildings clustered around the tomb itself. These were the precursors of the type of large, planned funerary complex, known as *külliye,* that was built by the Ottomans at Bursa and elsewhere beginning in the second half of the fourteenth century.

The tomb complexes sponsored by the Ilkhanid court, as one might expect, were the largest and finest of their time. The two outside Tabriz built for the ruler

Fig. 140 (cat. no. 79). Star tile, Iran (Kashan), A.H. Ramadan 663/A.D. June 1265. Fritware, overglaze luster-painted. Asian Art Museum of San Francisco, The Avery Brundage Collection (B60P2034)

Fig. 141. Tomb of Öljeitü at Sultaniyya, 1315–25

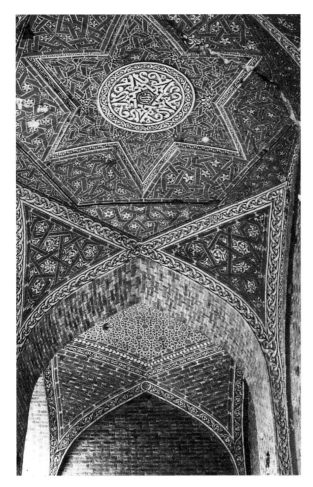

Fig. 142. Gallery vault in the tomb of Öljeitü, Sultaniyya, 1315–25

Ghazan and his vizier Rashid al-Din are known mainly from their endowment deeds,[67] but the tomb for Sultan Öljeitü survives at Sultaniyya (see fig. 141), although the surrounding lesser structures have disappeared.[68] The site, on the grassy plains between Tabriz and Qazvin, had been chosen by the Mongols for their capital, and the stunning tomb befits the name Sultaniyya, which means "imperial." The huge octagon, some 125 feet across, is crowned by an enormous dome more than 80 feet in diameter and 165 feet high and once ringed by eight minarets. Attached on the south is a rectangular hall measuring 50 by 65 feet. The monumental scale and sophisticated handling of space, notably the inter-penetration of volumes and the superbly decorated vaults in the galleries (fig. 142), place the tomb among the masterpieces of world architecture. Its builder was able to realize the sultan's desire for monumentality with sophistication and grace. The building remained the prototype for impe-rial tombs built by the Mongols for centuries, down to the Taj Mahal.

The interior of Öljeitü's tomb is sadly worn.[69] Originally deco-rated in tile (figs. 143, 144) and plaster, it was redecorated with painted plaster soon after its dedication in 1313. Above the strapwork dado, once-majestic inscriptions in white against a blue ground frame the interior iwans. The soffits are stuccoed with shallowly molded bands of ornament that were then painted and gilded. An enormous inscription rings the dome, which is also studded with huge ogival medallions of stucco shaped over bases of coarse cloth stiffened with glue or size. The upper galleries had low balustrades of wood or mar-ble; the windows were once fitted with bronze grilles ornamented at the juncture of the bars with bronze knobs and balls inlaid with gold

Fig. 143 (cat. no. 121). Section of a tile frieze, from the tomb of Öljeitü, Iran (Sultaniyya), 1307–13. Earthenware, glazed, cut and assembled as a mosaic. Los Angeles County Museum of Art, The Madina Collection of Islamic Art, Gift of Camilla Chandler Frost (M 2002.1.344)

Fig. 144 (cat. no. 122). Quadrangular tile, from the tomb of Öljeitü, Iran (Sultaniyya), 1307–13. Earthenware, underglaze painted. Private collection

Fig. 145 (cat. no. 171). Element from a window grille with scene of falconing, western Iran, early 14th century. Brass, inlaid with silver, gold, and a black compound. Keir Collection, England (132)

Fig. 146 (cat. no. 167). Talismanic plaque with Sufi inscription, Iran, 14th century. Bronze. The David Collection, Copenhagen (7/1996)

and silver. A few surviving specimens of these are inscribed with the name of the patron;[70] slightly smaller examples with a mounted horseman (fig. 145) must have been made for similar monuments. Many of the decorative designs in the tomb, particularly those in the galleries, recall contemporary book illumination, suggesting that in this period designers worked from pattern books and that patterns common to a number of media were executed by specialists in each.

Sufi orders played a crucial role in the religious affairs of the period (fig. 146). The two most important orders were the Suhravardiyya and the Kubraviyya, but there were many others, notably the Kazaruniyya, which gained such wealth from commerce that it was able to mint coins at the main shrine center outside Shiraz.[71] Sufi shaikhs (scholars or religious leaders) were responsible for the Ilkhanids' conversion to Islam, and members of court often belonged to these mystical orders.[72]

The type of wandering (Sufi) dervish known as a *qalandar* became widespread at this time. One of the most famous was Baraq Baba (d. 1307), a crypto-shamanic Anatolian Turkman who was close to the Mongol rulers Ghazan and Öljeitü, even serving as their official ambassador and possibly spy.[73] He was renowned for his outlandish appearance, which recalls that of a Mongol shaman: he usually went around filthy and naked except for a red loincloth, a felt turban with cow horns, and an assortment of bones and bells around his neck, to which he danced in imitation of bears and monkeys. A commentary on his writings written some fifty years after his death suggests that there was no clear line of demarcation between his type of crypto-shamanic Sufism and its more orthodox counterpart.

67. The abridged text of these is given in Rashid al-Din 1998, pp. 685–88; on the Rabʿ-i Rashidi (Rashid's quarter), see Blair 1984.
68. Blair 1986c.
69. Sims 1982.
70. A. U. Pope and Ackerman 1938–77, pl. 1357A.
71. Blair 1982a. For a biography of one of the members, Shaikh Amin al-Din Balyani, see Aigle 1997b.
72. There is a vast and growing literature on the subject of Sufism under the Mongols. On the role of Sufis in conversion, see DeWeese 1994; Melville 1990b.
73. Algar 1989; on *qalandar*s and popular religion in the Ilkhanid period, see Gronke 1997.

Fig. 147. Tomb of the dervish Baraq Baba at Sultaniyya, ca. 1310, with the ruins of an adjacent hospice added in 1333; two views

Funerary complexes like those built for Ilkhanid rulers and viziers were also created for Sufi shaikhs, both living and dead. Lisa Golombek nicknamed these complexes "little cities of God."[74] The finest to survive from the Ilkhanid period surround the graves of Bayazid Bastami at Bastam, the Suhravardi shaikh ʿAbd al-Samad at Natanz, Shaikh Safi at Ardabil, Shaikh Jam at Turbat-i Jam, and Pir-i Bakran at Linjan. In plan these Sufi shrines are generally additive and rather haphazardly arranged, as they were built over extended periods and often incorporated earlier structures on the site. A typical example includes iwans and some sort of monumentalization of the grave, either a tomb tower or an elevated fenced-in plot known as a *hazira*. The continued sanctity of these shrines may be the reason they have survived in better condition than similar tomb complexes for rulers and their courtiers.

Members of the Ilkhanid court often underwrote the major components of these Sufi shrines. Sultan Öljeitü commissioned some of the restorations at the shrine of Bayazid Bastami, including its flanged tower, which was intended as a tomb for the sultan's son.[75] Öljeitü's vizier Zain al-Din Mastari sponsored the construction of the buildings in the tomb complex for ʿAbd al-Samad in the first decade of the fourteenth century.[76] Öljeitü ordered a tomb built for Baraq Baba at Sultaniyya in about 1310 and assigned a daily stipend of fifty dinars for his followers there. Despite that shaikh's bizarre attributes and behavior, the tomb is a typical octagonal tower (fig. 147) and served as the model for one built in Isfahan in 1325 to honor the grave of the Imamzada Jaʿfar, a prominent Shiʿite. A *khanaqa* (hospice for Sufis) was added to the site of Baraq Baba's tomb in 1333. His influence lasted for generations; his successors in Anatolia had ties to the Ottoman court.[77]

Women were also patrons of Sufi shrines. Fars Malik Khatun, daughter of Mahmudshah (d. 1336), the governor of Fars province and founder of the Inju dynasty there, had a tomb complex built over the grave of the local Suhravardi saint Najib al-Din ʿAbd ibn Buzghush. He had been a disciple of Shihab al-Din ʿUmar al-Suhravardi (d. 1191), founder of the Suhravardiyya, a Sufi order that combined mysticism and philosophy.[78]

74. Golombek 1974.
75. Blair 1982b; Hillenbrand 1982.
76. Blair 1986a.
77. Baraq Baba's tomb tower, commonly known as the tomb of Chelebi Oghlu, and the adjacent complex are illustrated in Wilber 1969, no. 80. For identification and dating, see Blair 1986c, p. 142.
78. On Najib al-Din ʿAli ibn Buzghush, see Trimingham 1971, p. 5.
79. Spuler 1985; Lambton 1988; Soudavar 1992.

Women's capacity to be patrons of religious art reflects their political importance in Ilkhanid times, particularly in southern Iran. Abesh Khatun (ca. 1260–1286), enthroned at age four as Salghurid ruler of Fars, had the right to strike coins in her own name (fig. 43), making her the first female officially to reign over Persian territory in Islamic times. She married Hülegü's son Tash Möngke; her status as Chinghizid princess by marriage enabled her to escape persecution by the Ilkhan Arghun after her participation in an unsuccessful attempt to secure independence for the province

of Fars. Although Abesh was the last of the Salghurid line, her daughter Kordujin was later appointed governor of Fars under Abu Saʿid.[79] The role of women in day-to-day religious activities is harder to document; contemporary chronicles offer little on the subject. The upper story incorporated into many mosques built during this period (notably the congregational mosque at Yazd) has sometimes been interpreted as an area designated for women.

The tombs of Sufi saints were decorated with the finest materials money could buy. The tomb of ʿAbd al-Samad, a member of the Suhravardiyya, at Natanz is roofed with a stunning *muqarnas* vault (fig. 148), perhaps a reference to the *muqarnas* dome over the Baghdad tomb of the order's founder. The walls at Natanz were once revetted

Fig. 149 (cat. no. 114). Frieze tile with inscription of date, Natanz, Iran (Kashan), A.H. [Shawwa]l 707/A.D. March–April 1308. Fritware, overglaze luster-painted. The Metropolitan Museum of Art, New York, Gift of Emile Rey, 1912 (12.44)

Fig. 150 (cat. no. 115). Frieze tile with Koranic inscription, Natanz, Iran (Kashan), ca. 1308. Fritware, overglaze luster-painted. The Trustees of the British Museum, London (OA 1122)

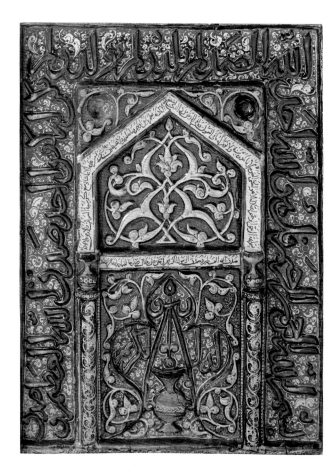

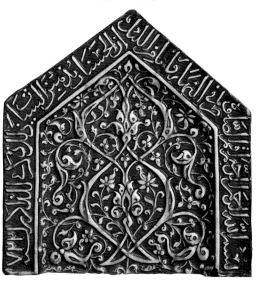

Fig. 151 (cat. no. 124). Mihrab tile, attributed to 'Ali ibn Ahmad ibn 'Ali Abi al-Husain, Iran (Kashan), early 14th century. Fritware, overglaze luster-painted. Victoria and Albert Museum, London (C1977-1910)

Fig. 152 (cat. no. 125). Tile from a mihrab, Iran, A.H. 722/A.D. 1322–23. Fritware, underglaze painted. The Metropolitan Museum of Art, New York, Gift of William Mandel, 1983 (1983.345)

with luster-glazed tiles, including those making up a dado of star and cross tiles surmounted by a frieze with inscriptions and birds. Many of these tiles, now dispersed in museums, are identifiable by their birds, whose heads have sometimes been defaced by a zealous iconoclast (figs. 149, 150). The mihrab in the tomb had an elaborate lusterware hood that clearly was specially crafted to fit the space. Its large size and three-dimensionality must have sometimes made the piece extremely difficult to fire.

A contemporary painting, *The Bier of Alexander* (fig. 153), gives us a good idea of the setting provided in these tombs for funerary services. Since elements in the painting correspond closely to surviving objects and to the description in the endowment for Rashid al-Din's tomb complex outside Tabriz, we can assume that this is an accurate, if generalized, depiction of real spaces and activities.[80] The scene is set in a room with a tiled dado and painted designs similar to those found in Öljeitü's tomb at Sultaniyya. In the center is the large wooden coffin, placed on a cenotaph. Aristotle weeps into his handkerchief, and Alexander's mother is prostrate with grief over the coffin. (Her figure, seen from the back like the chorus of veiled and wailing women in the foreground, is modeled on figures from contemporary Italian paintings.)

Four large candlesticks surround the bier; hanging lamps and incense burners are nearby. The arrangement matches the description of Rashid al-Din's tomb, which was to be lit by four hanging lamps and beeswax candles

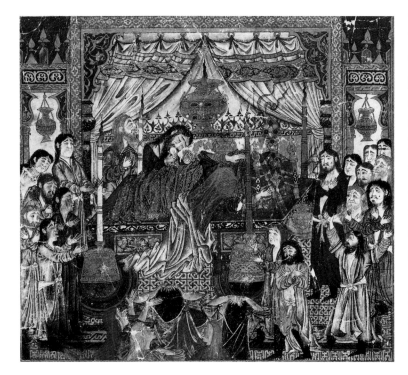

Fig. 153. *The Bier of Alexander,* from a page of the Great Mongol *Shahnama* (Book of Kings), probably Tabriz, 1330s. Ink and colors on paper. Freer Gallery of Art, Smithsonian Institution, Washington, D.C. (38.3-1)

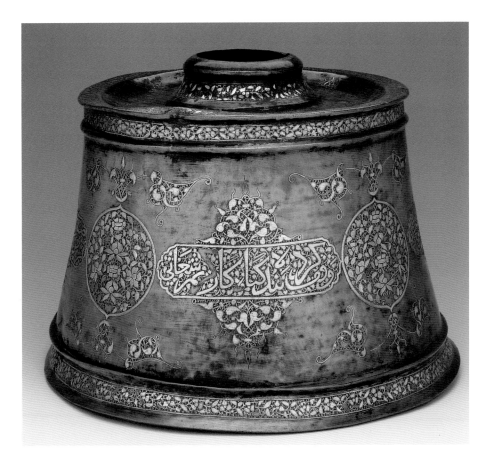

Fig. 154 (cat. no. 160). Candlestick, Iran, A.H. 708/A.D. 1308–9. Bronze, inlaid with silver. Museum of Fine Arts, Boston, Gift of Mrs. Edward Jackson Holmes (55.106)

in four large candlesticks, with incense perfuming the air. The candlesticks in the painting resemble the very large one that Öljeitü's vizier Karim al-Din Shughani presented to the shrine at Bastam in 1308–9 (fig. 154), of brass inlaid with silver and decorated with floral designs, cartouches, and a dedicatory inscription.[81] Candlesticks with inscriptions or geometric decoration were probably intended for mosques or tombs; similar candlestands with figural decoration (figs. 224, 228) may have been designed for household use.

The painting shows the cenotaph set on a carpet that has a repeating geometric field inside several borders of geometric designs or pseudo-Kufic letters. There is little with which to compare this image; only a few carpets survive from the period. Most are small animal carpets, which, to judge from contemporary paintings,[82] were designed to be set under thrones or in palaces. Cotton flat-weave (*zilu*) carpets with repeated niche designs (fig. 155) may have been intended for large congregational mosques, particularly in central Iran, where they are still produced and popular. So far, however, we know of no examples of the type of tomb carpet seen in the painting.

Manuscripts

Tombs were the setting for Koran recitation and prayers. According to the endowment deed for Rashid al-Din's tomb, a trio of Koran readers took turns reading from small minbars (pulpits) set near the latticed screen connecting the

Fig. 155 (cat. no. 78). Fragment of a flat-weave prayer rug, Iran, early 14th century. Cotton, weft-faced compound tabby. State Hermitage Museum, Saint Petersburg (IR-2253)

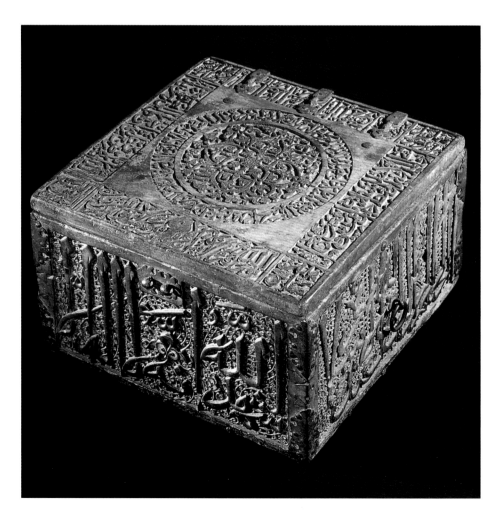

أمسكن عليكم واذكروا

أسم الله عليه واتقوا الله إن

الله سريع الحساب اليوم

أحل لكم الطيبات طعاما

الذين أوتوا الكتاب حل

Fig. 156 (cat. no. 65). Page from Öljeitü's
Mosul Koran, copied by ibn Zaid al-Husaini
'Ali ibn Muhammad, Iraq (Mosul), A.H. 706–11/
A.D. 1306–11. Ink, colors, and gold on paper.
The Trustees of the Chester Beatty Library,
Dublin (Is 1613.1, fol. 1v)

Fig. 157 (cat. no. 175). Koran box, made by Al-
Hasan ibn Qutlumak ibn Fakhr al-Din, north-
western Iran, A.H. shortly after mid-Rajab
745/A.D. November 1344. Carved, painted,
and assembled wood boards, bronze hinges. The
al-Sabah Collection, Dar al-Athar al-Islamiyyah,
Kuwait National Museum (LNS 35W)

80. Blair 1996.
81. See Melikian-Chirvani 1987.
82. See, for example, the scenes *Zahhak Enthroned*
 (Freer Gallery of Art, Washington, D.C., 23.5) and
 Faridun Going to Iraj's Palace (Arthur M. Sackler
 Gallery, Washington, D.C., S86.0100) from the
 Great Mongol *Shahnama*; Grabar and Blair 1980,
 nos. 1, 8. Ettinghausen 1959a.
83. On paper, see Bloom 2001.

tomb to the adjacent mosque. The reciters were to continue around
the clock and deliver special readings on holidays. Fittingly, Ilkhanid
patrons channeled much of their money into magnificent thirty-volume
copies of the Koran that were endowments to tombs and shrines.
Although illustrated manuscripts of the Ilkhanid period are the ones
most prized by scholars and collectors today, these monumental and
lavishly decorated (but unillustrated) copies of the Koran were
clearly the most important manuscripts in their own time (figs. 121,
158). The paper they are written on is some of the finest ever
produced; it was made in enormous sheets that were glazed and
polished to almost glassy perfection.[83] Most folios measure approxi-
mately 21 by 16 inches, but those of the whopping copy given to
Öljeitü's tomb at Sultaniyya are twice that size and fit descriptions
of so-called Baghdadi-size paper. More than two thousand enormous
Baghdadi-size sheets were required to make this extraordinary copy
of the Koran.

Equally fine is the calligraphy of these splendid works. Each page
typically has five lines of large script, written in a calligraphic style
that merges many features of the formal *muhaqqaq* with the more
curvilinear *thuluth*. The script is penned in gold or black ink, often
painstakingly outlined in ink of the other color (figs. 121, 156, 245).
The manuscripts were executed by the most famous calligraphers of

Fig. 158 (cat. no. 63). Right side of double-page frontispiece from the Anonymous Baghdad Koran, illuminated by Muhammad ibn Aybak ibn ʿAbdallah, Iraq (Baghdad), A.H. 701–7/A.D. 1302–8. Ink, colors, and gold on paper. The Trustees of the Chester Beatty Library, Dublin (Is 1614.2)

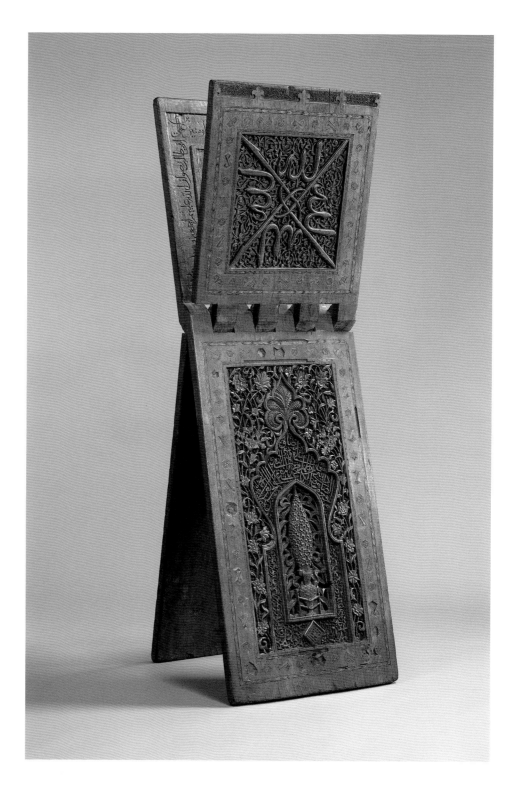

Fig. 159 (cat. no. 176). Koran stand, made by Hasan ibn Sulaiman al-Isfahani, Iran or Central Asia, A.H. Dhu al-Hijja 761/A.D. October–November 1360. Wood, carved and inlaid. The Metropolitan Museum of Art, New York, Rogers Fund, 1910 (10.218)

the day. One of these was Ahmad ibn al-Suhravardi (d. ca. 1331), known as Shaikhzada (son of the shaikh), who belonged to the family that supervised the Suhravardi *khanaqa* at Baghdad; there Ahmad became the leading calligrapher of his generation. Calligraphers worked on these Koran manuscripts in tandem with illuminators, and Ahmad ibn al-Suhravardi was paired with Muhammad ibn Aybak. The fact that both scribe and illuminator repeatedly signed their works attests to the status of these artists, who took as many as six years to complete a thirty-volume manuscript.

Women were among those who endowed their favorite shrines or their own tombs with lavish copies of the Koran. Tashi Khatun, wife of the Injuid Mahmudshah

and mother of his fourth son and ultimate successor, Abu Ishaq (r. 1343–53), gave such a work to the Shiʿite shrine of Ahmad ibn Musa al-Rida in Shiraz.[84] The manuscript shows that many of the traditions developed at the Ilkhanid capitals of Baghdad and Tabriz passed to the governors and successors of the Ilkhanids in Shiraz. Like its metropolitan counterparts, the Koran made for Tashi is transcribed on large sheets of half-Baghdadi-size paper with five lines of gold script per page. It too was produced by a team, the scribe Pir Yahya al-Sufi working with the illuminator Hamza ibn Muhammad al-ʿAlawi. However, the copies of the Koran produced in Shiraz and many other manuscripts made for the Injuids there are inferior to the manuscripts earlier produced at Baghdad and Tabriz. Although the calligraphy of the later manuscripts is good, the paper and pigments used are of poorer quality.

Tashi Khatun was not the only woman to commission a multipart manuscript of the Koran: Mahmudshah's daughter Fars Malik Khatun also did so (fig. 269). Smaller in size and with more lines to the page (seven) than that commissioned by Tashi, Fars Malik's copy of the Koran, despite its fine illumination, was a cheaper manuscript. According to the endowment deed, it was to be kept in her house until her death and then placed at the head of her tomb. Apparently the manuscript was still unfinished when Fars Malik died and was only completed some thirty years later; in 1375–76 it was given by the Muzaffarid vizier Turanshah to the Masjid-i ʿAtiq ("Old Mosque") in Shiraz.

While these glorious manuscripts of the Koran were the acme of Ilkhanid religious art, many of their features are also found (as with innovations of Ilkhanid religious architecture) in secular arts of the period. The large sheets of fine paper used for exquisite calligraphy and illumination also provided a smooth, expansive surface for painters, who consequently refocused their attention from pottery to paper. It is true that many of the secular manuscripts are on mediocre paper, but one of the first illustrated manuscripts to survive from the period, a copy of the Shiʿite encyclopedia *Rasaʾil ikhwan al-safaʾ* transcribed in Baghdad in 1287, has a stunning double-page frontispiece executed in glowing colors on extraordinarily fine polished paper.[85] Greater use of paper also gave artists a way to transfer designs from one medium to another, allowing motifs produced for book decoration to be used on glazed tiles, painted plaster, and carpets. Designs on the gallery vaults at Sultaniyya, for example, share many features with the geometric patterns decorating frontispieces of Koran manuscripts. The religious arts of the Ilkhanid period reflect the varieties of patronage and the vast range of media and techniques available at this time of extraordinary cross-continental interchange. The great achievements of Ilkhanid religious art, whether monumental mosques and tombs or exquisitely calligraphed manuscripts of the Koran, provided inspiration to artists both within Iran and beyond it for centuries to come, and their transcendent beauties still speak to us today.

84. Pars Museum, Shiraz (456); James 1988, no. 69. Ahmad, the son of the seventh imam, is commonly known as Shah-i Chiragh.

85. Ettinghausen 1962; Simpson 1982b, pp. 93–94; Blair and Bloom 1994, pp. 24–25.

خرندند زاشوبه منداز نش	سکندند بدید ایشاد آتش	درونش زاز نفط کده شیاه	بکردون میزان اندر بیش شاه	شواروتن وبان افروختند	بیخ وبیش درنگ مادوخند
وزان جار کرکشت برداخته	شمه را کار شد ساخته	که دید شاهی از آهن شاه	ازاهن بکرد بداسب و نواز	ازامن سپای بکردون براند	بفرمود تازان فرون ازهزار
بفند کنان برجا جوی	خرورسوار وسپه زار زدوزی	بدیدان سوار وسپه راز دوز	جون کند سواران جنگی ماند	باسب وبنفط آتش اندرزدند	
نجنید ازان که آهنین سپاه	همه لشکرش ابهم برزد نه			اراتش برافرحت نفت اسپاه	

رزم ا سکندر بافور هندی و صورت اسبان و مرداز از آهن

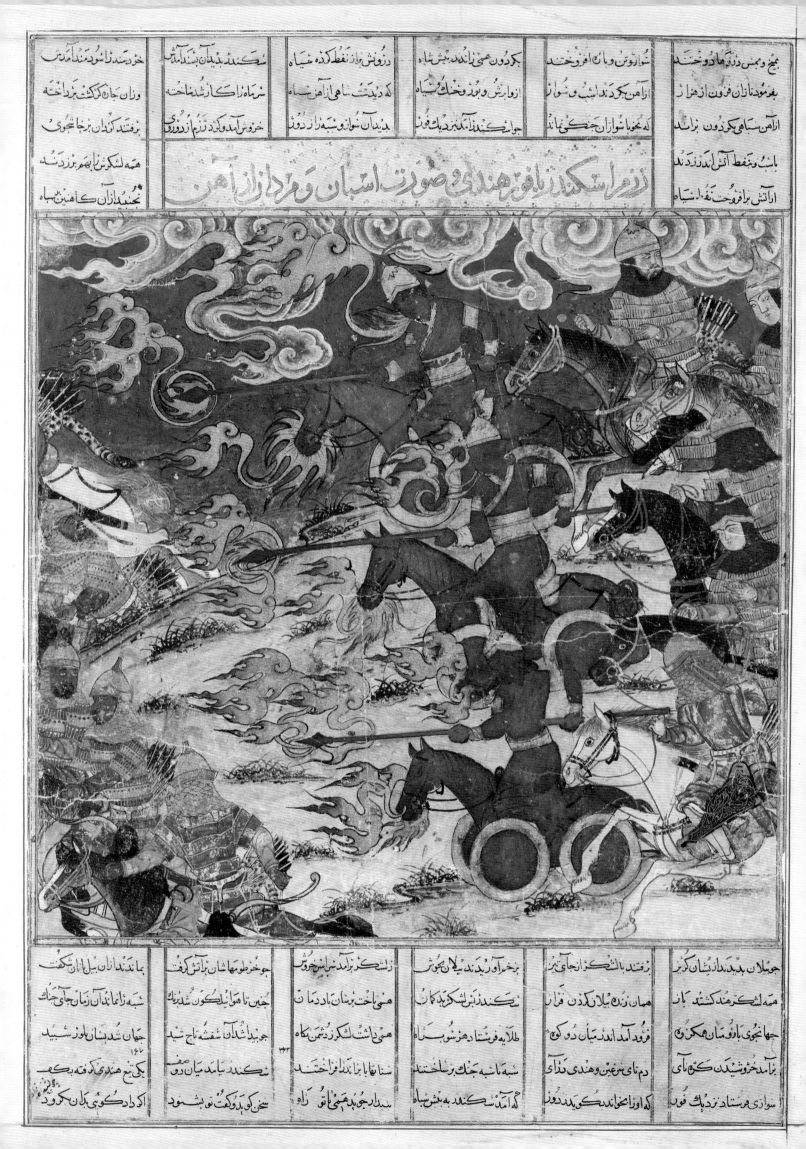

بماندند ازان بیل ازان شکست	جوخر طوعها شان براتش کفت	زاست کر براند نیان اندرخروش	بخرمرید رند نیلان بیوش	رفتند بالشکر دیشان کبیر	جیلان بدید ندا دیشان کبیر
شبه را ماندان زمان جای جنک	جین تا هماینکون شدینک	سکند زنیل شکردبداکار	همان زیں نیلان کردن فنار	همه لینکرمند کشته کبان	
جهان شد دیشان بلوز شبید	جوبید اشدان شفشه تاج شید	سوی داشت لشکر دشمن نگاه	طلای فتد اندراز هرسو بداه	فرود اندر میان دو کوی	جهان جوی بافو دیان مکن و
یکی نیج هندی که فتد بکه	سکند سام اندر دوز	سپها با با ازان جنگ برسلختند	سپه مانبه جنک برسلخت	دم نای برعین وهندی نژای	برامد خروشیدن کے کنای
اکرد کوی کلان نکرود	سخن کوی بد وکت تو بشنود	سپاران جوبد همی پا تو راه	آمد سکندی سوی یدشاه	لکه وراصغان اندکی بدآن	سواری برسناد ندزدک نوب

6

The Arts of the Book in Ilkhanid Iran *ROBERT HILLENBRAND*

*Then, the custom of portraiture flourished so in the lands of Cathay and the Franks until
sharp-penned Mercury scrivened the rescript of rule in the name of Sultan Abusaᶜid
Khudaybanda [i.e., until Sultan Abusaᶜid Khudaybanda came to the throne]. Master Ahmad
Musa, who was his father's pupil, lifted the veil from the face of depiction, and the [style of]
depiction that is now current was invented by him. Among the scenes by him that lighted on
the page of the world in the time of the aforementioned emperor, an* Abusaᶜidnama, *a* Kalila
u Dimna, *a* Miᶜrajnama *calligraphed by Mawlana Abdullah Sayrafi, and a* Tarikh-i
Chingizi *in beautiful script by an unknown hand were in the library of the late emperor
Sultan-Husayn Mirza.*

—Dust Muhammad, Preface to *The Bahram Mirza Album*[1]

To judge by what has survived, there can be no doubt that the luxurious decorated and illustrated books produced from about 1280 to about 1336 were, along with architecture, the principal achievement of the visual arts in Ilkhanid times. Ceramics and metalwork, which had developed so dramatically in technique, subject matter, and expressive range during the twelfth and early thirteenth centuries, failed to sustain quite the same momentum under the Ilkhans. Perhaps there was less call for them, which may reflect changes in the pattern of patronage, especially in mercantile circles, arising from the cataclysmic Mongol invasions. The massive loss of life in northern Iran and Khurasan would have greatly thinned the ranks of patrons[2] and also to some extent craftsmen,[3] causing a loss of continuity in technical expertise that could not readily have been rectified. Yet Abu al-Qasim Kashani's treatise on ceramic techniques, written about 1300;[4] such sumptuous new wares as *lajvardina;* and pictorially complex metalwork all indicate that these arts were still vibrant.

The sudden rise to prominence of book painting may stem in part from its capacity to carry more subtle messages than any other medium (fig. 161). Political developments are of direct relevance in this regard. The rapid conversion to Islam of the Mongol elite after 1295 had the most direct impact on the arts.[5] (Significantly, the year before, the death in China of Khubilai Khan, the supreme Mongol ruler, had given greater independence to the Mongols in Iran.) A building boom, concentrated on religious structures, was matched by a corresponding revival in the output of top-quality Korans. Of exceptionally large scale thanks to a special so-called Baghdadi paper, the finest then available,[6] these works also featured calligraphy and illumination of the highest possible standard. The new emphasis on massive scale continued in the field of book painting and also characterized several buildings ordered by the most exalted patrons in the land. Among these were the mosque of ᶜAlishah in Tabriz, the tomb of Öljeitü at Sultaniyya, and the mausoleum of Ghazan

1. *Muraqqaᶜ-yi Bahram Mirza. Dibacha-yi Dust
 Muhammad,* translated by Wheeler M. Thackston.
 Thackston 2001, pp. 12–13. I am very grateful to
 Sheila Blair and Linda Komaroff for taking the
 trouble to read my text carefully and to improve it
 with their astute and trenchant, but thoroughly
 helpful, criticism.
2. The subsequent economic collapse would also have
 been disastrous for the visual arts.
3. The Mongol practice of sparing and relocating
 artists (see Morris Rossabi's chapter 1, James
 Watt's chapter 3, and Linda Komaroff's chapter 7
 in this catalogue) must have reduced the death toll
 of artists and craftsmen but would still have
 removed them from the Iranian sphere.
4. Allan 1973.
5. Melville 1990b.
6. Bloom 2001, pp. 53, 62, 64, 70, 112, and p. 54,
 fig. 22; Loveday 2001, pp. 50, 59, 81.

Opposite: Fig. 160 (cat. no. 48). *Iskandar's Iron
Cavalry,* page from the Great Mongol *Shahnama*
(Book of Kings), Iran (probably Tabriz), 1330s.
Ink, colors, and gold on paper. Harvard
University Art Museums, Cambridge, Mass.,
Gift of Edward W. Forbes (1955.167)

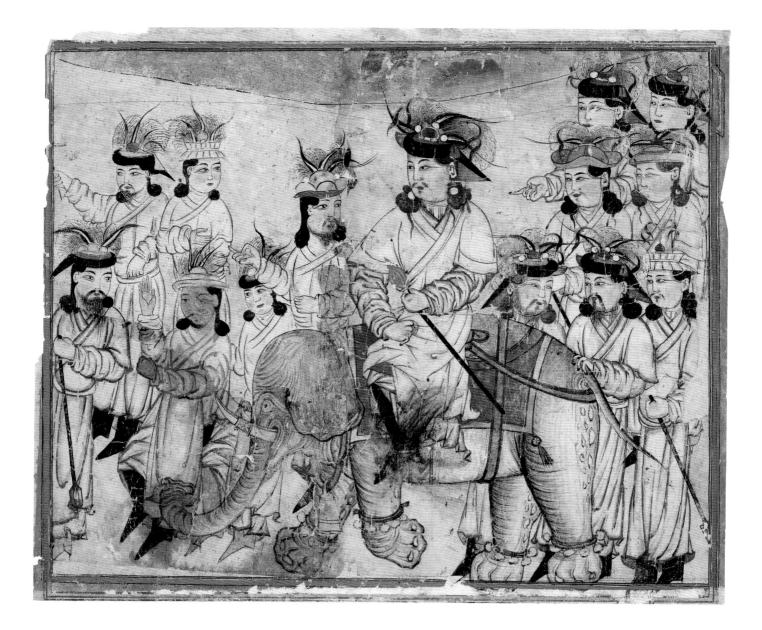

Fig. 161 (cat. no. 17). *Elephant and Rider,* illustration from the Diez Albums, Iran (possibly Tabriz), early 14th century. Ink, colors, and gold on paper. Staatsbibliothek zu Berlin— Preussischer Kulturbesitz, Orientabteilung (Diez A fol. 71, S. 56)

Khan himself,[7] whose liberal endowment paid for multiple copies of the Koran and also for regular readings from it, which gave the structure a religious function. Such high-profile emphasis on traditional Islamic piety found a somewhat less traditional counterpart in the creation of multiple images of the prophet Muhammad and narrative scenes from his life. Other gestures of ostentatious piety among the Mongol elite included building mosques and charitable institutions for the poor, honoring holy men, wearing Sufi garb, undertaking the *chilla* (a forty-day ascetic retreat), visiting popular shrines, and ordering public Koran readings. Ghazan Khan did all of these things.[8]

THE RISE OF BOOK PAINTING

A crucial side effect of the very public Mongol conversion, and of the Ilkhans' desire to draw propaganda capital from it, was a sudden surge in the production of manuscripts, made possible by the development on a grand scale of all the expensive facilities required to sustain such production. Papermaking factories were obviously the

7. O'Kane 1996, pp. 506–10.
8. Bausani 1968, pp. 542–43; Boyle 1968b, pp. 389, 393, 395; Melville 1990b, pp. 163, 168. He may also have been the patron of one of the finest of Ilkhanid Korans; see James 1988, pp. 12, 78, 96, 235.

key element, and surviving Ilkhanid manuscripts document how wide-ranging were the size and quality of their output. However, calligraphers and workers in their ancillary trades—those who prepared the paper, pens, and ink, bookbinders and leatherworkers, illuminators and painters—also benefited from the new direction taken by royal and vizierial patronage. In fact, the extremely rapid development of book painting in this period can be seen as an unexpected by-product of calligraphy, which contemporary culture regarded as its principal art form. But it also represents a distinct change of direction in artistic priorities, and thus a redeployment of the artistic energies then available.

Why book painting? An answer is perhaps more likely to be found in the purpose of the newly commissioned volumes than in the medium itself. All these books had a closely focused aim: to assert and promote either religion or heritage. The needs of the first were met principally by Korans, but also by prestigiously produced volumes of *hadith* (sayings of the Prophet) and *tafsir* (commentaries on the Koran). Heritage was served by history books such as ʿAta Malik Juvaini's *Tarikh-i jahan-gusha* (History of the World Conqueror, fig. 201), Abu al-Fadl Muhammad Balʿami's translation of al-Tabari's *Taʾrikh al-rusul wa al-muluk* (Chronicle of Prophets and Kings), and of course Rashid al-Din's *Jamiʿ al-tavarikh* (Compendium of Chronicles, fig. 162), as well as by a flood of illustrated copies of the *Shahnama* (Book of Kings), the Persian national epic (fig. 163). In such works, the hitherto stubbornly alien rulers of Iran were expressing a new and public commitment to the religion and cultural heritage of the very lands that they themselves had devastated some two generations previously—and doing so with an urgency that suggested they were making up for lost time.

Fig. 162 (cat. no. 7). *Mountains between Tibet and India,* from the *Jamiʿ al-tavarikh* (Compendium of Chronicles) by Rashid al-Din, Iran (Tabriz), A.H. 714/A.D. 1314–15. Fol. 261r; ink, colors, and gold on paper. The Nasser D. Khalili Collection of Islamic Art, London (MSS 727)

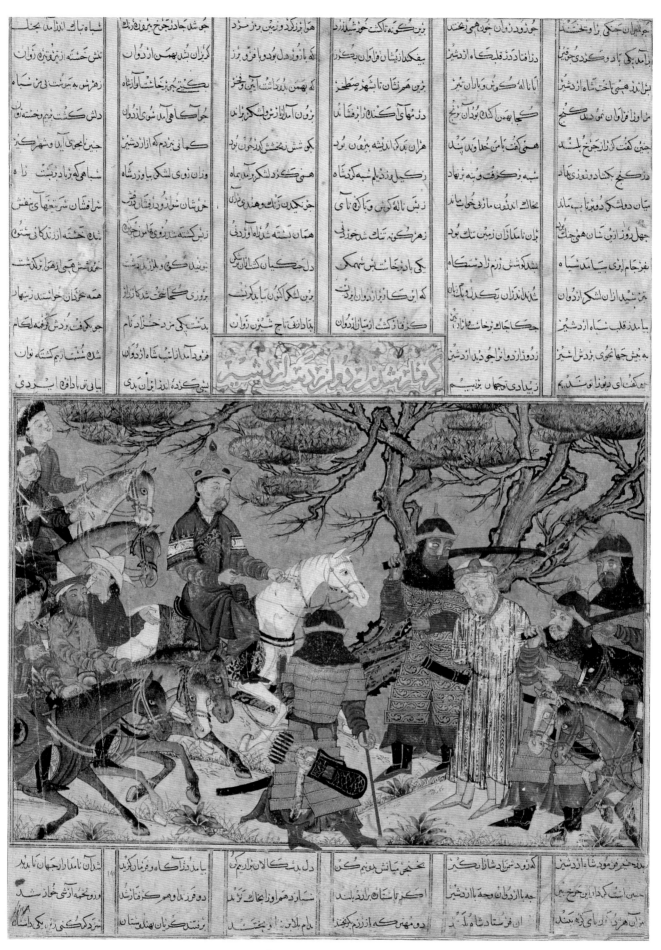

Fig. 163 (cat. no. 54). *Ardavan Captured by Ardashir,* page from the Great Mongol *Shahnama* (Book of Kings), Iran (probably Tabriz), 1330s. Ink, colors, and gold on paper. Arthur M. Sackler Gallery, Smithsonian Institution, Washington, D.C.; Purchase, Smithsonian Unrestricted Trust Funds, Smithsonian Collections Acquisition Program, and Dr. Arthur M. Sackler (S1986.103)

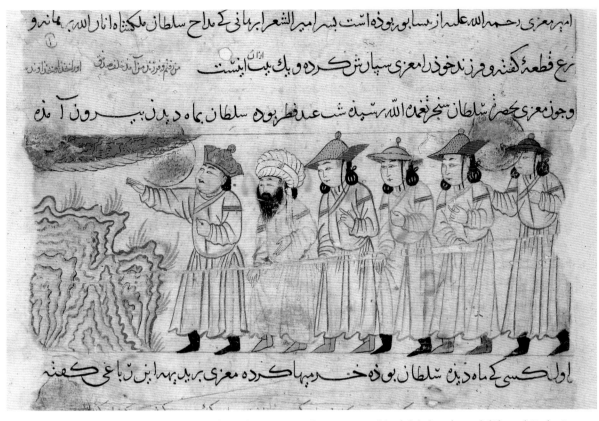

ا میر معزی رحمه الله علیه از رسا بوی بوده است بسر امیرالشعرا برهانی که مداح سلطان ملکشاه انار الله برهان و

رع فطعه ... گفته و مرزبند خوذ را معزی سپارش کرده و بك بیت اینست ... و رن و مرزبند خوذ را...

وجون معزی حصر سلطان سنجر رحمه الله ... بود در ن بیرون آ مدن

اول کسی که ماه دین سلطان بوذه خ دمهها کرده معزی برید بهها ابن دن باغی کشته

Fig. 164 (cat. no. 8). *Prince, Poet, and Courtiers,* from the *Anthology of Diwans,* copied by ʿAbd al-Muʾmin al-ʿAlawi al-Kashi, Iran (possibly Tabriz), A.H. 713–714/A.D. 1314–15. Fol. 1v; ink, colors, and gold on paper. The British Library, London (Manuscript 132)

THE EXTANT MANUSCRIPTS

Some three dozen illustrated manuscripts have survived in whole or in part from the Ilkhanid period. Clearly this amount of material allows for adequate study—enough to avoid skewed generalizations founded on too little evidence. It is possible to isolate significant trends while remaining alert to the remarkable variety of these manuscripts. Major centers of production can be identified, as can the most popular texts. But in order to make sense of what happened in this period, and to analyze how it relates to earlier and later production, a close, detailed focus on key manuscripts is required rather than brief and thus possibly superficial comments on all or most of them. This account therefore omits the various manuscripts of the *Kalila va Dimna* (a book of animal fables), none of which seem to be crucial to the argument;[9] the fascinating scientific anthology *Muʾnis al-ahrar* with its highly individual illustrations and precious evidence that a school of book painting flourished at Isfahan (fig. 261);[10] and other books on star lore,[11] cosmography (fig. 258),[12] history,[13] and ethics, several of them with a secure or at least likely Iraqi provenance.

The range of texts chosen for illustration in Iran during the Ilkhanid period is much wider than that of earlier Arab painting. In addition to the subject matter just cited, there are bestiaries, fables, epics,

Fig. 165. *Sultan, Poet, and Courtiers,* from the *Anthology of Diwans,* copied by ʿAbd al-Muʾmin al-ʿAlawi al-Kashi, Iran (possibly Tabriz), A.H. 713–714/A.D. 1314–15. Fol. 88v; ink, colors, and gold on paper. The British Library, London (Manuscript 132)

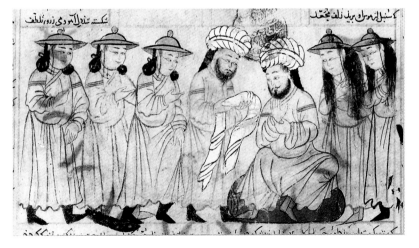

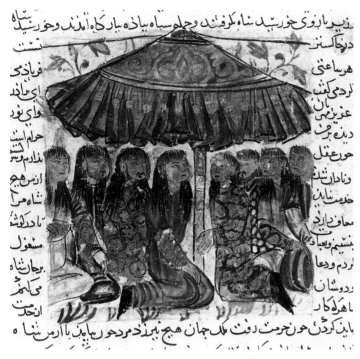

وزیر بابوتی خورشید شاه گرفتند وحلمه شاه بیاده بیاده آمدند وخورشید

درخاستند

هرساعتی

فریادی

کردند کیش

غنریمی

دین بر

حلم است

خور عقل

مقادم ورد

وبادار تم

ازبهیخ

خدمت شاید

شاه موا

معاون ایزد

دادکوش

بنسیم وبعبا

مشغول

لردم ودعا

بجان شاه

میکثم

ازدوشان

انحمت

ماهدکار

بایدکردن حون حومت دقت ملک جهان هیچ نبردزه مردجوان بااربمی شاه ه

Fig. 166 (above). Scene from the *Samak-i ʿayyar* (Samak the Knight-Errant)
by Sadaqa ibn Abu al-Qasim Shirazi, Iran, ca. 1330s. Fol. 217v; ink and colors
on paper. Bodleian Library, Oxford (MS Ouseley 379)

Fig. 167 (right). Page from the *Samak-i ʿayyar* (Samak the Knight-Errant) by Sadaqa
ibn Abu al-Qasim Shirazi, Iran, ca. 1330s. Fol. 257r; ink and colors on paper.
Bodleian Library, Oxford (MS Ouseley 380)

Fig. 168 (cat. no. 29). *Landscape,* illustration from the Diez Albums, Iran, 14th century.
Ink and colors on paper. Staatsbibliothek zu Berlin—Preussischer Kulturbesitz,
Orientabteilung (Diez A fol. 71, S. 10)

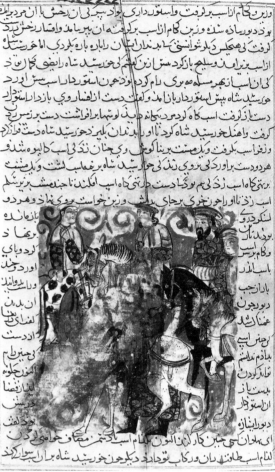

encyclopedias, works of philosophy, calendrical systems, lyric or panegyric poetry by various authors (figs. 164, 165), and even a prose romance (figs. 166, 167). This largely new material posed problems of illustration that could not be solved simply by reshuffling the standard iconographic components of earlier painting. Instead, it called for a fundamental reevaluation of the functions of illustrated books to keep abreast of the dramatic expansion in their subject matter. They became fashionable, collectible objects of high status, popular in many fields of learning and leisure, perhaps as a result of the educational function of several key manuscripts.

The variety of styles employed to illustrate this remarkable array of subjects is correspondingly wide, as is the range of centers at which the books were made. These styles were further enriched by borrowings from western Europe and from the Far East (fig. 168), and the latter in particular decisively broadened the pictorial (as distinct from the purely iconographic) repertoire. A readiness to experiment was, it seems, fostered by patrons who sought to use illustrated books for new purposes.

THE MORGAN BESTIARY

The sequence of key manuscript opens with a bestiary by Ibn Bakhtishuʿ, an ʿAbbasid court physician, that was originally written in Arabic and then translated into Persian as *Manafiʿ-i hayavan* (On the Usefulness of Animals). The Persian copy in the Pierpont Morgan Library, New York, was made in Maragha in 1297–98 or 1299–1300.[14] Though smaller (14 by 11 inches) than some of the other ambitious Ilkhanid manuscripts, it is typical of the school in its innovative approach to page layout, with illustrations big and small distributed throughout the available space and in different formats from page to page. The painters lift the depiction of living creatures out of the doldrums of stereotype and investigate the potential of naturalism, expressiveness, and even sheer fantasy.

In many images, this new interest in the depiction of specific rather than prototypical creatures goes hand in hand with an unprecedented awareness of the potential of landscape. This is an unmistakable response to Far Eastern works of art, although precisely what they were remains uncertain. Hence the Morgan Bestiary is an early but classic example of the Iranian encounter with Chinese art.[15] The impact of Chinese handscrolls can be sensed in the many pictures in which the frame abruptly terminates the scene, thereby forcing viewers to complete it in their imaginations.[16] Often enough, Chinese landscape features serve merely as a miniaturized decorative backdrop for the large-scale creatures occupying center stage, but they also occasionally suggest specific habitats, from misty mountain ranges to a bird's-eye view of a tropical island (fig. 169). The spatial relationships so integral to the types of Chinese art that inspired the Iranian artists (probably at one remove or more) are reversed, so that, for example, gigantic blossoms and birds contradict the proportions of the tree in which they are set.[17] Strong, assertive, clashing colors and powerful outlines replace the

9. For these, see the comprehensive monograph by Bernard O'Kane now in press; meanwhile, for the great Istanbul *Kalila va Dimna* and its context, see Cowen 1989.
10. Swietochowski and Carboni 1994, esp. pp. 8–66.
11. Carey 2001, p. 56.
12. Carboni 1992; see also Carboni 1988–89, pp. 15–31, and color pls. IV–VII.
13. Richard 1997, p. 41; Fitzherbert 2001.
14. Schmitz 1997, p. 11.
15. See Lorey 1935, an article that has worn surprisingly well.
16. The extension of the picture space by deliberately breaking the frame and thereby bringing it into "our" space is obviously a related device.
17. Linda Komaroff has pointed out to me that the landscapes depicted in Chinese textiles have many of the same spatial devices as those in Iranian painting. The Iranian artists thus obviously had media other than paintings before them.

وبرُود زنخابه که اندرنخابه از بعد سه دوز پدید آید و چه از سپیده خیزد و زردخورد و طعمه او باشد

اندر صورت سیمرغ

سیمرغ اندر دمار محیط باشد اندر جزیره ها بنزدیکی خط استوا و مردم بدانجای نشستند و هوای خوشردارد

Fig. 169 (cat. no. 2). *The Simurgh* (a mythical bird), from the *Manafiʿ-i hayavan* (On the Usefulness of Animals), copied by ʿAbd al-Hadi ibn Muhammad ibn Mahmud ibn Ibrahim al-Maraghi for Shams al-Din ibn Ziyaʾ al-Din al-Zushki, northwestern Iran (Maragha), A.H. 697 or 699/A.D. ca. 1297–1300. Fol. 55r; ink, colors, and gold on paper. The Pierpont Morgan Library, New York (MS M. 500)

restricted palette and deliberately ambiguous modeling of the putative Chinese originals, and thus their distinctive sense of illimitable space is lost. Rather than simply copying Chinese elements, then, the Iranian artists harnessed them to their own way of seeing. China was less a model than a catalyst.

The "Chronology of Ancient Nations"

That scientific manuscripts remained as popular in Ilkhanid times as in thirteenth-century Iraq is shown by the surviving manuscripts datable between 1275 and 1315. Along with two bestiaries, two cosmographies, and a book on the stars, there is the *Kitab al-athar al-baqiya* (Chronology of Ancient Nations) by the eleventh-century polymath Abu al-Rayhan al-Biruni, dated 707 (1307–8) and now in the Edinburgh University Library. Despite the rather forbidding nature of its contents—the calendrical systems of the known world, past and present, and their associated festivals—this lengthy, three-hundred-year-old text offers numerous if fleeting opportunities for illustration. The twenty-five illustrations of this copy present al-Biruni's text as a survey of the world's religions, true and false. The patron who ordered it made, while obviously sharing the author's fascination with other systems of belief, did not share his tolerance—or at any rate the painters commissioned to illustrate the book did not. An underlying charge of fervent sectarian belief can be detected throughout the cycle of illustrations; in particular, three of the five scenes depicting Muhammad have a markedly Shiʿite emphasis. Because of the wide-ranging scope of the text, entirely different subjects could have been chosen for illustration, and, by the same

Fig. 170 (cat. no. 4). *Muhammad Forbids Intercalation,* from the *Kitab al-athar al-baqiya ʿan al-qurun al-khaliya* (Chronology of Ancient Nations), copied by Ibn al-Kutbi, northwestern Iran or northern Iraq, A.H. 707/A.D. 1307–8. Fol. 6v; ink, colors, and gold on paper. Edinburgh University Library (MS. Arab 161)

Fig 171. *The Death of Eli,* from the *Kitab al-athar al-baqiya ʿan al-qurun al-khaliya* (Chronology of Ancient Nations), copied by Ibn al-Kutbi, northwestern Iran or northern Iraq, A.H. 707/ A.D. 1307–8. Fol. 133v; ink, colors, and gold on paper. Edinburgh University Library (MS. Arab 161)

token, the choices actually made must have been deliberate. Thus it is appropriate to look for evidence that the illustrations were an integrated cycle projecting specific ideas or at any rate to inquire what motivation lay behind the choices made.

Distinct emphases immediately assert themselves in the subject matter and placing of the pictures. The scenes involving the prophet Muhammad, for example, are strategically located at roughly the beginning of the book, on folios 6v (fig. 170), 10v; the middle, on folio 92r; and the end, on folios 161r, 162r—a symmetrical pattern of distribution that recalls the use of full-page illuminations at the beginning, middle, and end of Korans. This arrangement may have been intended as a means of sanctifying the entire book or at least of asserting the dominance of Islam amid so many other conflicting systems of belief. In the number of illustrations, too, Islam takes pride of place among the religions represented. Other marked attitudes detectable in the paintings are a hatred of heresy and freethinking, in both Islam and other faiths, and an interest in pre-Islamic Iranian beliefs and festivals.

The treatment of Buddhist, Judaic, and Christian images is particularly revealing. Special favor had been extended to these three faiths under the earlier Ilkhans, some of whom espoused Buddhism and Christianity; at that time all three faiths flourished as never before in Iran,[18] and Jews and Christians alike rose to high office. But the Mongol conversion to Islam was followed by state discrimination against, and even persecution of, other religions.[19] The razing of Buddhist temples, monasteries, and statues is referred to obliquely here in a painting of Abraham destroying the idols of the Sabians, which are anachronistically depicted with the shaven heads, ample bellies, cross-legged poses, mudras, and (in one case) gilded surfaces of Buddhist devotional images.

Judaism and Christianity, however, are approached in a somewhat more complex manner. Two images of Judaic content depict key moments in which God punished his chosen people by allowing foreigners to destroy or capture the symbols of his presence among them. The scene of Bukhtnassar (Nebuchadnezzar) overseeing the destruction by fire of Solomon's Temple in Jerusalem—here represented as the Dome of the Rock—records one of the great catastrophes of Jewish history, itself followed by the Babylonian exile. The other scene represents a disaster of comparable magnitude from the earlier era of the judges. The High Priest Eli, old, blind, and fat, falls back in shock, breaking his neck, as he hears the news that the Philistines have captured the Ark of the Covenant and that his two wicked sons have been killed (fig. 171).[20] When the images allocated to any given faith are so few, each carries a greater freight of meaning, and in this case the highlighting of two major disasters for the Jews could be interpreted as a sign of hostility on the part of the painter and perhaps also of his patron.

The treatment of Christian scenes reflects similar preoccupations, although here emphasis is secured by omission and commission alike. The omissions, in a text devoted to calendars and their associated festivals, are indeed striking. The central festivals of the Christian faith—Christmas, Good Friday, and Easter, normally rep-

18. Spuler 1955, pp. 198–249, gives a clear overall survey.
19. Bausani 1968, p. 542; Boyle 1968b, pp. 379–80; Melville 1990b, p. 170.
20. Eli's elaborately decorated chair subverts the standard format of an enthronement scene, while also suggesting a Torah shrine. For a brief discussion of this image, see Soucek 1975, pp. 141, 143.

resented by scenes of Christ's birth, Crucifixion, and Resurrection—are absent. The core of Christianity has, so to speak, been airbrushed out of the picture. Instead, the two images devoted to traditional Christian themes depict the Annunciation, an event alluded to in the Koran, and the Baptism of Christ— Nestorians believed that this was the moment when Jesus became divine. The latter is of course an event of central theological importance, but the artist has cleverly contrived to drain away its significance (while still ensuring that the scene is recognizable) by opting to illustrate not the Baptism itself but the moments after it. In thoroughly humdrum fashion John the Baptist helps Jesus to put on his coat, while the Savior's slippers float off downstream. Not surprisingly, the hand of God is absent, though related concepts were known to Islamic painters at the time;[21] the Holy Spirit, now metamorphosed into a bird of Chinese appearance, is not placed above Christ's head but in the middle distance to his right, thereby robbing this motif too of its traditional significance. In much the same spirit, Jesus is overlapped by Muhammad in the scene where they ride together, while on folio 161r (fig. 136) Muhammad triumphantly outfaces the Christians of Najran.

The stylistic hallmarks of these paintings are consistent: a preference for a strong graphic line, bright colors, and formulaic compositions involving single figures or tightly massed groups disposed serially along the frontal plane. The figures take up most of the space, with only intermittent attempts to develop a more sophisticated setting by means of Eastern landscape elements. Instead, the principal decorative accent is provided by obsessively convoluted drapery that seems to take on a life of its own and for which the closest parallels are in Byzantine rather than Islamic art. This feature suggests that the manuscript may have been produced in Mosul, with its preponderantly Christian population.

THE "COMPENDIUM OF CHRONICLES"

Nothing in earlier Islamic painting foreshadows the striking innovations found in the next major surviving manuscript, the *Compendium of Chronicles* of Rashid al-Din (1247–1318), the outstanding Ilkhanid vizier of his time. The earliest, though fragmentary, portion to survive is divided between the Edinburgh University Library and the Khalili Collection in London and is dated 714 (1314). The reasons for its importance have been laid out with exemplary clarity and scholarship by Sheila Blair in a series of pioneering publications.[22] The *Compendium* is indeed a phenomenon in itself, in which an ambitious concept was realized with remarkable discipline. Tabriz, the Ilkhanid capital, was perhaps the major metropolis of the contemporary world, a multicultural, multiconfessional, political, and commercial center that served as a bridge between Europe and East Asia. Rashid al-Din had the vision to capitalize on its unique advantages and to set in motion a colossal intellectual enterprise of which the *Compendium* was merely one facet. He founded a suburb, named Rabᶜ-i Rashidi after himself, that contained within a walled precinct his tomb, a hospice, a Sufi center, a hospital, and the so-called *rauda,* which had living and teaching accommodations plus a small mosque, arranged around a courtyard. The

21. See the image of Bahira and Muhammad in the *Compendium of Chronicles* of Rashid al-Din; D. T. Rice and Gray 1976, pl. 30.
22. Conveniently listed in Blair 1995, p. 121.

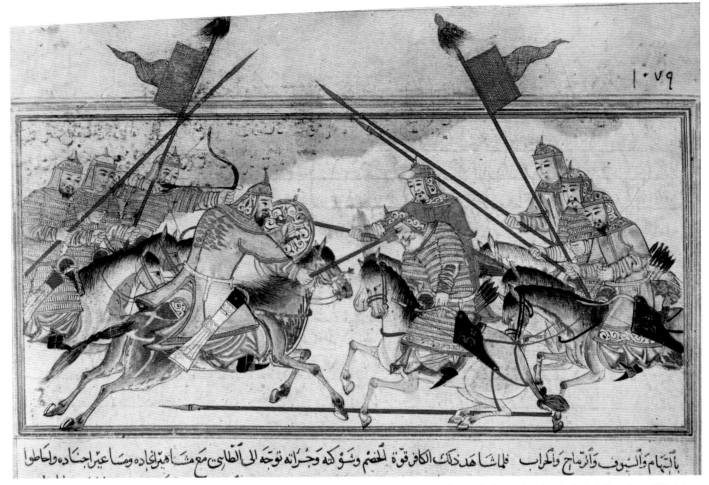

<div dir="rtl">

بِأَيتَهَامِ وَالسُّيُوفِ وَالرِّمَاحِ وَالْحِرَابِ فَلَمَّا شَاهَدَ ذَلِكَ الْكَافِرُ قُوَّةَ الْخَصْمِ وَشَوْكَتَهُ وَجَرَاءَتَهُ تَوَجَّهَ إِلَى الْأَطْرَافِ مَعَ مُشَاهِيرِ أَنْجَادِهِ وَمَسَاعِيرِ أَجْنَادِهِ وَأَحَاطُوا

</div>

Fig. 172 (cat. no. 6). *Mahmud of Ghazna's Conquest of India,* from the *Jamiᶜ al-tavarikh* (Compendium of Chronicles) by Rashid al-Din, Iran (Tabriz), ca. A.H. 714/A.D. 1314–15. Fol. 179v; ink, colors, and gold on paper. Edinburgh University Library (MS Arab 20)

23. Blair 1984, pp. 70, 74, 79. The inflated description (taken from the so-called Letters of Rashid al-Din) of the facilities that is so often quoted and is summarized by Wilber 1955, pp. 20–21, has been shown to be a Timurid forgery. See Morton 1999.

24. Boyle 1971b, p. 21.

25. For volume 2, see Blair 1995, p. 27. For volume 4, see Boyle 1971b, p. 21; Blair 1995, p. 115.

26. The severely trimmed original pages of the Edinburgh manuscript measure 17⅛ x 11⅝ inches. The estimated number of paintings excludes entirely formulaic images such as those of the Chinese emperors.

27. The Timurid versions of Rashid al-Din's text suggest, incidentally, that this section of his original work was indeed illustrated.

entire complex employed more than three hundred people,[23] and all its expenses were shouldered by Rashid al-Din himself. The detailed provisions of his endowment deed reveal the meticulous planning that underpinned the entire project.

The *Compendium* was commissioned successively by two Ilkhans, Ghazan (r. 1295–1304) and Öljeitü (r. 1304–16), and was nominally written by Rashid al-Din himself, though it is far more likely, given his onerous political and administrative responsibilities, that his major input was financial and editorial rather than authorial. In its final form, dating to about 1310,[24] it comprised a history of Ghazan Khan (volume 1), a universal history (volume 2) probably some four hundred folios in length, a survey of the genealogies of the Arabs, Jews, Mongols, Franks, and Chinese (volume 3), and a geographical compendium (volume 4).[25] The entire *Compendium* probably had no fewer than twelve hundred large-format folios and perhaps 540 paintings.[26]

What was the overall purpose of this work? The original commission makes sense as an attempt to display the Mongol commitment to Iran's cultural heritage, while also exalting the history of the Mongols themselves.[27] Those motives had obvious educational and propaganda dimensions that would be served (as well as contemporary technology allowed) by copying the text as widely as practicable. In addition, the exceptionally large size of the manuscripts made them well suited for display and even for study by several people at once.

Rashid al-Din's plan was to produce a copy, alternately in Arabic and Persian, every six months, not just of the *Compendium* but of each of his other six works, which dealt respectively with theology, philosophy, zoology, culture, industries, and architecture (four of them in several volumes).[28] It is worth considering in practical terms what is implied in executing such a colossal undertaking. After the initial translations had been done, an entire army of scribes, papermakers (there was a mill nearby),[29] burnishers, binders, leatherworkers, specialists in materials (inks, brushes, pigments, pens), and painters would have had to work in the closest harmony and under very tight supervision to achieve success. Moreover, they actually had less than six full months for the job, since this mountain of texts needed to be checked before being dispatched to the Arab or Persian city for which they were destined.

These highly unusual production circumstances strongly affected the nature of the illustrations. They made the development of a house style virtually mandatory. They encouraged speed at the expense of meticulous technique, and copying or adapting at the expense of originality.[30] Formulaic solutions were sought to the problems of composition, although the images still had to be impressive. To maintain the taxing production quotas, individual artists or groups of artists probably developed special time-saving skills for depicting particular subjects, such as landscapes, groups of almost identical figures, battle scenes (fig. 172), enthronements (fig. 173), or clothing; a given painting might therefore be subcontracted to several painters. The presence of certain extremely repetitive details suggests that the artists were working from painted prototypes that they subjected to successive minor modifications in order to avoid monotony.

Both the nature and the placement of the illustrations demand comment, and the two issues are intimately linked. The Edinburgh fragment, the most important one, will serve as our focus. A few singletons apart, its images can be easily divided into only four categories: scenes from the Old Testament, incidents from the life of the prophet Muhammad, battles or sieges, and enthronements. The images are by no means of equal interest visually: those in the first two categories are as varied as those in the last two are stereotypical. That distinction, which is quickly apparent, raises interesting questions about how the book was meant to be viewed, as distinct from being read.

Where the illustrations occur is no less interesting. In the Edinburgh fragment, the section on pre-Islamic Arabian prophets and Iranian mythical kings (which comes at the beginning of the manuscript in its present form) and that on the Old Testament are very lavishly illustrated. The opening folios are especially so, with images on both sides of successive folios and sometimes even two on a given side. Thus there are twenty-six illustrations in the first twenty-four folios. Suddenly, however, after folio 24r, this rapid rate of illustration falls off; the next illustration occurs at folio 34r, and the one after at folio 41r. At this point, the text takes a new direction as the section on the life of Muhammad

28. Blair 1995, p. 115.
29. Wilber 1955, p. 21.
30. This could explain some of the bunching discussed below, in which case it seems that speed of production counted for more than the visual consistency achieved by a steady rate of illustration.

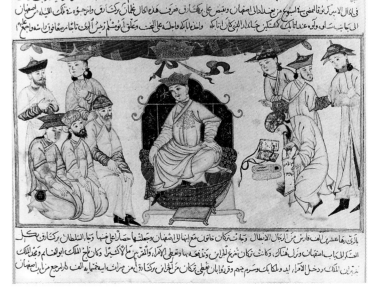

Fig. 173. *Sultan Berkyaruq ibn Malikshah* (r. 1093–1105), from the *Jami' al-tavarikh* (Compendium of Chronicles) by Rashid al-Din, Iran (Tabriz), A.H. 714/A.D. 1314–15. Fol. 187v; ink, colors, and gold on paper. Edinburgh University Library (MS Arab 20)

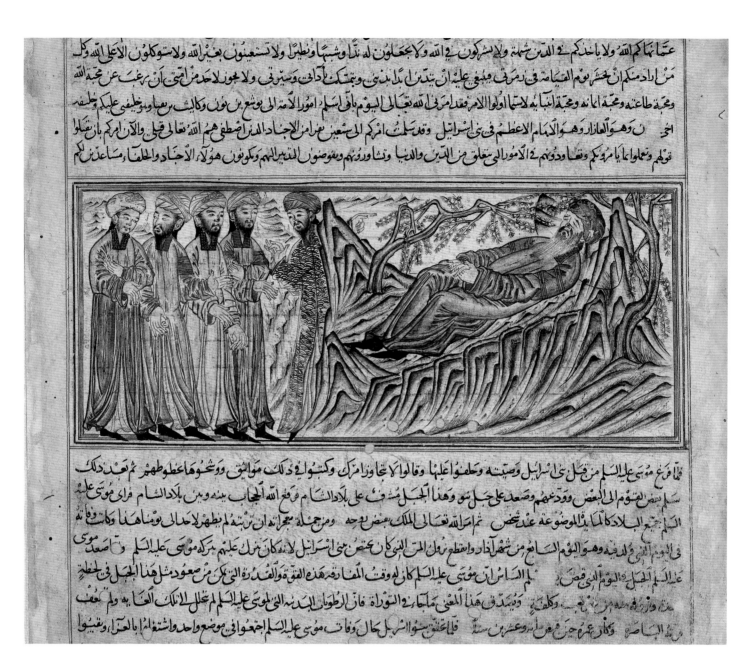

Fig. 174 (cat. no. 7). *The Death of Moses*, from the *Jami' al-tavarikh* (Compendium of Chronicles) by Rashid al-Din, Iran (Tabriz), A.H. 714/A.D. 1314–15. Fol. 294v; ink, colors, and gold on paper. The Nasser D. Khalili Collection of Islamic Art, London (MSS 727)

31. There are also imbalances in the coverage of the unillustrated sections. The portion on early Islamic history spans a period of well over three hundred years and fills fifty-seven folios, while that narrowly devoted to the eastern Islamic (i.e., Persian-speaking) world is substantially shorter (thirty-five folios) and covers a much smaller geographical area and a shorter period of time (some two hundred years). This very uneven approach to both text and illustrations implies a deliberate manipulation of emphasis. In that case, the process of production must have been much more complex than simple copying.

opens. Here again illustrations are relatively plentiful. After folio 57r there are no illustrations at all for the fifty-one folios of text covering the period of the Rightly Guided caliphs, the Umayyads, and the golden age of the 'Abbasids. Yet this is the most eventful and politically successful period of Islamic history up to the time of Rashid al-Din himself. The images begin again only when the text reaches the history of the eastern Iranian world from the late tenth century on—a period in which the Buyids, Samanids, Ghaznavids, and Seljuqs (to say nothing of lesser power blocs like the Simjurids and Qara-Khanids) were successively contending for mastery of these territories. Between folios 108 and 147 there are thirty-three pictures, a rate of illustration almost as intense as at the beginning of the manuscript.[31]

This bunching probably cannot be explained by regarding the Edinburgh fragment as part of an individualized copy intended for a city in eastern Iran. Nor does it seem plausible that its highly uneven rate of illustration reflects poor organization. It is most likely that the Edinburgh manuscript was "standard issue" and that its bunching of illustrations was part of an overall strategy. So what could this strategy have been?

The emphasis on the Old Testament can be explained in several ways. Such scenes would have been entirely appropriate to begin the story of mankind, spotlighting with a kind of visual fanfare the heroic figures of the key prophets and patriarchs of the Judaeo-Christian and Islamic traditions. The episodes depicted were also familiar from the popular commentaries that embroidered the tales of these personages with picturesque detail (fig. 174). Moreover, since Rashid al-Din was himself of Jewish birth, these Old Testament episodes might well have enjoyed a special place in his affections. Finally, Byzantine,[32] western European, and Jewish manuscripts (such as the nearly contemporary Golden Haggadah with its extensive Exodus images)[33] all provided ample models for such scenes—an especially important factor given that the Rashidiyya artists were, it seems, always pressed for time. In the contemporary West, too, the fashionable genre of world histories, as evidenced by the *Weltchronik* of Rudolf von Ems of about 1260, also featured a lengthy opening section from the Old Testament.[34]

The numerous scenes of violence and enthronement in the *Compendium* make some sense, since the major turning points of history are so often key battles and key usurpations of power. But here, too, a breakdown of the material is revealing. From folios 108v to 135r there are twenty-six scenes of actual or implied violence—four sieges, four executions or maimings, and eighteen images of war (figs. 172, 175)—some of them as extreme as the visual language of the time allowed. Such illustrations, conspicuously absent in the earlier part of the manuscript, represent a decisive change in tone. In particular, the effect of this repetition on the reader, whether casually leafing through the text or studying it carefully, should not be minimized. Successive large-scale and vivid images of warriors wreaking havoc—warriors clad in Mongol armor, carrying Mongol weapons and yak-tail standards, and mounted on wiry Mongol ponies—would have rammed home the reality of the Ilkhanids' military might. They may also be seen as attempts to "Mongolize" the past, imposing a Mongol pattern on pre-Mongol history. It may well be, as Sheila Blair has argued,[35] that the artists drew on illustrated histories of the Ghaznavids for this section of the text, just as the illustrations for the Old Testament episodes derived in part from already well-established models.

As suddenly as they erupted onto these pages, the warriors disappear, to be replaced in the last six images of the Edinburgh fragment by a series of bland enthronement scenes, possibly deriving from lost illustrated Seljuq histories (fig. 173).[36] The rulers are presented as quasi-divine beings, dispensing justice and representing the state. Solemn icons of power, they epitomize the absolute authority of the monarch. Yet here again the message often has a secondary purpose, for the presence of Persian advisers and scribes implies that the ruler does not exercise his power arbitrarily but calls on local people for counsel. An inclusive rather than exclusive pattern of government is thus advertised.

What of the cluster of images dealing with the life of the Prophet? The flirtations of earlier Ilkhans with Buddhism and

32. Allen 1985.
33. *Golden Haggadah* 1970.
34. Kratzert 1974; Günther 1993.
35. Blair 1995, pp. 55, 93.
36. I am grateful to Sheila Blair for this suggestion.

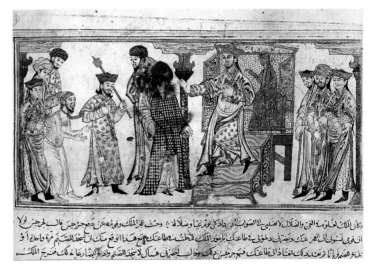

Fig. 175. *Jurjays Miraculously Protected When Tortured by the King of Mosul for Refusing to Worship Idols,* from the *Jamiʿ al-tavarikh* (Compendium of Chronicles) by Rashid al-Din, Iran (Tabriz), A.H. 714/A.D. 1314–15. Fol. 26r; ink, colors, and gold on paper. Edinburgh University Library (MS Arab 20)

37. Since painting at this time was in a state of flux, and since the subject matter of the *Mi'rajnama* was almost entirely unprecedented in Islamic painting, this discrepancy is not strange.

Christianity had accustomed them to religious images, and thus they had none of the traditional inhibitions of Muslims on this score. Instead, they might well have wished to celebrate, indeed broadcast, their recent conversion by honoring the Prophet and singling him out in this way. The very fact that the images in the *Compendium* are not isolated but, as in the al-Biruni manuscript, form a cycle signals a decisive change of pace and intention. However, for all their unmistakable religious content, even spiritual exaltation, these images of the Prophet are found in several different categories of manuscripts. Their location in books of historical, scientific, or epic character is of defining importance: religious painting entered Islamic art by the back door, and this may well have helped to secure its acceptance. In the Iranian world, at least, the moment for images of the Prophet had finally come.

The "Mi'rajnama"

The next and culminating stage of this particular fashion was a predictable one: a manuscript of exclusively hagiographic character. The first illustrated religious manuscript in the history of Islamic art is the fragmentary *Mi'rajnama* (Book of the Ascent) preserved in the Topkapı Palace Library, Istanbul, album H.2154. Its date is very hard to fix. Its images may well be the work of the artist Ahmad Musa, whom the Safavid librarian Dust Muhammad identifies as the chief painter for Abu Sa'id and to whom he attributes a *Mi'rajnama* (see the passage quoted at the head of this essay). While this identification might date the illustrations to the late Ilkhanid period, they do not correspond in style to any work from that time and could indeed be later.[37] The images are for the most part remarkably large: they have been removed from their parent manuscript and are now textless, but some of them might have occupied a full page. They are also brightly colored and of simple composition, which made them well suited for a devotional purpose. Their sustained emphasis on perhaps the most miraculous and otherworldly episode of Muhammad's life, his nocturnal journey to the seven heavens, underlines the special status of the Prophet. Parallels with Buddhist *apsaras*, contemporary Italian (especially Sienese) paintings, and Byzantine icons furnish yet another example of the fruitful interplay of East and West in fourteenth-century painting. But the unmistakable naïveté of this cycle, so different from the pictorial sophistication displayed in the Great Mongol *Shahnama*, betrays the uncertainty of the artists in tackling such a new and highly charged genre of painting. The stakes were high.

Illustrated Copies of the "Shahnama"

By far the most popular illustrated text of the period was the *Shahnama* (Book of Kings), an epic poem of some sixty thousand couplets written by Abu al-Qasim Firdausi about 1010. The ten illustrated *Shahnama*s datable from approximately 1300 to 1350 are all individual creations in the sense that their iconography does not

Fig. 176 (cat. no. 34). *Buzurjmihr Masters the Game of Chess,* page from the First Small *Shahnama* (Book of Kings), northwestern Iran or Baghdad, ca. 1300–1330. Ink, colors, gold, and silver on paper. The Metropolitan Museum of Art, New York, Purchase, Joseph Pulitzer Bequest, 1934 (34.24.1)

Fig. 177 (cat. no. 33). *Zal Visits Rudaba in Her Palace,* page from the First Small *Shahnama* (Book of Kings), northwestern Iran or Baghdad, ca. 1300–1330. Ink, colors, gold, and silver on paper. The Trustees of the Chester Beatty Library, Dublin (Per 104.5)

Fig. 178. *Combat between Rustam and Isfandiyar,* page from a copy of the *Shahnama* (Book of Kings), Iran (Shiraz), A.H. 741/A.D. 1340–41. Ink and colors on paper. Cleveland Museum of Art, Purchase from the J. H. Wade Fund (44.479)

Fig. 179. *Rustam Escapes from Isfandiyar,* page from a copy of the *Shahnama* (Book of Kings), Iran, early 14th century. Ink and colors on paper. Cincinnati Art Museum (1947.498)

derive from a single model but was fashioned anew for each successive manuscript. However, the obvious need to make the paintings reflect the main stories and emphases of the epic in an appropriate manner ensured that there was a great deal of overlap between the various pictorial programs.

The variety in the illustrations was a direct outgrowth of the nature of Firdausi's text and of the medieval approach to it, which was by no means reverential. The verses were, it seems, orally transmitted, and a standard text did not exist; thus no two medieval *Shahnama* manuscripts are textually identical. Firdausi himself, after all, did not compose his epic from scratch but assembled a motley series of oral narratives, recasting them as the *Shahnama*. It is only to be expected that some of the alternative versions, occasionally further lengthened or shortened by the scribes themselves, survived in the oral repertoire and generated illustrations.

The differences between the extant Ilkhanid cycles of this epic also partly result from its adaptable nature, which is furthered by the medium of painting, with its capacity to privilege certain aspects of the text above others. The poem can be interpreted as a succession of adventure stories, battles, fantastic episodes, or romances, but also as a guide to ethics, a chronicle, a celebration of royalty, and a manual for royal conduct. In fact, Firdausi's text is inherently suited to being adjusted, even manipulated, to fit the personal tastes of a patron or to transmit a particular message. The illustrations thus function as a parallel text, highlighting a given theme. And, as the familiar adage has it, a picture is worth a thousand words.

Fig. 180 (cat. no. 32). *Farud before His Mountain Fortress,* illustration from the Diez Albums, Iran (probably Isfahan), ca. 1335. Ink, colors, and gold on paper. Staatsbibliothek zu Berlin—Preussischer Kulturbesitz, Orientabteilung (Diez A fol. 71, S. 29, no. 2)

The surviving manuscripts, most of which have been broken up, have been attributed to various centers—Baghdad, Isfahan, Shiraz, and even India—and not surprisingly reflect several distinct styles. But in format and approach they have much in common. The most frequent pattern is that of a two-volume text containing about a hundred illustrations, each usually taking up between a fifth and a third of the framed text block. The standard illustration format, a horizontal oblong strip, encourages the disposition of figures along the frontal plane in a simple narrative sequence (figs. 176, 177). Yet square and stepped designs (figs. 178, 179) also occur, and sometimes a visual pun is attempted, as when the shape of the painting mimics a plunging shaft in a scene that depicts a well or pit. Since the human figure, in formulaic poses and gestures, dominates the pictorial space, little room is left for ambitious landscapes or highly detailed interiors: mere indications suffice. Bright, strong colors and simple, direct, though often powerful, compositions capture the surface verve of the *Shahnama* narratives (fig. 180) but are less well equipped to plumb their subtleties. By the same token they discourage experiment in the third dimension, the creation of subplots, and the development of a subsidiary focus of visual interest.

Despite isolated references to earlier examples,[38] the concentration of illustrated *Shahnama*s in the first half of the fourteenth century signals a dramatic new departure that cannot be explained by the previous history of the genre. Several theories have been proposed to explain the sudden fashion for such works, which did not all serve identical purposes. Marianna Shreve Simpson has argued convincingly

38. A. S. Melikian-Chirvani has unearthed a reference from the poet Suzani Samarqandi that he interprets as pointing to the existence of illustrated *Shahnama*s under the Qara-Khanids in the early twelfth century; he also proves conclusively that *Shahnama* scenes were painted on the walls of royal palaces in that century. Melikian-Chirvani 1988, pp. 43–45.

Fig. 181 (cat. no. 12). *Execution of Afrasiyab*, page from a copy of the *Shahnama* (Book of Kings) dedicated to the vizier al-Hasan al-Qavam al-Daula wa al-Din, copied by Hasan ibn Muhammad ibn ʿAli ibn Husain al-Mawsili, Iran (Shiraz), A.H. Ramadan 741 / A.D. February–March 1341. Ink, colors, and gold on paper. The Walters Art Museum, Baltimore (W.677b)

in favor of a teaching, even a propagandist, aim for the *Shahnama*s that she attributes to Baghdad, a motive that can be invoked for several other Ilkhanid manuscripts.[39] After the cultural havoc wrought by the Mongol invasion, in which cities and especially their educational establishments suffered grievously, there was much ground to be recovered in the world of learning. These *Shahnama*s could also have expressed a new Mongol commitment to the country and culture that they ruled, as suggested by the tiles with *Shahnama* inscriptions at Takht-i Sulaiman.[40] Moreover, the lavish use of illustrations would make the book accessible to Mongol patrons who, even if not illiterate, would derive more pleasure from images than from words.

Those *Shahnama*s made in areas outside direct Mongol political control, most notably in southern Iran, might have been intended to boost national sentiment. The vizier of the quasi-independent Inju dynasty in Shiraz, for example, ordered a celebrated *Shahnama* that is dated 1341 (fig. 181). Firdausi's original project, after all, had as one of its aims the assertion of Iranian identity vis-à-vis the alien Arabs—a motive that helps to explain why the poem ends with the last Sasanian king (see fig. 182), rather than continuing into the period of Arab domination, and why Firdausi so carefully purged its language of Arabic elements. Thus the illustrated

39. Simpson points out that the illustrations of the *Shahnama*s that she assigns to Baghdad stick closely to the text, which may imply an intended readership not very familiar with the poem, whereas the Shirazi painters seem to have felt free to stray from the text and thus may have assumed that their readers knew it well. For a penetrating discussion of the whole topic of text-image relationships, see Simpson 1982a. For other Ilkhanid manuscripts that seem to have served a teaching function, see Fitzherbert 2001, pp. 366–73.

40. See Tomoko Masuya's chapter 4 in this volume as well as the works of recent scholarship cited in it.

Shahnama could serve the purposes both of a Mongol elite seeking to ingratiate itself with hostile Iranians and of Iranians seeking to reassert their hitherto oppressed but millennial culture, of which this epic is the distillation.

Fig. 182 (cat. no. 58). *Bahram Gur Fighting a Wolf,* from a page of the Great Mongol *Shahnama* (Book of Kings), Iran (probably Tabriz), 1330s. Ink, colors, and gold on paper. Harvard University Art Museums, Cambridge, Mass., Bequest of Abby Aldrich Rockefeller (1960.190)

THE GREAT MONGOL "SHAHNAMA"

Given the dominant role of the *Shahnama* in Ilkhanid painting, it is entirely appropriate that the supreme masterpiece of that school should be the only royal copy of Firdausi's epic. Not only is it by far the largest of the *Shahnama* manuscripts, but its paintings in general are by far the most complex and sophisticated, and again the largest, of the entire school (fig. 184).

Controversy has surrounded the Great Mongol *Shahnama* for almost a century. Now only a torso, for it was cut up and mangled for the sake of profit in the early twentieth century, its folios are so widely scattered that a comprehensive study of the manuscript is difficult (figs. 183, 186). Moreover, it was never finished in the first place.[41] This may have been due to the hubris of those responsible for its design and execution, who perhaps simply took on more than they could handle; maybe

41. See Grabar and Blair 1980, pp. 11–12; Blair 1989, p. 128.

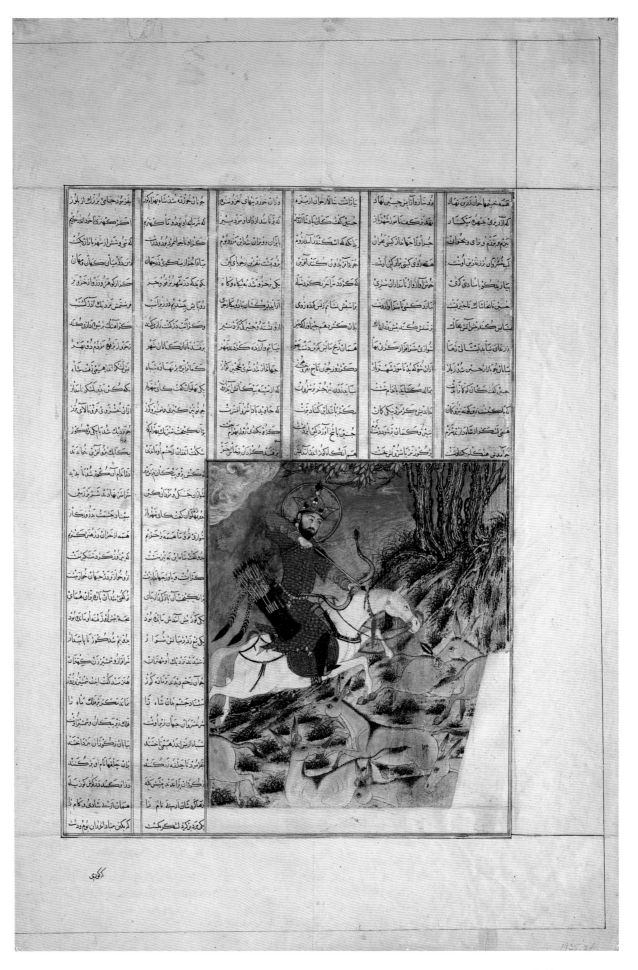

Fig. 183 (cat. no. 57). *Bahram Gur Hunting Onagers,* page from the Great Mongol *Shahnama* (Book of Kings), Iran (probably Tabriz), 1330s. Ink, colors, and gold on paper. Worcester Art Museum, Worcester, Mass., Jerome Wheelock Fund (1935.24)

time or money ran out. Or perhaps the project was cut short prematurely by entirely external factors such as political events, like the death of the vizier Ghiyath al-Din or indeed the fall of the Ilkhanid dynasty itself, a disaster that would have had a direct impact on the royal ateliers.

The majestic physical scale of the work, with trimmed pages measuring 16 by 11 5/8 inches and originally, when the margins were intact, very much more,[42] enabled its illustrators to think big (fig. 185). The original plan for the illustrations was probably equally ambitious and indeed unprecedented, calling for some two hundred paintings, of which fifty-seven survive.[43] Since *Shahnama* iconography was presumably still in its infancy, the painters had no models for scores of the projected images. Even existing models would have required thorough reworking to fit naturally into the unusually large spaces set aside for painting; mere proportional enlargements would not do. The continual pressure to be innovative propelled the painters into unfamiliar territory in search of fresh inspiration. It also required that they react more than mechanically or literally to the text. Such pressures perhaps account for the fact that their paintings speak with many voices.

This much may legitimately be inferred from the physical evidence provided by the manuscript itself. But the disappearance of much of the text itself, which may have been discarded by the Belgian dealer Georges Demotte when he broke up the bound manuscript, means that information vital for more detailed analyses is not at hand. For instance, the precise balance between illustrated and unillustrated folios as well as the exact subject matter of the lost or projected paintings remain matters for speculation.

Fig. 184 (cat. no. 53). *Ardashir Battling Bahman, Son of Ardavan,* from a page of the Great Mongol *Shahnama* (Book of Kings), Iran (probably Tabriz), 1330s. Ink, colors, and gold on paper. Detroit Institute of Arts, Founders Society Purchase, Edsel B. Ford Fund (35.54)

42. Sarah Bertalan's remarks on issues of paper and pigments in her technical study in this catalogue suggest that the Great Mongol *Shahnama* may have had more in common with the *Compendium of Chronicles* manuscripts than was previously thought; wide margins are only one aspect of this.

43. One of the fifty-eight to survive into the twentieth century (no. 16 in the standard numbering) was destroyed by fire in 1937.

Fig. 185 (cat. no. 36). Page of text, from the Great Mongol *Shahnama* (Book of Kings), Iran (probably Tabriz), 1330s. Ink, colors, and gold on paper. The Trustees of the Chester Beatty Library, Dublin (Per 111.8)

No colophon survives to provide key information as to date, provenance, patronage, and perhaps even the identity of the artists. These are formidable losses, but scholarship over the last sixty years or so has crystallized in favor of certain propositions regarding these issues. Among them are a date in the 1330s, though strong arguments have been made for both earlier and later dates;[44] a provenance in Tabriz, the Ilkhanid capital; a royal patron, probably Abu Saʿid; and the participation of Ahmad Musa,[45] the artist mentioned in the somewhat enigmatic and minimalist account of the history of Persian painting by the Safavid royal librarian Dust Muhammad (the Vasari of Iran), writing in the 1540s (see above).

Most previous accounts of this manuscript have emphasized its key significance in fourteenth-century painting without seeking to probe its illustrative program for deeper meanings. In keeping with the Eurocentric approach of scholars from the 1930s onward, which was preoccupied with questions of date, provenance, patronage, and style,[46] the tacit assumption was that the purpose of the paintings was to illustrate the accompanying text. Only two scholars, Oleg Grabar and Abolala Soudavar, have made a concerted effort to explain the paintings as something more than a succession of ambitious textual illustrations. Grabar proposed that the cycle of paintings revolved around four themes: death and mourning, legitimacy, human frailty, and divine revelation.[47]

Soudavar suggested a still more comprehensive interpretation, namely that the Great Mongol *Shahnama* is the manuscript described by Dust Muhammad as the *Abusaʿidnama* (Book of Abu Saʿid) and that it is nothing less than a daring attempt to reconfigure the *Shahnama* as a chronicle of the royal Mongol house.[48] By this reckoning, every episode chosen to be depicted in the illustrative program was selected because it also served to present some event in recent Mongol history and thus brought Firdausi's text right up to contemporary Iran. It is a most audacious theory and has thus not won universal acceptance.[49] Nevertheless, Soudavar has been able, thanks to his impressive familiarity with the historical sources, to propose a sequence of remarkably exact correlations between episodes in Firdausi's epic and Mongol history in the thirteenth and fourteenth centuries. To interpret all of these as accidental would be to stretch the proverbially long arm of coincidence well beyond breaking point. In its essentials, Soudavar's theory is compelling and has far-reaching implications for the study of Persian painting. In particular, attention must henceforth be paid to the political and propagandist (and perhaps at times religious) dimension in depictions of scenes from familiar texts. (Soudavar also marshals

44. For an earlier date, see Soudavar 1996, p. 179. For a later one, see Schroeder 1939, p. 131.

45. Schroeder admits this possibility but believes that the principal artist among the several painters who contributed to the manuscript was Shams al-Din. Schroeder 1939, pp. 131–32.

46. Both Schroeder and Ivan Stchoukine, for instance, assumed, with somewhat inconclusive results, the connoisseur's task of distinguishing a series of different hands in these paintings. Stchoukine 1958.

47. Grabar 1969. He developed this interpretation further in Grabar and Blair 1980, pp. 13–27.

48. Both of these propositions are controversial, but the second does not depend on the first. See Soudavar 1996.

49. Some scholars doubt that Dust Muhammad would have had access to this manuscript and that illustrations so disparate could be made to fit into an overall program; see, for example, Blair 2002b.

Fig. 186 (cat. no. 51). *Iskandar Emerging from the Gloom,* page from the Great Mongol *Shahnama* (Book of Kings), Iran (probably Tabriz), 1330s. Ink, colors, and gold on paper. Keir Collection, England (PP3)

Fig. 187 (cat. no. 56). *Bahram Gur Slaying a Dragon,* from a page of the Great Mongol *Shahnama* (Book of Kings), Iran (probably Tabriz), 1330s. Ink, colors, and gold on paper. The Cleveland Museum of Art, Grace Rainey Rogers Fund (1943.658)

ample evidence to suggest that the finest calligrapher of the time, ʿAbd Allah Sayrafi, renowned for his Korans, was the principal scribe for the manuscript.)

This elusive masterpiece also provides copious material for other types of investigation. It pioneers a new complexity in storytelling techniques, with plot and subplot artfully juxtaposed or interwoven, or the main event richly embroidered with complementary detail. The emotional range is wide and expertly orchestrated. The pictures capture the clangor, confusion, and carnage of battle (figs. 160, 184, 188), the gore-spattered scenes of monster slayings evoke a frisson of horror (fig. 187), and the images of death and mourning speak of grief by turns measured and frantic. Yet there is room too for images of love and passion, betrayal and fantasy. Many an image is shot through with conflicting emotions, with wonder, or with sly humor.

In general, all the surface is painted and all the space is used, thereby actively contributing to the narrative. The three-dimensional world thus created is made all the more credible by the meticulous rendering of detail, from costumes to carpets, from patterned floors to tiled dadoes, from frescoes and balconies to window grilles and lacquer thrones (fig. 189). In this one manuscript the largely lost court arts of the Ilkhanids are on display in concentrated splendor, complementing and enhancing each other to achieve a whole much more than the sum of its parts. They bring the technicolor ambience of the Ilkhanid court to vivid life.

The incomplete state of the manuscript means that not one of the illustrative cycles that punctuate Firdausi's poem can be followed pictorially in all its fullness. Yet even these fragments suggest that, quite apart from the pointed references to

Fig. 188 (cat. no. 41). *Rustam Shooting an Arrow into Isfandiyar's Eye,* page from the Great Mongol *Shahnama* (Book of Kings), Iran (probably Tabriz), 1330s. Ink, colors, and gold on paper. Harvard University Art Museums, Cambridge, Mass., Gift of Edward W. Forbes (1958.288)

Fig. 189 (cat. no. 38). *Zal Approaching Shah Manuchihr,* from a page of the Great Mongol *Shahnama* (Book of Kings), Iran (probably Tabriz), 1330s. Ink, colors, and gold on paper. The Trustees of the Chester Beatty Library, Dublin (Per 111.4)

50. This genre, popular in Arabic and Persian literature alike, could take many forms, ranging from ethical guides in the form of animal fables to manuals detailing how kings should behave. All of them used narratives, whether fictional or nonfictional, to convey a moral regarding statecraft.

Mongol history suggested by Soudavar, such cycles worked very successfully within the primary context of Firdausi's epic. This double life is typical of the multi-layered nature of the manuscript. Thus the paintings speak of patriotism, of succession disputes, of a fierce desire for justice, of the painful road from pride to humility, of the vanity of human wishes. They glorify kings rather than heroes, and sometimes, as in the case of the cycle of Iskandar (Alexander the Great; figs. 190, 191), they do so to an extent not equaled in earlier or later *Shahnamas.* Taken together, they create a memorable "Mirror for Princes," a pictorial equivalent to this fashionable literary genre.[50]

Perhaps nothing captures the boldness of these painters better than their confident appropriation of ideas from other cultures. Tabriz was thronged with European missionaries, Chinese officials, and merchants and diplomats from all over the old world. This cosmopolitanism must account in part for the truly unique openness to Christian images found in the Great Mongol *Shahnama.* Gospel archetypes such as the Adoration of the Magi, Entry into Jerusalem, Flagellation,

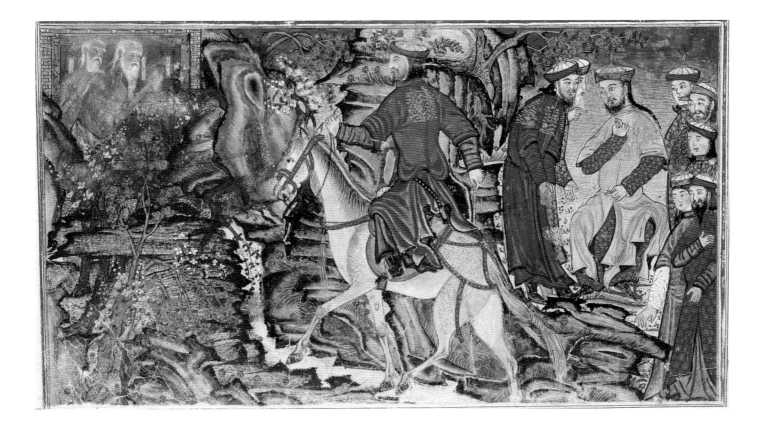

Fig. 190 (cat. no. 50).
*Taynush before Iskandar; The
Visit to the Brahmans,* from a
page of the Great Mongol
Shahnama (Book of Kings),
Iran (probably Tabriz),
1330s. Ink, colors, and gold
on paper. Arthur M. Sackler
Gallery, Smithsonian
Institution, Washington,
D.C.; Purchase, Smithsonian
Unrestricted Trust Funds,
Smithsonian Collections
Acquisition Program, and
Dr. Arthur M. Sackler
(S1986.105)

Fig. 191 (cat. no. 52). *Iskandar
Building the Iron Rampart,*
from a page of the Great
Mongol *Shahnama* (Book of
Kings), Iran (probably
Tabriz), 1330s. Ink, colors,
and gold on paper. Arthur M.
Sackler Gallery, Smithsonian
Institution, Washington,
D.C.; Purchase, Smithsonian
Unrestricted Trust Funds,
Smithsonian Collections
Acquisition Program, and
Dr. Arthur M. Sackler
(S1986.104)

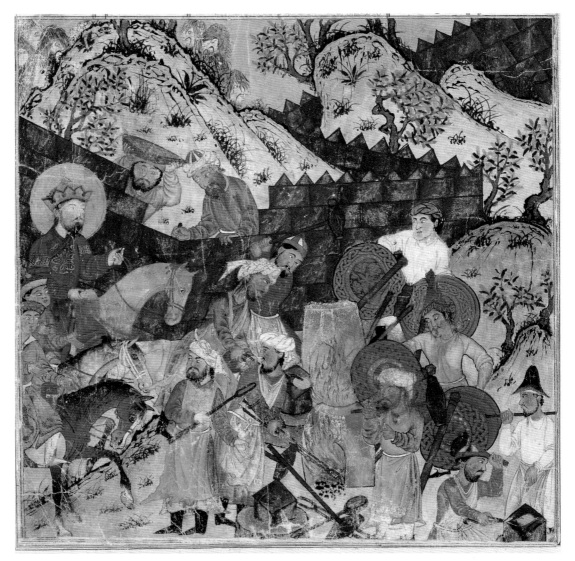

Fig. 192 (cat. no. 61). *Mihran Sitad Selecting a Chinese Princess,* page from the Great Mongol *Shahnama* (Book of Kings), Iran (probably Tabriz), 1330s. Ink, colors, and gold on paper. Museum of Fine Arts, Boston, Helen and Alice Colburn Fund and Seth K. Sweetser Fund (22.392)

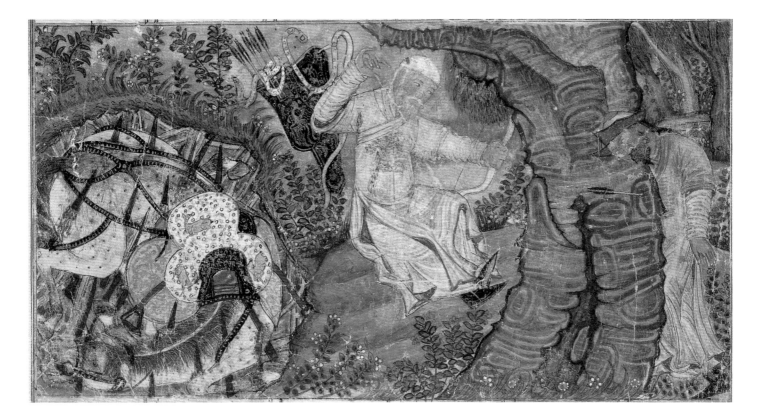

Fig. 193 (cat. no. 43). *Rustam Slaying Shaghad,*
from a page of the Great Mongol *Shahnama*
(Book of Kings), Iran (probably Tabriz), 1330s.
Ink, colors, and gold on paper. The Trustees of
the British Museum, London (1948.12-11.025)

Carrying of the Cross, Crucifixion, Deposition, Lamentation, and Entombment are
freely adopted and adapted, to say nothing of images of Dominicans, Franciscans,
warrior saints, and the Virgin Mary. Along with the recycling of these images, so
familiar in another context, come sudden unmistakable echoes of contemporary
European fashions and conventions, whether for plaited hair, the depiction of drap-
ery, or the stylized mime of grief.

This willingness to echo contemporary Italian and French art is balanced by an
equal readiness to copy and refashion elements of Chinese art (fig. 192). The paint-
ings contain details taken from Buddhist images, among them mudras, the trailing
leg, the recumbent pose, and the *triratna* (Three Jewels); dragons; the sacred fungus;
architecture; lacquer thrones; screens; and all kinds of Far Eastern textiles, includ-
ing a Chinese imperial robe for the dying Rustam. Above all, Chinese landscape
elements are widely used to create an atmosphere or to comment on the action,
rather than simply to provide a background (fig. 193). Their integration with large-
scale figures, a flouting of Chinese convention, is nonetheless pictorially and emo-
tionally compelling.

The Great Mongol *Shahnama* is a thoroughly appropriate place to end this sur-
vey. At once a climax and a coda, it built on past achievements but at every turn
unveiled new vistas. The team of masters who worked on it forged, with intuitive
mutual understanding, a new style. But that style was less important in itself than
for what it attempted to convey, for it embraced depths of meaning and expression
hitherto unknown in Islamic book painting. So ambitious were these artists that they
effectively broke the bounds of the medium, taking book art into areas for which it
was perhaps unsuited and from which their successors recoiled. Within the covers of
this two-volume book, one can trace the sequence from paintings that are simple
illustrations[51] to ones that are commentaries, then metaphors, and finally independent

51. It remains to be seen whether these different
approaches were undertaken in any particular
order; it is too early, for example, to assume that
those at the beginning of the poem were also the
first to be painted, as can be suggested *grosso modo*
for those at the beginning of the *Shahnama-i shahi*
of Shah Tahmasp.

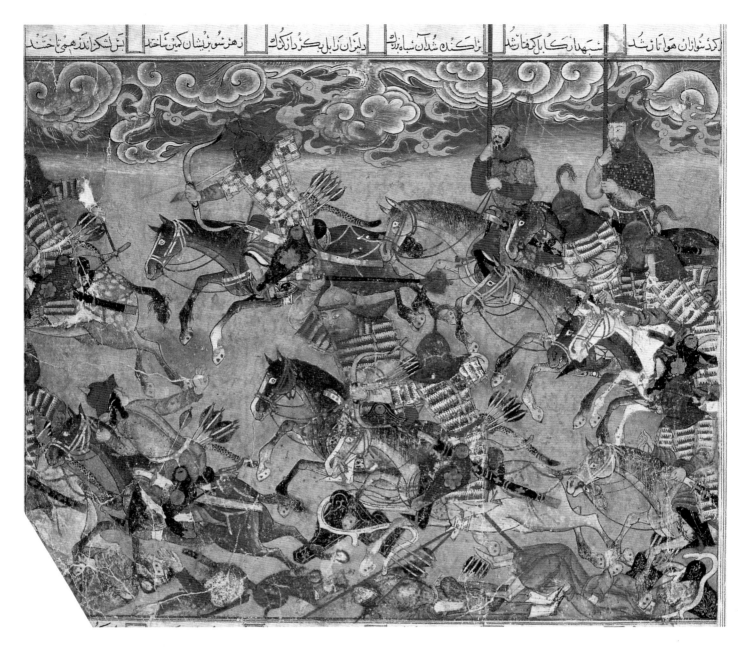

زكذرسوانزان هوا تارنشذ | سپهدار كابل كفتارنشذ | دليران زابل بكردازكرك | اركسكن شذان نسارنرك | زهرنسوزنيشان كمين ناخند | ابن تكرا اذذ همي تاخند

Fig. 194 (cat. no. 45). *Faramurz Pursuing the Kabulis,* from a page of the Great Mongol *Shahnama* (Book of Kings), Iran (probably Tabriz), 1330s. Ink, colors, and gold on paper. Musée du Louvre, Paris (7095)

works of art operating confidently on several levels of meaning. More and more content—descriptive, emotional (fig. 153), historical, symbolic—is gradually pumped into these paintings, and only an absolutely assured command of pictorial language enables the greatest of these painters to control the forces that they unleash (figs. 160, 194).

All this visual splendor and intellectual complexity are, however, destined for the eyes of only a very few. Thus to modern viewers there may seem to be an inherent mismatch between the medium and the message. It could be argued that the extremely limited intended readership makes it absurd to suggest that the images of the Great Mongol *Shahnama* carried a complex freight of politico-historical, let alone symbolic, meaning. But that would be to underestimate the despotic, unaccountable power of the Ilkhan as ruler, and indeed to misunderstand the very nature of Muslim panegyric, whose prime purpose was to exalt that ruler.[52]

Precisely because the text illustrated in the Great Mongol *Shahnama* was not written to glorify the Ilkhan Abu Saʿid but rather was written for the ages, the images in this manuscript—however relevant to Mongol history—have a timeless validity. So long as Iran has rulers, so long will the *Shahnama* remain relevant to its

52. Meisami 1987, pp. 40–76.

people. Ironically enough, it is only in the past century that these images have come into their own, and then in a way that could scarcely have been foreseen by their original patron. Extracted one by one from their parent volumes, reproduced in color in books and as posters, projected as slides, scanned as images on the Web, viewed by thousands of people at exhibitions, they can now at last be given their due as supreme masterpieces, not of an age but for all time.

CONCLUSION

Perhaps the most striking characteristic of the extraordinary half-century or so of achievement in Ilkhanid book painting is the sense of barely contained energy. Artists of this school responded vigorously and imaginatively to the new challenges posed by unfamiliar subject matter and hitherto alien ways of seeing. Content and style became the matrix for the transformation of Persian painting during this brief formative period.

The two greatest undertakings of Ilkhanid book painting—the *Compendium of Chronicles* and the Great Mongol *Shahnama*—can both be seen as attempts (one public, the other rigorously private) to harness the expressive powers of manuscript illustration to political and propagandist ends. In both cases the attempt miscarried, defeated by the nature of the medium itself, which does not lend itself to being experienced by many people at once. Manuscript painting is an exquisitely selfish art form; to be reminded of that fact one has only to try reading a book together with someone else. Even when the huge dimensions of books made large-scale paintings an option, even when the volume was displayed on a lectern in a mosque or a madrasa and thus visible to a group of readers, it remained in the very nature of a book for the memory of one image to be obliterated by the sight of the next. Referring back to earlier images to refresh the memory or for purposes of comparison is possible for only one reader at a time.

The ambitions of Ilkhanid patrons and painters, then, to some extent outran the means at their disposal. The enormous enterprise set in motion by Rashid al-Din, and the measures he took to ensure that it had the necessary financial backing, leave no doubt that the constraints were neither intellectual nor monetary. The sheer size of the books produced under these circumstances was crucial, giving them a palpable presence from the moment one saw them.[53] It opened new perspectives in book painting and pushed that medium to its very limit. Indeed, the next logical step would have been to emancipate painting altogether from the confines of the book by turning to fresco and easel painting. But this was not to be. Sadly, later generations of painters gracefully declined that implied challenge and chose to work on a reduced scale, loading more and more visual content into less and less space. Such pictures invite prolonged, absorbed meditation. Rather than explore the potential for expression and narrative offered by very large and lavishly illustrated books, artists preferred to reduce the number of images and to refine their techniques. And given the beguiling mix of intellectual complexity and visual splendor that marked mature Timurid painting in the following century, who is to say that they were wrong?

53. I have had the pleasure of verifying this proposition by means of the immediate reactions of generations of Edinburgh students who were seeing the Rashid al-Din manuscript for the first time.

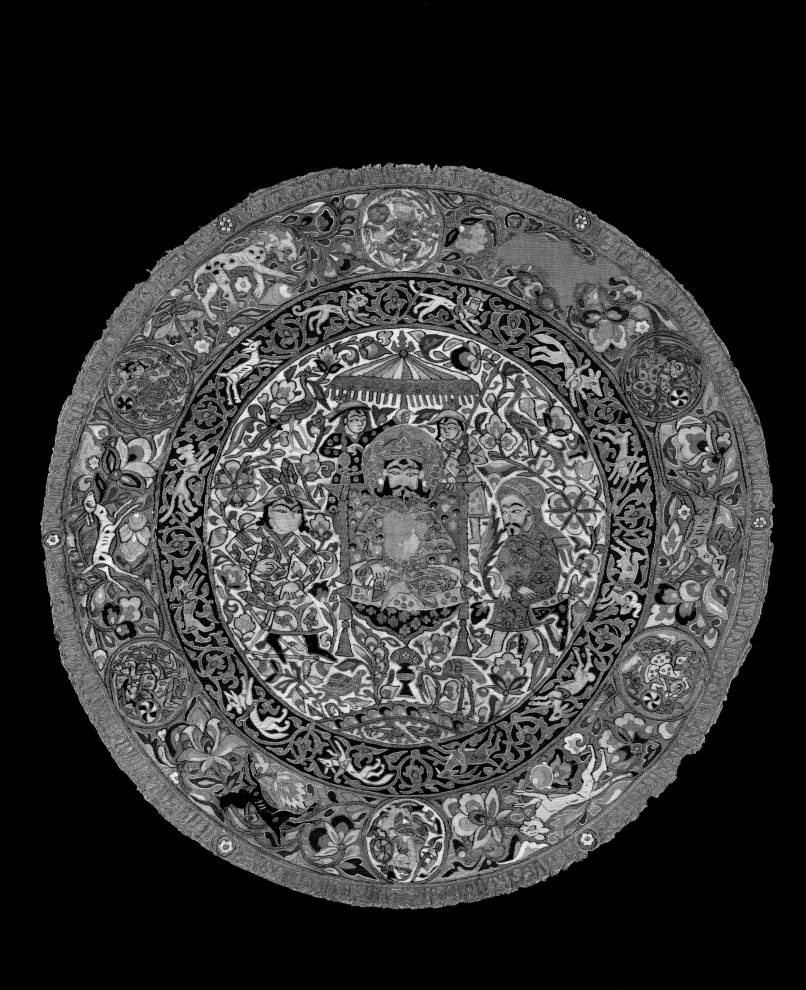

7.

The Transmission and Dissemination of a New Visual Language *LINDA KOMAROFF*

*The banner of Chingiz-Khan's fortune was raised and they issued forth from the straits of
hardship into the amplitude of well-being, from a prison into a garden, from the desert
of poverty into a palace of delight and from abiding torment into reposeful pleasances; their
raiment being of silk and brocade . . . and their everyday garments are studded with jewels
and embroidered with gold.*

> —ʿAlaʾ al-Din ʿAta Malik Juvaini, The History of the World Conquerer[1]

*And when you have ridden seven days eastward through this province [Tenduc, probably in
Inner Mongolia] you get near the provinces of Cathay [China]. You find throughout those
seven days' journey plenty of towns and villages, the inhabitants of which are Mahommetans,
but with a mixture also of Idolaters and Nestorian Christians. They get their living by trade
and manufactures: weaving those fine cloths of gold which are called* Nasich *and* Naques,
*besides silk stuffs of many other kinds. For just as we have cloths of wool in our country, manu-
factured in a great variety of kinds, so in those regions they have stuffs of silk and gold in like
variety. All this region is subject to the Great Kaan.*

> —Marco Polo, Il milione[2]

I lkhanid artists created a new visual language in response to the demands of
their patrons, whose aspirations and tastes were shaped not only by their
encounter with the urban, Islamic culture of Iran but also by contact with the
highly sophisticated civilization of China. As is indicated by James Watt in
chapter 3, cultural developments in China prior to the establishment of the Yuan
dynasty in 1271 seem to have contributed to the formation of an Ilkhanid artistic
idiom, with the arts of North China and to a lesser extent of Central Asia also being
vital elements in this creative process. Subsequent chapters examine several specific
aspects of Ilkhanid art. This essay considers, more broadly, that art's presumed
sources and transmission. One issue is the transfer of artistic ideas from eastern to
western Asia after 1256; another is the subsequent dissemination in Iran of an origi-
nal aesthetic idiom—characterized by new designs, compositions, and themes—
into a variety of media.

1. Juvaini 1958, vol. 1, p. 22.
2. Polo 1903, vol. 1, p. 285. Similarly Polo 1938,
 p. 183.

SOURCES AND TRANSMISSION: TEXTILES

Many artists and a great variety of works of art passed freely between eastern and
western Asia under the fluid conditions that prevailed during the Pax Mongolica.
However, one medium, textiles, seems to have played a dominant role in the creation
of a new aesthetic in Iran. Indeed, textiles were perhaps the principal transmitters

Opposite: Fig. 195 (cat. no. 72). Tapestry roundel
with enthroned prince, Iraq or Iran, first half
of the 14th century. Tapestry weave, silk, gold
thread wrapped around a cotton core. The
David Collection, Copenhagen (30/1995)

Fig. 196 (cat. no. 75). Striped brocade, Iran, 14th century. Lampas weave (satin and tabby), silk and gold thread. Staatliche Museen zu Berlin, Preussischer Kulterbesitz, Kunstgewerbemuseum (1875.259)

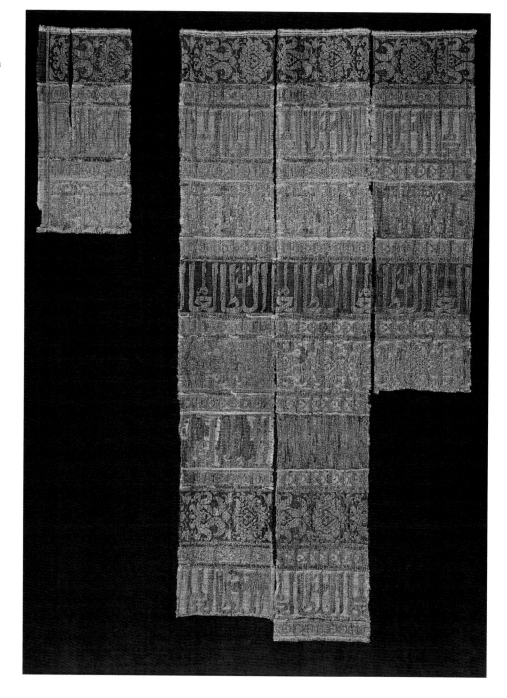

Fig. 197 (cat. no. 155). Dragon-handled cup, Golden Horde (Southern Russia), second half of the 13th century. Gold. State Hermitage Museum, Saint Petersburg (SAR-1625)

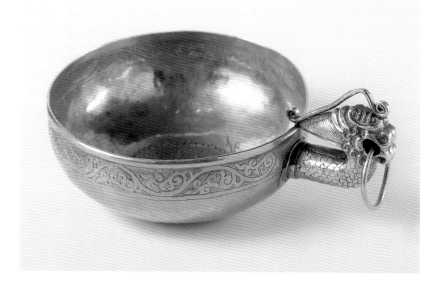

of East Asian (primarily Chinese) visual culture to the West. Their importance to the development of art in Iran after the Mongol invasions has been noted by others, particularly in relation to the motifs on tiles from Takht-i Sulaiman.[3] What is new is the substantial data on Mongol textiles published in recent studies by James Watt and Anne Wardwell[4] and by Thomas Allsen.[5] The former provides a wealth of information about the extant textiles, their contexts, and their antecedents, while the latter examines a large group of diverse texts with a bearing on the subject. Taken together these studies reveal the tremendous emphasis placed by the Mongols on the manufacture and acquisition of luxury textiles, delineate the methods of their production, and help visually define the textile art of this period.

The Importance of Textiles

These luxury textiles included silk woven with gold-wrapped thread and, especially, fabrics in which both pattern and ground were woven in gold on a silk foundation—the so-called cloth of gold (*nasij*) (figs. 58, 196). Apart from their obvious aesthetic appeal, there are several reasons why such textiles engaged the Mongols.[6] They were rare, costly, and easily transportable, and—as surely was well known to the Mongols—had long been a vital element in the highly profitable trade across Asia. As nomads, the Mongols were attuned to the concept of portable or wearable wealth. Among other luxury goods that they seem to have especially appreciated were belts and belt ornaments of gold or silver,[7] small drinking vessels that could be attached to the belt, and horse trappings and saddles of precious metals (see figs. 10, 63, 197, 198). Moreover, silk textiles had a value equivalent to that of currency and could serve for the payment of taxes or war indemnity or tribute.[8] Textiles were clearly a highly desirable commodity to the Mongols, who also must have appreciated them as symbols of political power and prestige.[9]

From the beginning of their rule, the Mongols appear to have gone to great lengths to obtain luxury textiles and to control the sources of their production. Under Genghis Khan (d. 1227) and his son and successor, Ögödei (r. 1229–41), communities of textile workers were established by the forced resettlement of

3. Most notably Yolande Crowe, in Crowe 1991. See also, for example, Lane 1957, pp. 3–6.
4. Watt and Wardwell 1997.
5. Allsen 1997a; on a related subject is Allsen 2001.
6. Actually, "cloth of gold and silk." *Nasij* is a shortened form of *nasij al-dhahab al-harir;* see Dozy 1967, p. 666. Watt and Wardwell 1997, p. 5, suggest that for the Mongols, "textiles were a higher form of the plastic arts than painting or sculpture"; see pp. 60–61 for the Mongol-period references that led them to this conclusion.
7. A well-known story from the *Secret History of the Mongols* tells that belts taken from the enemy were exchanged by Genghis Khan (then Temüjin) and his early ally Jamuka to renew their alliance after the defeat of the Merkits. Exchanges of belts, and of horses, were apparently means of concluding alliances among the peoples of the Mongolian steppes. See, for example, Ratchnevsky 1991, p. 20.
8. See Sheng 1999, p. 152, for the period immediately preceding that of the Mongols. For the Mongols specifically, see Allsen 1997a, pp. 28–29; Watt and Wardwell 1997, p. 18.
9. Allsen 1997a, pp. 50–52, suggests that for the Mongols textiles had other symbolic values as well.

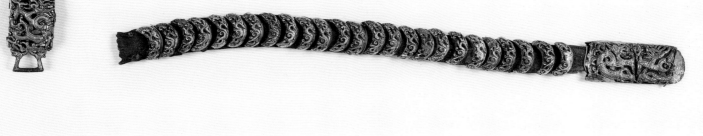

Fig. 198 (cat. no. 142). Set of belt fittings, Great Mongol State, 13th century. Silver gilt. State Hermitage Museum, Saint Petersburg (ZO-762)

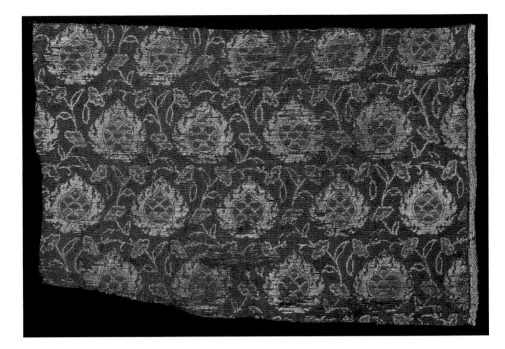

10. Ibid., pp. 38–45; Rossabi 1997, pp. 14–15.
11. Watt and Wardwell 1997, pp. 127ff.
12. Allsen 2001, pp. 41–46.
13. Rossabi 1997, p. 15.

Fig. 200. *Enthroned Patron in Royal Guise*, from the *Marzubannama* (Book of the Margrave), Baghdad, 1299. Fol. 7r; ink, colors, and gold on paper. Archaeology Museum Library, Istanbul (ms. 216)

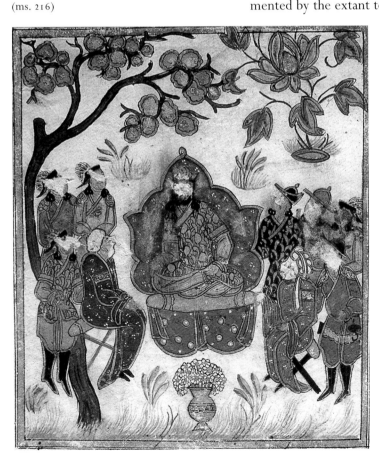

Persian artists in three locations on the southern boundaries of the Mongol homeland (see the Marco Polo quotation at the head of this chapter). The artists were taken primarily from Iranian cities in Khurasan (such as Herat, which was renowned for its silk and gold cloth) and in Turkestan (among them Samarqand). Going in a different direction, Chinese textile workers were relocated to eastern Central Asia, to produce fine fabrics for the Mongol overlords there.[10] This transfer of artists and their techniques, described in both historical sources and travelers' accounts, facilitated a kind of hybrid development in textile art and its technology that is documented by the extant textiles (figs. 20, 75, 196, 199).[11] Particularly significant for this essay, it provided an important means for the diffusion of East Asian motifs and forms to the West.

Textiles produced in China could also be obtained in Iran. They arrived through commercial channels, since under the Mongols, luxury textiles were a significant component of trade within Asia and beyond it to Europe, and Iran was both an intermediary and a destination of the overland and sea trade routes connecting East and West. Courtly prerogative also brought textiles westward: the Ilkhan Hülegü (r. 1256–65), and through him his Ilkhanid successors, had been allocated territories and financial interests in China, from which they received regular income—partly in the form of silks.[12]

Under the Yuan dynasty (1271–1368), the sheer number of government offices set up in China to regulate and control the manufacture of textiles further attests to the importance the Mongols placed on this medium.[13] To date there is only limited evidence that the Ilkhanids followed the Yuan practice of mobilizing and organizing textile workers and other artists by placing them under the control of

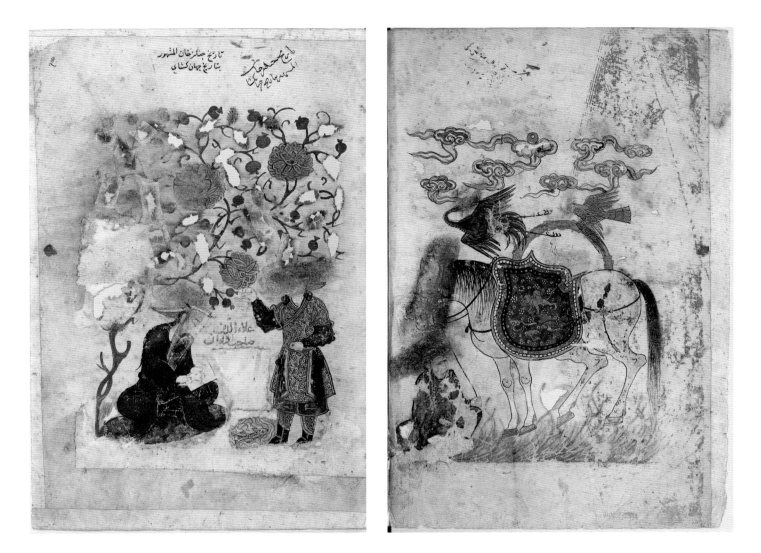

government agencies.[14] Still, a sufficient number of skilled textile workers could be pressed into service in Tabriz to fill an order for gold woven cloth intended as a diplomatic gift from the Ilkhan Tegüder Ahmad (r. 1282–84) to the Mamluk sultan in Egypt.[15]

Luxury textiles appear to make up the costumes and furnishings represented in Ilkhanid manuscript paintings. Only a few illustrated manuscripts survive from the late thirteenth century; in the depictions of the new Mongol rulers and ruling elite that they contain, the conquerors' ethnicity is conveyed not only by their physiognomies and costumes but also specifically by the fabrics of which their clothes, accoutrements, and even horses' accessories are made, as seen in frontispieces from the *Tarikh-i jahan-gusha* (History of the World Conqueror) of 1290 (fig. 201) and the *Marzubannama* (Book of the Margrave) of 1299 (fig. 200). The enthroned prince in the *Marzubannama* frontispiece wears a robe of what appears to be silk, decorated with a gold floral pattern. The turbaned figures seated to his left and right, both non-Mongols, are, significantly, clothed in robes with a simpler pattern, clusters of three dots.[16] This evident concern to delineate specific types of fabric continues in the more numerous early-fourteenth-century manuscript illustrations (see, for example, figs. 37, 51, 183, 193).[17] Manuscript illustrators were very likely depicting what they saw or knew to be so, namely, that the Mongols wore elaborate costumes and surrounded themselves with textiles of costly materials carrying specific types of designs. For example, in a scene from the Great Mongol *Shahnama* (Book of Kings),

Fig. 201 (cat. no. 1). *The Author with a Mongol Prince* and *A Horse and Groom,* double frontispiece from the *Tarikh-i jahan-gusha* (History of the World Conqueror), copied by Rashid al-Khwafi, probably Iraq (Baghdad), finished on A.H. 4 Dhu'l-hijja 689/A.D. December 8, 1290. Fols. 1v, 2r; ink, colors, and gold on paper. Bibliothèque Nationale de France, Paris (MSS or., Suppl. persan 205)

14. On the organization of artists under the Yuan dynasty in general, see Chu 1956. Also see C.Y. Liu 1992. In Iran, members of the Mongol royal family seem to have had artisan households in their retinues; the Persian author Rashid al-Din notes in his *Jamiʿ al-tavarikh* that in a contest for the throne, Tegüder's troops "seized all three hundred households of artisans who belonged to Arghun"; Allsen 1997a, p. 57.
15. According to Bar Hebraeus 1932, vol. 1, pp. 467–68; cited in Allsen 1997a, p. 34.
16. The author (a non-Mongol) depicted at the center of the right-hand frontispiece (fol. 3r) of the Shiʿite encyclopedia *Rasaʾil ikhwan al-safaʾ* of 1287 appears in a similarly patterned robe; see Ettinghausen 1962, p. 99.
17. On costumes in the *Jamiʿ al-tavarikh*, see D. T. Rice and Gray 1976, pp. 16–23.

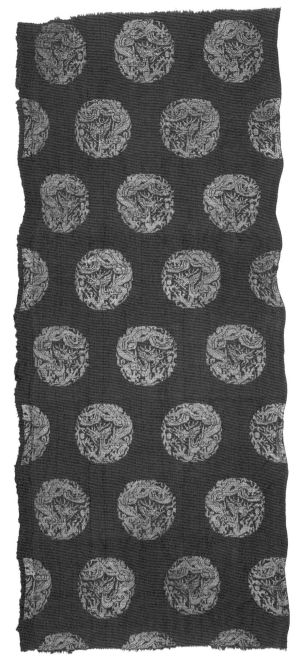

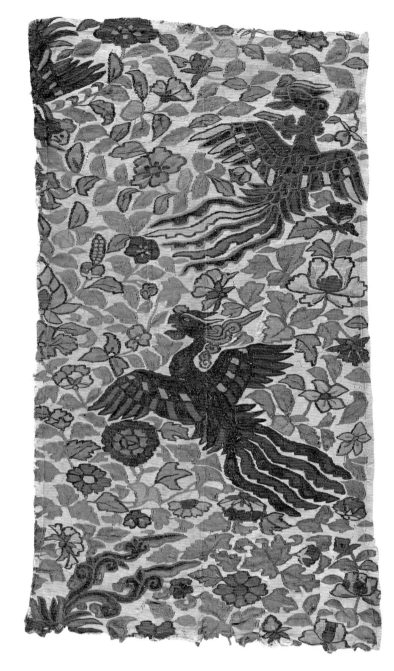

Fig. 202 (cat. no. 181). Textile with coiled dragons, China, Jin Dynasty (1115–1234). Tabby, brocaded, silk and gold thread. The Metropolitan Museum of Art, New York, Gift of Lisbet Holmes, 1989 (1989.205)

Fig. 203 (cat. no. 187). Textile with phoenixes on a field of flowers, eastern Central Asia, 13th century. Silk tapestry (*kesi*), silk and gold thread. Textile Traces Collection, Los Angeles (T-0292)

18. The motif, evidently popular in Ilkhanid Iran, was probably introduced through imported textiles. The same design is found on belt ornaments (figs. 62, 65) and on tiles from Takht-i Sulaiman (figs. 93, 218). On the significance of this motif under the Jin dynasty, see James Watt's chapter 3.

19. Watt and Wardwell 1997 is the single best source for relevant textiles, but also see Ogasawara 1989 and Fujian Provincial Museum 1982, for a large group of garments and silk pieces from a tomb dated to 1243.

Bahram Gur, a prince and later ruler of Iran, is shown wearing a robe decorated in gold with a recumbent deer, its head turned backward, set in a landscape (fig. 110). A very closely related motif, brocaded in gold on a red silk ground, forms the repeat pattern on a Chinese textile (fig. 66), probably a fragment of a garment, dating to the Jin dynasty (1115–1234).[18]

The range of textiles that played a part in the artistic transmission westward to the Iranian world goes beyond the products of Mongol patronage. It includes earlier textiles of the Northern Song (960–1127), Liao (907–1125), and Jin dynasties in China, as well as textiles of the eleventh to the thirteenth century from Central Asia.[19] These pre-Mongol luxury textiles (figs. 66, 202, 203, 207) display the motifs and techniques that the transplanted artists must have brought with them. It should be

noted that the Central Asian and Liao and Jin examples already represented a certain synthesis of Chinese and non-Chinese forms.[20]

The Spread to Other Media

Given the importance of luxury textiles to the Mongols and their evident presence in Iran, it is not surprising that designs and motifs found in textiles are mirrored in many aspects of Ilkhanid art and architectural decoration. Tiles, pottery, metalwork, and the arts of the book all reflect to varying degrees the impact of textile art, as the examples that follow should make clear.

The only excavated palace of the Mongol period in Iran, Takht-i Sulaiman, provides unique evidence of the types of architectural decoration produced for the Ilkhanid court in the 1270s. Most prominent among the finds at Takht-i Sulaiman are glazed tiles that decorated the interiors, particularly of the northern octagonal chamber at the northwest corner of the palace complex, which may have been part of the ruler's living quarters.[21] Numerous other tiles of identical types that were not obtained archaeologically have passed through the art market into public and private collections. Both the excavated and non-excavated tiles provide information on the broad range of motifs used to adorn the Ilkhan's private space and to express his royal status (figs. 59, 97, 100).

The walls of the northern octagonal pavilion had a tile revetment rising to a height of six feet composed of interlocking star and cross tiles. They were decorated

20. I am grateful to James Watt for pressing this important point in several conversations.
21. E. Naumann and R. Naumann 1969. See also Sheila Blair's chapter 5 in this catalogue.

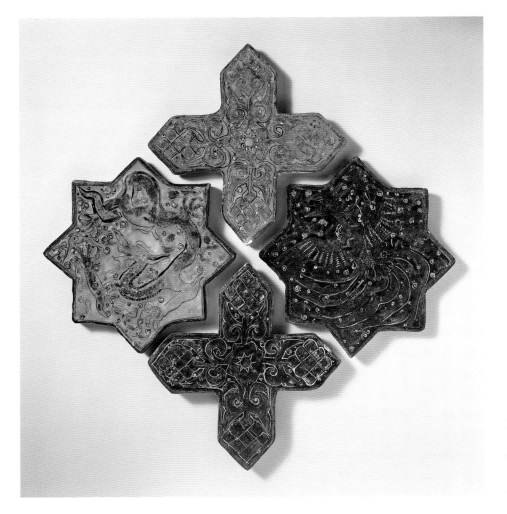

Fig. 204 (cat. no. 83). Star and cross tiles, Iran (probably Takht-i Sulaiman), 1270s. Fritware, overglaze painted (*lajvardina*). Los Angeles County Museum of Art, Shinji Shumeikai Acquisition Fund (AC1996.115.1–4)

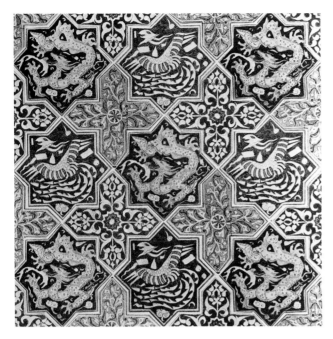

Fig. 205. Reconstruction drawing of *lajvardina* star and cross tiles from the North Octagon, Takht-i Sulaiman, Iran, 1270s. After R. Naumann 1977, fig. 67

in the overglaze painting technique that is known as *lajvardina*, after the Persian word *lajvard* (lapis lazuli), because of the distinctive deep blue employed. The tiles were made in molds and carry relief decoration: floral and abstract motifs on the cross tiles, and on the star tiles either a boldly rendered coiled dragon chasing what appears to be a flaming pearl—the well-known motif of dragon and pearl has its basis in Chinese literature—or a phoenix in flight with outstretched wings.[22] The tiles are glazed either turquoise or the previously noted deep cobalt blue (figs. 101, 204). They are overglaze-painted with red, white, and black for subsidiary details, and the relief design was originally entirely covered with gold leaf. Thus the star tiles would each have displayed a coiled dragon or a soaring phoenix rendered in gold against a turquoise or deep blue ground. According to the excavators, the star tiles may have been clustered in separate groups of either blue or turquoise.[23]

A reconstruction drawing suggests that the tile revetment presented a dense pattern of alternating dragons and phoenixes within star-shaped lozenges (fig. 205), not unlike a textile design. There is, in fact, a Chinese Yuan-period textile fragment decorated with staggered rows of medallions bearing either a coiled dragon chasing a flaming pearl or a soaring phoenix (fig. 206). Its mythical beasts are woven in gold against a blue ground.[24] Closely related designs also woven in gold, these with a repeat pattern limited to either the coiled dragon chasing a pearl or the soaring

Fig. 206 (cat. no. 183). Textile with dragons and phoenixes, China, Yuan dynasty (1271–1368). Lampas weave (twill and twill), silk and gold thread. The Cleveland Museum of Art, Edward L. Whittemore Fund (1995.73)

22. For a discussion of the dragon and the phoenix in Chinese art and their relationship to the Takht-i Sulaiman tiles, see Masuya 1997, pp. 564–81. For an interpretation of these motifs at Takht-i Sulaiman in an Iranian context, see Melikian-Chirvani 1984, pp. 317–31; also see Melikian-Chirvani 1991, pp. 102–9.

23. E. Naumann and R. Naumann 1969, p. 55.

24. The identical pattern is preserved on a cloud collar band in the Palace Museum, Beijing; see Watt and Wardwell 1997, p. 132, fig. 57.

25. For the pre-Mongol tiles, see O. Watson 1985, pp. 122–23, and figs. 105–7. A silk fragment of the eighth or ninth century from Iran (The Metropolitan Museum of Art, New York, 46.156.6) is decorated with a star and cross motif; it is tempting to think that this pattern was translated from textiles and wall hangings to tile revetment. For a discussion of the importance in general of textiles in the medieval Islamic world, see Golombek 1988.

26. In an album in the Topkapı Palace Library, Istanbul (H. 2152; see below), there is a small drawing of a phoenix enclosed by a ten-pointed star (fol. 89r), a configuration not found among the

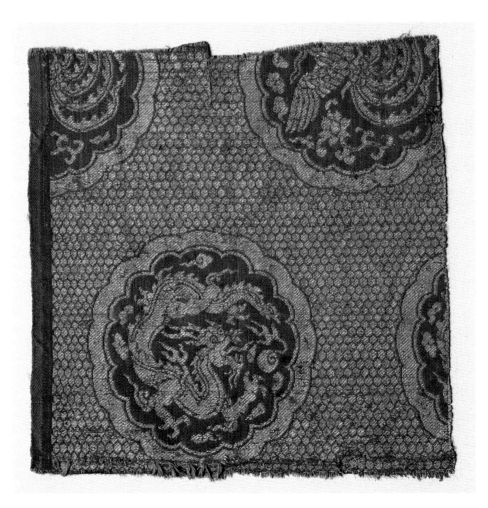

phoenix, are preserved from the Jin period (figs. 202, 207), and their golden creatures set against a turquoise or deep red ground compare somewhat more closely to the tile revetment. The imperial symbolism of the dragon and the phoenix is discussed by Tomoko Masuya in chapter 4; it may be that the combination of these two motifs on a textile or a wall revetment was intended as a particularly emphatic declaration of royalty.

Despite the greater density of its pattern, the tile revetment is strikingly similar to the textiles in overall effect. Textiles were certainly used as wall hangings under the Mongols (see fig. 189, where related tile decoration is also depicted, and fig. 90) and earlier in Iran, and it may be that the tile revetments at Takht-i Sulaiman were inspired by this medium. The star and cross format for tile revetment, and other patterns at Takht-i

Sulaiman created by the combination of tile shapes—see, for example, fig. 204—predate the Mongol invasions in Iran; the source for some of these patterns may well prove to be earlier Islamic textiles.[25]

The actual motifs of the dragon and the phoenix on these tiles are very close to those on the textiles just mentioned.[26] In fact, the textiles make it possible to read more clearly the subsidiary relief and other designs on the tiles—and to see that the dragon is indeed grasping at a pearl, or at least that such was probably the original idea of the design, perhaps not fully understood by the tile's Persian maker.[27]

Closely related *lajvardina* revetment tiles (this time hexagonal) bearing either a coiled dragon (fig. 102) or a soaring phoenix were also found in situ at Takht-i Sulaiman, in the central room between the two octagonal pavilions.[28] These would have produced a somewhat less densely patterned effect, perhaps even more reminiscent of a textile design. Dragons and phoenixes form the main decoration as well on a number of other types of tile from Takht-i Sulaiman (figs. 93, 101, 106, 275),[29] most notably large square frieze tiles with a relief dragon or phoenix amid clouds, rendered in both *lajvardina* and luster techniques (figs. 59, 97, 100). According to the excavators, the *lajvardina* tiles were set above the dragon and phoenix star and cross revetment in the north octagonal chamber.[30] All of these frieze tiles have a narrow upper border composed of a band of vine scrolls with large peony flowers and a narrower lower border with scrolling vine and rosettes. Their dragons are related to dragons depicted on a group of strikingly colored silk tapestries thought to have been made in Central Asia between the eleventh and early thirteenth centuries, and the floral motifs on the borders of the tiles have parallels in the same textiles.[31]

A group of ceramic bowls decorated with phoenixes that belong to the general category known as Sultanabad wares also bears comparison with textiles. In the past

Takht-i Sulaiman tiles and one significant for the argument presented later in this essay. See Roxburgh 2002, p. 46, fig. 5, beneath the horses's feet and to the left. It is tempting nonetheless to see this fifteenth-century drawing as a copy after an earlier design for a tile rather than as the artist's original attempt to enclose a design of a phoenix in a star.

27. One notable difference is in the number of the dragon's claws: five in the textiles, four in the tiles. As noted in chapter 4, the omission of one claw in the Ilkhanid version of this royal motif may be a sign of deference to the Great Khan.

28. E. Naumann and R. Naumann 1969, p. 55.

29. See Masuya 1997, pp. 256–57, pls. 28–29, for a discussion of the exterior tiles, and pp. 323–39, pls. 75–83, which include references to luster-painted versions of the star tiles.

30. E. Naumann and R. Naumann 1969, pp. 55–57.

31. Watt and Wardwell 1997, pp. 64–71, nos. 13–15, pp. 75–79, nos. 17, 18. Crowe 1991, p. 155, noted the relationship between textiles and the floral borders of the relief tile with dragons. One last type of paired tile group from Takht-i Sulaiman should be mentioned, also from the central room between the two octagonal pavilions, the hexagonal *lajvardina* tiles bearing either a leaping feline or a recumbent deer (figs. 93, 218) in a compressed landscape; E. Naumann and R. Naumann 1969, pp. 41–43. Both the figures of the animals and

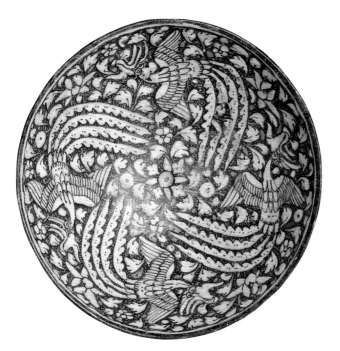

Fig. 208 (cat. no. 134). Bowl with four phoenixes, Iran, 14th century. Fritware, underglaze painted. Los Angeles County Museum of Art, The Nasli M. Heeramaneck Collection, Gift of Joan Palevsky (M.73.5.215)

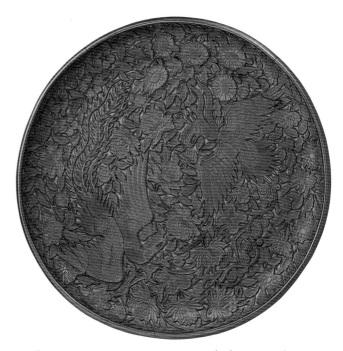

Fig. 209 (cat. no. 203). Lacquer tray with phoenixes, China, Southern Song dynasty (1127–1279). Red, yellow, and black lacquer on wood. Arthur M. Sackler Gallery, Smithsonian Institution, Washington, D.C.; Gift of Arthur M. Sackler (S1987.0396)

most of the landscape were molded in relief and covered with gold leaf, strikingly contrasting with the deep blue or turquoise ground. No exact parallels exist in textiles, but there are several comparisons worth making. The tile with recumbent deer is very similar in composition and overall effect to a silk with a design of reclining *djeiran,* or Central Asian antelope, within a landscape, brocaded in gold on a red ground and dating to the Jin dynasty (fig. 66). The design is repeated in reverse in alternate rows. The excavators' reconstruction drawing of the hexagonal tile revetment at Takht-i Sulaiman with alternating deer and feline, creating a pattern of golden animals and landscape elements against a blue or turquoise ground, is, although denser in feel, very similar to the design of the Jin textile; for the reconstruction drawing, see E. Naumann and R. Naumann 1969, fig. 5. The recumbent deer and the leaping feline also find parallels among the group of Central Asian silk tapestries noted above. The feline with tufted tail, possibly a lion, can be related to the playful lions with tufted tails chasing a ball against a floral background on an eastern Central Asian silk tapestry, or *kesi,* of the eleventh or twelfth century; for the *kesi,* see Watt and Wardwell 1997, p. 68, fig. 22. Crowe 1991, p. 157 and fig. 7, has compared the tile with a feline to a Song textile band that seems to lack any floral or landscape elements.

32. For a recent study of Sultanabad wares, see P. Morgan 1995.

33. See, for example, Allan 1991, pp. 34–35. P. Morgan 1995, pp. 35–36, suggests instead a connection with Chinese ceramics of two related types, Cizhou and Jizhou wares.

such wares were attributed to Sultanabad in western Iran, where many of these vessels were found, although there is no evidence that any of them were actually made there. They were probably produced during the first half of the fourteenth century.[32] The hemispherical shape of the bowls, their exterior decoration of radiating petal-like designs, and the muted gray-green color scheme have often led to the suggestion that so-called Sultanabad pottery was inspired by imported Chinese celadon wares (fig. 240; fig. 238 is an Iranian bowl imitating celadon).[33]

On the Sultanabad bowls under discussion, phoenixes depicted in pairs or groups of three or four are typically arranged in a radiating design that is emphasized by the birds' long, curved tail feathers (figs. 208, 242). This scheme is particularly well suited to the deep interior of the bowl. The phoenixes are set against a background of peonies, a typical feature of Sultanabad wares. A very closely related motif composed of two phoenixes, one with much fuller plumage than the other, was evidently popular under the Yuan dynasty and was rendered in a variety of media, although the design likely predates this period in China.[34] One example is a Yuan-period stone slab found at Dadu (Beijing), on which the motif, framed by a lobed medallion, is carved in relief. Floral blossoms fill the spaces between the phoenixes, which fly toward one another not unlike amorous birds of prey. The same dynamic motif occurs on more portable objects, such as a small carved lacquer tray (fig. 209) that has been dated to the Southern Song dynasty (1127–1279) and a silk canopy of the Yuan period on which the phoenixes are embroidered in gold thread (fig. 210). It seems likely that the radial phoenix motif found on early-fourteenth-century Sultanabad pottery was derived from the Chinese design related to it, and that textiles like the embroidered canopy served as the intermediaries.[35]

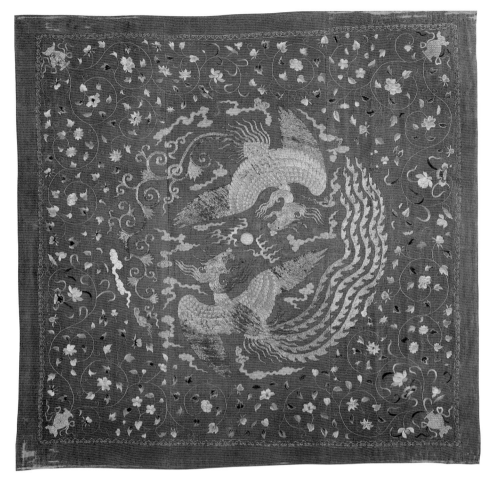

Fig. 210 (cat. no. 184). Canopy with phoenixes, China, Yuan dynasty (1271–1368). Embroidery, silk and gold thread. The Metropolitan Museum of Art, New York, Purchase, Amalia Lacroze de Fortabat Gift, Louis V. Bell and Rogers Funds, and Lita Annenberg Hazen Charitable Trust Gift, in honor of Ambassador Walter H. Annenberg, 1988 (1988.82)

34. Watt and Wardwell 1997, p. 60, see the motif as an innovation of the Yuan period and suggest that the phoenixes represent two different "species," although they note this design's presence in an illustrated Song encyclopedic work on architecture and architectural decoration from the early twelfth century, *Yingzao fashi*. For a different interpretation of the pair of phoenixes (male and female), see Rawson 1984, p. 100, which also includes examples that are said to predate the Yuan period. See also P. Morgan 1995, p. 30, which notes the occurrence of the motif in Yuan silver.

35. For example, a brocaded tabby in the Tokyo National Museum bears roundels with paired male and female phoenixes in gold on a red ground; see *Meibutsu-gire* 2001, no. 32. I am grateful to Nobuko Kajitani of the Metropolitan Museum for this reference.

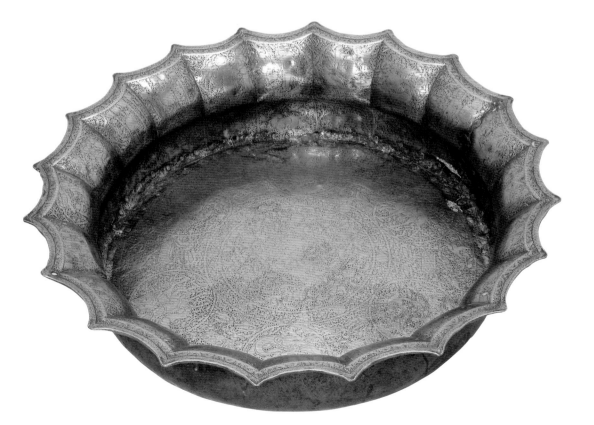

Fig. 211 (cat. no. 169). Basin, western Iran, early 14th century. Brass, inlaid with silver, gold, and black compound; engraved champlevé technique. Victoria and Albert Museum, London (546-1905)

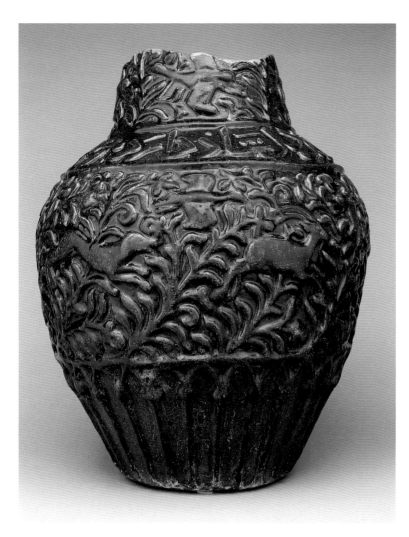

Fig. 212 (cat. no. 129). Jar with molded decoration, Iran, A.H. 681/A.D. 1282–83. Fritware, monochrome glaze. The Metropolitan Museum of Art, New York, H. O. Havemeyer Collection, Bequest of Horace Havemeyer, 1956 (56.185.3)

Motifs borrowed from textiles may also play a part in the decoration of some types of metalwork from the Ilkhanid period; one example is a large faceted brass basin originally inlaid with silver and gold (fig. 211). As very little has survived of the inlays, which carried most of the detail of the extensive figural decoration, what remains are mainly the outlines of the original compositions. While the form of the basin and the compartmentalization of its decoration in medallions and cartouches are familiar from earlier Iranian metalwork, most aspects of the decoration originated in the Ilkhanid period. The medallions bearing a coiled dragon or a soaring phoenix, the extensive aquatic landscape at the bottom of the basin, the use of waterfowl as a subsidiary motif in surrounding zones, the depiction of figures within a landscape, and the figures garbed in Mongol costume all indicate an Ilkhanid date.[36]

The images of the dragon and the phoenix within medallions are similar to those found on the star tiles from Takht-i Sulaiman (figs. 101, 204) and to the textiles already cited as related to them (figs. 202, 206, 207). On this basin, however, the resemblance to the textile designs is even more striking. As the coiled dragon grasps a flaming pearl, its lower torso coils and twists around toward the head to form a circle, just as on the textile. The soaring phoenix on the basin, with outstretched wings and elaborately trailing tail plumage, differs from the textile version mainly in flying downward rather than upward.[37] While the dragon and phoenix are similar to those on Chinese textiles of silk woven with gold like the ones noted, the other animal scenes on the basin are comparable to ones on certain silk tapestries ascribed to Central Asia of the eleventh to the thirteenth century.

The lush aquatic landscape, framed in a large medallion at the bottom of the basin, replete with waterfowl such as swans and geese, recalls the decoration of a silk tapestry, or *kesi,* with aquatic birds amid a dense pattern of lotus buds (fig. 213). The ducks or geese among floral blossoms in adjacent compartments on the basin are even more closely related to the textile design. On the faceted walls of the basin are twenty panels containing a variety of animals set against a vegetal, generally floral, background. Although decoration with bands of pacing animals predates the Ilkhanid period in Iran, the greater naturalism with which the animals are rendered here and the inclusion of "landscape" elements are features unknown earlier. Closely related bands of animals are used as subsidiary decoration on frieze tiles from Takht-i Sulaiman (figs. 50, 98, 107–109), while similar bands of animals against a floral background appear in relief on a large jar glazed cobalt blue and dated 1282–83 (fig. 212) and on silk tapestries ascribed to Central Asia.[38] It is perhaps textiles that introduced this motif to Ilkhanid Iran. In its original state, the densely decorated interior of the basin—with nearly all its surface covered with silver or gold,

36. For detail images and a discussion of this object within the context of Ilkhanid art and symbolism, see Melikian-Chirvani 1997, pp. 135–77, pls. XII–XXII.

37. Interestingly, the motifs of dragon and phoenix are combined within a single medallion on an inlaid brass basin in Berlin that also belongs to the Ilkhanid period, although some of its other decoration appears to have been reworked. See Enderlein 1973, p. 7, fig. 1, and pl. I, 1b.

38. For the relevant silk tapestries see Watt and Wardwell 1997, pp. 66–68, no. 14, pp. 80–82, no. 19.

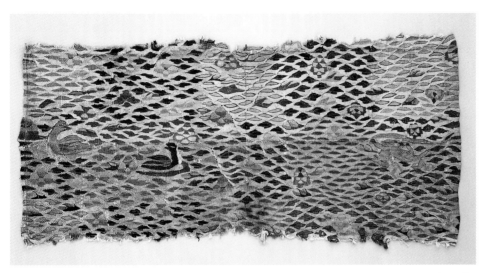

Fig. 213. Silk tapestry (*kesi*) with aquatic birds and recumbent animal, eastern Central Asia, 12th–13th century. The Metropolitan Museum of Art, New York, Purchase, Gifts in memory of Christopher C.Y. Chen, Gifts from various donors, in honor of Douglas Dillon, Barbara and William Karatz Gift, and Eileen W. Bamberger Bequest, in memory of her husband, Max Bamberger, 1997 (1997.7)

probably against a black inlaid ground—would have presented an elaborate pattern not unlike that of a textile.

The last Ilkhanid art form to be considered here in the context of textiles is manuscript illustration, whose development and main forms of expression are discussed in the preceding chapter. The relationship between textiles and manuscript illustration has exclusively to do with the presentation of landscape and the conception of space, both of which were dramatically transformed in the Ilkhanid period.

With depictions of landscape in Ilkhanid painting, particularly mountainous landscapes, the influence of East Asian art is undeniable. This is evident, for example, in illustrations from the *Manafiʿ-i hayavan* (On the Usefulness of Animals), the *Jamiʿ al-tavarikh* (Compendium of Chronicles), and the Great Mongol *Shahnama* (for example, figs. 162, 168, 187; see Robert Hillenbrand's chapter 6). The most obvious candidate for the role of transmitter, Chinese scroll painting, is perhaps not the likeliest or at least the most consistent source. Persian landscapes

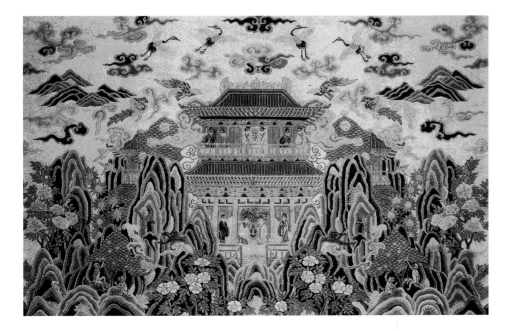

Fig. 214. *Immortals in a Mountain Pavilion,* leaf 5 from the album *Louhui jijin ce,* Northern Song dynasty (960–1127), early 12th century. Silk tapestry (*kesi*). National Palace Museum, Taipei

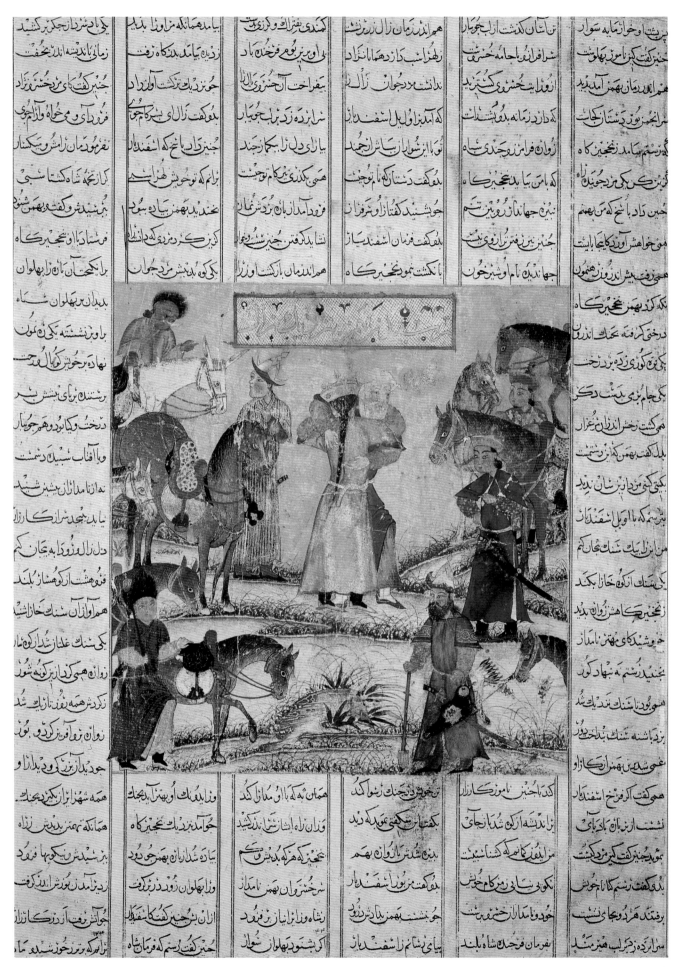

Fig. 215 (cat. no. 40). *Bahman Meeting Zal,* page from the Great Mongol *Shahnama* (Book of Kings), Iran (probably Tabriz), 1330s. Ink, colors, and gold on paper. Collection des Musées d'Art et d'Histoire, Geneva (1971-107/2a)

differ in both concept and detail from those depicted in Chinese paintings.[39] They do incorporate certain generic features from Chinese painting, for example the rugged contours of the mountains, but without the sense of mass, texture, space, monumentality, or intimacy of the originals, as though the models had been viewed at second hand or in a much distilled form.[40]

Textiles may be a more likely source than scroll painting for the introduction of certain Chinese landscape elements into Persian painting. For example, the silk tapestry *Immortals in a Mountain Pavilion* (fig. 214), made under the Northern Song dynasty in the early twelfth century, depicts a pavilion set in the mountains[41] and is obviously based upon a painting. In it the overlapping peaks of the mountains are defined by solid blue, green, and gold outlines that give them a dense, patternlike quality. This woven rendition of a mountainous landscape sheds light on the depictions of dense and spiky peaked mountain ranges in numerous Ilkhanid paintings, such as the *Shahnama* illustration *Bahram Gur Slaying a Dragon* (fig. 187), where the mountains are similarly defined by green, brown, and gold outlines with almost no additional color or detail. While Persian manuscript illustration was formulated with influences from a number of sources, Chinese textiles may have provided the foundation for its landscape imagery.[42]

Space is newly suggested in Ilkhanid paintings by a variety of means, including converging or overlapping diagonal planes within the landscape, marked by tufts of grass, as in the *Shahnama* illustration *Bahman Meeting Zal* (fig. 215). The same device is found in Chinese textiles. In the silk embroidery *Welcoming Spring* (fig. 216), dating to the Yuan period or later,[43] the figures are placed within or between diagonal lines that suggest planes and help to situate them in space. The gnarled tree at the top of the same embroidery, bending with the weight of years, is a frequent motif in Ilkhanid painting (fig. 200) and may also derive from Chinese textiles rather than Chinese painting. This is not to say that such pictorial devices do not occur in Yuan painting, for example as discussed in chapter 3, but rather that at present better evidence exists for textiles having served as the primary transmitter from East to West.

In China under the Yuan, a clear relationship linked silk tapestry and other patterned silks with painted portraits. Painted portraits served as models or cartoons for woven versions, which the Mongols evidently preferred.[44] This must have been the case with the royal portraits in the lower corners of the Yamantaka Mandala silk tapestry (figs. 125, 126).[45] The well-known painted imperial portraits of Khubilai Khan and his consort Chabi (figs. 14, 27) were very likely reproduced as woven images for a Lamaist Buddhist shrine.[46] This process may have been reversed in Iran; there, imported textiles provided models for paintings and drawings. Indeed, the interrelationships between textiles with complex weave structures and their two-dimensional counterparts may have been quite significant for the dissemination and adaptation of East Asian artistic ideas and motifs in Iran, and is the subject of the next section of this essay.

So far an attempt has been made to show that luxury textiles were an important means for the introduction of a new aesthetic to Iran. This is not to suggest that all manner of Persian artists had direct access to these expensive imported goods; textile workers, however, presumably did, if only for the purposes of producing copies.

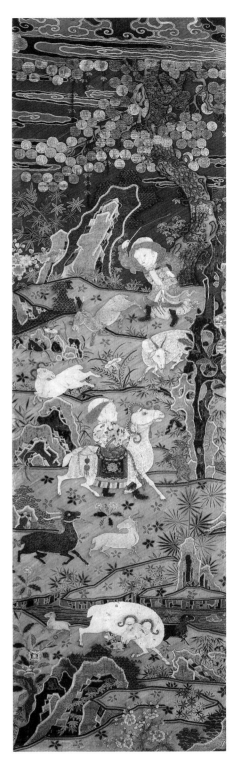

Fig. 216. *Welcoming Spring,* Yuan dynasty (1271–1368) or later. Embroidery. The Metropolitan Museum of Art, New York, Purchase, The Dillon Fund Gift, 1981 (1981.410)

39. This is not to imply that Chinese landscape painting speaks with a single voice; on the contrary. See, for example, Fong 1984, pp. 20 ff.

40. While there is no direct evidence that scroll paintings on silk traveled from China to Iran during this formative period for Persian painting, many have speculated whether Chinese paintings of this type were present at the Ilkhanid court. Blair 1995, pp. 46–50, discusses the possibility that Chinese

scrolls were kept in the Tabriz atelier of Rashid al-Din in the early fourteenth century, there serving as a models for the rectangular format of the *Jami*ᶜ *al-tavarikh* illustrations and for the repeated cropping of the pictorial surface at the sides; see, for example, figs. 130, 162, 174. However, as far as I am aware there is no conclusive evidence for direct contact with Chinese painting in Iran until the Timurid period (1370–1506), when, particularly during the reign of Shah Rukh (r. 1405–47), numerous diplomatic and commercial exchanges took place between the Timurid and the Ming courts. A delegation from the Chinese court that arrived in Iran in 1417 brought with it a painting, a gift from the Ming emperor. It depicted a pair of

Fig. 217 (cat. no. 70). Textile with paired rabbits, probably Iran, 14th century. Lampas weave (satin and tabby), silk and gold thread. Cooper-Hewitt National Design Museum, Smithsonian Institution, New York, Gift of John Pierpont Morgan (1902-1-262)

In the early Ilkhanid period textile workers were perhaps the principal group of artists familiar with the practice, if not the art, of drawing. It is proposed below that through drawings on paper, designs were made accessible to a wide range of artists in Iran anxious to please their Mongol patrons.

DISSEMINATION OF THE NEW VISUAL LANGUAGE: DRAWINGS ON PAPER

There was a design by Mir Dawlatyar for a saddle. Khwaja Mir Hasan copied it, and Khwaja Mir Hasan's son Mir Shamsuddin and Ustad Dawlat-Khwaja are busy executing it in mother-of-pearl. —Anonymous, *Arzadasht*[47]

The evident significance of luxury textiles in Mongol Asia both east and west and the number of correspondences between textiles and Ilkhanid art in various media are the grounds for the proposal that textiles were crucial in the transmission of artistic ideas and motifs from East Asia to Iran. It is possible that not only textiles but also textile workers were transported from China to Iran, and of the Islamic weavers and other specialists conscripted and sent to the East, at least some were allowed to return home.[48] If textiles did play such an important part in the formulation of a new visual language in Iran, perhaps textile artists and the techniques they employed also had a role in the dissemination of this new language throughout the Iranian world. In fact, the ascendancy of this medium may have brought with it, quite literally, a paper trail.

Only one textile bearing internal evidence that it was made for an Ilkhanid ruler survives,[49] but the Ilkhanids must certainly have set up and patronized textile workshops in Iran, since textual sources clearly indicate that the court commissioned luxury textiles. For example, cloth woven with gold was produced in Tabriz to be sent as diplomatic gifts to the Mamluk sultan by the Ilkhan Tegüder Ahmad, as noted above;[50] and from Rashid al-Din's account of the contest for the throne between Tegüder Ahmad and Arghun (r. 1284–91), we know that the latter sent orders to the workshops in Nishapur, Isfarayin, and Tus, all cities in Khurasan, for garments to be distributed to his military commanders.[51] A number of other

Fig. 218 (cat. no. 87). Hexagonal tile with recumbent deer, Iran (Takht-i Sulaiman), 1270s. Fritware, overglaze painted (*lajvardina*). Deutsches Archäologisches Institut, Berlin (DAI 2)

Fig. 219. Textile design in a sketchbook belonging to Jacopo Bellini, Italy, late 14th century. Fol. 88v; ink over metalpoint or silverpoint on parchment. Musée du Louvre, Paris (RF 1556v)

textiles have been attributed to Ilkhanid Iran, although their Iranian or in some cases even Islamic provenance is not assured. Whether Iranian, Egyptian, Italian, Chinese, or Central Asian, the textile artists who produced these luxury stuffs must have broadly shared a common technology and methodology.

Some form of graphic instruction was almost certainly necessary for the production of complex, patterned silk weavings of the types here under discussion, which must have been made on drawlooms.[52] A draft for a luxury woven textile had to be made by someone familiar with the workings of the loom and the specific requirements of the cloth; it would have been executed on squared paper and annotated.[53] Such drafts may themselves have been based on working drawings like those known from fourteenth-century Italy, which were likely produced for a silk-weaving workshop; an example is a drawing (fig. 219) in an album in the Louvre (in another twist, this particular drawing was probably derived, in part, from an Ilkhanid textile).[54] This is not to suggest that the paper trail was composed of the types of drawings known from Islamic albums or medieval European model-books,[55] but rather that the practice of making squared and annotated drafts helped to introduce and popularize the use of drawings as a means of transmitting and transferring designs. While it is true that drawloom textiles (based on some type of preplanned design) were made in Iran and elsewhere in the Islamic world prior to the Mongol invasions, the greatly enhanced importance and increased production of

grooms and a white horse that had been sent from Iran to China on a previous embassy. See Lentz and Lowry 1989, p. 187. Also see Thackston 1989, pp. 279–97, on the Timurid/Ming missions, in particular the one from Herat to Beijing in 1419, which included the artist Ghiyath al-Din; he left an important account of his trip, here translated by Thackston. On the impact of Chinese drawings on Persian drawings in the Timurid period, see Roxburgh 2002, pp. 50–53.

41. Fong and Watt 1996, p. 249 and pl. 127.
42. Soucek 1980, p. 89, briefly considers the role of textiles in the formation of landscape in Persian painting.
43. Watt and Wardwell 1997, pp. 194–96, no. 59, where it is dated to the Yuan period; however, James Watt has suggested in a conversation that the work might be a later copy of a Yuan embroidery.
44. Watt and Wardwell 1997, pp. 60–61.
45. Ibid., pp. 96–99.
46. Jing 1994b, pp. 53–55; also, Fong and Watt 1996, p. 267.
47. Thackston 2001, pp. 43–44.
48. Allsen 1997a, pp. 39–40, for the weavers who were eventually restored to their home in Herat.
49. This well-known gold and silk textile is inscribed with the name and titles of Abu Saʿid (r. 1316–35) and was subsequently used for the burial robe of Duke Rudolf IV of Austria (d. 1365). See Wardwell 1988–89, pp. 108 ff., and fig. 45, detail.

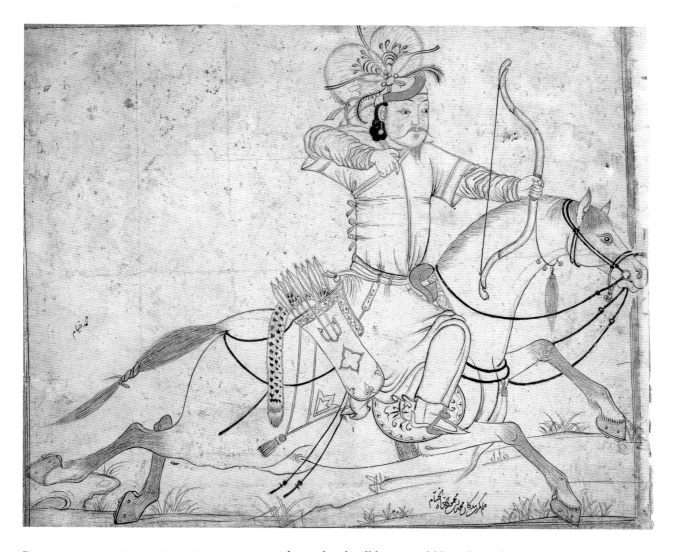

Fig. 220 (cat. no. 20). *Mongol Archer on Horseback,* illustration from the Diez Albums, signed Muhammad ibn Mahmudshah al-Khayyam, Iran, early 15th century. Ink and gold on paper. Staatsbibliothek zu Berlin—Preussischer Kulturbesitz, Orientabteilung (Diez A fol. 72, S. 13)

50. See n. 15.

51. Cited and translated in Allsen 1997a, p. 57; see also n. 14, above. Also see the passage by Juvaini quoted at the head of chapter 4 in this catalogue; perhaps the master craftsmen mentioned came from Tus.

52. On the drawloom and weaving techniques in general, see Burnham 1980, especially pp. 48–50.

53. On Islamic drawloom textiles, see a recent study of Ottoman silks, Atasoy et al. 2001, pp. 197–200; see also Mackie 1992 for a design book for modern Moroccan textiles. For Italian Renaissance textiles, many of which were inspired by Ilkhanid and Yuan silks, see Monnas 1987.

54. Scheller 1995, p. 267. See also Monnas 1987, p. 418, where the Louvre drawing, which is included in Jacopo Bellini's sketchbook, is ascribed to a professional silk designer's workshop.

55. On the all-important Persian albums in the Topkapı Palace Library, Istanbul, the most comprehensive work to date is Roxburgh 1996. The albums certainly include designs associated with textile art,

textiles under the Ilkhans would have brought new attention to the practical value of drawings and designs on paper.[56] Artists in Iran who produced designs containing unfamiliar motifs, such as the dragon and the lotus on woven silks (figs. 75, 199) or the deer on glazed tiles (fig. 218), may have copied the motifs from imported textiles of the types exemplified by figs. 202, 206, 207, with drawings on paper serving as the intermediary.

The quotation a few paragraphs above is from the *Arzadasht,* a kind of progress report written by the head of an atelier for his princely master in the early fifteenth century. This highly significant document may indicate that preparatory drawings were in use in Iran by the first half of the fourteenth century—before the Timurid period (1370–1506), when the practice is far better documented.[57] According to Dust Muhammad, a sixteenth-century Persian painter and historian, Mir Daulatyar was known for his pen-and-ink drawings and was an artist active at the court of the Ilkhan Abu Saʿid (r. 1316–35). During that reign, Ahmad Musa, Mir Daulatyar's teacher, is credited with inventing the art of Persian manuscript painting (see quotation at head of chapter 6).[58] It is not known what type of saddle (*zain*) or part thereof Mir Daulatyar's drawing originally represented. Perhaps the design was for a saddle covering made of gold (see figs. 9, 63) or possibly a woven or embroidered example like the one on the horse in the right-hand frontispiece of the *Tarikh-i jahan-gusha* (fig. 201), with a lion in a solar disk and clouds in gold on a blue ground.[59] Two other key facts emerge from the *Arzadasht* citation: first, Mir

Daulatyar's drawing was preserved and still in use a century after it had been made, indicating that such designs were considered worth saving; second, the design, although intended for use in one medium, was later copied to be executed in another (mother-of-pearl, not a suitable material for a saddle).

Among the numerous extant Persian drawings of the fourteenth through the sixteenth century, many survived because they were bound into albums. Most of these drawings were apparently not conceived as autonomous works of art but rather played an intermediary role in the creative process from preliminary design concept to finished object—whether that object was of paper, silk, or metal. Such designs were in a sense tools, and the majority of the drawings preserved today in albums in Istanbul and Berlin (see below) show marked signs of use and reuse.[60] The fact that many drawings were rebacked, patched, and ultimately incorporated into albums is a measure of their importance in Persian artistic practice. David Roxburgh, who has closely studied the Istanbul albums and their contents, cogently suggests that the "albums functioned as storehouses of models and visual ideas."[61]

The first albums, created in the fifteenth century, are seemingly random assemblages of paintings, calligraphy, pounces (tracings marked for transfer), sketches, and designs. Three albums in the Topkapı Palace Library, Istanbul (H. 2152, H. 2153, H. 2160), and a group of albums in the Staatsbibliothek, Berlin, long known as the Diez Albums (Diez A) incorporate material relevant to the Ilkhanid period.[62] They include early-fourteenth-century paintings, some perhaps made for an unfinished or dispersed copy of Rashid al-Din's *Jamiʿ al-tavarikh* and for a *Shahnama*. However, it is not yet possible to identify drawn designs that clearly date to the Ilkhanid period. Some of the drawings seem to be fifteenth-century copies after Ilkhanid designs, reflecting a practice already attested to in the passage from the *Arzadasht* quoted above (for example, fig. 223).

Especially significant for this discussion is a drawing in one of the Topkapı Palace Library albums (H. 2152; fol. 98r) composed of four bands of figural compositions and a fifth band of pacing animals, both real and imaginary (fig. 221).[63] Illustrated in the second and third bands are stories from the *Shahnama* of Firdausi—from the cycles of the legendary Persian heroes Bahram Gur (here shown with the ill-fated Azada) and Faridun (leading the even more unfortunate Zahhak, his hands bound behind). Depictions of these particular legends may have had special significance for an Ilkhanid audience, since the same or related scenes are featured on tiles from Takht-i Sulaiman (figs. 107, 108).[64] The drawing's first register shows a lady and her maid, both on horseback, an image that also may have some narrative function, while represented in the fourth band is a royal enthronement scene (as in the *Jamiʿ al-tavarikh;* see, for example, figs. 84, 222). The costumes and headdresses, horse trappings, accoutrements, and abbreviated landscape elements in the drawing are all reminiscent of Ilkhanid-period work. The halos seen here are common devices in Ilkhanid painting (figs. 51, 187) and decorative arts, such as metalwork and ceramics (for example, figs. 1, 108, 118, 224). The fifth register of the drawing is ornamental rather than narrative and carries depictions of a bull, a griffin whose curled tail terminates in a dragon's head, and a lion charging through an arabesque-like landscape of flowers.

such as drawings depicting cloud collar points; see Lentz and Lowry 1989, pp. 348–49, 352, nos. 95–97, 115, and pp. 352–53, no. 116, for a cloud collar. For model-book drawings, see Scheller 1995, p. 267, and figs. 147, 149. None of these drawings were necessarily the final versions used by the textile artist, but they may have been full-size working drawings.

56. On the relationship between textile production and the rise of paper in the Islamic world, see Bloom 2000, p. 21. Also see Bloom 2001, especially pp. 178–201, on the relationship between paper and the visual arts from the thirteenth century onward. I am grateful to Jonathan Bloom and especially Louise Mackie for patiently answering my naive questions on paper designs and Islamic drawloom textiles.

57. On the documentary significance of the *Arzadasht,* see Lentz and Lowry 1989, pp. 159ff.

58. Thackston 2001, pp. 12–13, 45 n. 19, where the Mir Daulatyar referred to in the *Arzadasht* is equated with the Mir Daulatyar described in Dust Muhammad's album preface. For a drawing in the Diez Albums (Staatsbibliothek, Berlin, fol. 73, S.46, #5) with the signature of, or more likely an ascription to, Mir Daulatyar, see Kühnel 1959, fig. 2.

59. Curiously, there is a small drawing in Istanbul of a lion with a sun disk; the drawing has been pounced (Topkapı Palace Library, Istanbul, H. 2152, fol. 86v, 6). See Roxburgh 1996, p. 753.

60. On the albums, see Roxburgh 1996, as well as Roxburgh 2002, which bears directly on the topic at hand. I am grateful to David Roxburgh for having provided me with a draft of this article. See also Scheller 1995, pp. 1–7; Swietochowski 1996, esp. pp. 537–39.

61. Roxburgh 2002, p. 45.

62. For the interrelationships among these four albums, see Roxburgh 1996, pp. 651–54.

63. I am most grateful to David Roxburgh for allowing me to study his slides and photocopies of many of the album pages in Istanbul and Berlin. While I do not agree with his dating of and his proposed sources for this drawing, I am certainly aware that if he had not pointed out its connection to the decorative arts (Roxburgh 1996, pp. 6, 769), the drawing would not have come to my attention.

64. Also see fig. 270, an inlaid metal bowl illustrating the story of Zahhak.

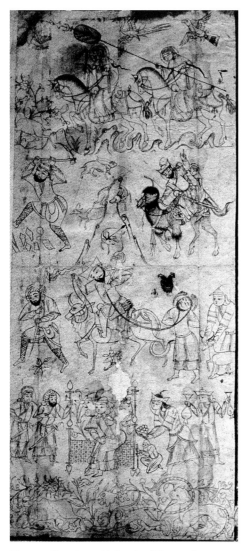

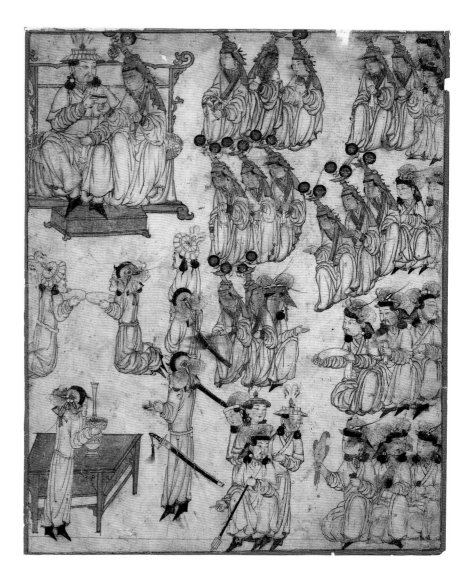

Fig. 221. Drawing with bands of figures, from an album, Iran, 14th century. Fol. 98r; ink on paper. Tokapı Palace Library, Istanbul (H. 2158)

Fig. 222 (above, right; cat. no. 18). *Enthronement Scene,* illustration from the Diez Albums, Iran (possibly Tabriz), early 14th century. Ink and colors on paper. Staatsbibliothek zu Berlin—Preussischer Kulturbesitz, Orientabteilung (Diez A fol. 70, S. 10)

Fig. 223. Drawing of designs in medallions, from an album, Iran, early 15th century, possibly after a 14th-century drawing. Ink and gold on paper. Staatsbibliothek zu Berlin—Preussischer Kulturbesitz, Orientabteilung (Diez A fol. 73, S. 47, #5)

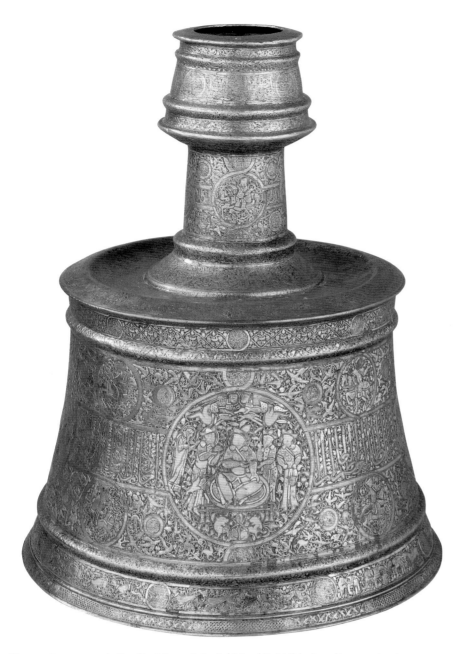

Fig. 224 (cat. no. 162). Candlestick, made by Sa'd ibn 'Abd Allah, Iran (Fars province), 1343–53. Brass, inlaid with silver and gold. Museum of Islamic Art, Doha, Qatar

Roxburgh dates the drawing to the second half of the fourteenth century and proposes that it is a kind of antiquarian work by an artist who looked back more than one hundred years at a variety of decorative objects[65] and copied their decoration. However, given the established practice of saving and copying earlier designs, it seems more likely that the artist selectively copied and combined two or more Ilkhanid drawings used to transmit motifs. Perhaps these were intended for translation into a variety of media. Compositions abridged from the *Shahnama* are found among the square frieze tiles from Takht-i Sulaiman (figs. 107, 108) and in the decoration of metalwork (fig. 270).[66] The enthronement scene is a common one on fourteenth-century metalwork (see below). Bands of pacing animals set against a rich foliate background also occur on the upper registers of certain frieze tiles from Takht-i Sulaiman (figs. 50, 98, 107–109) as well as on other molded tiles, as a subsidiary design in Ilkhanid metalwork (fig. 228), and in textiles. While the motif is

65. Which he dates prior to the Mongol invasions; Roxburgh 2002, pp. 57–59, fig. 17.
66. Although such scenes certainly occur earlier; see Simpson 1985.

Fig. 225. Drawing of *qilins,* from an album, Iran, 14th century. Red ink on paper. Staatsbibliothek zu Berlin, Preussischer Kulturbesitz, Orientabteilung (Diez A fol. 73, S. 46, #6)

Fig. 226. Drawing of cloud collar point with fantastic beings, Iran, early 15th century. Ink and colors on paper. Staatsbibliothek zu Berlin, Preussischer Kulturbesitz, Orientabteilung (Diez A fol. 73, S. 54, #1)

Fig. 227. Candlestick base, Iran, early 14th century, detail (see fig. 228). Brass, originally inlaid with silver and gold. The Trustees of The National Museums of Scotland, Edinburgh (A. 1909-547)

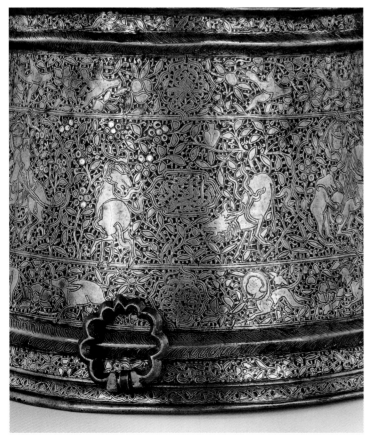

found in earlier Iranian art, it does not seem to occur in this precise form until the Ilkhanid period. Birds nearly identical to the cranes and the falcon (?) pictured above the female figures in the drawing's uppermost register are likewise seen flying above horsemen in the central register of frieze tiles from Takht-i Sulaiman and other related tiles (fig. 98).[67] The evident relationship between decorative arts and the Istanbul drawing, particularly as regards the *Shahnama* scenes, suggests that such drawings had a role in Ilkhanid art even apart from their obvious connection with manuscript illustration.

Another drawing important to the present discussion (fig. 223), from the Diez Albums in Berlin, is probably an early-fifteenth-century copy of several Ilkhanid designs.[68] The drawing contains two separate scenes of enthronement, one of the ruler and one of his consort, each enclosed in a roundel, with all figures clad in typical Ilkhanid costume and headgear. The enthronements obviously relate to early-fourteenth-century enthronement scenes illustrating the *Jami' al-tavarikh* (see figs. 84, 222) and to textiles (fig. 195).[69] But the closest analogues for the designs are in metalwork, such as a candlestick lavishly decorated with silver and gold inlay that has on its base four large figural compositions depicting enthronements set within medallions (fig. 224). Two of the medallions show the enthroned ruler with his attendants; in the third the ruler and his

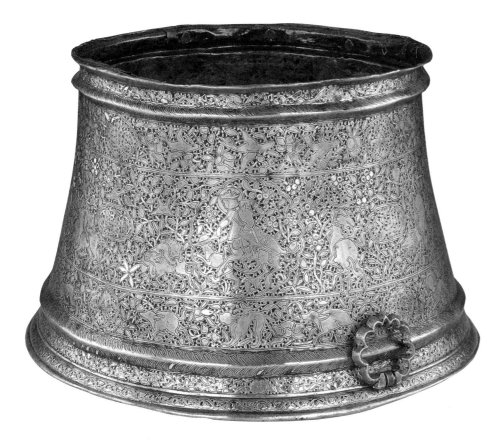

67. For line drawings of the Takht-i Sulaiman tile designs, see Masuya 1997, pp. 506–7.
68. Lentz and Lowry 1989, pp. 172, 173, 341–42, no. 60.
69. As first proposed by Lentz and Lowry 1989.
70. For a discussion of this headdress based on Persian sources, see Lambton 1988, p. 293. For a Western traveler's account that describes the *bughtaq* (*bocca*), see Ruysbroeck 1990, pp. 88–89. The comparison between the Berlin drawing and the candlestick was first noted in Komaroff 1994.

Fig. 228 (cat. no. 166). Candlestick, Iran, early 14th century. Brass, originally inlaid with silver and gold. The Trustees of The National Museums of Scotland, Edinburgh (A. 1909-547)

consort are represented together on one platformlike throne; and the fourth shows the enthroned consort, wearing the typical Mongol *bughtaq* on her head (as in figs. 27, 84, 122, 126).[70] The Ilkhanid designs on which the Berlin drawing is likely based must have survived into the fifteenth century. A related enthronement scene occurs

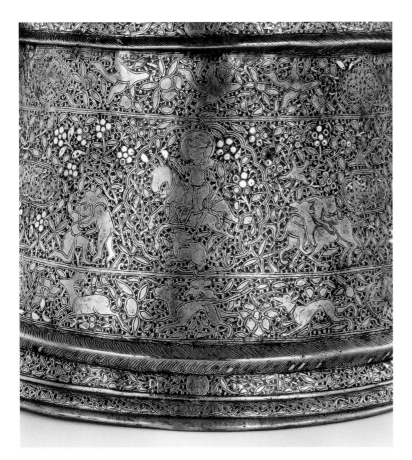

Fig. 229. Textile fragment with charging lion, northern China, Mongolia, or Central Asia, second half of the 13th century. Lampas, silk and gold thread. Museo Nazionale del Bargello, Florence (574)

Fig. 230. Candlestick base, Iran, early 14th century, detail (see fig. 228). Brass, originally inlaid with silver and gold. The Trustees of The National Museums of Scotland, Edinburgh (A. 1909-547)

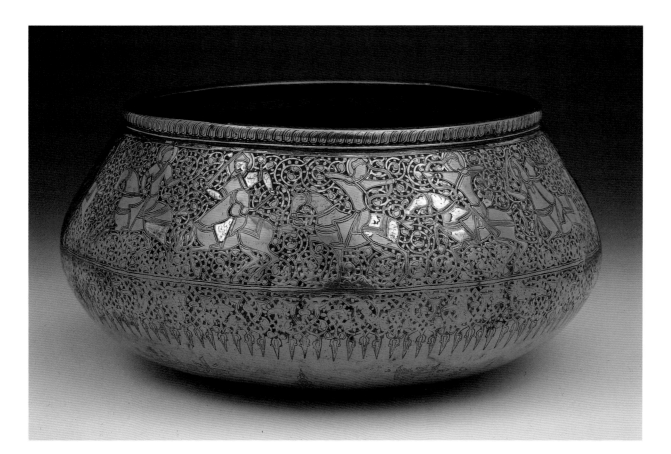

Fig. 231 (cat. no. 163). Bowl, Iran, A.H. 748/
A.D. 1347–48. Brass, originally inlaid with silver
and gold. Musée des Beaux-Arts, Lyon (E542-22)

71. Melikian-Chirvani 1982, pp. 182–84. The same
 type of deer appears in another drawing, in one of
 the albums in the Topkapı Palace Library, Istanbul
 (H. 2152, fol. 54v, bottom left); see Gray 1979,
 fig. 59. See also Watt and Wardwell 1997,
 pp. 66–69, for a Central Asian silk tapestry
 with the same motif. They suggest that the deer
 represents the reimportation of an originally
 Iranian motif.
72. See Lentz and Lowry 1989, pp. 194, 348–49,
 no. 96, pp. 216–17, no. 116, and pp. 352–53,
 no. 116, for a Persian cloud collar from the
 Timurid period. For a Chinese cloud collar
 of the Yuan dynasty, see Watt and Wardwell 1997,
 p. 132, fig. 57.
73. See Roxburgh 2002, fig. 3, for another design for a
 cloud collar point; here the beasts are referred to
 as bixies.
74. In fact, the decoration of the central portion of the
 candlestick is a veritable cornucopia of seemingly
 unrelated designs that are also found in drawings,
 a point not noted by Baer 1983, pp. 151–53,
 fig. 130, in her discussion of the candlestick's
 decoration.
75. Suriano and Carboni 1999, pp. 47–48, no. 11.
76. For example, in the Topkapı Palace Library, Istanbul
 (H. 2152, fol. 54v); see Gray 1979, fig. 59, bottom;
 also see Roxburgh 2002, fig. 18.
77. See Lentz and Lowry 1989, pp. 159ff.

on an Ilkhanid silk and gold tapestry (fig. 195). The motif in the third roundel of the drawing, a deer with mushroom-shaped antlers, is again found in metalwork of the Ilkhanid period.[71]

Two further drawings, both in the Diez Albums, are noteworthy. The first (fig. 225) is a design depicting two charging animals, either qilins (Chinese mythical deerlike creatures) or winged djeirans (antelopes). Whether qilin or djeiran, the beast on the right is shown from the back in a tortuous position, with head and forelegs twisted to the right. The second drawing (fig. 226) is a design for a cloud collar point, one of four scallop-shaped pieces making up the collar of a robe.[72] Here a pair of playfully combatant qilins in contorted but balanced poses dominate the drawing; such paired mythical beasts are a common theme in fifteenth-century album designs.[73] Significantly, a design similar to these two drawings occurs on the base of another candlestick of the Ilkhanid period, in Edinburgh (fig. 227). Most of the inlays have been lost, revealing the strong linear design of the candlestick's gracefully twisting qilins and emphasizing their relationship to those in the drawings.[74]

One or both of the fifteenth-century drawings from the Berlin albums may be based upon Ilkhanid designs that can in turn be linked to textiles. Decoration from the previously noted Edinburgh candlestick also helps to enhance the proposed links among designs, textiles, and drawings. The compressed power of the lion attacking a young camel on the candlestick (fig. 230) is strikingly similar to the open-mouthed, charging lion with twisting head on a fragment of a silk and gold cloth with a pseudo-Arabic inscription (fig. 229).[75] Related figures of combatant lions exhibiting a similar inner tension occur in fifteenth-century designs from the Istanbul albums that may be based on earlier drawings.[76] Drawings on paper evidently played an important part in the formulation and transfer of

designs in Iran during the Ilkhanid period, and that function continued into, and became a hallmark of, the Timurid period.[77]

One final example can be noted, a pair of inlaid brass bowls, one of which is dated 1347 and has lost most of its inlay (fig. 231). Both vessels (for the other, see fig. 232) are decorated with complicated and extensive figural compositions that recall contemporary manuscript illustration (see fig. 234). Perhaps not unexpectedly, at just about the time that Dust Muhammad said the veil was lifted from the face of painting in Iran (during the reign of Abu Saʿid, 1316–35; see chapter 6), a closely related phenomenon was occurring with the decoration of metalwork. From the 1330s to the 1350s the figural compositions of inlaid metalwork achieved their most elaborate form, becoming like paintings in silver and gold.[78]

On each of these bowls is a band presenting a variety of powerfully conceived, dynamic figures of huntsmen and warriors. In fact, the bowls display identical figures— see the pair of charging horsemen spearing a bear (figs. 232, 233)—but arranged in a different order. Furthermore, the internal and external outlines of certain figures showing how and where the inlay was to be applied are exactly alike on the two vessels. The details of their inlays themselves may have varied, just as the arrangements of the figures vary, the result being two consanguine but not identical compositions. It seems likely that the use of one or more drawings similar in type to fig. 220 accounts for the familial relationship between the two bowls. The striking resemblance of the swordsmen on the two bowls—each with a blade raised above his head and mounted on a rearing horse (fig. 231)—to the figure of Iskandar (Alexander) in the Great Mongol *Shahnama* of the 1330s (fig. 234) further emphasizes this connection.[79]

In manuscript illustration, the copying of figures or compositional elements is well known, going back at least to the end of the fourteenth century. Direct copying was one method; compositions, groups of figures, and single figures were also repeated by means of drawings, pounces, and sketches, many of which are preserved in the previously noted albums.[80] It now seems likely that drawings first became an important tool for the transmission and copying of compositions at an

78. As outlined in greater detail in Komaroff 1992, pp. 9 ff.

79. The same rearing horse and rider occur on the two previously discussed candlesticks, there enclosed in a roundel (fig. 230).

80. Komaroff 1992, pp. 13–14, but esp. Lentz and Lowry 1989, pp. 159 ff., 376–79; Adamova 1992; Roxburgh 2002, pp. 61–67, where the process and practice are described.

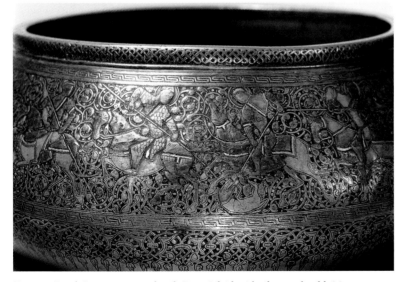

Fig. 232. Bowl, Iran, ca. 1347, detail. Brass inlaid with silver and gold. Museo Nazionale del Bargello, Florence (Bronzi 7161)

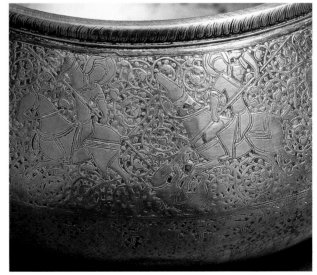

Fig 233. Bowl, Iran, A.H. 748/A.D. 1347–48, detail (see fig. 231). Brass, originally inlaid with silver and gold. Musée des Beaux-Arts, Lyon (E 542-22)

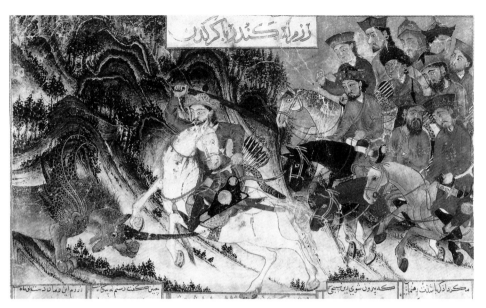

Fig. 234. *Iskandar Battling the Habash Monster,* from a page of the Great Mongol *Shahnama* (Book of Kings), Tabriz, 1330s. Museum of Fine Arts, Boston, Gift of Denman Waldo Ross Collection (10.105)

81. This does not mean that drawings on paper became the only source of preliminary designs. A luster-glazed cross tile excavated at Takht-i Sulaiman (National Museum of Iran, Tehran, no. 21731) preserves a sketch of a horse and rider on its reverse. Additional preliminary sketches are found on other Ilkhanid luster tiles. See Porter 1995, figs. 39, 40; one of the tiles shown is dated 1265.

82. W. Watson 2000, p. 44. The author proposes (pp. 44–46, 82) that an illustrated text known as *Yingzao fashi* (Techniques and Styles of Architecture), compiled in the Song dynasty and published in 1103, functioned as a kind of design manual that facilitated the transmission of motifs. However, there does not seem to be general agreement among scholars of Chinese art on either the specific intention or the subsequent use of this text. See, for example, Guo 1998, where even the title of the text is translated in a significantly different manner, as *State Building Standards.* Also see *Yingzao fashi* 1989, especially vols. 7, 8. I am grateful to J. Keith Wilson, Los Angeles County Museum of Art, to Jonathan Hay, Institute of Fine Arts, New York University, and especially to Craig Clunas, University of Sussex, for their insightful comments on this text and for the bibliographical references they suggested.

earlier date, in the Ilkhanid period, and that this tool was employed in a variety of media.[81] Furthermore, the diffusion of this practice may initially have been connected to the new importance of drawloom textiles and the method of their manufacture, for which designs on paper were essential.

To be sure, it is not solely drawings that facilitated the rapid, widespread dissemination of East Asian textile-derived motifs into Iranian art during the Mongol period. It is especially tempting to look for a more direct Chinese model and source in the form of design manuals or model books. At least one scholar of Chinese art has suggested that potters in China used woodblock prints to circulate ceramic designs and ideas for shapes.[82] Until there is more extensive study of the working methods of Chinese artists and the interactions of artisans in a variety of media, no model of artistic practice that might have been transplanted to Iran can be postulated. Nonetheless, if drawings did first come into general use in Iran during the Ilkhanid period, then this era represents a watershed not only for its infusion of Iranian art with new motifs, not only for the rise of newly important media (manuscript illustration, glazed tile revetment), but also for the introduction of an artistic practice that was to have a great impact on subsequent art in Iran, Ottoman Turkey, and Mughal India.

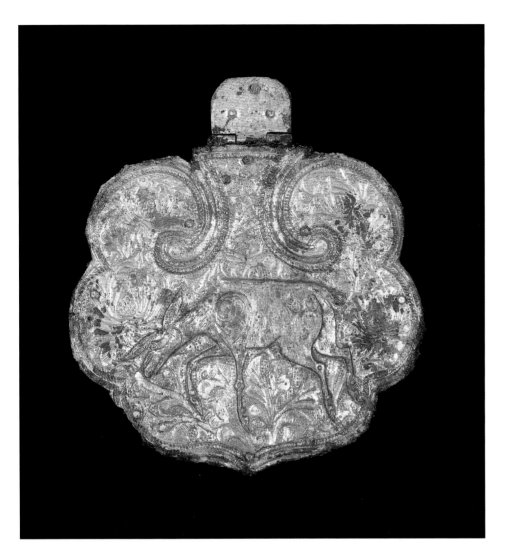

Fig. 235 (cat. no. 152). Two plaques, Iran, 14th century. Gilt bronze, worked in repoussé, chased, punched, and engraved, attached to metal base. The Nasser D. Khalili Collection of Islamic Art, London (JLY 503)

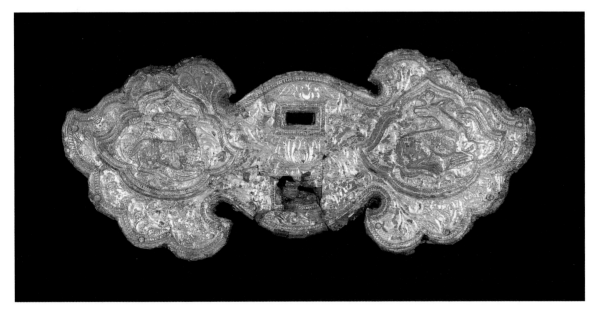

هر كاه كى سوى برج قوس آيد ماه حاجت زفصاه راهل علم اندر خوا
برده خروت زدوح كن ودر حمام دارو مخور و شحر خى داز رنج مكا

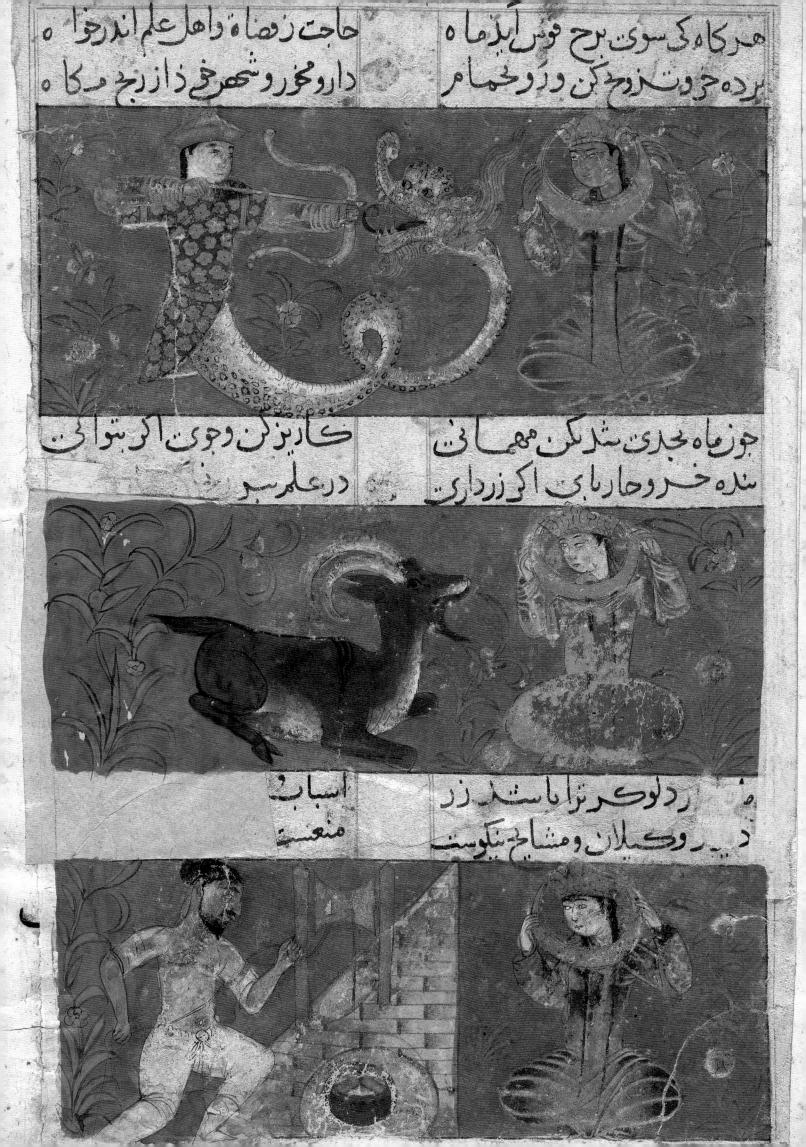

جوز ماه بجدى شد ركن مهمانى كاريز كن و جوى اكر بتوانى
شده خرو حار باب اكر زر دارى در علم سر

ر دلو كر نزا باشد زد اسباب
د....رو كيلان و مشايخ نيكوست منعسه

8.

Synthesis: Continuity and Innovation in Ilkhanid Art *STEFANO CARBONI*

When I entered Bagdad [in 1327], the Sultan of the two Iraks and Khorasan was Abu Sa'id Bahadur Khan. . . . He left no issue, and the consequence was, his Emirs each claimed and exercised the rule in those parts in which he had been placed. When Abu Sa'id left Bagdad for his own country, I travelled for ten days with him, and saw the wonderful arrangement of their march, and their numerous army. . . . I presented myself to him, and was honoured with a dress and other large presents.

—Ibn Battuta, *Travels*[1]

The sultan of Shiraz at the time of my visit [in 1347] was Abu Ishaq, one of the best of sultans, handsome and well-conducted, of generous character, humble, but powerful and the ruler of a great kingdom. . . . At one time Abu Ishaq desired to build a palace like the Aywan Kisra [at Ctesiphon], and ordered the inhabitants of Shiraz to undertake the digging of its foundations. They set to work on this, each corporation of artisans rivalling the other, and carried their rivalry to such lengths that they made baskets of leather to carry the earth and covered them with embroidered silk. . . . Some of them made tools of silver. . . . When they went to dig they put on their best garments, with girdles of silk, and the sultan watched their work from a balcony.

—Ibn Battuta, *Travels*[2]

T‍he Ilkhan Ghazan's conversion to Islam in 1295 was a significant moment for the Ilkhanate. His official acceptance of the faith that had been the region's predominant one before the arrival of the Mongols exerted an immediate impact on the religious arts, especially evident in the creation of luxury Koran manuscripts and the erection of buildings of devotion. The importance of this development is accentuated by the almost complete absence today—probably due both to deliberate demolition and to sheer neglect—of monuments and furnishings produced for followers of the various religions embraced by Ghazan's Mongol predecessors, from shamanism to Buddhism to Nestorianism (see Sheila Blair's chapter 5, particularly pp. 105–15).

This dramatic change in the religious arts reached its peak during the reign of Öljeitü (1304–16) and the years in office (1298–1318) of his vizier Rashid al-Din. Analysis of the secular arts and decorative vocabulary of the Ilkhanid period before and after the turn of the century reveals, however, a remarkable continuity in the artistic language. The most outstanding creations of the fourteenth century—such as Öljeitü's mausoleum of 1307–13 at Sultaniyya, the thirty-volume Koran manuscripts made for use in it (ca. 1302–13), copies of Rashid al-Din's *Jami' al-tavarikh* done about 1314–15, and the Great Mongol *Shahnama*, probably of the 1330s—as well as all other extant material from this period (alas, just a fraction of the original)

1. Ibn Battuta 1829, pp. 47–48.
2. Ibn Battuta 1929, p. 94.

Opposite: Fig. 236 (cat. no. 10). Page from the *Mu'nis al-ahrar fi daqa'iq al-ash'ar* (Free Men's Companion to the Subtleties of Poems), copied by the author and compiler, Muhammad ibn Badr al-Din Jajarmi, Iran (Isfahan), A.H. 741/A.D. 1340–41. Ink, colors, and gold on paper. The Metropolitan Museum of Art, New York, Cora Timken Burnett Collection of Persian Miniatures and Other Persian Art Objects, Bequest of Cora Timken Burnett, 1956 (57.51.25)

must be understood as part of a process that has its roots in the first forty years of Mongol domination in the region. Undeniably, however, the period corresponding to the reigns of Ghazan, Öljeitü, and Abu Saʿid (1295–1335) saw a newly heightened interest in current artistic trends on the part of the court, which took direct control of the most important ateliers and workshops in the Ilkhanid-dominated areas. The main intent of this essay is to present a brief exploration of the arts of the late or "mature" Ilkhanid period and an analysis of how this extraordinary chapter in the history of Islamic art influenced developments in the greater Iranian region and beyond.

The continued use throughout the Ilkhanid era of an existing ornamental language and of certain materials, techniques, styles, and subjects is evident in both secular and religious art. The luster-painted star and cross tiles and plastered walls in the shrine of Yahya at Veramin[3] (1260s) and the summer palace of Takht-i Sulaiman (1270s; figs. 101, 204) apparently provided direct inspiration for the lavish interior decoration of mosques, shrines, tombs, and palaces erected in the first decades of the fourteenth century, known from monuments such as the shrine of ʿAbd al-Samad at Natanz[4] (1299–1312; see figs. 149, 150), the mosque of ʿAli at Quhrad[5] (1300–1307), and the royal settings illustrated in the Great Mongol *Shahnama* of the 1330s[6] (for example, fig. 90). Another example is provided by a complex design drawn for *muqarnas* ("stalactite") vaulting, found at Takht-i Sulaiman, which is echoed in the vault of the dome over the 1307 tomb of ʿAbd al-Samad.[7] The dynastic motivations behind the celebrated *Shahnama* manuscript become clear when its layout and choice of illustrations are examined in the context of the long-standing tradition of such epic images in the region, since scenes and verses from the *Shahnama* appear on frieze tiles of the early Ilkhanid period from Takht-i Sulaiman (figs. 49, 111, 112).[8]

CERAMICS

The decoration of walls with luster-painted tiles is a centuries-old tradition that originated and developed in the Islamic world and enjoyed great success under the Seljuqs, predecessors of the Ilkhanids in Iran.[9] The lustrous finish is created when the design is drawn over an opaque off-white glaze with a paste that contains high levels of silver and copper, and then the tile is fired in a reduced atmosphere—that is, a kiln from which the oxygen is slowly removed.[10] During the Ilkhanid period, luster-painted ceramic became extremely popular as architectural decoration but less common, judging from the surviving material, on vessels and other functional objects (see fig. 3). These were more often decorated in underglaze painting or in the so-called *lajvardina* style.[11] The Iranian town of Kashan had a virtual monopoly on luster tile work under the Seljuqs and the Ilkhanids, and its craftsmen were commissioned for the decoration of buildings throughout the kingdom, especially during the most active period of construction in the first decades of the fourteenth century. The best ceramists sometimes signed and dated their creations, which included not only the ubiquitous star and cross tiles, ranging from A.H. 600 to 740 (1203 to 1340), but also impressive mihrabs faced with large square or rectangular

3. Bahrami 1937, pp. 87–92, figs. 26–35; O. Watson 1977, pp. 62–66; O. Watson 1985, pp. 131–32, pl. K.
4. Blair 1986a.
5. O. Watson 1975; O. Watson 1985, fig. 115.
6. Grabar and Blair 1980, for example figs. 8, 17, 50.
7. Blair 1986a, pp. 34–35, 50, pls. 34–38, 101; Blair and Bloom 1994, fig. 11.
8. See Tomoko Masuya's chapter 4. Melikian-Chirvani 1991.
9. Caiger-Smith 1985, figs. 32–44; O. Watson 1985, figs. 102–9.
10. Caiger-Smith 1985, pp. 196–209; O. Watson 1985, pp. 31–36.
11. O. Watson 1977, pp. 262–63, lists eleven vessels or vessel fragments dated within the Ilkhanid period; they range from A.H. 659 (1260–61) to A.H. 683 (1284–85), demonstrating that this technique became obsolete for functional vessels by the close of the thirteenth century. The two large round tiles in the Musée National de Céramique, Sèvres, dated 711 (1312; figs. 55, 56), although more elaborate than frieze tiles in function and design, can still be regarded as architectural decoration.

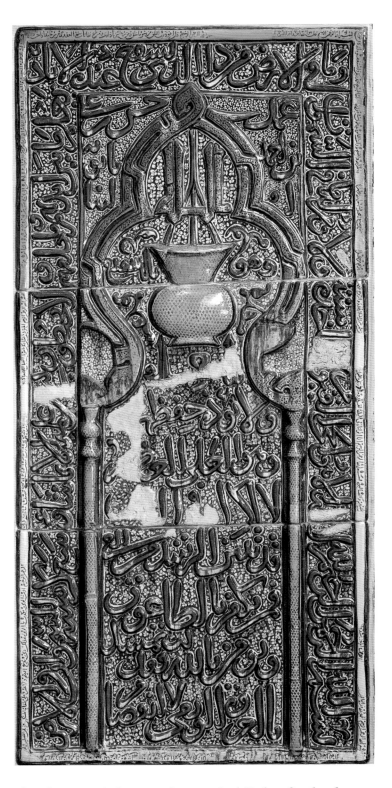

Fig. 237 (cat. no. 116). Tile panel, made by Hasan ibn ʿAli ibn Ahmad Babavaih, Iran (Kashan), early 14th century (probably 1310). Fritware, overglaze luster-painted. The Metropolitan Museum of Art, New York, Rogers Fund, 1909 (09.87)

tiles (fig. 237).[12] The most distinguished Kashan family of potters, spanning at least three generations under Ilkhanid rulers both non-Muslim and Muslim, was the Abu Tahirs.[13] The family is known not only from the works of its members, in particular frieze tiles and a mihrab signed by Yusuf ibn ʿAli ibn Muhammad ibn Abu Tahir,[14] but also through a text by Yusuf's brother Abu al-Qasim ʿAbd Allah Kashani, which contains a section on the technique of Kashan luster pottery.[15]

With the exception of luster-painted tile work, Ilkhanid pottery production was rather conservative from a technical viewpoint. Influenced by the stream of luxury items in porcelain arriving from East Asia, Iranian ceramists successfully imitated celadon ware (fig. 240) by firing a pale greenish glaze over a hard fritware; they also

12. O. Watson 1985, fig. 125.
13. Ibid., pp. 176–79.
14. Two frieze tiles signed by Yusuf once belonged to buildings dated to about 1309–10 on the basis of dated tiles from the frieze. The mihrab, now in the Iran Bastan Museum, Tehran, was originally in the shrine of ʿAli ibn Jaʿfar in Qom. See O. Watson 1977, pp. 255–56, nos. 100, 102, 112. See also O. Watson 1985, fig. 120.
15. The treatise on pottery is translated into English in Allan 1973.

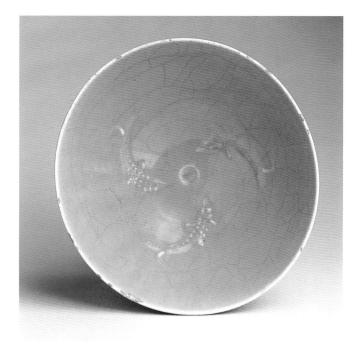

Fig. 238 (cat. no. 132). Bowl with three fishes, Iran, first half of the 14th century. Fritware, modeled and monochrome glazed. The Metropolitan Museum of Art, New York, H. O. Havemeyer Collection, Gift of Mrs. Horace Havemeyer, in memory of her husband, Horace Havemeyer, 1959 (59.60)

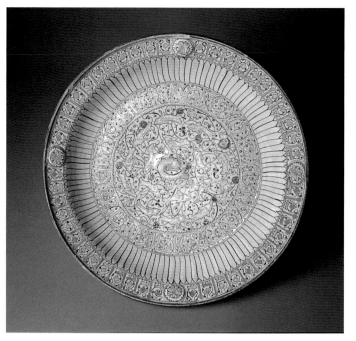

Fig. 239 (cat. no. 130). Plate with fishes, Iran, late 13th–early 14th century. Fritware, overglaze painted (*lajvardina*). Musée du Louvre, Paris (6456)

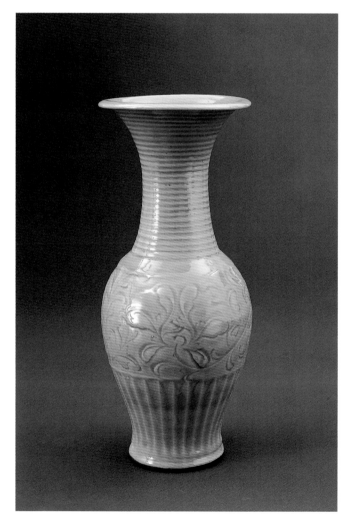

Fig. 240 (cat. no. 194). Vase, Longquan celadon ware, China, Yuan dynasty (1271–1368). Stoneware, molded decoration. Inner Mongolia Museum, Hohhot

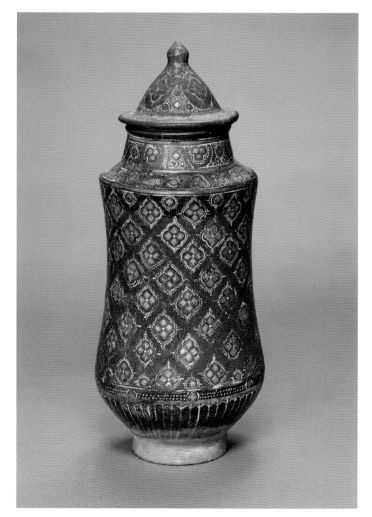

Fig. 241 (cat. no. 131). Storage jar (albarello), Iran, late 13th–14th century. Fritware, overglaze painted (*lajvardina*). The Metropolitan Museum of Art, New York, Henry G. Leberthon Collection, Gift of Mr. and Mrs. A. Wallace Chauncey, 1957 (57.61.12a, b)

16. See Lentz and Lowry 1989 for a few examples, nos. 130, 131, 132. For a comprehensive study of fifteenth- and sixteenth-century blue and white ceramics, see Golombek, Mason, and Bailey 1996.

17. For pale blue, see also Atil 1973, no. 76; for off-white, see *Treasures of Islam* 1985, no. 234.

18. Perhaps the two most celebrated examples of *mina'i* are a bowl and a beaker depicting a battle scene and scenes from the *Shahnama* in the Freer Gallery of Art, Washington, D.C.; see Ferrier 1989, p. 255, fig. 1; Atil 1973, nos. 44, 50.

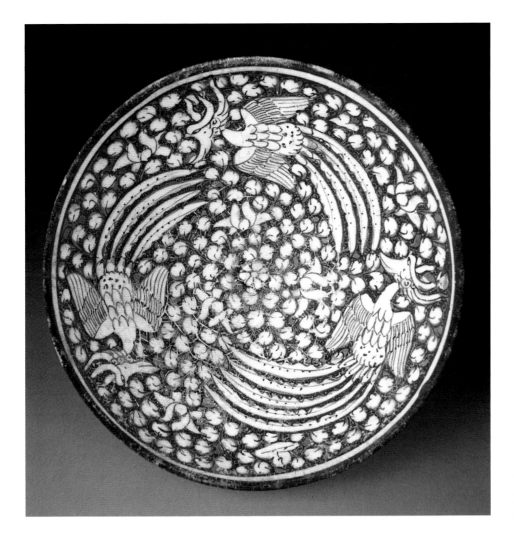

Fig. 242 (cat. no. 133). Bowl with three phoenixes, Iran, 14th century. Fritware, underglaze painted. Musée du Louvre, Paris (8177)

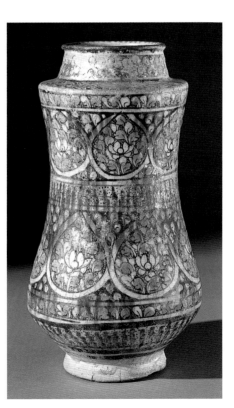

Fig. 243 (cat. no. 135). Storage jar (albarello), Iran, 14th century. Fritware, underglaze painted. The Trustees of the British Museum, London (1952.2-14.5)

copied Chinese designs, as can be seen on the bowl with three swirling fish on a bowl in the Metropolitan Museum (fig. 238). As far as we can tell, however, they did not attempt to imitate the renowned blue-and-white Chinese porcelain until later in the century, and this style became a trend only in the fifteenth and sixteenth centuries under the Timurids and the Safavids.[16]

The most distinctive type of ceramic ware produced under Ilkhanid rule, one apparently confined to a few decades in the late thirteenth and the fourteenth centuries, is commonly known as *lajvardina* (from *lajvard,* Persian for lapis lazuli) because of the deep blue glaze that characterizes most examples; less common are pale blue and off-white glazes (fig. 239).[17] *Lajvardina* ware was placed in the kiln twice, once to fire the glaze and the second time to fix enamel-like colors and gold over the glaze (see the technical study 2). This overglaze-painted technique was popular in Iran before the advent of the Ilkhanids and was used for a colorful ware, frequently decorated with lively figural scenes, known as *mina'i* (enameled).[18] *Lajvardina* is often described as a natural development of *mina'i,* which is perhaps true from a technical standpoint, although the two types are extremely different in color, decoration, and artistic intent. On *lajvardina* ware the coloring of the overglaze is limited to white and reddish pigments and gold, and the decoration consists almost exclusively of dense geometric and vegetal patterns that create a rich, textured surface like a woven pattern, usually set in contrast by a dark blue background (fig. 241). The generous use of gold, the refined decoration, and the typically large

dimensions of the bowls, bottles, and vases suggest that *lajvardina* filled a market demand for luxury ware under the new rulers, although one without a specific patronage, given the absence of dedicatory inscriptions.

Also important during this period is a type of pottery known as "Sultanabad"; in this case the ceramic, painted before a layer of clear, thick glaze (sometimes with blue highlights) is applied, requires only one firing.[19] The design is executed largely in white with black outlines against a pale-colored brown or gray thin slip, and this palette makes the ware distinctive in the realm of Persian pottery. The restrained color schemes and the subjects of direct Chinese origin—mostly zoomorphic scenes such as the oft-encountered revolving phoenixes (fig. 242)—suggest that this short-lived class of pottery was directly inspired by drawings of eastern origin and was meant to satisfy the taste of the new ruling class. The most successful creations are large bowls, sometimes with a thick inward-turned rim, and vases, shapes that are paralleled in *lajvardina* pottery (see figs. 241, 243); large mihrab tiles were also painted in these underglaze colors (fig. 152).

Continuity between the earlier and later Ilkhanid periods is noticeable as well in decorative details that entered the Iranian repertoire only following the Mongol invasion, such as the Chinese dragon, the phoenix, the lion, the crouching antelope (*djeiran*), the lotus, and the peony. These individual elements, studied in Linda Komaroff's chapter 7 to determine how they were transmitted to and disseminated within the Ilkhanid repertoire, initially had an imperial connotation linked to the court of the Great Khan in China; later they lost most of their original significance and became essentially decorative patterns.[20] The motifs were present in all media in the fourteenth century, from inlaid metalwork to ceramics to illuminated and illustrated manuscripts, greatly enriching the decorative language of late-Ilkhanid portable arts and remaining almost unchanged throughout.

MANUSCRIPTS

The pursuit of legitimacy for the Iranian dynasty was expressed in particular in the writings of ʿAlaʾ al-Din ʿAta Malik Juvaini (1226–1283)[21] and Rashid al-Din (1247–1318), both of whom were historians as well as high government officials, and in the creation of a new style of illustration and design. The effort coincided not only with unofficial independence from the Yuan dynasty in East Asia but also with the development of a new sense of spiritual mission and an active role in the Islamic world. To fulfill this mission the Ilkhanids made use of the cultural legacy of the westernmost area of their domains, allowing and even encouraging the mostly Arabic-speaking population of Iraq to continue cultivating their centuries-old traditions of paper and book production, calligraphy, and illumination. The city of Baghdad had suffered a heavy blow from its conquest by the Mongols, but it never entirely lost its crucial position in the cultural and artistic sphere of the Arab Islamic world, a role established as early as the eighth century, when the ʿAbbasid caliphate was founded.[22]

Emblematic in this regard is the figure of Yaqut al-Mustaʿsimi (ca. 1221–1298),

19. Lane 1971, pp. 10–20.
20. See Tomoko Masuya's chapter 4.
21. ʿAlaʾ al-Din ʿAta Malik ibn Muhammad Juvaini was a Persian officer who rose to the highest ranks of government in the early Ilkhanid period; he held the post of governor of Iraq for twenty years, beginning in 1259. He was also a historian whose best-known work is the *Tarikh-i jahan-gusha* (fig. 201). See Barthold and Boyle 1965.
22. Simpson 1982b.
23. Abu al-Majd Jamal al-Din Yaqut ibn ʿAbd Allah al-Mustaʿsimi was in the service of the last ʿAbbasid caliph of Baghdad when the city was besieged and sacked by the Mongols. His greatest contribution to the art of writing was devising a method for trimming reed pens to an oblique tip, which allowed him to impart a new elegance to the script. See Huart 1934; James 1992, pp. 58–59.

Fig. 244 (cat. no. 35). *Nushirvan Receives Mihras, the Envoy of Caesar,* page from the First Small *Shahnama* (Book of Kings), northwestern Iran or Baghdad, ca. 1300–1330. Ink, colors, gold, and silver on paper. The Metropolitan Museum of Art, New York, Purchase, Joseph Pulitzer Bequest, 1934 (34.24.3)

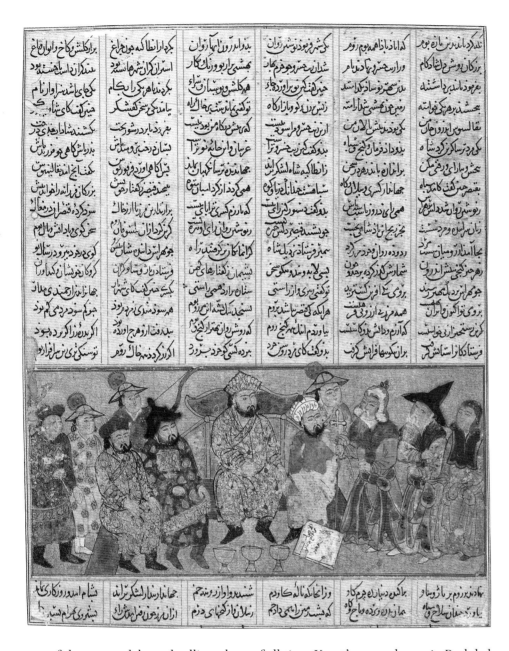

one of the most celebrated calligraphers of all time. Yaqut's career began in Baghdad under the last ʿAbbasid caliph and ended when the ruling Ilkhanids were officially turning to Islam.[23] A protégé of the powerful governor Juvaini (see n. 21) and an artist embedded in the tradition that called for the transmission of calligraphic skills in an uninterrupted chain, Yaqut trained his famous six pupils during the very decades when Baghdad was presumably on its knees and the Ilkhanids were showing little interest in their Iraqi province or Islamic matters. The pupils, led by the towering artist Ahmad ibn al-Suhravardi (d. ca. 1320), developed the so-called Six Pens, or six calligraphic styles (*al-aqlam al-sitta*) (see fig. 245).[24] They also devised the system and provided the models for the production of Koran manuscripts at the Ilkhanid court, an endeavor that culminated in the thirty-volume copies made in the fourteenth century for the mausoleum of Öljeitü at Sultaniyya (figs. 121, 156, 158, 245). The manuscripts were commissioned from the best calligraphers of the time in the main centers of book production in Iran and Iraq and were copied in the monumental *muhaqqaq, thuluth,* and *rayhan* scripts on the best and largest Baghdadi-size paper.[25]

These majestic works would never have been created for the Ilkhanid court had

24. More than twenty different scripts were in use by the late ninth century, of which six cursive styles came to be known as *al-aqlam al-sitta* or *shish qalam* (the Six Pens, or six calligraphic styles). Called *thuluth, naskh, muhaqqaq, rayhan, riqaʿ,* and *tawqiʿ,* they have each typically served for a particular function. *Naskh* and *muhaqqaq,* for example, have a wide application, being used for the text in Koran manuscripts and literary documents; *thuluth* is commonly employed as an ornamental script for inscriptions and titles; while *riqaʿ* and *tawqiʿ* are scripts for records and legal documents. See Safadi 1978, pp. 14–24.

25. Islamic manuscripts are composed of quires each made up of a variable number of sheets folded in two. The thirty-volume Koran manuscript made for Öljeitü in 1306–7 is composed of pages that measure about 28 by 20 inches, that is, 28 by 40 inches before folding. These dimensions correspond to the "full Baghdadi" size mentioned by the Egyptian historian al-Qalqashandi (d. 1418). One of the best papers ever produced in whiteness, smoothness, and evenness is that used for the Koran copied by Ahmad ibn al-Suhravardi (fig. 245). See Bloom 2001, pp. 53–54, 112.

Fig. 245 (cat. no. 64). Left side of a double-page colophon from the Anonymous Baghdad Koran, copied by Ahmad ibn al-Suhravardi al-Bakri, illuminated by Muhammad ibn Aybak ibn ʿAbd Allah, Iraq (Baghdad), A.H. 701–7/A.D. 1302–8. Ink, colors, and gold on paper. The Metropolitan Museum of Art, New York, Rogers Fund, 1955 (55.44)

Yaqut been forced to cease his activity following the conquest of Baghdad. The models provided by Ibn al-Suhravardi and his colleagues made possible a proliferation of both elaborate and less ambitious single-volume Korans in Iran, and this happened especially in Tabriz under the sponsorship of the vizier Rashid al-Din, whose collection in the Rabᶜ-i Rashidi (Rashid's Quarter) included at least a thousand high-quality copies of the Koran.[26] Yaqut and his pupils perfected the calligraphic styles that had been established by Abu al-Hasan ibn al-Bawwab (d. 1022)[27] in Baghdad, the premier center of development of calligraphy for centuries. With the six principal styles becoming increasingly popular, the days were long forgotten when Korans in Iran were copied in the angular, vertical script known as Eastern Kufic.[28] The refinement that the six styles represented also influenced calligraphers producing texts for other media, such as ceramics and metalwork. Tile friezes in early fourteenth-century buildings, for example, carry Koranic passages in flowing *thuluth* script[29] (figs. 149, 150), and the same calligraphic style appears on the inscriptions in cartouches on brass bowls, boxes, and candlesticks (figs. 224, 246).[30]

Fig. 246 (cat. no. 165). Polygonal box, Iran (probably Fars), first half of the 14th century. Brass, inlaid with silver and gold. Musée du Louvre, Paris (3355)

Illumination

Along with calligraphy, illumination—nonrepresentational decoration embellishing manuscript frontispieces and chapter headings—was integral to the development of Koran production in Baghdad. An important example, a volume from a thirty-part Koran, is an autograph copy by Yaqut done in *muhaqqaq* script and dated 681 (1282–83). The left half of its illuminated frontispiece displays a geometric composition that ultimately goes back to the period of Ibn al-Bawwab in Baghdad (fig. 5).[31] The page's decorative details belong to Baghdad's thirteenth-century development;

26. James 1988, pp. 127–28.
27. Abu al-Hasan ᶜAli ibn Hilal, known as Ibn al-Bawwab, an esteemed calligrapher from Baghdad, perfected an art of writing that was to be surpassed only by Yaqut al-Mustaᶜsimi. He also wrote a treatise and a didactic poem on calligraphy. See Miquel 1971.
28. For a typical and very fine example of the Eastern Kufic style, see *Islamic World* 1987, fig. 20. Six other pages from the same Koran manuscript are in the collection of The Metropolitan Museum of Art.
29. See examples in Carboni and Masuya 1993, figs. 17, 21, 23, 29.
30. See examples in Melikian-Chirvani 1973, pp. 70–73; *Islamische Kunst* 1986, nos. 208–11; Komaroff 1994, figs. 10a–c; *Golden Horde* 2000, p. 71.
31. Ettinghausen 1962, p. 171; D. S. Rice 1983.

Fig. 247 (cat. no. 62). Two pages with calligraphy and illumination from *juz*ʾ 15 of a thirty-part Koran, copied by Yaqut al-Mustaᶜsimi, Iraq (probably Baghdad), A.H. 681/A.D. 1282–83. Ink, colors, and gold on paper. The Nasser D. Khalili Collection of Islamic Art, London (QUR 29)

Fig. 248. Vault in the exterior galleries of the tomb of
Öljeitü at Sultaniyya, 1315–25

Fig. 249 (cat. no. 74). Textile with paired felines (detail),
western Iran, 1340–80. Lampas weave, silk. Cooper-
Hewitt National Design Museum, Smithsonian Institution,
New York, Gift of John Pierpont Morgan from the Miguel
y Badia Collection (1902-1-251). Shown on a diagonal
because of fragment's shape

32. Amitai-Preiss 1995, pp. 26–48.
33. Rogers 1972, p. 385. See also Charles Melville's
chapter 2 in this catalogue.
34. Holt 1986; Allsen 2001, p. 27, n. 18.
35. The main source for this information is the histo-
rian Abu al-Fida; see Abu al-Fida 1983, pp. 81, 84;
James 1988, p. 255, n. 19.
36. The textile fragment bearing an inscription refer-
ring to al-Nasir ibn Qalawun has frequently been
associated with the seven hundred silks, mentioned
in historical accounts, that were inscribed with al-
Nasir ibn Qalawun's name and sent to him by Abu
Sa'id in 1323; see Wardwell 1988–89, pp. 101–2.
A close relationship between Ilkhanid and Mamluk
textile production may also be inferred from a
fourteenth-century Mamluk textile fragment in the
Museum of Islamic Art, Cairo (Atil 1981, no. 114),
that has the same ivory-and-blue palette and overall
geometric pattern as cat. no. 74 (fig. 249), attrib-
uted by Wardwell (1988–89, p. 113, fig. 60; see
also Suriano and Carboni 1999, pp. 43–44) to
Ilkhanid production from Iran or Iraq.

its illumination may be attributed to the most prominent artist of the time,
Muhammad ibn Aybak. This painter collaborated with Ibn al-Suhravardi on one of
the most sumptuous Korans produced for the Ilkhanids, the so-called Anonymous
Baghdad Koran of 1301–7 (figs. 158, 245). His work demonstrates the stylistic con-
tinuity of illumination before and after the turn of the century and emphasizes
the vital role Baghdad played in the production of Korans. Like types of calligraphy, the
styles of illumination on frontispieces probably influenced designs used for other
ornamental purposes, such as those on the exterior gallery vaults of Öljeitü's mau-
soleum at Sultaniyya (fig. 248).

A digression is necessary at this point to demonstrate the important role that
Baghdad calligraphers and illuminators played in the development of their arts in
Mamluk Egypt and Syria as well. The Mamluks (1250–1517), a dynasty of Turkic
origin that became the dominant Muslim force in the Arab world, can be regarded
as the most formidable opponents of the Mongols. They repeatedly prevented the
Ilkhanid armies from conquering Syria (most famous is the victory at ʿAyn Jalut in

1260)[32] and settled for an uneasy truce, often jeopardized by border skirmishes and intelligence dealings, until the Ilkhanid Abu Saʿid (r. 1316–35) and the Mamluk al-Nasir ibn Qalawun (r. 1293–1341, with brief interruptions) signed a formal peace agreement in 1322.[33] The relationship between the Ilkhanids and the Mamluks was a complex one: although sworn rivals who mistrusted each other, they exchanged embassies frequently and kept various avenues of communication open.[34]

This close relationship is reflected in the arts—predictably so, since manuscripts, textiles, and portable objects not only were exchanged as gifts through high-level embassies but also were passed along the regular trading routes, which were never shut down or even seriously disrupted.[35] A fragmentary silk Ilkhanid textile in the Kunstgewerbemuseum, Berlin (fig. 75), for example, carries the name of the Mamluk sultan al-Nasir ibn Qalawun; another fragment, in the Cooper-Hewitt Museum in New York (fig. 249), has been assigned a Mamluk origin by some scholars and an Ilkhanid one by others.[36] Movements back and forth of large quantities of jewelry and items in gold and silver are mentioned in original sources.[37] Artistic influence seems to have traveled almost exclusively one way, east to west, following the general direction of trade in luxury items during the Pax Mongolica. Sometimes it is far-reaching and peculiar, as in the case of a large, wide-bodied bottle, a typical product of Cairene or Damascene glassmakers, which is enameled and gilded with

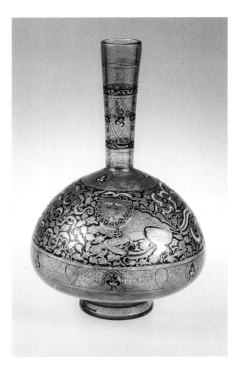

Fig 250. Bottle depicting crouching lions, Egypt or Syria, late 13th century. Enameled and gilded glass. Calouste Gulbenkian Museum, Lisbon (2370)

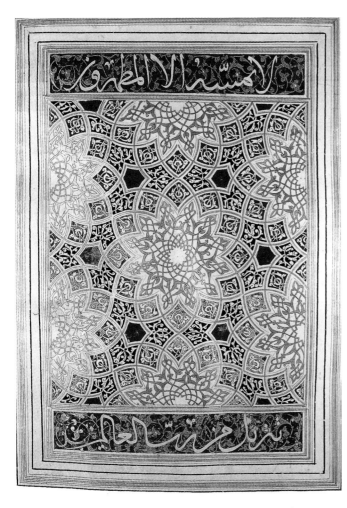

Fig. 251. Frontispiece page from the Hamadan Koran, Hamadan (Iran), completed September 1313. Fol. 1v; ink, gold, and colors on paper. National Library, Cairo (72)

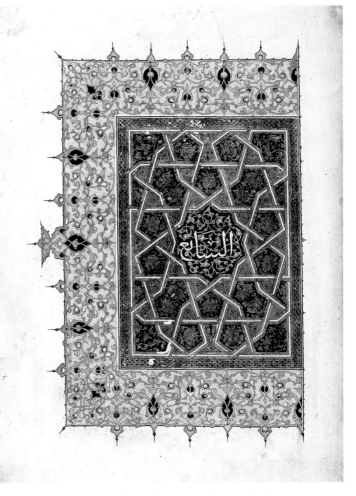

Fig. 252. Frontispiece page from a Koran made for the Mamluk sultan Baibars al-Jashnakir, Cairo, 1304–6. Fol. 2r; ink, gold, and colors on paper. British Library, London (Add. 22406-13)

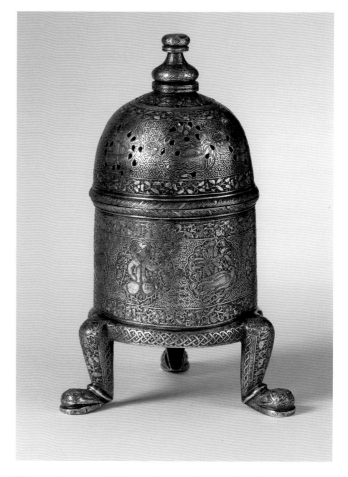

بِرَ سَايِلُ أُخُوَانِ الصَّفَاء وَخُلاَّنِ الوَفَاء

Fig. 253. *Authors with Attendants,* left side of the frontispiece from a *Rasa'il ikhwan al-safa'* (Epistles of the Sincere Brethren and the Loyal Companions), Baghdad, 1287. Fol. 4r; ink, gold, and colors on paper. Library of the Suleimaniyye Mosque, Istanbul (Esad Efendi 3638)

Fig. 254 (cat. no. 170). Incense burner, Iran, early 14th century. Brass, inlaid with silver, gold, and a black compound. The David Collection, Copenhagen (47/1967)

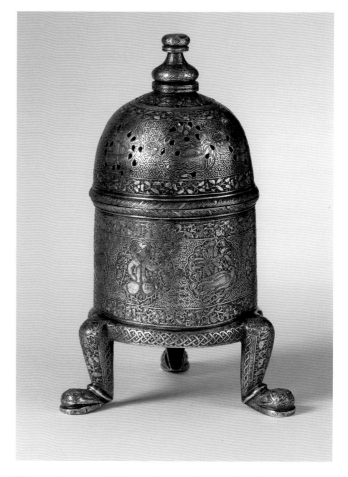

37. For a discussion of the exchange of silver, see Allsen 1997a, p. 34.
38. Carboni and Whitehouse 2001, pp. 256–57, no. 127.
39. Rogers 1972, pp. 388–89.
40. James 1988, pp. 111–26.
41. Ibid., p. 126 and nos. 1–6.

the imposing figures of two Chinese crouching lions with their typical attribute of a ball and ribbons (fig. 250).[38] There is little doubt that the glass painter's inspiration came from Ilkhanid textiles, which were readily available in the Mamluk capitals and served as "pattern books."

In the production of Mamluk Koran manuscripts, however, Ilkhanid-controlled Baghdad is once again the crucial factor. The illumination, calligraphy, and page layouts of courtly Mamluk Korans are so similar to those of their Ilkhanid counterparts that it has often been suggested that the lavish copies made in Cairo in the fourteenth century were directly modeled on a famous thirty-volume royal Koran made for Öljeitü.[39] This manuscript, dated 713 (1313) and now in the National Library in Cairo, is known as the Hamadan Koran after the city in Iran where, according to its colophon, it was created (fig. 251). Rather than going to its expected final home at Sultaniyya, it was taken to Cairo before 1326 for unknown reasons, perhaps as a gift during the final peace negotiations. It was given as an endowment to the *khanaqah* (hospice for the poor) of the Mamluk amir Baktimur.[40] The influence of this manuscript on Mamluk production in general was minimal, however, since Korans produced in Cairo in the first decade of the fourteenth century, before the Hamadan manuscript was copied, already show an "Ilkhanid" influence.[41] There was therefore a common source that inspired the creation of similarly conceived manuscripts in

Egypt and in the Ilkhanid area at the very beginning of the fourteenth century, and that source must be the works of Yaqut and his pupils in Baghdad. David James suggests that Ibn Mubadir, who was responsible for a number of illuminated frontispieces on a seven-volume copy made for the Mamluk sultan Baibars II in 1304–6 (fig. 252), was "an Iraqi-trained artist who had come to Cairo to work."[42] This seems plausible; certainly the impact of Baghdadi Ilkhanid works on Mamluk ones is indisputable. Whether the influence came by way of displaced artists or a flow of manuscripts toward the Mamluk area, Baghdad can in either event be regarded as the true source of the calligraphy and illumination of royal Ilkhanid Korans in Iran and also of their Egyptian Mamluk ramifications.

Illustration

Baghdad also played an important role supporting the creation of secular illustrated manuscripts in the Ilkhanid world. The production of illustrated codices in Baghdad may have taken two or three decades to recover from the havoc created by the Mongol conquest of the city, which resulted in the loss of thousands of volumes and the destruction of entire libraries. The very few extant works suggest, however, that the style of painting predominant in Iraq before the fall of the caliphate (often referred to as "Arab" or "Mesopotamian" and aptly described as "Byzantine art in Islamic garb")[43] survived into the last two decades of the thirteenth century, following the same pattern as calligraphy and the illumination of religious manuscripts. Its continued existence is reflected in literary works of different nature—philosophical and scientific texts and moral tales in both Arabic and Persian—giving evidence of an active literary life in Iraq during its days as the western province of the Ilkhanid kingdom. The best-known manuscript of this small group is a copy of the *Rasaʿil ikhwan al-safaʾ wa khullan al-wafaʾ* (Epistles of the Sincere Brethren and the Loyal Companions; fig. 253),[44] an encyclopedic Shiʿite text[45] with a double frontispiece that portrays the authors in the purest preconquest Baghdadi style. Dated 686 (1287), it is the last example of this style of painting, which was soon thereafter "corrupted" by the introduction of eastern features such as Mongol attire, peony and lotus flowers, and foreign landscape elements, all of which had been present in the Ilkhanid world in other media for some time.[46] A striking example of this development is provided by a copy made in 1299 of the *Marzubannama,* a collection of moralizing stories written by the Bawandid prince Marzuban ibn

42. Ibid., pp. 103–4.
43. Ettinghausen 1962, p. 67.
44. Perhaps the best study of this text is Bausani 1978.
45. Shiʿism was widespread particularly in southern Iraq.
46. See chapters 4 and 7.

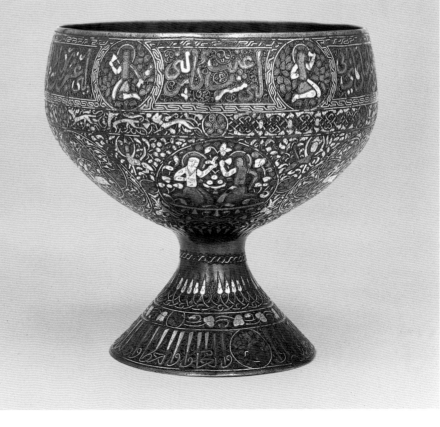

Fig. 255 (cat. no. 168). Footed cup, Iran, first half of the 14th century. High-tin bronze, inlaid with silver and gold. The Trustees of the British Museum, London (OA 1891.6–23.4)

Fig. 256. *Personification of the Planet Jupiter,* from a *Kitab ʿajaʾib al-makhluqat wa gharaʾib al-mawjudat* (Book of the Wonders of Creation and the Peculiarities of Existing Things), Wasit (Iraq), 1280. Fol. 16v; ink and colors on paper. Bayerische Staatsbibliothek, Munich (464)

47. Simpson 1982b, pp. 94–106.

48. See Linda Komaroff's chapter 7.

49. The earliest known dated illustrated Islamic manuscript is a copy of the *Book of the Images of the Fixed Stars* by ʿAbd al-Rahman al-Sufi (A.H. 400/ A.D. 1009–10) made only a few decades after the author's death in 986. It is presently in the Bodleian Library, Oxford, inv. no. Marsh 144; see Wellesz 1959. The tradition of scientific illustrated codices became well established early on throughout the Islamic world, although few examples have survived from before the Ilkhanid period.

50. Partial biographies of al-Qazvini are in Krachkovskii 1956, pp. 360–67; Lewicki 1978.

51. There is no complete translation into English of this work, only that of selected chapters. A partial translation of the text associated with the illustrations is in Carboni 1992, pp. 77–291.

52. This manuscript is in the Bayerische Staatsbibliothek, Munich (464). Two illustrations are reproduced in color in Ettinghausen 1962, pp. 138–39. The manuscript is studied in an unpublished doctoral dissertation, Bothmer 1971.

Rustam in about 1000 and then compiled in Persian by Saʿid al-Din al-Varavini in about 1210–25. The earliest known manuscript of al-Varavini's text contains three miniature paintings, adaptations of the "frontispiece" genre that was popular in pre-Mongol Baghdad and Mosul (northern Iraq) and that continued in Bagdhad in the second half of the thirteenth century.[47] In one of these illustrations, *Enthroned Patron in Royal Guise,* an oversize lotus or peony occupies the upper right corner (fig. 200). Looking awkwardly out of context in this miniature painting, the design was clearly copied from another medium. The wide, gold-painted outlines of the flower—similar outlines define the contours of figures and tree leaves in all three illustrations of the *Marzubannama*—have parallels in inlaid metalwork from the first half of the fourteenth century (figs. 254, 255). Although no dated examples of inlaid brass or bronze survive from before the end of the thirteenth century (apart from a pen box in the British Museum, fig. 46), in that period as well such work probably had wide outlines, since they make perfect sense for the inlay technique in which inner areas are filled and hammered in with color-contrasted silver. Thus, while textiles and possibly drawings may have provided the original models for metalwork,[48] the painter of the *Marzubannama* perhaps took direct inspiration from contemporary Iranian metalwork, which must have been widely traded in Baghdad in those years. Book illustration, a private art form mostly for personal enjoyment and consumption, was probably less susceptible to the rapid absorption of foreign elements than metalwork or other portable objects.

There had been a long history of production of scientific manuscripts in the Islamic world before the advent of the Mongols,[49] so it is not surprising to see the tradition continue uninterrupted under the Ilkhanids. Zakariya ibn Muhammad al-Qazvini (d. 1283) is a typical representative of the Persianized Arab intelligentsia who made the most of the situation developing in Iraq after the arrival of the Mongols. A *qadi* (legal officer) at Wasit, near Baghdad, under the last ʿAbbasid caliph, and a polymath, he allegedly retired from public life until he found a generous patron in the Ilkhanid governor Juvaini, just as the calligrapher Yaqut had done in the same years.[50] His scientific interests are summarized in a cosmography, or compendium of all scientific knowledge of the known universe, that he finished compiling in the 1270s and dedicated to his patron. Called *Kitab ʿajaʾib al-makhluqat wa gharaʾib al-mawjudat* (Book of the Wonders of Creation and the Peculiarities of Existing Things), it is a true synthesis of many sciences—astronomy, geography, botany, zoology—into a well-organized text that remained extremely successful for many centuries.[51] True to the tradition of scientific manuscripts, it is also one of the few texts that can be proved to have been conceived with original accompanying illustrations, since its earliest extant copy was finished in 679 (1280), during the author's lifetime and therefore probably with his supervision or approval (fig. 256).[52] This manuscript was copied in Wasit; its illustrations are, understandably, in the pre-Mongol style, although the pale watercolor-like palette is a foretaste of future developments.

Fig. 257 (cat. no. 14). *The Archangels Gabriel and Michael,* from a *Kitab ʿajaʾib al-makhluqat wa gharaʾib al-mawjudat* (Book of the Wonders of Creation and the Peculiarities of Existing Things), Iraq (possibly Mosul), ca. 1295–1310. Fol. 12r; ink, colors, and gold on paper. British Library, London (Or. 14140)

In a development certainly fueled by the keen interest Ilkhanid patrons took in scientific texts,[53] al-Qazvini's *Wonders of Creation,* both text and illustrations, rapidly became popular in Iran and Iraq, and painters working on copies soon adopted the new Chinese-influenced Persian style that was coming into being at the close of the thirteenth century. A fragmentary copy that surfaced recently on the art market and is presently in the British Library has been attributed to the first decade of the fourteenth century.[54] Its illustration is principally inspired by the developing new Persian style, and also by Anatolian models (fig. 257); some of the paintings look back to pre-Mongol times, while others defy any attribution (fig. 258). This mixture suggests that the work was produced in the northern Iraqi city of Mosul, where many stylistic strains coexisted. It is an intriguing fact that the miniature painting

53. See, for example, the Morgan Library *Bestiary* (fig. 169), discussed in chapter 6.
54. Carboni 1988–89; Carboni 1992.

إن ارض البقر تنفع من ظلمة العين كالكحل كلما احتاجة حيوان لا يقبل وصف كبرمن ...
توجد بارض ثبت خبر ... بينت النفسة قومت فيتح ومن خواصه ان بطن اذا وضع على حيوان مات ذلك الحيوان واذا واذا
عليه مات الصاحبة ايضا فواز الحيوان از عرف ذلك في تلك البلاد يعرض نفسها على الصاحبة فاصده عينها ...
صاحبة عليها فيموت فيسقى طعمة لعيالات زمانا طويلا والله اعلم واحكم

Fig. 258 (cat. no. 16). *The Beast Called Sannaja*, from a *Kitab 'aja' ib al-makhluqat wa ghara'ib al-mawjudat* (Book of the Wonders of Creation and the Peculiarities of Existing Things), Iraq (possibly Mosul), ca. 1295–1310. Fol. 129v; ink, colors, and gold on paper. British Library, London (Or. 14140)

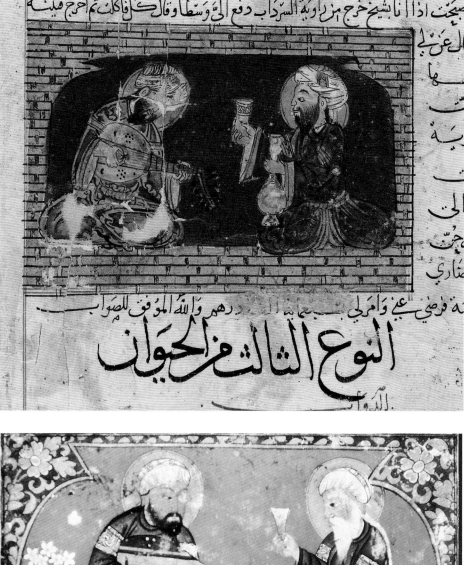

Fig. 259 (cat. no. 15). *The Singer Ibrahim and the Jinn*, from a *Kitab ʿajaʾib al-makhluqat wa gharaʾib al-mawjudat* (Book of the Wonders of Creation and the Peculiarities of Existing Things), Iraq (possibly Mosul), ca. 1295–1310. Fol. 102v; ink, colors, and gold on paper. British Library, London (Or. 14140)

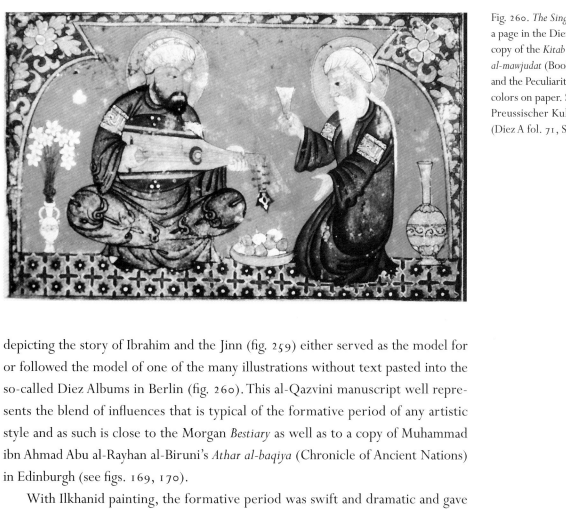

Fig. 260. *The Singer Ibrahim and the Jinn* (?), from a page in the Diez Album, probably from a lost copy of the *Kitab ʿajaʾib al-makhluqat wa gharaʾib al-mawjudat* (Book of the Wonders of Creation and the Peculiarities of Existing Things). Ink and colors on paper. Staatsbibliothek zu Berlin—Preussischer Kulterbesitz, Orientabteilung (Diez A fol. 71, S. 11)

depicting the story of Ibrahim and the Jinn (fig. 259) either served as the model for or followed the model of one of the many illustrations without text pasted into the so-called Diez Albums in Berlin (fig. 260). This al-Qazvini manuscript well represents the blend of influences that is typical of the formative period of any artistic style and as such is close to the Morgan *Bestiary* as well as to a copy of Muhammad ibn Ahmad Abu al-Rayhan al-Biruni's *Athar al-baqiya* (Chronicle of Ancient Nations) in Edinburgh (see figs. 169, 170).

With Ilkhanid painting, the formative period was swift and dramatic and gave birth to an extraordinary style that is recognized today as one of the finest and most exciting achievements in the history of Persian painting. In an outline of its progress based solely on the surviving manuscripts, the style was inaugurated with a manuscript

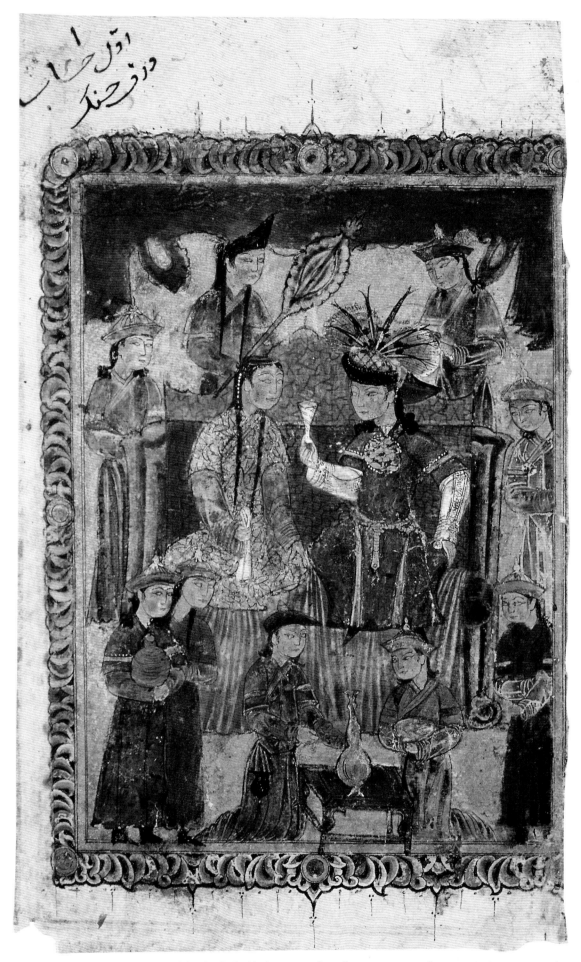

Fig. 261 (cat. no. 9). *Enthroned Couple,* left side of a double frontispiece from the *Muʾnis al-ahrar fi daqaʾiq al-ashʿar* (Free Men's Companion to the Subtleties of Poems), copied by the author and compiler, Muhammad ibn Badr al-Din Jajarmi, Iran (Isfahan), A.H. 741/A.D. 1341. Fol. 2r; ink, colors, and gold on paper. Kuwait National Museum, The al-Sabah Collection, Dar al-Athar al-Islamiyyah, Kuwait City (LNS 9 MS)

of Juvaini's *Tarikh-i jahan-gusha* (History of the World Conqueror), copied in 1290 and culminated in copies of the 1310s of the historical writings of Rashid al-Din, the *Jami* *al-tavarikh* (Compendium of Chronicles) and, especially, manuscripts of the 1330s of the Persian epic *Shahnama*. This exceptional moment is the subject of Robert Hillenbrand's chapter 6 in this catalogue and will not be further discussed here. It is the background for the new developments that took place shortly after, or possibly shortly before, the death of the sultan Abu Sa'id in 1335, which once again dramatically changed the style of Persian painting. That year is often regarded as the official date of the collapse of the dynasty, although in fact it corresponds only to the beginning of its end; the ensuing two decades saw different ruling groups and families position themselves in separate areas of the Ilkhanid realm (see Charles Melville's chapter 2).[55]

A small number of extant dated manuscripts copied and illustrated in the two decades following Abu Sa'id's death are evidence that the Ilkhanid style survived, while at the same time new styles developed in southern Iran and in Iraq. The *Mu'nis al-ahrar fi daqa'iq al-ash'ar* (Free Men's Companion to the Subtleties of Poems), an anthology of Persian poetry compiled and written in a clear hand by Muhammad ibn Badr al-Din Jajarmi in Isfahan in 1341, contains a damaged double frontispiece representing a hunting scene and an enthroned princely couple surrounded by attendants (fig. 261).[56] The courtly scene is unusual because it portrays the female figure at the right of the prince, suggesting that she is the more important person and possibly the patron of the book.[57] This "switched" position seems to be characteristic of southern Iranian painting and may reflect a distinct southern version of the princely ceremony. Isfahan, in central Iran, was more closely linked to the southern city of Shiraz than to the Ilkhanid capitals in the northwest. However,

55. A brief guide to this period can be found in Boyle 1968b, pp. 413–17.

56. The manuscript is discussed in Swietochowski and Carboni 1994, pp. 9–76.

57. Ibid., pp. 12–13, 17. See also Wright 1997, pp. 41–42, with a list of eight 14th-century illustrations showing the woman on the right.

Fig. 262. Scene from a *Mujmal al-tavarikh va al-qisas* (Summa of Histories and Stories), Iran, 1352–53. Fol. 180v; ink and colors on paper. Staatsbibliothek zu Berlin—Preussischer Kulturbesitz, Orientabteilung (Or. 2371)

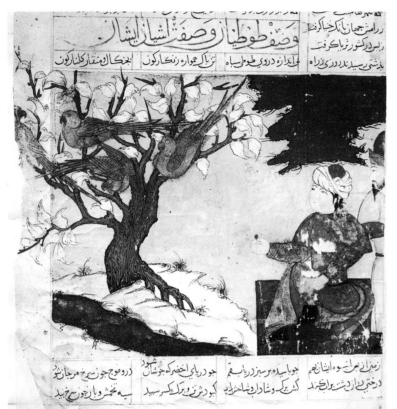

Fig. 263. *Garshasp Watches the Parrots on the Tree,* from a *Garshaspnama,* Iran, 1354. Fol. 28r; ink, gold, and colors on paper. Topkapı Palace Library, Istanbul (Hazine 774)

58. The manuscript is in the Staatsbibliothek zu Berlin—Preussischer Kulturbesitz (Orientabteilung, Or. 2371). A brief description and an illustration are in Harrassowitz 1966, p. 38.

59. Ettinghausen 1959, pp. 60–65, figs. 13–17; Çağman, Tanindi, and Rogers 1986, p. 67.

60. Boyle 1971a; Bosworth 1996, p. 266, gives 1325–53 as the official dates of the dynasty, beginning with Sharaf al-Din's formal independence from the Ilkhanid house.

61. A number of outstanding Persian poets, including Khvaju Kirmani (1290–ca. 1352) and Mafiz (ca. 1320–1390), lived in Shiraz and enjoyed Injuid patronage.

62. Grube 1978, pp. 15–16, esp. n. 43, in which the known manuscripts are listed.

63. The manuscript is now dispersed, and about eighty illustrated pages are in public and private collections, including seven in the Metropolitan Museum. The dedication page is in the Arthur M. Sackler Gallery, Smithsonian Institution, Washington, D.C. (Vever Collection, S86.0110). See Binyon, Wilkinson, and Gray 1933, p. 44, no. 24; A. U. Pope and Ackerman 1938–77, pls. 833, 834; Gray 1961, illus. p. 58; Lowry 1988, no. 76; Swietochowski and Carboni 1994, fig. 9; Simpson 2000.

64. See Sarah Bertalan's technical study, p. 228.

there is no doubt that the painting is of a Mongol royal couple, clearly identified as such by their attire, and that the entire scene follows the typical Ilkhanid style for depicting an open-air courtly reception—known, for example, from many illustrations in the *Jamiᶜ al-tavarikh* and the Diez Albums (figs. 84, 222). This frontispiece of the *Muᵓnis al-ahrar* can be considered the last set of illustrations produced in an almost untainted Ilkhanid style, although a few other surviving codices must also be attributed to this school of painting.

One of these is a little-known manuscript that has not appeared before in the scholarly literature, an early copy of a historical text entitled *Mujmal al-tavarikh wa al-qisas* (Summa of Histories and Stories), originally composed by an anonymous writer in the twelfth century.[58] The manuscript is firmly dated by its colophon to 751 (1352) and contains seven illustrations, mostly plans, maps, and depictions of buildings, in a geographical section that describes travels by sea. Although these are compositionally naive and clearly developed along provincial lines, their Ilkhanid style is evident, especially in details of the vegetation, such as a contorted tree and a stripe of grass with red flowers bordering the water in the manuscript's sole illustration of figures in a landscape (fig. 262).

The last dated codex in the Ilkhanid style has been known for some time, although its five brightly colored illustrations have been reproduced only in black and white. It is the earliest known copy of the epic poem *Garshaspnama* (Book of Garshasp), which narrates the life and heroic feats of Garshasp, an Iranian prince (and great-grandfather of Rustam, the hero of the *Shahnama*) and was written in Persian by ᶜAli ibn Ahmad al-Asadi for Abu Dulaf, ruler of Arran, in the eleventh century. The manuscript is in the Topkapi Palace Library, Istanbul; its five intact miniatures depict Garshasp killing a tiger, pursuing into the sea the dog-headed men of the island of Qalun, defeating the son of Bahu at sea, watching parrots on a tree (fig. 263), and meeting the daughter of the emperor of Byzantium.[59] The compositions of the illustrations and all the details of vegetation and costume are in the tradition of the best creations of Ilkhanid painting, while the vivid palette demonstrates that the painter learned the lessons of artistic developments of the 1330s and 1340s.

THE INJUIDS

A rather different style of illustration developed in southern Iran in the province of Fars, and especially in its capital, Shiraz. The Ilkhanids held this area as one of their royal estates when the Ilkhan Ghazan sent Sharaf al-Din Mahmud Shah to be its administrator in about 1303. Later, encouraged by the relative freedom (or lack of interest) accorded the area by the Ilkhan Abu Saᶜid, Mahmud Shah became

effectively independent, and historians are inclined to view the Injuids (from the original name for "royal estate," or *injü*) as a dynasty in their own right (ca. 1303–57).[60] The high point of Injuid rule in Shiraz and Fars, and the most significant for the arts and literature,[61] is usually thought to be the reign from 1343 to 1357 of Mahmud Shah's son Abu Ishaq, years that were also the final ones of this short-lived dynasty.

It is a sign of an effort paralleling or perhaps mimicking the Ilkhanid pursuit of dynastic legitimization that four of the seven known illustrated manuscripts attributable to Injuid patronage on stylistic grounds are copies of the *Shahnama*.[62] They range in date from 1330 to 1352. Only one has a dedication, a *Shahnama* executed for the vizier al-Hasan al-Qavam al-Din in 741 (1341) (figs. 264, 265).[63] However, the manuscripts are so similar stylistically that the entire group is attributed to the Injuid capital. Their simple, almost naive compositions and absence of refined detail, the rigid postures of figures, the oversize trees and plants, and the rapid, imprecise brushstrokes do not diminish the broad appeal of these illustrations. Vivid red-lead or orpiment-yellow backgrounds dominate the scenes, further emphasized by the sparing use of gold for armor and other metal objects, although unfortunately the once-brilliant orpiment yellow has now turned to a dull pale brown.[64]

These copies of the *Shahnama* were created in roughly the same years as the Great Mongol *Shahnama* discussed in chapter 6, but their stylistic viewpoint is so radically different that the Injuid

Fig. 264 (cat. no. 13). *Bahram Gur in the Peasant's House,* page from a copy of the *Shahnama* (Book of Kings) dedicated to the vizier al-Hasan al-Qavam al-Daula wa al-Din, copied by Hasan ibn Muhammad ibn ʿAli ibn Husain al-Mawsili, Iran (Shiraz), A.H. Ramadan 741/A.D. February–March 1341. Ink, colors, and gold on paper. The Walters Art Museum, Baltimore (W.677a)

Fig. 265 (cat. no. 11). *Bizhan Slaughters the Wild Boars of Irman,* page from a copy of the *Shahnama* (Book of Kings) dedicated to the vizier al-Hasan al-Qavam al-Daula wa al-Din, copied by Hasan ibn Muhammad ibn ʿAli ibn Husain al-Mawsili, Iran (Shiraz), A.H. Ramadan 741/A.D. February–March 1341. Ink, colors, and gold on paper. The Metropolitan Museum of Art, New York, H. O. Havemeyer Collection, Gift of Horace Havemeyer, 1929 (29.160.22)

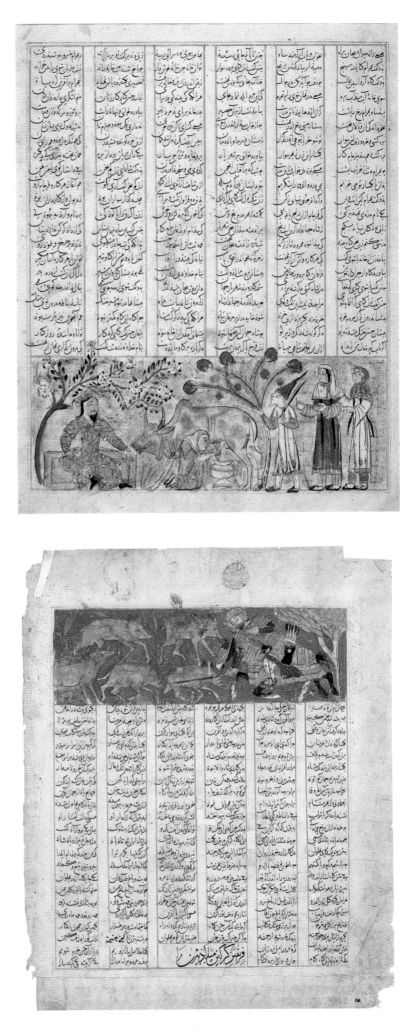

جون اینک ان فصل تمام شد بسینید ان دبل مادر شیر فت
واز وی عهد خواست تا آنح کید مستود ماند

وبل زو بقه و نا اید آنح ان ایشان شنود بود داد
کث و مواعظ کلیله واقرار دمنه مستوفی تقریر کرد
دیکر دوز ما در شریید بزاد بر آمد واو باجون غمناک

Fig. 266 (cat. no. 3). *Scenes
with Animals,* page from a *Kalila
va Dimna* (Kalila and Dimna)
copied by [Abu] al-Makarim
Hasan, Iran, A.H. 707/
A.D. 1307–8. Ink, colors, and
gold on paper. British Library,
London (Or. 13506)

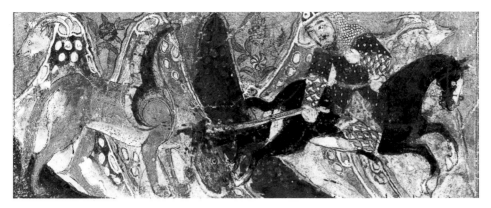

Fig. 267. *Gushtasp Slaying the Rhino-Wolf,* from a page of a dispersed copy of the *Shahnama* (Book of Kings), probably Isfahan (Iran), ca. 1335. Ink, gold, and colors on paper. The Metropolitan Museum of Art, New York, Bequest of Monroe C. Gutman, 1974 (1974.290.23v)

codices can hardly be regarded as minor works stemming from the same tradition, a mere provincial ramification of Ilkhanid painting. Yet despite their penchant for the old-fashioned, pre-Mongol compositions and color schemes that were still to be seen in the area, especially in wall paintings,[65] the painters of Shiraz did not work in total isolation. Many Chinese-type elements are superimposed on their generally archaic-looking compositions. Moreover, the red backgrounds and receding pointed mountain peaks that appear so often in Injuid works were not a novelty in the fourteenth century; they also appeared in Ilkhanid manuscripts, among them a *Kalila va Dimna* (a book of moral fables) dated 707 (1307–8; fig. 266),[66] one of the so-called Small *Shahnama* codices (figs. 176, 177),[67] pages in the so-called Diez Albums in Berlin, and the *Muʾnis al-ahrar* copied in Isfahan and discussed above (figs. 236, 261). Injuid manuscript illustration grew out of a fascinating combination of pictorial influences, beginning in Seljuq Iran and then incorporating the Ilkhanid style and local southern Iranian traditions. The Injuid style of painting was a local phenomenon that must be linked to a specific patronage. Subsequently, under the Muzaffarids (1314–93), it was replaced in that area by a rather different style, one influenced by developments taking place in the Jalayirid-controlled areas of the former Ilkhanid kingdom and in areas conquered by the rapidly rising Timurids. For that reason it was hardly at all influential in the subsequent development of Persian painting.

As noted, royal or courtly Injuid patronage cannot be firmly established for any illustrated codices except for Qavam al-Din Hasan's *Shahanama* of 1341. Since the production of Korans, with their calligraphy and illumination, always required high standards and rich patrons (an Ilkhanid example is fig. 268), it is not surprising that we know of two Injuid royal sponsors for them—in this case two related women, Tashi Khatun and Fars Malik Khatun, mother and sister of Abu Ishaq.[68] Sections of Korans made for each of them have survived, one in the Khalili Collection in London (fig. 269),[69] the other in the Pars Museum in Shiraz (inv. no. 456).[70] These Korans' flowing *muhaqqaq* calligraphy in gold letters with black outlines and their superb illumination are equal in refinement to those of contemporary Ilkhanid works (although the paper is not as fine or highly polished as that of the splendid Korans made for Öljeitü; see chapter 5, pp. 130, 133). Both schools of book arts stem from the excellent work done in Baghdad in the previous century.

65. Several scholars have emphasized the probable continued influence of Sasanian wall paintings in southern Iran; see, for example, Gray 1961, p. 58. Although likely to be correct, this hypothesis is speculative, since no Sasanian wall paintings survive in the Shiraz area.
66. Titley 1975, for example figs. 11, 12; Grube 1991, fig. 39.
67. Simpson 1979.
68. James 1992, p. 122, and see chapter 5 in this catalogue.
69. Ibid., p. 126, no. 29.
70. See James 1988, pp. 247–48, no. 69.

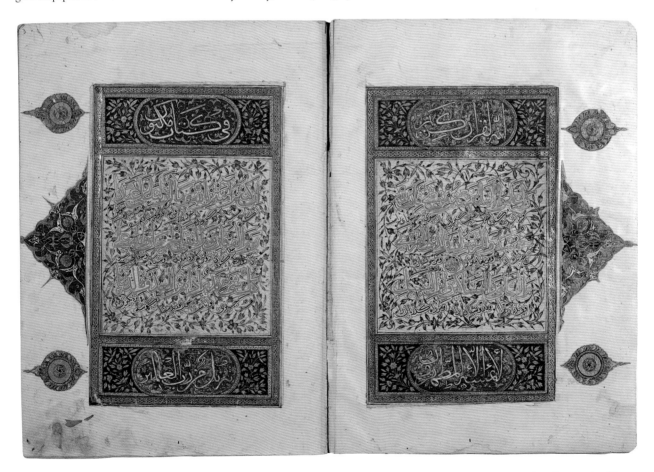

Fig. 268 (cat. no. 66). Opening pages from *juz'* 11 of a thirty-part Koran, copied by 'Abd Allah ibn Ahmad ibn Fadlallah ibn 'Abd al-Hamid al-Qadi al-Qazvini, Iran (Maragha), A.H. Shawwal 738–Shawwal 739/A.D. April 1338–April 1339. Fols. 1v, 2r; ink, colors, and gold on paper. The Trustees of the Chester Beatty Library, Dublin (Is 1470)

Fig. 269 (cat. no. 67). Opening pages from a *juz'* of a thirty-part Koran, Iran (Shiraz) ca. 1336–75. Fols. 2v, 3a; ink, colors, and gold on paper. The Nasser D. Khalili Collection of Islamic Art, London (QUR182)

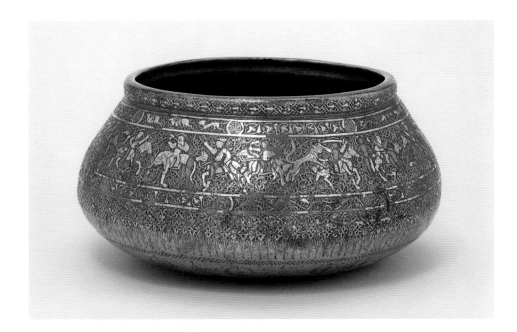

Fig. 270 (cat. no. 164). Bowl, made by Turanshah, Iran (perhaps Fars), A.H. 752 /A.D. 1351–52. Raised brass, inlaid with silver, gold, and a black compound; engraved champlevé technique. Victoria and Albert Museum, London (760-1889)

Injuid courtly patronage can also be established for the production of inlaid metalwork, which has rightly been called "one of the richest and most complex forms of artistic creation in the Iranian lands."[71] In the first half of the fourteenth century Shiraz was the most important and active center in Iran for this craft; this becomes clear from the study of a series of spectacular objects inlaid with silver and gold that either carry dates and names of patrons or can be linked to those that do by comparative features or formulaic inscriptions.[72] Perhaps the earliest is a bowl signed by a craftsman from Shiraz and seemingly dated 705 (1305) but more likely of 750 (1349–50), a date that would make the group even more homogeneous, since the majority of the dated or datable objects belong to the last two decades of Injuid rule over the region.[73] They range from a wine bucket made by a Shirazi artist, inscribed for Sharaf al-Din Mahmud Shah and dated 733 (1333; fig. 44) to a candlestick dedicated to Abu Ishaq (r. 1343–57) (fig. 224) to a bowl in the Victoria and Albert Museum completed in 1351–52 (fig. 270). Another important bowl of similar profile, dated 748 (1347; fig. 231),[74] and a sizable number of other works of different types, such as a polygonal lidded box and a footed cup (figs. 246, 255), have been linked to the same production.

The clear identification of an important metalworking center patronized by the Injuids, outside Ilkhanid control, is all the more striking because no such center has yet been identified in the Ilkhanid capitals, Maragha and Tabriz. Yet there is little doubt that a number of undated and unsigned objects of the same high artistic standard as these southern Iranian ones can be attributed to western Iran and the first half of the fourteenth century. They are exemplified in this catalogue by a large crenellated basin, a candlestick, and a ball joint for a grille (figs. 211, 228, 145); luxury items of the same type are depicted in many illustrations of the Great Mongol *Shahnama*. A comparison of the metalwork production of the two areas is a fascinating subject that calls for an in-depth comparative study. It is worth noting here that alongside many common elements are a few divergent ones. They include the fact that Chinese elements placed in confined spaces, usually medallions, are more common on Ilkhanid pieces, whereas Injuid craftsmen had a predilection for

71. Melikian-Chirvani 1982, p. 152.
72. A recurrent phrase honoring the royal patron, "heir to Solomon's kingdom," has been identified as typical of the region of Fars. See ibid., pp. 147–48.
73. Galleria Estense, Modena, inv. no. 8082. On the vessel's date, see Michele Bernardini in Curatola 1993, p. 267.
74. Melikian-Chirvani 1969. Its attribution to Fars is questioned, however, by Komaroff 1994, p. 32, n. 42. See also Wright 1997, pp. 31–35.

bands containing complex open-air scenes with mounted horsemen and royal couples (see figs. 231, 270), although with the notable exception of the candlestick in Qatar (fig. 224). As pointed out by Linda Komaroff, both manuscript illustrations and textiles may have been sources for the designs on metalwork.[75] The relationship between Ilkhanid miniature painting and metalwork is rather different, however, from that between the Injuid counterparts. With Ilkhanid production, inlaid metalwork entered the mainstream of artistic activity and followed the general style that was being developed at the time and that was characterized by the dissemination of patterns among different media. This generally high-quality production probably attracted a rich clientele but little direct sponsorship, which may partially explain why there are so few inscriptions, including those of patrons' names, linking the objects directly to the Ilkhanid court (see cat. no. 160, fig. 154). In southern Iran, on the other hand, inlaid metalwork reached a royal status and, being rather superior in quality to contemporaneous book illustrations, had little in common with it in terms of taste and refinement. Whether this was the result of an established tradition of excellence in metalwork going back to the Seljuq period or came about because metalworkers in Shiraz took inspiration from the book illustrations and textiles circulating in the Ilkhanid capitals is still a matter of speculation. In any event, fine inlaid metalwork from Fars contributes to the complex and fascinating picture we have of artistic developments in Iran following the death in 1335 of Abu Saʿid, the last Ilkhan.

JALAYIRID PAINTING

The 1330s through the 1350s are extremely important years for the development of the arts of the book, since they were witness simultaneously to traditional Ilkhanid painting, both courtly and provincial; production in the peculiar Injuid style; and the birth of the Jalayirid manner. Thus, while the *Muʾnis al-ahrar* (figs. 236, 261) and the *Garshaspnama* (fig. 263) were being copied and illustrated and the purely Ilkhanid style of painting was on its way to extinction, something different, and more central to the development of Persian painting than the Injuid parenthesis, was taking place. We cannot be sure where this Jalayirid style emerged, but a likely possibility is once again the city of Baghdad, where the Jalayirid Hasan Buzurg, one of the new lords profiting from the Ilkhanid downfall, had moved from Tabriz after governing Rum (Anatolia) under Abu Saʿid.[76]

The distinctive double-page frontispiece of a manuscript on alchemy, dated by its colophon to the year 739 (1339) and attributable to Baghdad, differs from most frontispieces, in which the author of the book and/or its patron are usually depicted.[77] This frontispiece illustrates the entrance and interior of a *barba,* or Hermetic temple, at Abu Sir in Egypt, as observed by the author and his companions (fig. 271).[78]

A mural painting at the temple's entrance is represented; in it, on the right, four men standing under an arch and a woman at the window above them observe the flight of nine predatory birds carrying curved sticks in their claws. On the left a

75. See Komaroff 1994, esp. pp. 14–21, and chapter 7 in this catalogue. In the case of the *Marzubannama* manuscript of the end of the thirteenth century, however, it seems clear, as noted earlier in this essay, that it was metalwork that influenced the manuscript illustration. Wright 1997, pp. 31–35, surmises that artists had moved from Tabriz to Shiraz by the 1340s and that this may account for high-quality inlaid objects like the Qatar candlestick (fig. 224), which show typical Ilkhanid features.

76. Hasan Buzurg had varied fortunes fighting the many rivals who claimed Ilkhanid succession after Abu Saʿid. In 1340 he abandoned Tabriz to concentrate his forces in Baghdad, where he asserted power as the founder of the Jalayirid dynasty. One of Hasan's most significant victories took place in 1337 at Sughurlukh (Takht-i Sulaiman), a symbol of Ilkhanid power (see chapter 2, p. 54, and chapter 4). The Jalayirid dynasty is also known as the Ilkani after Hasan's great-grandfather Ilka Noyan, a general of the Mongol Hülegü. See Boyle 1968b, esp. pp. 413–16.

77. Grube 1978, fig. 4. The codex, entitled *Al-Maʾ al-waraqi wa al-ard al-najmiyya* (The Moonlit Water and the Starlit Earth), is in the Topkapi Palace Library, Istanbul (ms. Ahmet III 2075). This small manuscript, finished on 11 Muharram, A.H. 740 (July 20, 1339), is a treatise on alchemy and the occult sciences originally compiled by Muhammad ibn Umayl ibn ʿAbd Allah in the first half of the tenth century. See Farès 1959, pp. 156–60, fig. 3; Grube 1978, pp. 18–19, fig. 4.

78. Hermes Trismegistos, a Greco-Egyptian god, was thought to be the author of Greek and Latin texts on mysticism, the occult sciences, and alchemy.

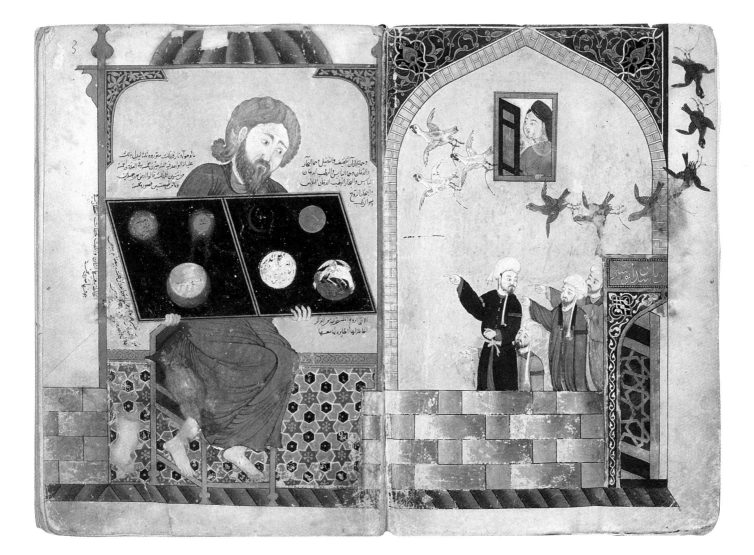

figure resembling a Byzantine icon, seated on a chair, holds the *Tabula chemica* (alchemical chart), symbolizing the contents of the book. Inside the domed temple building seen to the left is a wall panel composed of six-pointed star-shaped tiles, double-pentagonal tiles, and hexagonal ones in typical Ilkhanid style. The most remarkable elements in the frontispiece, however, the elongated, graceful figures on the right, are of a type that appears consistently in Jalayirid manuscripts only toward the end of the century. This painting in a codex dated 1339 thus represents the earliest, and an isolated, example of the style that later in the century entirely superseded Ilkhanid painting.[79]

The Jalayirid style leaves behind the type of dramatic, heroic compositions seen in the Great Mongol *Shahnama*. Most characteristic are lyrical scenes, with many graceful small figures set in lavish interiors or in gardens in full bloom. A taste for pastel colors, the integration of lines of text into the paintings, and in particular a preference for subjects from romantic Persian poetry rather than epic works are distinctive features of the new Jalayirid manner. As aptly described by Ernst Grube, it is "an academic tendency that tries to codify, to simplify, to reduce, and finally to freeze the sweeping energy of the new forms and movements created by the revolutionary masters, bringing them within the reach of all the artists of the period, making them palatable once again for general princely and courtly consumption."[80]

Yet the Jalayirid style seems to have sprung from nowhere, and one would be

Fig. 271. *Man with an Alchemical Chart and Figures Observing Birds,* double frontispiece from a copy of *al-Ma᾽ al-waraqi wa al-ard al-najmiyya* (The Moonlit Water and the Starlit Earth), probably Baghdad, 1339. Fols. 2v, 3r; ink, gold, and colors on paper. Topkapı Palace Library, Istanbul (Ahmet III 2075)

79. The most celebrated Jalayirid works are a manuscript with poetic verses by Khvaju Kirmani in the British Library, London, and the *Divan* (Collection of Poems) of the last Jalayirid ruler, Sultan Ahmad (d. 1410), in the Topkapı Palace Museum, Istanbul. See, for example, Gray 1961, figs. pp. 46, 47, 49; Klimburg-Salter 1976–77; Fitzherbert 1991.
80. Grube 1978, p. 39.

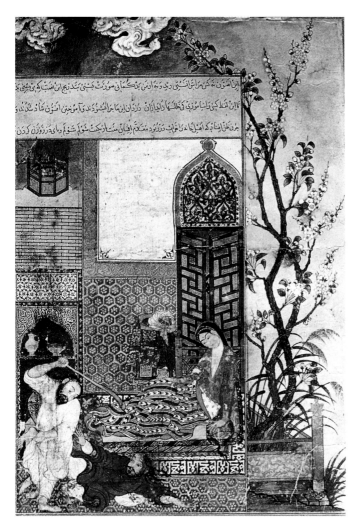

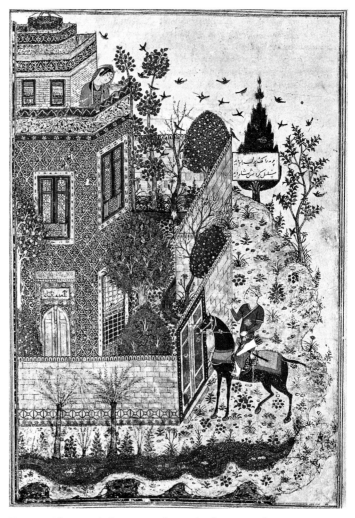

Fig. 272. *The Thief Beaten in the Bedroom,* from a partially preserved copy of the *Kalila va Dimna,* now in an album, Iran, third quarter of the 14th century. Fol. 24r; ink, gold, and colors on paper. University Library, Istanbul (F1422)

Fig. 273. *The Arrival of Humay at the Castle of Humayun,* from a *Divan* (Collection of Poems) by Khvaju Kirmani, Baghdad, 1396. Fol. 26v; ink, gold, and colors on paper. British Museum, London (Add. 18113)

81. Chagtai 1936; Thackston 1989, pp. 335–50; Thackston 2001, pp. 3–17; and see chapter 6 in this catalogue.

82. Baghdad became the true capital of the Jalayirids soon after the death of Abu Saʿid, while Tabriz changed hands often until the middle of the four-teenth century. The former city seems a better candidate for the early development of a Jalayirid artistic style. See also note 76 above.

inclined to believe the sixteenth-century assertion of Dust Muhammad[81] that it was one individual, Master Ahmad Musa, who dramatically changed the style of Persian painting. But Dust Muhammad also tells us that Ahmad Musa was active under the Ilkhanid Abu Saʿid and thus implies that the master was well acquainted with court-style Ilkhanid painting, if not one of its creators. Did Ahmad Musa really create a new kind of art after serving as one of the main painters under Abu Saʿid? Perhaps he went to work for Hasan Buzurg in Baghdad or directed an atelier for Hasan in Tabriz, also a Jalayirid city.[82]

The passage from the Ilkhanid to the Jalayirid manner was not, however, as sud-den as it seems. A hybrid style that looks both back to the Great Mongol *Shahnama* and forward to the late fourteenth century can be seen in the most accomplished copy ever produced of the *Kalila va Dimna.* The surviving illustrations of this work were collated and pasted in an album made for the Safavid shah Tahmasp in the first half of the sixteenth century and now in the University Library in Istanbul (fig. 272). Dust Muhammad mentions that Abu Saʿid commissioned from Ahmad Musa a spec-tacular copy of the *Kalila va Dimna,* and thus it has been speculated that the master began the work on the paintings now in the University Library album and that some

of his pupils finished the task in the years after his death, when the new style was better defined.[83] The same hybrid style occurs in illustrations from a *Miʿrajnama* pasted in the so-called Istanbul albums (see chapter 6, p. 150).[84]

Exactly what happened we do not know. We do know, however, that the Ilkhanid and Jalayirid styles coexisted for a short time in the central decades of the fourteenth century and that in just those years "the veil" was lifted "from the face of depiction," to use Dust Muhammad's words describing these dramatic stylistic changes in Persian book illustration;[85] although it still lingered over the face of a great, declining, short-lived Ilkhanid tradition.

Thus, Ilkhanid painting did not die with the demise of its last ruler. Jalayirid painters continued it for a few decades, creating from this style an ideal, quiet world of poetry and romance far from the dramatic epic images of the Great Mongol *Shahnama* (fig. 273). This is the world that will suit the vision of Timur (Tamerlane) and his princes at the beginning of the fifteenth century.[86] Timur was said to have been born in A.H. 736, the year that Abu Saʿid died, and there is no question but that the Timurids saw themselves as the heirs of the Mongols in Iran and found inspiration in their artistic achievements. In Persian miniature painting, however, there was a Jalayirid lily that bloomed after the Mongol lotus and peony and before the flower bed of the Timurid gardens.[87]

83. Cowen 1989; Grube 1990–91; Grube 1991, pp. 53–76.
84. Grube 1991, p. 59.
85. Thackston 2001, p. 12.
86. Paraphrasing the title of the splendid exhibition "Timur and the Princely Vision: Persian Art and Culture in the Fifteenth Century," shown in Los Angeles and Washington, D.C., in 1989 (Lentz and Lowry 1989).
87. The Chinese peony and lotus are among the hallmarks of Ilkhanid art; a tall red lily growing from a small bush with long leaves frequently appears in the backgrounds of Jalayirid manuscript illustrations.

همی رفت با دل پر از درد و غم | بیازید رخ چند کان زمان پر دژم | ...دارد رخ از لب جویبار | ... به دخت کردند
رخ جاده و نخن رفت و باز ... | ... کفت هست این نخن دلیذر | جوز روان بیامد بنده سرای | ... روزان که کار آمد
... نخن بر جان و منج کریحون | ... کی نیاز و تکر کار | ... به بذید این زمان شنید شاه | ... نهفته بدید و زبان ...
کنه یکم آمد سوی جهود | تخیشت کرد این دند و درود | جوبشید داد و بر هیار بلند | سواری دو سه که کرد رو
جوان بان باز کاه بلند | بشید داد و نرم شاه بلند | جهودان بنی نخن دلبذر | که بنا که زر از بین بک را
بخت آنخ زر روان بگفته بود | نخن هر چه اندر جهان رفته بود | ... بشنید و خیره ماند | بیش زیدان داد کرد شهر
... دست و راز جهان کند | زدن در دنجم بیش درش | جهان از ناز شنید ... زبان ... | کشید ... راحت و تن

یازان شنک و بازان تن | ... زدان رزبان ... کشف | ... رور زر همه ... | بک داد زر روان و یک جهود
... زر ها نین بک ش | ... زر یابان ...
جهان ایا یک سپرد نبه
که برد کشن ن کان بدر
رخیشان مهربد جندیخ
زنیشان یا بک تن یی د
یکی دختی یا نت بوشید ر
سه بند که نا نمایه نا جو
همه کج زر دان بدیشان
همه هرچه بد مال نزد حر
روانش رمهبند زبان ب
شب تخ تا زور زبان ب
زبردان همنی خوا شتی بین
همی نختی خون بزرگ
بدروش خشید بسیار جخ
زبانی بزار آفرین داشت ی

که بزدان که اهنت بخشد نکر | نشت کر نخ اد و زاد کر | یاز در که کدار به هنج د | کنی کو بود باک و بزدان بر | ... که زر نخ اد و زاد کر
اسکندر نشت نک خال شود | نهان جهان ترست کان او شود | کشاده کند روزر دم راز تو | اسک جند ترست و آواز تو | نهان بهر نشت نک از ان او شود
یعنی رنج باشی و یا کین یی رای | آری بهر یانی نی بهرد و سرای | سراآمد کنون زر دیا سیاه ستود | کنون کاز روان و مر دجهود | ...بهر یانی نی بهرد و سرای
جدا ان ز کر شاه ابی باد کر | خرد باد بای نا جز رنک | جوجان فی سنایش این ملک مد | چنان دان که کنی نوار آستی | جراز کرد و نمرت بیامد بس

TECHNICAL STUDY 1:

Close Examination of Leaves from the Great Mongol *Shahnama* SARAH BERTALAN

It is etched on the minds of the masters of the arcane that the garden of painting and illumination is an orchard of perfect adornment.

—Dust Muhammad, *The Bahram Mirza Album*[1]

Technical investigation is most meaningful when part of a collaboration between specialists. These observations are based on an examination intended to contribute physical evidence to the study of the remarkable Great Mongol *Shahnama,* whose history and significance are more fully discussed in Robert Hillenbrand's chapter 6. The most extensive treatment of the manuscript to date is that by Oleg Grabar and Sheila Blair.[2]

Two leaves of this dispersed work in the collection of The Metropolitan Museum of Art, New York, and nineteen leaves in other collections were examined using a binocular microscope, transmitted light, ultraviolet light, and infrared reflectography.[3] These tools aid visual examination and enhance our ability to scrutinize techniques, structure, and alterations to works of art. Fiber samples were taken from the paper supports of the Metropolitan Museum leaves in order to investigate distinctions noted during close observation of the supports.[4]

STYLES AND ALTERATIONS

The Great Mongol *Shahnama,* also known as the Ilkhanid or Demotte *Shahnama,* has been dated about 1330–35 and connected to Tabriz and the patronage of the vizier Ghiyath al-Din.[5] The two leaves in the Metropolitan Museum are stylistically diverse. Close examination under magnification has made it possible to further characterize these styles, and continued study of information gained may enable us to understand the nature of later alterations to the *Shahnama* leaves.

Isfandiyar's Funeral Procession (fig. 123) is executed with a limited palette of predominantly inorganic pigments. In keeping with the tradition of illustrations of the *Jami* al-tavarikh (Compendium of Chronicles) of 1314–15 (figs. 130, 162, 174), prominent areas of the image surface are unpainted. An unadorned paper surface is employed for the sky around the colorful clouds, the figures, faces, and hands. Pigments are used in pure, unmixed form. For example, on the figures, a thinned black is used to create gray rather than a mixture of black and white pigments. The contours of the figures are rendered in pure opaque color, and there is no detectable

1. *Muraqqa*-yi Bahram Mirza. Dibacha-yi Dust Muhammad,* translated by Wheeler M. Thackston. Thackston 2001, p. 11.

2. See Grabar and Blair 1980. Doris Brian was the first to propose an order for the images in Brian 1939.

3. I would like to thank Marjorie Shelley, Sherman Fairchild Conservator in Charge, Sherman Fairchild Center for Works on Paper and Photograph Conservation at The Metropolitan Museum of Art, for giving me the opportunity to work with the Museum's Islamic collections. I am also grateful to Daniel Walker, Patti Cadby Birch Curator; Marie Lukens-Swietochowski, Research Fellow; Stefano Carboni, Associate Curator; Navina Haidar, Assistant Curator; and the staff of the Department of Islamic Art at the Metropolitan Museum, who have afforded me rewarding and ideally collaborative experiences over the last five years. For this study, I would like to thank, at the Museum of Fine Arts, Boston, Julia Bailey of the Department of Asian Art for making its *Shahnama* leaves available to me, and my colleagues Joan Wright, Anne Evans, and Jacki Elgar of the Department of Asian Art Conservation for sharing equipment, time, and their stimulating collegial interest in this study. Martha Smith of the Freer Gallery of Art and Arthur M. Sackler Gallery, Smithsonian Institution, Washington, D.C., generously shared information, time, and equipment, making it possible for me to examine the large number of leaves in those institutions.

4. The leaves at the Freer Gallery of Art and Arthur M. Sackler Gallery have received the most extensive

Opposite: Fig. 274 (cat. no. 59). *Nushirvan Eating the Food Brought by the Sons of Mahbud* (?), page from the Great Mongol *Shahnama* (Book of Kings), Iran (probably Tabriz), 1330s. Ink, colors, and gold on paper. The Metropolitan Museum of Art, Purchase, Joseph Pulitzer Bequest, 1952 (52.20.2)

underdrawing or preparatory drawing. The figures are in some cases further tinted with a distinct wash of pure color, applied just within the opaque contour and without overlap, sometimes in washes so thin that the fibers of the support show through. Small areas of later retouching are easily distinguished, being glossy, thick color admixtures.[6]

Less obvious are alterations made to the delicately toned image with materials that are historically correct and/or not demonstrably modern.[7] Such changes may have been necessary in order to replace inherently unstable colors, repair damage, or emphasize details in the rendition of the epic as tastes and painting conventions changed. The sky in the *Isfandiyar* image is, atypically, broadly painted and opaque. Under magnification it becomes clear that there is extensive damage to the paper support in this area. This solid dark blue may have been applied to hide the damage and repair this area or to replace an original, unstable color.[8] The horse at the right is painted opaque gray in a mix of black and white pigments that is different from the gray used in the figures. Far more typical throughout the manuscript is a "tinted drawing" style for rendering animals in which the color is so thinly washed that the subtle drawing in carbon black is visible.

The saddles of the horses provide an example of an unstable color. Under magnification, the unmistakable, micalike flakes of orpiment are visible. This often fugitive pigment was widely used in Central Asia. Because of its tendency to fade or lose its brilliant yellow color, a brownish medium stain on early Islamic manuscripts is often a clue that orpiment had been used. The presence of a medium-rich layer under the painted gold in this image may be such a residue, indicating that orpiment was originally used there as well.[9] Similarly, the two ruled gold borders around the image are clearly not original. The inside ruled line covers an original brownish black line that has deteriorated the paper underneath it. This damage is consistent with the interaction of iron-gall ink and paper. The gold borders may have been painted on to cover the original damage, to satisfy a taste for the use of gold in manuscripts, or to enhance the appearance or value of the manuscript.

In the same way, a change in taste or the evolution of a local painting style may explain the opaque coating layer around the figures in this image. The figures themselves clearly belong to an earlier painting tradition in which the luster of the paper surface was employed evocatively. The background, however, is covered with a solid white paint layer that is now cracked overall, unevenly discolored, and darkened. The curious flowers and tufts of grass are out of scale with the figures in the composition and closer in style to those in paintings of later in the century.[10]

The second leaf in the Metropolitan Museum was tentatively identified by Grabar and Blair as *Nushirvan Eating the Food Brought by the Sons of Mahbud* (fig. 274).[11] The scene is rendered in shallow space, and the entire image surface is painted. The colors, predominantly inorganic, are applied both as pure pigments and as mixtures. Gold is used to fill the background and as a final layer to enrich some of the garments, creating the appearance of brocade. Thinly painted areas of pure color are limited to the trunk of the large tree and the vegetation at the top right of the composition, both rendered in the Chinese ink-painting style. A relatively thin brown wash or dye colors the second figure from the right and two rectangular details of

analytical attention. Elizabeth West FitzHugh has examined all of these paintings and analyzed pigments on numerous leaves; a small part of her results is published in FitzHugh 1988. Janet G. Snyder published her fiber analysis of two leaves from the Great Mongol *Shahnama* in Snyder 1988. In 1994, Martha Smith, collaborating with Victoria Bunting, Elizabeth West FitzHugh, Janet Douglas, and Richard FitzHugh, examined the borders attached to the leaves and prepared an internal memorandum (Conservation Department, Freer Gallery of Art and Arthur M. Sackler Gallery). In 1978, E. Z. Holmberg, working at the Harvard University Art Museums, analyzed pigments on *Shahnama* leaves in several collections. The unpublished results are on file at the Straus Center for Conservation and Technical Studies, Harvard University, Cambridge. For the present study, no pigment sampling was done and identification is based on microscopic appearance.

5. A variety of dates have been put forth for the manuscript. Several authors propose that some miniatures date from 1330–40 and some from the 1350s or 1360s. Others place the images at the beginning of the century, and still others date them all to the middle of the century. These datings are summarized in Ettinghausen 1959, p. 57. In Grabar and Blair 1980, p. 48, the manuscript is connected to the patronage of Ghiyath al-Din and the more exact date of November 1335 to May 3, 1336 is proposed, based on ideological and historical developments. Recent research is summarized and the same date maintained in Blair and Bloom 2001. Carboni in Swietochowski and Carboni 1994, p. 12, proposes a slightly broader date range.

6. Retouching is visible under shortwave ultraviolet illumination and with the binocular microscope. The largest example is a triangular-shaped area at the top left of the painting. In minute areas throughout, color was used to mask losses or tears in the paper support.

7. Artists tended to be faithful to traditional techniques and preparations, and the same palette was employed for hundreds of years. A consistent palette over five hundred years is demonstrated in FitzHugh 1988, p. 430. Therefore the manner in which colors were applied becomes a particularly important diagnostic tool.

8. Throughout the manuscript there are areas of sky where the original ultramarine has been lost, worn, or abraded, and these have been handled in various ways. In some cases the lost color has been restored with Prussian blue, which is clearly modern. In other cases losses have been repainted with natural ultramarine or indigo; these changes are not demonstrably modern. Here I again acknowledge the extensive work of Elizabeth West FitzHugh and the assistance of Martha Smith, who made available to me the information from Ms. FitzHugh's examination of the manuscript leaves in the Freer Gallery of Art and Arthur M. Sackler Gallery. The implications of a brown stain on the verso of the leaf corresponding to the area of the blue "sky" on the recto are not clear.

9. A well-known instance of this medium stain is in the so-called Small *Shahnama* of 1341 from Shiraz, which is known for its ocher-colored backgrounds.

the architecture. A purple stain corresponding to these areas on the reverse of the sheet suggests the use of a fugitive and possibly organic pigment or dye that has subsequently faded or altered in color. For the remaining figures, unmixed, inorganic pigments were used. The figures, in keeping with the Baghdad style, are rendered as a uniform, monochromatic field, with detailing on the surface in a darker color or in black. Rather than mixing or modulating color within the figures, the detailing layer is used to give shape and volume and to indicate garment folds. In the figures at left a masterful underdrawing can be detected where the opaque paint layer has been lost.

Unlike the figures, the architecture is thickly painted using mixtures of inorganic pigments. The color used to depict building facades varies throughout the manuscript, from off-white in the minimally colored paintings of *Darab Sleeping in the Vault* and *Bahram Gur in the Treasury of Jamshid* (both, Freer Gallery of Art, Smithsonian Institution, Washington, D.C.), to an implausibly bright pink.[12] Here the color is in the middle of this range and close to the coral that later becomes a convention for architecture. The brightly contrasting patterns of blue and white are also pigment mixtures that belie any sense of space, giving the impression that "separate pieces were rather clumsily added together."[13] While obvious distinctions in execution exist, and the image is today somewhat confusing due to subsequent alterations and damage, the palette is consistent throughout.

This leaf does not appear to have been subjected to restoration to increase its market value, since highly visible areas of damage were untouched. The prominent tree at the left is an indistinct smear. Obvious losses in the sleeves of the figures and other areas at the left of the image remain unrestored. When it was reproduced in black and white in 1939, gaping white losses were apparent in the figure at the right that either were unrepaired or had not been compensated with color (inpainted).[14] This was prior to the leaf's acquisition by the Metropolitan Museum but presumably after Georges Demotte dispersed the manuscript, when the page was in the possession of D. K. Kelekian, New York. Therefore, the restoration attributed to Demotte may not have been a sweeping and systematic campaign.

It is natural for the conservator to approach the compositions in the Great Mongol *Shahnama* from the point of view of palette and execution. Close examination of twenty-one leaves of the manuscript has shown that several hands employed pure and unmixed colors, allowing the paper surface to function as part of the image. This technical feature connects the works to an earlier generation of painting, the manuscripts of *On the Usefulness of Animals* of Ibn Bakhtishuʿ, the *Chronology of Ancient Nations* of Abu al-Rayhan al-Biruni, and Rashid al-Din's *Compendium of Chronicles*.[15] While the extent of nineteenth-century restoration of this *Shahnama* has often been discussed, it is also clear that alterations have been made using pigments and pigment mixtures consistent with the palette employed by artists for hundreds of years. Changes to the original may have been necessitated to replace unstable colors or after inadvertent water damage, evidenced by staining on some leaves (see below). Moreover, changes may have been made to underscore aspects of the iconography or as a taste for more fully colored or more colorful paintings developed. Such broad speculation is, however, beyond the scope of the current discussion of the Metropolitan Museum leaves.[16]

When the leaves of this *Shahnama* in the Department of Islamic Art at the Metropolitan Museum were examined under magnification, all the ocher areas contained flakes of orpiment, although the brilliant yellow color is lost. I thank Marjorie Shelley and Stefano Carboni for discussions on this condition, which is well worth investigating further. For the history and use of orpiment, see Gettens and Stout 1966, p. 135, and FitzHugh 1997, pp. 47–79. With exposure to light or certain conditions of air quality, orpiment has been observed to fade readily or suffer severe color loss; see FitzHugh 1997, p. 51. The use of orpiment was discussed in the eleventh century by Ibn Badis; see Levey 1962. In her analysis for the Vever Collection, Elizabeth West FitzHugh found orpiment in all the samples from India, Iran, and Iraq from the thirteenth through the sixteenth century: FitzHugh 1988, p. 426. It is also mentioned as a pigment in Qadi Ahmad al-Qumi's treatise of 1606; see al-Qumi 1959, pp. 174–201. It is the most common yellow in paintings from Iran, according to Purinton and Watters 1991.

10. This background is also extremely glossy and may have been treated with a consolidant.

11. The scene was previously identified in Brian 1939, no. 56. The identification was made tentative in Grabar and Blair 1980, p. 168.

12. The rendering of architecture varies enormously throughout the manuscript, but it generally appears off-white or pinkish in color, with glazes of red or white. When analyzed, the brightest pink turned out to be alizarin and lead white—again historically correct, although curious in appearance (research of Elizabeth West FitzHugh, cited in n. 8).

13. Grabar and Blair 1980, p. 168. Under magnification, all of the blues in the image appear granular and consistent with the microscopic appearance of ultramarine.

14. Brian 1939, fig. 29. The area is filled with a patch on the verso. The lost areas are now compensated with color on the recto.

15. See figs. 169; 136, 137, 170; 130, 162, 174. The present discussion does not include a large number of images from the Great Mongol *Shahnama* for which this connection is most obvious. In several fine images from the Iskandar (Alexander) cycle, the story of Ardavan and Ardashir, and the story of Bahram Gur, two approaches are combined in approximately equal proportions on an otherwise unpainted leaf: the tinted drawing or ink-painting Chinese style, used for landscape, and the Baghdad style of painting figures and animals.

16. The taste for polychromy in Islamic painting is discussed in Schroeder 1939, p. 128, n. 72.

FIBER IDENTIFICATION AND STRUCTURE

Grabar and Blair noted leaves where images are pasted onto unrelated text.[17] Thus we know that the supports and structure of the manuscript have been altered, but the extent and date of the alteration are not known. Both Sheila Blair and the conservators who conducted an analysis at the Freer Gallery of Art and Arthur M. Sackler Gallery found that strip borders of a short-fibered, wove paper of poor quality bearing a Russian watermark and date of 1839 were added to the folios.[18] (For a page, although not from that institution, shown with its strip borders, see fig. 183.) The borders are made up of four separate strips of paper, painstakingly beveled and attached to each edge of the manuscript leaf. On the basis solely of the physical evidence (without evaluating the written text) gathered while examining twenty-one leaves for the present study, three types of structure were noted. The first is a folio composed of a single, uniform sheet with four strips of wove paper attached with a beveled edge at the front and a straight cut edge at the back, slightly overlapping all edges of the manuscript leaf. (The final effect is like an inset or passe-partout.) The second is an image pasted onto a single and uniform folio, with the image partially covering some calligraphy and the folio inset as above. The last is an image inset into a "doubled" folio, with an area cut out of one side to create a "sink" for the image and the wove paper borders beveled and sandwiched between the two sheets. Water staining on the uniform, single-sheet supports suggests water damage and at least a hypothetical need for restoration, possibly earlier than the nineteenth century and for reasons other than market value. As previously noted by Grabar and Blair, in some cases the images appear to have been pried up or split from an original support.[19] Clues that indicate that splitting of the support sheet took place are extensive creases (vertical, horizontal, or diagonal creases at the corners), with associated loss to the media layer.

Initial scrutiny of the Metropolitan leaves was inconclusive regarding the uniformity of the support sheets. Sampling was undertaken not so much for definitive fiber identification but as a means of comparing various parts of the leaves to ascertain whether the supports were composed of a unified sheet or an assemblage of support papers.[20] The combined results of examination and sampling follow.

Close examination of *Isfandiyar's Funeral Procession* (fig. 123) showed that the paper support in the image area is a golden color—darker, more smoothly polished, and with a less open fiber structure than the text support. It is extremely brittle, with extensive tears and creasing at the top edge under the dark blue sky. This damage and the pronounced creases in the image are not evident on the verso of the folio. At the bottom left corner of the image, diagonal creases with associated loss to media are consistent with the mechanical damage caused by paper splitting. The image is separated from the text by a thin border, decorated with a pattern in carbon black ink and two ruled gold lines of differing colors. The inner gold border covers an original brown ruled border, possibly of iron-gall ink or a combination of iron-gall and carbon inks, that corroded the paper beneath it. On the lower third of the left edge and in three places along the top edge there are some damaged areas where one may arguably detect gaps between the image and the black and white border; this, however, is inconclusive.

17. Grabar and Blair 1980, pp. 1–12.

18. The subject was first discussed in Blair 1989. The results of the examination of fifteen leaves were summarized by Martha Smith and Victoria Bunting in an internal report, Freer Gallery of Art and Arthur M. Sackler Gallery, October 1994.

19. Grabar and Blair 1980, pp. 1–12, and throughout the discussions of the individual leaves.

20. Also, any physical evidence we can gather adds to the little known about papermaking at this time. We are fortunate that two books have recently been published on the subject of Islamic paper; see Bloom 2001 and Loveday 2001. For her publication on Islamic papers in the Vever Collection (now in the Arthur M. Sackler Gallery), Janet Snyder obtained samples from two leaves of the *Shahnama*. In one case, the image and text are on a single sheet, and she sampled from a damaged area on the image; the identification was inconclusive. The second leaf was composed of three pieces of paper; she identified linen from a sample taken from the border. See Snyder 1988, p. 437. For the present study, fibers were examined with a polarizing light microscope with magnification 100–400 times. Fiber length was measured using an ocular with a calibrated scale. I am grateful to Debora Dyer-Mayer, conservator of art and historic artifacts on paper (Portsmouth, New Hampshire), for graciously sharing her time and her expertise in fiber analysis.

In the text area of the folio, the support is light golden in color and soiled over-all. Where the paper has been creased, the surface appears burnished rather than abraded. No water stains were detected at the lower edge of the support, but there is a $1\frac{1}{2}$-inch-wide brown stain of residual adhesive along the bottom edge of the verso. The support is thick and relatively opaque to transmitted light compared with other papers examined. In strong transmitted light, the distribution of fibers appears uniform with few inclusions. Several discolored paper patches and a brown stain in the exact shape of the dark blue sky are present on the verso. However, areas where copper green was used in the image have not discolored to the verso.[21] The verso appears to be a uniform, single sheet. The edges of the folio have been strip lined with the Russian paper, beveled at the front and straight cut at the back, with new ruling lines added all around. Fiber samples taken from the support of *Isfandiyar's Funeral Procession* were not identical. The recto text area was sampled at the left column of the text above the image. The image area was sampled by teasing fibers under a lifted paper flap in the center of the foreground. The verso of the sheet was sampled at a crease approximately at the center of the image.

The fibers from the text recto, Sample 1, are extensively beaten and fibrillated. They are long, measuring from .4 to .7 millimeters. Beating is so extensive that diagnostic features are difficult to discern, and identification based on morphology was not possible for approximately half of the sample. Half of the fibers show characteristic features of a bast fiber, but further differentiation was not possible, given the small size of sample. Also present in abundance are flakes of a proteinaceous material, possibly sizing.

The fibers taken from the image recto, Sample 2, are uniformly and extremely short, .1 to .2 millimeters, up to eight times shorter than the text fibers. Not extensively beaten, all are easily identifiable as bast. Some proteinaceous flakes are also present. The fibers from the text verso, Sample 3, are comparable in length to those in Sample 1. Two-thirds of the fibers were readily identifiable by morphology as bast. Identification of the other third of the sample was not possible. There were no proteinaceous particles in the sample, although staining indicates the possibility that some fibers were saturated with a proteinaceous size; however, this is inconclusive, since yellow staining is also an indicator of lignin content. The fibers are generally more distinct and may be the same as those of Sample 1 but not processed to the same degree.

In the image *Nushirvan Eating the Food Brought by the Sons of Mahbud* (?), there are no unpainted areas available for examination. An incised horizontal line is visible at the area of the smeared tree in the left part of the top edge. This does not appear to be a gap or join between the text and image supports, however, and there are no other visible clues to the structure of the folio on the recto. The sequence of ruled border lines immediately adjacent to the image is two black, one red, one gold, one red. (The handling of borders immediately adjacent to the images is not uniform in the manuscript.) Extensive stains caused by the media on the verso of the sheet also suggest that this is a single sheet—that is, the painting was executed directly on this paper support. A dark-brown-stained area corresponds to the silver door, and purple stains correspond to the brown (possibly altered) color of the figure in the fore-

21. Identified by microscopic appearance.

22. On the recto, a patch was pasted onto the left column and the text was rewritten. There are several patches on the reverse of the sheet.

23. Helen Loveday has proposed a descriptive protocol for Islamic papers in Loveday 2001, pp. 55–58.

24. Fiber morphology was compared with samples published in Côté 1980. Also useful is Collings and Milner 1978. Staining was done with the Graff C Stain prepared by the Institute of Paper Science and Technology, Atlanta. In the sample from the text area on the back of the Nushirvan sheet, small particles of proteinaceous size (stained yellow by the C stain) were present but not abundant. Particles around the fibers from the text area on the front of the sheet initially appeared to stain blue; however, this was inconclusive. Samples from this leaf should be retested for the presence of size.

25. If so, the sheets have been expertly mounted and joined so that the attachments are very difficult to detect under magnification. The paper directly under the Isfandiyar image is so extremely brittle and fragile that it may have been remounted to preserve the image. This process may have included splitting or separating the front and back of the original sheet bearing the image, since the image has creases that could have been caused by the mechanical action of such delamination. Papers that have been extensively sized and finished have a weaker core or center and tend to delaminate with age. See Loveday 2001, p. 46, for an illustration of this characteristic of Islamic papers. This weakness in Islamic papers has been exploited not only to increase the monetary value of manuscripts but to preserve precious images or texts, assemble albums, replace damaged borders, and/or alter borders as tastes changed.

ground and of the two areas in the architecture noted above. There is an overall pattern of brown staining that corresponds to the building facade.[22]

The surface of the text area of the folio is golden and highly burnished; however, on both recto and verso, where abraded or damaged by water the surface is rough and feltlike, with distinct, long fibers that are visible to the unaided eye. The verso is a darker golden color, with a slick, highly burnished or polished surface. In transmitted light, dark stains are visible along the bottom edge of the sheet, indicating that the sheet has sustained damage from water. The paper is translucent and the fiber distribution is somewhat uneven or floccular, with numerous fiber clumps and inclusions that appear to be chaff from the raw fiber source. Some blue fibers are also present.[23] The ink over the fibrous, water-damaged area of the folio is feathered. The page is strip lined with the Russian wove paper, beveled at the front and straight cut at the back, and ruled with new borders.

The text on the verso was sampled in a slightly abraded area behind the image. The image was sampled at an area of damage in the door. The recto of the text support was sampled by lifting the roughed fibers from the surface of the water-damaged area under the image. The fibers from this folio are relatively unprocessed, with no sign of beating and no fibrillation. Based on the readily visible morphology, the fibers are uniformly bast. The fiber lengths vary enormously, ranging from approximately 1.5 or 2.0 millimeters to well off the scale. When stained and top lit, the fibers appear the characteristic pink of bast fibers. Under higher magnification and in transmitted light, individual fibers appear yellow, suggesting high lignin content. The ultimate tips of the long fibers are pointed.[24]

The samples taken from the support of the Nushirvan image show a uniformly processed bast fiber in identical condition at all three sites. This corroborates observations that the current support is a uniform sheet. The fibers sampled from the support of the Isfandiyar image differ significantly at all three sites, adding useful information to the inconclusive results of the visual examination. The fibers vary in their degree of processing and condition, suggesting that the leaf may be composed of several sheets of paper.[25]

Continued technical examination of the known leaves of this *Shahnama* should provide a larger context in which to consider the implications of the findings presented here.

TECHNICAL STUDY 2:

The Glazed Press-Molded Tiles of Takht-i Sulaiman

JOHN HIRX, MARCO LEONA, AND PIETER MEYERS

Thus if they want to compound a body out of which to make pottery objects . . . and house tiles, they take ten parts of the aforementioned white shukar-i sang *. . . and one part of ground glass frit mixed together and one part of white Luri clay dissolved in water.*
 —Abu al-Qasim ʿAbd Allah Kashani, *Treatise on Ceramics*[1]

Islamic ceramic technology has been the subject of extensive research drawing on archaeological excavations, critical translations of medieval treatises, scientific analysis of tiles and tile fragments, studies of twentieth-century crafts that preserve older traditions, and art-historical evaluation of extant objects. The manufacturing process of Islamic ceramics is now well understood. However, although the tiles of Takht-i Sulaiman have been extensively studied from the art-historical viewpoint,[2] to date there is only one (unpublished) technical study of them.[3] The organization of the exhibition "The Legacy of Genghis Khan" became the occasion for us to begin a comprehensive study of a number of excavated tile fragments from the site and complete objects not obtained archaeologically.[4] The aim of our study was, with the aid of petrographic and elemental analysis techniques, to achieve a detailed understanding of the fabrication of the ceramics from Takht-i Sulaiman. While the study is by no means complete, we can now offer a clear description of the materials that compose the tiles and their method of fabrication. As the project proceeds, we hope to be able to determine whether the Takht-i Sulaiman ceramics present any unique characteristics that could be used to conclusively link non-excavated objects to the site.[5]

MATERIALS AND TECHNIQUES

Ceramic Body

The tiles of Takht-i Sulaiman are composed of a fritware body glazed with either a translucent alkali glaze or a tin-opacified lead-alkali glaze. This material is referred to by a confusing variety of names: quartz-frit-clay paste, quartz-frit, faience, composite ware, artificial paste, stonepaste, and *kashi*. The term fritware will be used throughout this text.

Various descriptions of this technique exist, both historical and recent. One of the best known comes from Abu al-Qasim ʿAbd Allah Kashani, a potter himself and the member of a famous family of Kashan potters. In his treatise on ceramics

1. In Allan, 1973, pp. 113–14.
2. Masuya 1997.
3. U. Franke 1979.
4. Ceramic samples for this study were taken from both whole objects and fragments. Samples were kindly provided by Dr. Jens Kröger of the Museum für Islamische Kunst, Berlin, Mr. Hajime Inagaki of the Miho Museum, Shigaraki, Japan, and Dr. Linda Komaroff of the Los Angeles County Museum of Art.
5. We anticipate a future collaboration with the National Museum of Iran, Tehran, from which we hope to obtain more ceramic samples for study.

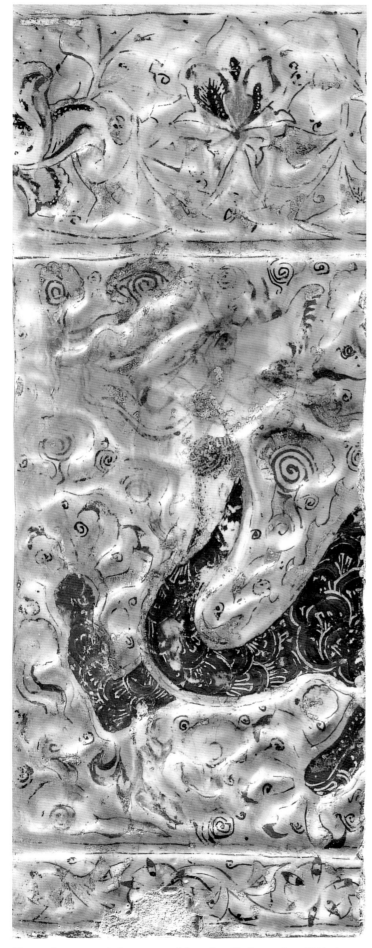

Fig. 275 (cat. no. 102), Fragmentary frieze tile with dragon, Iran (Takht-i Sulaiman), 1270s. Fritware, underglaze and overglaze painted (*lajvardina*). Staatliche Museen zu Berlin—Preussischer Kulturbesitz, Museum für Islamische Kunst (I. 4/67, 39)

of A.H. 700 (1301–2), Abu al-Qasim describes the manufacture of a ceramic ware composed of ten parts quartz, one part glass, and one part sticky white fine clay.[6] References to a similar material can be found in other ancient sources.[7] Modern writings on the subject essentially repeat and corroborate Abu al-Qasim's description.[8] A variety of theories have been voiced about the origin and development of this type of ceramic, but whether discovered in the attempt to reproduce Chinese porcelain or as an answer to the difficulty procuring fine clay that Iraqi potters experienced in Fatimid Egypt,[9] fritware represented a brilliant innovation.

To manufacture fritware, quartz from dry riverbeds or quartz quarries (or on rare occasions, sand) is finely ground and mixed with clay and glass frit.[10] The quartz provides bulk, compression strength, and chemical stability; the small percentage of highly refined clay lends plasticity to the body during shaping (gum arabic may also have been added to enhance the working qualities of the mixture). Fritware is truly a composite material in the modern, technical sense of the word; that is, raw materials having different properties are combined together to yield a new (composite) material with unique properties. By using fritware the potter was able to obtain a white ceramic body without having to consume large quantities of fine white clay, which was usually very expensive. The main ingredient, quartz pebbles, was abundant. The saving in the cost of materials may in part have offset the cost of additional fuel needed to produce fritware. Thus the use of the artificial ceramic body fritware rather than natural clays has socioeconomic implications that are extremely interesting; at present these have been only partially explored.[11]

The tiles from Takht-i Sulaiman can be divided into two categories. Tiles with a light body color, ranging from off-white to buff to light yellow to light pink, were used for interior walls and floors; tiles with a brown-colored body were reserved for exterior applications.[12] The majority of extant tiles are those with a lighter-colored body, which also have more sophisticated glaze decorations. The tiles examined in the present study are polygonal floor and wall tiles, some with sunken or raised designs and some with no design at all, as well as rectangular frieze tiles.

Our preliminary semi-quantitative analyses with the electron microscope (SEM-EDS) show that the tiles with a light-colored body have a compositional range that

approximately matches the one described by Abu al-Qasim. Based on the alumina content,[13] the initial fraction of clay must have been in the range of 11 to 15 percent, while the glass fraction, calculated from the total alkali (sodium and potassium oxides), lime, and magnesia content, should have been 8 to 11 percent. Alkali, lime, and magnesia have been grouped together because their relative proportions seem to match those in the ashes of desert plants (saltwort, or *Salsola soda,* and Russian thistle, *Salsola tragus*), a likely source of glass-making alkali.[14] The petrographic examination of thin sections of the tiles shows a ceramic fabric generally composed of: angular quartz grains, of varying sizes; grains of coarse and finer chert; occasional fibrous quartz; and sporadic mineral inclusions such as feldspar and plagioclase. The mineral grains are held together in a glassy matrix. Relic glass fragments are clearly visible as rounded pores with rims of microcrystals. This kind of petrofabric appears in a fragment from an irregular five-pointed star tile, shown in figure 276.

The brown-colored tiles contain a larger proportion of clay, up to 40 percent. This clay has a larger iron oxide content than the clay in the white-body tiles as well as a host of mineral inclusions seeming to indicate that the clay used in these tiles was not as pure or as refined as that in the white-body tiles. At the same time, the glass content is much lower than in the white-body tiles, approximately 3 percent—as should be expected, since the higher proportion of clay contributes to the stability of the fired tile, making glass a less necessary ingredient. An example of brown-body tile is seen in figure 277.

Fig. 276. Cross section of tin-opacified turquoise glazed tile with enamel decoration. From the top: enamel overpaint; tin-opacified lead-alkali glaze; quartz frit body. The body is composed of microcystalline quartz. Crossed polars, 100x. Tile fragment TS 23

Fig. 277. Cross section of clear-glazed brown-body tile. From the top: clear glaze; quartz frit intermediate layer; ceramic body. Parallel polars, 100x. Tile fragment TS 19

Ceramic Glaze

A glaze is essentially a glassy phase (meaning, in this case, a coating) on the body of a ceramic manufact; glazes display different characteristics, depending on their ingredients and production methods. Traditional glaze-making practices still followed in modern Iran call for quartz to provide silica, plant ashes as sources of alkali fluxes, lead oxide as an additional glass modifier, tin oxide as an opacifier, and various transition metal oxides as coloring agents.[15] In general, glazing can be carried out in two ways, either by applying the necessary glazing ingredients directly to the ceramic or by pre-fritting together quartz and alkali (and lead, tin, and coloring agents when opacity or color is desired) and applying the resulting material as a fine suspension. The solubility in water of plant ash alkalis (which would lead them to diffuse deeply into the ceramic body) and the toxic

6. Allan 1973.

7. Allan, Llewellyn, and Schweizer 1973.

8. Mason 1995, and references therein.

9. Mason and Tite 1994.

10. For this and other technical terms, see the glossary at the end of this study.

11. Centlivres-Demont 1971; Mason 1995.

12. Masuya 1997, pp. 288–300.

13. Tite 1989.

14. Kingery and Vandiver 1986, p. 114.

15. Wulff 1966, p. 160.

nature of some of the metal oxides make pre-fritting a very desirable step, since the glass precursors thus formed are safe and easy to handle. Additionally, the use of frits for glazing leads to more uniform glaze layers.[16]

Determining if a glaze is made from a frit is not straightforward, since the frit melts completely during firing, producing a continuous glassy phase. Evidence of the use of frits can sometimes be found in the form of relic fragments whose composition differs from that of the bulk of the glaze. A very uniform thickness and the presence of a very narrow glaze-body interface (the area where the glaze has reacted with the body to produce a glass phase of intermediate composition) can also be taken as an indication of pre-fritting. The cross sections of tile fragments in figures 276 and 277 show, respectively, a tin-opacified glaze and a clear glaze.

The question of whether the same glass composition was used for making the glazes and as an additive for the bodies is a most interesting one. The method of making glass from fine quartz and plant ashes described by Abu al-Qasim is practically identical to the procedure used by traditional potters in contemporary Iran. The ashes obtained from soda plants like *Salsola soda* or *Salsola tragus* were burned until all the volatile components had been removed. The solid mass resulting from this calcining process contains alkali but also magnesia and lime,[17] compounds that promote the formation of a hard, insoluble glass. Mixed with finely ground clear quartz pebbles in fairly equal proportions and heated to about 1,000 degrees centigrade, the quartz particles react with the alkali to form areas of glass. In practice the resulting frit is also ground, mixed, and fired several times, to produce a more or less homogeneous glass powder.

Our initial analyses of two glazes, an opaque white glaze and a clear blue translucent glaze, seem to indicate that the relative proportions of sodium, potassium, calcium, and magnesium in the glazes are identical to those in the bodies. Moreover, the ratios of potash, lime, and magnesia to soda closely follow the ratios in the ashes of soda plants. This might indicate that one glass frit composition was used throughout the tile-making process, both as an additive for the ceramic body and a precursor for the glazes. The glaze layers appear to be of very uniform thickness overall, and the glaze-body interface is always quite shallow, possibly hinting at the use of pre-fritted glazes.

Different types of glazed tiles have been identified at Takht-i Sulaiman:[18] monochrome glazed tiles, overglaze enamel–painted and gilded tiles, polychrome glazed tiles, and luster-painted tiles. In studying a ceramic, there is often a question as to the number of times the ware was fired. The most economical method of manufacture is to fire as few times as possible. The most complex tiles were fired at least twice.

Based on a knowledge of common ceramic glazing practices and on the microscopic study of photographic thin sections, several techniques for applying glazes can be proposed: dipping, ladling, and brushing a glaze slurry onto the surface (followed by removing excess glaze) are all possible application techniques for creating monochrome-glazed tiles, that is, tiles with a continuous uniform glaze layer.

16. Tite and Bimson 1986, and see glossary at the end of this essay for a discussion of fritting.
17. Kingery and Vandiver 1986, p. 114.
18. Masuya 1997.

The next more complex process is overglaze enameling and gilding. In this procedure, as confirmed in this study, the base glaze was locally gilded and then various enamels were applied to the surface, locking in the gilding, after which the ceramic was fired (fig. 278). The overglaze decoration of the tiles followed a definite color scheme. White, black, and red enamels were the only ones used. When gold leaf was applied it was not fused in position during a final firing, as is usually the case for modern ceramics. Rather, the gilding was applied to the fired glaze and then the various enamels were painted over it to create a design, visually incorporating the gilding into the design while mechanically locking the gilding in place. During firing, the enamels melted on top of the gilding and glaze, holding the gilding in position. It is interesting to note that the gilding protected the glaze to a certain extent. Ridges can often be seen in the glaze, formed after seven hundred years of aging, erosion, and exfoliation; they once defined the border of the gilding before it detached and became lost.

Another technique being studied is the local application of underglaze oxides, followed by the application of a translucent glaze layer directly to the ceramic, followed by the application of a translucent glaze (fig. 275). In this variation, the oxide migrates up and through the glaze, giving color to select areas rather than a monochromatic effect.[19]

The last category of glaze type is luster-painted ware. Here the glaze is a lead alkaline glaze, opacified by the addition of tin oxide. The luster is achieved by painting a compound containing copper or silver on the surface and subsequently firing the ware until the glaze is molten. At that time the kiln is slowly and controllably cooled until, at a predetermined point, oily organic materials are introduced into the kiln; these combust and make dense smoke, creating a reducing atmosphere. This results in the production of a colloidal suspension of metallic particles, with copper yielding a red metallic sheen and silver producing a yellow-golden sheen.

The chemical analysis of the two glazes from Takht-i Sulaiman confirms earlier results obtained on similar materials.[20] The translucent glazes at Takht-i Sulaiman are essentially composed of silica and alkali, while lead is found only in association with tin, in the opaque glazes. It is correct, therefore, to refer to the translucent glazes as alkali glazes and to the opaque ones as tin-opacified lead-alkali glazes. Historically, tin oxide is the opacifying agent of choice: its preparation and use have been described by Abu al-Qasim.[21] It is a powdery white material that is insoluble in the molten glaze; its fine crystals suspended in the glaze scatter light very efficiently, making the glaze opaque. Tin oxide is still made today according to the traditional process, in an oxidizing furnace where the tin and lead metal are heated in a crucible and the oxide forms on top of the molten metal.[22] The white skin is continuously lifted off with an iron scraper until the metal has completely converted to the oxide. Particles of tin oxide are readily apparent in cross sections of the glaze from a petrographic sample of a tile.

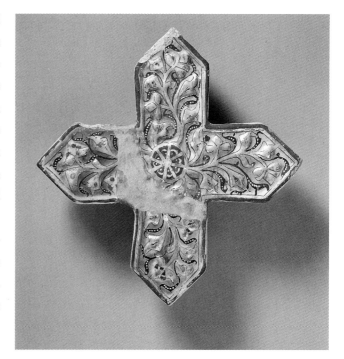

Fig. 278 (cat. no. 85). Cross tile, Iran (Takht-i Sulaiman), 1270s. Fritware, overglaze painted (*lajvardina*). Staatliche Museen zu Berlin—Preussischer Kulturbesitz, Museum für Islamische Kunst (I. 4/67, 21)

19. Without the benefit of information provided by cross-section analysis, Tomoko Masuya suggested a different scenario for these tiles. In her proposed model a translucent glazing material was applied to the surface, where it dried. Then a colored glaze was applied in certain preselected areas of the design (a technique she refers to as "inglazing"). After the glaze dried, the tiles were fired, gilded, painted with overglaze enamels, and fired again. At this time the technique described has not been confirmed.
20. Allan, Llewellyn, and Schweizer 1973; Tite 1989; Mason and Tite 1994; Tite et al. 1998; Mason et al. 2001.
21. Allan 1973.
22. Wulff 1966, p. 161.

23. R. Naumann 1977.

The range of colored glazes used for the Takht-i Sulaiman tiles is fairly restricted, mainly white, turquoise, and blue glazes. The white glaze contains only the opacifier, tin oxide. Colored glazes are produced by adding to the frit the usual range of metal oxides (blue/CoO; turquoise/CuO; brown, violet/MnO).

Examination of the Takht-i Sulaiman tile cross sections also helps explain the good fit of the glazes and the ceramic bodies. Adhesion of the glaze to the ceramic body is a serious concern in ceramic technology. Adhesion problems are often caused by differences in the thermal expansion characteristics of the glaze and the body when the glazed ceramic cools after firing. However, the fritware body and the alkaline glaze, being of similar composition, have similar coefficients of expansion and therefore "fit." A firing of up to 950 degrees centigrade causes the glazing mixture to melt and evenly coat the ceramic surface; additionally, the alkali and the lead oxide (if present) react with the silica and alumina in the body to form an interface layer. It is the formation of this interface that effectively binds the glaze to the ceramic body. An interesting case of manipulation of the ceramic tile structure to assure better glaze-body fit is represented by the tile in figure 277. It can be seen from the cross section that a thin layer of quartz frit is sandwiched between the glaze and the ceramic body proper. In this case, the quartz frit layer provides a transition zone between the glass frit of the glaze and the clay of the ceramic body.

Finally, details of the firing process can also be guessed at from the microscopic appearance of the glazes: in the case of Takht-i Sulaiman, it seems that the firing was of long enough duration to allow the glazes to mature properly, that is, to form and solidify without excessive porosity. Whether or not the tiles were all bisque-fired prior to glazing has not yet been determined.

PRODUCTION

Much information on the procedures used to manufacture the large numbers of glazed tiles at Tahkt-i Sulaiman has been gained from study of the structures and materials remaining at the site. The presence of a ceramic workshop in the palace and the discovery there of a number of molds confirm that tiles were mass-produced by molding at the site. The existence there of kilns, described and reconstructed by Rudolf Naumann,[23] indicates that kiln firing was done on-site as well. This does not exclude the possibility that some of the tiles that once clad the buildings were manufactured elsewhere.

Since it is very likely that raw materials such as clay, quartz, and plant ash were procured locally, it would be of interest to establish a unique characterization of the local fritware. Such a characterization could be used to determine whether the tiles from the palace were actually manufactured locally or were imported from established ceramic centers such as Kashan and transported as finished products to Takht-i Sulaiman. The characterization would also be useful

for identifying single tiles and other objects now in museum and private collections as part of the Takht-i Sulaiman production.

Instrumental neutron activation analysis (INAA) has long been recognized as an analytical technique ideally suited to characterize ceramics by their trace element patterns.[24] This technique was used to analyze twenty-five fritware samples extracted from tile fragments and museum objects.[25]

Although the number of samples analyzed is not yet large enough to allow statistically sound conclusions, it was observed that the majority of the samples constitute a relatively homogeneous compositional group. Clearly distinct from the group are two brown-colored tiles. Because of their considerably higher clay contents they were fully expected to have compositions different from those of the rest of the samples. Also deviant are a number of fritware objects not associated with Takht-i Sulaiman, one of them a vessel attributed to Kashan. This observation is significant because it demonstrates that local Takht-i Sulaiman products can be uniquely defined and that imports from established centers such as Kashan can readily be identified. Since the compositions of multicolored and luster-painted tiles, such as the Miho Museum frieze tile (fig. 98), are indistinguishable from those with simpler decoration, the tentative conclusion can be reached that even tiles with complex decorations were not imported but were manufactured locally.

Before the issue of local production versus importation can be fully addressed, it will be necessary to carry on additional trace element analyses on more material from Takht-i Sulaiman and other centers.

24. Neff, Bishop, and Bove 1989; Kuleff, Djingova, and Penev 1986.
25. Permission was obtained to sample seventeen tile fragments found at the site (now in the collections of the Museum für Islamische Kunst, Staatliche Museen–Preussischer Kulturbesitz, Berlin) and eight museum objects (from the Los Angeles County Museum of Art and the Miho Museum, Shigaraki, including nos. 83 (fig. 204), 94 (fig. 98), and 96 (fig. 109) in this catalogue. The fritware samples were analyzed by Dr. James Blackman at the National Institute of Science and Technology (NIST) in Gaithersburg, Maryland.
26. Masuya 1997, p. 242.

Fig. 279 (cat. no. 92). Fragmentary mold for a double pentagonal tile, Iran (Takht-i Sulaiman), 1270s. Gypsum. Deutsches Archäologisches Institut, Berlin

THE PRESS-MOLDING TECHNIQUE

Tiles were fabricated for the walls of the palace in a variety of shapes and sizes and with different types of glazes. The tiles were press-molded in gypsum plaster molds. Molds of gypsum plaster (calcium sulphate dihydrate) have been found at Takht-i Sulaiman; an example of a mold fragment from the site is cat. no. 92 (fig. 279).

Molds for some tiles were found at the pottery shop on the site.[26] The study of extant tiles has confirmed that all the tiles were mold-made. Many tiles have identical designs, indicating their mass production in standard molds. Thanks to the comprehensive study by Tomoko Masuya, who has catalogued all the known tiles, many aspects of the tile decoration of the palace can now be reconstructed. Because molds corresponding to all the various tile types from the site are not extant, the exact shape and design of all the molds used remains uncertain.

The initial step in the manufacture of the tiles would have been to create "models," or master tiles, to the exact dimensions desired. These positive forms were probably made of clay,

27. Both stone and plaster molds have been found on the site; ibid., p. 227.

28. Wulff 1966, fig. 234.

but since no original models have survived, this assumption cannot be verified. From the (positive) models, (negative) molds were cast in plaster.[27] Numerous tiny bubbles and air pockets that formed in the plaster slurry during the mixing and casting process are visible on the surface of the mold in figure 279. Although molds for the tiles found at the site could have been made in a number of ways, probable methods for preparing both open and two-part press molds are proposed here.

Plain-faced tiles could have been made in a one-piece open mold. Such a mold was probably made by placing the model—coated with a release agent such as grease, soap, or wax to prevent plaster from sticking to it—face down in an enclosed form. Plaster slurry would have been poured on the tile, covering it. Because of the release agent, the model tile would detach easily from the hardened plaster mold. The plaster one-piece mold would then be used to create numerous identical tiles. The process could be repeated to make many molds, increasing the number of tiles that could be made at one time. A plain tile with no relief decoration would have been made by pressing soft clay into the mold, scraping the excess clay from the exposed surface, and allowing the press-molded tile to dry in the sun.[28]

Tiles with relief decoration could have been made in two-piece molds. The master tile, coated with a release agent, would have been placed face down in a boxlike form. A bed of sand or sawdust, into which the relief face could be deeply pressed, may have been used to protect the tile face. Plaster slurry would have been poured over the tile, creating the back of the mold. When the plaster had dried, the mold and the tile would have been removed from the form as a unit, inverted, and placed again in the same form with the tile face up. The exposed plaster of the mold would then also be coated with a release agent and plaster slurry poured onto the face of the tile and the back of the mold to create the front of the mold. When dry, the two halves of the mold could be separated and the master tile removed.

To use the two-part mold, soft clay would first be pressed into the lower section, overfilling it; then the upper section with the relief design would be carefully pressed into the clay, imprinting it with the relief image. The mold sections might have been strapped together, squeezing out any excess clay, which could then be scraped away. When the clay had dried, the mold halves would be separated and the tile released from the mold.

Beveled edges are an unusual feature of many of the smaller non-rectangular tiles (star, cross, pentagonal, double pentagonal, or hexagonal shapes). Their side edges form an angle of less than 90 degrees with the decorated surface. Larger tiles, such as the frieze tiles, do not have this feature, even though they would have been placed on the same wall (for example, cat. no. 94, fig. 98). It is thought that these smaller beveled-edged tiles were designed to be self-grouting. During installation, tiles were placed into wet plaster. The inverted V shape formed by the abutted beveled edges of these tiles forced the wet plaster to ooze through the gap to the surface, where it was wiped away. Some of the original wall plaster into which the tiles were set still adheres to the back of the tiles. This method of

installation was labor-saving, since it eliminated the step of grouting the tiles after they were set in place.[29]

The beveled edges of the tiles may have been made in any of a variety of ways, and the subject is under debate. It is possible that the plaster molds were cast from master tiles with edges beveled toward the back surface. It is also possible that wedges were placed in the mold to create a beveled edge on the tile as it was formed in the mold.[30] The cutting of bevels by hand on each tile after the tile was removed from the mold is also a possibility. More molded tiles need to be carefully examined before definitive conclusions can be reached about that aspect of Takht-i Sulaiman tile manufacture. It is certain, however, that open-faced one-piece molds and two-piece molds were made and used to create tiles.

Glossary

Bisque, bisquit: Derived from the biscuitlike appearance of an unglazed body after firing, these terms are used to describe such a body, which is usually then coated with a glaze and subjected to a second ("glost," or glaze) firing. The firing process of unglazed ware is known as bisque firing.

Calcine: Heating a raw material or mixture of materials to eliminate combustible and volatile constituents and agglomerate the particles at a relatively low temperature, without the substantial formation of liquid.

Earthenware: Ware that has a permeable or porous body after firing below 1,200 degrees centigrade, with 10 to 15 percent absorption of water. A clay body fired at a temperature between 600 and 1,100 degrees C makes a thudding sound when struck and is usually colored red, gray, brown, or buff. The impurities in the earthenware, which usually contains a substantial amount of alkali, lime, and iron oxide, allow a hard product to be created at this low temperature.

Enamel: A fused vitreous nonhomogeneous superficial coating used on clayware, similar in its properties and use to glaze but differing in the uniform opacity of the fracture. Also: colored glass that fuses below 850 degrees C and is applied on a glass or glaze surface for decorative effect; the general term for a pigmented glass painted and fired on the surface of an underlying glaze as part of the decoration of porcelain or pottery.

Frit: From the past participle of the French verb *frire*, meaning to fry. A type of ground glass specifically prepared for one of the following purposes: 1, to act as a low-melting material to consolidate and initiate fusion of the components of fritware, i.e., quartz and clay; 2, to act as a homogeneous, low-melting material that can be applied in aqueous suspension onto a clay body and when fired result in a

29. The self-grouting method stands in interesting contrast to the grouting procedure used with modern tiles. Modern tiles can be made truly flat, thin, and square-edged, so that the amount of grouting is highly controlled. Grouting is applied after the tiles are set, when it is spread over the entire surface to fill all gaps between them evenly. When the grout dries, the surface of the tiles must be cleaned to remove the excess grout. The beveled edges of the Takht-i Sulaiman tiles allowed for their placement directly in the plaster. Pressing the tile delivered some of the plaster to the surface as grout, the excess of which was immediately removed, or manipulated as a design feature; no further steps were required. Further study of these tiles will also focus on the plaster materials used to attach them. It is possible that the grout contained abrasives that might have scratched the tiles if the grout was applied after setting.

30. A tile with uneven beveled edges in the Los Angeles County Museum of Art (M.2002.1.177) shows clear evidence of having been made in a simple open-faced mold with beveled edges integral to the mold walls. Although the tile is glazed, the edges have been left unfinished. A small rim of the excess clay that extended over and around the edges of the mold when the tile was pressed remains; it was not trimmed when the tile was removed from the mold. If the tile's edges had been cut into a bevel after being released from a square-sided mold, this edge of excess clay would have been removed at that time. These factors suggest a process in which the tile mold was taken from a master tile whose edges were beveled rather than one in which the edges of individual tiles were beveled after release from the mold.

glaze on the ceramic. Frit may have different compositions; it is mostly silica (from quartz) and will contain alkali (for example, from potash) and alumina (from clay). It is prepared by mixing ground-up quartz, potash, and clay in predetermined ratios (sometimes with additional ingredients), then firing the mix until fused. The product is cooled, ground, and mixed, and fired again. This process is repeated until a homogenous powdered mass is obtained.

Glaze: A thin, generally homogeneous, completely fused silicate mixture on the surface of clayware. It is a form of glass, usually with a high alumina content, that has a lower thermal expansion than glassware or window glass. It is specifically selected and prepared to match the expansion coefficient of the ceramic onto which it is to be fused.

CATALOGUE

MANUSCRIPTS AND SINGLE PAGES

1

Fig. 201

Tarikh-i jahan-gusha (History of the World Conqueror)

Copied by Rashid al-Khwafi
Probably Iraq (Baghdad), finished A.H. 4 Dhuʾl-hijja 689/A.D. December 8, 1290
Leather binding; 175 folios: ink, colors, and gold on paper
33 x 25.5 cm (13 x 10 in.)
Bibliothèque Nationale de France, Paris
(MSS or., Suppl. persan 205)
New York only

Historical writings, culminating with Rashid al-Din's *Jamiʿ al-tavarikh* (cat. nos. 6, 7), became popular with the Ilkhanids, in the interests of creating a permanent, written record of the Mongol role. The Persian author ʿAlaʾ al-Din ʿAta Malik Juvaini (1226–1283), whose family from Khurasan had been accustomed to serve in the Mongol administration, was governor of Baghdad and Iraq from 1259 to 1282. On account of his literary aptitude he became one of the Ilkhanids' most influential administrators and wrote the *History of the World Conqueror,* his best-known historical work, while in office.

This copy was finished only seven years after Juvaini's death.[1] The colophon gives the exact date of completion but unfortunately not the place of production; and the name of the patron once written on the first folio has been scratched off. Both Baghdad and Maragha have been suggested as the place of origin, on the basis of the style of the double-page frontispiece (fig. 201).[2] This shows an open-air scene set in a Chinese-inspired landscape in which the author of the book sits and writes as if taking dictation from a princely Mongol figure, who stands before him in front of a horse and squatting groom. The traditional "author" and "enthroned patron" frontispieces—often present in pre-Ilkhanid painting—have been seemingly consolidated into one unconventional image in which the patron is also a sort of muse for the writer. The princely figure, therefore, might be identified as Hülegü (r. 1256–65) or Abakha Khan (r. 1265–82). The painting is also the first datable occurrence in an illustrated manuscript of the integration, however awkward, of Chinese elements in the landscape, from the oversize peonylike flowers blooming on the pomegranate tree on the left to the cloud with a "flaming pearl" growing from it on the right.

1. Blochet 1926, p. 88; Ettinghausen 1959, pp. 44–52; Richard 1997, p. 41, no. 7.
2. From a comparison with the Morgan *Manafiʿ-i hayavan* (cat. no. 2), Ettinghausen 1959, pp. 44–52, suggested that Maragha was the more likely, but the discovery of the Istanbul *Marzubannama* has prompted Simpson 1982b, p. 115, and more recently Richard 1997, p. 41, no. 7, to opt for Baghdad.

2

Fig. 169

Manafiʿ-i hayavan (On the Usefulness of Animals)

Copied by ʿAbd al-Hadi ibn Muhammad ibn Mahmud ibn Ibrahim al-Maraghi for Shams al-Din ibn Ziyaʾ al-Din al-Zushki
Northwest Iran (Maragha), A.H. 697 or 699/A.D. ca. 1297–1300
Leather binding; 86 folios: ink, colors, and gold on paper
35.5 x 28 cm (14 x 11 in.)
The Pierpont Morgan Library, New York (MS M.500)

The text of the *Manafiʿ-i hayavan,* by Ibn Bakhtishuʿ (d. 1058), is a translation into Persian from the original Arabic made at the order of the Ilkhanid ruler Ghazan Khan (r. 1295–1304) after his accession to the throne. This manuscript,[1] the pages of which were reduced in size and restored over the centuries, is almost complete except for two missing folios. Made for an otherwise unknown patron, it is probably a copy of the original royal codex created for Ghazan Khan. The text, ultimately derived from Aristotelian sources, is a treatise on animals, including man, dealing with their physical characteristics and describing the medical properties of their organs.

Of the 103 illustrations in the manuscript, which seem to be the work of at least three painters, a large number have been restored and overpainted, and some were even added by modern restorers shortly before the copy was acquired by J. P. Morgan in 1912. The style of the originals is eclectic, influenced by both preexisting traditions in the area and elements newly introduced from East Asia. In this the book bears comparison with two other manuscripts of the period, a copy of the *ʿAjaʾib al-makhluqat* in the British Library (cat. nos. 14–16) and the Edinburgh University *Kitab al-athar al-baqiya* (cat. no. 4). On the basis of stylistic details, it has been postulated that the same painters illustrated all three manuscripts, a suggestion that needs to be further corroborated.[2] There is no doubt, however, that these manuscripts testify to the changes that took place in Persian miniature painting at the end of the thirteenth century.

Pages that exemplify the inclusion of East Asian elements, especially in the landscape details, and that have not suffered overmuch restoration are the images of the *simurgh,* a mythical bird represented as a Chinese phoenix (fol. 55r, fig. 169); the mare and stallion, with a gnarled tree trunk and recessed ground line (fol. 28r); the mountain goat, with mushroom-like rocks and an unusual view of the leaping animal (fol. 37v); and the mountains and clouds represented in the slightly retouched rendering of the mule (fol. 30r).

1. Martin 1912, pls. 21–26; A. U. Pope and Ackerman 1938–77, pls. 819–21; Ettinghausen 1950, pls. 10,

11, 40, 48; Grube 1978, figs. 1–3; Schmitz 1997, pp. 9–24, no. 1.
2. Schmitz 1997, pp. 9–24, no. 1, pls. 1–4, figs. 1–38; see also pp. 473–87, for the most up-to-date bibliography.

3

Fig. 266

Kalila va Dimna (Kalila and Dimna)

Copied by [Abu] al-Makarim Hasan
Iran, A.H. 707/A.D. 1307–8
Leather binding; 209 folios: ink, colors, and gold on paper
22 x 10 cm (8⅝ x 4 in.)
The British Library, London (Or. 13506)

Kalila va Dimna, a series of moralizing animal tales, many of them narrated by the two jackals named in the title, originated in India in the fourth century as a Sanskrit text. Two centuries later it was translated into Pahlavi, from which an Arabic version was made by Ibn al-Muqaffaʿ in the mid-eighth century. The Arabic in turn was translated into Persian by Abu al-Maʿali Nasr Allah Munshi in the twelfth century, possibly for the Ghaznavid sultan Bahramshah (r. 1117–57). Manuscripts of this text with elaborate illustrated cycles were copied from Egypt to Central Asia for many centuries, making it perhaps the most popular illustrated book in the Islamic world. The British Library's copy of 1307–8 is one of the earliest in Persian to have survived,[1] probably the third in date after manuscripts in Istanbul and Paris.[2] Others are known from the Ilkhanid period, including an Arabic version possibly completed in Baghdad in the late thirteenth century.[3]

The basic compositions and rather simple quality of the design place this small manuscript within the tradition of Seljuq painting. Its red backgrounds and pointed mountain peaks seem in some way to anticipate the style of painting that fully developed a few decades later in Inju-ruled southern Iran (see cat. nos. 11–13). The most appealing of its sixty-six illustrations are a crowded, vertically set double frontispiece showing a ruler and courtiers in a hunting area (fols. 2v–3r) and a number of small square images usually of two animals facing each other as the main characters in a story (fig. 266).

1. P. Waley and Titley 1975; Barrucand 1986; Grube 1991.
2. Topkapı Palace Library, Istanbul (H. 363), and Bibliothèque Nationale de France, Paris (MSS or., Suppl. persan 1965). See Grube 1991, p. 168, and figs. 25, 36, 38.
3. Royal Library, Rabat (MS 3655). See Barrucand 1986.

Figs. 136, 137, 170

Kitab al-athar al-baqiya ʿan al-qurun al-khaliya (Chronology of Ancient Nations)

Copied by Ibn al-Kutbi
Northwestern Iran or northern Iraq,
A.H. 707/A.D. 1307–8
179 folios: ink, colors, and gold on paper
31.1 x 19.1 cm (12¼ x 7½ in.)
Edinburgh University Library (MS Arab 161)

This work by the polymath Abu al-Rayhan al-Biruni (973–1048), one of the most outstanding literary and scientific figures of the medieval Islamic period, deals with calendrical systems and explores the customs and religions of different peoples. Known as the *Chronology of Ancient Nations* after the translation from the Arabic published by C. E. Sachau in 1879,[1] its title translates literally as "Remnants of the Past Centuries." The manuscript contains twenty-five paintings and represents one of only two illustrated copies of this text known to have survived, the second being a much later, exact copy of the Edinburgh codex.[2] According to its colophon the manuscript was copied by a certain Ibn al-Kutbi and finished in the year A.H. 707 (1307–8). It was illustrated by more than one anonymous painter, although its place of production remains unknown.[3] The patron, most likely a wealthy Shiʿite Muslim who wanted specific stories in the text to be illustrated and others ignored, is also unknown. It is possible, however, that the person responsible for the layout of the manuscript was himself one of the painters or that Ibn al-Kutbi was copying it for his personal library and no outside patron was involved.

Robert Hillenbrand has shown that the choice and placement of illustrations throughout the text can be seen as creating a cycle of images that emphasizes the interest of the Ilkhanids in different religions and at the same time demonstrates the prominence of Islam at the beginning of the fourteenth century.[4] The Shiʿite inclination of the patron or whoever was responsible is most evident in the two concluding images, the largest and most accomplished in the manuscript, illustrating two episodes in the life of Muhammad with ʿAli, Hasan, and Husayn as protagonists: *The Day of Cursing* (fol. 161r, fig. 136) and *The Investiture of ʿAli at Ghadir Khumm* (fol. 162r, fig. 137). A total of five images represent Muhammad—the earliest such set in Persian painting[5]—including the first miniature, in which the Prophet prohibits intercalation in the calendar (fol. 6v, fig. 170). Many illustrations in the sections on calendars and festivals depict specific episodes related to Manichaeism, Buddhism, Judaism, and Christianity. Others indicate a keen interest both in historical events and in scientific subjects; *The Birth of Caesar* (fol. 16r), for example, shows a rather realistic image

of a cesarean birth. The style of the miniatures, a hybrid between that of the pre-Mongol period in the Mesopotamian area and the Chinese-type landscape introduced under the Mongols, is in keeping with that of manuscripts illustrated in the time of the sultans Ghazan and Öljeitü (together, r. 1295–1316).

1. Al-Biruni 1879.
2. Soucek 1975; Hillenbrand 2000. For the seventeenth-century Ottoman copy (Bibliothèque Nationale de France, Paris, MS Arabe 1489), see T. W. Arnold and Grohmann 1929, pl. 40.
3. Soucek 1975, p. 156, suggests Tabriz or Maragha; Carboni 1988–89, p. 17, and Carboni 1992, esp. pp. 432–33, suggest Mosul on the basis of a comparison of some of its illustrations with others in the so-called London Qazvini (cat. nos. 14–16). Robert Hillenbrand (see above, chapter 6) supports the attribution to Mosul.
4. See Hillenbrand 2000 and his discussion of this manuscript above (chapter 6). See also Fontana 1994, esp. pp. 14–18.
5. The earliest extant representation of Muhammad in a Persian manuscript is in the *Marzubannama* of 1299 (Archaeology Museum Library, Istanbul, MS 216); see Simpson 1982b, fig. 49.

Fig. 54

Kitab jamiʿ al-tasanif al-rashidi (Collected Writings of Rashid al-Din)

Copied by Muhammad ibn Mahmud al-Baghdadi; illuminated by Muhammad ibn al-ʿAfif al-Kashi
Iran (Tabriz), A.H. 707–10/A.D. ca. 1307–10
Leather binding; 375 folios: ink and colors on paper
53.5 x 38.5 cm (21 x 15⅛ in.)
Bibliothèque Nationale de France, Paris (MSS or. Arabe 2324)

The vizier Rashid al-Din (1247–1318) was a polymath learned not only in history but also in theology, philosophy, and science. His writings, including a large number of theological treatises, were collected in bulky manuscripts copied in either Arabic or Persian, some of which, following the installation of his atelier in Tabriz, were kept in the capital, while others were dispersed in libraries throughout the Ilkhanid kingdom. The text of this work (also known as *Majmuʿa al-rashidiyya*) was dedicated to the sultan Öljeitü (r. 1304–16). Only the Arabic version has been preserved.[1]

The present manuscript,[2] in both calligraphy and illumination, compares well with Rashid al-Din's most celebrated work, the roughly contemporary *Jamiʿ al-tavarikh* (cat. nos. 6, 7), which was produced in the same atelier in the Rabʿ-i Rashidi (the Rashid's quarter) in Tabriz and which has survived in two sections in Edinburgh and London. The same artists worked on many manuscripts in the scriptorium, as is apparent from two signatures that appear consistently throughout the manuscript. One is that of Muhammad al-Kashi, who also illuminated sec-

tions of the *Jamiʿ al-tavarikh* and was most likely the painter of this codex; the other is that of Muhammad al-Baghdadi, who was well known as a rapid calligrapher and must have been its copyist. The illumination of the opening double-page frontispiece is one of the most refined among the manuscripts of royal quality, Korans in particular, created in Rashid al-Din's atelier.

1. Richard 1997, p. 44, no. 12.
2. *Trésors d'Orient* 1973, pp. 76–78, no. 209; Richard 1997, p. 44, no. 12.

6, 7 Two Sections of the *Jamiʿ al-tavarikh* (Compendium of Chronicles)

6

Figs. 130, 172

Iran (Tabriz), ca. A.H. 714/A.D. 1314–15
151 folios: ink, colors, and gold on paper
42 x 32 cm (16½ x 12½ in.)
Edinburgh University Library (MS Arab 20)

7

Figs. 162, 174

Iran (Tabriz), A.H. 714/A.D. 1314–15
59 folios: ink, colors, and gold on paper
43.5 x 30 cm (17⅛ x 11¾ in.)
The Nasser D. Khalili Collection of Islamic Art, London (MSS 727)

Ghazan (r. 1295–1304), the seventh ruler of the Ilkhanid dynasty and the first to convert to Islam, commissioned his vizier, Rashid al-Din (1247–1318), to write the history of the Mongols. During the reign of Ghazan's brother and successor, Öljeitü (r. 1304–16), this text developed into the earliest account of the world's history and has since been known as the *Jamiʿ al-tavarikh,* or *Compendium of Chronicles.* An addendum to the vizier's fifty-thousand-dinar endowment of his tomb complex in Tabriz stipulated that two copies of his work, one in Arabic and another in Persian, should be transcribed every year. The pages from the Arabic manuscript here are from the earliest-known copy of this chronicle, completed in 1315 and made under the author's supervision.[1]

This work initially comprised four volumes. The first, written for Ghazan, was an account of the Mongol rulers from Genghis Khan onward (see cat. nos. 17–19, 22–25, 27–31 for pages presumed to be from this volume). The second volume covered Öljeitü's life up to the time of writing (1310), together with the history of the Eurasian people. Only the second half of the second volume survives, narrating the history of the ancient Iranian and Arabian kings, the prophet Muhammad and the caliphs, the Jews, the non-caliphate rulers of Iran and Asia Minor, the

Franks, the Indians, and the Chinese.[2] The Edinburgh and Khalili manuscripts between them make up this section of the second volume.[3]

The two together contain over 200 folios; interspersed at various points in the text are 110 illustrations, plus 80 portraits of Chinese emperors and their attendants. The paintings seem to draw upon a wide range of sources including—but not limited to—pre-Mongol Persian and Arabic texts (both pre-Islamic and Islamic manuscripts), Chinese scrolls and woodblock illustrations from books, Byzantine religious and historical manuscripts, and Crusader painting with its French Gothic style.[4] Perhaps most significantly, non-Mongols are here recast in the guise of Mongols, with their characteristic features and costumes, thereby in a sense uniting all of world history with that of the Mongols. A case in point is the dramatic battle scene pictured in *Mahmud of Ghazna's Conquest of India* (cat. no. 6, fig. 172), in which the tenth-century Turkic conqueror (at left of center) is portrayed as a Mongol warlord, clothed in a silk robe decorated with golden clouds.

Nearly every painting reflects one or more sources of influence. For example, the composition of *The Birth of the Prophet Muhammad* has been adapted from a Christian Nativity scene (cat. no. 6, fig. 130). Its tripartite arrangement is a formula well known from thirteenth-century manuscript illustration associated with Baghdad.[5] In *The Death of Moses* (cat. no. 7, fig. 174), the prophet lies in state in a manner related to comparable scenes in Byzantine manuscript illustration,[6] while the mountain setting of Mount Jebo, where Moses delivered his final sermon, is rendered as a series of spiky triangulations reminiscent of Chinese landscape conventions as used, for example, in textiles.

Chinese influence in the *Jamiʿ al-tavarikh* is perhaps most evident in the depiction of landscape, mountainous landscape in particular, which is the dominant theme of *Mountains between India and Tibet*. This painting (cat. no. 7, fig. 162), which illustrates the section on India, not only incorporates Chinese conventions for the mountains; it also draws on a variety of Asian sources in representing the two buildings (one based on a Nepalese, the other on a Chinese, model) and the two figures, whose poses, costumes, and jewelry reflect Chinese, Tibetan, and Indian influences.[7]

In this way, the ingenious artists of the *Jamiʿal-tavarikh* repeatedly transformed existing models, compositions, and figural types to create new compositions that would recur in, or would influence, subsequent manuscript illustrations and drawings.

1. Blair 1984, pp. 81–82; Blair 1995, pp. 12–13.
2. Blair 1995, p. 23. Volume 3 was a geneaology of ruling houses, volume 4 a geographical work.
3. D. T. Rice and Gray 1976; Blair 1995.

4. Blair 1995, pp. 46–54. See also Robert Hillenbrand's chapter 6 above.
5. In the Mongol period this type of composition was already present in the double frontispiece from the *Rasaʾil al-ikhwan al-safaʾ* produced in Baghdad in 1287; see Ettinghausen 1962, pp. 98–101.
6. Blair 1995, p. 84.
7. Ibid., p. 77.

8 *Fig. 164*

Anthology of Diwans

Copied by ʿAbd al-Muʾmin al-ʿAlawi al-Kashi
Iran (possibly Tabriz), A.H. 713–14/A.D. 1314–15
Leather binding; 112 folios: ink, colors, and gold on paper
36.5 x 25.5 cm (14⅜ x 10 in.)
The British Library, London (Manuscript 132)

This manuscript, a collection of poetic works, like other early-fourteenth-century Ilkhanid manuscripts was copied on large sheets of paper and is profusely illustrated, with 53 paintings dispersed among its 112 folios.[1] Almost all of the illustrations have to do with a bearded, turban-clad poet offering a scroll, or reading from a scroll, to a Mongol prince, identifiable by his costume, features, and attendants. They would have done little to enhance the meaning of the text, but they do serve to underscore through repetition the idea of the Mongols as the new patrons of art and letters.

ʿAbd al-Muʾmin al-ʿAlawi al-Kashi, the scribe, dated his text in several places between 713/1314 and 714/1315. In terms of their style, the miniatures—essentially line drawings enlivened by washes of color, in which much of the horizontal pictorial surface has been left blank—are reminiscent of the *Jamiʿ al-tavarikh* illustrations of roughly the same date.[2] Those in the *Anthology*, however, can be characterized as a simplified or even provincial interpretation of the court style of Rashid al-Din's great manuscript project (see cat. nos. 6, 7).[3] Clearly the artist was not entirely conversant with every aspect of his subject matter, as the scrolls that are repeated in nearly all the illustrations often look more like sleeves or rolled napkins.

1. Robinson 1976b, pp. 3–10, pl. 1.
2. See Robert Hillenbrand's chapter 6 above.
3. Robinson 1976b, p. 4.

9 *Fig. 261*

Muʾnis al-ahrar fi daqaʾiq al-ashʿar (Free Men's Companion to the Subtleties of Poems)

Copied by the author and compiler, Muhammad ibn Badr al-Din Jajarmi
Iran (Isfahan), finished in A.H. Ramadan 741/A.D. February–March 1341
Leather binding; 257 folios: ink, colors, and gold on paper

20.5 x 14.2 cm (8⅛ x 5⅝ in.)
Kuwait National Museum, The al-Sabah Collection, Dar al-Athar al-Islamiyya, Kuwait City (LNS 9 MS)

This voluminous anthology of Persian poetry, which contains thirty chapters devoted to different genres and poetic forms and artifices, was the work of one Muhammad ibn Badr al-Din Jajarmi, an otherwise unknown fourteenth-century author and scribe, who, according to his own words, spent most of his life in Isfahan. The manuscript is valuable from the literary point of view because it includes a number of early poems that would otherwise be lost.

The bound codex was stripped of its illustrated twenty-ninth chapter (see cat. no. 10), but it still contains a double-page frontispiece (fols. 1v–2r) that depicts a hunting scene on the right and an enthroned couple surrounded by attendants on the left.[1] The text inside the dedicatory rosette at the beginning (fol. 1r) is rubbed off, leaving the couple unidentified; clearly, though, they wear Mongol attire, and the woman has a higher rank, since she sits on her companion's right. The painting has undergone some restoration and retouching but is largely original. As the political situation in Isfahan after the death of Abu Saʿid in 1335 was confused and the Ilkhanid succession a matter of dispute, it is not clear to whom the author might have wanted to dedicate his book. The frontispiece may have been added when the text was finished in the hope of presenting it to the current ruler and of being compensated accordingly. If so, the royal couple portrayed may be symbols of the post-Ilkhanid power struggle rather than real patrons.

1. Swietochowski and Carboni 1994, pp. 8–66, esp. pp. 12–17.

10 *Fig. 236*

Page from the *Muʾnis al-ahrar fi daqaʾiq al-ashʿar* (Free Men's Companion to the Subtleties of Poems)

Copied by the author and compiler, Muhammad ibn Badr al-Din Jajarmi
Iran (Isfahan), A.H. 741/A.D. 1341
Ink, colors, and gold on paper
20.3 x 14 cm (8 x 5½ in.)
The Metropolitan Museum of Art, New York, Cora Timken Burnett Collection of Persian Miniatures and Other Persian Art Objects, Bequest of Cora Timken Burnett, 1956 (57.51.25)

The six heavily illustrated folios that once formed the twenty-ninth chapter of Muhammad ibn Badr al-Din Jajarmi's *Muʾnis al-ahrar* (cat. no. 9) are now dispersed in collections in the United States.[1] They include a riddlelike illustrated poem in praise of the Seljuq sultan

Sulaimanshah written by Muhammad Ravandi (b. ca. 1165) and an astrological poem and a quatrain (ruba‘i) composed by Jajarmi himself.

Jajarmi's poem on lunar elections includes twelve quatrains and is illustrated by associated images of the twelve signs of the Zodiac in relation to the moon. It begins on the recto of this folio with Virgo, Libra, and Scorpio, and continues on the verso with Sagittarius, Capricorn, and Aquarius (fig. 236).[2] The planet Moon, a crowned woman holding a crescent around her head, sits in front of each sign of the Zodiac, the entire scene set against a red background with tall plants. Following Islamic tradition, Sagittarius is rendered as an archer with a long snaky tail ending in a dragon's head, who is in the act of shooting an arrow into the dragon's mouth. Capricorn is shown as a mountain goat, and Aquarius as the dark-skinned planet Saturn drawing water from a well. A sample of the text is as follows:

When the Moon has come to Capricorn,
　　hold entertainments.
Dig qanats and canals, if you are able.
Buy slaves and animals, if you have the
　　money.
Toil to acquire learning; do not behave
　　ignorantly.[3]

1. Two, including cat. no. 10, are in The Metropolitan Museum of Art, New York; the Arthur M. Sackler Museum at Harvard University, the Cleveland Museum of Art, the Princeton University Libraries, and the Freer Gallery of Art in Washington, D.C., have one each. See Swietochowski and Carboni 1994, pp. 26–47.
2. Ibid., pp. 42–45, no. 6a–f.
3. Translated by Alexander H. Morton in ibid., p. 64. For qanats, see ibid., p. 66, n. 54: "The subterranean aqueducts commonly used for irrigation on the Iranian plateau. The poet uses the alternative term kariz."

11–13 Three Folios from a Copy of the *Shahnama* (Book of Kings)

Dedicated to the vizier al-Hasan Qavam al-Daula wa al-Din
Copied by Hasan ibn Muhammad ibn ‘Ali ibn Husain al-Mawsili
Iran (Shiraz), A.H. Ramadan 741/A.D. February–March 1341
Ink, colors, and gold on paper
Page average: 37 x 30 cm (14⅝ x 11¾ in.)
Text area: 28 x 24 cm (11 x 9½ in.)

The *Shahnama,* or *Book of Kings,* written in Persian verses by Abu al-Qasim Firdausi (ca. 935–ca. 1020) and dedicated to Sultan Mahmud of Ghazna, was completed in 1010. The text is based on stories of ancient heroes and kings of pre-Islamic Iran, which in the context of the period can be understood in terms of an Iranian revival marked by interest in a national history. This epic remained one of the most popular throughout the Islamic world, with the first-known illustrated copies dating to the Ilkhanid period.

The source of these leaves is a dispersed copy of the *Shahnama,* of which about 150 folios (104 with illustrations) are known to exist in private and public collections. It is the only extant illustrated codex that carries the name of an Injuid patron and that can therefore confidently be assigned a Shirazi origin. Its colophon, in the Arthur M. Sackler Gallery in Washington, D.C. (Vever Collection, S86.0110, S86.0111),[1] names the dedicatee as the vizier al-Hasan Qavam al-Daula wa al-Din, who died in Shiraz in 1353 and was one of the patrons of the celebrated Persian poet Hafiz (1325/26–1390). With this codex as a comparative point of reference, therefore, three other copies of the *Shahnama* (complete or dispersed) and two other codices can be attributed to Injuid-controlled southern Iran.[2]

The style associated with Injuid illustrations is an unusual one, even though it was clearly influenced in its later phase, in the 1340s and 1350s, by mainstream Ilkhanid painting. Uncomplicated compositions, scant attention to detail, and the use of flat red or yellow backgrounds without any indication of depth are compensated for by a certain liveliness and monumentality that make these illustrations both appealing and distinctive. Although often mentioned in studies of Persian painting, the small group of Injuid illustrated manuscripts has yet to be fully explored.

1. Simpson 2000, pp. 218–19, pls. 1, 2.
2. The first scholar to identify the colophon was Ivan Stchoukine 1936, pp. 93–94, no. XIX. For a recent study of Injuid illustrated manuscripts, see Wright 1997, esp. pp. 12–31.

11　　　　　　　　　　　　　　　Fig. 265

Bizhan Slaughters the Wild Boars of Irman

The Metropolitan Museum of Art, New York, H. O. Havemeyer Collection, Gift of Horace Havemeyer, 1929 (29.160.22)

The shah Kaikhusrau sent Bizhan, one of his champions, to help the Armenians eliminate the wild boars—"in numbers numberless, with tusks like elephants', and big as hills"[1]—that were wreaking havoc on crops and cattle. Single-handedly Bizhan freed the land of these dangerous animals, first with his bow and arrow, then with his sword.

The illustration is true to the narrative, which tells of Bizhan pursuing the boars until they charged him in the final moments of the fight.[2] The Iranian champion looks powerful in his armor, his body as well as that of his horse driven forward as if in full motion. The oncoming boars, however, do not seem especially strong or menacing, diminishing the sense of

Bizhan's daunting task as a heroic mission. Such naïveté is common in Injuid illustrations and distinguishes them from Ilkhanid painting.

1. Firdausi 1905–25, vol. 3 (1908), p. 290, vv. 1070–71.
2. Swietochowski and Carboni 1994, p. 76, fig. 22.

12　　　　　　　　　　　　　　　Fig. 181

The Execution of Afrasiyab

The Walters Art Museum, Baltimore (W.677b)
New York only

Afrasiyab was the ruler of Turan, and the *Shahnama* devotes a large number of verses to his war with the Iranian ruler Kaikhusrau. The story ends with the capture of Afrasiyab and his brother Garsivaz, both of whom are to be beheaded. The illustration depicts the moment before Kaikhusrau executes Afrasiyab with his sword. Many representatives of the Iranian court witness the scene, while Garsivaz stands next to his brother awaiting his own fate.

In its composition and the relationship between the many characters illustrated, this scene is one of the most complex in the manuscript, although it is set against a flat background with no indication of vegetation.[1] In particular, the physical and spiritual proximity of the two captive brothers, half-naked and about to be killed, reveals all the drama of the situation.

1. Grube 1962, pp. 33–34, no. 25.

13　　　　　　　　　　　　　　　Fig. 264

Bahram Gur in the Peasant's House

The Walters Art Museum, Baltimore (W.677a)
Los Angeles only

Bahram Gur is one of the most celebrated rulers of the Sasanian dynasty in the *Shahnama.* The episode illustrated here concerns his stay in the house of a peasant while recovering from the poison of a dragon he had just slain. After the peasant's wife, unaware of the guest's identity, criticized the shah's righteousness, Bahram Gur decided to play the role of tyrant. When the peasant's wife tried to milk her cow to provide fresh milk for the guest, she realized that the animal was dry, a sure sign that the shah had become a tyrant. The episode ends with Bahram Gur repenting his anger and restoring the cow's flow of milk, thereby demonstrating his humanity and ultimate rectitude.

The scene here is dominated by the true protagonist of the story, the peasant's wife, in the act of milking the cow.[1] Her husband and their two daughters are passive onlookers, while

the shah is hardly in disguise, since he wears a crown. The wife is shown in profile with her back to the visitor, perhaps highlighting the fact that she is unaware of his royal status.

1. Gray 1961, illus. p. 58.

14–16 Three Folios from a Copy of the *Kitab ʿajaʾib al-makhluqat wa gharaʾib al-mawjudat* (Book of the Wonders of Creation and the Peculiarities of Existing Things)

Iraq (possibly Mosul), ca. 1295–1310
Ink, colors, and gold on paper
Page: 31.2 x 19.8 cm (12¼ x 7¾ in.)
The British Library, London (Or. 14140)

This incomplete manuscript, unknown before the British Library acquired it in 1983, represents one of the earliest copies of the text by Zakariya ibn Muhammad ibn Mahmud al-Qazvini (d. 1283), which was compiled in the 1270s. The surviving 135 folios, about two-thirds of the original codex, are at present unbound and individually matted after extensive restoration. There is no colophon, even though the last page of the manscript includes the end of the text. As is customary with scientific treatises, this copy of the *Wonders of Creation* is heavily illustrated; in its complete form it would have included some 520 miniatures.

A study of the 368 extant images reveals that the manuscript was illustrated around the turn of the fourteenth century in the Ilkhanid period.[1] At least three eclectic painters seem to have worked on it, showing an unusual and lively combination of stylistic influences. One is related to thirteenth-century pre-Mongol painting centered in Baghdad; another can be linked to the city of Mosul in northern Iraq; yet another is characteristic of southeastern Anatolia. The East Asian influence that appears at the end of the thirteenth century under the Ilkhanids is, however, predominant, making the manuscript stylistically comparable with the late-thirteenth-century Pierpont Morgan Library *Manafiʿ-i hayavan* (cat. no. 2) and the Edinburgh *al-Athar al-baqiya* of 1307–8 (cat. no. 4).

1. Carboni 1988–89; Carboni 1992.

14

Fig. 257

The Archangels Gabriel and Michael

(fol. 12r)
Images: 11.7 x 16.3 cm (4⅝ x 6⅜ in.);
12.2 x 16.3 cm (4¾ x 6⅜ in.)

The twelfth chapter of the *Wonders of Creation* is devoted to the angels, the inhabitants of the heavens. It begins with the Bearers of the Throne of God *(hamlat al-ʿarsh)* and continues with the Angel Ruh, the four Archangels, the Angels surrounding God *(al-karubiyyun),* the Angels of the Seven Skies, and six other classes of angels. Gabriel *(jabraʾil)* is the guardian of the revelation and the treasurer of holiness. Michael *(mikaʾil)* is in charge of the subsistence of bodies, of judgment, and of the knowledge of souls, and watches over the Flaming Sea of the Seventh Heaven. The two archangels, shown in royal garb and with elaborate halos, are described as powerful and immense entities with innumerable wings.

The painter conveyed a sense of energy and force by portraying Gabriel and Michael in left profile against a vivid red background, giving an impression of rapid movement to the left. Gabriel has long braids floating in the wind and a flaming "tail." Michael appears less powerful and seems to kneel over the Flaming Sea. Unfortunately, the faces of both archangels are damaged, as are large sections of the page, but the original vigor of these two illustrations is fully evident.[1]

1. Carboni 1988–89, pl. 5; Carboni 1992, pp. 83–85, 451–56.

15

Fig. 259

The Singer Ibrahim and the Jinn

(fol. 102v)
Image: 8 x 11.7 cm (3⅛ x 4⅝ in.)

The second chapter of the animal kingdom, following the first on Man, is devoted to the jinns, creatures that can assume diverse forms and live mostly in the underworld. Like humankind, jinns can be good and bad. Here, the scene illustrates the story of Ibrahim, who has been locked in the cellar by his master Muhammad al-Amin and is visited there by a jinn in the guise of an old man. The jinn offers him food and drink and is so impressed by Ibrahim's melodious voice that he convinces Muhammad to free him and give him a reward.

The painter cleverly creates the sense of confinement in a cellar by framing Ibrahim and the jinn within a brick wall in a vaulted space. Ibrahim seems focused on his singing and lute playing while the jinn, whose beard is not the conventional white of old age, offers him a glass of wine.[1] A very similar scene, perhaps copied from this or another, lost example of al-Qazvini's text, is found in the Diez Albums in Berlin (see fig. 260). There, the illustration is truer to the text, since the jinn's beard is white.[2]

1. Carboni 1988–89, pl. 7d; Carboni 1992, pp. 221–22.
2. Ipşiroğlu 1964, pl. III, fig. 7, pp. 11–12, no. 16; Carboni 1992, pp. 428–31, pl. 17b.

16

Fig. 258

The Beast Called Sannaja

(fol. 129v)
Image: 20.5 x 16.8 cm (8⅛ x 6⅝ in.)

The seventh species of animals includes reptiles and insects, the most fantastic of which is the so-called *sannaja,* or al-Qazvini's version of the Abominable Snowman, which lives in the mountains of Tibet and is the largest animal on earth. The Greek myth of the Gorgons must have had a part in this account because the *sannaja* can kill any animal that looks at it, although in the *sannaja's* case it is the one to die if it looks at the other animal first.

With no available models, and influenced perhaps by stories of mammoths, the painter allowed his creativity full rein. The result is one of the most startling and unusual inventions in Persian miniature painting: a creature with a demonlike head, pointed ears, four short tusks protruding from a smoking mouth, a brown body with extraordinary folds covered with black hair and colored spots, and two massive forepaws.[1] The *sannaja* is fierce and endearing, at once awe-inspiring and inoffensive.

1. Carboni 1988–89, pl. 6c; Carboni 1992, pp. 273–74, 498–500.

17–32 Illustrations from the Diez Albums

Staatsbibliothek zu Berlin—Preussischer Kulturbesitz, Orientabteilung (Diez A fols. 70–72)

Although the best-known and most spectacular Islamic albums are from Safavid Iran and Mughal India and comprise mainly sixteenth-to eighteenth-century material,[1] the first albums date from fifteenth-century Iran, during the period of Timurid rule. Some albums, including the earliest examples, were compiled as a means of gathering together, often in seemingly random fashion, paintings, calligraphy, drawings, sketches, and designs. These provide important information for the history of the arts of the book and artistic practice in the late medieval Islamic world. Three albums in the Topkapı Palace Library, Istanbul,[2] and the so-called Diez Albums in the Staatsbibliothek, Berlin, incorporate material relevant to the Ilkhanid period.[3]

The five Diez Albums (Diez A fols. 70–74) are known by the name of the man who compiled them: Heinrich Friedrich von Diez, a Prussian diplomat stationed in Istanbul between 1786 and 1790, who bequeathed them to the Königliche Bibliothek, Berlin, in 1817. They contain paintings, drawings, calligraphic works, and engravings that come from

a broad geographical area including China, Iran, Turkey, and Europe, and date from the late thirteenth to the late eighteenth century. Diez was an active collector of works of art, rare books, and coins, who acquired the material for his albums from various sources, among them albums in the Ottoman imperial palace, Istanbul, now the Topkapı Palace Museum.[4] His first three albums (Diez A fols. 70–72) contain Ilkhanid paintings and drawings, notably a series of illustrations from a dispersed or unfinished copy of the *Jamiʿ al-tavarikh*.[5]

1. For example, the well-known album in the Institute of Oriental Studies, Saint Petersburg; see *St. Petersburg Muraqqaʿ* 1996.
2. Albums H. 2152, H. 2153, and H. 2160.
3. For the interrelationship among the Istanbul and Berlin albums, see Roxburgh 1996, pp. 651–54.
4. Roxburgh 1995, pp. 112–14.
5. Ipşiroğlu 1964, pp. 1–34.

17 *Fig. 161*

Elephant and Rider

(Diez A fol. 71, S. 56)
Iran (possibly Tabriz), early 14th century
Ink, colors, and gold on paper
23 x 28 cm (9 x 11 in.)
New York only

This painting is one of several from the Diez Albums that may have originally belonged to an unfinished or dispersed early-fourteenth-century copy of Rashid al-Din's *Jamiʿ al-tavarikh,* or *Compendium of Chronicles.*[1] The horizontal orientation of the painting, its limited use of color, and the largely unpainted background are all characteristic of the *Jamiʿ al-tavarikh* pages (see cat. nos. 6, 7). Stylistic details also indicate a relationship: for example, the staggered grouping of figures at the right to suggest a crowd and the rendition of the elephant, its wrinkled flesh and heavy feet with articulated toes singled out for emphasis.[2] The costumes, especially the headdresses with owl feathers, are typically Mongol and are depicted in several illustrations from the *Compendium of Chronicles.*

 Although the events connected to Mahmud of Ghazna's conquest of India, as recounted in the *Jamiʿ al-tavarikh,* would be an obvious place in the text for an illustration featuring an elephant, the entirely peaceable nature of this scene suggests that it belongs to a different part of the narrative.[3]

1. Ipşiroğlu 1964, p. 21, no. 15.
2. For comparable depictions of elephants, see D. T. Rice and Gray 1976, pp. 134, 151, 152; Ettinghausen 1962, p. 134.
3. See D. T. Rice and Gray 1976, pp. 134, 151, 152.

18 *Fig. 222*

Enthronement Scene

(Diez A fol. 70, S. 10)
Iran (possibly Tabriz), early 14th century
Ink and colors on paper
37 x 30.8 cm (14⅝ x 12⅛ in.)
Los Angeles only

19 *Fig. 84*

Enthronement Scene

(Diez A fol. 70, S. 22)
Iran (possibly Tabriz), early 14th century
Ink, colors, and gold on paper
35.4 x 26.6 cm (14 x 10½ in.)
Los Angeles only

The monumental *Jamiʿ al-tavarikh,* or *Compendium of Chronicles,* written by the Ilkhanid historian and vizier Rashid al-Din, was initially commissioned as a history of the Mongols by Ghazan (r. 1295–1304). It was expanded into the first-known universal history under Ghazan's brother and successor, Öljeitü (r. 1304–16). There is no extant complete illustrated version of the *Jamiʿ al-tavarikh* from the Ilkhanid period, and only a few illustrated portions of the original multivolume work survive (see cat. nos. 6, 7). Albums in Istanbul,[1] however, as well as the Diez Albums in Berlin contain detached paintings that may belong to the first volume on the Mongols— the *Tarikh-i Ghazani,* written for Ghazan.[2] These paintings are in the form of single- and double-page compositions depicting the enthroned ruler and his consort surrounded by members of the court, both male and female, arranged in rows. The figures are generally portrayed in all their sartorial splendor, as in these two enthronement scenes from the Diez Albums,[3] in which the men wear characteristic feathered hats and the women balance atop their heads tall conical bonnets surmounted by peacock feathers. This distinctive Mongol headdress, known as a *bughtaq,* was a sign of a woman's special status as an official wife.[4] Also known as a *guguan,* it was worn by noble ladies throughout the empire, for example, in the well-known pendant portrait of Chabi (fig. 27), consort of Khubilai Khan.[5] Two other identically bonneted women are depicted in the lower right corner of a silk tapestry Yamantaka mandala from the fourteenth century (cat. no. 185, fig. 126). Similarly attired women are also represented on Ilkhanid metalwork. Such images appear to reflect the new, more powerful roles played by royal women in Mongol society.[6]

1. Topkapı Palace Library, H. 2153; see Çağman, Tanindi, and Rogers 1986, p. 69, nos. 43, 44. On the

important albums in the Topkapı Palace Library, the most comprehensive work to date is Roxburgh 1996.
2. See Rührdanz 1997, fig. 3, for an example of a double-page enthronement scene in the Diez Albums. See also Blair 1995, p. 95.
3. Cat. no. 18: Ipşiroğlu 1964, p. 22, nos. 17, 18. Cat. no. 19: Ipşiroğlu 1964, pl. VII, fig. 11, p. 22, no. 16; Blair 1995, p. 96, fig. 58.
4. For two incidents demonstrating the significance of the *bughtaq,* see Lambton 1988, p. 393.
5. See Fong and Watt 1996, pl. 137.
6. On women in Mongol society, see Lambton 1988, pp. 272–96. See also Rossabi 1979.

20 *Fig. 220*

Mongol Archer on Horseback

(Diez A fol. 72, S. 13)
Signed (lower right): Muhammad ibn Mahmudshah al-Khayyam
Iran, early 15th century
Ink and gold on paper
23.7 x 30 cm (9⅜ x 11¼ in.)
Los Angeles only

The first albums were assembled in Iran in the fifteenth century, gathering together a diverse body of paintings, calligraphy, sketches, designs, and pounces for transferring designs. In this way they helped to preserve visual resources dating back to the Ilkhanid period, which served as models and source material for later generations of artists. The drawing of a Mongol archer on horseback,[1] signed by Muhammad ibn Mahmudshah al-Khayyam, can be dated to the early fifteenth century.[2] It seems likely that the artist, who is known from a number of signed drawings, copied his composition from an earlier work. Although the drawing belongs to the Timurid period (1370–1507), its subject is not a contemporary one. For example, the rider's costume, including his distinctive owl-feathered headdress, was no longer the fashion at the Timurid court, although the imagery must have appealed to a Timurid audience given the dynasty's claims to Mongol ancestry (legitimate and otherwise). The overall composition can be broadly related to Ilkhanid paintings (e.g., cat. nos. 22, 23), suggesting that the artist followed his prototype fairly closely, but the subtle execution of the drawing and its more powerful flowing line are characteristic of a later age.[3]

1. Ipşiroğlu 1964, pl. LV, fig. 83, p. 81, no. 48; Roxburgh 2002, pp. 59–61, fig. 19.
2. See Roxburgh 2002, pp. 72–73, n. 60, where Muhammad ibn Mahmudshah al-Khayyam's activities are associated with the Timurid prince, calligrapher, and bibliophile Baysonghur (1397–1424). For a different, late-fifteenth-century dating, see Rogers 1990, p. 22, fig. 2.
3. Roxburgh 2002, pp. 59–60, fig. 20, has proposed a closely related drawing in an Istanbul album, which he sees as a likely prototype.

21 Fig. 133

Angel and Three Figures in a Landscape; Mongol Ruler and Consort (six scenes)

(Diez A fol. 71, S. 63, nos. 1–7)
Iran, early 14th century
Ink, colors, and gold on paper
14 x 22.8 cm (5½ x 9 in.); 6 images,
each approx. 6.6 x 6.6 cm (2⅝ x 2⅝ in.)
New York only

The idea of combining on an album page a man-uscript illustration and six small images of the Mongol ruler and his consort belongs to an age later than that of the compositions themselves.[1] There is, however, a logical basis for this assem-bly: all of the elements can be associated with Rashid al-Din's *Jamiʿ al-tavarikh,* or *Compendium of Chronicles.* The scene of three turbaned men in a landscape, one of whom converses with an angel, was probably intended to illustrate a sec-tion of the text dealing with the history of the Jews or the life of the prophet Muhammad (see cat. nos. 6, 7).[2] Furthermore, the horizontal format of the composition, the landscape ele-ments, and the figures of the angel and the tur-baned men, including the ginghamlike lining of the latters' robes, all relate the painting to illus-trations from the two Arabic fragments of the text, suggesting a comparable date. The diminu-tive square or squarish paintings of a Mongol and his consort, each of whom wears a head-dress announcing his or her elevated status, could have been intended for the first volume of the *Compendium,* which recounts the history of the Mongols, where they might have accompa-nied genealogical charts.[3]

1. Ipşiroğlu 1964, pp. 28–29, no. 42; Rührdanz 1997, pp. 297–98, fig. 1.
2. On the difficulties of identifying the specific scenes depicted in the album pages, all of which are devoid of text, see Blair 1995, pp. 93, 112, n. 19.
3. Rührdanz 1997, pp. 297–98.

22 Fig. 39

Mongol Traveling

(Diez A fol. 71, S. 53)
Iran (possibly Tabriz), early 14th century
Ink and colors on paper
18.8 x 27.5 cm (7⅜ x 10⅞ in.)
Los Angeles only

This painting is one of several that may have come from an incomplete or dispersed early-fourteenth-century copy of Rashid al-Din's *Jamiʿ al-tavarikh,* or *Compendium of Chronicles* (see cat. nos. 18, 19, 23–25).[1] As is typical of such Diez Album images, it lacks any text and may have been cut down; in this instance the subject matter, a Mongol prince or official perhaps traveling in state, is insufficient on its

own to suggest a specific connection to a scene or event from the *Compendium.*[2] In terms of its composition and style, however, it appears to belong chronologically somewhere between the Arabic fragments of Rashid al-Din's work, dat-ing from about 1314–15, and the Great Mongol *Shahnama,* in the 1330s. For example, the way in which the horsemen move in and out of the pic-torial space, the landscape suggested by tufts of grass among converging diagonal ground lines, the rendering of the small, long-necked horses, and the easy manner in which the central horse-man and his companion to the left turn around in their saddles are closer to several of the illus-trations from the Great Mongol *Shahnama* (e.g., cat. nos. 40, 45, 49) than to similar composi-tions from the *Jamiʿ al-tavarikh* of 1314–15 (see cat. nos. 6, 7).[3] In fact, the painting is most closely related to another Diez Album page depicting a Mongol prince traveling in state (cat. no. 23).

1. Ipşiroğlu 1964, p. 21, no. 14.
2. On the connections between some of the Diez Album paintings and the *Jamiʿ al-tavarikh,* see Rührdanz 1997.
3. Perhaps this and other illustrations of the *Jamiʿ al-tavarikh* in the Diez Albums can be dated around the same time as the enthronement scenes in the Topkapı Palace Library album H. 2153, also presumably from a dis-persed *Jamiʿ al-tavarikh,* to which they are related stylis-tically. See, e.g., Çağman, Tanindi, and Rogers 1986, p. 69, nos. 43, 44, where they are dated ca. 1330. For a similar dating for other related Diez Album pages, see Rührdanz 1997, p. 305.

23 Fig. 68

A Royal Procession

(Diez A fol. 71, S. 50)
Iran, early 14th century
Ink, colors, and gold on paper
22.3 x 27.5 cm (8¾ x 10⅞ in.)
New York only

The illustration, from a dispersed or unfinished copy of Rashid al-Din's *Jamiʿ al-tavarikh,* shows a prince on horseback followed by his retinue, one of whom holds a large parasol above the prince's head, signaling his rank.[1] Other signs of the exalted status of the central horseman are his headdress, with three long, curved eagle feathers, and the royal folding stool carried by the riderless horse in the foreground. The scene might be understood simply as one of a prince traveling in state except for an unusual element. The entourage is preceded by a bearded man wearing a fringed, pointed hat and a tasseled belt, holding a crook over his left shoulder and a roll in his raised right hand. This curious figure is very likely a royal envoy. Key to such an inter-pretation is the nature of the oval object pierced above the center and suspended from a cord worn around his neck. It has recently been identified as a *paiza*—a type of official tablet

issued under the Mongols that served as a safe-conduct pass for its bearer.[2] A few examples have survived from the period,[3] indicating that they could take several forms (see cat. nos. 154, 197).

If the figure is indeed an emissary attached to a mission, the roll in his right hand could be an official communication. On the basis of com-parisons between this scene and related illustra-tions from two later versions of the *Jamiʿ al-tavarikh* and their associated texts, it has been suggested that an important moment in Mongol history is here represented: Hülegü, grandson of Genghis Khan and founder of the Ilkhanid dynasty, setting out in 1256 against the Ismaʾilis, or Assassins, who were ensconced in the moun-tain fortress at Alamut.[4] The envoy might then be shown bearing Hülegü's offer of a pardon for Rukn al-Din Khurshah, the leader of the Assassins, if he were to surrender (as he did not). Hülegü himself led one of three large divisions in the successful assault against the Assassins.

1. Ipşiroğlu 1964, pl. X, fig. 14, p. 21, no. 13; Barthold and Rogers 1970, figs. 1–3 (details); Swietochowski and Carboni 1994, p. 13, fig. 5; Blair 2002a, fig. 1.
2. Blair 2002a. The object had previously been interpreted by J. M. Rogers (Barthold and Rogers 1970, pp. 224–27) as the drum of a shaman leading a Mongol royal funeral procession.
3. A related figure, also carrying a roll and a staff, is depicted on a *paiza* dating from the reign of Abu Saʿid (1317–35). See Ghouchani 1997, pp. 42–44.
4. Blair 2002a. On the probable relationship between the detached paintings in the Diez Albums and the first volume of the *Jamiʿ al-tavarikh,* see also Rührdanz 1997.

24 Fig. 33

The Conquest of Baghdad

(Diez A fol. 70, S. 7)
Iran, 14th century
Ink and colors on paper
38 x 30.3 cm (15 x 11⅞ in.)
New York only

25 Fig. 35

The Conquest of Baghdad

(Diez A fol. 70, S. 4)
Iran, 14th century
Ink and colors on paper
38.3 x 30.3 cm (15⅛ x 11⅞ in.)
New York only

These two pages depict the Mongol conquest of Baghdad and are variations on the same compo-sition, probably once forming a double-page illustration.[1] The paintings are divided into four horizontal planes, with the river separating the city from a defensive wall. The foreground is an open space with catapults and soldiers, and in cat. no. 24 two generals are shown issuing commands to archers who stand armed and

poised to shoot. In the lower right foreground of cat. no. 25 is a group of three figures, the one in the center beating a flattened drum which is supported on cords slung around the necks of the other two; these are the only figures in the two paintings to be dressed clearly in Mongol costume and given distinctly Mongol features. In addition, the warriors are identifiable as Mongol by their lamellar armor worn under a tunic, as seen in illustrations of the *Jamiʿ al-tavarikh*.[2] The helmets are familiar from other Ilkhanid paintings, but the plume is a feature not seen in earlier headgear.[3] In the upper left of cat. no. 25 are three figures dressed in Arab fashion with loose robes, turbans, and full beards—the caliph and his attendants fleeing the city in a boat.

Various elements in the paintings have been simplified to create a decorative effect. The water, for example, both of the river and of the channel along the defensive wall, is rendered in a highly ornamental, Chinese-inspired manner. The broad, wavy patterns of the river and the tightly controlled, overlapping streams in the moat, though very different in appearance, equally convey a sense of the speed and force of the water. With their shapes and colors, the shields of the warriors placed regularly along the city walls are also reduced to a decorative element.

1. Cat. no. 24: Ipşiroğlu 1964, pl. V, fig. 9, p. 17, no. 1; Blair 1995, p. 99, fig. 63. Cat. no. 25: Blair 1995, p. 98, fig. 62.
2. Nicolle 1999, pp. 241, 450, fig. 624A–R.
3. Blair 1995, p. 96.

26 — *Fig. 52*

Four Sleeping Kings

(Diez A fol. 72, S. 29)
Iran, 14th century
Ink, colors, and gold on paper
25.6 x 31 cm (10⅛ x 12¼ in.)
Los Angeles only

The painting shows the figure of a king entering a vaulted space that is depicted in a horizontal cross-section view resembling a four-petaled flower.[1] Each of the four chambers in the space features the reclining figure of a crowned king; from their bent knees and variously placed arms, all four men appear to be asleep. Near each bed are a ewer placed in a basin and a cup filled with liquid. A man wearing a turban appears in the upper left chamber. The scene has a narrative quality to it and seems to be part of an illustrated manuscript, perhaps an epic, heroic tale, or historical account, in which the accompanying text would have made its meaning clear. The distinctly decorative effect of the painting is due to the floral shape of the vaulted space and to the

colors, which are deeper and more vibrant than in most of the other Diez Album pages.

1. Ipşiroğlu 1964, pl. XVIII, fig. 24, p. 40, no. 7.

27 — *Fig. 87*

Funeral Scene

(Diez A fol. 72, S. 25)
Iran, early 14th century
Ink and colors on paper
29 x 34.3 cm (11⅜ x 13½ in.)
New York only

28 — *Fig. 122*

Funeral Scene

(Diez A fol. 71, S. 55)
Iran, early 14th century
Ink, colors, and gold on paper
21.5 x 27.5 cm (8½ x 10⅞ in.)
New York only

Scenes pertaining to the rituals of death and mourning occupy a prominent place among extant paintings from the Ilkhanid period, one that may reflect the ways in which the Mongols observed the passing of their leaders.[1] There are two very similar paintings of a funeral in the Diez Albums that come from a dispersed or unfinished version of the *Jamiʿ al-tavarikh*, possibly from the first volume *(Tarikh-i ghazani)*, which deals with the history of the Mongols.[2] In each instance the coffin rests on a thronelike dais, indicating the lofty status of the deceased. The dais is closely related to the thrones depicted in enthronement scenes also associated with the first volume of the *Jamiʿ al-tavarikh* (see cat. nos. 18, 19),[3] a connection that coincides with the description of the burial rites of the great khan Möngke (r. 1251–59) given in Rashid al-Din's text, in which the coffin is said to have been placed on a throne.[4] Reinforcing this royal association, the back of the dais in cat. no. 28 bears an almost entirely obliterated inscription that preserves the word "Sultan," written in a heavier hand. In both scenes the dais and the coffin are each surmounted by a lotus, a flower associated with Buddhist funerary rites.

The two paintings show groups of mourners symmetrically ranged around the dais. The women, in the upper right, appear somewhat more sedate than the bareheaded men, who beat their chests, keen, and tear their clothes and hair. Such figures are strikingly similar to those accompanying Isfandiyar's bier in a page from the Great Mongol *Shahnama* (see cat. no. 42), which also incorporates Buddhist imagery associated with death. In the foreground of cat. no. 28 is a low table bearing a two-handled bowl with a constricted neck, probably a container for meat or

koumiss (fermented mare's milk). According to Mongol burial customs, mourners lament with loud wailing while koumiss and meat are placed on a table before the deceased, especially one of high rank. He would be buried with his yurt, a mare and her foal, and a horse with bridle and saddle. In this way, when the deceased arrived in the next world, he would have shelter, a mare to give him milk and to breed future herds, and a horse to ride.[5]

1. See, e.g., Barthold and Rogers 1970.
2. Rührdanz 1997, fig. 11. Similarly Barthold and Rogers 1970, p. 224.
3. Rührdanz 1997, pp. 304–5.
4. Cited in Barthold and Rogers 1970, p. 208.
5. Spuler 1972, pp. 76, 98.

29 — *Fig. 168*

Landscape

(Diez A fol. 71, S. 10)
Iran, 14th century
Ink and colors on paper
20.4 x 29 cm (8 x 11⅜ in.)
New York only

This landscape is from a *Jamiʿ al-tavarikh* manuscript rendered in the Rashidiyya style seen in cat. nos. 6 and 7.[1] Rashid al-Din's painters looked outside the Islamic tradition for models for his illustrated histories, using different types of Chinese handscrolls and woodblocks as well as various Byzantine manuscripts to provide new pictorial devices.[2] Landscape painting is not a traditional Islamic genre, and in this illustration Chinese sources have been drawn on for the natural elements, which are rendered in a markedly linear style though ultimately somewhat removed from the Chinese original. The river is shown with a regular, rhythmic patterning of curling waves that terminate in crests; gnarled, leafless trees form a dense network in the background, and their placement evokes a sense of deep space. Stylized, organic rock formations in the Chinese tradition are colored with blue, olive green, and red washes to create a dramatic landscape.

1. Ipşiroğlu 1964, pl. XI, fig. 15, p. 33, no. 45.
2. Blair 1995, pp. 45–58.

30 — *Fig. 86*

Preparations for a Banquet; An Encounter

(Diez A fol. 70, S. 18, nos. 1, 2)
Iran, 14th century
Ink and colors on paper
27.4 x 26.8 cm (10¾ x 10½ in.); 12.8 x 26.4 cm (5 x 10⅜ in.)
Los Angeles only

Two independent illustrations of Rashid al-Din's *Jamiʿ al-tavarikh* are pasted onto a single page,

both rendered in delicate lines and colored with washes.[1] The upper scene, in a vertical format, is set before a white tent with decorative patterned bands in blue; its entrance curtains are knotted back to reveal the bare interior of the tent. Wearing a variety of Mongol headdresses decorated with eagle feathers, several figures are shown involved in preparations for a festive occasion. Two men in the left foreground carry a table laden with dishes, while a third man in the group holds two bowls. In the center foreground is a figure turning his head toward a party of women approaching from the right. His hat, which is taller and more elaborate than those of the other men, and the staff in his hands suggest his relatively higher social position; he is perhaps the master of ceremonies or overseer of the event. Gesticulating hands, figural poses, and open mouths indicate conversation and interaction, and attest to the bustling activity.

The narrative content of the lower painting is more difficult to interpret, although gestures and poses imply one. Three mounted figures are shown emerging onto the scene from the left and approaching a woman, probably a servant or peasant from her attire, who is on foot and leading a horse behind her by its leading rein. The foremost horseman extends one hand as if engaging in conversation with the woman, while she holds her right hand to her mouth in a gesture of surprise or comprehension. The figures are set in an open landscape where different spatial planes are denoted by the placement of clustered flowering plants. A further sense of space is created by the truncation of the scene to left and right—two of the riders and their mounts and the woman's horse are visible only in part—suggesting an extension of what is actually seen. Such a treatment is reminiscent of Chinese handscrolls, which are normally viewed piecemeal as they are unrolled. It first occurs in Persian painting in the illustrations of the *Manafi‘-i hayavan* manuscript dated 1297–1300 (cat. no. 2), notably in the picture of a mare followed by a stallion, where only the head of the stallion is visible.[2]

1. Ipşiroğlu 1964, p. 27, nos. 33, 34.
2. Gray 1961, illus. p. 21; Schmitz 1997, pl. 4.

single page.[1] The upper image here, again in a vertical format, shows a large tent like the one in cat. no. 30, with the panels similarly knotted back to reveal the interior. Two men are seated inside, each reading the Koran from a copy supported on the *rahle,* or Koran stand, before him. The prayer caps on their heads, along with the open access to the tent and the inscriptions—above the entrance on the left, "All sovereignty belongs to God" *(al-mulk lillah),* and on the two standards extending from the top, "Allah"—suggest that this may be a mobile mosque. The Mongols would have had a dedicated prayer space even as they traveled between palace residences, especially after the conversion of Ghazan Khan to Islam in 1295.

The lower scene, a horizontal one, shows on the left a woman lying prone soon after giving birth, with the newborn baby by her side. She is attended by female servants and by three Mongol noblewomen (their status denoted by their headdresses) seated nearby. Three bearded men clad in loose robes, wearing turbans and holding astrolabes, are grouped at the right. The presence of Arab astrologers at the birth to map the child's astrological charts indicates the importance of the event, although there are no inscriptions on the painting to identify any of the figures.

It is interesting to compare this birth scene with that of the cesarean delivery of Julius Caesar in the historical text *al-Athar al-baqiya* by al-Biruni (cat. no. 4). There, the painting shows the mother lying nude and lifeless while male surgeons draw out her baby. In the Diez Album painting the live mother lies fully clothed, covered by a sheet and with the infant beside her. The influence of accessible Byzantine illustrations of the Nativity probably contributed to this composition (see also cat. no. 6, fig. 130). The clinical quality of the al-Biruni image suggests that its prototype was taken from a scientific text or medical handbook, a context in which the representation of nudity was considered acceptable.[2]

1. Ipşiroğlu 1964, pl. VIII, fig. 12, p. 26, nos. 30, 31.
2. Soucek 1975, pp. 109–10, fig. 3.

the Diez Albums.[1] Although it has no associated text, the subject matter—a man in front of a mountain fortress slaying a horseman with his bow and arrow—can be identified with the story of Farud. Shah Kaikhusrau sent his army to invade Turan, Iran's arch rival, warning Tus, his commander in chief, to avoid the mountain where Farud, his half brother, dwelled. Ignoring the shah's instructions, Tus chose the mountain route. First Tus's son-in-law Rivniz rode up to Farud's fortress and then his son Zarasp. Both were killed in turn by Farud, whose vizier, Tukhwar, each time urged him to shoot the man and not his horse. Finally, when Tus rode out to avenge his son-in-law and son, Farud shot the horse and not the man.[2]

The painting depicts Farud outside his fortress, his vizier beside him, having just slain Rivniz (or, less likely, Zarasp). Two women look down from the ramparts, one of them perhaps Farud's mother, Jarira, with a member of her household. The deep red background, conical mountains, spiky-leafed foliage, and tufts of grass, together with the overall figural style, help to link this and related paintings in the Diez Albums to the *Mu’nis al-ahrar,* dated 1341, which was produced in a suburb of Isfahan (cat. no. 9).[3] A similar attribution, though with a slightly earlier date, may be proposed here.[4]

1. Ipşiroğlu 1964, pl. II, fig. 3, p. 6, no. 12; esp. Swietochowski and Carboni 1994, pp. 67ff., fig. 16.
2. Summarized in Firdausi 1985, pp. 110–16.
3. Swietochowski and Carboni 1994, pp. 68ff., where the so-called Gutman *Shahnama* in the Metropolitan Museum is also linked with this group.
4. Ibid., p. 81.

33–35 Three Folios from the First Small *Shahnama* (Book of Kings)

Northwestern Iran or Baghdad, ca. 1300–1330
Ink, colors, gold, and silver on paper
Page: approx. 19 x 13.2 cm (7½ x 5¼ in.); written surface: 15.5 x 12.5 cm (6⅛ x 4⅞ in.)

The manuscript known as the First Small *Shahnama* is one of the few small-format copies of Firdausi's text to have survived from the Ilkhanid period, all of them in dispersed form.[1] Given their fragmentary condition and the absence of colophons, various dates and places have been suggested for the production of these illustrated manuscripts, ranging mainly from about 1300 to 1340 and including Shiraz, Isfahan, Baghdad, and even India.[2] One of the manuscripts, known as the Gutman *Shahnama* after its former owner, is stylistically distinct from the others and has recently been attributed to Isfahan in about 1335.[3] A thorough investigation of the First and Second Small *Shahnama*s led Marianna Shreve Simpson to conclude that

31 *Fig. 134*

Tent Mosque; Birth Scene

(Diez A fol. 70, S. 8, nos. 1, 2)
Iran, 14th century
Ink and colors on paper
29.5 x 26.6 cm (11⅝ x 10½ in.); 13.5 x 17.3 cm (5¼ x 6¾ in.)
Los Angeles only

As in cat. no. 30, two unconnected illustrations of the *Jami‘ al-tavarikh* have been pasted onto a

32 *Fig. 180*

Farud before His Mountain Fortress

(Diez A fol. 71, S. 29, no. 2)
Iran (probably Isfahan), ca. 1335
Ink, colors, and gold on paper
12.1 x 20 cm (4¾ x 7⅞ in.)
Los Angeles only

This small painting very likely once illustrated a manuscript of the *Shahnama,* along with fourteen other stylistically related images, now in

they were probably produced in Baghdad in about 1300, an attribution that is accepted with some reservations by most scholars.

The lively compositions, bright colors, generous use of gold, and treatment of the landscape and details leave little doubt that these small manuscripts were made in the first half of the fourteenth century for a rich clientele, though not in response to specific commissions. In the absence of comparable dated copies, they seem most likely to have originated in northwestern Iran or possibly Baghdad in the early decades of the century.

1. Simpson 1979.
2. See Binyon, Wilkinson, and Gray 1933, pp. 42–43, nos. 19, 20, pls. XIV, A–C; A. U. Pope and Ackerman 1938–77, vol. 3, pp. 1833–34, pls. 830, 831; Arberry et al. 1959, p. 12; Grube 1978, pp. 16–18; Simpson 1979; Blair and Bloom 1994, p. 34.
3. Swietochowski and Carboni 1994, pp. 67–145.

33 *Fig. 177*

Zal Visits Rudaba in Her Palace

The Trustees of the Chester Beatty Library, Dublin (Per 104.5)

The romance of the hero Zal, a valiant warrior in the court of Shah Manuchihr of Iran, with Rudaba, daughter of the rival king of Kabul, is narrated early in the text of the *Shahnama* (see cat. nos. 37, 38). The two hear high praise of the other's appearance, charm, and character from King Mihrab of Kabul and fall in love before setting eyes on each other. Notwithstanding the political implications of their actions and using Rudaba's maidens as intermediaries, the two arrange to meet one night in Rudaba's pavilion, which is lavishly set up for the occasion.

Illustrated here is the actual encounter between Zal and Rudaba,[1] less commonly depicted than the episode preceding it, when Zal climbs a rope to reach Rudaba's chambers.[2] The scene is placed in an interior, which according to the text the servants had "draped with brocades from Chin [China]" and where they "set golden trays about as ornaments, then mingled wine with musk and ambergris. . . . Here were narcissus, violet, cercis-bloom and rose, there lily and the jasmine-spray."[3] Zal and Rudaba are shown seated in a close embrace against a backdrop of gold draperies, clearly enjoying each other's company and being served food and wine by attendants dressed in Chinese-inspired attire.

1. Arberry et al. 1959, pp. 11–16, no. 104, pl. 4, b; Simpson 1979, pl. 8. The bulk of the First Small *Shahnama* is in the possession of the Chester Beatty Library, Dublin, which owns 77 folios incorporating 80 illustrations.
2. See, e.g., Grabar and Blair 1980, pp. 74–75, no. 9.
3. Firdausi 1905–25, vol. 1 (1905), pp. 269–70.

34 *Fig. 176*

Buzurjmihr Masters the Game of Chess

The Metropolitan Museum of Art, New York, Purchase, Joseph Pulitzer Bequest, 1934 (34.24.1)

The *Shahnama* has its own version of how the game of chess was introduced into Iran from India. In order to avoid paying tribute to the Sasanians, the rajah of Hind sent an envoy challenging the Iranian ruler Nushirvan to figure out how this war game was played. Buzurjmihr, the clever vizier, gained the tribute for his king by solving the problem.

The Iranians in attendance on Nushirvan are dressed in Mongol costumes, whereas the vizier is given an "erudite" status by his Arab-style tunic and turban. The Indian envoy, all alone among the Iranians as if underscoring his defeat at the game, is typically represented as a dark-skinned man wearing baggy clothes and a loose turban. The composition, set against a plain gold background, is strictly symmetrical, focusing attention on the three main characters in the center and especially on the stark white of the chessboard.[1]

1. Simpson 1979, fig. 63; Swietochowski and Carboni 1994, p. 123, fig. 35.

35 *Fig. 244*

Nushirvan Receives Mihras, the Envoy of Caesar

The Metropolitan Museum of Art, New York, Purchase, Joseph Pulitzer Bequest, 1934 (34.24.3)

According to the *Shahnama,* the Byzantine emperor, generically called "Caesar," was concerned about the possibility of an invasion by the mighty Iranian forces of Nushirvan and sent an embassy under his general Mihras. Mihras brought with him a letter of conciliation and lavish gifts, and a peaceful agreement was eventually concluded.

In the miniature,[1] the letter—which assumes a special significance in this context since the Ilkhanid rulers and the pope exchanged similar missives[2]—and the gifts in the form of gold cups are clearly visible at the foot of Nushirvan's throne. Mihras is shown as a kind of Crusader, something between a warrior and a priest, wearing a helmet and holding a cross; he is followed by two other envoys. The vizier, Buzurjmihr, and Nushirvan's attendants are shown costumed as they are in cat. no. 34. Here too there is a plain gold background.

1. Simpson 1979, fig. 93.
2. See, e.g., Spuler 1972, pp. 68–70.

36–61 Pages from the Great Mongol *Shahnama* (Book of Kings)

Iran (probably Tabriz), 1330s
Ink, colors, and gold on paper

One of the most elaborate and luxurious manuscripts of the Ilkhanid period, and of Persian painting in general, is a now-dispersed fourteenth-century copy of the *Book of Kings:* the so-called Great Mongol *Shahnama,* more familiarly the Demotte *Shahnama* after the dealer responsible for its dismemberment. It exists today in the form of 57 known illustrations and some text pages scattered among several public and private collections.[1] Extensive study of the manuscript initiated by Oleg Grabar and Sheila Blair and pursued by the latter has revealed that the original was probably a two-volume production of about 280 large folios with approximately 190 illustrations.[2] The paper, now sometimes stained, is well polished and of good quality. In a nineteenth-century restoration every folio was given an extended border using paper produced in an unidentified Russian paper mill in 1839.[3]

The manuscript was taken apart by a dealer in Paris, Georges Demotte, between 1910 and 1915, and some folios with illustrations on both sides were split and the resulting two leaves sold individually. New text pages were commissioned to paste on the backs of the split leaves that were undamaged, and where they were damaged the salvaged image was pasted onto a newly commissioned folio. As a result, some paintings on the extant pages are unrelated to the accompanying text, and others have text that is incomplete.

The frontispiece and colophon that might have revealed information on the patron, the calligrapher, and the date and place of production are lost, and it is therefore not known where and when the manuscript was produced. Grabar and Blair have attributed it to the patronage of the vizier Ghiyath al-Din ibn Rashid al-Din in Tabriz between November 1335, when he organized the appointment of Arpa (r. 1335–36) as successor of Abu Saʿid, and Ghiyath al-Din's death on May 3, 1336.[4] A dating in the 1330s is widely accepted by most scholars.

1. A fifty-eighth illustration was destroyed in 1937 and is known only from a photograph. See Grabar and Blair 1980, pp. 88–89, no. 16.
2. Grabar and Blair 1980; Blair 1989; Blair and Bloom 2001.
3. Blair and Bloom 2001, p. 42.
4. Grabar and Blair 1980, pp. xi–xiii. Soudavar 1996, pp. 95–97, however, attributes the production of the manuscript to Abu Saʿid's reign (1316–35).

Page of Text

Written surface: 41 x 29 cm (16⅛ x 11⅜ in.)
The Trustees of the Chester Beatty Library, Dublin
(Per 111.8)

This is one of the few extant pages of text and
illumination that were left intact when the man-
uscript was broken up, and it demonstrates the
minute calligraphy of the original and the qual-
ity of its illuminated cartouches.[1] The text is
written in six columns separated by gold rul-
ings, with thirty-one lines in *naskh* cursive script
to each full column. Chapter headings are in
white *thuluth* calligraphy within illuminated
panels that are simply but elegantly filled with
vegetal scrolls in gold and other colors against a
dark background.

1. Unpublished.

**Sindukht Becoming Aware
of Rudaba's Actions**

Image: 24.8 x 19.7 cm (9¾ x 7¾ in.)
Arthur M. Sackler Gallery, Smithsonian Institution,
Washington, D.C.; Purchase, Smithsonian
Unrestricted Trust Funds, Smithsonian Collections
Acquisition Program, and Dr. Arthur M. Sackler
(S1986.102)

The story of Zal, son of Sam, a paladin of Shah
Manuchihr of Iran, and of his love for Rudaba,
daughter of the rival king of Kabul, is told in the
early chapters of the *Shahnama* (see cat. no. 33).
After consulting his sages, Sam granted his son
permission to marry Rudaba. On hearing of the
approval, Zal sent word to his beloved by way of
her maid, who was richly rewarded and sent
back to Zal with gifts. Rudaba's mother,
Sindukht, however, intercepted the messenger
and questioned her. The maid began to lie about
her activities, but Sindukht searched her and
found the gifts. Angered and saddened by
Rudaba's secretiveness, Sindukht shut herself in
the palace and summoned her daughter.

The subject of the painting is identified here
by the title above it and shows Sindukht, her
hand raised in admonition, with Rudaba and the
maid.[1] An elaborate necklace, almost identical
to cat. no. 148, is prominently displayed in the
foreground. This is a slight deviation from the
text, which makes no mention of a necklace as
part of the maid's reward, and reports only that
Rudaba generously gave her gold coins and
clothing and sent a fine turban and a ring to Zal.

1. Grabar and Blair 1980, pp. 76–77, no. 10; Lowry
1988, p. 80, no. 9.

Zal Approaching Shah Manuchihr

Image: 17 x 20 cm (6¾ x 7⅞ in.)
The Trustees of the Chester Beatty Library, Dublin
(Per 111.4)

Infuriated upon hearing of Zal and Rudaba's
romance, Shah Manuchihr sent Sam, Zal's
father, to wage war on Mihrab, ruler of Kabul,
descendant of the evil king Zahhak and father of
Rudaba. Zal pleaded with his father to intercede
with the king on his behalf and settle the matter
peacefully. Armed with a letter from Sam, Zal
made his way to Manuchihr's court to try to
persuade the king not to wage war.

The illustration shows Zal, identifiable by his
distinctive white beard (he was born with white
hair), kissing Manuchihr's foot in a gesture of
deference.[1] The king raises his hand in acknowl-
edgment, and courtiers stand at attention
around the throne. In a two-storied architec-
tural extension on the left, a seated guard fills
the doorway below and a woman looks down
from the balcony above. Both figures become
traditional staffage in Persian painting of the
Timurid and Safavid periods (15th–17th cen-
turies). The chapter heading above identifies the
scene, but both the painting and the heading are
pasted onto an irrelevant text page.

1. Grabar and Blair 1980, pp. 78–79, no. 11.

Shah Zav Enthroned

Image: 25.1 x 29.2cm (9⅞ x 11½ in.)
Arthur M. Sackler Gallery, Smithsonian Institution,
Washington, D.C.; Purchase, Smithsonian
Unrestricted Trust Funds, Smithsonian Collections
Acquisition Program, and Dr. Arthur M. Sackler
(S1986.107)

The tyrannical king Naudar, son of Manuchihr,
ruled Iran oppressively for several years and was
eventually beheaded in a campaign against the
rival Turanians. Neither of Naudar's two sons
was considered fit to rule, and the throne
remained vacant until Zav, a descendant of
Faridun, one of the great rulers of Iran, was
crowned on Zal's advice. Zav was already an old
man at the time of his coronation. He ruled for
only five years, but his reign was marked with a
prosperity and justice that ended upon his death.

The *Shahnama* includes a short section on
Zav that speaks mainly of the prosperity he
brought about. This painting shows his
enthronement, when everyone, including Zal
(the white-haired figure in the left foreground),
came to shower him with praises and offerings.[1]
He is seen here seated on his throne with Zal at
his side and surrounded by courtiers, one of

them on his knees presenting a gift. The chapter
heading incorporated into the painting refers to
Zav's brief, five-year reign.

Enthronement scenes are featured in thirteen
of the fifty-seven extant paintings from the Great
Mongol *Shahnama* (see also cat. nos. 46, 60). They
largely follow a standard composition in which
the central crowned figure is seated on an elabo-
rate throne before an architectural setting and is
surrounded by courtiers, soldiers, and officials.

1. Grabar and Blair 1980, pp. 84–85, no. 14; Lowry
1988, pp. 82–83, no. 10.

Bahman Meeting Zal

Image: 21 x 20 cm (8¼ x 7⅞ in.)
Collection des Musées d'Art et d'Histoire, Geneva
(1971-107/2a)

The narrative continues with the lives of other
kings, and several sections are devoted to
Isfandiyar, one of the prince-heroes of the epic
and son of Shah Gushtasp of Iran. Isfandiyar had
been promised the throne but his father refused
to abdicate. Gushtasp eventually agreed to do
so, on condition that Isfandiyar bring before him
in chains the great hero Rustam, who had
affronted the king by not recognizing his author-
ity. Isfandiyar thereupon sent his son Bahman as
an emissary to persuade Rustam to pay homage
to Gushtasp.

The painting shows Bahman, seen from the
back, greeted by Zal, Rustam's father, who has
sighted the approaching party from a watch-
tower and come to receive them.[1] Bahman is
richly dressed and wears a crown, following his
father's directives to make his royal status
immediately known. Figures with their backs to
the viewer reflect a Chinese influence on
Persian painting (see also cat. nos. 53, 54, 56).

1. Grabar and Blair 1980, pp. 92–93, no. 18; *Treasures of
Islam* 1985, p. 54, no. 21.

**Rustam Shooting an Arrow into
Isfandiyar's Eye**

Image: 20 x 29 cm (7⅞ x 11⅜ in.)
Harvard University Art Museums, Cambridge,
Mass., Gift of Edward W. Forbes (1958.288)

Rustam agreed to accompany Isfandiyar to the
court of Shah Gushtasp, but the two quarreled
and subsequently engaged in single combat
to settle their dispute. Although severely
wounded, Rustam managed to escape alive. On
Zal's advice, he sought help from the *simurgh,*
the miraculous bird that had reared his father.

The *simurgh* healed Rustam's wounds and encouraged him to try conciliation as a means of settling the dispute. At the same time it gave him a double-pointed arrow that would kill the valiant Isfandiyar if shot into one of his eyes. After meeting his opponent and making a failed attempt at persuasion, Rustam resorted to use of the deadly arrow. The painting shows Rustam having discharged the arrow, while Isfandiyar, struck in the eye, falls forward on his horse.[1]

1. Grabar and Blair 1980, pp. 98–99, no. 21; Simpson 1980, pp. 30–31, no. 7.

42 *Fig. 123*

Isfandiyar's Funeral Procession

Image: 22 x 29 cm (8⅝ x 11⅜ in.)
The Metropolitan Museum of Art, New York,
Purchase, Joseph Pulitzer Bequest, 1933 (33.70)

With his dying breath, Isfandiyar entrusted Rustam with the guidance of his son, after declaring that his death was caused not by Rustam but by fate and his father's ambitions. Rustam made arrangements to send Isfandiyar's body back to Iran. He ordered a fine iron coffin smeared with pitch on the inside, draped with rich Chinese brocades, and sprinkled with musk and ambergris. He shrouded the body in brocade and placed on it Isfandiyar's turquoise crown.

The details of the painting follow the text faithfully.[1] Members of the procession, with distinctly Mongol features, are shown wailing and tearing their hair in grief. As a sign of mourning, Isfandiyar's horse has its mane and tail shorn, and the saddle, with Isfandiyar's mace, quiver, and helmet hanging from it, is reversed. This illustration of a royal Mongol funeral procession is rendered with smooth calligraphic lines that derive from Chinese painting. The Chinese clouds above, with the three geese that in Buddhist belief were to bear the soul to heaven, also speak of the strong Chinese influences in the Ilkhanid period.

1. Grabar and Blair 1980, pp. 100–101, no. 22; *Islamic World* 1987, pp. 72–73, pl. 53.

43 *Fig. 193*

Rustam Slaying Shaghad

Image: 16 x 29 cm (6¼ x 11⅜ in.)
The Trustees of the British Museum, London
(1948.12-11.025)

Shaghad, Rustam's jealous half brother, plotted with the king of Kabul to destroy the hero, and they devised a scheme to trap him under the pretext of a hunting trip. Shaghad conspired to lure Rustam and his brother Zavara into a forest rich

with game, which had been prepared with spear-lined pits deceptively covered with turf. Despite the protests of his faithful horse, Rakhsh, Rustam rode forward and fell into one of the pits. He managed to crawl out of it and with his dying breath asked Shaghad to string a bow so that he could ward off predatory animals. Then he used this one shot left to him to slay Shaghad.

This depiction of Rustam's final act of courage and retribution shows him having just discharged the arrow, pinning Shaghad to the tree he had used as cover.[1] The figure of the elderly Rustam is framed by the arched branches of the tree, and the massive form of Rakhsh impaled in the pit reinforces the tragedy of a hero's death.

1. Grabar and Blair 1980, pp. 102–3, no. 23.

44 *Fig. 124*

Rustam's and Zavara's Biers

Image: 16 x 29 cm (6¼ x 11⅜ in.)
Museum of Fine Arts, Boston, Helen and Alice
Colburn Fund and Seth K. Sweetser Fund (22.393)
Not in exhibition

Faramurz, Rustam's son, was sent to retrieve the bodies of his father and uncle from Kabul. The painting shows the funeral procession with mourners bearing standards and incense, and the biers that passed from hand to hand on their way back to Zabulistan, Rustam's kingdom.[1] The body of Rakhsh, mounted on the back of an elephant, follows its master in death.

1. Grabar and Blair 1980, pp. 104–5, no. 24.

45 *Fig. 194*

Faramurz Pursuing the Kabulis

Image: 22 x 29 cm (8⅝ x 11⅜ in.)
Musée du Louvre, Paris (7095)
Los Angeles only

At the end of the mourning period, Faramurz took an army to Kabul to avenge the deaths of his father and uncle. The intensity of the ensuing battle is described in the text, which speaks of the throngs of horses and warriors, and of the noise and action on the field. The painting captures much of that intensity, with the armies of Faramurz charging aggressively and driving the Kabulis into retreat.[1] Dismembered bodies, a Kabuli horseman seen from the back in a twisted three-quarter pose with an upraised arm as if to ward off the attackers, and the swirling, Chinese-inspired clouds in the sky all enhance the drama of the event.

1. Grabar and Blair 1980, pp. 106–7, no. 25.

46 *Fig. 51*

Iskandar Enthroned

Image: 29 x 20 cm (11⅜ x 7⅞ in.)
Musée du Louvre, Paris (7096)
New York only

Iskandar (Alexander the Great) was another of the popular hero-kings in the Persian epic, and according to the text was the son of the just king Darab and a princess of Rum (Byzantium). Several sections in the *Shahnama* are devoted to him, and interestingly, these stories are heavily represented in the Great Mongol *Shahnama*: twelve of the extant paintings belong to the Iskandar cycle. Many of the stories in the chapter on Iskandar recount his travels and adventures in strange and far-off lands. He ruled over Rum until he invaded Iran, defeated his half brother, and assumed power in Iran.

The painting shows a haloed Iskandar seated on his throne, framed by the niche behind him, and flanked by numerous attendants.[1] In front is a low partition. The heading above the miniature reads: "The beginning of the story," while the subject of the miniature is identified in a panel above the throne.

1. Grabar and Blair 1980, pp. 112–13, no. 28.

47 *Fig. 131*

King Kayd of Hind Recounting His Dream to Mihran

Image: 22 x 20 cm (8⅝ x 7⅞ in.)
The Trustees of the Chester Beatty Library, Dublin
(Per 111.5)

Iskandar had set his sights on kingdoms far and wide. The wise King Kayd of Hind (India) had a recurring nightmare for ten days that neither he nor his ministers were able to interpret. He visited a famous sage, Mihran, who lived as a hermit in the wilderness, in order to seek an answer. Mihran interpreted the dreams as a premonition that Iskandar of Rum would invade Hind; and he advised the king to avoid destruction by offering Iskandar his four most prized possessions: his daughter, his sage, his magic cup, and his physician. Iskandar in his wisdom and justice, according to the hermit, would ask for no more and would pass through the land peacefully.

The miniature shows King Kayd on foot, dismounted from his horse and approaching the sage deferentially.[1] The king wears Iranian clothing, but his retinue and the sage are dressed in Indian attire, and several figures have a Central Asian physical appearance.

1. Grabar and Blair 1980, pp. 114–15, no. 29.

48 — Fig. 160

Iskandar's Iron Cavalry

Image: 27 x 29 cm (10⅝ x 11⅜ in.)
Harvard University Art Museums, Cambridge,
Mass., Gift of Edward W. Forbes (1955.167)

Iskandar accepted King Kayd's offer of his four most prized possessions and left his lands unharmed. He then proceeded to the kingdom of Fur (Porus) and invited him to surrender. Fur refused, preferring to battle for supremacy. After Iskandar was advised by his spies that his troops would be no match for the fearsome army of Indian elephants, his sages designed a cavalry of iron riders and horses mounted on wheels, filled with naphtha and set aflame. The Indian army, despite its strength, turned back in retreat before Iskandar's fire-spewing forces.

This painting is probably the most visually arresting of the manuscript.[1] Its dynamic composition, together with its use of color and devices such as the swirling clouds in the sky, which are echoed in the flames emitted by the iron horses, effectively captures the drama of the moment. The truncated figures of the retreating Indian army create an illusion of space and underscore the impact of the illustration.

1. Grabar and Blair 1980, pp. 116–17, no. 30; Simpson 1980, pp. 26–27, no. 5; Hattstein and Delius 2000, p. 387.

49 — Fig. 36

Iskandar Killing Fur of Hind

Image: 20 x 29 cm (7⅞ x 11⅜ in.)
Keir Collection, England (PP1)
Los Angeles only

To avoid the bloodshed of battle, Iskandar and King Fur agreed to fight in single combat. Fur, a mighty and valiant warrior, proved a formidable opponent, and Iskandar began to fear for his life. However, a loud disturbance arose from the ranks and as the distracted Fur turned his head in that direction, Iskandar seized the opportunity to strike a fatal blow.

The painting, which follows the text closely, shows the two mounted combatants in action, with their armies behind them.[1] As Fur of Hind, on the right, turns his head toward the noise, Iskandar charges forward, brandishing his sword. The decorated border around the illustration is unusual and does not appear on the other paintings from this manuscript.

1. Grabar and Blair 1980, pp. 118–19, no. 31.

50 — Fig. 190

Taynush before Iskandar and The Visit to the Brahmans

Image: 15.1 x 28.6 cm (6 x 11¼ in.)
Arthur M. Sackler Gallery, Smithsonian Institution, Washington, D.C.; Purchase, Smithsonian Unrestricted Trust Funds, Smithsonian Collections Acquisition Program, and Dr. Arthur M. Sackler (S1986.105)
Los Angeles only

Moving westward from Hind, Iskandar went on a pilgrimage to Mecca and made his way to Andalusia in Spain, ruled by Queen Qaidafa. The queen entered into a pact with Iskandar and was left unharmed. Her son Taynush, however, who was the son-in-law of the slain Fur of Hind, was eager to seek retribution for Fur's death. Qaidafa had also received Iskandar's promise not to harm her son; yet wanting to test Taynush himself, Iskandar contrived an ambush and forced Taynush into a confrontation. When assured of the prince's loyalty, Iskandar ordered a throne and banquet to be set up in the forest and celebrated with Taynush and his companions.

After leaving Andalusia, Iskandar proceeded to the country of the Brahmans in order to question them about the meaning of life and death. The Brahmans, world-renouncing hermits and ascetics, lived in the forest. They told Iskandar that greed and need were the two greatest evils in life, and that death was inevitable regardless of one's worldly achievements.

The painting, which has no title or heading to identify the subject, appears to be a composite of the two narratives.[1] In the right one-third of the image is the feast prepared for Iskandar, who is seated beneath the boughs of a tree as described in the text, surrounded by Taynush and his companions. The remaining pictorial space is devoted to Iskandar's visit to the Brahmans, who are framed by a generic architectural setting in the upper left corner and can be recognized by their long beards and naked torsos.

1. Grabar and Blair 1980, pp. 120–21, no. 32; Lowry 1988, pp. 84–85, no. 11.

51 — Fig. 186

Iskandar Emerging from the Gloom

Image: 21 x 20 cm (8¼ x 7⅞ in.)
Keir Collection, England (PP3)
New York only

On another adventure, Iskandar was returning from a visit to the angel of death in the land of darkness when a voice called out from the gloom announcing that whoever picked up a stone from the path would grieve and whoever did not would grieve even more. Puzzled by the cryptic message, some of Iskandar's men collected stones

from the path. On emerging into the light they saw that these were precious stones, and those who had picked up a few regretted not gathering more, while those who had picked up none were even sorrier.

The right side of the painting has been damaged. Early photographs show a blank space here; this is today filled with part of a text folio, the rest of which is in the Chester Beatty Library, Dublin.[1]

1. Grabar and Blair 1980, pp. 128–29, no. 36.

52 — Fig. 191

Iskandar Building the Iron Rampart

Image: 27 x 27 cm (10⅝ x 10⅝ in.)
Arthur M. Sackler Gallery, Smithsonian Institution, Washington, D.C.; Purchase, Smithsonian Unrestricted Trust Funds, Smithsonian Collections Acquisition Program, and Dr. Arthur M. Sackler (S1986.104)
New York only

Iskandar subsequently came upon a mountain city plagued by the monstrous peoples of Yajuj and Majuj (Gog and Magog), creatures with black faces and tongues and boarlike teeth, who wreaked havoc and terrorized the citizens. He ordered a wall made of fused iron, copper, sulfur, charcoal, and naphtha to be built across the mountain from its base to its crest to protect the inhabitants.

The painting shows blacksmiths and masons at work on the rampart.[1] Their varied attire follows the description in the text, which speaks of craftsmen assembled from all over the world. In the background, the denizens of Yajuj and Majuj are seen peering from behind the rocks.

1. Grabar and Blair 1980, pp. 130–31, no. 37; Lowry 1988, pp. 86–87, no. 12.

53 — Fig. 184

Ardashir Battling Bahman, Son of Ardavan

Image: 17 x 29 cm (6¾ x 11⅜ in.)
Detroit Institute of Arts, Founders Society Purchase, Edsel B. Ford Fund (35.54)

The account of Iskandar ends with his death. The narrative moves next to the rule of Ardavan, last of the Parthian kings. Ardavan had heard of the prowess of a gifted and gallant youth, Ardashir, born of a local princess and a shepherd, and summoned him to the court to live with his sons. Ardashir fell out of favor when he surpassed the king's sons at hunting, and he was banished to the stables. Subsequently, Ardavan was warned by his sages that one of his servants would soon overthrow him. Fearing for his life, Ardashir

escaped from the court with his beloved, Gulnar, Ardavan's favorite slave-girl, and the two were pursued by the king. Ardavan, however, was unable to catch up with the couple and ordered his son Bahman to continue the chase. Reaching his homeland, Ardashir gathered an army to face Bahman, and a fierce battle ensued. Finally, Ardashir charged at Bahman, who fled wounded.

The painting shows the combatants in the center with their armies at the sides.[1] The charging Ardashir is depicted with his back to the viewer. Although the title above was originally inscribed "Ardashir battling Ardavan," the text above describes the confrontation between Ardashir and Bahman, and the words "Bahman, son of" have been inserted before "Ardavan" in the title by a later hand.

1. Grabar and Blair 1980, pp. 138–39, no. 41.

54 Fig. 163

Ardavan Captured by Ardashir

Image: 19.4 x 28.7 cm (7⅝ x 11¼ in.)
Arthur M. Sackler Gallery, Smithsonian Institution, Washington, D.C.; Purchase, Smithsonian Unrestricted Trust Funds, Smithsonian Collections Acquisition Program, and Dr. Arthur M. Sackler (S1986.103)
Los Angeles only

Ardavan, learning of Bahman's defeat and flight, marched upon Ardashir himself. The two fought intensely for forty days until Ardavan was wounded and taken captive. He was brought before Ardashir, who ordered the prisoner to be cleaved in two.

Pictured here is the moment when the defeated Ardavan stands before Ardashir and hears of his impending death.[1] The composition is divided by the central figure in the foreground: a Mongol soldier seen from the back. His feet and mace extend beyond the border, a pictorial device often seen in the illustrations of the *Jamiᶜ al-tavarikh* (cat. nos. 6, 7). It serves to focus the viewer's attention and to emphasize the dramatic intensity of the scene.

1. Grabar and Blair 1980, pp. 140–41, no. 42; Lowry 1988, pp. 88–89, no. 13; Bloom and Blair 1997, no. 105.

55 Fig. 110

Bahram Gur Hunting with Azada

Image: 21 x 29 cm (8¼ x 11⅜ in.)
Harvard University Art Museums, Cambridge, Mass., Gift of Edward W. Forbes (1957.193)

Ardashir was the first king of the Sasanian dynasty, and the *Shahnama* continues with accounts of the Sasanians. Bahram Gur (the sobriquet Gur, or onager, referred to his prowess at hunting), another popular hero-king, is featured in several sections of the text, and this fragmentary copy of the *Shahnama* includes seven paintings depicting his exploits. His father, the king Yazdigard, was a tyrant, and in order to preserve the prince Bahram from his evil influence, the sages persuaded him to send the child to be raised and educated by the Arabs.

The text recounts an episode in Bahram Gur's life frequently represented in Persian art (see cat. nos. 97, 169). One day he went deer hunting with his favorite harp player, Azada. She challenged him to prove his skill by changing a buck into a doe, a doe into a buck, and then to shoot a deer so as to pin its foot to its ear. Despite his successful completion of these tasks, Azada taunted Bahram by saying that only the devil could shoot as he had done. This infuriated Bahram Gur, who flung her from the camel and trampled her to death.

The painting includes the entire episode in a single image: Bahram Gur is seen performing all three feats and at the same time trampling Azada under the hooves of his camel.[1]

1. Grabar and Blair 1980, pp. 150–51, no. 47; Blair and Bloom 2001, fig. 2.

56 Fig. 187

Bahram Gur Slaying a Dragon

Image: 20 x 29 cm (7⅞ x 11⅜ in.)
The Cleveland Museum of Art, Grace Rainey Rogers Fund (1943.658)

One day while hunting, Bahram Gur came across a fearsome dragon with hair to the ground and breasts like a woman's. He shot arrows at the creature's head and chest and dispatched it with his sword.

The greater part of this illustration is filled with the writhing body of the dragon pierced with arrows.[1] Bahram Gur is seen from the back with sword in hand, having dismounted from his horse to deliver the fatal blow. The artist has vividly captured the description of the beast, with its flowing hair and its sharp teeth and claws. Its powerfully sinuous body, elaborately scaled and speckled, wraps around a tree trunk in an upward diagonal across the picture space. The mountains in the background and some of the landscape elements in the foreground are rendered in a Chinese-inspired style.

1. Grabar and Blair 1980, pp. 154–55, no. 49.

57 Fig. 183

Bahram Gur Hunting Onagers

Image: 20 x 29 cm (7⅞ x 11⅜ in.)
Worcester Art Museum, Worcester, Mass., Jerome Wheelock Fund (1935.24)

On another hunt, Bahram Gur astounded his companions with his skill by shooting at an onager so that the arrow entered the animal's rump and came out of its breast, and then by cleaving another in half with a single stroke of the sword. Pleased with his success and as a gesture of generosity, Bahram ordered six hundred onagers to be earmarked with gold rings and another six hundred to be branded, all to be distributed among the people.

Like other such scenes (see cat. no. 55), this one illustrates different moments in the narrative.[1] Bahram Gur is shown with an arrow at the ready, while another has already hit its mark in an onager's rump. Other onagers are seen with brands on their rumps and gold rings in their ears. The lower right corner is damaged and repaired with blank paper.

1. Grabar and Blair 1980, pp. 158–59, no. 51.

58 Fig. 182

Bahram Gur Fighting a Wolf

Image: 21 x 29 cm (8¼ x 11⅜ in.)
Harvard University Art Museums, Cambridge, Mass., Bequest of Abby Aldrich Rockefeller (1960.190)

Disguised as an envoy of the shah of Iran, Bahram Gur made his way to the court of Hind, ruled over by an unjust king, Shangul, to observe the kingdom and its troops. One evening after a sumptuous banquet, Bahram Gur mistakenly displayed his prowess and roused the suspicions of the king, who tried to trick Bahram into revealing his identity. When this ruse failed, Shangul decided to dispatch the hero by sending him to slay a fearsome horned wolf. Bahram Gur pierced the wolf with arrows and cut off its head with his sword.

Unlike other scenes of Bahram Gur's hunting triumphs, this miniature does not show him in the act of slaying his prey.[1] Instead, a relaxed, confident Bahram Gur is depicted after the deed, with mace in hand, a quiver full of arrows, and a sheathed sword. The still-writhing corpse of the wolf figures prominently in the foreground, a feature that is not specifically mentioned in the text.

1. Grabar and Blair 1980, pp. 162–63, no. 53; Simpson 1980, pp. 28–29, no. 6.

59

Fig. 274

Nushirvan Eating the Food Brought by the Sons of Mahbud (?)

Image: 21 x 25 cm (8¼ x 9⅞ in.)
The Metropolitan Museum of Art, New York,
Purchase, Joseph Pulitzer Bequest, 1952 (52.20.2)

After Bahram Gur's peaceful death, the *Shahnama* continues with the history of his descendants, dwelling at length on episodes in the reign of Nushirvan the Just. Mahbud, one of Nushirvan's paladins, was entrusted with the daily duty of preparing the royal meals, which were cooked by Mahbud's wife and brought to the palace by his two sons. Mahbud's privileged position was the cause of much envy, and for none more than Zuran, an evil chamberlain, who conspired with a sorcerer to remove him. His sons were tricked into uncovering the tray of food on the pretext of checking it for freshness, at which point the sorcerer rendered the food poisonous by means of the evil eye. As Nushirvan sat to eat his meal, Zuran warned him that it might be poisoned and suggested that Mahbud's sons taste it first. The two youths immediately succumbed. Angered by this apparent treachery, Nushirvan ordered Mahbud and his wife to be executed, and Zuran and the sorcerer became the king's most trusted advisers. Sometime later, however, Nushirvan uncovered the plot and had Zuran hanged.

The painting is unusual in that its subject is not easily identifiable.[1] As Grabar and Blair have observed, the surrounding text deals with the construction of the gallows for Zuran, which is not depicted. The composition is divided into two architectural settings. On the right, behind two armed guards, is a palace facade; a young woman looks down from an upper story. On the left a crowned couple is seated in an interior. The man, who raises a goblet, must represent Nushirvan and the woman his queen, though the latter does not figure in the story.

1. Grabar and Blair 1980, pp. 168–69, no. 56.

60

Fig. 45

Nushirvan Writing to the Khaqan of China

Image: 19 x 20 cm (7½ x 7⅞ in.)
The Trustees of the Chester Beatty Library, Dublin
(Per 111.7)

Finding himself in a confrontational situation with Nushirvan and in order to avoid bloodshed, the *khaqan* of Chin (China) wrote to the shah proposing a peaceful alliance between their powerful kingdoms. Nushirvan, though initially surprised, recognized the wisdom in this and sent a response to the *khaqan,* agreeing with him.

The painting, another of the enthronement

scenes from this copy of the *Shahnama,* shows an interior architectural setting with Nushirvan in the center and a scribe in the right foreground writing at his dictation.[1] The subject is identified in the title above.

1. Grabar and Blair 1980, pp. 170–71, no. 57.

61

Fig. 192

Mihran Sitad Selecting a Chinese Princess

Image: 18 x 27 cm (7⅛ x 10⅝ in.)
Museum of Fine Arts, Boston, Helen and Alice
Colburn Fund and Seth K. Sweetser Fund (22.392)

Intimidated by reports of Nushirvan's power and eager to seal their alliance, the *khaqan* offered the shah one of his daughters in marriage. Nushirvan agreed and sent his trusted adviser Mihran Sitad to the Chinese court to select the most nobly born of the princesses. The *khaqan* had several daughters, but his daughter by the queen was his dearest and he did not want to lose her. So he ordered all her half sisters to be attired in the finest garments and jewels in the hope that the one plainly dressed maiden would escape notice. Mihran Sitad immediately recognized the nobility and charm of the *khaqan*'s favorite child and selected her as Nushirvan's bride.

The illustration shows Mihran Sitad, with three lesser figures, behind a balustrade gazing at the Chinese princesses.[1] According to the text of the *Shahnama,* the queen's daughter was the simplest and least adorned of her sisters, but here she is dressed more elaborately than the others. She is seated in the center of the group, and her importance is further emphasized by the flame above her head. The architectural setting reflects markedly Chinese elements, especially in the roof.

1. Grabar and Blair 1980, pp. 172–73, no. 58.

62

Fig. 5

Juz 15 of a Thirty-Part Koran

Copied by Yaqut al-Musta'simi
Iraq (probably Baghdad), A.H. 681/A.D. 1282–83
Leather binding; 58 folios: ink, colors, and gold on paper, 5 lines of *muhaqqaq* script to the page
24.5 x 17 cm (9⅝ x 6¾ in.)
The Nasser D. Khalili Collection of Islamic Art,
London (QUR 29)

Yaqut al-Musta'simi (d. 1298) was a master in all the principal scripts, but Korans copied by him in *muhaqqaq* are extremely rare, especially an example that still has its original illuminations. In addition to the present volume, three other sections of the manuscript—originally

bound in thirty volumes, the most common method of subdivision in the Ilkhanid period—have survived, two in Istanbul and one in Dublin.[1]

Yaqut was such an important source of inspiration and imitation among calligraphers that his signature was often placed at the end of later Korans, thus making the identification of his original work uncertain. While his signature on the last folio of the present section may be a later addition, there is no doubt that the signature on *juz* 8 of the same Koran (in Dublin) is authentic. The illuminations throughout are in the style current in the late thirteenth century, exemplified by the work of Muhammad ibn Aybak (see cat. nos. 63, 64), although they also seem to have been influenced by the work of Ibn al-Bawwab (10th–11th century) in Baghdad. In its four extant sections, this manuscript constitutes one of the most important survivals to document the style of calligraphy and illumination in Iraq at the end of the thirteenth century.

1. James 1992, pp. 60–67, no. 11. *Juz* 2 and 12 are in the Topkapı Palace Library, Istanbul (EH226, 227); *juz* 8 is in the Chester Beatty Library, Dublin (1452).

63, 64 Two Folios from the Anonymous Baghdad Koran

Copied by Ahmad ibn al-Suhrawardi al-Bakri; illuminated by Muhammad ibn Aybak ibn 'Abd Allah
Iraq (Baghdad), A.H. 701–7/A.D. 1302–8
Ink, colors, and gold on paper, 5 lines of *muhaqqaq* script to the page
50 x 35 cm (19⅝ x 13¾ in.)

The so-called Anonymous Baghdad Koran,[1] now dispersed, is perhaps the most outstanding of all large-format manuscripts created for the Ilkhanid rulers at the beginning of the fourteenth century (see also cat. no. 65). A few complete sections of this codex survive in Istanbul and Tehran, while isolated folios are in the Chester Beatty Library, Dublin, and The Metropolitan Museum of Art, New York.[2] The extant sections give the names of the calligrapher and the illuminator, Ahmad ibn al-Suhravardi (d. ca. 1320–21) and Muhammad ibn Aybak (active ca. 1290–1320), respectively, whose partnership was perhaps the most splendid ever seen in the production of luxury Korans. Unfortunately, however, the surviving portions do not reveal the names of their patrons. From the dates included in the colophons, these may be tentatively identified as the sultans Ghazan (r. 1295–1304) and Öljeitü (r. 1304–16).

1. James 1988, pp. 79–92, 235, no. 39.
2. *Juz* 2, 4, and 13 are in the Topkapı Palace Library, Istanbul. Most of *juz* 10, 25, 26, and 28 are in the Iran Bastan Museum, Tehran, although a few folios from these sections are in Dublin and New York.

63 *Fig. 158*

Double-Page Frontispiece (right side)

The Trustees of the Chester Beatty Library, Dublin
(Is 1614.2)

The master illuminator Muhammad ibn Aybak has created a geometric composition based on the repetition of larger blue octagons, smaller brown or gold octagons, and gold pentagons.[1] Vegetal scrolls fill all the available spaces in a striking combination of gold, black, blue, red, and a distinctive chocolate brown. The expanding pattern is framed by a double band of gold-and-black strapwork inside a rich outer border that includes a medallion on the right; this would have been mirrored in the symmetrical illumination on the facing page. Each *juzʾ* of this thirty-part Koran would have included a similar lavishly illuminated double-page frontispiece but with a different geometric pattern and a different color scheme, making each one an exceptional work of art in itself.

1. Arberry 1967, pl. 40, no. 92 (reversed); James 1988, fig. 49. Another illuminated page from a different *juzʾ* of the same Koran in the Chester Beatty Library has the same accession number (Is 1614, fol. 1); see James 1980, p. 60, no. 43.

64 *Fig. 245*

Double-Page Colophon (left side)

The Metropolitan Museum of Art, New York,
Rogers Fund, 1955 (55.44)

Perhaps the most important extant page of the Anonymous Baghdad Koran for documentary purposes,[1] this half of the colophon of one of the last four sections reveals not only the names of both the calligrapher and the illuminator but also the date and place of the completion of the volume. The illuminator, Muhammad ibn Aybak, wrote in Kufic script inside the two illuminated bands: "Baghdad, may Allah the Exalted protect it, in the months of the year seven hundred and seven [1307–8] of the lunar calendar." The three lines of superb *muhaqqaq* calligraphy read: "Ahmad ibn al-Suhravardi al-Bakri, praising Allah and blessing his prophet Muhammad, his family, and his companions and committing [his cause to God]." Ibn al-Suhravardi, a pupil of Yaqut (see cat. no. 62), was born in Baghdad and is credited with the copying of thirty-three Korans, many of which were owned by the vizier Rashid al-Din.

1. James 1988, fig. 47; Schimmel 1992, p. 16, no. 19.

65 *Figs. 121, 156*

Two Folios from Öljeitü's Mosul Koran

Copied by ibn Zaid al-Husaini ʿAli ibn Muhammad
Iraq (Mosul), A.H. 706–11 / A.D. 1306–12
Ink, colors, and gold on paper, 5 lines of *muhaqqaq* script to the page
44.6 x 30 cm (17½ x 11¾ in.)
The Trustees of the Chester Beatty Library, Dublin
(Is 1613.1, 1613.2)

The copy known as Öljeitü's Mosul Koran is one of the spectacular, large-size thirty-part manuscripts intended for the sultan's mausoleum in Sultaniyya (see also cat. nos. 63, 64). According to the long genealogical sequence *(isnad)* in his signature, the scribe, who was probably also the illuminator, was a direct descendant of the caliph ʿAli ibn Abi Talib (d. 661). The superb gold *muhaqqaq* calligraphy with black outlines demonstrates that Zaid al-Husaini, the otherwise unknown early-fourteenth-century scribe, was an outstanding master of this style in Mosul, where the Koran was commissioned. The colophons at the end of the extant parts (most of them in Turkey, with some in Iran, Britain, and Ireland) prove that he was a fast writer who was able to complete a single *juzʾ* in less than a month. He probably stopped halfway, however, to execute the illuminations, and it took about six years, therefore, for the manuscript to be completed.[1]

1. James 1980, p. 61, no. 44; James 1988, pp. 100–103, 237, no. 42, figs. 64–72.

66 *Fig. 268*

Juzʾ 11 of a Thirty-Part Koran

Copied by ʿAbdallah ibn Ahmad ibn Fadl Allah ibn ʿAbd al-Hamid al-Qadi al-Qazvini
Iran (Maragha), A.H. Shawwal 738–Shawwal 739 / A.D. April 1338–April 1339
Leather binding; 22 folios: ink, colors, and gold on paper, 7 lines of *naskh* script to the page
31.5 x 23 cm (12⅜ x 9 in.)
The Trustees of the Chester Beatty Library, Dublin
(Is 1470)

The Koran from which this is taken is preserved almost in its entirety, with twenty-three of its original thirty parts now in the Ethnographic Museum in Ankara, two in the Museum of Fine Arts, Boston, and the present one in Dublin.

 The manuscript was compiled after the death of Abu Saʿid in 1335 and is therefore one of the few surviving Korans to be produced in a major Ilkhanid center during the period of turmoil that ensued. The choice of the *naskh* calligraphic style is unusual, especially when the average page contains only seven lines of rather small script (unlike the more common *muhaqqaq* and *thuluth*), leaving ample white

space between them. The effect of the spaced lines against the white polished paper, however, is perhaps the most appealing characteristic of this manuscript. The opening double page is elaborately illuminated and contains facing cartouches in white Kufic script with a dark and pale outer border that is typical of the period.[1] The leather binding is original and is decorated with large, blind-tooled, lobed circles on the two covers as well as on the flap.[2]

1. James 1980, pp. 64–65, nos. 47, 48; James 1988, p. 245, no. 61.
2. Ettinghausen 1958, p. 539, fig. 351; James 1980, p. 66, no. 49.

67 *Fig. 269*

Juzʾ 10 and 14 of a Thirty-Part Koran

Iran (Shiraz), ca. 1336–75
Leather binding; 51 folios: ink, colors, and gold on paper, 7 lines of *muhaqqaq* script to the page
42.6 x 31 cm (16⅜ x 12¼ in.)
The Nasser D. Khalili Collection of Islamic Art, London (QUR 182)

Tashi Khatun and Fars Malik Khatun, the mother and sister respectively of the Injuid ruler Abu Ishaq (r. 1343–53), were two prominent women of the Injuid dynasty who commissioned fine, lavishly illuminated Korans. The present manuscript includes, in a single binding, sections 10 and 14 of a codex that was probably commissioned by Fars Malik Khatun after 1336; it was not completed, however, until 1357, and parts of its illumination were probably executed as late as the 1370s.[1] The text, in flowing gold *muhaqqaq* with black outlines and fillings, blue vocalization, and interlinear Persian translation in black *naskh,* is likely to have been finished by the time of the patron's death in 1344 or 1348. The illumination, however, was completed and nonconsecutive sections were bound together only under the patronage of the Muzaffarid Turanshah in the 1370s. Intended for placement at the head of Fars Malik's tomb, the manuscript as a whole was therefore unfinished at the time of her death and never served its original purpose.

 The quality of the calligraphy and of the illumination compares well with Ilkhanid production, and royal patronage is clearly revealed in the lavish use of gold as well as in the refinement and quality of the pigments applied in the illumination. The work's long period of gestation, spanning two dynasties in Shiraz, exemplifies the degree of esteem and reverence that such manuscripts commanded.

1. James 1992, pp. 126–29, no. 29. The Khalili Collection also owns *juzʾ* 24 and 25 (QUR 181); ibid., pp. 130–35, no. 30. *Juzʾ* 1, 12, 13, and 30 are in the Pars Museum in Shiraz.

DOCUMENT

68 — Firman of Geikhatu

Fig. 47

Northwestern Iran, A.H. early Jumada II 692/
A.D. May 1293
Ink on paper
88 x 27.5 cm (34⅝ x 10⅞ in.)
Art and History Trust, Courtesy of the Arthur M.
Sackler Gallery, Smithsonian Institution,
Washington, D.C. (LTS 1995.2.9)

Official documents on paper from the Ilkhanid period are exceedingly rare. This firman, or decree, in the form of a scroll is the earliest such document to survive.[1] Written in Persian, except for the first three lines, which are in Turkish, and stamped twice in red ink with the Chinese seal of Khubilai Khan, the Yuan ruler (r. 1260–94), the decree exempts from taxes and other levies the endowment of a hospice for dervishes, which received revenue from the village of Mandeshin near the Caspian Sea.

The firman was issued by the Ilkhanid ruler Geikhatu (r. 1291–95), using his Mongolian name of Arinjin Turji, and was countersigned by the powerful amirs Shiktur, Aq-Buqa, and Toghajar and the *sahib-i divan* (minister of finance) Ahmad Khalid Zanjani. The document was written not in a city atelier but "in the royal camp of [Kariz?]" and was therefore the work of an official scribe following Geikhatu's mobile encampment somewhere in northwestern Iran in the spring of 1293. With its combination of Turkish and Persian scripts and its Chinese seals, it bears witness to the disparate influences and cultures present in the Ilkhanid court.

1. Soudavar 1992, pp. 34–35, no. 9.

TEXTILES

69 — Textile with Winged Lions and Griffins

Fig. 58

Central Asia, mid-13th century
Lampas weave (tabby and tabby), gold thread on silk foundation
124 x 48.8 cm (48⅞ x 19¼ in.)
The Cleveland Museum of Art, Purchase from the J. H. Wade Fund (1989.50)

Silk textiles woven with gold-wrapped thread and especially textiles in which both the pattern and the ground were woven in gold on a silk foundation—so-called cloth of gold (*nasij*)—seem to have had a special appeal for the Mongols. From the start of their Asian conquests in the early thirteenth century, they sought out skilled weavers in the subjugated territories, especially in Iran and Central Asia, and relocated them, the better to make use of their services. This magnificent cloth of gold,[1] decorated with rows of medallions enclosing pairs of addorsed winged lions, with similarly paired griffins in the interstices, represents the type of hybrid style that might be expected to emerge from the commingling of diverse transplanted artists and artistic traditions. In both concept and detail, the symmetrically paired animals can be linked to the Iranian world, while the cloudlike patterns on the lions' wings and the floral designs that fill the background are derived from the artistic vocabulary of lands farther east.[2]

1. Wardwell 1992, figs. 1–3; Watt and Wardwell 1997, pp. 142–43, no. 35; Watt 1998, fig. 5.
2. See Wardwell 1992, pp. 357–58.

70 — Textile with Paired Rabbits

Fig. 217

Probably Iran, 14th century
Lampas weave (satin and tabby), silk and gold thread
61.6 x 43.8 cm (24¼ x 17¼ in.)
Cooper-Hewitt National Design Museum,
Smithsonian Institution, New York, Gift of John
Pierpont Morgan (1902-1-262)
Los Angeles only

This handsome textile is one of a large group that combines Iranian, Chinese, Italian, and Syro-Egyptian decorative elements, thereby rendering the issue of provenance difficult and at times impossible to establish.[1] The design in this instance[2]—addorsed rabbits contained by leafy medallions, the latter set within an overall pattern of ovals defined by scrolling vines with blossoms—seems more specifically Islamic in nature. Whether the textile was produced in Iran under Ilkhanid patronage or in Egypt or Syria under the Mamluks is an open question. Technical similarities with certain Mamluk textiles could be the result of practices brought with them by the weavers who emigrated to Iran from the Mamluk empire, either by choice or under compulsion.[3]

1. See Wardwell 1988–89, pp. 112–15.
2. Ibid., fig. 64.
3. See ibid., p. 115. Another piece from the same cloth in the Abegg-Stiftung, Riggisberg, has recently been attributed to Egypt; Otavsky and Salim 1995, pp. 214–17.

71 — Textile with Paired Parrots and Dragons

Fig. 75

Central Asia, first half of the 14th century
Lampas weave (twill and tabby), silk and gold thread
72.5 x 36 cm (28½ x 14⅛ in.)
Staatliche Museen zu Berlin, Preussischer
Kulturbesitz, Kunstgewerbemuseum (1875.258)

This fragmentary silk and gold textile has a repeat pattern of addorsed parrots set within dodecagons, the interstices filled with East Asian–inspired dragons; on each bird's wing is a medallion containing an Arabic inscription.[1] The composite nature of the design suggests a Central Asian, rather than an Iranian or Chinese, provenance. The text of the inscription further complicates the issue of the textile's origins: "Glory to our lord the sultan the king the just the wise Nasir al-Din" (?); at the center is the name Muhammad (?).[2] This may refer to the Mamluk ruler of Egypt and Syria, Al-Nasir Nasir al-Din Muhammad ibn Qalawun (r. 1293–1341, with interruptions). Such an attribution is substantiated by a frequently cited account by the historian Abu al-Fida. He noted that upon the conclusion of a peace treaty between the Ilkhanids and the Mamluks in 1323, the Ilkhan Abu Saʿid sent a substantial gift to the Mamluk sultan that included seven hundred silks, some inscribed with the sultan's titles.[3] Perhaps this textile was a part of that largesse.[4]

1. *Arts of Islam* 1976, no. 15; Mackie 1984, pp. 141–42, pp. 47–48, pl. 23; Wardwell 1988–89, fig. 19; Wilckens 1992, pp. 47–48, no. 75.
2. For the inscription, see *Arts of Islam* 1976, p. 80; Wardwell 1988–89, p. 101.
3. Wardwell 1988–89, p. 101.
4. For the interrelationship of Chinese, Ilkhanid, and Mamluk art, see Stefano Carboni, chapter 8 above.

72 — Tapestry Roundel

Fig. 195

Iraq or Iran, first half of the 14th century
Tapestry weave, silk, gold thread wrapped around a cotton core
Diam. 69 cm (27⅛ in.)
The David Collection, Copenhagen (30/1995)

This exceptional silk- and gilt-thread woven tapestry embodies the art of the Ilkhanid period, combining as it does Islamic, Iranian, Chinese, and Central Asian elements;[1] it also seems to draw upon the traditions of manuscript illustration and metalwork in Ilkhanid Iran. The main motif of the enthroned prince with attendants is well known in Iranian art both before and especially after the Mongol invasions (for the latter, see cat. nos. 18, 19,

159, 162). Here the ruler is depicted in Mongol garb, as are the members of his entourage with the exception of the figure in the right foreground, who may be a Persian or Arab adviser. The composition is set in a dense landscape inhabited by animals and birds, a contrivance introduced into Iran from eastern Asia. Related compositions occur in contemporary manuscript illustration (see cat. no. 39)—the tapestry-weave technique can be compared to painting, using colored thread rather than pigment—and metalwork; analogies with the latter are especially pertinent, as medallions in this medium likewise enclose royal enthronements (see cat. nos. 159, 162). In the foreground below the ruler is the motif of a fishpond, common in Iranian luster pottery of the thirteenth and early fourteenth centuries.[2]

The central medallion is surrounded by a band of animals, both real and imaginary, pacing within a leafy arabesque. While the latter is a purely Islamic motif, the animals and their vegetal background are reminiscent of silk tapestries made in China and especially Central Asia in the eleventh to thirteenth centuries (e.g., cat. no. 187).[3] Around this is a wider band with pacing animals amid large blossoms and leaves, interrupted by six small medallions each featuring an armed warrior. This band, too, recalls eleventh-to-thirteenth-century Chinese and Central Asian tapestries, while the use of small figural medallions is a common feature of Islamic decorative arts.[4] Around the entire medallion is a narrow outer band inscribed in Arabic, in gold on a blue ground. The text repeats a series of good wishes of a type frequently found among the inscriptions on medieval Islamic objects: "Perpetual Glory, and Prosperity, and Perfect [sic], and Wealth, and Happiness, and Well-Being, and Ease."[5]

These somewhat generic good wishes do not enhance our understanding of the original context of the roundel and its function. Its cotton backing is said to be contemporary with the tapestry,[6] which may have once formed part of a larger composition, possibly a spectacular wall-hanging, canopy, or tent panel.

1. Folsach 1996; Folsach 2001, no. 642.
2. For the motif in early-fourteenth-century manuscript illustration, see Folsach 1996, p. 117, n. 6.
3. Ibid., p. 87; see also Watt and Wardwell 1997, pp. 66–69, 80–83, nos. 14, 15, 19, 20.
4. The bands of animals within scrolling floral designs and the enthronement scene are reminiscent of similar imagery in a drawing that may be based on Ilkhanid designs (see fig. 22), perhaps suggesting a common source for such themes.
5. Folsach 1996, p. 83.
6. Ibid., pp. 83, 87; the results of the carbon 14 test on the roundel produced a date in the fourteenth century.

73 *Fig. 42*

Tent Hanging

Eastern Iran or Central Asia, late 13th–early 14th century
Lampas weave (tabby and twill), silk, gilded strips
222 x 61 cm (87 ⅜ x 24 in.)
The David Collection, Copenhagen (40 / 1997)

This panel,[1] a superb example of *nasij* (cloth of gold), is almost certainly one of a large series that would have covered the interior of a royal Mongol tent.[2] The refined pattern shows vertical rows of large medallions enclosing confronted roosters, separated by a stylized Tree of Life, alternating with pairs of smaller, lobed roundels with coiled dragons. The background is filled with vegetal scrolls and stylized peonies and lotus flowers. The rows of medallions are separated by narrow vertical bands that form slender columns for the lobed pointed arch on the upper part of the textile. When all the panels were sewn together and draped inside a tent or pavilion, thus creating the effect of an arcade, the impression of a richly decorated architectural interior must have been a splendid one.

That this was most likely a royal commission is confirmed by the high quality of the fabric and the lavish use of gold (on its own in the form of flat threads and as a wrapping for silk), and perhaps by the sophisticated weaving technique on a drawloom. This is the earliest known example of a tent interior. The combination of gold-wrapped silk and flat gold threads is rare but not unheard of in West and Central Asia.[3] What is exceptional here is the combination of threads wrapped with a paper substrate and flat threads having an animal substrate.

A provenance from the eastern Iranian regions of Khurasan and Transoxiana or from Central Asia, rather than from China, is likely on both technical and stylistic grounds. The upper edge of the hanging reveals the remains of a pseudo-Kufic, decorative inscription that is found occasionally on textiles woven in the eastern Iranian regions and that clearly points to the Islamic area.[4] The rooster motif is a well-known design element harking back to the Sasanian and early Islamic periods.[5] The frames of the medallions, with their interlocking inner and outer circles, have close parallels in twelfth- and thirteenth-century metalwork. Many details, however, such as the coiled dragons enclosed in lobed roundels and the ducklike birds incorporated into the medallion frames, are hybrids of eastern and western Asian models, the result of an extraordinary artistic language that unified all of Asia during the Mongol period.

1. Folsach 2001, no. 641.
2. See Wardwell 1988–89. Ten more almost identical

hangings, almost certainly from the same set, have survived. Still unpublished, they are now in private hands.
3. It is present, for example, in a textile in Cleveland with felines and eagles and in the so-called Tiraz of Abu Bakr in Copenhagen. See Watt and Wardwell 1997, pp. 154–57, nos. 43, 44.
4. For example, a textile with griffins in The Metropolitan Museum of Art, New York; see ibid., p. 135, fig. 63.
5. Louise Mackie of the Cleveland Museum of Art suggests in a written communication that these roosters, with red eyes, are associated with wine. As a design on the interior walls of a tent, they celebrate festivities.

74 *Fig. 249*

Textile with Paired Felines

Western Iran, 1340–80
Lampas weave, silk
42 x 34 cm (16 ½ x 13 ⅜ in.)
Cooper-Hewitt National Design Museum, Smithsonian Institution, New York, Gift of John Pierpont Morgan from the Miguel y Badia Collection (1902-1-251)
New York only

There are two interlocking patterns on this fragment: the larger design is of addorsed felines, probably cheetahs, enclosed within a circular medallion edged with vegetal motifs and framed by an eight-pointed star; the other is a floral motif set within a diamond-shaped frame at the center of a cross.[1] The arrangement recalls the star-and-cross tile revetments, often bearing animal motifs, that were popular in Ilkhanid architecture in Iran. The designs are woven in ivory and blue, creating a subtly shaded effect on the dark blue background.

The blue and white color scheme, often using two shades of blue, is seen in several Mamluk silks. Its popularity was perhaps due to the widespread availability and relatively low cost of indigo.[2] This fragment suggests that there may have been an exchange of influence between Mamluk and Ilkhanid textile producers despite their political antagonism. Luxury textiles were often used as diplomatic gifts, as is suggested by the eyewitness account of the historian Abu al-Fida cited in cat. no. 71.[3] Furthermore, Mamluk weavers are known to have worked in Iran in the thirteenth and early fourteenth centuries, and an exchange of skills and ideas with local craftsmen seems likely to have been the result.[4]

1. Wardwell 1988–89, p. 166, fig. 60. For another fragment from the same textile, see Suriano and Carboni 1999, pp. 42–44, no. 10.
2. The authors are grateful to Louise Mackie, The Cleveland Museum of Art, for her comments on this textile.
3. Wardwell 1988–89, pp. 101–2. See also Stefano Carboni, chapter 8 above.
4. Wardwell 1988–89, p. 115.

75

Fig. 196

Striped Brocade

Iran, 14th century
Lampas weave (satin and tabby), silk and gold thread
Combined: 76 x 52 cm (29⅞ x 20½ in.)
Staatliche Museen zu Berlin, Preussischer
Kulturbesitz, Kunstgewerbemuseum (1875.259)

Following their first wave of conquests in the early thirteenth century, the Mongols established communities of resettled textile workers from eastern Iran and China along the southern boundaries of the Mongol homeland and in Central Asia. This striped brocade,[1] now in two pieces, with its bands of lotus blossoms alternating with registers inscribed in Arabic, may be viewed as a later development of the amalgamation of artistic traditions and techniques that ensued, in which chinoiserie elements were combined with traditional pre-Mongol Islamic epigraphic ornament. Such striped polychrome textiles, woven with gold thread, are described in medieval European inventories, helping to date them to the fourteenth century.[2] This particular striped cloth was evidently exported to Europe to be used for ecclesiastical vestments; it was formerly in the fourteenth-century Church of Saint Mary, the Marienkirche, Gdańsk (Danzig).[3] Its Arabic inscription repeats the phrase "the sultan the wise."

1. Wilckens 1992, pp. 50–51, no. 82.
2. Wardwell 1988–89, pp. 108–9, and App. II, pp. 20–22.
3. Wilckens 1992, p. 50. For vestments made from the same cloth, also from the Marienkirche, see Wardwell 1988–89, figs. 41, 42.

76

Fig. 199

Textile with Lotus Blossoms

Greater Iran, 14th century
Lampas weave (twill and tabby), silk and gold thread
52 x 38 cm (20½ x 15 in.)
Staatliche Museen zu Berlin, Preussischer
Kulturbesitz, Kunstgewerbemuseum (K6118)

Set against a coral red background, the decoration of this textile comprises staggered rows of golden lotus blossoms that are framed by scrolling vines.[1] The dense pattern is an interesting combination of design concepts drawn from eastern and western Asia. A contemporary Chinese brocade, using the same color scheme and decorated with a related pattern of lotus blossoms within lotus-bud-shaped medallions, likewise shows a mixing of Chinese forms with an Islamic/Iranian emphasis on symmetry.[2]

1. Wilckens 1992, p. 53, no. 85.
2. See Watt and Wardwell 1997, pp. 122–23, no. 33.

77

Fig. 26

Purse

Golden Horde (Southern Russia), second half of the 13th century
Silk, woven, gold-embroidered
11.5 x 8.5 cm (4½ x 3⅜ in.)
State Hermitage Museum, Saint Petersburg (ZO-763)

This small purse is made up of five fragments, each from a different textile.[1] A rectangular piece of silk, embroidered with a crane in flight and a cloud motif below a decorative upper border, forms the central section; a gold-patterned brocade and a woven silk are used for the two sides. The reverse shows the back of a hooved animal. A silk cord is threaded through the opening to form a drawstring closure.

Bird motifs were in popular use on Chinese textiles, ceramics, silver, and lacquer, and the flying crane was a symbol of good fortune and longevity. The cloud motif, traditionally associated with the heavens where the immortals ride above the earth, was common as a decorative filler; here it appears with a mushroom-like head, a form employed in Chinese art from the tenth century onward.[2]

The purse was discovered in 1999 at Khadzhytarkhan, a destroyed burial site in the region of Astrakhan.

1. Unpublished. We are grateful to Mark Kramarovsky of the Hermitage for his advice on this entry.
2. Rawson 1984, pp. 139–40.

78

Fig. 155

Flat-Weave Fragment

Iran, early 14th century
Cotton, weft-faced compound tabby
104.5 x 46 cm (41⅛ x 18⅛ in.)
State Hermitage Museum, Saint Petersburg (IR-2253)

There are two basic types of prayer rug, one designed with a single mihrab and meant for individual worship, the other with multiple niches and intended for a place of public prayer such as a mosque. It is to the second type, known as *saf,* that this fragment belongs.[1] Inscriptions in Kufic script, which are repeated in mirror image, are its primary decoration. They reiterate the words "glory" and "power" in the upper sections of the carpet, while the vertically oriented inscriptions in the central field quote from the Koran (sura 112). A second vertical inscription to the left, again repeated in mirror image, gives the name of the manufacturer or possibly the

weaver, ʿAli Nushabadi, who is otherwise unknown.

The reversible inscriptions are due to the particular weaving technique (called *zilu),* which is done on a vertical drawloom that automatically forms designs in mirror image. Weaving in two colors causes the design to be reversible. *Zilu* were commonly used as floor coverings in Iranian mosques instead of knotted pile carpets.[2] This fragment has been dated to the first half of the fourteenth century by reason of the particular letter forms of the inscriptions, which makes it the earliest extant example of a flat-weave carpet from Islamic Iran.[3]

1. *Islamic Art in the Hermitage Museum* 1990, pp. 24–25, no. 61; Piotrovsky 1999, no. 1. We are grateful to Louise Mackie for bibliographical references and other assistance with this entry.
2. On the technique of *zilu* manufacture, see Wulff 1966, pp. 210–11; Thompson and Granger-Taylor 1995–96.
3. For *zilu* dated A.H. 808/A.D. 1405, with twenty-four niches, see Wilber 1981.

CERAMICS

79

Fig. 140

Star Tile

Iran (Kashan), A.H. Ramadan 663/A.D. June 1265
Fritware, overglaze luster-painted
Diam. 20.5 cm (8⅛ in.)
Asian Art Museum of San Francisco, The Avery Brundage Collection (B60P2034)

Shimmering luster tiles from Iran, such as this example,[1] began to attract the attention of Western collectors, public and private, in the last decades of the nineteenth century. To satisfy the demand, entire buildings in Iran, such as the shrine complex of ʿAbd al-Samad in Natanz, the Imamzada Yahya at Veramin, and the Imamzada Jaʿfar at Damghan, all dating to the Ilkhanid period, were virtually stripped of their luster tilework, which found its way into European and American collections (e.g., cat. nos. 107, 114–16).[2] This eight-pointed star tile, which is inscribed with Koran verse 97 and dated 663 (1265), is one of a large group of over thirty luster examples of similar dimensions, all of which carry the identical date.[3] In their geometric, floral, and vegetal designs these tiles are very similar to ones from Veramin, which are dated between October and December 1262, although these are significantly smaller.[4]

1. Unpublished.
2. On this phenomenon, see, e.g., Masuya 2000.
3. O. Watson 1985, App. III, p. 191, no. 31. The Metropolitan Museum of Art, New York, has one example,

the Los Angeles County Museum of Art two; on the former, see Carboni and Masuya 1993, p. 16, no. 11.

4. They average 21 cm (8¼ in.) in diameter as compared with the Veramin tiles' 31 cm (12¼ in.). The San Francisco tile is in fact ascribed to Veramin on an old French label, dating from the early twentieth century, on its reverse. For the Veramin tiles, see, e.g., Porter 1995, p. 35, fig. 19.

80–82 Frieze Tiles with Calligraphy

Iran (Takht-i Sulaiman), 1270s
Fritware, overglaze luster-painted

80 Fig. 49

29.7 x 30.3 cm (11⅞ x 12 in.)
The Trustees of the British Museum, London
(OA 1878. 12-30.573b)

81 Fig. 111

30 x 30 cm (11⅞ x 11⅞ in.)
Asian Art Museum of San Francisco, The Avery
Brundage Collection (B60P2145)

82 Fig. 112

28.6 x 27.9 cm (11¼ x 11 in.)
Asian Art Museum of San Francisco, The Avery
Brundage Collection (B60P2146)

These frieze tiles,[1] each of them inscribed, are part of a large group of over forty similar tiles, most of them not excavated, from the palace complex at Takht-i Sulaiman.[2] Although none of the excavated examples was found in situ, the tiles were clearly intended to be set above panels of smaller tiles. Their inscriptions quote from the Iranian national epic, the *Shahnama*, or *Book of Kings*—cat. no. 80 from the book of Bahram Gur, cat. nos. 81 and 82 from the book of Gushtasp[3]—and were perhaps meant in a general sense to link the Ilkhanid ruler with the ancient traditions of kingship in Iran.[4] Inscriptions taken from the *Shahnama* are not unique to Takht-i Sulaiman, but their preponderance at this site does suggest some special significance and one that is perhaps in accord with other types of tile decoration from the complex (e.g., see cat. nos. 95, 97). Their intended audience and precise interpretation, however, have still to be determined.

1. Cat. no. 80: Porter 1995, p. 37, fig. 22. Cat nos. 81, 82: unpublished.
2. See Masuya 1997, pp. 484–502.
3. Identified in ibid., p. 497.
4. See Melikian-Chirvani 1984 and Melikian-Chirvani 1991. See also Masuya 1997, pp. 493–502, for some alternate interpretations of the inscriptions.

83–85 Star and Cross Tiles

83 Fig. 204

Two Star Tiles and Two Cross Tiles

Iran (probably Takht-i Sulaiman), 1270s
Fritware, overglaze painted (*lajvardina*)
H. each 24.8 cm (9¾ in.)
Los Angeles County Museum of Art, Shinji
Shumeikai Acquisition Fund (AC1996.115.1–4)

84 Fig. 101

Star Tile with Phoenix

Iran (probably Takht-i Sulaiman), 1270s
Fritware, overglaze painted (*lajvardina*)
Diam. 20 cm (7⅞ in.)
Arthur M. Sackler Gallery, Smithsonian Institution,
Washington, D.C., Gift of Osborne and Gratia
Hauge (S1997.114)

85 Fig. 278

Cross Tile

Iran (Takht-i Sulaiman), 1270s
Fritware, overglaze painted (*lajvardina*)
H. 21.5 cm (8½ in.)
Staatliche Museen zu Berlin—Preussischer
Kulturbesitz, Museum für Islamische Kunst
(I. 4/67, 21)

One consequence of the Mongol invasions and subsequent establishment of Ilkhanid rule in Iran was the introduction of new Chinese-inspired motifs such as the dragon and the phoenix. These motifs, which may have been brought westward via imported textiles (see cat. nos. 180, 181, 183), quickly became part of the new vocabulary of ornament that was reflected in the tile decoration of the royal residence at Takht-i Sulaiman.[1]

Star and cross tiles such as the present examples were produced in molds, which accounts for the repetition and duplication of compositions. The method of manufacture also helps to identify nonexcavated tiles with Takht-i Sulaiman, as in the case of cat. nos. 83 and 84,[2] which evidently shared the same molds with tiles uncovered at the site (cat. no. 85). Star tiles bearing a dragon or a phoenix, separated by cross tiles and arranged in alternate clusters of turquoise or cobalt blue, were found in the so-called North Octagon, part of a larger complex of a vaulted hall flanked by two octagonal chambers.[3] Such brilliantly glazed and gilt revetment must have dazzled visitors to the palace.

1. See above, chapter 7, for Linda Komaroff's comparison of the overall effect of the tile revetment with textiles, and chapter 4 for Tomoko Masuya's discussion of the palace itself.
2. Cat. no. 83: Komaroff 1998, fig. 15. Cat. no. 84: Lawton and Lentz 1998, p. 136. Cat. no. 85: unpublished.
3. See R. Naumann 1977, pp. 84–86, pls. 66, 67.

86, 87 Two Hexagonal Tiles

Iran (Takht-i Sulaiman), 1270s
Fritware, overglaze painted (*lajvardina*)

86 Fig. 102

Hexagonal Tile with Dragon

18.7 x 21.3 cm (7⅜ x 8⅜ in.)
Staatliche Museen zu Berlin—Preussischer
Kulturbesitz, Museum für Islamische Kunst
(I. 6/71c)

87 Fig. 218

Hexagonal Tile with Recumbent Deer

19 x 21.3 cm (7½ x 8⅜ in.)
Deutsches Archäologisches Institut, Berlin

Both of these tiles come from the so-called West Iwan complex at Takht-i Sulaiman, from a central room located behind the iwan.[1] The two each formed groups with other types of hexagonal tile: the dragon tile with one featuring a phoenix; the deer with a lion tile and a vegetal composition. All five types were produced in cobalt blue and turquoise versions. From the location in which some tiles were found it appears that groups of a single color were clustered together, set on point, to form a densely patterned design.[2] The combination of dragon and phoenix tiles was used elsewhere at this Ilkhanid palace, in the nearby north octagonal chamber (see cat. nos. 83, 84).

The motifs in both groups of tiles were probably imported into Iran via East Asian textiles (see, e.g., cat. nos. 179–83). Even the patterns formed by the gold on blue (or turquoise) dragons and phoenixes are reminiscent of the decorative programs of the textiles. The little vignette of a recumbent deer in a landscape (with its sliver of a fishpond) is comparable to the reclining *djeiran* amid vegetation in a gold-on-red brocade (cat. no. 179). Its companion vegetal tile finds a general parallel in a brocade decorated with a repeat pattern of floral designs enclosed within a lotus bud.[3] The motif of the lion with a tufted tail on the third tile in this group has also been likened to such imagery in textiles.[4] It is possible that the elaborate and colorful gilt tile revetments at Takht-i Sulaiman were meant to be reminiscent of the woven interior of the tents that formed such an important part of Mongol tradition (for an example of a gold and silk tent panel, see cat. no. 73).

1. Cat. no. 86: Gierlichs 1993, no. 11. Cat. no. 87: Hoepfner and Neumeyer 1979, p. 179.
2. See R. Naumann 1977, pp. 83–84, pls. 63, 64; Masuya 1997, pp. 316–22. See also Tomoko Masuya, chapter 4 above.
3. See Watt and Wardwell 1997, pp. 122–23, no. 33, in gold on red.
4. See, e.g., Crowe 1991, p. 157. See also Linda Komaroff's essay, chapter 7 above.

88–91 Hexagonal and Double Pentagonal Tiles

Iran (Takht-i Sulaiman), 1270s
Fritware, underglaze painted
Staatliche Museen zu Berlin—Preussischer
Kulturbesitz, Museum für Islamische Kunst

88 *Fig. 93*

Hexagonal Tile with Flying Bird

(I. 13/69, 15h)
18.1 x 15.2 cm (7⅛ x 6 in.)

89 *Fig. 93*

Hexagonal Tile with Recumbent Deer

(I. 13/69, 15h)
18.7 x 21.3 cm (7⅜ x 8⅜ in.)

90 *Fig. 93*

Double Pentagonal Tile with Two Flying Geese

(I. 13/69, 15)
14.9 x 25.4 cm (5⅞ x 10 in.)

91 *Fig. 93*

Double Pentagonal Tile with Dragon

(I. 13/69, 15e; I. 4/67, 8)
14.9 x 25.4 cm (5⅞ x 10 in.)

These hexagons and double pentagons, along with six-pointed stars, once formed part of an elaborate and colorful tile revetment on the lower walls of the West Iwan, a large vaulted chamber overlooking the central courtyard and the artificial lake within, at Takht-i Sulaiman.[1] The use of underglaze painted turquoise and cobalt blue conforms to the color scheme associated with other tiles from this site (see cat. nos. 83–87). Birds, recumbent deer, and especially the dragon, here set amid foliage or clouds, are recurrent motifs in the tile decoration of this palace complex.[2]

1. See R. Naumann 1977, pp. 81–83, figs. 60 (a plan of this section of the complex), 62 (a photograph of the tiles that were found in situ). See also Tomoko Masuya, chapter 4 above.
2. See Masuya 1997, pp. 564–88.

92 *Fig. 279*

Mold for a Double Pentagonal Tile

Iran (Takht-i Sulaiman), 1270s
Gypsum
17.8 x 13.3 cm (7 x 5¼ in.)
Deutsches Archäologisches Institut, Berlin

This fragment of a gypsum mold for a double-pentagonal dragon tile (cat. no. 91) was discovered near the potter's workshop at Takht-i Sulaiman, demonstrating that such tiles were produced at the site.[1]

1. R. Naumann 1977, p. 103, fig. 86.

93 *Fig. 106*

Double Pentagonal Tile with Dragon

Iran, late 13th–early 14th century
Fritware, overglaze painted (*lajvardina*)
15.4 x 24.4 cm (6⅛ x 9⅝ in.)
Keir Collection, England (196)

Tiles of this shape were used on wall surfaces with six-pointed star and hexagonal tiles (see cat. nos. 88–91). Cobalt blue and turquoise were evidently popular color combinations for such decoration. This cobalt blue tile is molded in relief with the long sinuous body of a dragon, its head turned backward, against a background of clouds outlined in red and highlighted with gold.[1] The dragon is outlined in gold, and details of its scaly body are picked out in red and white pigment. This tile is almost identical in shape and motif to cat. no. 91, except that the latter is not overglaze painted.[2] The dragon on both these double pentagonal tiles is very similar to those on frieze tiles of a quite different shape and decorative technique (cat. nos. 100, 101). Such resemblances attest to the widespread use of certain popular designs and even, in some instances, of the same tile molds.

1. Grube 1976, p. 255, no. 196.
2. Masuya 1997, p. 304, suggests that this tile was indeed produced at Takht-i Sulaiman.

94 *Fig. 98*

Frieze Tile

Iran (probably Takht-i Sulaiman), 1270s
Fritware, overglaze painted (*lajvardina*)
52.5 x 44.5 cm (20⅝ x 17½ in.)
Miho Museum, Shigaraki, Japan (SS1480)

As in other frieze tiles of the period, the molded relief decoration here is in three registers: a broad central zone between two narrower bands of unequal width that serve as borders.[1] In the upper register is a file of animals depicted in various states of activity: a running bull, a pacing lion, and a rabbit that has paused to look behind. The lower register is filled by a scrolling leaf vine with six-petaled rosettes. In the central zone is a pair of mounted hunters, one crowned and holding a hawk, the other accompanied by a cheetah seated on his horse's rump. The riders

gallop to the left across a conceptualized landscape of tall, leafy, flowering plants, while a trio of birds flies above their heads.

Tiles evidently made from the same mold but decorated in the luster technique were excavated at Takht-i Sulaiman.[2] Assadullah Souren Melikian-Chirvani has related the central scene to two events described in the *Shahnama* (Book of Kings): Bizhan's hunt in Gurgan, and Bahram Gur's hunt with a hawk and a cheetah.[3] Companion frieze tiles depicting mounted hunters shooting at birds were also excavated at Takht-i Sulaiman and have likewise been associated with the Iranian national epic.[4] Such tiles, along with others inscribed with verses from the *Shahnama* that were excavated at Takht-i Sulaiman (see cat. nos. 80–82), may have been intended to link the founders of this palace with the traditions of Iranian kingship.

1. Miho Museum 1997, pp. 304–5, no. 148.
2. E. Naumann and R. Naumann 1969, fig. 6; R. Naumann and E. Naumann 1976, pp. 51–53. See also Masuya 1997, pp. 506–8.
3. Melikian-Chirvani 1984, pp. 268–69. Gluck 1980, no. 278, also connects this scene to the *Shahnama*, but identifies the two hunters as King Naiman and Bahram.
4. R. Naumann and E. Naumann 1976, pp. 51–53, pl. 8a; Masuya 1997, pp. 505–6. See also Melikian-Chirvani 1984, pp. 269–70.

95 *Fig. 107*

Frieze Tile with Faridun and Two Attendants

Iran (Takht-i Sulaiman), 1270s
Fritware, overglaze luster-painted
28 x 28 cm (11 x 11 in.)
The Walters Art Museum, Baltimore (48.1296)

Faridun is a heroic figure in the Iranian national epic, the *Shahnama*, who is destined to overthrow and succeed the evil ruler, Zahhak (see cat. no. 164). As revealed to Zahhak in a dream, the cause of his downfall would be a youth bearing an ox-headed mace. The scene in the central register of this tile shows Faridun, armed with his ox-headed mace and accompanied by two attendants, perhaps on his way to do battle with Zahhak.[1] Faridun's humpbacked bovine mount is presumably Birmaya, the miraculous cow whose milk had nourished him, although at this point in the narrative sequence Birmaya had in fact already been slain by Zahhak. The pair of Persian couplets inscribed below this scene, in the lowest register of the tile, is from the *Shahnama* but from a part of the text unrelated to the Faridun story.[2]

Whether visual or verbal, imagery from the *Shahnama*, with its emphasis on kingship and legitimacy, was appropriate to a royal residence such as Takht-i Sulaiman, even if the palace's chief occupant—the Ilkhan Abakha (r. 1265–82)—was himself less than familiar with the epic and its

symbolic connotations. Although this tile was not excavated at Takht-i Sulaiman, fragments of a tile produced in the same mold were uncovered at the site.[3]

1. Walters Art Gallery 1936, fig. 2; Giuzal'ian 1949, pl. 4; Simpson 1985, fig. 15.
2. Giuzal'ian 1949, pp. 77–78; also see Simpson 1985, p. 139.
3. The fragments were of a monochrome turquoise glazed tile rather than of one in luster; see R. Naumann and E. Naumann 1976, pp. 51–52; Masuya 1997, pp. 530–31. For another nonexcavated luster tile in Philadelphia, probably from the same mold, see Simpson 1985, fig. 16.

96 *Fig. 109*

Frieze Tile with Elephant and Rider

Iran (probably Takht-i Sulaiman), 1270s
Fritware, overglaze luster-painted
28 x 28.6 cm (11 x 11¼ in.)
Los Angeles County Museum of Art, The Nasli M. Heeramaneck Collection, Gift of Joan Palevsky (M.73.5.222)

Although the specific figural scene was not found at the site, this tile is closely related in size and format to luster frieze tiles excavated at Takht-i Sulaiman[1] and seems likely to have been intended for that complex.[2] As in the frieze tiles specifically associated with Takht-i Sulaiman (cat. nos. 95, 97), the decoration, molded in relief, is in three registers. In the upper border is a tile of three spotted dogs (?). Below, in the main field, is an elephant mounted by a mahout and bearing a passenger seated in a palanquin; two male figures, one walking ahead and the other behind, form an escort. The figural imagery on tiles of this type is often associated with the *Shahnama* (e.g., cat. no. 95) and accompanied by inscriptions quoting from the text. The composition here may have to do with the story of Bahram Gur when he returned from India with his bride.[3] The luster inscription in the lowest register is too fragmentary to be legible.

1. Pal 1973, p. 46, no. 68.
2. See Masuya 1997, pp. 534–44, where an identical tile in The Metropolitan Museum of Art, New York, is noted.
3. Ibid.

97, 98 Two Frieze Tiles

97 *Fig. 108*

Frieze Tile with Bahram Gur and Azada

Iran (Takht-i Sulaiman), ca. 1270–75
Fritware, overglaze luster-painted
31.5 x 32.3 cm (12⅜ x 12¾ in.)
Victoria and Albert Museum, London (1841-1876)

98 *Fig. 50*

Frieze Tile with Two Hunters

Iran (probably Takht-i Sulaiman), ca. 1270–75
Fritware, overglaze luster-painted
27.3 x 33.7 cm (10¾ x 13¼ in.)
The Metropolitan Museum of Art, New York, Gift of George Blumenthal, 1910 (10.9.1)

These two frieze tiles each have a figural subject in the main register, set against very similar densely vegetal backgrounds with birds in flight; in each case the narrow, almost identical border below is divided into small compartments that contain a highly stylized design. Both tiles have molded details accentuated in cobalt blue and turquoise pigment; owing to its volatile nature, the latter has spread in cat. no. 97, creating streaks on the surface of the tile.

Cat. no. 97 features two characters from the *Shahnama* (Book of Kings), Bahram Gur and his favorite harp player, Azada (see cat. nos. 55, 169).[1] They are shown mounted on a camel, with Bahram Gur shooting at a deer while Azada plays her harp. In the upper register of the tile is a row of three running quadrupeds, two gazelles and a sphinx, set against a floral background. Cat. no. 98 shows two horsemen, one approaching from the right and the other from the left, in the act of dispatching the deer trapped between them with their swords.[2] The composition suggests a narrative allusion, but none has yet been identified. The upper register of this tile is missing, but it is likely to have resembled that of cat. no. 97 in showing a sequence of animals.

The only Ilkhanid frieze tiles of known origin with pictorial representations come from Takht-i Sulaiman, and several examples of this type are in various collections.[3] Images or text drawn from the *Shahnama* (see also cat. nos. 80–82, 95), such as the scene of Bahram Gur and Azada, were clearly deemed especially appropriate for this palace complex.

1. O. Watson 1985, pl. L,a.
2. Carboni and Masuya 1993, p. 23, no. 18.
3. See O. Watson 1977, pp. 109–10 and related notes.

99–101 Three Frieze Tiles

Iran (probably Takht-i Sulaiman), ca. 1270s
Fritware, overglaze luster-painted

99 *Figs. 79, 97*

Frieze Tile with Phoenix

37.5 x 36.2 cm (14¾ x 14¼ in.)
The Metropolitan Museum of Art, New York, Rogers Fund, 1912 (12.49.4)

100 *Fig. 100*

Frieze Tile with Dragon

35.7 x 36.5 cm (14 x 14⅜ in.)
Victoria and Albert Museum, London (541-1900)

101 *Fig. 59*

Frieze Tile with Dragon

35.5 x 33.5 cm (14 x 13¼ in.)
The Nasser D. Khalili Collection of Islamic Art, London (POT 790)

These three rectangular frieze tiles share a common decorative scheme.[1] The upper register in each tile shows the same pattern of alternating blossoms and buds within a scrolling vine, and the lower register has a floral scroll with a six-petaled rosette. The central register is occupied in cat. no. 99 by a soaring phoenix with elaborate plumage; and in the other two tiles by an identical open-mouthed dragon, head turned back toward a flaming pearl. The backgrounds of all three tiles are filled with rounded cloud motifs that derive from the form of Chinese lobed clouds sometimes described as fungus-shaped or read as the magical fungus *lingzhi*.[2]

Tiles bearing the same motifs and presumably produced from the same molds, decorated in both the luster and *lajvardina* (e.g., cat. no. 102) techniques, were excavated at Takht-i Sulaiman.[3] The phoenix and the dragon were popular subjects for imperial architectural decoration in China, and their use on tiles, though not traditionally common, became more widespread after the Mongol invasions, appearing on important buildings throughout the empire.[4] It is likely that these associations caused the motifs to be seen as well suited to the decoration of Abaqa Khan's palace in Iran.

1. Cat. no. 99: Carboni and Masuya 1993, cover and p. 24, no. 19. Cat. no. 100: O. Watson 1985, pl. L,b. Cat. no. 101: unpublished.
2. Rawson 1984, p. 139.
3. Masuya 1997, pp. 510–19. For *lajvardina* tiles found at Takht-i Sulaiman, see E. Naumann and R. Naumann 1969, pp. 55–56.
4. Masuya 1997, pp. 573–77.

102 *Fig. 275*

Fragmentary Frieze Tile with Dragon

Iran (Takht-i Sulaiman), 1270s
Fritware, underglaze and overglaze painted (*lajvardina*)
35.6 x 16.8 cm (14 x 6⅝ in.)
Staatliche Museen zu Berlin—Preussischer Kulturbesitz, Museum für Islamische Kunst (I. 4/67, 39)

A number of frieze tiles featuring dragons, evidently made from the same molds and decorated

in both the luster and the *lajvardina* techniques, were excavated at Takht-i Sulaiman.[1] As two fragmentary *lajvardina* tiles were found near the kiln in the potter's workshop, it appears highly likely that the tiles in this technique were produced at the site.[2] The excavated *lajvardina* tiles are the earliest datable instances of this overglaze process, and the range of colors and glazes among them, though not among later *lajvardina* tiles and ceramic vessels (e.g., cat. no. 131), suggests that a certain amount of experimentation with the process may have been undertaken at Takht-i Sulaiman.[3] The brilliant and technically complicated juxtapositions of underglaze and overglaze painted colors, as in this fragmentary cobalt blue dragon modeled in relief against a turquoise background,[4] do not seem to have been repeated elsewhere.

1. See Masuya 1997, pp. 510–14. The majority of extant luster examples were not excavated.
2. Ibid., p. 213.
3. See technical study 2 above.
4. Gierlichs 1993, no. 9.

103–105 Exterior Tiles

Iran (Takht-i Sulaiman), 1270s
High-clay fritware, unglazed and
underglaze painted
Staatliche Museen zu Berlin—Preussischer
Kulturbesitz, Museum für Islamische Kunst

103 *Fig. 95*

Hexagonal Tile with Phoenix

(I. 1988.10)
18.7 x 21.3 cm (7⅜ x 8⅜ in.)

104 *Fig. 94*

Tile Panel

(I. 4/67; I. 6/71a–b)
Overall, unmounted: 94.6 x 64.8 cm
(37¼ x 25½ in.)

105 *Fig. 96*

Hexagonal Tile Panel

(I. 13/69)
Overall, unmounted: 49.5 x 55.9 cm
(19½ x 22 in.)

As a royal summer palace built for the Ilkhanid ruler Abakha (r. 1265–82), the complex at Takht-i Sulaiman would have been lavishly decorated, as is demonstrated by the overglaze painted tiles found in or associated with the interior walls of the palace (see, e.g., cat. nos. 93–101). By contrast, the exterior tiles, which were subjected to the prevailing weather conditions, were fabricated from a thicker, red-

bodied clay that was left unglazed, or decorated in a hardier, underglaze technique, or rendered in a combination of the two. These tiles are nonetheless attractively decorated, frequently with geometric designs, and less commonly with a flying phoenix, as in cat. no. 103.[1] The panel in cat. no. 104 was constructed in the manner of a mosaic, using turquoise-glazed eight-pointed star tiles and larger, squarish tiles indented at one corner and incorporating bands in relief that define blue- and turquoise-glazed geometric motifs. In combination, these tiles form a complex pattern based on an eight-pointed star: four tiles plus one star tile are a single unit.[2] In cat. no. 105, the overall pattern is composed of interlocking hexagonal tiles decorated with interwoven bands in relief defining irregular stars and hexagons, the latter glazed blue and turquoise.[3] Hexagonal tiles with an unglazed dragon or phoenix depicted in relief against a turquoise-glazed ground were probably used in combination with this pattern (e.g., cat. no. 103), as fragments of the two types of tile, geometric and figural, were found together.[4] Here important royal motifs of Chinese inspiration—the dragon and the phoenix—represented among the interior tiles have been carried over to the exterior of the palace,[5] which appears to have been decorated last.

1. Gierlichs 1993, no. 38. For a summary of the different types of exterior tiles from Takht-i Sulaiman, see Masuya 1997, pp. 242–82.
2. *Museum für Islamische Kunst* 1980, pp. 74–75, no. 31. None of these tiles was found in situ; this panel represents a reconstruction. See R. Naumann 1977, p. 93, fig. 77, lower; Masuya 1997, p. 261.
3. Unpublished. Tiles such as these may have been arranged in rows of ten, framed by rectangular border tiles. See Masuya 1997, pp. 251–53.
4. E. Naumann and R. Naumann 1969, p. 58; Masuya 1997, pp. 256–58.
5. On the overall significance of the decorative scheme of the palace, see Tomoko Masuya, chapter 4 above.

106 *Fig. 38*

Two Star Tiles

Iran (Kashan), second half of the 13th century
Fritware, overglaze luster-painted
Diam. each 20.1 cm (7⅞ in.)
The Trustees of the British Museum, London
(OAG 1983.212, 229)

These tiles, one portraying a man, the other a horse, may best be understood as genre scenes rather than representations of a particular story.[1] The horse, depicted with the spots that Kashan potters seem to have been so fond of, is shown with a typical Mongol saddle and saddle-cloth (see cat. nos. 1, 42), while the seated male figure, relaxing with his cup, is clad in a richly decorated robe and owl-plumed headdress

characteristic of the Ilkhanid period. Although he is identifiable as a Mongol by his costume, this figure conforms to standards of beauty that predate the Mongol invasions. The formula of prominent eyebrows, long, narrow eyes, and moon face crowned by thick locks presents an ideal type that evidently suited both the Turkic Seljuqs and their Mongol successors.[2]

1. Porter 1995, p. 33, fig. 17.
2. Ibid., p. 42.

107 *Fig. 2*

Star and Cross Tiles

Iran (Kashan), later 13th century
Fritware, overglaze luster-painted
Diam. each 20.1 cm (7⅞ in.)
The Trustees of the British Museum, London
(OAG 1983.230, 231, 232 a & b)

Decorated in the overglaze technique known as luster painting, alternating star and cross tiles served as a sparkling, ornamental skin covering the mundane brick interiors of secular and religious structures in Iran, beginning around 1200.[1] Output at the kilns of Kashan, the main center for the manufacture of tiles, was slowed but not stopped by the Mongol invasions of the early thirteenth century. Large-scale production resumed in the 1260s, the period to which these star and cross tiles probably belong.[2] In fact, these tiles are believed to have formed part of a larger group that once decorated the interior of a Shiʿite shrine, the Imamzada Jaʿfar, in Damghan, dated 1267.[3] Like the luster star and cross tiles known to have come from Damghan, these examples are decorated with the lively spotted animals typically associated with Kashan (here hares, cheetahs, foxes, and hounds [?]) and with Persian verses inscribed around the borders of the stars. These verses suggest that the tiles were perhaps not originally intended for a religious monument.

Rendered in *naskh* script, the poetic inscriptions are from the *Shahnama*,[4] the national epic that recounts the tales of the kings of ancient Iran and was regarded as a book on secular authority. As such, quotations from this text were considered appropriate for the decoration of a palace. Hence it seems likely these tiles were originally intended to adorn a royal residence but were instead used or reused in the shrine at Damghan.[5]

1. O. Watson 1985, p. 123.
2. Godman 1901, pl. XIXA; A. U. Pope and Ackerman 1938–77, pl. 723A, B; *Arts of Islam* 1976, p. 258, no. 384; O. Watson 1985, pp. 131–34; Porter 1995, pp. 36–37, fig. 21.
3. *Arts of Islam* 1976, p. 258; Porter 1995, p. 36.
4. Ghouchani 1992, pp. 38–40; Porter 1995, p. 36.

5. Excerpts from the *Shahnama* were part of a traditional decorative program for palace architecture in Iran; see Masuya 1997, pp. 611–12. While "love" poetry inscribed on tiles may have been acceptable in the planned decoration of religious monuments of this period on account of its Sufi undertones (see Porter 1995, p. 36), the intentional use of *Shahnama* verses seems unlikely in this context. For other instances in which evidently secular tiles, probably from the palace complex at Takht-i Sulaiman, were reused in a religious monument, see Masuya 2000, pp. 49–50.

108–110 Three Star Tiles

Iran (Kashan)
Fritware, overglaze luster-painted
Diam. each approx. 21 cm (8¼ in.)
The David Collection, Copenhagen

108 *Fig. 113*

Star Tile with Bull

(13/1963)
A.H. 689/A.D. 1290–91

109 *Fig. 114*

Star Tile with Elephants

(14/1963)
A.H. 689/A.D. 1290–91

110 *Fig. 115*

Star Tile with Horse

(12/1963)
A.H. Muharram 689/A.D. January 14–February 13, 1290

Kashan, located about 150 miles south of Tehran, was the main center for ceramic production in Iran, both before and after the Mongol invasions. Among the best-known and most numerous products from the Kashan kilns are lusterwares, including tile revetment (see cat. no. 126 for a luster tile specifically related by its inscription to Kashan).[1] Luster star tiles were produced for both secular and religious edifices. While it is generally held that tiles with figural decoration were made only for secular buildings such as palaces, they were evidently reused in religious monuments.[2] This trio of tiles belongs to a comparatively large group bearing dated inscriptions from the 680s A.H., which has not as yet been associated with a specific building.[3] There are a number of such extant star tiles decorated with lively, sometimes humorously depicted animals and birds set in a landscape (see also cat. nos. 112, 117, 118). As is typical of the Kashan style, the animals here are spotted, regardless of their natural appearance. All four of them seem to be moving within and beyond their pictorial space. The three tiles can be compared to illustrations from the slightly later manuscript of the *Manafiᶜ-i hayavan* (cat. no. 2); this is especially true of cat. no. 109, with its caparisoned elephants.[4]

Figural tiles are often accompanied by inscribed borders quoting lines from seemingly unrelated Persian poetry. Here, for example, cat. nos. 109 and 110 respectively are framed by the following verses, in each case with the date of the tile added:

> Oh you for whose love all those satiated
> ones are hungry
> [For whom] all the brave ones are afraid of
> separation from you
> [With eyes like yours the deer have
> nothing to offer]
> Oh you whose hair ties the feet of the
> lion-like heroes.[5]

> Do you know, Oh my admired one, why
> My two oppressed eyes are full of tears
> [My eyes] draw forth from the desire
> of your lips
> Water from the mouth of my pupils.[6]

So popular was the second of these verses that it was much repeated as an inscription on tiles and other ceramics (see cat. nos. 111, 117, 118, 128).[7]

1. For the history of the luster industry in Kashan, see O. Watson 1985.
2. See Masuya 2000, esp. pp. 49–50.
3. Folsach 1990, no. 144; Folsach 2001, no. 210 (cat. nos. 108, 109). For a list of dated tiles from the 680s A.H., see O. Watson 1985, pp. 192–93.
4. See Ettinghausen 1962, illus. p. 134.
5. Read and translated in 1999 by Manijeh Bayani, who interprets the date as 681/1282–83. The inscriptions on cat. no. 108 have not as yet been deciphered.
6. This verse is by Shaikh Majd al-Din al-Baghdadi (d. 1209 or 1219–20); see Ghouchani 1992, p. 75. Ghouchani notes, however, that some sources ascribe it to Razi al-Din Nishaburi (d. 1201–2). The reading here follows, with some variation, that of O. Watson 1985, p. 152. On Shaikh Majd al-Din, see Browne 1928, vol. 2, pp. 494–95.
7. On its popularity, see O. Watson 1985, pp. 151–52. It may be that the tilemakers made use of the poetry they were most familiar with rather than that most relevant to the decoration or context of the tiles; see Ghouchani 1992, pp. 20ff.

111 *Fig. 40*

Star Tile with Seated Man

Iran (Kashan), A.H. 689/A.D. 1290–91
Fritware, overglaze luster-painted
Diam. 20.3 cm (8 in.)
Private collection

Two boys peer down from the left and right spandrels of this star tile at a solitary man in Mongol costume seated before a tent.[1] Although it is not uncommon for an image and an inscription to bear no relation to one another (see, e.g., cat. nos. 109, 110), the isolation of the central figure here is in keeping with the mood of the verse inscribed in the border of the tile, beginning in the upper right point:

> Do you know, Oh my admired one, why
> My two oppressed eyes are full of tears
> [My eyes] draw forth from the desire
> of your lips
> Water from the mouth of my pupils.

The agonies of love were a popular literary theme, and this quatrain by Shaikh Majd al-Din al-Baghdadi is one of the most frequent examples of the genre to be found on tiles and other ceramics (see cat. nos. 110, 117, 118, 128).[2] An often-quoted couplet by the tenth-century poet Daqiqi is inscribed on the right side of the star: "May your fate be in accordance with your wishes. May the Lord be your guardian," followed by the date.[3]

1. Unpublished.
2. On the identification of the poet and the popularity of this verse, see cat. nos. 108–10, notes 6, 7.
3. The couplet by Daqiqi was identified by Melikian-Chirvani 1982, p. 141; see also p. 139, where the same variant as on this tile is noted on two examples of fifteenth-century metalwork. For a very similarly decorated tile, also dated 1290, see Folsach 2001, p. 210, lower left, where horses are substituted for the male attendants in the spandrels.

112, 113 Star and Cross Tiles

112 *Fig. 120*

Star Tiles with Phoenixes

Iran, late 13th–early 14th century
Fritware, underglaze and overglaze luster-painted
Diam. each 20.3 cm (8 in.)
Victoria and Albert Museum, London
(1893+a-1897)

113 *Fig. 120*

Cross Tiles

Iran, late 13th–early 14th century
Fritware, underglaze painted
Each 21.2 x 21 cm (8⅜ x 8¼ in.)
Victoria and Albert Museum, London (546-1900)

The eight-pointed star tiles (cat. no. 112) each show a luster-painted, molded relief pattern of a phoenix in flight amid foliage in the center with an inscription from the Koran around the border.[1] The inscription appears in white against a blue background; the cobalt blue pigment is somewhat volatile and tends to run, and the letters are outlined in luster paint so that they remain clearly legible. Koranic inscriptions are unusual on this type of tile when it is decorated with bird or animal motifs, and appear more frequently on similar tiles with floral decoration.

The cross tiles (cat. no. 113) have a vegetal pattern in molded relief and are covered with a turquoise glaze.[2] Star and cross tiles were frequently combined in an alternating arrangement for dado panels or to cover tomb structures.

1. O. Watson 1985, pp. 122, 142, 146, pl. M.
2. See, e.g., O. Watson 1977, p. 86; Carboni and Masuya 1993, p. 29, no. 24.

114, 115 Frieze Tiles from Natanz

114 *Fig. 149*

Iran (Kashan), A.H. [Shawwa]l 707 / A.D. March–April 1308
Fritware, overglaze luster-painted
38.1 x 38.1 cm (15 x 15 in.)
The Metropolitan Museum of Art, New York,
Gift of Emile Rey, 1912 (12.44)

115 *Fig. 150*

Iran (Kashan), ca. 1308
Fritware, overglaze luster-painted
35.8 x 36.8 cm (14⅛ x 14½ in.)
The Trustees of the British Museum, London
(OA 1122)

At Natanz in central Iran, the grave of ʿAbd al-Samad (d. 1299), a leading Suhravardi shaikh, was transformed into a major shrine complex by one of his disciples, Zain al-Din Mastari (d. 1312), a lieutenant of Saʿd al-Din Sivaji, chief vizier under Sultan Öljeitü.[1] Such monuments attest to the growing popularity and legitimization of Sufi, or mystical, orders in the Ilkhanid period.

The interior of the tomb was once richly adorned with luster tiles: a wall dado of star and cross tiles surmounted by a frieze.[2] Some twenty components of the frieze survive, these two tiles among them.[3] In each the main register carries part of an inscription in molded relief against a painted background of dense foliage inhabited by birds. In cat. no. 114 this inscription gives the last part of the date "[Shawwa]l 707," or March–April 1308; in cat. no. 115 the inscription quotes from the Koran, sura 76, verse 9. The upper border of the tiles is a band of paired birds against a vegetal background. The narrow lower border is divided into square compartments with an abstract design.

The heads of the birds on both tiles, as on all the other surviving tiles of the frieze, have been chipped off, presumably by iconoclasts who believed that representational imagery had no place in a religious context. The presence of birds as part of the design may have been an allusion to the popular tradition that "the souls of martyrs are like green birds who will eat the fruits of paradise."[4]

Like most of the extant tiles from Natanz, the frieze tiles were removed from the shrine complex in the later nineteenth century.[5]

1. Blair 1986a, pp. 5–7.
2. Ibid., pp. 50, 64, pl. 47.
3. Cat. no. 114: Carboni and Masuya 1993, p. 25, no. 20. Cat. no. 115: Porter 1995, p. 36, fig. 44.
4. Blair 1986a, p. 21, where the verse is cited.
5. See Masuya 2000.

116 *Fig. 237*

Tile Panel

Hasan ibn ʿAli ibn Ahmad Babavaih
Iran (Kashan), early 14th century (probably 1310)
Fritware, overglaze luster-painted
123.2 x 59.7 cm (48½ x 23½ in.)
The Metropolitan Museum of Art, New York,
Rogers Fund, 1909 (09.87)

This set of three molded luster tiles comes from the tomb of ʿAbd al-Samad in Natanz (see also cat. nos. 114, 115).[1] The tiles form a panel representing a mihrab (or niche indicating the direction of prayer) composed of colonnettes supporting a trilobed arch from which hangs a mosque lamp. The end of Koran verse 2:136 ("And God will suffice you against them and He is the Listener, the Omniscient") forms the arch itself and fills part of the archway. The arch is made from the compound word FASAYAKFIKAHUM ("And He will suffice you against them").[2] Another verse, Koran 2:255, frames the arch and fills the space between the colonnettes.[3]

An inscription in the spandrels identifies the panel as the work of Hasan ibn ʿAli ibn Ahmad Babavaih, a tile maker from Kashan, who was responsible for the decoration of the interior of the tomb at Natanz.[4] The outermost band of inscription includes short passages from Koran suras 1, 97, 100, and 112–14; the date, most likely Shawwal [70]3 (March 1310); and the signature of the scribe who "wrote" the inscriptions: ʿAli ibn Muhammad ibn Fadl Allah.[5]

1. O. Watson 1985, pp. 122, 142, 180, pl. 126; Blair 1986a, pl. 54; Blair 1986b, fig. 1; M. Jenkins 1983b, p. 28, fig. 29.
2. M. Jenkins 1983b, p. 28.
3. Blair 1986a, p. 65.
4. Ibid., p. 35.
5. Blair 1986b, p. 394. This dating is further supported by the panel's similarity to a mihrab in the Gulbenkian Foundation, Lisbon, dated 710 (1310), as noted by M. Jenkins 1983b, p. 28.

117 *Fig. 116*

Star Tile with Horse

Iran, A.H. 710 / A.D. 1310–11
Fritware, overglaze luster-painted
Diam. 19.6 cm (7¾ in.)
Museum of Fine Arts, Boston, Maria Antoinette

Evans Fund and Gift of Edward Jackson Holmes (31.729)

The study and identification of the Persian verses inscribed on Iranian ceramics are still in an early stage.[1] It is often unclear if and how the choice of a particular verse was related to the subject matter of the decoration. The repetition of certain verses, regardless of the context, may indicate that some poetry had a particular significance for those who used or viewed the object on which it was inscribed.

There is, for example, no apparent connection between the horse on this star tile and the verse invoking the woes of love that is inscribed along the border.[2] The verse, by the poet Shaikh Majd al-Din al-Baghdadi, is found on other ceramics of the thirteenth and fourteenth centuries.[3] Indeed, it appears here on another star tile depicting a spotted horse (cat. no. 110), two other star tiles (cat. nos. 111, 118), and a luster dish (cat. no. 128).

It has been suggested that the presence of the Persian script may have been more important in itself than what is actually said.[4] Perhaps the potters copied and recopied verses from a single source if none was specified by the patron. This is an issue, however, that deserves further attention.

1. See, e.g., Ghouchani 1992.
2. Ettinghausen 1936a, p. 226, fig. 9; Welch 1979, pp. 120–22, pl. 45; O. Watson 1985, p. 140, pl. 119.
3. For the text of the inscription, see cat. nos. 110, 111. For the identification of the poet and the popularity of this verse, see cat. nos. 108–10, notes 6, 7.
4. Welch 1979, p. 122.

118 *Fig. 117*

Star Tile with Camel

Iran, early 14th century
Fritware, overglaze luster-painted
Diam. 20.5 cm (8⅛ in.)
Museum of Fine Arts, Boston, Gift of the Estate of Mrs. Martin Brimmer (06.1896)

A camel wearing a saddlecloth and bridle stands as though waiting either for its rider or for the cargo that it will carry on a journey.[1] While it is common for images on tiles to appear to be unrelated to the inscriptions that frame them, this figure of a camel ready to embark is suggestive of one of the verses inscribed along the tile's border:

> When my friend to journey intends,
> For me all happiness of heart ends.
> My heart said in envy that the soul could
> In excitement escape.[2]

The rest of the inscription repeats a verse by Shaikh Majd al-Din al-Baghdadi frequently

found on tiles and other ceramics (see cat. nos. 110, 111, 117, 128).[3]

1. Welch 1979, p. 122, pl. 46.
2. This is followed by a fragment: "now all thou hast"; ibid.
3. For the verse, see cat. nos. 110, 111. On the poet and the popularity of this verse, see cat. nos. 108–110, notes 6, 7.

119, 120 Pair of Tiles from the Shrine of the Footprint of ʿAli

Iran, A.H. 711/A.D. 1311–12
Fritware, overglaze luster-painted
Musée National de Céramique, Sèvres

119 *Fig. 55*

Tile with Imprint of Camel's Hoof

(MNC 26903)
Diam. 32.8 cm (12⅞ in.)

120 *Fig. 56*

Tile with Imprint of Horse's Hoof

(MNC 22688)
Diam. 28.5 cm (11¼ in.)

The two tiles function like facing pages of an open book.[1] Together they served as foundation plaques for the Shrine of the Footprint of ʿAli, a commemorative structure northwest of the city of Kashan, where they were presumably made. Like an illustrated book the tiles convey in words and image the story of how the shrine was founded.

In summary, the Persian text recounts that on 1 Shawwal 711 (Thursday, February 10, 1312) a certain Sayyid Fakhr al-Din Hasan Tabari dreamed that he was in a garden beyond one of Kashan's gateways. A large number of people were gathered around a tent, in front of which were a horse, a camel, and a lance between them. Invited into the tent by a young man, the sayyid found himself in the presence of ʿAli, the Prophet's son-in-law and the first imam recognized by Shiʿite Muslims. ʿAli indicated that he and the young man who had issued the invitation—the Mahdi, or twelfth and final imam—were going to India to convert the nonbelievers. For those who could not travel to India to see him, ʿAli suggested a shrine be built on that spot as an alternate site of pilgrimage. When the sayyid awoke, he went to the garden and marked the place where he had seen the imam and marked as well the hoofprints of the horse and camel. The imam appeared to several pious individuals and asked them to convey to a certain Haidar Faris that he should build a mosque there, which Haidar Faris undertook that very day.[2]

Each of these unique tiles bears the form of the hoofprint of the camel and horse respectively, the sayyid's tangible proof of the reality of his dream. Along with the shrine itself, the tiles attest to the prevalence of Shiʿite practice in the region of Kashan and the increasing reverence for ʿAli among Sunnis in the Ilkhanid period.[3]

1. Adle 1972, pp. 277–97, pl. 1 (insert); O. Watson 1975a, pp. 69–70; Adle 1982, pp. 199–218, pl. 76; Alexander 1996, vol. 2, pp. 178–79.
2. For the full text, see Adle 1972, pp. 283–85; for an English translation, see Alexander 1996, vol. 2, p. 178. A summary is also given by O. Watson 1985, p. 146.
3. Adle 1972, p. 293.

121, 122 Tiles from Öljeitü's Mausoleum

121 *Fig. 143*

Section of a Tile Frieze

Iran (Sultaniyya), 1307–13
Earthenware, glazed, cut and assembled as a mosaic
18.1 x 27.6 cm (7⅛ x 10⅞ in.)
Los Angeles County Museum of Art, The Madina Collection of Islamic Art, Gift of Camilla Chandler Frost (M.2002.1.344)

122 *Fig. 144*

Quadrangular Tile

Iran (Sultaniyya), 1307–13
Earthenware, underglaze painted
8.6 x 11.4 cm (3⅜ x 4½ in.)
Private collection

Of the four principal capitals of the Ilkhanids—Maragha, Tabriz, Sultaniyya, and Baghdad—only Sultaniyya retains a major royal monument, in this case the greatest extant building of the period, the mausoleum of Öljeitü. Sultan Öljeitü (r. 1304–16) transferred his capital to this former summer residence, known as Sultaniyya, or "Imperial," where he built an extensive complex around his own tomb. The mausoleum is the only part of this complex that survives. It takes the form of an enormous octagon with a rectangular chamber on the south side. Both exterior and interior were once extensively decorated. The interior decoration, comprising a wide variety of designs rendered in brick, carved stucco, and tile, was completed in 1313, the year that the building was dedicated.[1] The interior was then entirely covered with painted plaster sometime between 1313 and 1316, when Öljeitü died.

These two tiles belong to the initial phase of decoration, reflecting its predominant color scheme of cobalt blue and turquoise, often on a white ground.[2] Elements of the mosaic frieze are still in situ in the lower section of the

southern rectangular chamber, while the lotus-blossom motif used in cat. no. 122 is found on other tiles from the mausoleum.[3]

1. On the Phase I interior decoration at Sultaniyya, see Sims 1988, pp. 143–50.
2. Unpublished.
3. See Pickett 1997, fig. 48 (for cat. no. 121), fig. 45 (for cat. no. 122).

123 *Fig. 118*

Star Tile with Two Men Fighting

Iran (Kashan), early 14th century
Fritware, overglaze luster-painted
Diam. 20.5 cm (8⅛ in.)
The Walters Art Museum, Baltimore
(48.1288)

The inscription on a tile often has little obvious connection to the image that decorates it. Such is apparently the case here.[1] The inscription, quoting from a passage in the *Shahnama* having to do with the hero Rustam's preparations for the hunt, accompanies an unusual scene of two men brawling.[2] The combatants are poised in perfect equilibrium as one grabs for the beard of the other, who in turn swings a club as he grasps his antagonist's hair. The depiction of this somewhat undignified duo may relate to a particular event or illustrate a story with special meaning for a medieval audience. The scene is remarkable not only for its level of realism but also because it is shown on a star tile, whose eight-pointed shape the composition perfectly echoes.

1. Guest and Ettinghausen 1961, fig. 72; Welch 1979, pp. 118–19, no. 44; O. Watson 1985, pl. 123.
2. On the inscriptions, see O. Watson 1985, p. 146. See also Welch 1979, p. 118, where the inscription is translated; Welch suggests that the scene on the tile alludes the hand-to-hand fight to the death that occurs later in the story of Rustam. For another tile, also in Baltimore, depicting two wrestlers, see Guest and Ettinghausen 1961, fig. 71.

124 *Fig. 151*

Mihrab Tile

Attributed to ʿAli ibn Ahmad ibn ʿAli Abi al-Husain
Iran (Kashan), early 14th century
Fritware, overglaze luster-painted
62 x 42 cm (24⅜ x 16½ in.)
Victoria and Albert Museum, London
(C1977-1910)

Single-tile mihrabs are among the largest objects created by the luster potters of Kashan. Although none remains in situ—meaning that their function as directional niches set into the qibla wall cannot be established with certainty[1]—it is likely that they were used in sets of two, since two pairs survive that have very similar dimensions and

decorative programs. The present tile is one of a pair now in the Victoria and Albert Museum, London.[2] Date and patron are not identified in either case, and only the other tile is signed by the artist ʿAli ibn Ahmad ibn ʿAli Abi al-Husain, presumed to be the maker of the pair.[3]

A total of fourteen single-tile mihrabs has been recorded, five of which are dated from 668 (1269–70) to 707 (1307–08).[4] Single-tile mihrabs are true miniature versions of multiple-tile niches, containing some or all of the same elements: the outer calligraphic frieze, the arch resting on two slender columns, the hanging lamp, a rich vegetal background, and omnipresent Koranic inscriptions. Here the text, copied in cursive script, is almost entirely from the Koran (sura 112 along the outer border and sura 2, verse 255, inside the arch).

1. O. Watson 1985, p. 149, suggests that they might have been used as tombstones set on either side, or at either end, of a cenotaph.
2. A. U. Pope and Ackerman 1938–77, pl. 1726A; Lane 1960, p. 4, pl. 1a; O. Watson 1985, pl. N.
3. Acc. no. 1527-1876; see *Arts of Islam* 1976, p. 254, no. 375; O. Watson 1985, p. 147, pl. 125. The other pair, which unlike the Victoria and Albert set has identical inscriptions, is split between the Musée des Arts Décoratifs, Paris (7643a), and the Gulbenkian Foundation, Lisbon.
4. O. Watson 1977, p. 120.

125
Fig. 152

Tile from a Mihrab

Iran, A.H. 722/A.D. 1322–23
Fritware, underglaze painted
69.5 x 66 cm (27⅜ x 26 in.)
The Metropolitan Museum of Art, New York, Gift of William Mandel, 1983 (1983.345)

This large tile,[1] fired in a single piece, most likely represents the top of a tall, slender, three-tile mihrab similar to the complete luster-painted niche (cat. no. 116), also in the Metropolitan Museum. The best parallel is provided by a damaged, underglaze-painted mihrab in the Museum of Islamic Art, Cairo, which is made up of three large tiles of slightly smaller dimensions.[2] Underglaze-painted niches—the so-called Sultanabad type of pottery (see cat. nos. 133–135)—are much less common than luster-painted examples (e.g., cat. no. 124) in the Ilkhanid period.

A peculiarity of this tile is that the pointed arch actually forms the upper frame of the mihrab, making it a pentagonal object, instead of being contained within a rectangular tile (as in cat. no. 116). Closely following stucco and stone models, the decoration is calligraphic on the outer band, whereas the inner field is filled with vegetal patterns. As in the Cairo mihrab, the central tile would probably have been more elaborate with recessed niches. The inscription is from the Koran, 11:114: "In the name of Allah, the

Merciful, the Compassionate. Keep up prayer in the two parts of the day and in the first hours of the night. Surely good deeds take away evil deeds. This is a reminder to the mindful." This verse is followed by the year 722 written in Arabic numerals (January 20, 1322–January 10, 1323).

1. Schimmel 1992, pp. 29–30, fig. 29; Carboni and Masuya 1993, p. 30, no. 25.
2. Approximately 54 x 63 cm (21¼ x 24¾ in.), with a total height of 160 cm (63 in.). See Wiet 1933, pp. 134–35, no. 719, pl. H. The mihrab is dated 719/1319–20 and was ordered by a certain ʿAli ibn Abi Talib ibn Abi Nasr.

126
Fig. 119

Star Tile with Seated Man and Attendant

Iran (Kashan), A.H. 739/A.D. 1338–39
Fritware, overglaze luster-painted
Diam. 21.5 cm (8½ in.)
The Trustees of the British Museum, London (OA + 1123)

This eight-pointed star tile is important evidence for the continuity of luster pottery production at Kashan well into the fourteenth century.[1] The inscription along the border of the star contains verses of a love poem (not fully deciphered), the date 739 written out, and the words "In the place Kashan. May God the exalted protect it from the accidents of time."[2] Two figures clad in typical Mongol garb are depicted on the star: one stands holding a flask; the other is seated and appears to be on the verge of enjoying the fruit set before him in a tripod vessel. The heads of two servants peek out from the corner spandrels.

A number of features link this tile to Kashan workmanship of the thirteenth and early fourteenth centuries: the minute, delicately drawn design in which no space is left undecorated, the plump, haloed bird in flight (in the upper center), and the dense background pattern of dots and commas.[3] It comes at the end of the long history of luster tile production in medieval Kashan, making the prayer inscribed on it seem all the more poignant.

1. Ettinghausen 1936, fig. 15; *Arts of Islam* 1976, p. 257, no. 383; O. Watson 1985, pl. 122; Porter 1995, fig. 35.
2. The inscriptions are partly in Persian, partly in Arabic. The base of the star contains the beginnings of a verse from the *Shahnama* and is apparently a replacement of the original tile where this was broken. See Ettinghausen 1936, p. 59. Porter 1995, p. 45, closely follows Ettinghausen's reading.
3. O. Watson 1985, p. 142; see also p. 196.

127
Fig. 28

Square Tile

Golden Horde (Southern Russia, New Saray),
14th century

Fritware, underglaze painted
24.7 x 24.7 cm (9¾ x 9¾ in.)
State Hermitage Museum, Saint Petersburg (GE SAR-1491)

This isolated, intact find demonstrates that buildings in the second Golden Horde capital of New Saray (Saray al-Jadid) were decorated with tile panels following models that were widespread in Ilkhanid Iran.[1] Confirming this influence is the Persian text that frames the outer border of the tile, copied in a hurried *naskh* script and thus far not translated. The tile has, however, no close parallels either in shape (small tiles in Iran were usually star- or cross-shaped) or in design and color. The concentric pattern—a decorated square, with dense, stylized leaf designs, inside an undecorated band—and the use of cobalt blue as the only color against the white slip of the ceramic body represent a distinctive taste that seems to have been specific to the Golden Horde potters of the fourteenth century. The colorless glaze has now turned brownish, but the original contrast of blue and white must have been a striking one.

1. Basilov 1989, p. 80.

128
Fig. 3

Luster-Painted Dish

Iran (Kashan), A.H. 667/A.D. 1268–69
Fritware, overglaze luster-painted
Diam. 28.5 cm (11¼ in.)
The David Collection, Copenhagen (Isl. 95)

Although the Mongol invasions disrupted the production of luster-painted tiles and pottery in Iran, they did not extinguish this important industry. There is ample testimony to the resumption of luster tile production on a grand scale in the 1260s and 1270s, for the decorative revetment of religious edifices and of palatine monuments such as Takht-i Sulaiman (e.g., cat. nos. 79–82).[1] The production of luster-painted pottery also resumed but not at the same level as in the pre-Mongol period. New shapes were introduced, probably under the influence of imported Chinese wares, as is evident from this imposing dish with a strongly articulated rim.[2] The decoration skillfully combines medieval Islamic and Far Eastern elements. For instance, the compartmentalization of the decoration within a geometric pattern is frequently found on earlier and contemporaneous Iranian metalwork,[3] while the floral motifs of plump blossoms and buds have been related to the Chinese rendition of the prunus—a flowering tree with six-petaled blossoms.[4] The exterior of the rim is inscribed with Persian poetry that has not been fully deciphered,[5] followed by the date.

1. For a star-and-cross tile panel from the Imamzada Jaʿfar, in Damghan, now in the Musée du Louvre, Paris,

dated 1266–67, see O. Watson 1985, pl. 110.

2. O. Watson 1985, pl. 89a, b; Folsach 1990, no. 146; Soucek 1999, fig. 4; Folsach 2001, no. 212.

3. See, e.g., Melikian-Chirvani 1982, p. 63, fig. 26, for a twelfth-century basin, and pp. 207–9, for an Ilkhanid tray.

4. See Soucek 1999, pp. 134–35. Similarly articulated floral designs also occur on luster tiles excavated at Takht-i Sulaiman; see, e.g., Ghouchani 1992, nos. 59, 66.

5. The first quatrain is one previously noted; see Ghouchani 1992, p. 20. For the translation, see cat. nos. 110, 111. On the poet and the popularity of this verse, see cat. nos. 108–10, notes 6, 7.

129 Fig. 212

Jar with Molded Decoration

Iran, A.H. 681/A.D. 1282–83
Fritware, monochrome glaze
H. 54.6 cm (21 ½ in.)
The Metropolitan Museum of Art, New York, H. O. Havemeyer Collection, Bequest of Horace Havemeyer, 1956 (56.185.3)

Even if this handsome jar did not carry an inscription dating it, its decoration clearly belongs to the period of Mongol rule in Iran, while the Persian verse that it carries seems to suit the uncertainty of the times as well.[1] The vessel is circumscribed by a large central register filled with a dense, lush landscape inhabited by antelope, rabbits, and other animals; on the neck is a narrow band of geese or swans in flight amid tall, leafy plants. While decorative bands of animals predate the Ilkhanid period in Iran, the greater naturalism with which the animals move and the detailed landscape settings are new. Closely related bands of animals are used as subsidiary decoration on frieze tiles from Takht-i Sulaiman (e.g., cat. nos. 94–98) and on silk tapestries ascribed to Central Asia.[2] The motif of birds in flight among foliage is also found on earlier Chinese silk tapestries and silk and gold brocades.[3] Imported textiles perhaps served to introduce these motifs to Ilkhanid Iran. The band of paneling around the base of the jar can be related to the lotus-petal molding common on certain Chinese wares, including celadons.[4]

The inscription on the shoulder of the vessel reads in translation: "Tumultuous air and boiling earth. / Joyous is he whose heart is happy. Drink!"[5]

1. Frelinghuysen 1993, pp. 108, 109, pl. 99; M. Jenkins 2000, p. 85, fig. 17.

2. For the silk tapestries, see Watt and Wardwell 1997, pp. 66–68, 80–82, nos. 14, 19.

3. Ibid., pp. 82–84 and pp. 112–13 respectively.

4. See Allan 1991, pp. 34–35. For a similarly decorated cobalt blue jar, dated 683/1284–85 (Freer Gallery, Washington, D.C.), see Atil 1973, pp. 168–69, no. 77, where it is suggested that the two jars came from the same workshop. Certain large, mold-made celadons of the Yuan dynasty, datable to the fourteenth century, incorporate similar designs such as a bird flying amid dense foliage, representing the shared decorative

vocabulary of the Mongol era; see, e.g., Medley 1974, p. 75, fig. 69.

5. The date, 681, is given in cipher. We are grateful to Mina Eghbal for her help with this translation, which differs significantly from that in Frelinghuysen 1993.

130 Fig. 239

Plate with Fishes

Iran, late 13th–early 14th century
Fritware, overglaze painted (lajvardina)
H. 6.8 cm (2 ⅝ in.); diam. 35.7 cm (14 in.)
Musée du Louvre, Paris (6456)

A large, handsome plate such as this should be viewed as a luxury item not only on account of its size and aesthetic appeal but also because its elaborate decoration required at least two firings.[1] The turquoise was applied and fired first; then the white and black were applied, as well as the gold leaf, and the dish was fired a second time. The overglaze painting technique known as lajvardina (after the Persian word lajvard, meaning lapis lazuli), was probably an offshoot of the so-called mina'i wares developed in the late twelfth century, which seem to have ceased production with the Mongol invasions.

The outermost band of pseudocalligraphy, punctuated by four relief medallions bearing rosettes, and the inner inscriptional frieze, presenting a series of good wishes in Arabic, are derived from the general repertoire of medieval Islamic art. As is typical of Ilkhanid art, however, Islamic motifs well known in the Iranian world are here combined with designs introduced from China, such as the radiating petal pattern in the second band from the outside and the central motif with fishes, which may have been inspired by imported celadons.[2] For another Ilkhanid ceramic vessel, this one with three fishes circling the interior, that clearly imitates Chinese celadon ware, see cat. no. 132.

1. Arts of Islam 1976, p. 253, no. 372, for the inscriptions; Arabesques et jardins de paradis 1989, p. 114, no. 87.

2. For a brief discussion of the fish motif in Chinese art, see Rawson 1984, pp. 114–17. On this type of decoration in Islamic metalwork, where it has been referred to as a "fishpond" motif, see Baer 1968; Baer 1983, pp. 279–82.

131 Fig. 241

Storage Jar (Albarello)

Iran, late 13th–14th century
Fritware, overglaze painted (lajvardina)
H. with cover 37.5 cm (14 ¾ in.)
The Metropolitan Museum of Art, New York, Henry G. Leberthon Collection, Gift of Mr. and Mrs. A. Wallace Chauncey, 1957 (57.61.12a, b)

This type of storage jar with concave sides, which allow it to be more easily handled when ranged

with a number of similarly shaped jars, is known in the West as an albarello, reflecting its use in Italy from the fifteenth century onward. The shape, however, was originally an import from the Islamic world, where such ceramic vessels were produced over a wide area, including Spain, Egypt and Syria, and Iran. This albarello, which is exceptional in still having its lid, is decorated in lajvardina, the opulent overglaze painting technique that was practiced only in Ilkhanid Iran.[1] Its ornament, an allover design of golden quatrefoils enclosed by lobed medallions, is somewhat reminiscent of the patterning of the silk and gold textiles that were so highly prized by the Mongols.[2]

For an Ilkhanid albarello of the so-called Sultanabad type, see cat. no. 135.

1. M. Jenkins 1983b, pp. 26–27, no. 28.

2. For a relevant thirteenth-to-fourteenth-century silk and gold tabby weave attributed to Central Asia, see Watt and Wardwell 1997, pp. 160–61, no. 46.

132 Fig. 238

Bowl with Three Fishes

Iran, first half of the 14th century
Fritware, monochrome glazed
H. 12.8 cm (5 in.); diam. 25.7 cm (10 ⅛ in.)
The Metropolitan Museum of Art, New York, H. O. Havemeyer Collection, Gift of Mrs. Horace Havemeyer, in memory of her husband, Horace Havemeyer, 1959 (59.60)

One of the clearest examples of direct Chinese influence on the Islamic arts of the Ilkhanid period is a virtually straightforward imitation of celadon wares produced from the Song period (960–1279) through the Yuan. The typical green glaze, a color otherwise seldom employed by Iranian potters, was imitated with varying degrees of success, the present bowl being one of the more outstanding.[1] In a dynamic composition three fish with curved bodies are shown swimming in a circle, their heads pointing to the center of the bowl as if they were about to be swallowed up by the vortex in the middle. A parallel in shape and decoration among Chinese models is a bowl in the Metropolitan Museum with two fish in applied relief on the inside, which was created in the kilns of Lung Ch'uan in the Song period.[2] The fish, an almost universal symbol of good omen, was used as a decorative motif on drinking vessels and water containers in western Asia before the advent of the Ilkhanids and became especially popular on Syrian gilded and enameled glass of the thirteenth century.[3]

1. M. Jenkins 1983b, pp. 28–29, no. 31; Islamic World 1987, pp. 74–75, no. 54. Another example of Iranian "celadon" is in the Victoria and Albert Museum, London; see Lane 1957, pl. 86.

2. Acc. no. 34.113.8.

3. See, e.g., Orient de Saladin 2001, pp. 189, 192, nos. 198, 205.

133, 134 Bowls with Phoenixes

Iran, 14th century
Fritware, underglaze painted

133 *Fig. 242*

Bowl with Three Phoenixes

25.4 x 21 cm (10 x 8¼ in.)
Musée du Louvre, Paris (8177)

134 *Fig. 208*

Bowl with Four Phoenixes

21.5 x 10.2 cm (8½ x 4 in.)
Los Angeles County Museum of Art,
The Nasli M. Heeramaneck Collection, Gift of
Joan Palevsky (M.73.5.215)

These bowls belong to a general category of Persian ceramics known as Sultanabad ware,[1] after the western Iranian city (between Hamadan and Isfahan) where many of the objects were found, although there is no proof that any of them were actually made there.[2] Sultanabad vessels decorated with phoenixes set amid a floral background were probably produced in the first half of the fourteenth century. Their hemispheric shape, exterior decoration of radiating petal-like designs, and muted gray-green color scheme have frequently led to the hypothesis that this pottery was inspired by imported Chinese celadon (see cat. nos. 132, 194).[3] The phoenix motif, in which the mythical birds are depicted in pairs or groups of three (cat. no. 133) or four (cat. no. 134), typically arranged in the form of a revolving design emphasized by the birds' long, curving tail feathers, may also represent a Chinese import. For example, the same vibrant motif occurs on a small, carved lacquer tray from the Southern Song dynasty (1127–1279) (cat. no. 203). Textiles, for instance, an embroidered Yuan canopy (cat. no. 184), also carried this design and may have helped to transmit it to Iran, where the two varieties of elaborate plumage found among the Chinese versions have been reduced to a single, simplified type of tail feather.

1. Cat. no. 133: *Étrange et le merveilleux en terres d'Islam* 2001, no. 30. Cat. no. 134: Pal 1973, no. 95.
2. See Lane 1957, p. 10. For a recent study of Sultanabad ware, see P. Morgan 1995.
3. See, e.g., Allan 1991, pp. 34–35. P. Morgan 1995, pp. 35–36, suggests a connection with Chinese ceramics of two related types, Cizhou and Jizhou wares.

135 *Fig. 243*

Storage Jar (Albarello)

Iran, 14th century
Fritware, underglaze painted
H. 33 cm (13⅕ in.)

The Trustees of the British Museum, London
(1952.2-14.5)

So-called Sultanabad ware seems to have been an original development in the Ilkhanid period that drew upon Chinese decorative vocabulary—most notably the peony—for some of its characteristic designs, perhaps inspired by imported textiles. The decoration on this albarello[1]—bands of varying width interrupted by floral medallions—also parallels designs found on textiles of the Ilkhanid period (see cat. no. 75).[2] While Sultanabad slip-painted vessels use a gray-green color, which produces a somber, grisaillelike effect (cat. nos. 133, 134), brilliant, luminous hues applied under a transparent glaze, such as the blue and turquoise outlined with black that are seen here, are also typical.

1. Lane 1957, pp. 10–12, pl. 3; *Arts of Islam* 1976, p. 251, no. 368.
2. Lane 1957, p. 11.

METALWORK

136 *Fig. 7*

Saber

Iran, mid-13th–mid-14th century
Steel, iron
96.5 x 8.9 cm (38 x 3½ in.)
Lent by Oliver S. Pinchot

This sword, unique so far as is known, provides a crucial missing link between the protosabers used by Eurasian steppe nomads in the sixth to the twelfth century and the fully developed western Asian forms of the later fifteenth century.[1] It was probably made for a nomadic horseman, possibly in northeastern Iran during the reign of the Ilkhanids (1256–1353). Its long, curved, single-edged blade served to augment the natural action of the swordsman's arm when swung from horseback, although the sharp back edge of the blade also made it an effective thrusting weapon. Its tang, the extension of the blade that was once covered by grips (now lost) made of horn or wood, is oriented slightly toward the cutting edge and is set with three large iron studs. These studs had the dual purpose of securing the grips and improving the user's hold on the weapon.[2] Consonant with other steppe examples, the sword would originally have had a small, cylindrical metal cap or pommel that protected the end of the grip.

The guard, which was designed to protect the wielder's hand and is a separate piece that fits over the tang, is cruciform in shape with a central ridge on either side. Highly unusual in its configuration, it has the flattened-ovoid form (with or without a central ridge) found on

nomadic Turkic sabers of the ninth to the thirteenth century excavated in the regions of Kursk and Kiev in Ukraine.[3] It differs from the guards of the Ukrainian finds, however, in two important respects. First, the pair of langets (narrow projections set on either side of the guard to fix this firmly to the grips and also to allow the blade to fit snugly in the scabbard) give it a cruciform shape: one langet points up toward the grip and the other down toward the blade. Langets appear on one thirteenth-to-fourteenth-century sword used by the Jochids (Golden Horde) and excavated in the Kuban region,[4] but they are considerably more diminutive than those in the present example, suggesting that the form was just beginning among the Horde nomads and was therefore probably borrowed from Iran. Langets become more common on the guards of fourteenth-century steppe swords found in modern Turkmenistan. Second, the cruciform central ridge on either side of this guard begins to appear more uniformly in the Near East after about 1400.

1. The owner, Oliver S. Pinchot, expects to publish this sword himself in 2003. In the meantime, we are grateful to him for sharing the information presented here and for his collaboration on this entry. For a late-fifteenth-century example, see Yücel 2001, p. 128, no. 87.
2. Tangs oriented toward the cutting edge with similar grip studs appear on tenth- to twelfth-century sabers excavated in modern Kirghizstan. See Khudiakov 1980, p. 41, figs. 1-1, 1-3.
3. See, e.g., Nicolle 1999, p. 471, figs. 725c, 725d.
4. Ibid., p. 468, fig. 703.

137, 138 Saddle Arches and Fittings

137 *Fig. 9*

Saddle Arches and Fittings

Mongol empire, first half of the 13th century
Gold, worked in repoussé, remains of iron rivets
29.7 x 30.5 cm (11¼ x 12 in.); 24.2 x 34 cm
(9½ x 13⅜ in.)
The Nasser D. Khalili Collection of Islamic Art,
London (MTW 795)

138 *Fig. 63*

Saddle Arches

Mongol empire, first half of the 13th century
Silver gilt, worked in repoussé
22.5 x 22.5 cm (8⅞ x 8⅞ in.); 18.5 x 27.5 cm
(7¼ x 10⅞ in.)
State Hermitage Museum, Saint Petersburg
(ChM-1199, -1200)

Saddle arches such as these would have been mounted along with other plates or fittings on lightweight wooden frames supporting short stirrups. The tradition of covering a hard saddle with plates of gold or silver may have been

introduced from North China, where it was perhaps first used under the Liao (907–1125).[1] The general form of these saddles, with the pommel higher and narrower than the cantle, may also have been initiated in North China during the Liao dynasty, to judge from a mid-eleventh-century tomb painting in which a horse is depicted with a saddle of the same shape.[2] Saddles of this type, which are represented in Ilkhanid manuscript illustrations (see cat. nos. 40, 56) and in Yuan painting,[3] may have been standard issue among the various branches of the Mongol dynasty. Gold saddle plates would probably have been reserved for the exclusive use of the ruler and his family, Mongols of lesser rank qualifying for versions in silver.[4] Given the ample application of gold, which would have covered the entire saddle except for the seat itself, the Khalili arches (cat. no. 137) are likely to have been made for an important member of the royal family.[5] The elaborately worked silver-gilt facings for the pommel and cantle of a saddle, decorated with a pair of horses and rabbits respectively (cat. no. 138),[6] were found in 1845 in a disturbed burial site near a village along the Molochnaya River in southern Ukraine.[7]

Given the importance of the horse in Mongol society, it is not surprising that horse trappings were produced in precious metals, perhaps not for military purposes but rather for hunting and parade. Decorated fittings of precious metal or gilt base metal were also used en suite to embellish leather saddle and bridle straps (see, e.g., cat. nos. 141, 152).

1. See Kramarovsky 1996, p. 50, where the Khalili saddle (cat. no. 137) is dated to the thirteenth century. For examples from an early-eleventh-century Liao tomb, that of the princess of Chen, see *Treasures on Grassland* 2000, pp. 236–39.
2. See Kessler 1994, p. 95, fig. 58. For a Liao-dynasty panel painting of a horse and groom, see C.Y. Liu and Ching 1999, p. 99, fig. 6.
3. See, e.g., the hanging scroll *Khubilai Khan Hunting* by Liu Kuan-tao, in Fong and Watt 1996, pl. 138.
4. Alexander 1996, vol. 2, p. 157.
5. Alexander 1992, pp. 42–47, no. 14.
6. Basilov 1989, p. 68; Alexander 1996, vol. 2, p. 157; *Golden Horde* 2000, pp. 61, 215–16, nos. 17, 18. We are indebted to Mark Kramarovsky of the State Hermitage Museum for assistance on this and several other entries relating to metalwork in the Hermitage collection.
7. Kramarovsky 1996, p. 50; *Golden Horde* 2000, pp. 215–16.

139 *Fig. 11*

Cup with Fish-Shaped Handles

Golden Horde (Southern Russia),
late 13th–14th century
Gold sheet, handles worked in repoussé and engraved
H. 12 cm (4¾ in.); w. (with handles) 17.8 cm (7 in.)
State Hermitage Museum, Saint Petersburg
(SAR-1613)

In its simple and refined design, the use of gold as its only material, and its large size, this drinking cup is one of the most memorable objects attributable to metalworkers, goldsmiths in particular, of the branch of the Mongol dynasty known as the Golden Horde.[1] Dragon- and fish-shaped handles were common in the repertoire of the Chinese-influenced Mongols of the Golden Horde, representing symbols of good omen especially for drinking vessels (see cat. no. 155).[2] Here, the contrast between the elaborate, sculptural repoussé handles and the plain gold surface of the cup makes for a remarkable work of art that has miraculously survived destruction or melting down for reuse. An Arabic inscription, thus far unread, is engraved underneath the base.

The cup was found in 1848 at the archaeological site of New Saray (Saray al-Jadid), or modern Tzarevo Gorodishe, the second capital of the Golden Horde along the lower course of the Volga.[3] New Saray was founded in the 1330s and flourished in the fourteenth century until the arrival of Timur's army, although this cup may have been brought from the old capital as a family heirloom.

1. Lentz and Lowry 1989, pp. 48, 330, no. 11; *Golden Horde* 2000, pp. 59, 214–15, no. 15.
2. See also the discussion on the symbolism of the fish at cat. no. 132.
3. A short history of New Saray is included in Allsen 1997b, p. 41. See also James Watt's essay, chapter 3 above.

140 *Fig. 4*

Two Belt Ornaments

Iran or Southern Russia, late 13th–14th century
Gold, pierced, chased, and worked in repoussé
Each 6 x 7.5 cm (2⅜ x 3 in.)
Staatliche Museen zu Berlin—Preussischer
Kulturbesitz, Museum für Islamische Kunst (I.889)

The popularity of gold and silver belt fittings among the Mongols is attested by the objects themselves (see cat. nos. 142, 143, 150, 151) and by their depiction in manuscript illustration in Ilkhanid Iran, most notably in the Great Mongol *Shahnama* (see cat. nos. 38–40, 46, 53, 55, 56). To judge from the paintings, belts with gold ornaments, like the sumptuous silk robes decorated with gold designs, seem to have been an essential element of Mongol sartorial splendor. Paired griffins and rabbits combined with a foliate or floral design that functions as a central axis, as in these two belt ornaments,[1] are also common decorative devices on silk textiles woven with gold-wrapped thread produced in an area covering Italy, Syria and Egypt, Iran and Central Asia (cat. nos. 69, 70), and China (cat. no. 182).[2] While it is tempting to suggest that belt ornaments and robes were produced as

similarly decorated sets, concrete support for this possibility is still lacking.[3]

1. *Museum für Islamische Kunst* 1980, pp. 72–73, no. 30, ascribed to Azerbaijan, late thirteenth century; Gladiss 1998, pp. 127–28, no. 74, ascribed to Anatolia or the Caucasus, thirteenth century, and said to have been found in Tbilisi, in the former Soviet Republic of Georgia.
2. See esp. Wardwell 1988–89.
3. See Gladiss 1998, p. 127. However, James Watt (chapter 3 above) notes that officers attached to the Jin emperor wore the symbol of the deer on their uniforms and accoutrements.

141 *Fig. 10*

Horse Trappings

Probably Greater Iran, 13th–14th century
Silver gilt, worked in repoussé, chased, and incised
Individual pieces range from 7.2 x 7.2 cm
(2⅞ x 2⅞ in.) to 2 x 2.5 cm (¾ x 1 in.)
The Nasser D. Khalili Collection of Islamic Art,
London (MTW 795)

Although horse straps and buckles have a long history in the decorative arts of Iran, the set of horse trappings in the Khalili Collection, which clearly demonstrate East Asian influence, are perhaps more closely related to Eastern traditions.[1] These ornamental elements, mainly in the form of stylized lotuslike blossoms, would have been attached to the bridle and the straps, presumably made of leather, across the horse's chest, sides, and rump. Each of them has a series of five lugs for attachment, while in some cases their silver washers are preserved.[2] Part of a seventy-seven-piece group, they are said to have been found with the gold saddle plates also in the Khalili Collection (cat. no. 137).

In both Ilkhanid manuscript illustration and Yuan painting the well-caparisoned horse is frequently depicted wearing gold trappings (see cat. nos. 40, 49, 50, 51, 53, 54, 56–58).

1. Alexander 1992, pp. 48–51, no. 15.
2. Ibid., p. 48.

142 *Fig. 198*

Set of Belt Fittings

Mongol empire, 13th century
Silver gilt
L. fittings: 2.3–8 cm (⅞–3⅛ in.); remains of belt: 50 cm (19¾ in.)
State Hermitage Museum, Saint Petersburg
(ZO-762)

Ornamental belts, in which gold or silver garnitures and buckles were attached to leather or cloth, had a long and varied history among the Chinese and the seminomadic peoples who lived along their northern and western borders.[1] The Mongols had evidently adopted this

tradition by the time of Genghis Khan, when dragons came to be used on military officers' belts and belt buckles almost like a heraldic device. It has in fact been suggested that the motif was consciously selected as an emblem for the officer corps.[2]

Decorated with dragons, the fittings in this set consist of a buckle, a belt head, twenty-five crescent-shaped pieces, a small sliding girdle, and two girdles with looped ends for carrying the sword sheath.[3] Like many belt ornaments of the period, they were found in the lower Volga region; exceptionally, a fragment of the original leather belt had survived as well.

1. See So 1997.
2. *Golden Horde* 2000, p. 204.
3. Ibid., pp. 69, 216–17, no. 19.

143 Figs. 57, 62

Set of Belt Fittings

Golden Horde (Southern Russia) and China,
13th century
Gold sheet, engraved, stamped, chased, and punched, worked in repoussé
Largest element: 5.4 x 3.6 cm (2⅛ x 1⅜ in.)
State Hermitage Museum, Saint Petersburg
(KUB-705–721)

Nomadic peoples used belts not only as articles of wear but also as symbols of social distinction. This set of gold belt fittings, decorated in high relief with artistically accomplished images of deer amid foliage, was clearly meant for an officer of the highest rank.[1] He has been identified as belonging to the family of Batu (r. 1227–55), the founder of the Golden Horde, on the basis of a small charm found with the set, which shows the *tamgha* (a kind of heraldic device) of the house of Batu. The fittings were discovered in 1890 in a mound near Gashun Uta, in the region of Stavropol. The motifs of the deer and the lotus flower—the latter is present in the center of an almond-shaped element—became popular throughout Asia in the Mongol period, as is demonstrated by a number of works in this catalogue.[2]

The elements in the set, which seems to be incomplete, were originally attached to a leather strap that has not survived. They include a buckle, three rectangular elements (two of them with a hook at the bottom for the attachment of the sword sheath typical of Asian belts), an almond-shaped piece (also with a hook, perhaps where the charm mentioned above was once fastened), and an elongated component that was attached to the end section of the belt. Smaller parts include five semicircular openwork elements, a lobed piece, and four loops.

1. Basilov 1989, pp. 84–85; *Golden Horde* 2000, pp. 63–66, 218–19, nos. 23–39.
2. The design on the belt is paralleled in the silver and gold belt plaques in the Khalili Collection (cat. nos. 150, 151). Also see James Watt's chapter 3, page 67 and note 11, where the author discusses the use of this motif as an emblem by officers in the Jin army and relates these belt fittings to Jin workmanship.

144 Fig. 29

Comb and Sheath

Golden Horde (Southern Russia),
14th–15th century
Silver gilt, engraved, chased, punched, and inlaid with a black compound
Comb: 14 x 2.8 cm (5½ x 1⅛ in.);
sheath: 14.7 x 3 cm (5¾ x 1⅛ in.)
State Hermitage Museum, Saint Petersburg
(TB-43a, b)

Everyday objects of toiletry rarely survive the test of time, so this silver comb was a particularly interesting find when it surfaced in 1896 near Belorechensk, Russia, in the northern Caucasus.[1] It is also remarkable that it was found with its sheath, which is likewise made of silver gilt and is decorated with engraved vegetal scrolls, palmettes, and geometric patterns on both sides. The motif is mirrored in the simple band that frames the teeth of the comb, which is inlaid with a black substance similar to niello. Both objects have a ring attached at one end for suspension from a belt or some other item of clothing.

1. *Golden Horde* 2000, pp. 89, 236–37, no. 81.

145 Fig. 30

Pendant

Mongol empire, mid-13th century
Gold sheet, worked in repoussé, engraved, filigree, granulation, set with rock crystal
H. 12 cm (4¾ in.)
State Hermitage Museum, Saint Petersburg
(SA-8091)

In 1902 a fabulous hoard was discovered by chance in Shahr-i Sabz, near Samarqand, and this remarkable pendant, or perhaps horse pectoral, was among the treasures found there.[1] In addition to the central rock crystal, small pearls once formed part of its decoration.

In both technique and style the piece can be related to pre-Mongol goldwork from China. On the obverse the fine spiral filigree work, in which gold wire has been transformed into different decorative configurations, has been compared to openwork filigree on jewelry of the Song dynasty (960–1279), which may have served as a prototype. On the reverse are delicately chased floral designs of Chinese inspiration,

perhaps by way of northern China.[2] Three loops on the reverse suggest that the piece was once intended for attachment, although its precise function is unclear. However it was meant to be worn, the Mongols clearly had a taste not only for precious materials but also for fine workmanship.

1. *Golden Horde* 2000, pp. 114–15, 254–55, no. 165.
2. See Kramarovsky 2000, pp. 206–7.

146 Fig. 74

Amulet Case

Golden Horde (Southern Russia), 14th century
Gold, worked in repoussé, engraved, set with jasper
9 x 5.8 cm (3½ x 2¼ in.)
State Hermitage Museum, Saint Petersburg
(ChM-978)

This finely worked case for prayer texts was discovered in the Crimea in a clay vessel along with a large number of other objects and almost 500 coins that allow for a fourteenth-century, Golden Horde dating.[1] The find was made in 1886 on the right bank of the river Zuya, about 12½ miles northeast of Simferopol. A very similar amulet case, now in Moscow, formed part of the Simferopol Treasure, together with a large group of gold belt fittings, buckles, bracelets, and earrings, some of which are of Syrian or Egyptian workmanship; this hoard is datable to the first half of the fourteenth century.[2] It is possible that such phylacteries were also made in Mamluk Egypt or Syria and sent as trade items or gifts to the Mongols of the Golden Horde.[3] Wherever the cases were made, jewelry of this type seems to have been popular in the Iranian world; similarly shaped examples, strung from elaborate necklaces, are depicted in Persian manuscript illustrations of the fourteenth to the sixteenth century (see cat. no. 37).[4]

1. *Islamic Art in the Hermitage Museum* 1990, no. 66; *Golden Horde* 2000, pp. 99, 279, no. 251.
2. The Simferopol Treasure, State Historical Museum, Moscow, n.d. See *Golden Horde* 2000, pp. 311ff., nos. 46off. See also M. Jenkins 1988.
3. M. Jenkins 1988, pp. 29–31.
4. Ibid., figs. 9, 10.

147 Fig. 31

Bracelet

Golden Horde (Southern Russia), early
14th century
Gold sheet and wire, engraved, stamped, chased, and punched, with a black compound
Diam. 6.5 cm (2⅗ in.)
State Hermitage Museum, Saint Petersburg
(ZO-717)

This piece of jewelry, together with two other identical bracelets and numerous gold coins, was found in 1924 buried in a cache at Djuke-tau (Chistopol) on the left bank of the river Kama in modern Tatarstan.[1] The coins included some minted in 741 (1340–41) in the name of the sultan of Delhi, Muhammad Shah ibn Tughluq Shah (r. 1325–51) and others in the name of the ʿAbbasid caliph in Cairo, Abu Rabiʿa al-Mustaqfi (r. 1302–40).[2] The eclectic range of the coins and the presence of a similar bracelet in the treasure found at Simferopol (Crimea) make it difficult to determine the provenance of the present object, although there is no doubt that it can be dated to the first decades of the fourteenth century. Both the Crimea and the Middle East, possibly Anatolia, have been proposed as its source. The Persian verse that the bracelet incorporates and the dec-oration, which has several Golden Horde fea-tures, suggest instead a northwestern Iranian (Azerbaijan) or western Caspian Sea origin. The verse—"May the Creator protect the owner of this [bracelet] wherever he may be"—follows a well-established formula in the Islamic world.

The bracelet is made of two halves con-nected by a hinge at the back and a central plaque that includes a lobed medallion filled with vegetal motifs; two rings are attached to the plaque, one above and one below it. The decoration, executed in rather high relief, is finely crafted and gives this piece of jewelry a sculptural appeal.

1. *Islamic Art in the Hermitage Museum* 1990, pp. 25, 96, no. 64; *Golden Horde* 2000, pp. 88, 242–43, no. 111.
2. The ʿAbbasid caliphate ended with the Mongol capture of Baghdad in 1258, though the lineage nominally con-tinued in Mamluk Egypt from 1259.

148 Fig. 89

Necklace

Iran, possibly 14th century
Gold sheet, chased and set with turquoise, gray chalcedony, and glass
Medallion 7.3 x 6.9 cm (2⅞ x 2¼ in.);
half-medallion: 4.5 x 6.9 cm (1¾ x 2¼ in.);
cartouches: 1.9 x 1.2 cm (¾ x ½ in.)
The Metropolitan Museum of Art, New York, Rogers Fund, 1989 (1989.87a–l)

Relatively few examples of jewelry have sur-vived from Ilkhanid Iran (see cat. nos. 145–47). As a result, their dating often depends upon sources external to the medium, such as manu-script illustrations and drawings.[1] Necklaces sim-ilar to this one,[2] composed of a large medallion and a series of cartouches that form a kind of chain, are depicted in fourteenth- to sixteenth-century Persian manuscripts (the half-medallion was likely worn at the back and so would not

appear in an illustration). This example is very similar to a necklace represented in the Great Mongol *Shahnama*, of the 1330s (cat. no. 37). Additional evidence for dating the necklace is provided by the embossed scenes on the back of the two main elements, depicting a gazelle amid foliage and a lion attacking a gazelle, set among branches with blossoms. Both the figural style and the rendition of the floral motifs suggest a date in the fourteenth century, by comparison with drawings of related designs.[3] Similar designs also occur on gilt-bronze plaques that have been ascribed to the Ilkhanid period (see cat. no. 152).

1. See, e.g., Keene and M. Jenkins 1981–82.
2. Ibid., pp. 255–56, fig. 24a, b; Golombek 1991.
3. Ibid., p. 64, noted a similarity between the lion and gazelle group and closely related figural compositions in a drawing in one of the Istanbul albums (Topkapı Palace Library, H. 2152), which she dates to the fif-teenth century. It seems more likely, however, that the drawing in question may represent a later fourteenth- or early-fifteenth-century copy of an Ilkhanid original; see Linda Komaroff's essay, chapter 7 above.

149 Fig. 13

Handled Cup

Golden Horde (Southern Russia), late 13th–14th century
Gold sheet, engraved, chased, and worked in repoussé
H. 5.1 cm (2 in.); W. (with handle) 14.5 cm (5¾ in.)
State Hermitage Museum, Saint Petersburg (SK-589)

One of the most successful and long-lived types of vessel is a shallow drinking cup with a multi-lobed flange that extends horizontally from below the rim and runs along about one half of the cup's circumference, forming a handle. Relatively large numbers of such cups have been found in the area and from the period of the Golden Horde.[1] The present example was exca-vated in 1891 on the southern borders of their vast regions, in the area of Zhety Su (Kazakh for "Seven Rivers") in modern Kazakhstan.[2] This type of cup later became fashionable in Russia and was produced there consistently until mod-ern times.

Simple and functional in shape, the more elaborate of these cups are made of precious metal, gold or silver, and the handle and the upper section of the exterior, and sometimes the interior as well, are decorated with vegetal motifs. Here the cup is plain, but the handle is engraved and chased with vegetal scrolls and has a lotus flower in repoussé below the apex of the central lobe. The design of the flower, inspired by Far Eastern models, entered the repertoire of the Golden Horde but was not as widespread and popular as in neighboring Ilkhanid Iran and Mamluk Egypt and Syria.

The shape of the flanged cup was also popular in northern China in the twelfth and thirteenth centuries, under the Jin dynasty (1115–1234), and many examples of it survive in porcelain and stoneware.[3]

1. For eight such cups excavated in several areas of the former Soviet Union, see *Golden Horde* 2000, nos. 16, 40, 41 (cat. no. 149), 58, 60, 69, 91, 136.
2. *Islamic Art in the Hermitage Museum* 1990, pp. 25, 95, no. 63; Ward 1993, illus. p. 98; *Golden Horde* 2000, pp. 70, 220, no. 41.
3. Emersen, Chen, and Gates 2000, p. 45, pl. 3.8.

150, 151 Belt Fittings

150 Fig. 64

Belt Plaque

Central Asia, 13th century
Silver, repoussé, chased and engraved decoration
With ring: 8 x 4.1 cm (3⅛ x 1⅝ in.)
The Nasser D. Khalili Collection of Islamic Art, London (JLY 1825)

151 Fig. 65

Three Belt Plaques

Southern Russia or Central Asia, 13th century
Gold, repoussé, chased and engraved, granulation
With ring: 4.4 x 2.9 cm (1¾ x 1⅛ in.); 2.8 x 2.8 cm (1⅛ x 1⅛ in.); 2.3 x 3.7 cm (⅞ x 1½ in.)
The Nasser D. Khalili Collection of Islamic Art, London (JLY 1012, 1836)

To judge by the number of extant examples, many preserved through burial with the deceased, belts and belt ornaments of gold and silver seem to have been among the luxury goods especially prized by the Mongols.[1] In addition to their obvious value as status sym-bols, there is a well-known story from the *Secret History of the Mongols* of how belts taken from the enemy were exchanged between Genghis Khan, then Temüjin, and his early ally Jamuka as a means of renewing their alliance after the defeat of the Merkits.[2] In fact, the exchange of belts and horses seems to have been a means of concluding alliances among the peoples of the Mongolian steppes.

The three square gold ornaments (cat. no. 151), each decorated with a pair of deer set within dense vegetation,[3] are very similar to several related belt fittings in the Hermitage (see cat. no. 143), especially in the figures of the reclining deer, with heads turned backward and gracefully arched necks. The silver plaque (cat. no. 150) features a single recumbent deer, its head turned back, in a thicket of spiraling veg-etal motifs; a small hare forms part of the scene.[4] The image of one or more deer set amid vegetation was a common one in the art of the Mongol empire. It was perhaps introduced

through contact with the art or artists of the Jin dynasty (1115–1234), when the motif was a standard decoration among officers in the emperor's entourage.[5]

1. Kramarovsky 2000, p. 204.
2. See, e.g., Ratchnevsky 1991, p. 20.
3. Alexander 1992, p. 30, no. 4.
4. Ibid., p. 30, no. 3.
5. See James Watt's chapter 3, above.

152 *Fig. 235*

Two Plaques

Iran, 14th century
Gilt bronze, worked in repoussé, chased, punched, and engraved, attached to metal base
15.5 x 14.4 cm (6⅛ x 5⅝ in.); 11 x 26 cm (4⅜ x 10¼ in.)
The Nasser D. Khalili Collection of Islamic Art, London (JLY 503)

These plaques, both of which have less well pre-served mates, were made from a decorated sheet of gilt bronze attached by rivets to a thicker base of cast metal.[1] The medallionlike hinged plaque shows a deer grazing, surrounded by vegetation in the form of oversize floral motifs. The elongated plaque, decorated with similar motifs, has at each end a recumbent deer, its head turned backward, framed by a lobed cartouche. Stylistically, the animals can be related to those on a necklace (cat. no. 148), as well as to drawings that may represent early-fifteenth-century copies of fourteenth-century designs (see chapter 7).[2]

It is unclear how these plaques were origi-nally used. Although their forms are similar to those of a set of gold plaques from a necklace or garland in the Royal Ontario Museum, Toronto,[3] the hinge on the smaller plaque and the consid-erable size of the elongated one suggest some other function, perhaps as saddle or belt orna-ments or as attachments to a box or chest.[4]

1. Alexander 1992, pp. 52–54, no. 16. On the basis of numerous points of comparison with examples of Iranian art, an attribution to Iran seems far more likely than the Anatolian provenance proposed by Alexander.
2. Both the animal and the floral and vegetal motifs are reminiscent of numerous drawings in the Diez Albums, although in most instances the metal versions seem earlier in date on account of their stiffer, less fluid line. For the drawings, see Lentz and Lowry 1989, pp. 345, 347–48, nos. 77, 78, 90, 94. On the possible use of drawings for the transmission of designs in Ilkhanid Iran, see chapter 7 above.
3. Golombek 1991, figs. 10, 11.
4. Alexander 1992, p. 54, suggests that the hinged plaques may have been used to decorate the front of belt pouches.

153 *Fig. 12*

Covered Goblet with Bird Finial

Probably Iran, late 13th–early 14th century
Silver, punched, engraved, chased
H. 19 cm (7½ in.); diam. 12 cm (4¾ in.)
State Hermitage Museum, Saint Petersburg (KUB-364)

Silver had a long history in Iran in both Islamic and pre-Islamic times, when it was highly prized at court and among the military aristocracy, especially for drinking vessels.[1] It continued as a popular material for tableware in the Ilkhanid period, when there was perhaps a convergence of indigenous Iranian and transplanted Mongol taste for objects fashioned of precious metal. This silver goblet was presumably used for wine,[2] whose flavor could be enhanced by aromatic herbs inserted between the two pierced disks on the cover, which served as a mixer and filter.

Both the bird-shaped finial of the cover and the overall scrolling floral and leaf designs help to locate this vessel within the Iranian world, although it was found near Belarechenskaya, in the Kuban region of Ukraine, in 1906. Similar three-dimensional birds, with prominent eyes, are well known in earlier metalwork of the twelfth and thirteenth centuries.[3] Closely related scrolling foliate designs, in which the leaves and blooms are marked by curved lines, often in pairs, and set against a cross-hatched back-ground, became a standard means of decorating copper and brass metalwork later in the four-teenth century and especially in the fifteenth.[4]

1. See Melikian-Chirvani 1986.
2. Basilov 1989, pp. 68–69; *Golden Horde* 2000, p. 231, no. 70.
3. See A. U. Pope and Ackerman 1938–77, pls. 1321–27.
4. For the fifteenth-century examples, see Komaroff 1992, pp. 92ff.

154 *Fig. 34*

Paiza (Passport)

Golden Horde (Southern Russia), ca. 1362–69
Engraved silver, inlaid with gold
28 x 9 cm (11 x 3½ in.)
State Hermitage Museum, Saint Petersburg (ZO-295)

In order to regulate communications and encourage the exchange of ideas in the largest empire ever created, one of the innovations of the Mongol administrators was the distribution of inscribed metal plaques that were used either as patents of office or as passports. Only about a dozen examples are known to have survived.

This *paiza*, a surface find near modern Dnepropetrovsk (Ukraine) in 1845, is a rectan-gular one with a hole near the top that would have allowed it to be attached to a belt or worn

suspended from the neck for convenience and visibility.[1] It is made of silver sheet inlaid with gold inscriptions. The script is Uyghur, which was employed in the Mongolian areas of western Asia. The text reads: "[With the] force of eternal heaven, [with the] grace of majesty and might, those who do not submit to Abdullah's order will be guilty and die." The ruler named has been tentatively identified as Özbeg Abdullah, who had control of the Golden Horde intermittently in a period of unrest between 1362 and 1369.

It is noteworthy that this *paiza* is inscribed in terms similar to those found on a Chinese circular example (cat. no. 197), proclaiming "guilty" those who do not honor it. Also shared with the Chinese *paiza* is the stylized lion mask at the top, indicating that these objects were based on certain models familiar in different areas of the Mongol empire. In this case, how-ever, the design has an obvious Central Asian, nomadic inspiration.

1. Basilov 1989, p. 82; *Golden Horde* 2000, pp. 233–34, no. 77. For another rectangular *paiza*, see above, fig. 70, and for an early-fourteenth-century illustration in which a figure has been identified as a royal envoy armed with a *paiza*, see cat. no. 23.

155 *Fig. 197*

Dragon-Handled Cup

Golden Horde (Southern Russia), second half of the 13th century
Gold
4.7 x 13 cm (1⅞ x 5⅛ in.)
State Hermitage Museum, Saint Petersburg (SAR-1625)

Dragon-handled cups in both gold and silver formed part of the portable wealth of the Mongol elite. Such shallow drinking vessels were meant to be worn suspended from the belt by the loop in the dragon's mouth. Most were found among grave goods in the territories of the Golden Horde, which occupied an area encompassing parts of the Caucasus, the Crimea, and the vaste steppe region north of the Caspian Sea.[1] None is exactly alike or has the same inte-rior decoration. This example was sent to Saint Petersburg in 1727, as part of Peter the Great's so-called Siberian collection; presumably the cup was found in Siberia.[2]

The prototype for such vessels perhaps comes from northern China, under the Liao (907–1125), and so to some extent already rep-resents a synthesis of Chinese and non-Chinese forms.[3] It has been suggested that the dragon motif, as on these cups and on related belts, was specifically adopted in the early thirteenth cen-tury as a unifying symbol for Genghis Khan's newly formed officer corps and continued in use among the Golden Horde.[4]

1. The single largest group is in the State Hermitage Museum, Saint Petersburg; see *Golden Horde* 2000, pp. 204–5, 212–14, 218, nos. 12, 14, 21. See also Kramarovsky 1991.
2. Meister 1938, figs. 2a, b; Basilov 1989, p. 72; *Golden Horde* 2000, pp. 57, 213–14, no. 13.
3. *Golden Horde* 2000, p. 204.
4. Ibid.

156, 157 Footed Vessels

156 *Fig. 53*

Footed Cup

Greater Iran or Golden Horde (Southern Russia),
late 13th–early 14th century
Silver gilt, punched and incised
7.5 x 11.4 cm (3 x 4½ in.)
The David Collection, Copenhagen (47/1979)

157 *Fig. 32*

Footed Bowl

Golden Horde (Southern Russia),
early 14th century
Silver gilt, worked in repoussé, punched,
engraved, and chased
12.5 x 27 cm (4⅞ x 10⅝ in.)
State Hermitage Museum, Saint Petersburg
(ZO-741)

Footed cups and bowls in silver gilt as well as gold were evidently produced in the greater Iranian world prior to the Mongol invasions.[1] However, such luxury vessels seem to have had a special place in Mongol society, particularly among the Golden Horde, in whose extensive territory many such objects have been discovered.[2] The bowl in the Hermitage (cat. no. 157), which was found in 1957 in the central Urals near Ivdel, is decorated with medallions engraved on its twelve lobes, eight of which are filled with animals, both real and imaginary, such as the sphinx.[3] The latter motif, probably derived from Islamic art, occurs in other media in the Mongol period.[4] The vegetal decoration and punched ground on the David Collection vessel (cat. no. 156) suggest but do not dictate a Golden Horde provenance.[5] Like the prized "cloth of gold" that the Mongol ruling elite so coveted, silver-gilt and gold vessels and accoutrements were no doubt viewed as articles of prestige and power.

1. For a similar silver-gilt footed cup with gadrooned sides worked in repoussé that predates the Mongol period, see Ward 1993, fig. 65. A related type of stem cup in brass, generally inlaid with silver and gold, is common in fourteenth-century Iran; see, e.g., Melikian-Chirvani 1982, nos. 84, 85.
2. See *Golden Horde* 2000 for a number of excavated examples, including a very similarly shaped vessel, pp. 74, 224–26, no. 55.
3. Basilov 1989, p. 80; *Art Treasures of the Hermitage* 1994, vol. 1, pp. 472–73, no. 453; *Golden Horde* 2000, pp. 77, 224–25, no. 54.

4. For a contemporary brocaded silk robe from a tomb in Inner Mongolia also decorated with sphinxes, see Kessler 1994, fig. 104.
5. Folsach 1990, no. 334. For related designs on a punched ground on Golden Horde material, see *Golden Horde* 2000, pp. 70, 76, 220, 223, nos. 41, 47.

158 *Fig. 46*

Pen Case

Mahmud ibn Sunqur
Iran, A.H. 680/A.D. 1281–82
Brass, inlaid with silver and gold
L. 19.7 cm (7¾ in.)
The Trustees of the British Museum, London
(OA 91.6-23.5)

This small brass box, elaborately inlaid within and without in silver and gold, was meant to hold writing paraphernalia, including reed pens and an inkwell (now missing). Given the importance of calligraphy in the Islamic world, it is not surprising that a pen case would be produced as a luxury item or bear the signature of its maker. Here the name Mahmud ibn Sunqur and the date 681 are inscribed on the hasp, which would be hidden from view when the lid was closed.[1]

In style and decoration the pen case reflects metalwork prior to the Mongol invasions, from both the eastern and western Iranian world.[2] Astrological symbols were popular subjects for representation, and here select zodiacal signs are combined with images associated with the literary themes of *bazm-u-razm*, or "feasting and fighting," connected with the princely cycle.[3] On the inside of the lid, the seven planetary figures depicted are (from left): the Moon, Mercury, Venus, the Sun, Mars, Jupiter, and Saturn. Contained within a roundel on the exterior of the lid, the four astrological signs shown with their planetary lords are (from the top and reading clockwise): Mercury in Virgo (two men holding ears of corn), the Sun in Leo (the sun rising above a lion), Mars in Scorpio (a warrior grasping two scorpions by their tails), and Venus in Libra (a woman playing a harp under a pair of scales). The interior of the box shows dancers and musicians, and the base two pairs of horsemen jousting and hunting.[4]

1. Barrett 1949, p. xviii, pls. 32, 33; Atil 1981, p. 61; Ward 1993, pp. 90–91, pls. 69–71.
2. The figures of the planets on the interior of the lid are reminiscent of metalwork from Mosul, dating to the first half of the thirteenth century, while the interlaced animal-headed arabesques and the combat scenes on the base reflect the style of late-twelfth- and early-thirteenth-century Khurasan. This combination of styles from two opposite ends of the Iranian world may have come about as a result of the massive displacement of craftsmen caused by the Mongol invasions in the thirteenth century; see Ward 1993, p. 88.
3. Melikian-Chirvani 1982, p. 141.
4. Ward 1993, p. 90.

159 *Fig. 1*

Tray

Northwestern Iran, late 13th century
Brass, inlaid with silver and gold
Diam. 46.3 cm (18 in.)
The Trustees of the British Museum, London
(OA 1878.12–30.706)

Mosul (in present-day Iraq) was an important center for inlaid metalwork in the first half of the thirteenth century. The city was conquered by the Mongols in 1261, and metalworkers were likely transplanted to the Ilkhanid courts in northwestern Iran. This tray may have been made by such a transplanted craftsman or by one trained in the Mosul style,[1] as it demonstrates technical and iconographic features associated with Mosul—for example, the seated figures each bearing a crescent moon and enclosed by lobed medallions—but updated and produced on a grander scale to appeal to or reflect Ilkhanid patronage.[2] The enthronement scene in the large central medallion indicates a continuation of pre-Mongol iconography, as does some of the imagery in the smaller medallions. In certain instances (such as the huntsman mounted on a rearing horse, in the medallion above the enthronement scene), however, the composition clearly reflects the figural style of the day (cf. cat. nos. 163, 166).

1. Barrett 1949, p. xv, pl. 23; Ward 1993, p. 87, pl. 66.
2. For a brief summary of the evidence for Mosul-style metalwork in late-thirteenth century Iran, see Komaroff 1992, p. 2; Ward 1993, p. 87.

160 *Fig. 154*

Candlestick

Iran, A.H. 708/A.D. 1308–9
Bronze, inlaid with silver
32 x 46 cm (12⅝ x 18⅛ in.)
Museum of Fine Arts, Boston, Gift of Mrs. Edward Jackson Holmes (55.106)

The practice of endowing religious shrines with means of lighting was viewed as a meritorious one in Iran even before the advent of Islam. The silver inlaid *muhaqqaq* inscription on the base of this candlestick,[1] which has lost its shaft and socket, announces the name of its donor, the shrine to which it was given, and the date: "The guilty servant [or slave], Karim [al-Din al-] Shughani, donated to the blessed mausoleum of the Sultan of Spiritual Masters, Sultan Abu Yazid, may God sanctify his soul and illuminate his sarcophagus. In one of the months of the year seven hundred and eight of the hijra."[2]

Objects of this type, along with the construction or renovation of the buildings for which they were intended, illustrate the growing acceptance and legitimation of Sufi, or mystical

orders, in Ilkhanid society. This exceptionally large candlestick was undoubtedly an impressive and costly gift, befitting the status of the donor, a vizier of Sultan Öljeitü, and the tomb of the Sufi saint Abu Yazid al-Bastami, at Bastam. It is perhaps worth noting that Karim al-Din al-Shughani, along with four other lieutenants of the sultan's chief vizier, Saʿd al-Din Savaji, was executed in 1312 on the charge of embezzlement of state funds.[3]

1. A. U. Pope and Ackerman 1938–77, pl. 1355; Melikian-Chirvani 1987, pp. 121–26, fig. 7-11.
2. Melikian-Chirvani 1987, p. 123.
3. Ibid., pp. 124–25. See also Blair 1986a, pp. 6–7.

161 *Fig. 44*

Bucket

Muhammad Shah al-Shirazi
Iran (probably Shiraz), A.H. 733/A.D. 1332–33
Brass, inlaid with gold and silver
H. 48.7 cm (19⅛ in.)
State Hermitage Museum, Saint Petersburg
(IR-1484)

The Arabic and Persian inscriptions on this bucket,[1] whose entire surface was once richly ornamented with gold and silver designs, make it one of the most important surviving examples of fourteenth-century Iranian metalwork. Around the upper rim is written:

> On the order of the master, the great possessor, honor and order of Iran, ornament of the state, peace and faith, Amir Siyavush al-Ridaʿi [may God] strengthen his following and his rule. Work of the feeble slave Muhammad Shah al-Shirazi the least among slaves of the great amir, Khusraw of the horizons, Amir Sharaf al-Din Mahmud Inju [may God] increase his justice in the year 733.

> May the world comply with your wishes and heaven be your friend.
> May the Creator of the world be your protector.

Inscribed in cartouches around the middle section is the following text:

> In the days of the rule of the greatest sultan, master of the necks of nations, lord of the Arabs and the non-Arabs, inheritor of the kingdom of Solomon, the Alexander of [his] time, supported by heaven in his victories over enemies, God's shadow on earth, suppressor of faithlessness and paganism [may God] preserve his kingdom and perpetuate his rule, his well-being, and his sultanate.[2]

From these inscriptions we learn that the bucket was made in 733 (1332–33) on the order of a certain Amir Siyavush by Muhammad Shah al-

Shirazi, who refers to himself as the servant of the great amir—Amir Sharaf al-Din Mahmud Inju, or Mahmud Shah, as he is generally known. Under the Ilkhanids Mahmud Shah became the vice-regent of the southern Iranian province of Fars in 1304–5. In 1325 he broke away from his Ilkhanid overlords and briefly established his own independent dynasty, which lasted until 1357.[3] It is thus likely that the bucket, dating from 1332–33, was made in Fars, probably in its capital, Shiraz.[4]

The bucket is one of several inlaid metal objects made for a member of the Injuid dynasty. For a candlestick inscribed in the name of Mahmud Shah's son, Jamal al-Din Abu Ishaq, who became ruler of Fars in 1343, see cat no. 162.

1. Kühnel 1925, pl. 56; Giuzal'ian 1963; *Islamic Art in the Hermitage Museum* 1990, pp. 21–22, no. 51; Piotrovsky 2001, p. 65.
2. For a complete transcription and translation of the inscriptions, see *Islamic Art in the Hermitage Museum* 1990, pp. 21–22, no. 51. The inscriptions were first read by Giuzal'ian 1963.
3. On the Injuid dynasty, see Boyle 1971a.
4. Muhammad Shah al-Shirazi's signature, with its use of the *nisba* ("al-Shirazi," of Shiraz), suggests that he was in some way attached to Mahmud Shah's court. On the significance of the title "inheritor of the kingdom of Solomon" applied to Mahmud Shah, see Melikian-Chirvani 1971b. See also Komaroff 1994, p. 9, n. 29.

162 *Fig. 224*

Candlestick

Saʿd ibn ʿAbd Allah
Iran (Fars province), 1343–53
Brass, inlaid with silver and gold
H. 34.2 cm (13½ in.); diam. 28.2 cm (11⅛ in.)
Museum of Islamic Art, Doha, Qatar

Encircling the base of this remarkable candlestick are four large enthronement scenes enclosed by medallions.[1] Two of the scenes depict the ruler seated on a throne supported by lions and attended by members of his entourage. In one, he wears an elaborate Mongol headdress composed of rounded owl feathers and other, spikier plumage—probably eagle feathers; the identical type of headdress is worn by a Mongol ruler in the frontispiece of the *Muʾnis al-ahrar,* dated 1341 (cat. no. 9). A third medallion shows a ruler and his consort sharing a platformlike throne, as in enthronement scenes associated with the *Jamiʿ al-tavarikh* (cat. nos. 18, 19); the consort wears the conical headdress reserved for Mongol noblewomen and known as a *bughtaq.*[2] In the fourth medallion the consort, again wearing the *bughtaq,* is depicted alone on her throne, as in a related drawing in the Diez Albums, Berlin, of an enthroned consort framed by a medallion (see fig. 223). The existence of this drawing, taken together with similarities between the other enthronement scenes on the candlestick and those found in manuscript illustrations,

suggests that metalworkers and manuscript illuminators alike may have been able to refer for their models to a common iconographic source in the form of drawings.[3]

Arabic inscriptions set in cartouches on the base are especially significant as they give the name and titles of a member of the Injuid dynasty, Abu Ishaq (r. 1343–53),[4] who succeeded his father, Mahmud Shah, as ruler of Fars (see cat. 161). Although it is tempting to regard the enthronement scenes as some form of visual accompaniment to the inscriptions, it is impossible at this time to identify them with specific historical figures or events.[5] At the base of the socket is a diminutive inscription providing other important information. It reads: "made by the feeble slave Saʿd ibn ʿAbd Allah."

1. *Art from the World of Islam* 1987, p. 100, no. 168; Komaroff 1994, pp. 12–13, figs. 10a–c; Allan 2002, pp. 34–39, no. 6.
2. As in the *Muʾnis al-ahrar* frontispiece, the woman sits to the right of the man and has a handkerchief in her right hand; here, however, an attendant stands beside her holding a parasol above her head, emphasizing her elevated status.
3. See Komaroff 1994, pp. 28–31. See also chapter 7 above.
4. For a transcription and translation of the inscriptions, see *Art from the World of Islam* 1987, p. 100, no. 168.
5. Allan 2002, pp. 37–38, suggests that the candlestick was made for Abu Ishaq.

163 *Fig. 231*

Bowl

Iran, A.H. 748/A.D. 1347–48
Brass, originally inlaid with silver and gold
Diam. 18.2 cm (7⅛ in.)
Musée des Beaux-Arts, Lyon (E542–22)

Among the most complex compositions rendered in inlaid metalwork is the one on this bowl, which must have been spectacular when its precious metals were still intact.[1] Set within a single uninterrupted band that encircles the vessel is a frieze of powerfully conceived and commanding huntsmen and warriors. The underside of the bowl is inscribed with the date 748 (1347–48). Another, somewhat better preserved bowl in Florence (fig. 232) includes the same figures but arranged in a different order.[2] In fact, the outlines of certain figures, which indicate the original placement of the inlay, are exactly alike on each bowl. Details carried by the inlay may have varied, just as the sequence of figures diverges, producing two related but not duplicate works of art.

Some of the figures are strikingly similar in concept and pose to those in contemporary manuscript illustration. For example, the hunter mounted on a twisting, rearing horse can be compared to the figure of Iskandar in a scene from the Great Mongol *Shahnama* (see fig. 234).[3]

Perhaps both metalworker and manuscript painter worked in a related fashion, using drawings and possibly design books,[4] or else directly copying from earlier works or models.

1. Melikian-Chirvani 1969; Komaroff 1994, pp. 15–19.
2. Curatola 1993, no. 152. The bowl in Florence is slightly smaller than the one in Lyon—17 cm (6¾ in.) in diameter.
3. For another similar composition, see cat. no. 166.
4. Komaroff 1994, pp. 14–20.

164

Fig. 270

Bowl

Turanshah
Iran (perhaps Fars), A.H. 752/A.D. 1351–52
Raised brass, inlaid with silver, gold, and black compound; engraved champlevé technique
H. 11.9 cm (4⅝ in.); diam. 22.7 cm (8⅞ in.)
Victoria and Albert Museum, London (760-1889)

Signed and dated inlaid metalwork objects from the first half of the fourteenth century are usually assigned a southern Iranian origin by comparison with a bowl in the Galleria Estense, Modena, and another in the Hermitage, Saint Petersburg. These are dated 1305 and 1333 respectively and are associated directly with Shiraz, the capital city of Fars.[1] By extension, a number of other bowls depicting sequences of figural images and/or bearing specific epigraphic formulas, such as this basin,[2] dated to 1351–52, have been attributed to the same metalworking school. The attribution has recently been challenged on the grounds of insufficient evidence, although an alternative origin within the Ilkhanid-controlled areas has not as yet been established.[3]

The basin is signed by an otherwise unknown artist who names himself Turanshah, a short form that gives no hint of his origins. The owner of the basin and presumably the patron who commissioned it was a certain Muhammad ibn Muhammad ibn ʿAbd Allah al-Jurjani, whose family originally came from the Gurgan area east of the Caspian Sea. The sequence of horsemen around the main band shows certain scenes that clearly derive from the *Shahnama,* such as a depiction of Faridun and Zahhak, although the general composition seems to be a rather free interpretation of popular epic and courtly themes. Assadullah Souren Melikian-Chirvani has identified six independent scenes with multiple characters arranged in two cycles of three scenes each.[4] Whether it was made for an Ilkhanid or an Injuid patron, this basin is an excellent example of the masterful art of Persian metalworkers.

1. For a different reading of the date on the Modena bowl, see chapter 8 above, n. 73; see also cat. no. 161.
2. Melikian-Chirvani 1982, pp. 223–29, no. 104.
3. Komaroff 1984, pp. 31–50; Komaroff 1994, esp. pp. 32–33, notes 42, 44.
4. Melikian-Chirvani 1982, p. 223.

165

Fig. 246

Polygonal Box

Iran (probably Fars), first half of the 14th century
Brass, inlaid with silver and gold
H. 24.2 cm (9½ in.); diam. 26.9 cm (10⅝ in.)
Musée du Louvre, Paris (3355)

This twelve-sided box with a domed cover, whose distinctive shape is probably based on an architectural form, is lavishly ornamented with inscriptional bands and medallions organized according to a well-established formula.[1] Enclosed within the medallions are armed and mounted warriors and huntsmen, the latter wearing typically Mongol wide-brimmed hats. The Arabic inscriptions offer a series of good wishes, some lines of verse, and a series of royal titles and eulogistic phrases, all of which help to link this object to the province of Fars, in southern Iran.[2] Furthermore, the organization of the decoration, the particular subsidiary motifs (e.g., an interlocking "z" pattern), and the figural and epigraphic styles are all comparable to inlaid metalwork datable to the first half of the fourteenth century and specifically associated with Fars.

1. Melikian-Chirvani 1971a, pp. 376–78, figs. 6–8; Melikian-Chirvani 1982, p. 150, fig. 56; Alexander 1996, vol. 2, p. 133, no. 106.
2. See Melikian-Chirvani 1971a, pp. 389–90, figs. 17, 18, for a transcription of the inscriptions.

166

Fig. 228

Candlestick

Iran, early 14th century
Brass, originally inlaid with silver and gold
H. 20.3 cm (8 in.); diam. 30.5 cm (12 in.)
The Trustees of The National Museums of Scotland, Edinburgh (A. 1909-547)

This candlestick,[1] only the base of which survives, belongs to a group of inlaid brass objects whose energetic and vividly rendered figural compositions often suggest some connection between metalwork and the arts of the book, possibly through the intermediary of drawings. A case in point here is the figure of a huntsman mounted on a rearing horse and striking downward with his sword at a lion. This is related to the mounted huntsman in a small medallion on another candlestick and on a bowl dated 1347 (cat. nos. 162, 163); and all three instances in metal are echoed in an illustration from the Great Mongol *Shahnama* (fig. 234).[2] It is perhaps because most of the inlays have been lost that the strength of the line beneath is revealed in the figural decoration on the candlestick,[3] which helps to relate the gracefully twisting combatant animals, for example, to the medium of drawing (see figs. 225, 226). In fact, the decoration of

the central portion of the candlestick base is a cornucopia of seemingly unrelated designs of animals, both real and imaginary, and mounted huntsmen that are also found in fourteenth- to fifteenth-century drawings.[4]

1. Baer 1983, pp. 151–53, figs. 130, 190, 194.
2. The same figural composition occurs on an unpublished candlestick base in the Georgian State Museum, Tbilisi (A46). See also Komaroff 1994, p. 32, n. 43.
3. The precious-metal inlays generally carried all the details, such as the features and the elements of costume. Once the inlays were lost, what remains are the outlines of the composition, not unlike, perhaps, the preliminary underdrawing of a manuscript illustration; see, e.g., Lentz and Lowry 1989, pp. 342–43, no. 64.
4. See above, chapter 7.

167

Fig. 146

Talismanic Plaque

Iran, 14th century
Bronze
5.8 x 5.7 cm (2¼ x 2¼ in.)
The David Collection, Copenhagen (7/1996)

The inscription, which constitutes the sole ornament on this plaque,[1] is written in reverse in a decorative script known as square Kufic. Beginning at the center and proceeding concentrically, the text reads: "Abu Ishaq the Shaikh, the Guide. May God sanctify his soul." Shaikh Abu Ishaq (963–1033) was the founder of a Sufi order in Kazarun, his birthplace in southern Iran.[2] The Kazaruni order spread eastward by sea to India and China, and is known to have offered protection to sea travelers through the sale of the shaikh's *baraka* (blessing) and of soil from his grave. A traveler would pledge a certain amount of money, payable to the agents of the order upon the traveler's safe arrival at a distant port. This activity was formalized in the early fourteenth century, and it may be that the plaque—possibly a seal or stamp, given its diminutive scale and the fact that the inscription is written in retrograde—was somehow connected with it.

1. Unpublished.
2. See Algar 1978.

168

Fig. 255

Footed Cup

Iran, first half of the 14th century
High-tin bronze, inlaid with silver and gold
H. 12.7 cm (5 in.)
The Trustees of the British Museum, London
(OA 1891.6-23.4)

Footed cups, produced in precious metals in the Mongol period (e.g., cat. nos. 153, 156, 157), were also fabricated of base metal in Ilkhanid Iran.[1] This example, richly embellished with

silver and gold inlays, depicts celebrants, singly and in pairs, enjoying the good life while drinking from cups not unlike the one they decorate.[2] These figures, along with sphinxes and hares, are set against a lush floral background of East Asian inspiration. At the foot of the cup an Arabic inscription offering good wishes to the unnamed owner continues a long tradition in medieval Islamic metalwork. Along with the Chinese-inspired floral decoration, however, the Persian poem inscribed below the rim links this vessel to post-Mongol Iran, when poetry in Persian that makes some reference to the function of the object on which it appears began to supplant Arabic good wishes, or *duʿa*:[3]

> O sweet beverage of our pleasures
> O transparent Fount of Mirth
> If Alexander had not seen you
> O world-revealing bowl of Mani's
> How could his mind have conceived
> The notion of the Fount of Life?[4]

These lines, which are found on several other vessels,[5] can be understood on one level as alluding to the wine that might be drunk from such a cup. At the same time they have a mystical sense that relates to Alexander's search for the Fountain of Life.

1. On vessels of this type dating to the Ilkhanid period, see Melikian-Chirvani 1982, pp. 146, 187–90.
2. Ward 1993, pp. 95, 100, fig. 73.
3. See, e.g., Komaroff 1992, p. 63.
4. Melikian-Chirvani 1982, p. 188, where the Persian text is also transcribed.
5. For other cups inscribed with the same verses, see ibid.

169 *Fig. 211*

Basin

Western Iran, early 14th century
Brass, inlaid with silver, gold, and black compound; engraved champlevé technique
H. 16 cm (6¼ in.); diam. 77.2 cm (30⅜ in.)
Victoria and Albert Museum, London (546-1905)

Examples of the large hand basin with a crenellated rim called in Persian *tasht* or *lagan* are rare in Iranian metalwork,[1] and their production seems to have been limited to the Ilkhanid period. Of the few such basins to survive, this is the most accomplished,[2] together with one in The Metropolitan Museum of Art, New York.[3]

The decoration inside the basin is mostly figural. On the bottom is a large central roundel showing a stylized pool with fish and birds swimming in it. Around this, six smaller roundels are arranged in two sets of three, symmetrically depicting a dragon, a *simurgh* (both of Chinese inspiration), and a figure mounted on a dromedary. The two mounted figures depict different characters: one a woman in a howdah,

the other Bahram Gur hunting with the harpist Azada, a popular scene from the *Shahnama* (see cat. nos. 55, 97). On the lower interior walls are twenty small panels each depicting a wild animal—gazelle, bear, cheetah, and so on. Above these panels is a row of figural scenes illustrating court life under the Ilkhanids, exemplified by their Mongol robes and headdresses. Well-wishing inscriptions in *naskh* and *thuluth* are legible between the panels.

The decorative program may perhaps be read as a series of scenes related to the life of Bahram Gur.[4] It may also be seen more simply, however, as a splendid cross section of royal, literary, and symbolic images that circulated widely in the Ilkhanid period, especially through manuscript illustrations, and that became popular with skilled metalworkers. Despite the present condition of the basin, which has lost most of its gold and silver inlay, it remains one of the most memorable inlaid brasses made under the patronage of the Ilkhanids.

1. An illustration in the *Muʾnis al-ahrar* manuscript of 1341 (cat. no. 9) depicts this type of basin; the associated verse describes it as a *tasht*, whereas a *lagan* is illustrated as a candlestick, perhaps an error on the part of the painter. Melikian-Chirvani 1982, p. 202, calls the present example a *lagan*.
2. Melikian-Chirvani 1982, pp. 202–7, no. 93; Melikian-Chirvani 1997, pls. 12–22.
3. Acc. no. 91.1.521; see *Islamic World* 1987, p. 6. For other examples, see Melikian-Chirvani 1982, pp. 205–6, n. 2.
4. Such is the interpretation by Melikian-Chirvani 1982, p. 203.

170 *Fig. 254*

Incense Burner

Iran, early 14th century
Brass, inlaid with silver and gold
H. 21.5 cm (8½ in.)
The David Collection, Copenhagen (47/1967)

Perfuming the body with the aromatic smoke of burning incense was a common practice in the medieval Islamic world, and numerous bronze and brass incense burners of various types have survived. As the scented fumes rose, the user wafted them by hand in his or her direction.[1] In the thirteenth and fourteenth centuries the most prevalent form of incense burner was of the type shown here: a cylindrical container mounted on three tall feet with a pierced, dome-shaped cover surmounted by a round knobbed finial.[2] While this particular shape was better known in Syria and Egypt, some versions, such as this one, can be ascribed to Iran on the basis of their decoration. The convivial, cup-bearing seated figures enclosed by medallions wear typical Mongol costume; these alternate with medallions showing waterfowl, lotuses, and other aquatic motifs of Far Eastern

inspiration that belong to the artistic idiom of Ilkhanid Iran.

1. See Baer 1983, p. 43.
2. *Art from the World of Islam* 1987, p. 101, no. 170; Folsach 1990, no. 338; Folsach 2001, no. 514.

171 *Fig. 145*

Element from a Window Grille

Western Iran, early 14th century
Brass, inlaid with silver, gold, and black compound
H. 13 cm (5⅛ in.); diam. 9.7 cm (3⅞ in.)
Keir Collection, England (132)

Artistic metalwork production is usually associated with portable vessels, water containers, and basins, but it can also involve door fittings and other types of architecturally related elements. In the decorative program of important buildings erected under the Ilkhanids, richly inlaid metalwork in the shape of ball joints was used to embellish large window grilles. The individual globular elements, with socket extensions above and below and pierced on either side, were suspended at regular intervals along horizontal bars threaded through them and connected vertically by means of rods inserted into the sockets that locked the balls in place. The construction was simple and effective. Unfortunately, owing to the destruction or deterioration of many buildings and to the relative lack of interest in collecting such elements, only a few ball joints are known to have survived. One bears the name of the Ilkhanid sultan Öljeitü (r. 1304–16) and was probably made for his mausoleum at Sultaniyya.[1]

Although the absence of inscriptions makes it impossible to suggest that the present ball joint was also used at Sultaniyya, its early-fourteenth-century date is evident from the background decoration full of peonies and from the Mongol-looking falconer inside two large roundels on the most visible sides.[2] The rider is seen in profile holding the reins in one hand and his bird of prey in the other, while the object of the hunt is indicated by the antelope running between the horse's legs. Surrounding ball joints in the grille would probably have shown other courtly activities, thus providing a complex scene of royal entertainment.

1. Formerly in the Harari Collection, it is now in the Islamic Art Museum in Cairo. Its decoration, unlike that of cat. no. 171, is vegetal and epigraphic, but the dimensions are the same. See Wiet 1933, pp. 45–46, pl. 7; A. U. Pope and Ackerman 1938–77, pl. 1357A. Another ball joint, without inscriptions, is in the Los Angeles County Museum of Art (M73.5.124).
2. Fehérvári 1976, pp. 110–11, no. 132, pl. J. Such window grilles are depicted in Ilkhanid paintings; see an illustration from the Great Mongol *Shahnama* in Grabar and Blair 1980, p. 143, no. 43.

COINS

172–174 Three Gold Coins

172 *Fig. 43*

Dinar of Abesh Khatun

Iran (Shiraz), A.H. 673/A.D. 1274–75
Gold, 9.8 g
Art and History Trust Collection

173 *Fig. 48*

Dinar of Geikhatu

Iran (Tabriz), A.H. 691/A.D. 1291–92
Gold, 4.32 g
Art and History Trust Collection

174 *Fig. 135*

Double Dinar of Öljeitü

Iran (Shiraz), A.H. 714/A.D. 1314–15
Gold, 8.64 g
Art and History Trust Collection

The coinage and other currency issued by the Ilkhanids reflect in large degree the enormous social and economic changes under way in Iran during this period. Under the Mongols women, at least members of the ruling elite, often occupied positions of power and influence. Such is the case with Abesh Khatun (r. 1265–86/87, with interruption), hereditary ruler of Fars in southwestern Iran, who married into the Ilkhanid family to help preserve her own sovereignty and the independence of her kingdom.[1] She is one of the very few women in the history of the Islamic world to strike coins in her own name, as in the gold dinar issued in 1274–75 in her capital, Shiraz (cat. no. 172).[2]

In order to replenish the state's empty treasury, paper money was issued for the first time in Iran during the reign of Geikhatu (1291–95), as a stopgap measure, based on the Chinese model of the *chao* (see cat. no. 198). The plan was disastrous for the economy and had to be rescinded.[3] Gold dinars were, however, issued in Geikhatu's name prior to his ill-fated monetary reform. This example (cat. no. 173) was struck in the capital, Tabriz, in the first year of his reign.[4]

Geikhatu's reign and especially that of his successor Baidu (1295) were short-lived. The brilliant ruler and reformer Ghazan, who established Islam as the official religion of the realm and reorganized Iran's monetary system, followed them. The standard gold coinage issued under Ghazan continued during the reign of his brother, Öljeitü (r. 1304–16), whose coins not only reflect the newly enacted monetary reforms but also his own changing religious

beliefs. In 1308 Öljeitü converted from Sunni to Shi'ite Islam, and the double dinar (cat. no. 174) struck in 714/1314–15 illustrates his new persuasion.[5] It is inscribed on the obverse with the expanded Shi'ite proclamation of faith: "There is no god but God. Muhammad is the messenger of God. 'Ali is the friend of God."[6]

1. See Lambton 1988, pp. 272–75; Soudavar 1992, p. 32.
2. Soudavar 1992, p. 32, no. 4. Abesh Khatun's daughter was appointed governor of Fars during the reign of the Ilkhanid Abu Sa'id (1316–35); see ibid., p. 52, n. 17.
3. See Jahn 1970. See also Charles Melville's essay, chapter 2 above.
4. Soudavar 1992, p. 33, no. 6.
5. Ibid., p. 33, no. 8.
6. See Blair 1983; Soudavar 1992, p. 33. See also Sheila Blair's essay, chapter 5 above.

WOODWORK

175 *Fig. 157*

Koran Box

Al-Hasan ibn Qutlumak ibn Fakhr al-Din
Northwestern Iran, shortly after A.H. mid-Rajab 745/A.D. November 1344
Carved, painted, and assembled wood boards, bronze hinges
25 x 43.2 x 43.2 cm (9⅞ x 17 x 17 in.)
The al-Sabah Collection, Dar al-Athar al-Islamiyyah, Kuwait National Museum (LNS 35W)

This large box, constructed to hold a multi-volume Koran manuscript endowed by a certain 'Izz al-Din Malik ibn Nasir Allah Muhammad, was made for the tomb of the deceased Fakhr al-Din by his own grandson.[1] The box, a rare survival from this early period, is elaborately carved on its four sides as well as on the lid with calligraphic inscriptions set against a vegetal background, revealing much information about its patronage and dating. Thus we learn that the late Fakhr al-Din, the last element of whose name as inscribed seems to read "Choban,"[2] passed away in mid-Rajab of the Muslim year 745 (late November 1344) and that the box with its contents must be placed in his mausoleum for eternity. The connection between the deceased and the patron of this Koran and of its box, 'Izz al-Din, is not indicated, although their names do not suggest that they were related. The craftsman, on the other hand, states that he was the dead man's grandson, naming himself "Hasan, the son of Qutlumak, the son of the late Fakhr al-Din."

The historical information is provided in the medallion on the lid and in the rectangular compartments and the square corners around its perimeter. The larger and more refined calligraphy in *thuluth* on the sides, which are mitered or

dovetailed, includes the Koran's sura 3, verses 18 and 19. The entire box was once painted with bright colors, residues of which are still visible. The interior is divided into five compartments, a central square surrounded by four rectangular sections that would have contained the Koran volumes.

1. M. Jenkins 1983a, p. 110; Atil 1990, pp. 213–14, no. 71.
2. The Chobanid family had an important historical role during and soon after the period of the Ilkhanid ruler Abu Sa'id. Amir Choban was one of the most powerful figures during the first ten years of Abu Sa'id's reign, and family members ruled over parts of Azerbaijan, Anatolia, and Iraq until the death of Choban's grandson, Malek Ashraf, in 1357. See Melville and Zaryab 1992.

176 *Fig. 159*

Koran Stand

Hasan ibn Sulaiman al-Isfahani
Iran or Central Asia, A.H. Dhu al-Hijja 761/
A.D. October–November 1360
Wood, carved and inlaid
130.2 x 41 cm (51¼ x 16⅛ in.)
The Metropolitan Museum of Art, New York, Rogers Fund, 1910 (10.218)

Perhaps because of the relative scarcity of wood in large parts of the Islamic world, Muslim woodcarvers with highly developed skills achieved special renown, and it was not uncommon for them to sign their work, as is the case with this Koran stand, or *rahla*.[1] The signature of its maker, Hasan ibn Sulaiman al-Isfahani, includes a type of geographic suffix known as a *nisba* that suggests he came from the Iranian city of Isfahan, although the stand itself may have been made elsewhere in Iran or even Central Asia.[2] Other inscriptions on the stand provide additional information, namely its date and the name of the patron who had it made for a madrasa, or theological college. Although the inscriptions do not indicate where this was located, it may well have been a Shi'ite school, since the richly carved calligraphy within a niche above the cypress tree that decorates each side calls for blessings upon the Prophet and the Twelve Imams.[3] The upper sections of the stand are decorated with the word "Allah" repeated four times so that the initial letters *alif* interlock to create an X-shaped design; this is set against a deeply carved arabesque ground.

Koran stands were a common furnishing in mosques and other places of worship; in fact, two are depicted in use in an Ilkhanid painting of the early fourteenth century (cat. no. 31).

1. Lentz and Lowry 1989, p. 330, no. 9; Crowe 1992, pp. 174–76, fig. 7. See also Mayer 1958, pp. 11–19, 40.

2. Bernard O'Kane has proposed an attribution to Iran, based on the shallow carved relief of the vegetal designs at the top of the stand, which he relates to other fourteenth-century Iranian woodcarving (memorandum, Metropolitan Museum, Islamic Department files, 1995). The Koran stand has in the past been ascribed on stylistic grounds to Central Asia, e.g., Lentz and Lowry 1989, p. 330, no. 9.

3. On Shi'ism in fourteenth-century Iran, see Sheila Blair's essay, chapter 5 above.

WORKS FROM CHINA AND MONGOLIA

177 *Fig. 24*

Six Horses

China, late 12th or early 13th century
and 14th century
Handscroll, ink and color on paper
47 x 167 cm (18½ x 65¾ in.)
The Metropolitan Museum of Art, New York,
Bequest of John M. Crawford Jr., 1988
(1989.363.5)

The first half (right side) of this extensive handscroll dates to the late twelfth or early thirteenth century, a period when China was ruled by the Jin dynasty (1115–1234), nomadic tribesmen from Manchuria.[1] By an unidentified artist, the painting sympathetically presents three nomads and their horses in a simple landscape; the three are perhaps having a respite from the hunt, as the central figure has a falcon on his arm. The second half (left side) of the scroll, painted as though it were part of a continuous composition, is the work of a later artist of the Yuan dynasty (1271–1368), also unidentified.[2] It depicts in a bolder, more penetrating fashion two horses grazing beside a tree and a Mongol mounted bareback; the latter seems to play with an archer's ring on his thumb in a distracted manner, again suggestive of a break from the hunt. Although there was a long tradition of depicting horses, in sculpture and especially in painting, in China prior to the Mongol period, the horse as celebrated in this handscroll was essential to the success of the Mongol army and of previous invading nomadic forces. The easy familiarity with which the rider sits astride his mount, looking back toward the two other horses, suggests the indispensable and intimate nature of the Mongol relationship with horses.

1. Fong 1992, p. 189, pl. 25.
2. Ibid., p. 436, pl. 25a.

178 *Figs. 6, 15*

Mongol Rider with Administrator

China, Yuan dynasty (1271–1368)
Color on silk
34.3 x 45.3 (13½ x 17⅞ in.)
Art and History Trust, Courtesy of the Arthur M.
Sackler Gallery, Smithsonian Institution,
Washington, D.C. (LTS 1995.2.7)

This painting, which is perhaps a fragment of a larger scroll, depicts two realistically and sensitively portrayed riders.[1] The one in the foreground is armed with bow and arrows; completely swathed in fur, with only his upper face visible, he is hunched forward in the saddle, conveying an impression of extreme cold. Beyond him the second rider, his horse slightly in the lead, sits erect, wrapped in a voluminous cloak and boldly staring outward at the viewer. Neither his clothes nor his features are Chinese; rather, he may represent a nomad of the steppes. Both figures and their mounts are richly turned out, suggesting their affluence and importance. It has been suggested that the fur-clad rider, a Mongol, is traveling in the company of an administrator, possibly a tax collector, of Persian or Central Asian origin.[2] Regardless of their precise identities, this carefully detailed painting gives a sense both of the material wealth of the Mongol elite and of the harsh climate of the winter steppe.

1. Soudavar 1992, p. 30, no. 1.
2. Ibid.

179 *Fig. 66*

Textile with *Djeiran* in a Landscape

China, Jin dynasty (1115–1234)
Tabby, brocaded; silk and gold thread
109.8 x 38.5 cm (43¼ x 15⅛ in.)
The Cleveland Museum of Art, Purchase from the
J. H. Wade Fund (1991.4)

The compact image of a gold-brocaded recumbent *djeiran* (a Central Asian antelope, shown here with wings) set in a dense floral landscape, its head turned back and gazing up at a full moon amid clouds, is repeated on this textile in staggered rows with alternating orientations.[1] The scene has been identified as one from popular Chinese literature, although the composition of the recumbent *djeiran,* gazing back and up (see cat. no. 195), may have ultimately been derived from similar motifs in silver, from the Iranian world.[2] A closely related motif, with a deer instead of an antelope, was introduced into that world in the Mongol period, as is indicated by decorated tiles from the palace at Takht-i Sulaiman (cat. nos. 87, 89). Jin textiles such as this may have served as the intermediary. They may also have inspired the general color scheme

of the tiles (gold on dark blue or turquoise) and the idea of using such a gold-figured pattern on a solid ground to cover a large surface.[3] That textiles incorporating the motif were known in Iran, either as imports or copies, is demonstrated in a scene from the Great Mongol *Shahnama* (cat. no. 55): the protagonist, Bahram Gur, wears a robe with a gold design showing a recumbent deer, its head turned back, set amid foliage.[4]

1. Wardwell 1992–93, pp. 244–46, fig. 4; Watt and Wardwell 1997, pp. 114–15, no. 29; Watt 1998, p. 74, fig. 3.
2. See Watt and Wardwell 1997, pp. 114–15. The cow of Wu, which mistakes the moon for the sun, was apparently substituted for the *djeiran* by some Chinese authors; ibid. Interestingly, a silk and gold Chinese brocade in the Textile Traces Collection (no. T-0198), Los Angeles, presents a detailed vignette of a recumbent cow in a landscape with a crescent moon above.
3. See Linda Komaroff's essay, chapter 7 above. On the motif of the deer amid foliage in Jin art, see James Watt, chapter 3 above.
4. Two other fragments with the same design, one on a red ground, the other on a gold, were in the collection of the late Krishna Riboud; see Riboud 1995, pp. 97–99, figs. 13, 15, 18.

180 *Fig. 207*

Textile with Phoenixes Soaring amid Clouds

China, Jin dynasty (1115–1234)
Tabby, brocaded; silk and gold thread
56.2 x 62.1 cm (22⅛ x 24½ in.)
The Cleveland Museum of Art,
John L. Severance Fund (1994.292)

The soaring bird with lavish tail feathers, brocaded in gold and repeated in staggered rows alternately oriented on this textile,[1] is probably to be identified as the Chinese mythical bird, the *fenghuang,* which has come to be associated with the phoenix of Western legend.[2] Introduced into Iran under the Ilkhanids, the motif was reproduced in a variety of media, especially in ceramics (see cat. nos. 133, 134). Textiles such as this, which were probably exported to Iran, may have helped to effect the transmission westward. Certain tiles from Takht-i Sulaiman decorated with the image of the phoenix bear close comparison with this textile in terms of style and the gold-on-blue color scheme (see cat. nos. 83, 84).[3]

1. Watt and Wardwell 1997, pp. 118–19, no. 31.
2. For the phoenix in Chinese art, see Rawson 1984, pp. 99–107.
3. For another silk fragment of the same type in the collection of the late Krishna Riboud, see Riboud 1995, p. 95.

181

Textile with Coiled Dragons

Fig. 202

China, Jin Dynasty (1115–1234)
Tabby, brocaded; silk and gold thread
74.5 x 33.2 cm (29⅜ x 13⅛ in.)
The Metropolitan Museum of Art, New York, Gift
of Lisbet Holmes, 1989 (1989.205)

Prizing the productions of Central Asian and
Islamic weavers, the Mongols developed at least
three settlements of textile workers at the begin-
ning of their rule.[1] This resulted in a fruitful
exchange of motifs and techniques among Central
Asian, Muslim, Uyghur, and Chinese craftsmen.

The gold-brocaded motif of a coiled dragon
chasing a pearl, repeated on this textile in stag-
gered rows against a red background,[2] dates
from the early Jin dynasty. The dragon with the
pearl, probably of Central Asian origin, has been
associated with Chinese literature of the Han
period (206 B.C.–A.D. 220) and appeared on
objects in the Tang dynasty (618–907).[3] Typical
of Jin textiles, the design here has no borders;
the selvage is preserved on the left side, where
the motif appears to be interrupted. Textiles
such as this may have helped to transmit the
motif of the dragon to the Iranian world in the
second half of the thirteenth century, when it
began to make its appearance there in a variety
of media.

1. Rossabi 1997, pp. 14–15. See also James Watt's essay,
 chapter 3 above.
2. Watt and Wardwell 1997, pp. 116–17, no. 30.
3. Ibid., p. 116.

182

Textile with Griffins

Fig. 20

China, Yuan dynasty (1271–1368)
Lampas weave, silk
118 x 204 cm (46½ x 80⅜ in.)
Inner Mongolia Museum, Hohhot

The Mongols went to great lengths to acquire
luxury textiles and to control their sources.
Under Genghis Khan (d. 1227) and his son and
successor Ögödei (r. 1229–41), three centers of
textile production were established along the
southern perimeter of the Mongol homeland
through the forced relocation of workers. Many
of these were conscripted from eastern Iranian
cities such as Herat, in Khurasan, which had
been renowned for its silk and gold cloth.[1] The
resulting blend of motifs and styles is docu-
mented by textiles such as this remarkable
panel, which was part of a hoard discovered in
1976 in a large ceramic jar, along with seven
other silks, at the site of the Yuan city Jininglu,
in Inner Mongolia.[2]

The main decoration is a repeat design of
lobed medallions enclosing a pair of rampant

addorsed griffins with heads turned back to face
one another. The medallions are set against a
pattern of hexagons each bearing a rosette
formed from seven circles. While the griffin is a
motif better known in West rather than East
Asian art, here the creatures have been given
curvaceous, scroll-like wings and tails that sug-
gest an influence east of the Iranian world.[3]
The hexagon-patterned ground is particularly
significant, as such hexagons and especially
rosettes constituted one of the hallmarks of
late-twelfth- and early-thirteenth-century inlaid
metalwork from Khurasan and possibly Herat,
up to the Mongol invasions.[4] The borders,
which were woven in one piece with the main
pattern, are decorated with a scrolling peony
design and are more in keeping with East Asian
artistic tradition.

1. Allsen 1997a, pp. 38–45; Rossabi 1997, pp. 14–15.
2. *Treasures on Grassland* 2000, p. 250. We are grateful to
 Nobuko Kajitani, Conservator in Charge, Textile
 Conservation Department, The Metropolitan
 Museum of Art, for help with technical information
 on this textile.
3. For paired griffins on a silk and gold cloth in the
 Metropolitan Museum, which has been ascribed to the
 eastern Iranian world, see Watt and Wardwell 1997,
 pp. 156–57, no. 44. These griffins are depicted in a
 stiffly symmetrical manner in contrast to the sinuous
 and more gracefully rendered creatures on the
 Hohhot textile. Related motifs also occur in Mamluk
 textiles; see, e.g., *Museum für Islamische Kunst* 1980,
 pp. 80–81, no. 34.
4. As on certain large candlesticks, in which the hexa-
 gons are worked in repoussé. See, e.g., Atil, Chase,
 and Jett 1985, figs. 36–38.

183

Textile with Dragons and Phoenixes

Fig. 206

China, Yuan dynasty (1271–1368)
Lampas weave (twill and twill); silk and gold
thread
20.3 x 20.3 cm (8 x 8 in.)
The Cleveland Museum of Art, Edward L.
Whittemore Fund (1995.73)

Although it has obviously been cut down from a
larger piece of cloth, this textile is sufficiently
well preserved to enable its pattern, in gold on
a blue ground, to be reconstructed:[1] staggered
rows of medallions, on a background of small
hexagons, enclose alternately a dragon chasing
a flaming pearl or a soaring phoenix.[2] Both the
dragon (*long*) and the phoenix (*fenghuang*), each
with various meanings and associations, have a
long history as decorative motifs in Chinese
art.[3] When the two were paired together, how-
ever, they became symbols of imperial sover-
eignty, which under the Yuan dynasty came to be
reserved for the specific use of the emperor and
his family. The same royal symbolism is proba-
bly reflected in the Chinese-inspired dragon and
phoenix motifs frequently found on tiles from

Takht-i Sulaiman (see cat. nos. 83, 84, 99–101)
which in concept and design may have been
derived from imported Chinese textiles.[4]

1. Watt and Wardwell 1997, p. 153, no. 42; Watt 1998,
 p. 77, fig. 9.
2. For a cloud collar fabricated of cloth in a very similar
 but not identical structure, using the same pattern but
 in gold on a red ground, see Watt and Wardwell 1997,
 p. 132, fig. 57.
3. See Rawson 1984, pp. 93–107.
4. See Tomoko Masuya's essay, chapter 4 above.

184

Canopy with Phoenixes

Fig. 210

China, Yuan dynasty (1271–1368)
Embroidery, silk and gold thread
143 x 135 cm (56¼ x 53⅛ in.)
The Metropolitan Museum of Art, New York,
Purchase, Amalia Lacroze de Fortabat Gift, Louis V.
Bell and Rogers Funds, and Lita Annenberg Hazen
Charitable Trust Gift, in honor of Ambassador
Walter H. Annenberg, 1988 (1988.82)
New York only

The lavish use of gold in this embroidery, fur-
ther enhanced by the especially thick paper sub-
strate for the gold threads, which gives the areas
in which they are used a relieflike effect, no
doubt reflects the Mongol taste for luxury tex-
tiles.[1] At the center of the canopy, distinguished
by their different sets of tail feathers, is a pair of
phoenixes in flight toward one another. The
birds' curved wings and elaborate plumage cre-
ate a dynamic radial composition, which was
evidently popular under the Yuan dynasty as it
was rendered in more than one medium. The
same motif, framed by a lobed medallion, was
carved in relief on a Yuan-period stone slab
found at Dadu (Beijing), while similar figures
occur in more portable form: on a small carved
lacquer tray (cat. no. 203) dated to the Southern
Song dynasty (1127–1279); and on two blue-
and-white Chinese porcelain dishes,[2] said to
date to the fourteenth century, from the Ardabil
Shrine, Iran. The same type of design is found
in early-fourteenth-century Iran among the so-
called Sultanabad wares (see cat. nos. 133, 134),
where it seems likely to have been derived from
the Chinese motif, with textiles such as this
embroidered canopy serving as a means of
transmission.

1. Watt and Wardwell 1997, pp. 196–99, no. 60.
2. See Rawson 1984, figs. 82, 86; see also J. A. Pope
 1981, pls. 17, 21. Watt and Wardwell 1997, p. 196,
 view this composition as an innovation of the Yuan
 period and suggest that the phoenixes represent two
 different "species," although they note the presence of
 the design in an early-twelfth-century illustrated Song
 encyclopedic work on architecture and architectural
 decoration, *Yingzao fashi*. For a different interpretation
 of the two phoenixes, as male and female, including
 examples that are said to predate the Yuan period, see
 Rawson 1984, p. 100.

185

Figs. 125, 126

Mandala with Imperial Portraits

China, Yuan dynasty (1271–1368), ca. 1330–32
Silk tapestry (*kesi*)
245.5 x 209 cm (96⅝ in. x 82¼ in.)
The Metropolitan Museum of Art, New York,
Purchase, Lila Acheson Wallace Gift, 1992
(1992.54)
New York only

The mandala,[1] following Buddhist conventions, represents the cosmic and sacred realm where the deity at the center (here Yamantaka, also known as Vajrabhairava), the ultimate subject of meditation, is surrounded by symbols of the spiritual stages that the devotee must pass through in order to reach the center or attain enlightenment. The overall decoration of the mandala is detailed and complex. The donors are represented in the lower corners and can be identified by the Tibetan inscriptions above their portraits: (at left) Yuan emperor Togh Temür (r. 1328–32), who was the great-great-grandson of Khubilai Khan and reigned as Emperor Wenzong, and his brother Khoshila (reigned briefly in 1329); (at right) Budashiri and Babusha, their respective consorts.

Kesi, or silk tapestry, was used for various purposes under the different Chinese dynasties—as covers for handscroll paintings, furnishings, clothing, footwear, and headgear. The Southern Song period (1127–1279) was, for instance, renowned for *kesi* that reproduced contemporary court paintings. In the Yuan period woven images were thought to exhibit greater skill than painted ones, and from 1294 onward imperial portraits were commissioned as paintings so that they could be converted into woven silk. Orders were also given for the painting and weaving of imperial portraits as part of mandalas under the supervision of the Superintendency for Buddhist Icons. These would have been placed in the portrait hall of a temple complex where portraits of an emperor and his consort were housed and where religious rites honoring the deceased emperor and empress were conducted.[2] The image of Togh Temür in this mandala appears to be based on a silk portrait of him in the Collection of the National Museum, Taipei. While more than one copy of the *kesi* was made, cat. no. 185 is the only complete example from the Mongol empire of this distinctive type of imperial commission.

1. Watt and Wardwell 1997, pp. 95–100, no. 25. For more detail on the iconography of the mandala, see ibid., p. 100.
2. Ibid., pp. 60–61.

186

Fig. 25

Textile with Paired Parrots

China or Mongolia, 13th–14th century
Tabby, brocaded; silk and gold thread
61.2 x 54 cm (24⅛ x 21¼ in.)
Art and History Trust, Courtesy of the Arthur M. Sackler Gallery, Smithsonian Institution, Washington, D.C. (LTS 1995.2.8)
Los Angeles only

Brocaded in gold against a light green ground, the design of this sumptuous textile consists of paired confronted parrots enclosed by lobed medallions that alternate with smaller four-lobed cartouches each bearing a stylized flower.[1] The meandering-cloud motif that fills the background adds to the richness of the pattern.

This brocade demonstrates a fusion in textile art and its technology that came about as a direct consequence of the Mongol invasions of eastern and western Asia and the subsequent relocation of textile workers from both the Iranian world and China.[2] On technical grounds, the textile can be associated with a group of tabby-weave silks brocaded with gold and silk ascribed to twelfth- and thirteenth-century China (cat. nos. 179–181). The eclectic nature of the decoration, however, suggests a dating in the Mongol period (see cat. no. 182). The overall density of the decoration indicates Islamic influence, as do specific design elements such as the vegetal device between the confronted parrots, which in Islamic art, including textiles and ceramics, is often a transformation of the birds' wattles into a stylized tree (see cat. no. 73, where the paired roosters are similarly separated).[3] Other sections of the pattern reflect East Asian forms, the cloud bands, for example, and the four-lobed cartouches; the latter are reminiscent of designs on thirteenth-to fourteenth-century goldwork (see cat. nos. 137, 201).

1. This is one of three unpublished fragments from the same piece of cloth. Another fragment is in the Brooklyn Museum of Art (1992.81), while another belonged to the late Krishna Riboud. We are grateful to Francesca Galloway for this information.
2. Rossabi 1997, pp. 14–15.
3. See, e.g., several tenth- to twelfth-century Persian or Iraqi textiles in the Abegg-Stiftung, Riggisberg; Otavsky and Salim 1995, pp. 117–21, 130–36, nos. 72, 73, 78–80.

187

Fig. 203

Textile with Phoenixes on a Field of Flowers

Eastern Central Asia, 13th century
Silk tapestry (*kesi*); silk and gold thread
55.9 x 33 cm (22 x 13 in.)
Textile Traces Collection, Los Angeles (T-0292)

Kesi, or tapestry-woven textiles, make up an important class of luxury fabrics that represents a developing area of research in the field of Asian textiles.[1] This fragment,[2] depicting brilliantly colored phoenixes (perhaps male and female) against a background of flowers, may belong to a recently defined group of *kesi* that have been associated with Central Asia. Many of these textiles are characterized by the representation of real and mythical animals and birds on a varied floral ground of unevenly sized and spaced elements and by a boldly imaginative color scheme.[3] It has been suggested that these *kesi* may have been used originally as garments of the type woven by the Uyghur, as described in a twelfth-century Southern Song source.[4] Designs depicted on the Central Asian *kesi,* including the soaring phoenix with elaborate tail feathers, found their way into the arts of western Asia in the aftermath of the Mongol invasions (see, e.g., cat. nos. 99, 103, 133, 134), and perhaps textiles such as this played some role in the transmission process.[5]

1. See Watt and Wardwell 1997, pp. 53ff.
2. Unpublished.
3. Most, like cat. no. 187, are relatively small, rectangular fragments, evidently cut down from larger pieces of cloth; Watt and Wardwell 1997, pp. 53–54. Compare this example with fig. 213 above.
4. Ibid., pp. 54, 61.
5. See Linda Komaroff's essay, chapter 7 above.

188–190 Three Architectural Elements

China (Inner Mongolia), Yuan dynasty (1271–1368)
Glazed earthenware
Inner Mongolia Museum, Hohhot

188

Fig. 105

Roof Tile

21.5 x 10 cm (8½ x 4 in.)

189

Fig. 83

Two Roundels

Diam. each 12 cm (4¼ in.)

190

Fig. 22

Dragon Mask

H. 29 cm (11⅜ in.)

Tiles were elements of traditional Chinese architecture as early as the Zhou dynasty (1122–256 B.C.).[1] The triangular-shaped roof tile, *dishui* (cat. no. 188), found in Jininglu, was placed at the end of a row of flat roof tiles at the eaves, where it served a functional purpose as a channel for rainwater; the largely decorative roundel, or *goutou* (cat. no. 189), was inserted,

again at the eaves, at the end of a row of hemispherical roof tiles.[2] This roof tile and the two roundels are decorated with a dragon motif molded in relief and are glazed in three colors (*sarcai*) with green, yellow, and cream glazes. Additional sculptural elements adorned the ridge ends of the roof. Typically, a group of running animal figures on the descending ridges was flanked at either end by two animal masks such as the dragon mask (cat. no. 190),[3] placed on the corner rafter and on the ridge. These masks served as auspicious or guardian symbols, and their number on the roof corners also denoted the owner's social rank.

Dragon and phoenix motifs on *dishui* and *goutou* became popular in China after the Yuan dynasty, although some examples are known from the pre-Mongol periods of the Liao (907–1125) and Jin (1115–1234), continuing through the Ming and Qing dynasties (together, 1368–1911).[4] The dragon motif was especially common on tiles produced during the Yuan period, and examples have been excavated in various Mongol cities such as Dadu, Khara Khorum, and Shangdu.[5]

1. L. G. Liu 1989, p. 20.
2. Both unpublished.
3. Unpublished.
4. Masuya 1997, pp. 574–75.
5. Kiselev 1965, table XXXI, pl. 187; Masuya 1997, p. 722, chart XX.

191 *Fig. 128*

Plate with Coiled Dragon

China, Yuan dynasty (1271–1368), 14th century
Porcelain, with celadon glaze and biscuit
Diam. 43.2 cm (17 in.)
The Cleveland Museum of Art, John L. Severance Fund (1961.92)

A variation in the production of celadon-glazed porcelain in the Yuan period is a ware that shows a distinctive contrast between the pale green glaze and the brown hue of the biscuit in which the main decorative motifs are raised. Large plates, such as the present one,[1] were particularly suited for bold depictions of creatures typical of the potter's repertoire, including cranes, dragons, phoenixes, and fish, in addition to human figures.[2] The coiled dragon here, a rather menacing beast, is surrounded by five small clouds in biscuit, a wave pattern incised under the glaze, and five-petaled rosettes in biscuit around the rim. The smallest cloud, in front of the dragon's open mouth, may also represent the flaming pearl that would complete its customary iconography in this period (see cat. no. 192).

1. Lee and W. Ho 1968, no. 82.
2. Ibid., nos. 74–83.

192 *Fig. 18*

Stem Cup with Dragon

China, Yuan dynasty (1271–1368)
Porcelain, underglaze painted
H. 11.8 cm (4⅝ in.); diam. 13.3 cm (5¼ in.)
The Cleveland Museum of Art, Severance and Greta Millikin Collection (1964.169)

The appearance of the stem cup among Chinese ceramics may coincide with the introduction of blue-and-white porcelain around the second quarter of the fourteenth century. This kind of small vessel, possibly an imported shape, seems to have been made for domestic use rather than for the export market in blue-and-white porcelain (see, e.g., cat. no. 193).[1] The inside of such cups is typically decorated with a floral spray; in the present example this takes the form of a stylized six-petaled flower. The exterior of the stem cup characteristically bears a vigorously painted dragon chasing after a flaming pearl.[2] The latter motif is also found in Ilkhanid art, particularly among the decorated tiles associated with the palace complex at Takht-i Sulaiman (see cat. nos. 91, 93, 100–102).

1. Medley 1986, pp. 187–89.
2. Lee and W. Ho 1968, no. 130; Medley 1986, fig. 139.

193 *Fig. 17*

Wine Jar with Lion-Head Handles

China, Yuan dynasty (1271–1368)
Porcelain, underglaze painted
39.4 x 37.5 cm (15½ x 14¾ in.)
The Cleveland Museum of Art, John L. Severance Fund (1962.154)

Underglaze painted porcelain using cobalt as a blue colorant is generally believed to be the great innovation of the Yuan period. Kashan, the most important Iranian center of ceramic production in the Middle Ages, is one likely source for the ore, which was probably exported to China by Persian merchants via sea routes. In fact, it is generally held that the introduction and rise of cobalt-blue-decorated porcelain in China around the second quarter of the fourteenth century was due to the import of foreign tastes and goods and to the profitability of the export market.[1] Objects such as this wine jar were evidently made for the overseas market, including Iran.[2] Their main impact on Persian art postdates the Mongol era, belonging instead primarily to the later fourteenth and fifteenth centuries. Such Yuan blue-and-white wares are relevant nonetheless to the history of Ilkhanid art not only because they indicate that there was also a west–east avenue for the transmission of artistic ideas and techniques, but also because they demonstrate a shared artistic

vocabulary. Examples here are the cloud-collar motif, disengaged into quarters on the shoulder of the jar, and the band of soaring phoenixes, each set against a floral ground, that circles the body (see cat. nos. 112, 133, 134).

1. See Medley 1974, pp. 32–34; Fong and Watt 1996, p. 431.
2. Lee and W. Ho 1968, no. 156; Medley 1974, p. 55, pl. 45B. For the same or similar types of closed shapes and related decoration, see J. A. Pope 1956, pls. 25–28.

194 *Fig. 240*

Vase

China, Yuan dynasty (1271–1368)
Stoneware, molded decoration, Longquan celadon ware
H. 50.4 cm (19⅞ in.)
Inner Mongolia Museum, Hohhot

This large, robust vessel, which was unearthed near Hohhot,[1] can be ascribed to the Yuan dynasty on the basis in part of numerous formal and stylistic analogies with a well-known vase dated 1327 in the Percival David Foundation Collection, London.[2] Both vases are decorated with bold floral motifs on the neck and scrolling blossoms on the body, and each has a distinctive, wide, trumpetlike mouth, which is said to be particular to so-called Longquan celadons in this period. The term Longquan is used to describe a type of celadon ware produced in the Longquan district, in what is now the modern province of Chekiang, in southern China. Under the Yuan Longquan wares were widely exported throughout Asia, and their distinctive gray-green coloring and petal-like molding, as on the base of this vase, were frequently imitated in Ilkhanid Iran (see cat. nos. 132–34).

1. *Cao yuan wen hua* 1996, p. 238, no. 299.
2. See Medley 1974, pp. 65–66, pl. 58.

195 *Fig. 67*

Mirror Stand

China, Song, Jin, or Yuan dynasty,
12th–14th century
Gilt bronze
L. 27 cm (10⅝ in.)
Victoria and Albert Museum, London (M.737-1910)

The motif of the *djeiran* (a Central Asian antelope) seen in profile so that its two horns appear as one became popular in China on the back of bronze mirrors in the Jin period (1115–1234) and survived well into the Yuan. The seventh-century origins of the motif, however, can be traced back to Sogdian Central Asia, whence it traveled east. In China the antelope, originally

reclining amid foliage, became associated with the sun or moon supported by clouds, a composition that is generally known as "a *xiniu* gazing at the moon," the *xiniu* being a rhinoceros.[1] This may well have been the original Central Asian meaning of the image. In Islamic bestiaries and cosmographies, the rhinoceros is one of several creatures with a single horn; these include gazelle- or antelopelike animals with their heads seen in profile—two horns becoming one—such as the *harish* and the *shah-davar*.[2] Such antecedents probably contributed to the lore and myth of the unicorn that later developed in Europe.

This exquisite gilt-bronze mirror stand portrays the *djeiran* in its customary reclining position, though the figure is rendered in a more dynamic manner than usual, with a bent foreleg and the head turned backward, showing a single horn.[3] The spray of clouds on its back once provided the base for the circular mirror, now lost, which symbolized the sun or the moon, thus completing the poetic image of the *xiniu* gazing at the moon.

1. See Watt and Wardwell 1997, pp. 114–15.
2. For an important study of the unicorn in Islamic iconography, see Ettinghausen 1950. Al-Qazvini in his *Wonders of Creation* (cat. nos. 14–16) includes three other wild animals with a single horn in addition to the *harish* and the *shah-davar:* the rhinoceros (*karkadann*), a type of hare called *miʿraj*, and the narwhal (*quqi*); see Carboni 1992, pp. 231, 237–38, 351, 353.
3. Kerr 1990, p. 100, fig. 87; Kerr 1991, pp. 142–43; Watt and Wardwell 1997, p. 114, fig. 46.

196 *Fig. 61*

Footed Cup

China, Yuan dynasty (1271–1368)
Gold
H. 14.5 cm (5¾ in.); diam. 11.4 cm (4½ in.)
Inner Mongolia Museum, Hohhot

Footed cups of assorted shapes and sizes seem to have enjoyed great popularity throughout the Mongol empire, as such vessels, presumably for wine, were produced in precious and base metals as well as in porcelain (see cat. nos. 153, 156, 157, 168, 192). Various footed cups are represented in several of the enthronement scenes associated with the *Jamiʿ al-tavarikh* that depict the Mongol court. In one instance (cat. no. 19), a clear distinction seems to have been made among the cups being carried forward on a table; some are painted gold and others white, the latter perhaps intended to suggest porcelain. Tall footed cups such as the present one, which was discovered in Inner Mongolia,[1] are also on occasion represented among Ilkhanid scenes of the Mongol court,[2] while the same manner of vessel was evidently prevalent among the Golden Horde, to judge by the examples found within their territories.[3]

1. Zhang Jingming and Zhao Aijun 1999, p. 52, pl. i, 2.
2. An illustration in the Diez Albums (fol. 70, S. 11) shows one such cup with a cover on the table, while a woman seated just to the right of the table seems to hold a similar cup; see Rührdanz 1997, pl. 3 (right-hand page).
3. *Golden Horde* 2000, nos. 7, 8, 42–45, 56.

197 *Fig. 69*

Paiza (Passport)

China, Yuan dynasty (1271–1368),
late 13th century
Cast iron, inlaid with silver
H. 18.1 cm (7⅛ in.)
The Metropolitan Museum of Art, New York,
Purchase, Bequest of Dorothy Graham Bennett,
1993 (1993.256)

Developed as early as the reign of Genghis Khan (1206–27), the *paiza* was made in different shapes, though mostly circular or rectangular (see cat. no. 154), and in different metals, mainly iron, gold, or silver. The recent discovery of a gold *paiza* from the Liao period (907–1125) has shown that this article was known before the Mongols made ubiquitous use of it.[1]

The present example, probably issued during the reign of Khubilai Khan (1260–94), is made of iron with inscriptions inlaid on both sides in silver.[2] The characters are in the so-called Phagspa script, which was developed by the eponymous Tibetan monk (1235–1280), an adviser to Khubilai. In translation, the inscriptions read: "By the strength of Eternal heaven, an edict of the Emperor [Khan]. He who has no respect shall be guilty." A Mongol on an official mission or an important foreign diplomat or visitor would have carried this type of safe-conduct pass throughout Asia. Although the cast iron makes it rather heavy, the ring on top allowed it to be attached to a belt or suspended on a cord around the neck (see cat. no. 23). The only artistic invention is in the transitional section between the medallion and the ring in the form of a lobed handle; this shows a Tibetan-style frontal lion's head probably derived from the Indian *kirttimukha* (lion mask).

1. See James Watt's chapter 3 above.
2. Leidy, Siu, and Watt 1997, p. 9; see also a similar example in *Golden Horde* 2000, p. 211, no. 10.

198 *Fig. 16*

Paper Bill

China, Yuan dynasty (1271–1368)
Ink on paper
30 x 21.6 cm (11¾ x 8½ in.)
State Hermitage Museum, Saint Petersburg
(GE KH-3027)

The Mongol experiment with a type of paper currency, the earliest ever attempted on such a pan-Asian scale, was short-lived.[1] Paper currency had a long tradition in China and the Mongols were quick to adopt it, although its widespread use did not begin in Yuan China until the reign of Khubilai (1260–94). Chinese paper money was introduced in Iran in 1294 by Geikhatu, and while various reasons for issuing bills are given in different sources, the need to replenish the treasury with precious metals and the bankruptcy of Geikhatu's regime owing to extravagance, corruption, and mismanagement appear to have been key factors.[2]

One of the rare survivors of that experiment, given the functional use of such bills and the fragile nature of the medium, is this note preserved in the Hermitage.[3] Though printed in the pre-Yuan period from a wood or bronze block, it was used as legal tender in Yuan China. According to the inscriptions in both Chinese and Phagspa, it was worth "two bundles" (two thousand coins),[4] making it the highest value of such notes.[5]

1. Rossabi 1988b, pp. 123–24.
2. Allsen 2001, p. 177.
3. Basilov 1989, p. 74.
4. For another example of the Phagspa script, see the Chinese *paiza*, cat. no. 197.
5. They were issued in denominations of 10, 20, 50, 100, 200, 300, 500, 1,000, and 2,000. See Allsen 2001, p. 178.

199 *Fig. 71*

Covered Box

China, Yuan dynasty (1271–1368)
Gold, pierced, chased, and worked in repoussé
H. 7.5 cm (3 in.)
Art and History Trust Collection

The main decoration on this delicate box is pierced and finely worked in repoussé, set against a plain background.[1] On top of the cover a central medallion encloses a pair of birds among peonies, while on the sides is a wide band of lappets that bear alternately flowers or birds; the band of lappets is repeated on the base. The openwork bird and floral motifs have been related to silverwork of the Yuan period.[2] Similar designs occur on a large Yuan underglaze blue and red porcelain jar in the Percival David Foundation Collection, London, which is decorated around its wide center with four openwork panels with blossoms and leaves applied in relief.[3] The box also compares closely with a similarly shaped, small covered box carved in ivory, which has been dated to the Yuan period.[4]

1. Sotheby's 1997, lot 27.
2. See ibid. For a closely related silver-gilt jar, see ibid., lot 128. See also Medley 1974, p. 52. Related decoration

also occurs in Song goldwork; for a small perfume container worked in repoussé with pierced and chased designs, see White and Bunker 1994, no. 98.

3. See Medley 1974, p. 52, pl. B.

4. See Lee and W. Ho 1968, no. 299, which is likewise compared to the Percival David Foundation jar.

200, 201 Personal Ornaments

China, Yuan dynasty (1271–1368)
Inner Mongolia Museum, Hohhot

200

Fig. 72

Two Hairpins

Gold, worked in repoussé and chased
H. 14 cm (5½ in.); 12 cm (4¾ in.)

201

Fig. 73

Five Headdress Ornaments

Gold, worked in repoussé
Largest: 9 x 4.2 cm (3½ x 1⅝ in.)

Personal adornment was one means by which the Mongols were able to express their new positions of power and wealth. Under the Yuan, the woman's hairpin, which had a long history in China, became bolder and more elaborate in its decoration.[1] This included flowers and birds, occasionally dragons, rendered in deep repoussé with finely chased details,[2] as in the two examples from Hohhot (cat. no. 200), which were excavated in 1957 at Khahar Youyi Khianqi, Inner Mongolia.[3] Mongol noblewomen also expressed their status through a distinctive type of conical headdress, known as a *bughtaq* or *guguan*.[4] This could be embellished with a variety of decorations, including perhaps such ornaments as the five from Hohhot (cat. no. 201), which were found in Aohanqi, Inner Mongolia, in 1990.[5] Images of noblewomen wearing the *bughtaq* indicate that gold ornaments were placed around its narrow crown. See, for example, the royal women in Ilkhanid enthronement scenes (cat. nos. 18, 19), and the two royal women depicted in the lower right corner of a silk-tapestry Yamantaka mandala (cat. no. 185).

1. For a brief history of the hairpin in China, see White and Bunker 1994, pp. 25–27.

2. Ibid., nos. 103, 104.

3. Information from the records of the Inner Mongolia Museum.

4. For two events demonstrating the importance of the *bughtaq* in Mongol society, see Lambton 1988, p. 393.

5. Information from the records of the Inner Mongolia Museum.

202

Fig. 60

Torque

China, probably Yuan dynasty (1271–1368)
Silver, worked in repoussé

Diam. approx. 17 cm (6¾ in.)
Inner Mongolia Museum, Hohhot

Paired dragons already formed part of the traditional vocabulary of Chinese art in the eleventh century under the Liao dynasty.[1] Arranged within a square or a circular frame, they are usually seen as if chasing each other in a circle amidst clouds. The dragons on this torque or choker,[2] one of the finest examples of medieval Chinese silver jewelry, represent a variation in which the designer cleverly adapted this auspicious iconography to the required shape. Following the curve of the neck, each of the long, snake-bodied dragons forms a semicircle, from back to front, where their rather ferocious heads are confronted in the center. The symmetrical composition that results is reminiscent of the large-scale architectural dragons carved at Viar, north-central Iran, discussed earlier in this volume.[3] The bodies of the torque dragons were formerly each punctuated by two semiprecious stones (now missing), and most likely a larger stone or pearl was once set in the front between their fangs.

The craftsmanship of this object, worked in repoussé, wire, chasing, and punching, is remarkable, as is its state of preservation, only the stones having been lost. Like the gold hairpins and headdress ornaments (cat. nos. 200, 201), this silver torque clearly belonged to a high-ranking woman of the Yuan period.

1. See, e.g., Rawson 1984, p. 96, fig. 75.

2. Unpublished.

3. See Sheila Blair's essay, chapter 5 above.

203

Fig. 209

Lacquer Tray with Phoenixes

China, Southern Song dynasty (1127–1279)
Red, yellow, and black lacquer on wood
4.8 x 31.4 cm (1⅞ x 12⅜ in.)
Arthur M. Sackler Gallery, Smithsonian Institution, Washington, D.C.; Gift of Arthur M. Sackler (S1987.0396)

In China lacquer made from the sap of a tree was applied to a variety of objects fabricated in ephemeral materials such as wood, bamboo, or textiles, giving them a more resilient surface that was suitable for a broad range of time-consuming and elaborate decorative techniques. Carved lacquers, for example, could require the application of hundreds of layers of lacquer and take over a year to complete. Objects produced from this seemingly humble material were in fact luxury goods, often demanding the highest level of artistic skill.[1] Such is the case with this precisely carved lacquer tray,[2] decorated with

opposed phoenixes in flight, set among flowers representing each of the four seasons (winter plum blossoms, spring peonies, summer lotuses, and autumn chrysanthemums). Paired phoenixes, each with different tail feathers and arranged in a circular configuration, became a common theme under the Yuan dynasty (1271–1368) in a variety of media (e.g., cat. no. 184), as well as in Ilkhanid Iran (e.g., cat. nos. 133, 134).

1. See *Asian Art in the Arthur M. Sackler Gallery* 1987, pp. 249–51.

2. Ibid., pp. 256–57.

204

Fig. 21

Dragon Protome

China, Yuan dynasty (1271–1368), second half of the 13th century
White marble
31.5 x 33.5 x 79 cm (12⅜ x 13⅛ x 31⅛ in.)
Inner Mongolia Museum, Hohhot

In 1258 Khubilai Khan completed the second Mongol capital (the first was Khara Khorum); named Kaiping, it was renamed Shangdu, or "Upper Capital," five years later. Located some 160 miles north of Beijing in the modern province of Inner Mongolia, Shangdu functioned as the summer capital after Dadu (present-day Beijing) became the official capital of the Yuan dynasty. In Shangdu the inner Imperial City lay within the Palace City, and this in turn was surrounded by the Outer City, a plan that can be viewed as a sequence of concentric squares.

Excavations at Shangdu revealed an extensive use of stone, particularly white marble, to sculpt figures in the round, such as two large, now headless statues, one perhaps representing Khubilai Khan himself,[1] as well as architectural elements that decorated the city walls. Among the latter was this impressive dragon protome, or forepart, which together with many similar elements protruded from a wall, where it served as both a decorative and a protective figure.[2] The L-shaped, roughly carved rear section of the stone was set into the wall, leaving the finely carved head of a hornless dragon (*chi*) visible in order to impress visitors and residents alike. This type of architectural decoration became popular throughout the Mongol empire in Asia, as indicated by similar pieces found in western Siberia in the territories of the Golden Horde.[3]

1. The two are centerpieces of the Inner Mongolia Museum in Hohhot. See *Cao yuan wen hua* 1996, p. 224, nos. 269, 270.

2. Kessler 1994, p. 166, fig. 111.

3. *Golden Horde* 2000, pp. 208–9, nos. 2, 3.

Cenotaph

China, Yuan dynasty (1271–1368), 14th century
Stone
65 x 45 x 165 cm (25⅝ x 17¾ x 65 in.)
Inner Mongolia Museum, Hohhot

This cenotaph,[1] found near the city of Chifeng in Inner Mongolia, represents one of the most interesting discoveries to demonstrate the presence of Muslims among the higher echelons of the population under the Yuan dynasty. The relief carving includes the typical repertoire of the late Yuan period. Dramatic clouds and large peonies fill the larger bands on the sides, vegetal scrolls with peonies and lotuses are carved inside narrower bands below, and lotus or peony flowers seen from above are shown in the vertical bands at both ends of the cenotaph. The top is also decorated with dense vegetal patterns.

The decoration at the head of the cenotaph makes it clear that the latter was once placed above the tomb of a Muslim. Below a lobed arch with a lotus flower at its apex is the incised Arabic inscription: *la ilah illa allah muhammad rasul allah* (There is no God but Allah. Muhammad is the messenger of Allah). This is the *shahada,* or profession of faith, the first of the so-called Five Pillars (*arkan*) of Islam. The inscription was drawn by a calligrapher familiar with the styles current in that period in the Islamic world, though it has a distinctive slender, vertical thrust that links it to the Chinese Islamic calligraphic style.

Another cenotaph found in Inner Mongolia, now also in the Inner Mongolia Museum, Hohhot, shows a similar decorative program.[2] The vegetal background is less complex, however, and a reclining deer is carved on either side of the stone. The figural element may imply that this cenotaph was not meant for a Muslim tomb. The Arabic inscription on cat. no. 205 was engraved—not carved in relief, like the rest of the decoration—inside an area left empty at its head. It is possible, therefore, that it was originally meant for an affluent Mongol or Chinese customer and subsequently turned into a Muslim cenotaph on request.

1. Unpublished.
2. Unpublished.

Dragon's Head Finial

China, Yuan dynasty (1271–1368)
Jade
6.9 x 24.3 cm (2¾ x 9⅝ in.)
Arthur M. Sackler Gallery, Smithsonian Institution, Washington, D.C.; Gift of Arthur M. Sackler (S1987.819)

The powerful carving and sinuous movement of this jade dragon's head,[1] possibly a finial intended to be mounted as a standard, belie its relatively small size. Its curved tusks, upturned snout, bifurcated antlers, prominent eyebrows, and flowing mane are defined by crisply carved lines that complement and echo one another. A related type of dragon protome, but at the other extreme in terms of scale, is a Yuan-dynasty marble architectural element (cat. no. 204), although in that instance the mythical beast is hornless. Dragons fabricated in gold or molded in ceramic also figure prominently in the art and architectural decoration of the western branches of the Mongol dynasty (cat. nos. 86, 91, 93, 100–102, 155).

1. *Asian Art in the Arthur M. Sackler Gallery* 1987, p. 131, no. 85.

Bibliography

Abu al-Fida 1983

Abu al-Fida. *The Memoirs of a Syrian Prince: Abul-Fida, Sultan of Hamah (672–732/ 1273–1331).* Translated by Peter Malcolm Holt. Freiburger islamstudien, 9. Wiesbaden: Steiner, 1983.

Abu-Lughod 1989

Janet L. Abu-Lughod. *Before European Hegemony: The World System, A.D. 1250–1350.* New York: Oxford University Press, 1989.

Adamova 1992

Adel' Tigranovna Adamova. "Repetition of Compositions in Manuscripts: The *Khamsa* of Nizami in Leningrad." In *Timurid Art and Culture: Iran and Central Asia in the Fifteenth Century,* edited by Lisa Golombek and Maria Subtelny, pp. 67–75. Studies in Islamic Art and Architecture, Supplements to *Muqarnas,* 6. Leiden and New York: Brill, 1992.

Adamova and Giuzal'ian 1985

Adel' Tigranovna Adamova and Leon Tigranovich Giuzal'ian. *Miniatiury rukopisi poemy "Shakhname" 1333 goda* (Miniatures from the *Shahnama* manuscript of 1333). Leningrad: "Iskusstvo," Leningradskoe otdelenie, 1985.

Addis 1984

J. M. Addis. "The Evolution of Techniques at Jingdezhen, with Particular Reference to the Yuan Dynasty." In *Jingdezhen Wares: The Yuan Evolution/Chiang-hsi Ching-te-chen: Yuan-tz'u ti yen-pien,* pp. 11–19. Exhib. cat. Fung Ping Shan Museum, University of Hong Kong. Hong Kong: Oriental Ceramic Society of Hong Kong, 1984.

Adle 1972

Chahryar Adle. "Un Disque de fondation en céramique (Kâšân, 711/1312)." *Journal asiatique* 260 (1972), pp. 277–97.

Adle 1982

Chahryar Adle. "Un Diptyque de fondation en céramique lustrée, Kâšân, 711/1312 (Recherche sur le module et le tracé correcteur/régulateur dans la miniature orientale, II)." In *Art et société dans le monde iranien,* edited by Chahryar Adle, pp. 199–218. Institut Français d'Iranologie de Téhéran, Bibliothèque iranienne, 26. Recherche sur les grandes civilisations, Synthèse, 9. Paris: Éditions Recherche sur les civilisations, 1982.

Aigle 1997a

Denise Aigle, ed. *L'Iran face à domination mongole.* Bibliothèque iranienne, 45. Tehran: Institut Français de Recherche en Iran; Louvain: Diffusion, E. Peeters, 1997.

Aigle 1997b

Denise Aigle. "Le Soufisme sunnite en Fārs: Šayḫ Amīn al-Dīn Balyānī." In Aigle 1997a, pp. 231–60.

Alexander 1992

David Alexander. *The Arts of War: Arms and Armour of the Seventh to Nineteenth Centuries.* Nasser D. Khalili Collection of Islamic Art, 21. London: Nour Foundation in association with Azimuth Editions and Oxford University Press, 1992.

Alexander 1996

David Alexander. *Furusiyya.* 2 vols. Vol. 1, *The Horse in the Art of the Near East.* Vol. 2, *Catalogue.* Exhib. cat. Riyadh: King Abdulaziz Public Library, 1996.

Algar 1978

H. Algar. "Kāzerūnī." In *Encyclopaedia of Islam* 1960–, vol. 4 (1978), pp. 851–52.

Algar 1989

H. Algar. "Barāq Bābā." In *Encyclopaedia Iranica* 1985–, vol. 3 (1989), pp. 754–55.

Allan 1973

James W. Allan. "Abū'l-Qāsim's Treatise on Ceramics." *Iran* 11 (1973), pp. 111–20.

Allan 1978

James W. Allan. "From Tabrīz to Siirt: Relocation of a Thirteenth Century Metalworking School." *Iran* 16 (1978), pp. 182–83.

Allan 1991

James W. Allan. *Islamic Ceramics.* Ashmolean-Christie's Handbooks. Oxford: Ashmolean Museum, 1991.

Allan 2002

James W. Allan. *Treasures from the Islamic Courts.* London, 2002.

Allan, Llewellyn, and Schweizer 1973

James W. Allan, L. R. Llewellyn, and F. Schweizer. "The History of So-called Egyptian Faience in Islamic Persia: Investigations into Abū'l Qāsim's Treatise." *Archaeometry* 15 (July 1973), pp. 165–73.

Allen 1985

Terry Allen. "Byzantine Sources for the *Jāmiʿ al-Tawārīkh* of Rashīd al-Dīn." *Ars Orientalis* 15 (1985), pp. 121–36.

Allen 1988–90

Terry Allen. "Notes on Bust." *Iran* 26 (1988), pp. 55–68; 27 (1989), pp. 57–66; 28 (1990), pp. 23–30.

Allouche 1990

Adel Allouche. "Tegüder's Ultimatum to Qalawun." *International Journal of Middle East Studies* 22 (November 1990), pp. 437–46.

Allsen 1987

Thomas T. Allsen. *Mongol Imperialism: The Politics of the Grand Qan Möngke in China, Russia, and the Islamic Lands, 1251–1259.* Berkeley: University of California Press, 1987.

Allsen 1989

Thomas T. Allsen. "Mongolian Princes and Their Merchant Partners, 1200–1260." *Asia Major,* 3d ser., 2, no. 2 (1989), pp. 83–126.

Allsen 1991

Thomas T. Allsen. "Changing Forms of Legitimation in Mongol Iran." In Seaman and Marks 1991, pp. 223–41.

Allsen 1994

Thomas T. Allsen. "Two Cultural Brokers of Medieval Eurasia: Bolad Aqa and Marco Polo." In *Nomadic Diplomacy, Destruction, and Religion from the Pacific to the Adriatic,* edited by Michael Gervers and Wayne Schlepp, pp. 63–78. Toronto: Joint Centre for Asia Pacific Studies, University of Toronto, 1994.

Allsen 1996

Thomas T. Allsen. "Biography of a Cultural Broker: Bolad Ch'eng-Hsiang in China and Iran." In Raby and Fitzherbert 1996, pp. 7–22.

Allsen 1997a

Thomas T. Allsen. *Commodity and Exchange in the Mongol Empire: A Cultural History of Islamic Textiles.* Cambridge Studies in Islamic Civilization. Cambridge and New York: Cambridge University Press, 1997.

Allsen 1997b

Thomas T. Allsen. "Saray." In *Encyclopaedia of Islam* 1960–, vol. 9 (1997), pp. 41–44.

Allsen 2001

Thomas T. Allsen. *Culture and Conquest in Mongol Eurasia.* Cambridge Studies in Islamic Civilization. Cambridge and New York: Cambridge University Press, 2001.

Amitai-Preiss 1995

Reuven Amitai-Preiss. *Mongols and Mamluks: The Mamluk-Īlkhānid War, 1260–1281.* Cambridge Studies in Islamic Civilization. Cambridge and New York: Cambridge University Press, 1995.

Amitai-Preiss 1999

Reuven Amitai-Preiss. "Sufis and Shamans: Some Remarks on the Islamization of the

Mongols in the Ilkhanate." *Journal of the Economic and Social History of the Orient* 42 (February 1999), pp. 27–46.

Amitai-Preiss 2001
Reuven [Amitai-]Preiss. "The Conversion of Tegüder Ilkhan to Islam." *Jerusalem Studies in Arabic and Islam* 25 (2001), pp. 15–43.

Amitai-Preiss and D. O. Morgan 1999
Reuven Amitai-Preiss and David O. Morgan, eds. *The Mongol Empire and Its Legacy*. Islamic History and Civilization, Studies and Texts, 24. Leiden: Brill, 1999.

Amuzgar 1989
Z. Amuzgar. "Bahrām(-e) Paždū." In *Encyclopaedia Iranica* 1985–, vol. 3 (1989), pp. 524–25.

al-Aqsarayi 1944
Karim al-Din Mahmud ibn Muhammad al-Aqsarayi. *Musamarat al-akhbar wa musayarat al-akhyar* (Conversations on matters of the past and adaptations of admirable things). Edited by Osman Turan. Türk Tarih Kurumy yayinlarindan, 3d ser., 1. Ankara: Türk Tarih Kurumy Basimevi, 1944.

Arabesques et jardins de paradis 1989
Arabesques et jardins de paradis: Collections françaises d'art islamique. Exhib. cat. Musée du Louvre. Paris: Éditions de la Réunion des Musées Nationaux, 1989.

Arberry 1967
Arthur J. Arberry. *The Koran Illuminated: A Handlist of the Korans in the Chester Beatty Library*. Dublin: Hodges, Figgis, 1967.

Arberry et al. 1959
Arthur J. Arberry, M. Minovi, and E. Blochet. *The Chester Beatty Library: A Catalogue of the Persian Manuscripts and Miniatures*. Edited by J. V. S. Wilkinson. Vol. 1, MSS. 101–150. Dublin: Hodges, Figgis, 1959.

L. Arnold 1999
Lauren Arnold. *Princely Gifts and Papal Treasures: The Franciscan Mission to China and Its Influence on the Art of the West, 1250–1350*. San Francisco: Desiderata Press, 1999.

T. W. Arnold 1928
Thomas Walker Arnold. *Painting in Islam: A Study of the Place of Pictorial Art in Muslim Culture*. Oxford: Clarendon Press, 1928. Reprint, with an introduction by B. W. Robinson, New York: Dover Publications, 1965.

T. W. Arnold and Grohmann 1929
Thomas Walker Arnold and Adolf Grohmann. *The Islamic Book: A Contribution to Its Art and History from the VII–XVIII Century*. Paris: Pegasus Press; New York: Harcourt, Brace and Company, 1929.

Art from the World of Islam 1987
Art from the World of Islam, Eighth–Eighteenth Century. Louisiana Revy, 27, no. 3 (March 1987). Humlebœk, Denmark: Louisiana Museum, 1987.

Art Treasures of the Hermitage 1994
Great Art Treasures of the Hermitage, St. Petersburg. 2 vols. New York: Harry N. Abrams, 1994.

Arts de l'Islam 1971
Arts de l'Islam, des origines à 1700, dans les collections publiques françaises. Exhib. cat. Orangerie des Tuileries. Paris: Réunion des Musées Nationaux, 1971.

Arts of Islam 1976
The Arts of Islam. Exhib. cat. Hayward Gallery. London: Arts Council of Great Britain, 1976.

Asian Art in the Arthur M. Sackler Gallery 1987
Asian Art in the Arthur M. Sackler Gallery: The Inaugural Gift. Washington, D.C.: Arthur M. Sackler Gallery, 1987.

Atasoy et al. 2001
Nurhan Atasoy, Walter Denny, Louise W. Mackie, and Hülya Tezcan. *Ipek, the Crescent and the Rose: Imperial Ottoman Silks and Velvets*. Compiled and edited by Julian Raby and Alison Effeny. London: Azimuth Editions, 2001.

Atil 1972
Esin Atil. "Two Īl-H̱ānid Candlesticks at the University of Michigan." *Kunst des Orients* 8 (1972), pp. 1–33.

Atil 1973
Esin Atil. *Ceramics from the World of Islam*. Exhib. cat. Freer Gallery of Art. Washington, D.C.: Smithsonian Institution, 1973.

Atil 1981
Esin Atil. *Renaissance of Islam: Art of the Mamluks*. Exhib. cat. National Museum of Natural History, Washington, D.C, and other institutions. Washington, D.C.: Smithsonian Institution, 1981.

Atil 1990
Esin Atil, ed. *Islamic Art and Patronage: Treasures from Kuwait*. Exhib. cat. Organized by the Trust for Museum Exhibitions, Washington, D.C. New York: Rizzoli, 1990.

Atil, Chase, and Jett 1985
Esin Atil, William Thomas Chase, and Paul Jett. *Islamic Metalwork in the Freer Gallery of Art*. Exhib. cat. Washington, D.C.: Freer Gallery of Art, Smithsonian Institution, 1985.

Aubin 1953
Jean Aubin. "Les Princes d'Ormuz du XIIIe au XVe siècle." *Journal asiatique* 241 (1953), pp. 77–138.

Aubin 1963
Jean Aubin. "Y a-t-il eu interruption du commerce par mer entre le Golfe Persique et l'Inde du XIe au XIVe siècle?" *Studia* [Centro de Estudos Históricos Ultramarinos] 11 (1963), pp. 165–71.

Aubin 1975
Jean Aubin. "Le Patronage culturel en Iran sous les Ilkhans: Une Grande Famille de Yazd." *Le Monde iranien et l'Islam: Sociétés et cultures* 3 (1975), pp. 107–18.

Aubin 1976–77
Jean Aubin. "La Propriété foncière en Azerbaydjan sous les Mongols." *Le Monde iranien et l'Islam: Sociétés et cultures* 4 (1976–77), pp. 79–132.

Aubin 1989
Jean Aubin. "Le Témoignage d'Ebn-e Bazzâz sur la turquisation de l'Azerbaydjan." In *Études irano-aryennes offertes à Gilbert Lazard*, edited by Charles-Henri de Fouchécour and Philippe Gignoux, pp. 5–17. Studia Iranica, Cahier 7. Paris: Association pour l'Avancement des Études Iraniennes, 1989.

Aubin 1991
Jean Aubin. "Le *Qurıltaı* de Sultân-Maydân (1336)." *Journal asiatique* 279 (1991), pp. 175–97.

Aubin 1995
Jean Aubin. *Émirs mongols et vizirs persans dans les remous de l'acculturation*. Studia Iranica, Cahier 15. Paris: Association pour l'Avancement des Études Iraniennes, 1995.

Auliya Allah Amuli 1969
Auliya Allah Amuli. *Tarikh-i ruyan* (The history of Ruyan). Edited by Manuchihr Sutudeh. Tehran, 1969.

Baer 1968
Eva Baer. "'Fish pond' Ornaments on Persian and Mamluk Metal Vessels." *Bulletin of the School of Oriental and African Studies* 30, no. 1 (1968), pp. 14–28.

Baer 1973–74
Eva Baer. "The Nisan Tasi: A Study in Persian-Mongol Metal Ware." *Kunst des Orients* 9 (1973–74), pp. 1–46.

Baer 1983
Eva Baer. *Metalwork in Medieval Islamic Art*. Albany: State University of New York Press, 1983.

Bahrami 1937
Mehdi Bahrami. *Recherches sur les carreaux de revêtement lustré dans la céramique persane du XIIe au XVe siècle (étoiles et croix)*. Paris: Les Presses Modernes, 1937.

Baibars al-Mansuri 1998
Baibars al-Mansuri. *Zubdat al-fikra fi taʾrikh al-hijra* (Choicest thoughts on the history of hegira). Edited by Donald S. Richards. Nasharat al-Islamiyya, 42. Beirut, 1998.

al-Baidavi 1935
Qadi ʿAbd Allah al-Baidavi. *Nizam al-tawarikh* (Ordering of the chronicles). Edited by Bahman Karimi. Tehran: Kitabkhana ʿIlmi, 1935.

Ball 1976
W. Ball. "Two Aspects of Iranian Buddhism." *Bulletin of the Asia Institute of Pahlavi University*, 1976, nos. 1–4, pp. 103–63.

Bar Hebraeus 1932
Bar Hebraeus. *The Chronography of Gregory Abûʾl Faraj, the Son of Aaron, the Hebrew Physician Commonly Known as Bar Hebraeus;*

Being the First Part of His Political History of the World. Translated by Ernest A. Wallis Budge. 2 vols. London: Oxford University Press, 1932.

Barrett 1949

Douglas Barrett. *Islamic Metalwork in the British Museum.* London: Trustees of the British Museum, 1949.

Barrucand 1986

Marianne Barrucand. "Le *Kalīla wa Dimna* de la Bibliothèque Royale de Rabat: Un Manuscrit illustré īl-khānide." *Revue des études islamiques* 54 (1986), pp. 17–48.

Barthold and Boyle 1965

V. V. Barthold and John A. Boyle. "Djuwaynī." In *Encyclopaedia of Islam* 1960–, vol. 2 (1965), pp. 606–7.

Barthold and Rogers 1970

V. V. Barthold. "The Burial Rites of the Turks and the Mongols." Translated, with a note on iconography, by J. M. Rogers. *Central Asiatic Journal* 14 (1970), pp. 195–227.

Basilov 1989

Vladimir N. Basilov, ed. *Nomads of Eurasia.* Translated by Mary Fleming Zirin. Exhib. cat. Natural History Museum of Los Angeles County; Denver Museum of Natural History; National Museum of Natural History, Washington, D.C. Los Angeles: Natural History Museum of Los Angeles County, 1989.

Bauer 1979

Wolfgang Bauer, ed. *Studia Sino-Mongolica: Festschrift für Herbert Franke.* Münchener ostasiatische Studien, 25. Wiesbaden: Steiner, 1979.

Bausani 1968

Alessandro Bausani. "Religion under the Mongols." In Boyle 1968a, pp. 538–49.

Bausani 1978

Alessandro Bausani. *L'enciclopedia dei Fratelli della Purità: Riassunto, con introduzione e breve commento, dei 52 trattati o epistole degli Ikhwan al-Safaʾ.* Series minor, Istituto Universitario Orientale, Seminario di Studi Asiatici, 4. Naples: Istituto Universitario Orientale, 1978.

Bausani 1982

Alessandro Bausani. "The Observatory of Marāghe." In *Solṭāniye III,* pp. 125–51. Quaderni del Seminario di Iranistica, Uralo-Altaistica e Caucasologia dell'Università degli Studi di Venezia, 9. Venice, 1982.

Berchem 1909

Max van Berchem. "Une Inscription du sultan mongol Uldjaitu." In *Mélanges Hartwig Derenbourg (1844–1908): Recueil de travaux d'érudition dédiés à la mémoire d'Hartwig Derenbourg par ses amis et ses élèves,* pp. 367–78. Paris: Ernest Leroux, 1909.

Berger and Bartholomew 1995

Patricia Berger and Terese Tse Bartholomew. *Mongolia: The Legacy of Chinggis Khan.* Exhib.

cat. Asian Art Museum, San Francisco; Denver Art Museum; National Geographic Society, Washington, D.C. New York: Thames and Hudson in association with the Asian Art Museum of San Francisco, 1995.

Bickford 1985a

Maggie Bickford. "The Flowering Plum in Painting." In *Bones of Jade, Soul of Ice: The Flowering Plum in Chinese Art,* pp. 45–150. Exhib. cat. University Art Museum, Berkeley; Yale University Art Gallery, New Haven; Saint Louis Art Museum. New Haven: Yale University Art Gallery, 1985.

Bickford 1985b

Maggie Bickford. "The Flowering Plum: Literary and Cultural Traditions." In *Bones of Jade, Soul of Ice: The Flowering Plum in Chinese Art,* pp. 17–44. Exhib. cat. University Art Museum, Berkeley; Yale University Art Gallery, New Haven; Saint Louis Art Museum. New Haven: Yale University Art Gallery, 1985.

Binyon, Wilkinson, and Gray 1933

Laurence Binyon, J. V. S. Wilkinson, and Basil Gray. *Persian Miniature Painting, Including a Critical and Descriptive Catalogue of the Miniatures Exhibited at Burlington House, January–March 1931.* London: Oxford University Press, 1933. Reprint, New York: Dover Publications, 1971.

Biran 1997

Michal Biran. *Qaidu and the Rise of the Independent Mongol State in Central Asia.* Surrey: Curzon, 1997.

al-Biruni 1879

Muhammad ibn Ahmad Abu al-Rayhan al-Biruni. *The Chronology of Ancient Nations: An English Version of the Arabic Text of the Athâr-ul-Bâkiya of Albîrûnî, or "Vestiges of the Past," Collected and Reduced to Writing by the Author in A.H. 390–1, A.D. 1000.* Translated and edited by C. Eduard Sachau. London: W. H. Allen and Company, 1879.

Blair 1982a

Sheila S. Blair. "The Coins of the Later Ilkhanids: Mint Organization, Regionalization and Urbanism." *American Numismatic Society Museum Notes* 27 (1982), pp. 211–30.

Blair 1982b

Sheila S. Blair. "The Inscription from the Tomb Tower at Basṭām: An Analysis of Ilkhanid Epigraphy." In *Art et société dans le monde iranien,* edited by Chahryar Adle, pp. 263–86. Institut Français d'Iranologie de Téhéran, Bibliothèque iranienne, 26. Recherche sur les grandes civilisations, Synthèse, 9. Paris: Éditions Recherche sur les civilisations, 1982.

Blair 1983

Sheila S. Blair. "The Coins of the Later Ilkhanids: A Typological Analysis." *Journal of the Economic and Social History of the Orient* 26 (October 1983), pp. 295–317.

Blair 1984

Sheila S. Blair. "Ilkhanid Architecture and Society: An Analysis of the Endowment Deed of the Rabʿ-i Rashīdī." *Iran* 22 (1984), pp. 67–90.

Blair 1985

Sheila S. Blair. "The Madrasa at Zuzan: Islamic Architecture in Eastern Iran on the Eve of the Mongol Invasions." *Muqarnas* 3 (1985), pp. 75–91.

Blair 1986a

Sheila S. Blair. *The Ilkhanid Shrine Complex at Natanz, Iran.* Harvard Middle East Papers, Classical Series, 1. Cambridge, Mass.: Center for Middle Eastern Studies, Harvard University, 1986.

Blair 1986b

Sheila S. Blair. "A Medieval Persian Builder." *Journal of the Society of Architectural Historians* 45 (December 1986), pp. 389–95.

Blair 1986c

Sheila S. Blair. "The Mongol Capital of Sulṭāniyya, 'The Imperial.'" *Iran* 24 (1986), pp. 139–51.

Blair 1987

Sheila S. Blair. "The Epigraphic Program of the Tomb of Uljaytu at Sultaniyya: Meaning in Mongol Architecture." *Islamic Art* 2 (1987), pp. 43–96.

Blair 1989

Sheila S. Blair. "On the Track of the 'Demotte' *Shāhnāma* Manuscript." In *Les Manuscrits du Moyen-Orient: Essais de codicologie et de paléographie; actes du colloque, Istanbul, mai 26–29, 1986,* edited by François Déroche, pp. 125–31. Varia turcica, 8. Istanbul: Institut Français d'Études Anatoliennes; Paris: Bibliothèque Nationale, 1989.

Blair 1993a

Sheila S. Blair. "The Development of the Illustrated Book in Iran." *Muqarnas* 10 (1993), pp. 266–74.

Blair 1993b

Sheila S. Blair. "The Ilkhanid Palace." *Ars Orientalis* 23 (1993), pp. 239–48. Special issue, *Pre-Modern Islamic Palaces,* edited by Gülru Necipoğlu.

Blair 1995

Sheila S. Blair. *A Compendium of Chronicles: Rashid al-Din's Illustrated History of the World.* Nasser D. Khalili Collection of Islamic Art, 27. London: Nour Foundation in association with Azimuth Editions and Oxford University Press, 1995.

Blair 1996

Sheila S. Blair. "Patterns of Patronage and Production in Ilkhanid Iran: The Case of Rashid al-Din." In Raby and Fitzherbert 1996, pp. 39–62.

Blair 1997

Sheila S. Blair. "Sulṭāniyya, 2: Monuments." In *Encyclopaedia of Islam* 1960–, vol. 9 (1997), pp. 860–61.

Blair 2002a

Sheila S. Blair. "A Mongol Messenger." In *Studies in Honor of Robert Hillenbrand,* edited by Bernard O'Kane. Edinburgh: Edinburgh University Press, 2002.

Blair 2002b

Sheila S. Blair. "Rewriting the History of the Great Mongol Shahnama." In *Shahnama: The Visual Language of the Persian Book of Kings,* edited by Robert Hillenbrand. Edinburgh: Edinburgh University Press and VARIE, 2002.

Blair and Bloom 1994

Sheila S. Blair and Jonathan M. Bloom. *The Art and Architecture of Islam, 1250–1800.* Yale University Press Pelican History of Art. New Haven and London: Yale University Press, 1994.

Blair and Bloom 2001

Sheila S. Blair and Jonathan M. Bloom. "Epic Images and Contemporary History: The Legacy of the Great Mongol *Shāh-Nāma.*" *Islamic Art* 5 (2001), pp. 41–52.

Blochet 1926

Edgard Blochet. *Les Enluminures des manuscrits orientaux, turcs, arabes, persans de la Bibliothèque Nationale.* Paris: Éditions de la Gazette des Beaux-Arts, 1926.

Bloom 2000

Jonathan M. Bloom. "The Introduction of Paper to the Islamic Lands and the Development of the Illustrated Manuscript." *Muqarnas* 17 (2000), pp. 17–23.

Bloom 2001

Jonathan M. Bloom. *Paper before Print: The History and Impact of Paper in the Islamic World.* New Haven and London: Yale University Press, 2001.

Bloom 2002

Jonathan M. Bloom. "The Great Mongol Shahnama in the Qajar Period." In *Shahnama: The Visual Language of the Persian Book of Kings,* edited by Robert Hillenbrand. Edinburgh: Edinburgh University Press and VARIE, 2002.

Bloom and Blair 1997

Jonathan M. Bloom and Sheila S. Blair. *Islamic Arts.* Art and Ideas. London: Phaidon Press, 1997.

Bombaci 1959

Alessio Bombaci. "Introduction on the Excavations at Ghazni." *East and West,* n.s., 10, nos. 1–2 (March–June 1959), pp. 3–22.

Bombaci 1966

Alessio Bombaci. *The Kufic Inscription in Persian Verses in the Court of the Royal Palace of Mas'ud III at Ghazni.* Reports and Memoirs, 5. Rome: Istituto Italiano per il Medio ed Estremo Oriente, 1966.

Bonaparte 1895

Roland Bonaparte. *Documents sur l'époque mongole des XIII^e et XIV^e siècles.* Paris: Roland Bonaparte, 1895.

Borstlap and Teske 1995

Alessandra V. Borstlap and Jef Teske. *Het Mongoose rijk tijdens de Yuan dynastie, 1279–1368 / The Mongolian Empire during the Yuan Dynasty, 1279–1368.* Leeuwarden: Museum het Princessehof, 1995.

Bosworth 1968

Clifford Edmund Bosworth. "The Political and Dynastic History of the Iranian World (1000–1217)." In Boyle 1968a, pp. 1–202.

Bosworth 1994

Clifford Edmund Bosworth. *The History of the Saffarids of Sistan and the Maliks of Nimruz (247/861 to 949/1542–3).* Columbia Lectures on Iranian Studies, 8. Costa Mesa, Calif., and New York: Mazda Publishers in association with Bibliotheca Persica, 1994.

Bosworth 1996

Clifford Edmund Bosworth. *The New Islamic Dynasties: A Chronological and Genealogical Manual.* Rev. ed. New York: Columbia University Press, 1996. 1st ed., Edinburgh: Edinburgh University Press, 1967.

Bothmer 1971

Hans-Caspar Graf von Bothmer. "Die Illustrationen des 'Münchener Qazwini' von 1280 (cod. Monac. arab. 464): Ein Beitrag zur Kenntnis ihres Stils." Ph.D. thesis, Ludwig-Maximilians-Universität München, 1971.

Bowman and Thompson 1967–68

John Bowman and J. A. Thompson. "The Monastery-Church of Bar Hebraeus at Maragheh in West Azerbaijan." *Abr-Nahrain* 7 (1967–68), pp. 35–61.

Boyce 1985

Mary Boyce. "Ādur Gušnasp." In *Encyclopaedia Iranica* 1985–, vol. 1 (1985), pp. 475–76.

Boyle 1961

John A. Boyle. "The Death of the Last 'Abbasid Caliph: A Contemporary Muslim Account." *Journal of Semitic Studies* 6 (autumn 1961), pp. 145–61.

Boyle 1968a

John A. Boyle, ed. *The Cambridge History of Iran.* Vol. 5, *The Saljuq and Mongol Periods.* Cambridge: Cambridge University Press, 1968.

Boyle 1968b

John A. Boyle. "Dynastic and Political History of the Ilkhāns." In Boyle 1968a, pp. 303–421.

Boyle 1971a

John A. Boyle. "Īndjū." In *Encyclopaedia of Islam* 1960–, vol. 3 (1971), p. 1208.

Boyle 1971b

John A. Boyle. "Rashīd al-Dīn: The First World Historian." *Journal of the British Institute of Persian Studies* 9 (1971), pp. 19–26.

Boyle 1972

John A. Boyle. "The Seasonal Residences of the Great Khan Ögedei." *Central Asiatic Journal* 16 (1972), pp. 125–31.

Boyle 1977

John A. Boyle. *The Mongol World Empire, 1206–1370.* London: Variorum Reprints, 1977.

Bray 1997

Francesca Bray. *Technology and Gender: Fabrics of Power in Late Imperial China.* Berkeley: University of California Press, 1997.

Brent 1976

Peter Brent. *Genghis Khan: The Rise, Authority, and Decline of Mongol Power.* New York: McGraw-Hill, 1976.

Brian 1939

Doris Brian. "A Reconstruction of the Miniature Cycle in the Demotte *Shah Namah.*" *Ars Islamica* 6, pt. 1 (1939), pp. 97–112.

Browne 1928

Edward Granville Browne. *A Literary History of Persia.* 4 vols. Cambridge: Cambridge University Press, 1928.

Buell 1990

Paul D. Buell. "Pleasing the Palate of the Qan: Changing Foodways of the Imperial Mongols." *Mongolian Studies* 13 (1990), pp. 57–81.

Buell and Anderson 2000

Paul D. Buell and Eugene N. Anderson. *A Soup for the Qan: Chinese Dietary Medicine of the Mongol Era as Seen in Hu Szu-Hui's Yin-shan Cheng-yao; Introduction, Translation, Commentary and Chinese Text.* Sir Henry Wellsome Asian Series. London: Kegan Paul, 2000.

Bundy 1996

David Bundy. "The Syriac and Armenian Christian Responses to the Islamification of the Mongols." In *Medieval Christian Perceptions of Islam: A Book of Essays,* edited by John Victor Tolan, pp. 33–53. Garland Reference Library of the Humanities, 1768. Garland Medieval Casebooks, 10. New York and London: Garland Publishing, 1996.

Burnham 1980

Dorothy K. Burnham. *Warp and Weft: A Textile Terminology.* Toronto: Royal Ontario Museum, 1980.

Çağman, Tanindi, and Rogers 1986

Filiz Çağman and Zeren Tanindi. *The Topkapi Saray Museum: The Albums and Illustrated Manuscripts.* Translated, expanded, and edited by J. M. Rogers. Boston: Little, Brown and Company, 1986.

Cai 1984

Cai Meibiao. "Yuandai yuanpai liangzhong kaoshi" (On two types of round pai[zi] of the Yuan period). In *Yuanshi lunji* (Collected articles on the history of the Yuan dynasty), pp. 698–710. Nanjing daxue lishi xi Yuanshi yanjiushi edition (Seminar on History of the Yuan Dynasty, Department of History, Nanjing University). Beijing: Renmin chubanshe, 1984.

Caiger-Smith 1985

Alan Caiger-Smith. *Lustre Pottery: Technique,*

Tradition, and Innovation in Islam and the Western World. New York: New Amsterdam Books, 1985.

Calmard 1997

Jean Calmard. "Le Chiisme imamite sous les Ilkhans." In Aigle 1997a, pp. 261–92.

Canby 1993

Sheila R. Canby. *Persian Painting.* Eastern Art Series. London: British Museum, 1993.

Canfield 1991

Robert L. Canfield, ed. *Turko-Persia in Historical Perspective.* Cambridge and New York: Cambridge University Press, 1991.

Cao yuan wen hua 1996

Cao yuan wen hua (Culture of the grasslands). Edited by Zhao Fangzhi. Hong Kong: The Commercial Press, 1996.

Carboni 1987

Stefano Carboni. "Two Fragments of a Jalayirid Astrological Treatise in the Keir Collection and in the Oriental Institute in Sarajevo." *Islamic Art* 2 (1987), pp. 149–86.

Carboni 1988

Stefano Carboni. *Il Kitāb al-bulhān di Oxford.* Quaderni del Dipartimento di Studi Eurasiatici, Università degli Studi di Venezia, 6. Turin: Editrece Tirrenia Stampatori, 1988.

Carboni 1988–89

Stefano Carboni. "The London Qazwīnī: An Early Fourteenth-Century Copy of the ʿAjāʾib al-makhlūqāt." *Islamic Art* 3 (1988–89), pp. 15–31.

Carboni 1992

Stefano Carboni. "The Wonders of Creation and the Singularities of Ilkhanid Painting: A Study of the London Qazwīnī, British Library Ms. Or. 14140." Ph.D. diss., School of Oriental and African Studies, University of London, 1992.

Carboni 2001

Stefano Carboni. *Glass from Islamic Lands: The al-Sabah Collection.* Kuwait National Museum. New York and London: Thames and Hudson, 2001.

Carboni and Masuya 1993

Stefano Carboni and Tomoko Masuya. *Persian Tiles.* Exhib. cat. New York: The Metropolitan Museum of Art, 1993.

Carboni and Whitehouse 2001

Stefano Carboni and David Whitehouse. *Glass of the Sultans.* Exhib. cat. New York: The Metropolitan Museum of Art; Corning, N.Y.: Corning Museum of Glass; Athens: Benaki Museum; New Haven: Yale University Press, 2001.

Carey 2001

M. Carey. "Painting the Stars in a Century of Change: A Thirteenth-Century Copy of al-Sufi's Treatise on the Fixed Stars (British Library Or. 5323)." Ph.D. diss., School of Oriental and African Studies, University of London, 2001.

Centlivres-Demont 1971

Micheline Centlivres-Demont. *Une Communauté de potiers en Iran: Le Centre de Meybod (Yazd).* Beiträge zur Iranistik. Wiesbaden: L. Reichert, 1971.

Chagtai 1936

Muhammad Abdullah Chagtai, ed. *A Treatise on Calligraphists and Miniaturists by Dust Muhammad, the Librarian of Behram Mirza, d. 1550.* Lahore: Chabuk Sawaran, 1936.

Chambers 1988

James Chambers. *The Devil's Horsemen: The Mongol Invasion of Europe.* London: Cassell Publishers, 1988.

Chan 1991

Chan Hok-lam. "Siting by Bowshot: A Mongolian Custom and Its Sociopolitical and Cultural Implications." *Asia Major,* 3d ser., 4, no. 2 (1991), pp. 53–78.

Chan and De Bary 1982

Chan Hok-lam and William Theodore De Bary, eds. *Yüan Thought: Chinese Thought and Religion under the Mongols.* Neo-Confucian Studies. New York: Columbia University Press, 1982.

Chen Dasheng 1984

Chen Dasheng, ed. *Quanzhou yisilanjiao shike* (Islamic inscriptions in Quanzhou). Fuzhou: Fujian renmin chubanshe, 1984.

Chen Dezhi 1984

Chen Dezhi. "Yuan Chahan Naoer xinggong jindi kao" (On the identification of the Chaghan Naʾur palace of the Yuan dynasty). In *Yuanshi lunji* (Collected articles on the history of the Yuan dynasty), pp. 669–80. Nanjing daxue lishi xi Yuanshi yanjiushi edition (Seminar on History of the Yuan Dynasty, Department of History, Nanjing University). Beijing: Renmin chubanshe, 1984.

Chen Gaohua and Shi 1988

Chen Gaohua and Shi Weimin. *Yuan Shangdu* (Shangdu of the Yuan dynasty). Changchun: Jilin jiaoyu chubanshe, 1988.

Chen Yaocheng, Guo Yanyi, and Chen Hong 1993–94

Chen Yaocheng, Guo Yanyi, and Chen Hong. "Sources of Cobalt Pigment Used on Yuan Blue and White Porcelain Wares, Shanghai Institute of Ceramics, Chinese Academy of Sciences." *Oriental Art* 40, no. 1 (spring 1993–94), pp. 14–19.

Christensen 1993

Peter Christensen. *The Decline of Iranshahr: Irrigation and Environments in the History of the Middle East, 500 B.C. to A.D. 1500.* Translated by Steven Sampson. Copenhagen: Museum Tusculanum Press and University of Copenhagen, 1993.

Chu 1956

Chu Ch'ing-yuan. "Government Artisans of the Yüan Dynasty." In *Chinese Social History: Translations of Selected Studies,* translated and

edited by E-tu Zen Sun and John DeFrancis, pp. 234–46. Studies in Chinese and Related Civilizations, 7. Washington, D.C.: American Council of Learned Societies, 1956. Reprint, New York: Octagon Books, 1972.

Cleaves 1976

Francis Woodman Cleaves. "A Chinese Source Bearing on Marco Polo's Departure from China and a Persian Source on His Arrival in Persia." *Harvard Journal of Asiatic Studies* 36 (1976), pp. 181–203.

Cleaves 1982

Francis Woodman Cleaves, trans. *The Secret History of the Mongols.* Cambridge, Mass.: Harvard University Press, 1982.

Clinton 1976

Jerome W. Clinton. "The *Madāen Qasida* of Xāqāni Sharvāni." *Edebiyât* 1 (1976), pp. 153–70.

Clinton 1977

Jerome W. Clinton. "The *Madāen Qasida* of Xāqāni Sharvāni, II: Xāqāni and al-Buhturī." *Edebiyât* 2 (1977), pp. 191–206.

Collings and Milner 1978

Thomas Collings and Derek Milner. "The Identification of Oriental Paper-Making Fibres." *Paper Conservator* [Institute of Paper Conservation] 3 (1978), pp. 51–79.

Combe, Sauvaget, and Wiet 1931

Étienne Combe, Jean Sauvaget, and Gaston Wiet. *Répertoire chronologique d'épigraphie arabe.* Cairo: Institut Français d'Archéologie Orientale, 1931.

Conermann and Kusber 1997

Stephan Conermann and Jan Kusber, eds. *Die Mongolen in Asien und Europa.* Beiträge zur osteuropäischen Geschichte, 4. Frankfurt am Main: P. Lang, 1997.

Côté 1980

Wilfred A. Côté, ed. *Papermaking Fibers: A Photomicrographic Atlas.* Syracuse: Renewable Materials Institute of the State University of New York, College of Environmental Science and Forestry; Syracuse: Syracuse University Press, 1980.

Cowen 1989

Jill Sanchia Cowen. *Kalīla wa-Dimna: An Animal Allegory of the Mongol Court. The Istanbul University Album.* New York and Oxford: Oxford University Press, 1989.

Crowe 1976

Yolande Crowe. "The Islamic Potter and China." *Apollo* 103 (April 1976), pp. 296–301.

Crowe 1991

Yolande Crowe. "Late Thirteenth-Century Persian Tilework and Chinese Textiles." *Bulletin of the Asia Institute,* n.s., 5 (1991), pp. 153–61.

Crowe 1992

Yolande Crowe. "Some Timurid Designs and Their Far Eastern Connections." In *Timurid Art and Culture: Iran and Central Asia in the Fifteenth*

Century, edited by Lisa Golombek and Maria Subtelny, pp. 168–78. Studies in Islamic Art and Architecture, Supplements to *Muqarnas,* 6. Leiden and New York: Brill, 1992.

Crump 1980

James Irving Crump. *Chinese Theater in the Days of Kublai Khan.* Tucson: University of Arizona Press, 1980.

Curatola 1979

Giovanni Curatola. "Le Grotte di Behestān nella Khamse: Descrizione del sito." In *Solṭāniye II,* pp. 7–11. Quaderni del Seminario di Iranistica, Uralo-Altaistica e Caucasologia dell'Università degli Studi di Venezia, 5. Venice, 1979.

Curatola 1982

Giovanni Curatola. "The Viar Dragon." In *Solṭāniye III,* pp. 71–88. Quaderni del Seminario di Iranistica, Uralo-Altaistica e Caucasologia dell'Università degli Studi di Venezia, 9. Venice, 1982.

Curatola 1987

Giovanni Curatola. "Some Ilkhanid Woodwork from the Area of Sultaniyya." *Islamic Art* 2 (1987), pp. 97–116.

Curatola 1993

Giovanni Curatola, ed. *Eredità dell'Islam: Arte islamica in Italia.* Exhib. cat. Palazzo Ducale. Venice: Silvana, 1993.

Curatola and Spallanzani 1981

Giovanni Curatola and Marco Spallanzani. *Mattonelle islamiche / Islamic Tiles.* Lo specchio del Bargello, 6. Florence: Museo Nazionale del Bargello, 1981.

Daiber and Ragep 2000

H. Daiber and F. J. Ragep. "al-Ṭūsi, Naṣīr al-Dīn." *Encyclopaedia of Islam* 1960–, vol. 10 (2000), pp. 746–52.

Dardess 1972–73

John W. Dardess. "From Mongol Empire to Yüan Dynasty: Changing Forms of Imperial Rule in Mongolia and Central Asia." *Monumenta Serica* 30 (1972–73), pp. 117–65.

Dars 1972

Sarah Dars. "L'Architecture mongole ancienne." *Études mongoles* 3 (1972), pp. 159–223.

Dawson 1955

Christopher Dawson, ed. *The Mongol Mission: Narratives and Letters of the Franciscan Missionaries in Mongolia and China in the Thirteenth and Fourteenth Centuries.* Makers of Christendom. New York: Sheed and Ward, 1955.

De Atley, Blackman, and Olin 1982

Suzanne P. De Atley, M. James Blackman, and Jacqueline S. Olin. "Comparison of Data Obtained by Neutron Activation and Electron Microprobe Analyses of Ceramics." In *Archaeological Ceramics,* edited by Jacqueline S. Olin and Alan D. Franklin, pp. 79–87. Washington, D.C.: Smithsonian Institution, 1982.

DeWeese 1978–79

Devin A. DeWeese. "The Influence of the Mongols on the Religious Consciousness of Thirteenth Century Europe." *Mongolian Studies* 5 (1978–79), pp. 41–78.

DeWeese 1994

Devin A. DeWeese. *Islamization and Native Religion in the Golden Horde: Baba Tükles and Conversion to Islam in Historical and Epic Tradition.* University Park, Pa.: Pennsylvania State University Press, 1994.

Dickinson and Wrigglesworth 1990

Gary Dickinson and Linda Wrigglesworth. *Imperial Wardrobe.* London: Bamboo Publishing, 1990.

Doerfer 1963–75

Gerhard Doerfer. *Türkische und mongolische Elemente im Neupersischen, unter besonderer Berücksichtigung älterer neupersischer Geschichtsquellen, vor allem der Mongolen- und Timuridenzeit.* 4 vols. Akademie der Wissenschaften und der Literatur, Veröffentlichungen der Orientalischen Kommission, 16, 19–21. Wiesbaden: Steiner, 1963–75.

Dozy 1967

Reinhart Pieter Anne Dozy. *Supplément aux dictionnaires arabes.* 2 vols. 3d ed. Leiden: Brill; Paris: G. P. Maisonneuve et Larose, 1967.

Dreyer 1982

Edward L. Dreyer. *Early Ming China: A Political History, 1355–1435.* Stanford: Stanford University Press, 1982.

Elgood 1979

Robert Elgood, ed. *Islamic Arms and Armour.* London: Scolar Press, 1979.

Elias 1995

Jamal J. Elias. *The Throne Carrier of God: The Life and Thought of ʿAlaʾ al-Dawla as-Simnānī.* Albany: State University of New York Press, 1995.

Emerson, Chen, and Gates 2000

Julie Emerson, Jennifer Chen, and Mimi Gardner Gates. *Porcelain Stories from China to Europe.* Exhib. cat. Seattle: Seattle Art Museum in association with the University of Washington Press, 2000.

Encyclopaedia Iranica 1985–

Encyclopaedia Iranica. Edited by Ehsan Yarshater. London and New York: Routledge and Kegan Paul, 1985–.

Encyclopaedia of Islam 1960–

The Encyclopaedia of Islam. New ed. Edited by H. A. R. Gibb et al. Leiden: Brill, 1960–.

Enderlein 1973

Volkmar Enderlein. "Das Bildprogramm des Berliner Mosul-Beckens." *Forschungen und Berichte* [Staatliche Museen zu Berlin] 15 (1973), pp. 7–40.

Endicott-West 1989

Elizabeth Endicott-West. "Merchant Associations in Yüan China: The *Ortoy.*" *Asia Major,* 3d ser., 2, no. 2 (1989), pp. 127–54.

Étrange et le merveilleux en terres d'Islam 2001

L'Étrange et le merveilleux en terres d'Islam. Exhib. cat. Musée du Louvre. Paris: Éditions de la Réunion des Musées Nationaux, 2001.

Ettinghausen 1936

Richard Ettinghausen. "Evidence for the Identification of Kāshān Pottery." *Ars Islamica* 3 (1936), pp. 44–75.

Ettinghausen 1936a

Richard Ettinghausen. "Dated Persian Ceramics in Some American Museums." *Bulletin of the American Institute for Persian Art and Archaeology* 4 (June 1936), pp. 145–51; 4 (December 1936), pp. 222–28.

Ettinghausen 1950

Richard Ettinghausen. *The Unicorn.* Freer Gallery of Art, Occasional Papers, vol. 1, no. 3. Studies in Muslim Iconography, 1. Washington, D.C., 1950.

Ettinghausen 1955

Richard Ettinghausen. "An Illuminated Manuscript of Ḥāfiẓ-i Abrū in Istanbul." *Kunst des Orients* 2 (1955), pp. 30–44.

Ettinghausen 1959

Richard Ettinghausen. "On Some Mongol Miniatures." *Kunst des Orients* 3 (1959), pp. 44–65.

Ettinghausen 1959a

Richard Ettinghausen. "New Light on Early Animal Carpets." In *Aus der Welt der islamischen Kunst: Festschrift für Ernst Kühnel, zum 75. Geburtstag am 26.10.1957,* edited by Richard Ettinghausen, pp. 93–116. Berlin: Gebr. Mann, 1959.

Ettinghausen 1962

Richard Ettinghausen. *Arab Painting.* Treasures of Asia. Geneva: Skira, 1962.

Ettinghausen 1970

Richard Ettinghausen. "The Flowering of Seljuk Art." *Metropolitan Museum Journal* 3 (1970), pp. 113–31.

Ettinghausen 1979

Richard Ettinghausen. "Bahram Gur's Hunting Feats or the Problem of Identification." *Iran* 17 (1979), pp. 25–31.

Ettinghausen 1984

Richard Ettinghausen. "On the Covers of the Morgan *Manāfiʿ* Manuscript and Other Early Persian Bookbindings." In *Islamic Art and Archaeology: Collected Papers,* edited by Myriam Rosen-Ayalon, pp. 521–42. Introduction by Oleg Grabar. Berlin: Gebr. Mann, 1984. Reprinted from *Studies in Art and Literature for Belle da Costa Greene,* edited by Dorothy Miner, pp. 459–73. Princeton: Princeton University Press, 1954.

Ettinghausen, Grabar, and M. Jenkins 2001

Richard Ettinghausen, Oleg Grabar, and Marilyn Jenkins-Madina. *Islamic Art and Architecture, 650–1250.* New Haven and London: Yale University Press, 2001.

Fairbanks 1987
S. C. Fairbanks. "Atābakān-e Yazd." In *Encyclopaedia Iranica* 1985–, vol. 2 (1987), pp. 900–902.

Farès 1959
Bishr Farès. "Figures Magiques." In *Aus der Welt der islamischen Kunst: Festschrift für Ernst Kühnel, zum 75. Geburtstag am 26.10.1957,* edited by Richard Ettinghausen, pp. 154–62. Berlin: Gebr. Mann, 1959.

Farquhar 1990
David M. Farquhar. *The Government of China under Mongolian Rule: A Reference Guide.* Münchener ostasiatische Studien, 53. Stuttgart: Steiner, 1990.

Fedorov-Davydov 2001
German Alekseevich Fedorov-Davydov. *The Silk Road and the Cities of the Golden Horde.* Berkeley: Zinat Press, 2001.

Fehérvári 1976
Géza Fehérvári. *Islamic Metalwork of the Eighth to the Fifteenth Century in the Keir Collection.* London: Faber and Faber, 1976.

Ferrier 1989
Ronald W. Ferrier, ed. *The Arts of Persia.* New Haven and London: Yale University Press, 1989.

Fiey 1975
J. M. Fiey. *Chrétiens syriaques sous les Mongols (Il-Khanat de Perse, XIIIᵉ–XIVᵉ s.).* Corpus Scriptorum Christianorum Orientalium, 362. Louvain: Secrétariat du Corpus Scriptorum Christianorum Orientalium, 1975.

Firdausi 1905–25
Abu al-Qasim Firdausi. *The Sháhnáma of Firdausi.* Translated by Arthur George Warner and Edmond Warner. 9 vols. London, 1905–25.

Firdausi 1985
Abu al-Qasim Firdausi. *The Epic of the Kings: Shah-Nama, the National Epic of Persia.* Translated by Reuben Levy. London and Boston: Routledge and Kegan Paul, 1985. 1st ed., 1967.

Fischel 1968
Walter J. Fischel. *Jews in the Economic and Political Life of Mediaeval Islam.* London: Royal Asiatic Society of Great Britain and Ireland, 1968. 1st ed., 1937.

Fitzherbert 1991
Teresa Fitzherbert. "Khwājū Kirmānī (688–753/1290–1352): An *Éminence Grise* of Fourteenth Century Persian Painting." *Iran* 29 (1991), pp. 137–51.

Fitzherbert 2001
Teresa Fitzherbert. "Balʿami's 'Tabari': An Illustrated Manuscript of Balʿami's *Tarjama-yi Tarikh-i Tabari* in the Freer Gallery of Art, Washington (F.59.16, 47.19 and 30.21)." Ph.D. diss., University of Edinburgh, 2001.

FitzHugh 1988
Elizabeth West FitzHugh. "Study of Pigments on Selected Paintings from the Vever Collection." In Lowry and Beach 1988, pp. 425–32.

FitzHugh 1997
Elizabeth West FitzHugh. "Orpiment and Realgar." In *Artists' Pigments: A Handbook of Their History and Characteristics,* vol. 3, edited by Elizabeth West FitzHugh, pp. 47–79. New York: Cambridge University Press; Washington, D.C.: National Gallery of Art, 1997.

Flemming 1927
Ernst Richard Flemming. *An Encyclopaedia of Textiles from the Earliest Times to the Beginning of the Nineteenth Century.* New York: E. Weyhe, 1927.

Fletcher 1986
Joseph Fletcher. "The Mongols: Ecological and Social Perspectives." *Harvard Journal of Asiatic Studies* 46 (June 1986), pp. 11–50.

Flood 1993
F. B. Flood. "Islamic Buildings Survey." In "The International Merv Project: Preliminary Report on the First Season." *Iran* 31 (1993), pp. 58–60.

Folsach 1990
Kjeld von Folsach. *Islamic Art: The David Collection.* Copenhagen: Davids Samling, 1990.

Folsach 1996
Kjeld von Folsach. "Pax Mongolica: An Ilkhanid Tapestry-Woven Roundel." *Hali,* no. 85 (March–April 1996), pp. 80–87, 117.

Folsach 2001
Kjeld von Folsach. *Art from the World of Islam in the David Collection.* Copenhagen: David Collection, 2001.

Fong 1984
Wen C. Fong. *Images of the Mind: Selections from the Edward L. Elliott Family and John B. Elliott Collections of Chinese Calligraphy and Painting at the Art Museum, Princeton University.* Exhib. cat. Princeton: The Art Museum, Princeton University, 1984.

Fong 1992
Wen C. Fong. *Beyond Representation: Chinese Painting and Calligraphy, Eighth–Fourteenth Century.* Princeton Monographs in Art and Archaeology, 48. New York: The Metropolitan Museum of Art, 1992.

Fong and Watt 1996
Wen C. Fong and James C. Y. Watt. *Possessing the Past: Treasures from the National Palace Museum, Taipei.* Exhib. cat. New York: The Metropolitan Museum of Art, 1996.

Fontana 1986
Maria Vittoria Fontana. *La leggenda di Bahram Gur e Azada: Materiale per la storia di una tipologia figurativa dalle origini al XIV secolo.* Series minor, Istituto Universitario Orientale, Dipartimento di Studi Asiatici, 24. Naples: Istituto Universitario Orientale, 1986.

Fontana 1994
Maria Vittoria Fontana. *Iconografia dell'Ahl al-Bayt: Immagini di arte persiana dal XII al XX secolo.* Naples: Istituto Universitario Orientale, 1994.

Fragner 1997
Bert G. Fragner. "Iran under Ilkhanid Rule in a World History Perspective." In Aigle 1997a, pp. 121–31.

H. Franke 1978
Herbert Franke. *From Tribal Chieftain to Universal Emperor and God: The Legitimation of the Yüan Dynasty.* Sitzungsberichte, Bayerische Akademie der Wissenschaften, Philosophisch-Historische Klasse, 1978, 2. Munich: Verlag der Bayerischen Akademie der Wissenschaften, 1978.

H. Franke 1981
Herbert Franke. "Tibetans in Yüan China." In *China under Mongol Rule,* edited by John D. Langlois Jr., pp. 296–328. Princeton: Princeton University Press, 1981.

U. Franke 1979
U. Franke. "Die Baukeramik von Taht-i Suleiman, Azerbaiğan, Iran." Master's thesis, Georg-August Universität, Göttingen, 1979.

Frelinghuysen 1993
Alice Cooney Frelinghuysen. "The Forgotten Legacy: The Havemeyers' Collection of Decorative Arts." In Alice Cooney Frelinghuysen et al., *Splendid Legacy: The Havemeyer Collection,* pp. 99–113. Exhib. cat. New York: The Metropolitan Museum of Art, 1993.

Fu 1978
Fu Shen. "Nucang jia huangzi dazhang gongzhu: Yuandai huangshi shuhua shilüe [Nü-ts'ang chia huang-tzu ta-chang kung-chu: Yüan-tai huang-shih shu-hua shou-ts'ang shih-lüeh]" (Historical sketch of the collection of paintings of the Yüan emperors: The collection of Princess Sengge). *Gugong jikan [Ku-kung chi-k'an]* 13, no. 1 (autumn 1978), pp. 25–52.

Fuchs 1946
Walter Fuchs. "Analecta zur mongolischen Übersetzungsliteratur der Yüan-Zeit." *Monumenta Serica* 11 (1946), pp. 33–64.

Fujian Provincial Museum 1982
Fujian Provincial Museum. *Fuzhou Nansong Huang Sheng mu* (The southern Song tomb of Huang Sheng in Fuzhou). Beijing: Wenwu chubanshe, 1982.

Gettens and Stout 1966
Rutherford J. Gettens and George L. Stout. *Painting Materials: A Short Encyclopaedia.* Rev. ed. New York: Dover Publications, 1966. 1st ed., New York: D. Van Nostrand, 1942.

Ghouchani 1992
ʿAbd Allah Ghouchani. *Ashʿari farsi-yi kashiha-yi takht-i sulaiman* (Persian poetry on the tiles of Takht-i Sulaiman). Bastanʾshinasi va tarikh, 17. Tehran: Markaz-i Nashr-i Danishgahi, 1992.

Ghouchani 1997

ʿAbd Allah Ghouchani. "Payezeh." *Mirāth-e Farhangi,* no. 17 (summer 1997), pp. 42–45.

Gierlichs 1993

Joachim Gierlichs. *Drache, Phönix, Doppeladler: Fabelwesen in der islamischen Kunst.* Exhib. cat. Museum für Islamische Kunst. Berlin: Gebr. Mann, 1993.

Gilli-Elewy 2000

Hend Gilli-Elewy. *Bagdad nach dem Sturz des Kalifats: Die Geschichte einer Provinz unter ilhanischer Herrschaft (656–735/1258–1335).* Islamkundliche Untersuchungen, 231. Berlin: Schwarz, 2000.

Giovanni da Pian del Carpine 1955

Giovanni da Pian del Carpine. "History of the Mongols." In Dawson 1955, pp. 1–76.

Giuzal'ian 1949

Leon Tigranovich Giuzal'ian. "Frizovye izraztsy XIII v. S poeticheskimi fragmentami" (Friezelike tiles of the thirteenth century with poetical fragments). *Epigrafika Vostoka* 3 (1949), pp. 72–81.

Giuzal'ian 1963

Leon Tigranovich Giuzal'ian. "Tri indzhuidskikh bronzvykh sosuda (K voprosu o lokalizatsii iugo-zapadnoi gruppy srednevekovoi khudozhestvennoi bronzy Irana)" (Three Injuid bronze vessels [Localization of a south-western group of medieval Iranian bronzes]). In *Trudy dvadtsat' piatogo Mezhdunarodnogo kongressa vostokovedov, Moskva 9–16 avgusta 1960* (Papers of the Twenty-fifth International Congress of Orientalists, Moscow, August 9–16, 1960), vol. 2, *Zasedaniia sektsii VI–IX, XII* (Sessions of sections VI–IX, XII), pp. 174–78. Moscow, 1963.

Gladiss 1998

Almut von Gladiss. *Schmuck im Museum für Islamische Kunst.* Veröffentlichungen des Museums für Islamische Kunst, 2. Berlin: Staatliche Museen zu Berlin, Preussischer Kulturbesitz, and Museum für Islamische Kunst, 1998.

Gluck 1980

Jay Gluck. *7000-nen no rekishi to asobu: Perushia tōki no sekai* (Enjoying 7,000 years of history: The world of Persian pottery). Ōtsu: Seibu Hōru, 1980.

Godman 1901

Frederick Du Cane Godman. *The Godman Collection of Oriental and Spanish Pottery and Glass.* London, 1901.

Golden Haggadah 1970

Bezalel Narkiss, ed. *The Golden Haggadah: A Fourteenth-Century Illuminated Hebrew Manuscript in the British Museum.* 2 vols. London: Eugrammia Press, 1970.

Golden Horde 2000

Altyn urda khazinalare/Sokrovishcha Zolotoi ordy/The Treasures of the Golden Horde. Exhib. cat. Organized by the State Hermitage Museum and other institutions. Saint Petersburg: Slaviia, 2000.

Golombek 1974

Lisa Golombek. "The Cult of Saints and Shrine Architecture in the Fourteenth Century." In *Near Eastern Numismatics, Iconography, Epigraphy and History: Studies in Honor of George C. Miles,* edited by Dickran K. Kouymjian, pp. 419–30. Beirut: American University of Beirut, 1974.

Golombek 1988

Lisa Golombek. "The Draped Universe of Islam." In *Content and Context of Visual Arts in the Islamic World,* edited by Priscilla P. Soucek, pp. 25–38. Monographs on the Fine Arts, 44. University Park, Pa., and London: Pennsylvania State University Press, 1988.

Golombek 1991

Lisa Golombek. "Golden Garlands of the Timurid Epoch." In *Jewellery and Goldsmithing in the Islamic World: International Symposium, the Israel Museum, Jerusalem, 1987,* edited by Naʾama Brosh, pp. 63–71. Jerusalem: The Israel Museum, 1991.

Golombek, Mason, and Bailey 1996

Lisa Golombek, Robert B. Mason, and Gauvin A. Bailey. *Tamerlane's Tableware: A New Approach to the Chinoiserie Ceramics of Fifteenth- and Sixteenth-Century Iran.* Islamic Art and Architecture, 6. Costa Mesa, Calif.: Mazda Publishers in association with the Royal Ontario Museum, 1996.

Goodrich and Feng 1945–46

L. C. Goodrich and Feng Chia-sheng. "The Early Development of Firearms in China." *Isis* 36, no. 2 (1945–46), pp. 114–23.

Grabar 1969

Oleg Grabar. "Notes on the Iconography of the 'Demotte *Shāh-nāma.*'" In *Paintings from Islamic Lands,* edited by Ralph H. Pinder-Wilson, pp. 32–47. Oriental Studies, 4. Oxford: Bruno Cassirer, 1969.

Grabar and Blair 1980

Oleg Grabar and Sheila Blair. *Epic Images and Contemporary History: The Illustrations of the Great Mongol Shahnama.* Chicago: University of Chicago Press, 1980.

Gray 1955

Basil Gray. "Art under the Mongol Dynasties of China and Persia." *Oriental Art,* n.s., 1 (winter 1955), pp. 159–67.

Gray 1961

Basil Gray. *Persian Painting.* Treasures of Asia. New York: Skira, 1961.

Gray 1969

Basil Gray. "Some Chinoiserie Drawings and Their Origin." In *Forschungen zur Kunst asiens: In Memoriam Kurt Erdmann, 9. September 1901–30. September 1964,* edited by Oktay Aslanapa and Rudolf Naumann, pp. 159–71. Istanbul: Istanbul Üniversitesi Edebiyat Fakültesi, Türk ve İslâm Sanatı Kürsüsü, 1969.

Gray 1977

Basil Gray. *Persian Painting.* Treasures of Asia. New York: Rizzoli; Geneva: Skira, 1977.

Gray 1978

Basil Gray. *The World History of Rashid al-Din: A Study of the Royal Asiatic Society Manuscript.* London: Faber and Faber, 1978.

Gray 1979

Basil Gray, ed. *The Arts of the Book in Central Asia, Fourteenth–Sixteenth Centuries.* Boulder: Shambhala; Paris: UNESCO, 1979.

Grekov and Iakubovskii 1939

Boris Dmitrievich Grekov and Aleksandr Iur'evich Iakubovskii. *La Horde d'Or: La Domination tatare au XIIIᵉ et au XIVᵉ siècle de la Mer Jaune à la Mer Noire.* Translated by François Thuret. Bibliothèque historique. Paris: Payot, 1939.

Grigor of Akancʿ 1954

Grigor of Akancʿ. *History of the Nation of the Archers (the Mongols).* Translated and edited by Robert P. Blake and Richard N. Frye. Cambridge, Mass.: Harvard University Press, 1954.

Gronke 1997

Monika Gronke. "La Religion populaire en Iran mongol." In Aigle 1997a, pp. 205–30.

Grousset 1939

René Grousset. *L'Empire des steppes: Attila, Gengis-Khan, Tamerlan.* Bibliothèque historique. Paris: Payot, 1939. English ed., *The Empire of the Steppes: A History of Central Asia,* translated by Naomi Walford, New Brunswick, N.J.: Rutgers University Press, 1970.

Grousset 1972

René Grousset. *Conqueror of the World.* Translated by Denis Sinor and Marian MacKellar. A Viking Compass Book. New York: Viking Press, 1972.

Grube 1962

Ernst J. Grube. *Muslim Miniature Paintings from the XIII to XIX Century from Collections in the United States and Canada.* Cataloghi di mostre, 18. Venice: N. Pozza, 1962.

Grube 1976

Ernst J. Grube. *Islamic Pottery of the Eighth to the Fifteenth Century in the Keir Collection.* London: Faber and Faber, 1976.

Grube 1978

Ernst J. Grube. *Persian Painting in the Fourteenth Century: A Research Report.* Naples: Istituto Orientale, 1978.

Grube 1981

Ernst J. Grube. "Ilkhānid Stucco Decoration: Notes on the Stucco Decoration of Pīr-i Bakrān." In *Isfahan,* pp. 85–96. Quaderni del Seminario di Iranistica, Uralo-Altaistica e Caucasologia dell'Università degli Studi di Venezia, 10. Venice, 1981.

Grube 1990–91

Ernst J. Grube. Review of Cowen 1989. *Islamic Art* 4 (1990–91), pp. 488–93.

Grube 1991

Ernst J. Grube, ed. *A Mirror for Princes from India: Illustrated Versions of the Kalilah wa Dimnah, Anvar-i Suhayli, Iyar-i Danish, and Humayun Nameh.* Bombay: Marg Publications, 1991.

Guest and Ettinghausen 1961

Grace D. Guest and Richard Ettinghausen. "The Iconography of a Kāshān Luster Plate." *Ars Orientalis* 4 (1961), pp. 25–64.

Günther 1993

Jörn-Uwe Günther. *Die illustrierten mittel-hochdeutschen Weltchronikhandschriften in Versen: Katalog der Handschriften und Einordnung der Illustrationen in die Bildüberlieferung.* Tuduv-Studien, Reihe Kunstgeschichte, 48. Munich: Tuduv, 1993.

Guo 1998

Guo Qinghua. "Yingzao fashi: Twelfth-Century Chinese Building Manual." *Architectural History* 41 (1998), pp. 1–13.

Hafiz-i Abru 1971

Hafiz-i Abru. *Zail-i jamiʿ al-tavarikh-i rashidi* (Analysis of the *Compendium of Chronicles* of Rashid al-Din). 2d ed. Edited by Khanbaba Bayani. Tehran: Tehran University Press, 1971.

Halperin 1985

Charles J. Halperin. *Russia and the Golden Horde: The Mongol Impact on Medieval Russian History.* Bloomington: Indiana University Press, 1985.

Hamd Allah Mustaufi Qazvini 1915–19

Hamd Allah Mustaufi Qazvini. *The Geographical Part of the Nuzhat-al-Qulūb Composed by Hamd-Allāh Mustawfī of Qazwīn in 740 (1340).* Vol. 1 in Persian. Vol. 2, translated into English by Guy Le Strange. E. J. W. Gibb Memorial Series, 23. Leiden: Brill; London: Luzac and Company, 1915–19.

Hamd Allah Mustaufi Qazvini 1958

Hamd Allah Mustaufi Qazvini. *Nuzhat al-qulub* (A pleasure trip for the heart). Edited by Muhammad Dabir-siyaqi. Tehran: Kitabkhana-i Tahuri, 1958.

Haneda 1997

Masashi Haneda. "The Pastoral City and the Mausoleum City: Nomadic Rule and City Construction in the Eastern Islamic World." In *Islamic Urbanism in Human History: Political Power and Social Networks,* edited by Tsugitaka Sato, pp. 142–70. London and New York: Kegan Paul International, 1997.

Hangin 1973

John Hangin, trans. *Köke sudur (The Blue Chronicle): A Study of the First Mongolian Historical Novel by Injannasi.* Asiatische Forschungen, 38. Wiesbaden: Harrassowitz, 1973.

Hansen 1993

Henry Harald Hansen. *Mongol Costumes.* Carlsberg Foundation's Nomad Research Project. London and New York: Thames and Hudson; Copenhagen: Rhodos International Science and Art Publishers, 1993.

Harada 1941

Yoshito Harada, with Komai Kazuchika. *Shang-tu: The Summer Capital of the Yüan Dynasty in Dolon-Nor, Mongolia.* Archaeologica orientalis, ser. B., 2. Tokyo: Toa-Koko Gakukai, 1941.

Harb 1978

Ulrich Harb. *Ilkhanidische Stalaktitengewölbe: Beitr. zu Entwurf u. Bautechnik.* Archäologische Mitteilungen aus Iran, Ergänzungsband, 4. Berlin: Reimer, 1978.

Harrassowitz 1966

Orientalische Handschriften: Türkische, persische und arabische Mss. des XIV. bis XIX. Jahrhunderts. Otto Harrassowitz, catalogue 500. Wiesbaden, 1966.

Hartog 1996

Leo de Hartog. *Russia and the Mongol Yoke: The History of the Russian Principalities and the Golden Horde, 1221–1502.* London and New York: British Academic Press, 1996.

Hattstein and Delius 2000

Markus Hattstein and Peter Delius. *Islam: Kunst und Architektur.* Cologne: Könemann, 2000.

Hearn 1996

Maxwell K. Hearn. "Reunification and Revival." In Fong and Watt 1996, pp. 269–97.

Heidemann 1994

Stefan Heidemann. *Das Aleppiner Kalifat (A.D. 1261): Vom Ende des Kalifates in Bagdad über Aleppo zu den Restaurationen in Kairo.* Islamic History and Civilization, Studies and Texts, 6. Leiden and New York: Brill, 1994.

Heissig 1966

Walther Heissig. *A Lost Civilization: The Mongols Rediscovered.* Translated by D. J. S. Thomson. London: Thames and Hudson, 1966.

Heissig 1971

Walther Heissig, with Charles R. Bawden. *Catalogue of Mongol Books, Manuscripts and Xylographs.* Copenhagen: The Royal Library, 1971.

Herzfeld 1926

E. Herzfeld. "Reisebericht." *Zeitschrift der Deutschen Morgenländischen Gesellschaft* 80 (1926), pp. 225–84.

Hillenbrand 1977

Robert Hillenbrand. *Imperial Images in Persian Painting.* Exhib. cat. Scottish Arts Council Gallery. Edinburgh: Scottish Arts Council, 1977.

Hillenbrand 1982

Robert Hillenbrand. "The Flanged Tomb Tower at Basṭām." In *Art et société dans le monde iranien,* edited by Chahryar Adle, pp. 237–61. Institut Français d'Iranologie de Téhéran, Bibliothèque iranienne, 26. Recherche sur les grandes civilisations, Synthèse, 9. Paris: Éditions Recherche sur les civilisations, 1982.

Hillenbrand 1994

Robert Hillenbrand, ed. *The Art of the Saljūqs in Iran and Anatolia: Proceedings of a Symposium Held in Edinburgh in 1982.* Costa Mesa, Calif.: Mazda Publishers, 1994.

Hillenbrand 1996

Robert Hillenbrand. "The Iskandar Cycle in the Great Mongol *Šāhnāma.*" In *The Problematics of Power: Eastern and Western Representations of Alexander the Great,* edited by Margaret Bridges and J. Christoph Bürgel, pp. 203–29. Schweizer asiatische Studien, Monographien, 22. Bern: Peter Lang, 1996.

Hillenbrand 2000

Robert Hillenbrand. "Images of Muhammad in al-Biruni's *Chronology of Ancient Nations.*" In *Persian Painting from the Mongols to the Qajars: Studies in Honour of Basil W. Robinson,* edited by Robert Hillenbrand, pp. 129–46. Pembroke Persian Papers, 3. London and New York: I. B. Tauris in association with the Centre of Middle Eastern Studies, University of Cambridge, 2000.

Hillmann 1990

Michael C. Hillmann. *Iranian Culture: A Persianist View.* Lanham: University Press of America, 1990.

Ho Peng-yoke 1969

Ho Peng-yoke. "The Astronomical Bureau in Ming China." *Journal of Asian History* 3 (1969), pp. 137–57.

Hobson 1932

Robert Lockhart Hobson. *A Guide to the Islamic Pottery of the Near East.* British Museum. London, 1932.

Hoepfner and Neumeyer 1979

Wolfram Hoepfner and Fritz Neumeyer. *Das Haus Wiegand von Peter Behrens in Berlin-Dahlem: Baugeschichte und Kunstgegenstände eines herrschaftlichen Wohnhauses.* Das Deutsche Archäologische Institut, Geschichte und Dokumente, 6. Mainz: P. von Zabern, 1979.

Hoffmann 1997

Birgitt Hoffmann. "The Gates of Piety and Charity: Rašīd al-Dīn Fadl Allāh as Founder of Pious Endowments." In Aigle 1997a, pp. 189–202.

Holmgren 1986

Jennifer Holmgren. "Observations on Marriage and Inheritance Practices in Early Mongol and Yuan Society." *Journal of Asian History* 20, no. 2 (1986), pp. 127–92.

Holt 1986

Peter M. Holt. "The Īlkhān Aḥmad's Embassies to Qalāwūn: Two Contemporary Accounts." *Bulletin of the School of Oriental and African Studies* 49 (1986), pp. 128–32.

Honda 1991

Honda Minobu. "Iruhan no toeichi, kaeichi" (The winter and summer camps of the Ilkhans). In Honda Minobu, *Mongoru jidai-shi kenkyu* (Historical studies on the Mongol domination), pp. 357–81. Tokyo: Tokyo Daigaku Shuppankai, 1991.

Hopkirk 1992

Peter Hopkirk. *The Great Game: The Struggle for Empire in Central Asia*. New York and Tokyo: Kodansha International, 1992.

Howorth 1876–1927

Henry H. Howorth. *History of the Mongols, from the Ninth to the Nineteenth Century*. 4 pts. London and New York: Longmans, Green, and Company, 1876–1927. Reprint, New York: Ben Franklin, 1966.

Huart 1934

C. Huart. "Yāḳūt al-Mustaʿṣimī." In *Encyclopaedia of Islam*, vol. 4, p. 1154. Leiden: Brill; London: Luzac and Company, 1934.

Huff 1989–90

Dietrich Huff. "Takht-i Sulaiman." In *Shahr-ha-yi Iran* (Cities of Iran), edited by Muhammad Yusuf Kiyani, vol. 3, pp. 1–33. Tehran, 1989–90.

Hunarfar 1977

Lutf Allah Hunarfar. *Ganjina-yi athar-i tarikhi-yi isfahan* (Treasures among the historical monuments of Isfahan). Tehran, 1977.

Hung 1951

William Hung. "The Transmission of the Book Known as *The Secret History of the Mongols*." *Harvard Journal of Asiatic Studies* 14 (December 1951), pp. 433–92.

Ibn ʿAbd al-Zahir 1961

Muhyi al-Din ibn ʿAbd al-Zahir. *Tashriq al-ayyam* (The days of the ascent). Edited by Murad Kamil. Cairo, 1961.

Ibn al-Fuwati 1997

Ibn al-Fuwati. *Kitab al-ḥawadith* (Book of traditions). Edited by Bashshar ʿAwwad Maʿruf and Imad Abdessalam Raʾuf. Beirut: Dar al-Gharb al-Islami, 1997.

Ibn Battuta 1829

Shams al-Din ibn Battuta. *The Travels of Ibn Batūta; Translated from the Abridged Arabic Manuscript Copies, Preserved in the Public Library of Cambridge with Notes, Illustrative of the History, Geography, Botany, Antiquities, &c. Occurring throughout the Work*. London: Oriental Translation Committee, 1829.

Ibn Battuta 1929

Shams al-Din ibn Battuta. *Travels in Asia and Africa, 1325–1354*. Translated and edited by H. A. R. Gibb. Argonaut Series, 7. New York: Robert M. McBride and Company, 1929. Reprint, New Delhi and Madras: Asian Educational Services, 1992.

Ibn Battuta 1962

Shams al-Din ibn Battuta. *Travels of Ibn Baṭṭūṭa, A.D. 1325–1354*. Vol. 2. Translated by H. A. R. Gibb from the Arabic text edited by C. Defrémery and B. R. Sanguinetti. Works Issued by the Hakluyt Society, 2d ser., no. 117. Cambridge: Cambridge University Press, 1962.

Ibn Fadl Allah al-ʿUmari 1968

Ibn Fadl Allah al-ʿUmari. *Das Mongolische Weltreich: Al-ʿUmari's Darstellung der mongolischen Reiche in seinem Werk Masalik al-absar fi mamalik al-amsar*. Edited by Klaus Lech. Asiatische Forschungen, 22. Wiesbaden: Harrassowitz, 1968.

Ibn Khurdadhbih 1889

ʿUbayd Allah ibn ʿAbd Allah ibn Khurdadhbih. *Kitab al-masalik wa al-mamalik (Liber Viarum et Regnorum)*. Edited and translated by Michael Jan de Goeje. Leiden: Brill, 1889.

Ipşiroğlu 1964

Mazhar Şevket Ipşiroğlu. *Saray-Alben: Diez'sche Klebebände aus den Berliner-Sammlungen. Beschreibung und stilkritische Anmerkungen. Verzeichnis der orientalischen Handschriften in Deutschland, 8*. Wiesbaden: Steiner, 1964.

Ipşiroğlu 1967

Mazhar Şevket Ipşiroğlu. *Paintings and Culture of the Mongols*. Translated by E. D. Phillips. New York: Harry N. Abrams; London: Thames and Hudson, 1967.

Irwin 1997

Robert Irwin. *Islamic Art in Context: Art, Architecture, and the Literary World*. Perspectives. New York: Harry N. Abrams, 1997.

Islamic Art in the Hermitage Museum 1990

Badaʾiʿ al-fann al-islami fi-mathaf al-harmitaj biʾl-ittihad al-sufyati / Shedevry islamskogo iskusstva v Ermitazhe SSSR / Masterpieces of Islamic Art in the Hermitage Museum. Exhib. cat. Introduction by Anatoly A. Ivanov. Kuwait: Dar al-Athar al-Islamiyyah, 1990.

Islamic World 1987

The Islamic World. Introduction by Stuart Cary Welch. New York: The Metropolitan Museum of Art, 1987.

Islamische Kunst 1986

Islamische Kunst, verborgene Schätze: Ausstellung des Museums für Islamische Kunst, Berlin. Exhib. cat. Schloss Cappenberg, Selm; Berlin-Dahlem. Berlin: Staatliche Museen, Preussischer Kulturbesitz, 1986.

Jackson 1978

Peter Jackson. "The Dissolution of the Mongol Empire." *Central Asiatic Journal* 22 (1978), pp. 186–244.

Jackson 1987

Peter Jackson. "Arpā Khan." In *Encyclopaedia Iranica* 1985–, vol. 2 (1987), pp. 518–19.

Jackson 1991

Peter Jackson. "The Crusade against the Mongols (1241)." *Journal of Ecclesiastical History* 42 (January 1991), pp. 1–18.

Jackson 1992

Peter Jackson. "Čāv." In *Encyclopaedia Iranica* 1985–, vol. 5 (1992), pp. 96–97.

Jackson 1993a

Peter Jackson. "Čormāḡūn." In *Encyclopaedia Iranica* 1985–, vol. 6 (1993), p. 274.

Jackson 1993b

Peter Jackson. "Muẓaffarids." *Encyclopaedia of Islam* 1960–, vol. 7 (1993), pp. 820–22.

Jackson 1999

Peter Jackson. "From *Ulus* to Khanate: The Making of the Mongol States, c. 1220–c. 1290." In Amitai-Preiss and D. O. Morgan 1999, pp. 12–38.

Jackson 2001

Peter Jackson. "Gaykātū Khan." In *Encyclopaedia Iranica* 1985–, vol. 10 (2001), pp. 344–45.

Jackson and Melville 2001

Peter Jackson and Charles Melville. "Ḡīāṯ-al-Dīn Moḥammad." In *Encyclopaedia Iranica* 1985–, vol. 10 (2001), pp. 598–99.

Jahn 1970

Karl Jahn. "Paper Currency in Iran: A Contribution to the Cultural and Economic History of Iran in the Mongol Period." *Journal of Asian History* 4 (1970), pp. 101–35.

James 1980

David Lewis James. *Qurʾans and Bindings from the Chester Beatty Library: A Facsimile Exhibition*. London: World of Islam Festival Trust, 1980.

James 1988

David Lewis James. *Qurʾans of the Mamluks*. New York: Thames and Hudson, 1988.

James 1992

David Lewis James. *The Master Scribes: Qurʾans of the Tenth to the Fourteenth Centuries A.D.* Nasser D. Khalili Collection of Islamic Art, 2. London: Nour Foundation in association with Azimuth Editions and Oxford University Press, 1992.

G. Jenkins 1974

Gareth Jenkins. "A Note on Climatic Cycles and the Rise of Chinggis Khan." *Central Asiatic Journal* 18 (1974), pp. 217–26.

M. Jenkins 1983a

Marilyn Jenkins[-Madina], ed. *Islamic Art in the Kuwait National Museum: The al-Sabah Collection*. London: Sotheby, 1983.

M. Jenkins 1983b

Marilyn Jenkins[-Madina]. "Islamic Pottery: A Brief History." *The Metropolitan Museum of Art Bulletin* 40, no. 4 (spring 1983).

M. Jenkins 1988

Marilyn Jenkins[-Madina]. "Mamluk Jewelry: Influences and Echoes." *Muqarnas* 5 (1988), pp. 29–42.

M. Jenkins 2000

Marilyn Jenkins-Madina. "Collecting the 'Orient' at the Met: Early Tastemakers in America." *Ars Orientalis* 30 (2000), pp. 69–89. Special issue, *Exhibiting the Middle East: Collections and Perceptions of Islamic Art*, edited by Linda Komaroff.

Jia 1977

Jia Zhoujie. "Yuan Shangdu diaocha baogao" (Report on the investigation of Shangdu of the Yuan dynasty). *Wenwu*, 1977, no. 5, pp. 65–74.

Jing 1994a

Anning Jing. "Buddhist-Daoist Struggle and a

Pair of 'Daoist' Murals." *Bulletin* [Museum of Far Eastern Antiquities (Östasiatiska Museet)], Stockholm), no. 66 (1994), pp. 117–81.

Jing 1994b
Anning Jing. "The Portraits of Khubilai Khan and Chabi by Anige (1245–1306), a Nepali Artist at the Yuan Court." *Artibus Asiae* 54 (1994), pp. 40–86.

Jinshi 1975
Tuotuo et al. *Jinshi* (History of the Jin dynasty). 8 vols. Beijing: Zhonghua shuju, 1975.

***Journey into China's Antiquity* 1997**
A Journey into China's Antiquity: *National Museum of Chinese History*. 4 vols. Beijing: Morning Glory Publishers, 1997.

Juvaini 1958
ʿAlaʾ al-Din ʿAta-Malik Juvaini. *History of the World-Conqueror*. Translated by John A. Boyle from the text of Mizra Muhammad Qazvini. 2 vols. Manchester: Manchester University Press, 1958. Reprint, with a new introduction and bibliography by David O. Morgan, Seattle: University of Washington Press, 1997.

Juzjani 1970
Juzjani. *Tabakat-i-Nasiri: A General History of the Muhammadan Dynasties of Asia, Including Hindustan, from A.H. 194 (810 A.D.) to A.H. 658 (1260 A.D.) and the Irruption of the Infidel Mughals into Islam.* Translated by Henry George Raverty. 2 vols. Reprint. New Delhi: Oriental Books Reprint Corporation, 1970. 1st ed., London, 1881.

Kahn 1984
Paul Kahn. *The Secret History of the Mongols: The Origin of Chinghis Khan. An Adaptation of the "Yuan ch'ao pi shih," Based Primarily on the English Translation by Francis Woodman Cleaves.* San Francisco: North Point Press, 1984.

Karamustafa 1994
Ahmet T. Karamustafa. *God's Unruly Friends: Dervish Groups in the Islamic Later Middle Period, 1200–1550.* Salt Lake City: University of Utah Press, 1994.

Kashani 1970
Abu al-Qasim ʿAbd Allah Kashani. *Tarikh-i uljaytu* (The history of Uljaytu). Edited by Mahin Hambli. Tehran, 1970.

Keene and M. Jenkins 1981–82
Manuel Keene and Marilyn Jenkins[-Madina]. "Djawhar." In *Encyclopaedia of Islam: Supplement; New Edition,* fascs. 1–2, pp. 250–62. Leiden: Brill, 1981–82.

Kennedy 1968
E. S. Kennedy. "The Exact Sciences in Iran under the Saljuqs and Mongols." In Boyle 1968a, pp. 659–79.

Kerr 1990
Rose Kerr. *Later Chinese Bronzes.* Far Eastern Series. London: Bamboo Publishing and the Victoria and Albert Museum, 1990.

Kerr 1991
Rose Kerr, ed. *Chinese Art and Design: The T. T. Tsui Gallery of Chinese Art.* Texts by Rose Kerr,

Verity Wilson, and Craig Clunas. London: Victoria and Albert Museum, 1991.

Kessler 1994
Adam Theodore Kessler. *Empires beyond the Great Wall: The Heritage of Genghis Khan*. Exhib. cat. Los Angeles: Natural History Museum of Los Angeles County, 1994.

Khudiakov 1980
Iu. S. Khudiakov. *Vooruzhenie eniseiskikh kyrgyzov VI–XII vv* (Arms and armor of the Yenisei Kyrgyz, VI–XII century). Novosibirsk: Nauka Sibirskoe otdelenie, 1980.

Kingery and Vandiver 1986
W. David Kingery and Pamela B. Vandiver. *Ceramic Masterpieces: Art, Structure, and Technology.* New York: Free Press; London: Collier MacMillan, 1986.

Kiselev 1965
S. V. Kiselev, L. A. Evtiukhova, L. R. Kyzlasov, N. Ia. Merpert, and V. P. Levashova. *Drevnemongol'skie goroda* (Ancient Mongolian cities). Moscow: Izdatel'stvo "Nauka," 1965.

Klimburg-Salter 1976–77
Deborah E. Klimburg-Salter. "A Sufi Theme in Persian Painting: The Dīwān of Sultan Aḥmad Ǧalāʾir in the Freer Gallery of Art, Washington, D.C." *Kunst des Orients* 11 (1976–77), pp. 43–84.

Komaroff 1984
Linda Komaroff. "The Timurid Phase in Iranian Metal-Work: Formulation and Realization of a Style." 2 vols. Ph.D. diss., Institute of Fine Arts, New York University, 1984. Microfilm, Ann Arbor: University Microfilms.

Komaroff 1992
Linda Komaroff. *The Golden Disk of Heaven: Metalwork of Timurid Iran.* Persian Art Series, 2. Costa Mesa, Calif.: Mazda, 1992.

Komaroff 1994
Linda Komaroff. "Paintings in Silver and Gold: The Decoration of Persian Metalwork and Its Relationship to Manuscript Illustration." *Studies in the Decorative Arts* 2, no. 1 (fall 1994), pp. 2–34.

Komaroff 1998
Linda Komaroff. *Islamic Art at the Los Angeles County Museum of Art.* Los Angeles: Los Angeles County Museum of Art, 1998.

Kotwicz 1950
Władysław Kotwicz. "Les Mongols: Promoteurs de l'idée de paix universelle au début du XIIIᵉ siècle." *Rocznik Orientalistyczny* 16 (1950), pp. 428–34.

Krachkovskaia 1931
V. Krachkovskaia. "Notices sur les inscriptions de la mosquée djoumʿa à Véramine." *Revue des études islamiques* 5 (1931), pp. 25–58.

Krachkovskii 1956
Ignatii Iulianovich Krachkovskii. *Taʾrikh al-adab al-jughrafi al-ʿarabi* (History of the literary works on Arab geography). Cairo, 1956.

Krahl 1989
Regina Krahl. "Designs on Early Chinese Textiles." *Orientations* 20, no. 8 (August 1989), pp. 62–73.

Krahl 1991
Regina Krahl. "Glazed Roofs and Other Tiles." *Orientations* 22, no. 3 (March 1991), pp. 47–61.

Krahl 1998
Regina Krahl. "Some Notes on Song and Yuan Silver." *Oriental Art* 44, no. 2 (summer 1998), pp. 39–43.

Kramarovsky 1991
Mark Kramarovsky. "The Culture of the Golden Horde and the Problem of the 'Mongol Legacy.'" In Seaman and Marks 1991, pp. 255–73.

Kramarovsky 1994
Mark Kramarovsky. "Metalwork of the Golden Horde." In *Art Treasures of the Hermitage* 1994, vol. 1, pp. 470–73.

Kramarovsky 1996
Mark Kramarovsky. "Mongol Horse Trappings in the Thirteenth and Fourteenth Centuries." In Alexander 1996, vol. 1, pp. 48–53.

Kramarovsky 2000
Mark Kramarovsky. "The Gold of the Chingissids: The Juchids' Treasury." In *Golden Horde* 2000, pp. 202–7.

Kratzert 1974
Christine Kratzert. "Die illustrierten Handschriften der Weltchronik des Rudolf von Ems." Ph.D. diss., Freie Universität Berlin, 1974.

Krueger 1966–67
John R. Krueger. "Chronology and Bibliography of The Secret History of the Mongols." *Mongolia Society Bulletin* 5 (1966–67), pp. 25–31.

Kühnel 1925
Ernst Kühnel. "Three Mosul Bronzes at Leningrad." In *The Year Book of Oriental Art and Culture, 1924–1925,* edited by Arthur Waley, pp. 100–101. London: Ernest Benn, 1925.

Kühnel 1959
Ernst Kühnel. "Malernamen in den Berliner 'Saray'-Alben." *Kunst des Orients* 3 (1959), pp. 66–77.

Kuleff, Djingova, and Penev 1986
I. Kuleff, R. Djinova, and I. Penev. "Instrumental Neutron Activation Analysis of Pottery for Provenance." *Journal of Radioanalytical and Nuclear Chemistry* 99 (1986), pp. 345–58.

Kuwabara 1928
Kuwabara Jitsuzō. "On P'u Shou-kêng." *Memoirs of the Research Department of the Tōyō Bunko (The Oriental Library),* no. 2 (1928), pp. 1–79.

Lambton 1969
Ann Katharine Swynford Lambton. *Landlord and Peasant in Persia: A Study of Land Tenure and Land Revenue Administration.* 2d ed. London: Oxford University Press, 1969.

Lambton 1986

Ann Katharine Swynford Lambton. "Mongol Fiscal Administration in Persia." *Studia Islamica,* no. 64 (1986), pp. 79–99.

Lambton 1987

Ann Katharine Swynford Lambton. "Mongol Fiscal Administration in Persia (Part II)." *Studia Islamica,* no. 65 (1987), pp. 97–123.

Lambton 1988

Ann Katharine Swynford Lambton. *Continuity and Change in Medieval Persia: Aspects of Administrative, Economic, and Social History, Eleventh–Fourteenth Century.* Columbia Lectures on Iranian Studies, 2. Albany, N.Y.: Bibliotheca Persica, 1988.

Lambton 1997

Ann Katharine Swynford Lambton. "*Awqāf* in Persia: Sixth–Eighth/Twelfth–Fourteenth Centuries." *Islamic Law and Society* 4 (October 1997), pp. 298–318.

Lambton 1998

Ann Katharine Swynford Lambton. "Economy, V: From the Arab Conquest to the End of the Il-Khanids." In *Enyclopaedia Iranica* 1985–, vol. 8 (1998), pp. 107–32.

Lane 1957

Arthur Lane. *Later Islamic Pottery: Persia, Syria, Egypt, Turkey.* Faber Monographs on Pottery and Porcelain. London: Faber and Faber, 1957.

Lane 1960

Arthur Lane. *A Guide to the Collection of Tiles.* 2d ed. Victoria and Albert Museum. London: H. M. Stationery Office, 1960.

Lane 1971

Arthur Lane. *Later Islamic Pottery: Persia, Syria, Egypt, Turkey.* 2d ed. Faber Monographs on Pottery and Porcelain. London: Faber and Faber, 1971.

Langlois 1981

John D. Langlois Jr., ed. *China under Mongol Rule.* Princeton: Princeton University Press, 1981.

Lawton and Lentz 1998

Thomas Lawton and Thomas W. Lentz, eds. *Beyond the Legacy: Anniversary Acquisitions for the Freer Gallery of Art and the Arthur M. Sackler Gallery.* Washington, D.C.: Smithsonian Institution, 1998.

Lee and W. Ho 1968

Sherman E. Lee and Wai-kam Ho. *Chinese Art under the Mongols: The Yuan Dynasty, 1279–1368.* Exhib. cat. Cleveland: The Cleveland Museum of Art, 1968.

Leidy, Siu, and Watt 1997

Denise P. Leidy, Wai-fong Anita Siu, and James C. Y. Watt. "Chinese Decorative Arts." *The Metropolitan Museum of Art Bulletin* 55, no. 1 (summer 1997).

Lentz and Lowry 1989

Thomas W. Lentz and Glenn D. Lowry. *Timur and the Princely Vision: Persian Art and Culture in the Fifteenth Century.* Exhib. cat. Los Angeles:

Los Angeles County Museum of Art; Washington, D.C.: Arthur M. Sackler Gallery, Smithsonian Institution, 1989.

Leslie and Youssef 1988

Donald Daniel Leslie and Ahmad Youssef. "Islamic Inscriptions in Quanzhou: A Review." *T'oung Pao* 74 (1988), pp. 255–72.

Levey 1962

Martin Levey. *Mediaeval Arabic Bookmaking and Its Relation to Early Chemistry and Pharmacology.* Transactions of the American Philosophical Society, n.s., 52, pt. 4. Philadelphia, 1962.

Lewicki 1978

T. Lewicki. "al-Ḳazwīnī." In *Encyclopaedia of Islam* 1960–, vol. 4 (1978), pp. 865–67.

B. Lewis 1976

Bernard Lewis, ed. *Islam and the Arab World: Faith, People, Culture.* New York: Knopf, 1976.

F. D. Lewis 2000

Franklin D. Lewis. *Past and Present, East and West: The Life, Teaching and Poetry of Jalâl al-Din Rumi.* Oxford and Boston: Oneworld, 2000.

Li Zichang 1931

Li Zichang. *The Travels of an Alchemist: The Journey of the Taoist, Ch'ang-ch'un, from China to the Hindukush at the Summons of Chingiz Khan, Recorded by His Disciple, Li Chih-ch'ang.* Translated by Arthur Waley. London: Routledge and Kegan Paul, 1931.

Limbert 1985

J. W. Limbert. "Abū Eshāq Īnjū." In *Encyclopaedia Iranica* 1985–, vol. 1 (1985), pp. 273–74.

Lippard 1984

Bruce G. Lippard. "The Mongols and Byzantium, 1243–1341." Ph.D. diss., Indiana University, 1984. Microfilm, Ann Arbor: University Microfilms.

C. Y. Liu 1992

Cary Y. Liu. "The Yüan Dynasty Capital, Ta-tu: Imperial Building Program and Bureaucracy." *T'oung Pao* 78 (1992), pp. 264–301.

C. Y. Liu and Ching 1999

Cary Y. Liu and Dora C. Y. Ching, eds. *Arts of the Sung and Yuan: Ritual, Ethnicity, and Style in Painting.* Princeton: The Art Museum, Princeton University, 1999.

L. G. Liu 1989

L. G. Liu. *Chinese Architecture.* London: Academy Editions, 1989.

Liu Xinyuan 1993

Liu Xinyuan. "Yuan Dynasty Official Wares from Jingdezhen." Translated by Anthony Hua-tien Lin. In *The Porcelains of Jingdezhen,* edited by Rosemary E. Scott, pp. 33–46. Colloquies on Art and Archaeology in Asia, 16. London: Percival David Foundation of Chinese Art, School of Oriental and African Studies, University of London, 1993.

Lorey 1935

Eustache de Lorey. "L'École de Tabriz: L'Islam aux prises avec la Chine." *Revue des arts asiatiques* 9 (March 1935), pp. 27–39.

Loveday 2001

Helen Loveday. *Islamic Paper: A Study of the Ancient Craft.* London: Don Baker Memorial Fund, 2001.

Lowry 1988

Glenn D. Lowry, with Susan Nemazee. *A Jeweler's Eye: Islamic Arts of the Book from the Vever Collection.* Washington, D.C.: Arthur M. Sackler Gallery, Smithsonian Institution, 1988.

Lowry and Beach 1988

Glenn D. Lowry and Milo Cleveland Beach, with Roya Marefat and Wheeler M. Thackston, and contributions by Elisabeth West FitzHugh, Susan Nemazee, and Janet G. Snyder. *An Annotated and Illustrated Checklist of the Vever Collection.* Washington, D.C.: Arthur M. Sackler Gallery, Smithsonian Institution, 1988.

Mackie 1984

Louise W. Mackie. "Toward an Understanding of Mamluk Silks: National and International Considerations." *Muqarnas* 2 (1984), pp. 127–46.

Mackie 1992

Louise W. Mackie. "Pattern Books for Drawloom Weaving in Fès, Morocco." *Bulletin du CIETA,* no. 70 (1992), pp. 169–76.

Mackie 1996

Louise W. Mackie. "Increase the Prestige: Islamic Textiles." *Arts of Asia* 26, no. 1 (1996), pp. 82–93.

Maginnis 2001

Hayden B. J. Maginnis. *The World of the Early Sienese Painter.* University Park, Pa.: Pennsylvania State University Press, 2001.

Marshak and Kramarovsky 1996

Boris Ilich Marshak and Mark Kramarovsky, eds. *Sokrovishcha Priob'ia/Treasures from the Ob' Basin.* Saint Petersburg: Formika, 1996.

Marshall 1993

Robert Marshall. *Storm from the East: From Genghis Khan to Khubilai Khan.* Berkeley: University of California Press, 1993.

Martin 1912

F. R. Martin. *The Miniature Painting and Painters of Persia, India and Turkey from the Eighth to the Eighteenth Century.* 2 vols. London: B. Quaritch, 1912.

Mason 1995

Robert B. Mason. "Criteria for the Petro-graphic Characterization of Stonepaste Ceramics." *Archaeometry* 37 (August 1995), pp. 307–21.

Mason 1997

Robert B. Mason. "Mediaeval Iranian Lustre-Painted and Associated Wares: Typology in a Multidisciplinary Study." *Iran* 35 (1997), pp. 103–35.

Mason and Tite 1994

Robert B. Mason and M. S. Tite. "The Beginnings of Islamic Stonepaste Technology." *Archaeometry* 36 (February 1994), pp. 77–91.

Mason et al. 2001

Robert B. Mason, M. S. Tite, S. Paynter, and C. Salter. "Advances in Polychrome Ceramics in the Islamic World of the 12th Century A.D." *Archaeometry* 43 (May 2001), pp. 191–209.

al-Masʿudi 1894

Abu al-Hasan ʿAli ibn al-Husayn al-Masʿudi. *Kitab al-tanbih wa al-ishraf* (The book of exhortation and supervision). Edited by Michael Jan de Goeje. Leiden: Brill, 1894.

Masuya 1997

Tomoko Masuya. "The Ilkhanid Phase of Takht-i Sulaiman." 2 vols. Ph.D. diss., New York University, 1997. Microfilm, Ann Arbor: University Microfilms.

Masuya 2000

Tomoko Masuya. "Persian Tiles on European Walls: Collecting Ilkhanid Tiles in Nineteenth-Century Europe." *Ars Orientalis* 30 (2000), pp. 39–54. Special issue, *Exhibiting the Middle East: Collections and Perceptions of Islamic Art*, edited by Linda Komaroff.

Mathews and Taylor 2001

Thomas F. Mathews and Alice Taylor. *The Armenian Gospels of Gladzor: The Life of Christ Illuminated*. Exhib. cat. Los Angeles: J. Paul Getty Museum, 2001.

Mathews and Wieck 1994

Thomas F. Mathews and Roger S. Wieck, eds. *Treasures in Heaven: Armenian Illustrated Manuscripts*. Exhib. cat. The Pierpont Morgan Library, New York; The Walters Art Gallery, Baltimore. New York: The Pierpont Morgan Library, 1994.

Mayer 1958

Leo Ary Mayer. *Islamic Woodcarvers and Their Works*. Geneva: A. Kundig, 1958.

McChesney 1996

R. D. McChesney. *Central Asia: Foundations of Change*. Leon B. Poullada Memorial Lecture Series. Princeton: Darwin Press, 1996.

Medley 1973

Margaret Medley. "Chinese Ceramics and Islamic Design." In *The Westward Influence of the Chinese Arts, from the Fourteenth to the Eighteenth Century*, edited by William Watson, pp. 1–10. Colloquies on Art and Archaeology in Asia, 3. London: Percival David Foundation of Chinese Art, School of Oriental and African Studies, University of London, 1973.

Medley 1974

Margaret Medley. *Yüan Porcelain and Stoneware*. New York: Pitman, 1974.

Medley 1986

Margaret Medley. *The Chinese Potter: A Practical History of Chinese Ceramics*. Ithaca, N.Y.: Cornell University Press, 1986.

***Meibutsu-gire* 2001**

Meibutsu-gire: Torai Orimono eno akogare (From loom to heirloom: World of *Meibutsu-gire* textiles). Tokyo: Gotō Bijutsukan, 2001.

Meisami 1987

Julie Scott Meisami. *Medieval Persian Court Poetry*. Princeton: Princeton University Press, 1987.

Meister 1938

P. W. Meister. "Edelmetallarbeiten der Mongolen-Zeit." *Ostasiatische Zeitschrift*, n.s., 24 (1938), pp. 209–13.

Melikian-Chirvani 1969

Assadullah Souren Melikian-Chirvani. "Bassins iraniens du XIVᵉ siècle au Musée des Beaux-Arts." *Bulletin des Musées et Monuments Lyonnais* 4 (1969–71; pub. 1969), pp. 189–206.

Melikian-Chirvani 1971a

Assadullah Souren Melikian-Chirvani. "Nouvelles Remarques sur l'école du Fars: À propos des bassins iraniens du XIVᵉ siècle au Musée des Beaux-Arts." *Bulletin des Musées et Monuments Lyonnais* 4 (1969–71; pub. 1971), pp. 361–91.

Melikian-Chirvani 1971b

Assadullah Souren Melikian-Chirvani. "Le Royaume de Salomon: Les Inscriptions persanes des sites achéménides." In *Le Monde iranien et l'Islam: Sociétés et cultures*, vol. 1, pp. 1–41. Centre de Recherches d'Histoire et de Philologie, IVᵉ section, École Pratique des Hautes Études, 4. Hautes études islamiques et orientales d'histoire comparée, 4. Geneva: Librarie Droz; Paris: Librairie Minard, 1971.

Melikian-Chirvani 1973

Assadullah Souren Melikian-Chirvani. *Le Bronze iranien*. Paris: Musée des Arts Décoratifs, 1973.

Melikian-Chirvani 1976

Assadullah Souren Melikian-Chirvani. *Islamic Metalwork from Iranian Lands (Eighth–Eighteenth Centuries)*. Exhib. cat. Victoria and Albert Museum. N.p.: Crown, 1976.

Melikian-Chirvani 1979

Assadullah Souren Melikian-Chirvani. "Conceptual Art in Iranian Painting and Metalwork." In *Akten des VII. Internationalen Kongresses für Iranische Kunst und Archäologie, München 7.–10. September 1976*, pp. 392–400. Archaeologische Mitteilungen aus Iran, 6. Berlin: Dietrich Reimer, 1979.

Melikian-Chirvani 1982

Assadullah Souren Melikian-Chirvani. *Islamic Metalwork from the Iranian World, Eighth–Eighteenth Centuries*. Victoria and Albert Museum Catalogues. London: H. M. Stationery Office, 1982.

Melikian-Chirvani 1984

Assadullah Souren Melikian-Chirvani. "Le *Shāh-Nāme*, la gnose soufie et le pouvoir mongol." *Journal asiatique* 272 (1984), pp. 249–337.

Melikian-Chirvani 1986

Assadullah Souren Melikian-Chirvani. "Silver in Islamic Iran: The Evidence from Literature and Epigraphy." In *Pots and Pans: A Colloquium on Precious Metals and Ceramics in the Muslim, Chinese and Graeco-Roman Worlds, Oxford 1985*, edited by Michael Vickers, pp. 89–106. Oxford Studies in Islamic Art, 3. Oxford: Oxford University Press, 1986.

Melikian-Chirvani 1987

Assadullah Souren Melikian-Chirvani. "The Lights of Sufi Shrines." *Islamic Art* 2 (1987), pp. 117–47.

Melikian-Chirvani 1988

Assadullah Souren Melikian-Chirvani. "Le Livre des Rois: Miroir du destin." *Studia Iranica* 17 (1988), pp. 7–46.

Melikian-Chirvani 1991

Assadullah Souren Melikian-Chirvani. "Le Livre des Rois: Miroir du destin. II: Il-Takht-e Soleymān et la symbolique du *Shāh-Nāme*." *Studia Iranica* 20 (1991), pp. 33–148.

Melikian-Chirvani 1996

Assadullah Souren Melikian-Chirvani. *Les Frises du "Shah Name" dans l'architecture iranienne sous les Ilkhan*. Studia Iranica, Cahier 18. Paris: Association pour l'Avancement des Études Iraniennes; Louvain: Diffusion, E. Peeters, 1996.

Melikian-Chirvani 1997

Assadullah Souren Melikian-Chirvani. "Conscience du passé et résistance culturelle dans l'Iran mongol." In Aigle 1997a, pp. 135–77.

Melville 1990a

Charles Melville. "The Itineraries of Sultan Öljeitü, 1304–16." *Iran* 28 (1990), pp. 55–70.

Melville 1990b

Charles Melville. "*Pādshāh-i Islām*: The Conversion of Sultan Maḥmūd Ghāzān Khān." In *Persian and Islamic Studies in Honour of P. W. Avery*, edited by Charles Melville, pp. 159–77. Pembroke Papers, 1. Cambridge: Centre of Middle Eastern Studies, University of Cambridge, 1990.

Melville 1990c

Charles Melville. "Bologān Kātūn." In *Encyclopaedia Iranica* 1985–, vol. 4 (1990), pp. 338–39.

Melville 1992

Charles Melville. "'The Year of the Elephant': Mamluk-Mongol Rivalry in the Hejaz in the Reign of Abū Saʿīd (1317–1335)." *Studia Iranica* 21 (1992), pp. 197–214.

Melville 1994

Charles Melville. "The Chinese-Uighur Animal Calendar in Persian Historiography of the Mongol Period." *Iran* 32 (1994), pp. 83–98.

Melville 1995

Charles Melville. "The Barbarians Civilized? A Look at the Acculturation of the Mongols in Iran." *Isfahan University Research Bulletin* 6, nos. 1–2 (March 1995), pp. 28–39.

Melville 1996a

Charles Melville. "'Sometimes by the Sword, Sometimes by the Dagger': The Role of the Ismaʿilis in Mamlūk-Mongol Relations in the Eighth/Fourteenth Century." In *Mediaeval Ismaʿili History and Thought*, edited by Farhad Daftary, pp. 247–63. New York: Cambridge University Press, 1996.

Melville 1996b

Charles Melville. "Wolf or Shepherd? Amir Chupan's Attitude to Government." In Raby and Fitzherbert 1996, pp. 79–93.

Melville 1997a

Charles Melville. "Abū Saʿīd and the Revolt of the Amirs in 1319." In Aigle 1997a, pp. 89–120.

Melville 1997b

Charles Melville. "Sarbadārids." In *Encyclopaedia of Islam* 1960–, vol. 9 (1997), pp. 47–49.

Melville 1998a

Charles Melville. "Ḥamd Allāh Mustawfī's *Ẓafarnāmah* and the Historiography of the Late Ilkhanid Period." In *Iran and Iranian Studies: Essays in Honor of Iraj Afshar*, edited by Kambiz Eslami, pp. 1–12. Princeton: Zagros Press, 1998.

Melville 1998b

Charles Melville. Review of Aubin 1995. *Bulletin critique des Annales islamologiques* 14 (1998), pp. 110–13.

Melville 1999a

Charles Melville. *The Fall of Amir Chupan and the Decline of the Ilkhanate, 1327–1337: A Decade of Discord in Mongol Iran*. Papers on Inner Asia, 30. Bloomington: Research Institute for Inner Asian Studies, Indiana University, 1999.

Melville 1999b

Charles Melville. "The Īlkhān Öljeitü's Conquest of Gīlān (1307): Rumour and Reality." In Amitai-Preiss and D. O. Morgan 1999, pp. 73–125.

Melville 2001

Charles Melville. "From Adam to Abaqa: Qāḍī Baiḍāwī's Rearrangement of History." *Studia Iranica* 30 (2001), pp. 67–86.

Melville forthcoming

Charles Melville. "History and Myth: The Persianisation of Ghazan Khan." *Studia Orientalia* II [Peter Pázmány Catholic University, Piliscsaba, Hungary] (2002). Special issue, *Irano-Turkick Cultural Contacts in the Eleventh–Seventeenth Centuries*.

Melville and Zaryab 1992

Charles Melville and ʿAbbas Zaryab. "Chobanids." In *Encyclopaedia Iranica* 1985–, vol. 5 (1992), pp. 496–502.

Miho Museum 1997

Miho Museum. *Miho Museum: South Wing*. Shigaraki: Miho Museum, 1997.

Minert 1985

L. K. Minert. "Drevneishie pamiatniki mongol'skogo monumental'nogo zodchestva" (Oldest remains of Mongolian monumental architecture). In *Drevnie kul'tury Mongolii* (Ancient Cultures of Mongolia), edited by Ruslan Sergeevich Vasil'evskii, pp. 184–209. Novosibirsk: Izdatel'stvo "Nauka," Sibirskoe otdelenie, 1985.

Minorsky 1954

Vladimir Minorsky. "A Mongol Decree of 720/1320 to the Family of Shaykh Zāhid." *Bulletin of the School of Oriental and African Studies* 16 (1954), pp. 515–27.

Minorsky 1964

Vladimir Minorsky. "Roman and Byzantine Campaigns in Atropatene." In *Iranica: Twenty Articles*, pp. 86–109. Publications of the University of Tehran, 775. Tehran, 1964.

Miquel 1971

A. Miquel. "Ibn Baṭṭūṭa." In *Encyclopaedia of Islam* 1960–, vol. 3 (1971), pp. 735–36.

Monnas 1987

Lisa Monnas. "The Artists and the Weavers: The Design of Woven Silks in Italy, 1350–1550." *Apollo* 125 (June 1987), pp. 416–24.

D. O. Morgan 1982

David O. Morgan. "Persian Historians and the Mongols." In *Medieval Historical Writing in the Christian and Islamic Worlds*, edited by David O. Morgan, pp. 109–24. London: School of Oriental and African Studies, University of London, 1982.

D. O. Morgan 1986a

David O. Morgan. "The 'Great *Yāsā* of Chingiz Khān' and Mongol Law in the Īlkhānate." *Bulletin of the School of Oriental and African Studies* 49 (1986), pp. 163–76.

D. O. Morgan 1986b

David O. Morgan. *The Mongols*. Oxford and New York: Basil Blackwell, 1986.

D. O. Morgan 1989

David O. Morgan. "The Mongols and the Eastern Mediterranean." *Mediterranean Historical Review* 4 (June 1989), pp. 198–211.

D. O. Morgan 1996

David O. Morgan. "Mongol or Persian: The Government of Īlkhānid Iran." *Harvard Middle Eastern and Islamic Review* 3 (1996), pp. 62–76.

P. Morgan 1995

Peter Morgan. "Some Far Eastern Elements in Coloured-ground Sultanabad Wares." In *Islamic Art in the Ashmolean Museum*, edited by James W. Allan, pt. 2, pp. 19–43. Oxford Studies in Islamic Art, 10. Oxford: Oxford University Press, 1995.

Morton 1999

A. H. Morton. "The Letters of Rashīd al-Din: Īlkhānid Fact or Timurid Fiction?" In Amitai-Preiss and D. O. Morgan 1999, pp. 155–99.

Moses 1977

Larry W. Moses. *The Political Role of Mongol Buddhism*. Indiana University, Uralic and Altaic Series, 133. Bloomington: Asian Studies Research Institute, Indiana University, 1977.

Moses and Halkovic 1985

Larry W. Moses and Stephen A. Halkovic Jr. *Introduction to Mongolian History and Culture*. Indiana University, Uralic and Altaic Series, 149. Bloomington: Research Institute for Inner Asian Studies, Indiana University, 1985.

Museum für Islamische Kunst 1980

Die Meisterwerke aus dem Museum für Islamische Kunst Berlin, Staatliche Museen Preussischer Kulturbesitz. Belser Kunstbibliothek. Stuttgart and Zurich: Belser, 1980.

E. Naumann and R. Naumann 1969

Elisabeth Naumann and Rudolf Naumann. "Ein Köşk im Sommerpalast des Abaqa Chan auf dem Tacht-i Sulaiman und seine Dekoration." In *Forschungen zur Kunst asiens: In Memoriam Kurt Erdmann, 9. September 1901–30. September 1964*, edited by Oktay Aslanapa and Rudolf Naumann, pp. 35–65. Istanbul: Istanbul Üniversitesi Edebiyat Fakültesi, Türk ve Islâm Sanatı Kürsüsü, 1969.

R. Naumann 1960

Rudolf Naumann. "Ausgrabungen auf dem Takht-i-Suleiman." *Mitteilungen* [Institut für Auslandsbeziehungen], July–December 1960, pp. 211–16.

R. Naumann 1963

Rudolf Naumann. "Eine keramische Werkstatt des 13. Jahrhunderts auf dem Takht-i Suleiman." In *Beiträge zur Kunstgeschichte asiens: In Memoriam Ernst Diez*, edited by Oktay Aslanapa, pp. 301–7. Istanbul: Istanbul Üniversitesi Edebiyat Fakültesi, 1963.

R. Naumann 1977

Rudolf Naumann. *Die Ruinen von Tacht-e Suleiman und Zendan-e Suleiman und Umgebung*. Führer zu archäologischen Plätzen in Iran, 2. Berlin: Reimer, 1977.

R. Naumann, Huff, and Schnyder 1975

Rudolf Naumann, Dietrich Huff, and R. Schnyder. "Takht-i Suleiman: Bericht über die Ausgrabungen, 1965–1973." *Archäologischer Anzeiger* 90 (1975), pp. 109–204.

R. Naumann and E. Naumann 1976

Rudolf Naumann and Elisabeth Naumann. *Takht-i Suleiman: Ausgrabung des Deutschen Archäologischen Instituts in Iran*. Exhib. cat. Ausstellungskataloge der Prähistorischen Staatssammlung, 3. Munich: Prähistorische Staatssammlung, 1976.

Neff, Bishop, and Bove 1989

H. Neff, R. L. Bishop, and F. J. Bove. "Compositional Patterning Ceramics from Pacific Coastal Highland Guatemala." *Archaeomaterials* 3, no. 2 (1989), pp. 97–109.

Netzer 1998

Amnon Netzer. "Esther and Mordechai." In *Encyclopaedia Iranica* 1985–, vol. 8 (1998), pp. 657–58.

Nicolle 1999

David Nicolle. *Arms and Armour of the Crusading Era, 1050–1350: Islam, Eastern Europe and Asia.* London: Greenhill Books; Mechanicsburg, Pa.: Stackpole Books, 1999. 1st ed., 2 vols., White Plains, N.Y.: Kraus International Publications, 1988.

Ogasawara 1989

Sae Ogasawara. "Chinese Fabrics of the Song and Yuan Dynasties Preserved in Japan." *Orientations* 20, no. 8 (August 1989), pp. 32–44.

O'Kane 1979

Bernard O'Kane. "The Friday Mosques of Asnak and Saravar." *Archaeologische Mitteilungen aus Iran* 12 (1979), pp. 341–51.

O'Kane 1996

Bernard O'Kane. "Monumentality in Mamluk and Mongol Art and Architecture." *Art History* 19 (December 1996), pp. 499–522.

Olbricht 1954

Peter Olbricht. *Das Postwesen in China unter der Mongolenherrschaft im 13. und 14. Jahrhundert.* Göttinger asiatische Forschungen, 1. Wiesbaden: Harrassowitz, 1954.

Olschki 1946

Leonardo Olschki. *Guillaume Boucher: A French Artist at the Court of the Khans.* Baltimore: Johns Hopkins Press, 1946.

Orient de Saladin **2001**

L'Orient de Saladin: L'Art des Ayyoubides. Exhib. cat. Paris: Institut du Monde Arabe and Gallimard, 2001.

Osten and R. Naumann 1961

Hans Henning von der Osten and Rudolf Naumann, eds. *Takht-i-Suleiman: Vorläufiger Bericht über die Ausgrabungen 1959.* Teheraner Forschungen, 1. Berlin: Gebr. Mann, 1961.

Otavsky and Salim 1995

Karel Otavsky and Muhammad ʿAbbas Muhammad Salim. *Mittelalterliche Textilien.* Vol. 1, *Ägypten, Persien und Mesopotamien, Spanien und Nordafrika.* Die Textilsammlung der Abegg-Stiftung, 1. Riggisberg: Abegg-Stiftung, 1995.

Pal 1973

Pratapaditya Pal, ed. *Islamic Art: The Nasli M. Heeramaneck Collection, Gift of Joan Palevsky.* Los Angeles County Museum of Art. Los Angeles, 1973.

Paone 1981

Rosario Paone. "The Mongol Colonization of the Isfahān Region." In *Isfahan,* pp. 1–30. Quaderni del Seminario di Iranistica, Uralo-Altaistica e Caucasologia dell'Università degli Studi di Venezia, 10. Venice, 1981.

Parmelee 1951

Cullen Warner Parmelee. *Ceramic Glazes.* 2d ed. Edited and revised by E. D. Lynch and A. L. Friedberg. Chicago: Industrial Publications, 1951.

Paviot 1997

Jacques Paviot. "Les Marchands italiens dans l'Iran mongol." In Aigle 1997a, pp. 71–86.

Pelliot 1927

Paul Pelliot. "Une Ville musulmane dans la Chine du Nord sous les Mongols." *Journal asiatique* 211 (October–December 1927), pp. 261–79.

Peterson 1992

Susan Peterson. *The Craft and Art of Clay.* Englewood Cliffs: Prentice Hall, 1992.

Petrushevsky 1968

I. P. Petrushevsky. "The Socio-Economic Condition of Iran under the Īl-Khāns." In Boyle 1968a, pp. 483–537.

Pfeiffer 1999

Judith Pfeiffer. "Conversion Versions: Sultan Öljeytü's Conversion to Shiʿism (709/1309) in Muslim Narrative Sources." *Mongolian Studies* 22 (1999), pp. 35–67.

Pickett 1997

Douglas Pickett. *Early Persian Tilework: The Medieval Flowering of Kashi.* London: Associated University Presses, 1997.

Piotrovsky 1999

Mikhail B. Piotrovsky, ed. *Earthly Beauty, Heavenly Art: Art of Islam.* Edited by John Vrieze. Exhib. cat. De Nieuwe Kerk, Amsterdam. Amsterdam: De Nieuwe Kerk; London: Lund Humphries, 1999.

Piotrovsky 2001

Mikhail B. Piotrovsky. *On Islamic Art.* Saint Petersburg: State Hermitage Museum, 2001.

Polo 1903

Marco Polo. *The Book of Ser Marco Polo, the Venetian, Concerning the Kingdoms and Marvels of the East.* 3d ed. Translated and edited by Henry Yule. Revised by Henri Cordier. 2 vols. London: John Murray, 1903. Reprint, *The Travels of Marco Polo: The Complete Yule-Cordier Edition,* New York: Dover Publications, 1993.

Polo 1938

Marco Polo. *The Description of the World.* Translated and annotated by Arthur Christopher Moule and Paul Pelliot. 2 vols. London: George Routledge and Sons, 1938.

A. U. Pope and Ackerman 1938–77

Arthur Upham Pope and Phyllis Ackerman, eds. *A Survey of Persian Art from Prehistoric Times to the Present.* 16 vols. London and New York: Oxford University Press, 1938–77.

J. A. Pope 1956

John Alexander Pope. *Chinese Porcelains from the Ardebil Shrine.* Washington, D.C.: Freer Gallery of Art, 1956.

J. A. Pope 1981

John Alexander Pope. *Chinese Porcelains from the Ardebil Shrine.* 2d ed. London: Sotheby Parke Bernet, 1981.

Porter 1995

Venetia Porter. *Islamic Tiles.* London: Eastern Art Series. London: British Museum, 1995.

Pugachenkova 1967

G. A. Pugachenkova. *Iskusstvo Turkmenistana* (Art of Turkmenistan). Moscow: Iskusstvo, 1967.

Purinton and Watters 1991

Nancy Purinton and Mark Watters. "A Study of the Materials Used by Medieval Persian Painters." *Journal of the American Institute for Conservation* 30 (fall 1991), pp. 125–44.

al-Qumi 1959

Qadi Ahmad al-Qumi. *Calligraphers and Painters: A Treatise by Qadi Ahmad, Son of Mir Munshi (circa A.H. 1015/A.D. 1606).* Translated by V. Minorsky. Occasional Papers, Freer Gallery of Art, 3, no. 2. Washington, D.C., 1959.

al-Qumi 1980–84

Qadi Ahmad al-Qumi. *Khulasat al-tavarikh* (Historical excerpts). Edited by Ehsan Eshraghi. 2 vols. Tehran: Tehran University Press, 1980–84.

Raby and Fitzherbert 1996

Julian Raby and Teresa Fitzherbert, eds. *The Court of the Il-Khans, 1290–1340.* Oxford Studies in Islamic Art, 12. Oxford: Oxford University Press, 1996.

Rachewiltz 1962

Igor de Rachewiltz. "Yeh-lü Ch'u-ts'ai (1189–1243): Buddhist Idealist and Confucian Statesman." In *Confucian Personalities,* edited by Arthur F. Wright and Denis Twitchett, pp. 189–216. Stanford Studies in the Civilizations of Eastern Asia. Stanford: Stanford University Press, 1962.

Rachewiltz 1971

Igor de Rachewiltz. *Papal Envoys to the Great Khans.* London: Faber and Faber, 1971.

Rachewiltz 1997

Igor de Rachewiltz. "Marco Polo Went to China." *Zentralasiatische Studien* 27 (1997), pp. 34–92.

Rachewiltz et al. 1993

Igor de Rachewiltz, Hok-lam Chan, Hsiao Ch'i-ch'ing, and Peter W. Grier, with May Wang. *In the Service of the Khan: Eminent Personalities of the Early Mongol-Yüan Period (1200–1300).* Asiatische Forschungen, 121. Wiesbaden: Harrassowitz, 1993.

Rajabzadah 1998

Hashim Rajabzadah. *Khwajah rashid al-din fazl-allah* (His Excellency Rashid al-Din Fazl Allah). Bunyanguzaran-i farghang-i imruz, 43. Tehran: Tarh-i Naw, 1998.

Rall 1960

Jutta Rall. "Zur persischen Übersetzung eines *Mo-chüeh,* eines chinesischen medizinischen Textes." *Oriens Extremus* 7 (1960), pp. 152–57.

Rall 1970

Jutta Rall. *Die vier grossen Medizinschulen der Mongolenzeit: Stand und Entwicklung der chinesischen Medizin in der Chin- und Yüan-Zeit.*

Münchener ostasiatische Studien, 7. Wiesbaden: Steiner, 1970.

Rashid al-Din 1971

Rashid al-Din. *The Successors of Genghis Khan.* Translated by John A. Boyle. Persian Heritage Series, 10. New York: Columbia University Press, 1971.

Rashid al-Din 1994

Rashid al-Din. *Jamiᶜ al-tavarikh* (Compendium of chronicles). Edited by Muhammad Rawshan and Mustafa Musavi. 4 vols. Tehran, 1994.

Rashid al-Din 1998–99

Rashid al-Din. *Rashiduddin Fazlullah's "Jamiʿuʾt-tawarikh": Compendium of Chronicles.* Pts. 1–3, *A History of the Mongols.* Translated and annotated by Wheeler M. Thackston. Sources of Oriental Languages and Literatures, 45. Central Asian Sources, 4. Cambridge, Mass.: Harvard University, Department of Near Eastern Languages and Civilizations, 1998–99.

Ratchnevsky 1991

Paul Ratchnevsky. *Genghis Khan: His Life and Legacy.* Translated and edited by Thomas Nivison Haining. Oxford: Blackwell Publishers, 1991.

Rawson 1984

Jessica Rawson. *Chinese Ornament: The Lotus and the Dragon.* London: British Museum, 1984.

Remler 1985

Philip Remler. "New Light on Economic History from Ilkhanid Accounting Manuals." *Studia Iranica* 14 (1985), pp. 157–77.

Riasanovsky 1965

Valentin A. Riasanovsky. *Fundamental Principles of Mongol Law.* Indiana University, Uralic and Altaic Series, 43. Bloomington: Indiana University, 1965.

Riboud 1995

Krishna Riboud. "A Cultural Continual: A New Group of Liao and Jin Dynasty Silks." *Hali,* no. 82 (August–September 1995), pp. 92–105.

D. S. Rice 1954

David S. Rice. "The Seasons and the Labors of the Months in Islamic Art." *Ars Orientalis* 1 (1954), pp. 1–39.

D. S. Rice 1983

David S. Rice, ed. *The Unique Ibn al-Bawwab Manuscript: Complete Facsimile Edition of the Earliest Surviving Naskhi Qurʾan, Chester Beatty Library, Dublin, Manuscript K.16.* Graz: Akademische, 1983.

D. T. Rice and Gray 1976

David Talbot Rice. *The Illustrations to the "World History" of Rashīd al-Dīn.* Edited by Basil Gray. Edinburgh: Edinburgh University Press, 1976.

Richard 1997

Francis Richard. *Splendeurs persanes: Manuscrits du XIIᵉ au XVIIᵉ siècle.* Exhib. cat. Paris: Bibliothèque Nationale de France, 1997.

Robinson 1976a

Basil William Robinson. *Islamic Painting and the Arts of the Book.* Keir Collection. London: Faber and Faber, 1976.

Robinson 1976b

Basil William Robinson. *Persian Paintings in the India Office Library: A Descriptive Catalogue.* London: Sotheby Parke Bernet, 1976.

Roemer 1986

H. R. Roemer. "The Jalayirids, Muzaffarids and Sarbadārs." In *The Cambridge History of Iran,* vol. 6, *The Timurid and Safavid Periods,* edited by Peter Jackson and Laurence Lockhart, pp. 1–39. Cambridge and New York: Cambridge University Press, 1986.

Rogers 1969

J. M. Rogers. "Recent Work on Seljuk Anatolia." *Kunst des Orients* 6 (1969), pp. 134–69.

Rogers 1972

J. M. Rogers. "Evidence for Mamlūk-Mongol Relations, 1260–1360." In *Colloque international sur l'histoire du Caire, 27 mars–5 avril 1969,* pp. 385–403. Cairo: General Egyptian Book Organization, 1972.

Rogers 1990

J. M. Rogers. "Siyah Qalam." In *Persian Masters: Five Centuries of Painting,* edited by Sheila R. Canby, pp. 21–38. Bombay: Marg Publications, 1990.

Rossabi 1979

Morris Rossabi. "Khubilai Khan and the Women in His Family." In Bauer 1979, pp. 153–80.

Rossabi 1981

Morris Rossabi. "The Muslims in the Early Yüan Dynasty." In *China under Mongol Rule,* edited by John D. Langlois Jr., pp. 257–95. Princeton: Princeton University Press, 1981.

Rossabi 1988a

Morris Rossabi. "Genghis Khan." In *Encyclopedia of Asian History,* edited by Ainslie T. Embree, vol. 1, pp. 496–98. New York: Charles Scribner's Sons; London: Collier Macmillan, 1988.

Rossabi 1988b

Morris Rossabi. *Khubilai Khan: His Life and Times.* Berkeley: University of California Press, 1988.

Rossabi 1988c

Morris Rossabi. "Khubilai Khan: His Life and Times." Typescript. 1988. Rare Book and Manuscript Library, Columbia University.

Rossabi 1992a

Morris Rossabi. "The Study of the Women of Inner Asia and China in the Mongol Era." *Gest Library Journal* 5, no. 2 (winter 1992), pp. 17–28.

Rossabi 1992b

Morris Rossabi. *Voyager from Xanadu: Rabban Sauma and the First Journey from China to the West.* Tokyo and New York: Kodansha International, 1992.

Rossabi 1997

Morris Rossabi. "The Silk Trade in China and Central Asia." In Watt and Wardwell 1997, pp. 7–19.

Roxburgh 1995

David J. Roxburgh. "Heinrich Friedrich von Diez and His Eponymous Albums: Mss. Diez A. Fols. 70–74." *Muqarnas* 12 (1995), pp. 112–36.

Roxburgh 1996

David J. Roxburgh. "'Our Works Point to Us': Album Making, Collecting, and Art (1427–1565) under the Timurids and Safavids." 3 vols. in 2. Ph.D diss., University of Pennsylvania, 1996. Microfilm, Ann Arbor: University Microfilms.

Roxburgh 2002

David J. Roxburgh. "Persian Drawing, ca. 1400–1450: Materials and Creative Procedures." *Muqarnas* 19 (2002), pp. 44–77.

Rührdanz 1997

Karin Rührdanz. "Illustrationen zu Rašīd al-Dīns *Taʾrīḫ-i Mubārak-i Ġāzānī* in den Berliner Diez-Alben." In Aigle 1997a, pp. 295–306.

Ruysbroeck 1990

Willem van Ruysbroeck. *The Mission of Friar William of Rubruck: His Journey to the Court of the Great Khan Möngke, 1253–1255.* Translated by Peter Jackson. Introduction, notes, and appendices by Peter Jackson and David O. Morgan. London: Hakluyt Society, 1990.

Ryan 1998

James D. Ryan. "Christian Wives of Mongol Khans: Tatar Queens and Missionary Expectations in Asia." *Journal of the Royal Asiatic Society,* 3d ser., 8, no. 3 (April 1998), pp. 411–21.

Rypka 1968

J. Rypka. "Poets and Prose Writers of the Late Saljuq and Mongol Periods." In Boyle 1968a, pp. 550–625.

Safadi 1978

Yasin Hamid Safadi. *Islamic Calligraphy.* London: Thames and Hudson, 1978.

Sayili 1960

Aydin Sayili. *The Observatory in Islam and Its Place in the General History of the Observatory.* Publications of the Turkish Historical Society, 7th ser., 38. Ankara: Türk Tarih Kurumu Basimevi, 1960.

Scarcia 1975

Gianroberto Scarcia. "The 'Vihār' of Qonqor-olong: Preliminary Report." *East and West,* n.s., 25, nos. 1–2 (March–June 1975), pp. 99–104.

Scerrato 1981

Umberto Scerrato. "Some Observations on Iranian Architecture of the XIV Century." In *Isfahan,* pp. 31–52. Quaderni del Seminario di Iranistica, Uralo-Altaistica e Caucasologia dell'Università degli Studi di Venezia, 10. Venice, 1981.

Scheller 1995

Robert Walter Hans Peter Scheller. *Exemplum: Model-Book Drawings and the Practice of Artistic Transmission in the Middle Ages (ca. 900–ca. 1470).* Translated by Michael Hoyle. Amsterdam: Amsterdam University Press, 1995.

Schimmel 1992

Annemarie Schimmel, with Barbara Rivolta. "Islamic Calligraphy." *The Metropolitan Museum of Art Bulletin* 50, no. 1 (summer 1992).

Schmitz 1997

Barbara Schmitz, with Pratapaditya Pal, Wheeler M. Thackston, and William M. Voelkle. *Islamic and Indian Manuscripts and Paintings in the Pierpont Morgan Library.* New York: The Pierpont Morgan Library, 1997.

Schroeder 1939

Eric Schroeder. "Ahmed Musa and Shams al-Dīn: A Review of Fourteenth Century Painting." *Ars Islamica* 6, pt. 1 (1939), pp. 113–42.

Seaman and Marks 1991

Gary Seaman and Daniel Marks, eds. *Rulers from the Steppe: State Formation on the Eurasian Periphery.* Ethnographics Monograph Series, 2. Los Angeles: Ethnographics Press, Center for Visual Anthropology, University of Southern California, 1991.

Serjeant 1972

Robert Bertram Serjeant. *Islamic Textiles: Material for a History Up to the Mongol Invasions.* Beirut: Librairie du Liban, 1972.

Sheng 1999

Angela Sheng. "Why Ancient Silk Is Still Gold: Issues in Chinese Textile History." *Ars Orientalis* 29 (1999), pp. 147–68.

Shiraishi 2001

Shiraishi Noriyuki. *Chingisu Kan no kokōgaku* (Archaeology of Chinggis Qan). Tokyo: Dōseisha, 2001.

Simpson 1979

Marianna Shreve Simpson. *The Illustrations of an Epic: The Earliest "Shahnama" Manuscripts.* Outstanding Dissertations in the Fine Arts. New York and London: Garland Publishing, 1979.

Simpson 1980

Marianna Shreve Simpson. *Arab and Persian Painting in the Fogg Art Museum.* Fogg Art Museum Handbooks, 2. Cambridge, Mass.: Fogg Art Museum, Harvard University, 1980.

Simpson 1982a

Marianna Shreve Simpson. "The Pattern of Early Shanama Illustration." *Studia Artium Orientalis et Occidentalis* 1 (1982), pp. 43–53.

Simpson 1982b

Marianna Shreve Simpson. "The Role of Baghdād in the Formation of Persian Painting." In *Art et société dans le monde iranien,* edited by Chahryar Adle, pp. 91–116. Institut Français d'Iranologie de Téhéran, Bibliothèque iranienne, 26. Recherche sur les grandes

civilisations, Synthèse, 9. Paris: Éditions Recherche sur les civilisations, 1982.

Simpson 1985

Marianna Shreve Simpson. "Narrative Allusion and Metaphor in the Decoration of Medieval Islamic Objects." In *Pictorial Narrative in Antiquity and the Middle Ages,* edited by Herbert L. Kessler and Marianna Shreve Simpson, pp. 131–49. Studies in the History of Art [National Gallery of Art], 16. Center for Advanced Study in the Visual Arts, Symposium Series, 4. Washington, D.C.: National Gallery of Art, 1985.

Simpson 2000

Marianna Shreve Simpson. "A Reconstruction and Preliminary Account of the 1341 *Shahnama* with Some Further Thoughts on Early *Shahnama* Illustration." In *Persian Painting from the Mongols to the Qajars: Studies in Honour of Basil W. Robinson,* edited by Robert Hillenbrand, pp. 217–47. Pembroke Persian Papers, 3. London and New York: I. B. Taurus in association with the Centre of Middle Eastern Studies, University of Cambridge, 2000.

Sims 1982

Eleanor G. Sims. "The Internal Decoration of the Mausoleum of Öljeitü Khudābanda: A Preliminary Re-Examination." In *Solṭāniye III,* pp. 89–123. Quaderni del Seminario di Iranistica, Uralo-Altaistica e Caucasologia dell'Università degli Studi di Venezia, 9. Venice, 1982.

Sims 1988

Eleanor G. Sims. "The 'Iconography' of the Internal Decoration in the Mausoleum of Ūljāytū at Sultaniyya." In *Content and Context of Visual Arts in the Islamic World,* edited by Priscilla P. Soucek, pp. 139–75. Monographs on the Fine Arts, 44. University Park, Pa., and London: Pennsylvania State University Press, 1988.

Smith 1970

John Masson Smith Jr. *The History of the Sarbadar Dynasty, 1336–1381 A.D., and Its Sources.* The Hague and Paris: Mouton, 1970.

Smith 1975

John Masson Smith Jr. "Mongol Manpower and the Persian Population." *Journal of the Economic and Social History of the Orient* 18 (October 1975), pp. 271–99.

Smith 1999

John Masson Smith Jr. "Mongol Nomadism and Middle Eastern Geography: Qīshlāqs and Tümens." In Amitai-Preiss and D. O. Morgan 1999, pp. 39–56.

Smith 2000

John Masson Smith Jr. "Dietary Decadence and Dynastic Decline in the Mongol Empire." *Journal of Asian History* 34 (2000), pp. 35–52.

Snyder 1988

Janet G. Snyder. "Study of the Paper of

Selected Paintings from the Vever Collection." In Lowry and Beach 1988, pp. 433–40.

So 1997

Jenny F. So. "The Ornamented Belt in China." *Orientations* 28, no. 3 (March 1997), pp. 70–78.

Songshi 1985

Tuotuo et al. *Songshi* (History of the Song dynasty). 40 vols. Beijing: Zhonghua shuju, 1985.

Sotheby's 1997

Fine Chinese Ceramics and Works of Art. Auction cat. Sotheby's, London, December 2, 1997.

Soucek 1975

Priscilla P. Soucek. "An Illustrated Manuscript of al-Bīrūnī's *Chronology of Ancient Nations.*" In *The Scholar and the Saint: Studies in Commemoration of Abu'l-Rayhan al-Bīrūnī and Jalal al-Din al-Rūmī,* edited by Peter J. Chelkowski, pp. 103–68. New York: Hagop Kevorkian Center for Near Eastern Studies, New York University Press, 1975.

Soucek 1980

Priscilla P. Soucek. "The Rôle of Landscape in Iranian Painting to the Fifteenth Century." In *Landscape Style in Asia,* edited by William Watson, pp. 86–110. Colloquies on Art and Archaeology in Asia, 9. London: Percival David Foundation of Chinese Art, School of Oriental and African Studies, University of London, 1980.

Soucek 1987

Priscilla P. Soucek. "Art in Iran, VII: Islamic, Pre-Safavid." In *Encyclopaedia Iranica* 1985–, vol. 2 (1987), pp. 603–18.

Soucek 1988

Priscilla P. Soucek. "The Life of the Prophet: Illustrated Versions." In *Content and Context of Visual Arts in the Islamic World,* edited by Priscilla P. Soucek, pp. 193–217. Monographs on the Fine Arts, 44. University Park, Pa., and London: Pennylvania State University Press, 1988.

Soucek 1998

Priscilla P. Soucek. "Tīmūrid Women: A Cultural Perspective." In *Women in the Medieval Islamic World: Power, Patronage, and Piety,* edited by Gavin R. G. Hambly, pp. 199–226. New Middle Ages, 6. New York: St. Martin's Press, 1998.

Soucek 1999

Priscilla P. Soucek. "Ceramic Production as Exemplar of Yuan-Ilkhanid Relations." *Res 35* (spring 1999), pp. 125–41.

Soudavar 1992

Abolala Soudavar. *Art of the Persian Courts: Selections from the Art and History Trust Collection.* New York: Rizzoli, 1992.

Soudavar 1996

Abolala Soudavar. "The Saga of Abu-Saʿid Bahādor Khān: The Abu-Saʿidnāmé." In Raby and Fitzherbert 1996, pp. 95–218.

Soustiel 1993

L. Soustiel. "L'Islam: Berceau de la céramique occidentale." *Dossier de l'art,* 1993, pp. 12–15.

Speel 1998

Erika Speel. *Dictionary of Enamelling.* Adershot, Hants, England, and Brookfield, Vermont: Ashgate Publishing, 1998.

Spuler 1955

Bertold Spuler. *Die Mongolen in Iran: Politik, Verwaltung und Kultur der Ilchanzeit, 1220–1350.* 2d ed. Berlin: Akademie-Verlag, 1955.

Spuler 1965

Bertold Spuler. *Die Goldene Horde: Die Mongolen in Russland, 1233–1502.* 2d ed. Wiesbaden: Harrassowitz, 1965.

Spuler 1972

Bertold Spuler. *History of the Mongols, Based on Eastern and Western Accounts of the Thirteenth and Fourteenth Centuries.* Translated by Helga Drummond and Stuart Drummond. London: Routledge and Kegan Paul, 1972.

Spuler 1976

Bertold Spuler. "Le Christianisme chez les Mongols au XIII^e et XIV^e siècles." In *Tractata Altaica: Denis Sinor, Sexagenario Optime de Rebus Altaicis Merito Dedicata,* edited by Walther Heissig, John R. Krueger, Felix J. Oinas, and Edmond Schütz, pp. 621–31. Wiesbaden: Harrassowitz, 1976.

Spuler 1985

Bertold Spuler. "Ābeš Kātūn." In *Encyclopaedia Iranica* 1985–, vol. 1 (1985), p. 210.

Spuler 1987a

Bertold Spuler. "Atābakān-e Fārs." In *Encyclopaedia Iranica* 1985–, vol. 2 (1987), pp. 894–96.

Spuler 1987b

Bertold Spuler. "Atābakān-e Lorestān." In *Encyclopaedia Iranica* 1985–, vol. 2 (1987), pp. 896–98.

Stchoukine 1936

Ivan Stchoukine. *La Peinture iranienne sous les derniers ʿAbbâsides et les Îl-Khâns.* Bruges: Imprimerie Sainte Catherine, 1936.

Stchoukine 1958

Ivan Stchoukine. "Les Peintures du Shāh-Nāmeh Demotte." *Arts asiatiques* 5 (1958), pp. 83–96.

Steinhardt 1983

Nancy Shatzman Steinhardt. "The Plan of Khubilai Khan's Imperial City." *Artibus Asiae* 44 (1983), pp. 137–58.

Steinhardt 1988

Nancy Shatzman Steinhardt. "Imperial Architecture along the Mongolian Road to Dadu." *Ars Orientalis* 18 (1988), pp. 59–93.

Steinhardt 1990

Nancy Shatzman Steinhardt. *Chinese Imperial City Planning.* Honolulu: University of Hawaii Press, 1990.

St. Petersburg Muraqqaʿ 1996

The St. Petersburg Muraqqaʿ: Album of Indian and Persian Miniatures from the Sixteenth through the Eighteenth Century and Specimens of Persian Calligraphy by ʿImad al-Hasani. 2 vols. Milan: Leonardo Arte; Lugano: Art Restoration of Cultural Heritage, 1996.

Suriano and Carboni 1999

Carlo Maria Suriano and Stefano Carboni. *La seta islamica: Temi ed influenze culturali / Islamic Silk: Design and Context.* Exhib. cat. Florence: Museo Nazionale del Bargello, 1999.

Swietochowski 1996

Marie Lukens Swietochowski. "Drawing." In *Encyclopaedia Iranica* 1985–, vol. 7 (1996), pp. 537–47.

Swietochowski and Carboni 1994

Marie Lukens Swietochowski and Stefano Carboni. *Illustrated Poetry and Epic Images: Persian Paintings of the 1330s and 1340s.* Exhib. cat. New York: The Metropolitan Museum of Art, 1994.

Tao Zongyi 1959

Tao Zongyi. *Nancun chuogeng lu* (Nancun's memoir of stopping plowing). Beijing: Zhonghua shuju, 1959.

Teule 1998

Herman G. B. Teule. "Ebn al-ʿEbrī." In *Encyclopaedia Iranica* 1985–, vol. 8 (1998), pp. 13–15.

Thackston 1989

Wheeler M. Thackston, ed. and trans. *A Century of Princes: Sources on Timurid History and Art.* Cambridge, Mass.: Aga Khan Program for Islamic Architecture, 1989.

Thackston 2001

Wheeler M. Thackston. *Album Prefaces and Other Documents on the History of Calligraphers and Painters.* Supplements to *Muqarnas,* 10. Leiden, Boston, and Cologne: Brill, 2001.

Thompson and Granger-Taylor 1995–96

Jon Thompson and Hero Granger-Taylor. "The Persian Zilu Loom of Meybod." *Bulletin du CIETA,* no. 73 (1995–96), pp. 27–53.

Tite 1989

M. S. Tite. "Iznik Pottery: An Investigation of the Methods of Production." *Archaeometry* 31 (August 1989), pp. 115–32.

Tite and Bimson 1986

M. S. Tite and M. Bimson. "Faience: An Investigation of the Microstructures Associated with the Different Methods of Glazing." *Archaeometry* 28 (February 1986), pp. 69–78.

Tite et al. 1998

M. S. Tite, I. Freestone, Robert B. Mason, J. Molera, M. Vendrell-Saz, and N. Wood. "Lead Glazes in Antiquity: Methods of Production and Reasons for Use." *Archaeometry* 40 (August 1998), pp. 241–60.

Titley 1975

Nora M. Titley. "The Miniatures." In P. Waley and Titley 1975, pp. 43–61.

Titley 1983

Norah M. Titley. *Persian Miniature Painting and Its Influences on the Arts of Turkey and India: The British Library Collections.* London: British Library, 1983.

Treasures of Islam 1985

Treasures of Islam. Exhib. cat. Musée Rath, Geneva. London: Sotheby's/Philip Wilson Publishers, 1985.

Treasures on Grassland 2000

Cao yuan gui bao: Nei Menggu wenwu kaogu jing pin / Treasures on Grassland: Archaeological Finds from the Inner Mongolia Autonomous Region. Exhib. cat. Shanghai Museum. Shanghai: Shanghai shu hua chubanshe, 2000.

Trésors d'Orient 1973

Trésors d'Orient. Exhib. cat. Paris: Bibliothèque Nationale, 1973.

Trimingham 1971

John Spencer Trimingham. *The Sufi Orders in Islam.* Oxford: Clarendon Press, 1971. Reprint, with a new foreword by John O. Voll, New York and Oxford: Oxford University Press, 1998.

Tu 1962

Tu Ji [T'u Chi]. *Mengwuer shiji [Meng-wu-erh shih-chi]* (Historical records of the Mongols). Taipei: Shijie shuju [Shih-chieh shu-chu], 1962.

Vardjavand 1975

Parviz Vardjavand. "Rapport préliminaire sur les fouilles de l'observatoire de Marâqe." *Le Monde iranien et l'Islam: Sociétés et cultures* 3 (1975), pp. 119–24.

Vardjavand 1979

Parviz Vardjavand. "La Découverte archéologique du complexe scientifique de l'observatoire de Maraqé." In *Akten des VII. Internationalen Kongresses für Iranische Kunst und Archäologie, München 7.–10. September 1976,* pp. 527–36. Archaeologische Mitteilungen aus Iran, 6. Berlin: Dietrich Reimer, 1979.

Vassaf al-Hazrat 1852–53

ʿAdud Allah Vassaf al-Hazrat. *Kitab-i mustatab-i vassaf* (Vassaf's excellent book). Lithographed ed. Bombay: Aga Mirza Muhammad Hasan Kashani, 1852–53.

Vladimirtsov 1969

Boris Iakovlevich Vladimirtsov. *The Life of Chingis-Khan.* Translated by D. S. Mirsky. New York: Benjamin Blom, 1969.

Walbridge 1992

John Walbridge. *The Science of Mystic Lights: Qutb al-Din Shirazi and the Illuminationist Tradition in Islamic Philosophy.* Harvard Middle Eastern Monographs, 26. Cambridge, Mass.: Harvard University Press, 1992.

A. Waley 1963

Arthur Waley. *The Secret History of the Mongols, and Other Pieces.* London: Allen and Unwin, 1963.

P. Waley and Titley 1975
P. Waley and Nora M. Titley. "An Illustrated
Persian Text of Kalīla and Dimna Dated
707/1307–8." *British Library Journal* 1 (spring
1975), pp. 42–61.

Walters Art Gallery 1936
Walters Art Gallery. *Handbook of the Collection.*
Baltimore: Walters Art Gallery, 1936.

Ward 1993
Rachel Ward. *Islamic Metalwork.* Eastern Art
Series. London: British Museum Press, 1993.

Wardwell 1988–89
Anne E. Wardwell. "*Panni Tartarici:* Eastern
Islamic Silks Woven with Gold and Silver
(Thirteenth and Fourteenth Centuries)."
Islamic Art 3 (1988–89), pp. 95–173.

Wardwell 1992
Anne E. Wardwell. "Two Silk and Gold
Textiles of the Early Mongol Period." *Bulletin
of the Cleveland Museum of Art* 79 (December
1992), pp. 354–78.

Wardwell 1992–93
Anne E. Wardwell. "Important Asian Textiles
Recently Acquired by the Cleveland Museum
of Art." *Oriental Art* 38 (winter 1992–93),
pp. 244–51.

Wardwell 2000
Anne E. Wardwell. "Indigenous Elements in
Central Asian Silk Designs of the Mongol
Period, and Their Impact on Italian Gothic
Silks." *Bulletin du CIETA,* no. 77 (2000),
pp. 86–98.

O. Watson 1975
Oliver Watson. "The Masjid-i ʿAlī, Quhrūd: An
Architectural and Epigraphic Survey." *Iran* 13
(1975), pp. 59–74.

O. Watson 1975a
Oliver Watson. "Persian Lustre Ware, from the
Fourteenth to the Nineteenth Centuries." *Le
Monde iranien et l'Islam: Sociétés et cultures* 3
(1975), pp. 63–80.

O. Watson 1977
Oliver Watson. "Persian Lustre Tiles of the
Thirteenth and Fourteenth Centuries." 2 vols.
Ph.D. diss., School of Oriental and African
Studies, University of London, 1977.

O. Watson 1985
Oliver Watson. *Persian Lustre Ware.* Faber
Monographs on Pottery and Porcelain.
London: Faber and Faber, 1985.

W. Watson 2000
William Watson. *The Arts of China, 900–1620.*
Yale University Press Pelican History of Art.
New Haven: Yale University Press, 2000.

Watt 1998
James C. Y. Watt. "Textiles of the Mongol
Period in China." *Orientations* 29, no. 3 (March
1998), pp. 72–83.

Watt and Wardwell 1997
James C. Y. Watt and Anne E. Wardwell.
*When Silk Was Gold: Central Asian and Chinese
Textiles.* Exhib. cat. The Cleveland Museum
of Art; The Metropolitan Museum of Art.
New York: The Metropolitan Museum of
Art, 1997.

Weidner 1982
Marsha Smith Weidner. "Painting and
Patronage at the Mongol Court of China,
1260–1368." Ph.D. diss., University of
California, Berkeley, 1982. Microfilm, Ann
Arbor: University Microfilms.

Weidner 1988
Marsha Smith Weidner. "Yüan Dynasty Court
Collections of Chinese Paintings." *Central and
Inner Asian Studies* 2 (1988), pp. 1–40.

Weidner 1989a
Marsha Smith Weidner. Appendices to "Yüan
Dynasty Court Collections of Chinese
Paintings." *Central and Inner Asian Studies* 3
(1989), pp. 83–104.

Weidner 1989b
Marsha Smith Weidner. "Aspects of Painting
and Patronage at the Mongol Court,
1260–1368." In *Artists and Patrons: Some Social
and Economic Aspects of Chinese Painting,* edited
by Chu-tsing Li, pp. 37–59. Lawrence, Kans.:
Kress Foundation Department of Art History,
University of Kansas; Kansas City: Nelson-
Atkins Museum of Art; Seattle: University of
Washington Press, 1989.

Welch 1979
Anthony Welch. *Calligraphy in the Arts of the
Muslim World.* Exhib. cat. Asia House Gallery,
New York. Austin: University of Texas Press,
1979.

Wellesz 1959
Emmy Wellesz. "An Early al-Ṣūfī Manuscript
in the Bodleian Library in Oxford: A Study in
Islamic Constellation Images." *Ars Orientalis* 3
(1959), pp. 1–26.

White and Bunker 1994
Julia M. White and Emma C. Bunker.
*Adornment for Eternity: Status and Rank in
Chinese Ornament.* Exhib. cat. Denver:
Denver Art Museum, 1994.

Wiet 1933
Gaston Wiet. *L'Exposition persane de 1931.*
Cairo: L'Institut Français d'Archéologie
Orientale, 1933.

Wilber 1955
Donald N. Wilber. *The Architecture of Islamic
Iran: The Il-Khanid Period.* Princeton
Monographs in Art and Archaeology, 29.
Princeton Oriental Series, 17. Princeton:
Princeton University Press, 1955.

Wilber 1969
Donald N. Wilber. *The Architecture of Islamic
Iran: The Il-Khanid Period.* New York:
Greenwood Press, 1969.

Wilber 1981
Donald N. Wilber. "A Very Old Flat-Weave?"
Hali 3, no. 4 (1981), p. 309.

Wilckens 1992
Leonie von Wilckens. *Mittelalterliche
Seidenstoffe.* Berlin: Staatliche Museen zu
Berlin, Kunstgewerbemuseum, 1992.

Wright 1997
Elaine Julia Wright. "The Look of the Book:
Manuscript Production in the Southern
Iranian City of Shiraz from the Early-
Fourteenth Century to 1452." 3 vols. Ph.D.
diss., Faculty of Oriental Studies, Oxford
University, 1997.

Wulff 1966
Hans E. Wulff. *The Traditional Crafts of Persia:
Their Development, Technology, and Influence on
Eastern and Western Civilizations.* Cambridge,
Mass.: M.I.T. Press, 1966.

Xiao Qiqing 1966
Xiao Qiqing [Hsiao Ch'i-ch'ing]. *Xiyuren yu
Yuan chu zhengzhi* [Hsi-yu-jen yu Yuan ch'u
chen-chih] (Central Asians and early Yuan
government). Guoli Taiwan daxue wenshi
congkan, 19. [Kuo-li Taisain ta-hsueh wan-shih
tsung-kan]: Guoli Taiwan daxue wenxueyuan
[Kuo-li Taiwan ta-hsueh wen-hsueh-yuan],
1966.

Xiao Xun 1980
Xiao Xun. *Gugong yilu* (Memory of the old
palace). In *Beiping kao* (A study of Beiping),
pp. 69–77. Beijing: Beijing guji chubanshe,
1980.

Xin Yuanshi 1962–69
Ke Shaomin [K'o Shao-min], ed. *Xin yuanshi
[Hsin Yüanshi]* (New History of the Yüan).
Taipei: Kaiming shudian [K'ai-ming shu-tien],
1962–69.

Yang 1983
Yang Boda. "Nüzhen zi *chunshui qiushan* yu
kao" (Two kinds of jades carved with different
designs of the Nüzhen nationality). *Gugong
bowuyuan yuankan* (Palace Museum Journal),
no. 2 (1983), pp. 9–16.

Ye 1987
Ye Xinmin. "Yuan Shangdu gongdian louge
kao" (The palaces and temples in Shangdu of
the Yuan dynasty). *Nei Menggu daxue xuebao
(zhexue shehui kexue ban),* 1987, no. 3, pp. 33–40.

Ye 1992
Ye Xinmin. "Liang du xunxing zhi yu Shangdu
de gongting shenghuo" (The system of the
emperor's seasonal residence in the two capi-
tals and imperial court life in Shangdu). In
Yuanshi luncong (Studies in Yuan history),
no. 4, pp. 148–59. Beijing, 1992.

Yingzao fashi 1989
Lie Ji. *Yingzao fashi* (Techniques and styles
of architecture). 8 vols. Beijing: Zhongguo
shudian, 1989.

Yongle dadian 1962
Yongle dadian (The grand compilation of Yongle,
1403–24). Shijie shuju ed. Taipei: Shangwu
yinshuguan [Shang-wu yin-shu-kuan], 1962.

Yuanshi 1976

Song Lian et al. *Yuanshi* (History of the Yuan dynasty). Beijing: Zhonghua shuju, 1976.

Yücel 2001

Ünsal Yücel. *Islamic Swords and Swordsmiths.* Islamic Art Series, 10. Istanbul: O. I. C. Research Centre for Islamic History, Art and Culture, IRCICA, 2001.

Yule 1966

Henry Yule, ed. and trans. *Cathay and the Way Thither; Being a Collection of Medieval Notices of China.* New ed., revised by Henri Cordier. 4 vols. in 2. Hakluyt Society, Works, 2d ser., 33. Taipei: Ch'eng-wen Publishing Company, 1966. First ed., 1913.

Zaky 1979

Abdel Rahman Zaky. "Medieval Arab Arms." In *Islamic Arms and Armour,* edited by Robert Elgood, pp. 202–12. London: Scolar Press, 1979.

Zhang and Zhao 1999

Zhang Jingming and Zhao Aijun. "Nei Menggu diqu Meng Yuan shiqi jin ying qi" (Gold and silverware of the Meng-Yuan period in Inner Mongolia). *Nei Menggu wenwu kaogu* [Cultural Bureau of Inner Mongolia and the Inner Mongolia Archaeology Museum Society, Hohhot], 1999, no. 2, pp. 51–56.

Zhou 1997

Zhou Shuqing. "Guanyu Bieshibali ju" (On the Besh Baliq office). In *Yuanshi luncong* (Studies in Yuan history), no. 6, pp. 221–23. Beijing, 1997.

Index

Page references for illustrations are in *italics*. Page references for main catalogue entries are in **boldface**. Figure numbers (fig.) and catalogue numbers (cat. no.) follow the page numbers. Where two numbers are separated by a colon, the first is that of the catalogue entry, the second that of the note within it.

astrology, 108

astrologers, 116, 252

astronomers, 20, 26, 44, 108

'Ata Malik Juvaini. *See* Juvaini, 'Ala' al-Din 'Ata Malik

Athar al-baqiya. See *Kitab al-athar al-baqiya 'an al-qurun al-khaliya*

Auliya Allah Amuli, *Tarikh-i Ruyan*, 37

Auragha, seasonal camp of Genghis Khan, 77, *77*; fig. 81

Authors with Attendants, from a *Rasa'il ikhwan al-safa'*, 208, *209*; fig. 253

Author with a Mongol Prince, The, and *A Horse and Groom*, from the *Tarikh-i jahan-gusha*, copied by Rashid al-Khwafi, 137, *173*, 173, 186, 202n. 21, **244**, 266; fig. 201; cat. no. 1

Autumn Colors on the Qiao and Hua Mountains (by Zhao Mengfu), 72–73, *73*; fig. 78

Awag, 115

awliya Allah, 122

awqaf, 46, 54

'Ayn Jalut, battle of (1260), 50, 206–7

Azada, 98, 99, 102, 103n. 81, *179*, 187, *188*, 257, 265, 280; figs. 108, 110, 211, 221; cat. nos. 55, 97, 169

Azerbaijan, 44, 45, 47–49, 50, 60, 77, 81, 91, 281n. 175:2

Aziran, mosque at, 120, 121

Baba Ya'qubiyan, 58

Babusha, 109, 284, 287; fig. 126; cat. no. 185

Baghdad, 3, 5, 6, 7, 16, 34, 37, 43, 47, 50, 60, 77, 117, 121, 133, 153, 154, 197, 202, 203, 210, 222 and n. 76, 224n. 81, 244, 269

conquest of, 36, 38, *39*, 45; figs. 33, 35; cat. nos. 24, 25

as a manuscript and calligraphy center, 5, 133, 209, 229 and n. 15, 252, 253

Koran production, 205, 206, 209, 219. *See also* Anonymous Baghdad Koran; thirty-part Koran copied by Yaqut al-Musta'simi

secular manuscripts, 154n. 39, 209. *See also* First Small *Shahnama*; al-Ma' al-waraqi wa al-ard al-najmiyya; *Marzubannama*; *Rasa'il ikhwan al-safa'*; *Tarikh-i jahan-gusha*: copy by Rashid al-Khwafi

tomb of Shihab al-Din 'Umar al-Suhravardi, 127; *khanaqa*, 132

Baghdadi-size paper, 130, 133, 135, 203 and n. 25

Bahman, 157, 254, 257

Bahman Meeting Zal, from the Great Mongol *Shahnama*, 73, *182*, 183, **254**, 273; fig. 215; cat. no. 40

Bahram Gur, 98, 99, 102, 103n. 81, *155*, 156, 160, 174, *179*, 187, 217, 229 and n. 15, 247–48, 257, 258, 263, 264, 265, 280, 282; figs. 108, 110, 182, 183, 187, 211, 264; cat. nos. 13, 55, 57, 58, 65, 97, 169

Bahram Gur Fighting a Wolf, from the Great Mongol *Shahnama*, 154, *155*, **257**, 273; fig. 182; cat. no. 58

Bahram Gur Hunting Onagers, from the Great Mongol *Shahnama*, 154, *156*, 173, 230, **257**, 273; fig. 183; cat. no. 57

Bahram Gur Hunting with Azada, from the Great Mongol *Shahnama*, 98, 174, **257**, *257*, 265, 273, 280, 282; fig. 110; cat. no. 55

Bahram Gur in the Peasant's House, page from a copy of the *Shahnama* dedicated to the

vizier al-Hasan Qavam al-Daula wa al-Din, 217, *217*, 244, **247–48**; fig. 264; cat. no. 13

Bahram Gur in the Treasury of Jamshid, from the Great Mongol *Shahnama*, 229

Bahram Gur Slaying a Dragon, from the Great Mongol *Shahnama*, 160, *160*, 181, 183, 187, 254, **257**, 273; fig. 187; cat. no. 56

Bahram Mirza Album (Dust Muhammad), 135, 227

Bahram Padzu, *Bahariyat*, 111n. 20

Bahramshah (r. 1117–57), 244

Baibars I, Mamluk sultan (r. 1260–77), 50

Baibars al-Jashnakir (Baibars II), Mamluk sultan (r. 1308–9), Koran for, 209; frontispiece from, 207, 209; fig. 252

al-Baidavi. *See* Qadi 'Abd Allah al-Baidavi

Baidu (r. 1295), 11, 55, 88, 281

Bai Ordu, 78

Baktimur, Mamluk amir, 208

Bal'ami, Abu al-Fadl Muhammad, translated by, *Tarikh al-rusul wa al-muluk*, 117, 137

Balkh, 44

ball joints for window grilles, *125*, 280 and n. 171:1; fig. 145; cat. no. 171

Barakh (r. 1266–71), 51

Baraq Baba (d. 1307), 58, 125; tomb of, Sultaniyya, 126 and n. 77, *126*; fig. 147

barba, 222

Bar Hebraeus (1226–1286), 30, 111

Bar Sauma. *See* Rabban Sauma

Barsiyan, 120

basin, *179*, 180–81, 221, 257, 265, **280**; fig. 211; cat. no. 169

Bastam, shrine of Bayazid Bastami (Abu Yasid al-Bastami), 126, 129, 277, 278

battle scenes, 36, *39*, *134*, *146*, 147, 149, *149*, 157, 166, 256; figs. 33, 35, 160, 172, 175, 184, 194; cat. nos. 24, 25, 45, 48, 53

Batu (r. 1227–56), 11, 42, 67, 274

Bayazid Bastami, shrine of. *See* Bastam

Baysonghur (1397–1424), 249n. 20:2

bazm-u-razm, 277

Beast Called Sannaja, The, from a *Kitab 'aja'ib al-makhluqat wa ghara'ib al-mawjudat*, 139, 211, *212*, 245n. 4:3, **248**; fig. 258; cat. no. 16

Beijing, 14, 15, 63. *See also* Dadu

Belarechenskaya, Ukraine, 276

Bellini, Jacopo, textile design in a sketchbook belonging to, 185, *185*, 186n. 54; fig. 219

Belorechensk, Russia, near, 274

belt fittings (gold set), 17, 62, 66–67, *67*, 174n. 18, 273, **274**, 275; figs. 57, 62; cat. no. 143

belt fittings (silver; incomplete set), from Simferopol, 67

belt fittings (silver gilt set), 170–71, *171*, 273, **273–74**; fig. 198; cat. no. 142

belt fittings, depicted in scenes from the *Shahnama*, ii, *41*, 53, 98, 157, 160, 162, 182, 273; figs. 37, 51, 110, 184, 187, 189, 215; cat. nos. 38, 39, 40, 46, 53, 55, 56

belt ornaments, *5*, 5, 17, **273**; fig. 4; cat. no. 140

belt plaque (silver), 67, 273, 274n. 143:2, **275–76**; fig. 64; cat. no. 150

belt plaques (gold), 67, *67*, 174n. 18, 273, 274n. 143:2, **275–76**; fig. 65; cat. no. 151

belt plaques (gold), from Simferopol, 67

belts, 171 and n. 7, 275

Berke Khan (r. 1257–67), 50

Berkyaruq ibn Malikshah, Sultan (r. 1093–1105), *147*; fig. 173

Besh Baliq, 63, 65, 70

Bianjing, 65; Xichunge, 88

Bier of Alexander, The, from the Great Mongol *Shahnama*, 128, 128–29, 166; fig. 153

bird motif, *18*, 66, 92, 127, 128, 180, *180*, *181*, 262, 264, 268, 271 and n. 129:4, 276; figs. 12, 93, 149, 150, 212, 213; cat. nos. 88, 114, 115, 153. *See also* crane; geese; parrot; phoenix; *simurgh*

Birmaya, 264

Birth of Caesar, from the *Kitab al-athar al-baqiya 'an al-qurun al-khaliya*, copied by Ibn al-Kutbi, 245, 252

Birth of the Prophet Muhammad, The, from the *Jami' al-tavarikh*, 112, 114, 117, 184n. 40, 227, 246, 249, 250, 252; fig. 130; cat. no. 6

al-Biruni, Muhammad ibn Ahmad Abu al-Rayhan (973–1048), 245; *Chronology of Ancient Nations*, see *Kitab al-athar al-baqiya*

Bisitun, 110n. 18

bisque, bisquit, terms, 241

bixies, 192n. 73

Bizhan, 247, 264

Bizhan Slaughters the Wild Boars of Irman, page from a copy of the *Shahnama* (Book of Kings) dedicated to the vizier al-Hasan Qavam al-Daula wa al-Din, 217, *217*, 244, **247**; fig. 265; cat. no. 11

Black Sea, 45

blue-and-white wares, 21, 285; figs. 17, 18; cat. nos. 192, 193

Bolad Chingsang, 51

book arts, 114, 135–67, 175. *See also* book painting and illustration; calligraphy; illumination

Book of Changes, 19

Book of the Images of the Fixed Stars (by 'Abd al-Rahman al-Sufi), 4n. 11, 210n. 49

Book of the Margrave. See *Marzubannama*

Book of the Wonders of Creation. See *Kitab 'aja'ib al-makhluqat wa ghara'ib al-mawjudat*

book painting and illustration, 5–6, 112–15, 133, 135, 136–37, 209–19, 222–25

Chinese influences, 71–73, 255

and textiles, 173–74, 181–84

See also illustrated manuscripts; Persian painting

bottle with crouching lions, 207, 208; fig. 250

Boucher, Guillaume, 27

bowls, ceramic

with fishes, 178, 200, 201, 271, **271**, 272, 285; fig. 238; cat. no. 132

with phoenixes, 177–78, *178*, 201, 202, 270, **272**, 272, 282, 283, 284, 285, 287; figs. 208, 242; cat. nos. 133, 134

bowls, metal

footed. *See* footed bowl

with inlaid frieze of huntsmen and warriors: Florence bowl, 193, *193*, 278; fig. 232; Lyon bowl, 192, 193, *193*, 222, 277, **278–79**, 279; figs. 231, 233; cat. no. 163

from Khara Khorum, 67

from Ob' basin, 67

signed by Turanshah, 187n. 64, 189, 221, *221*, 222, **279**; fig. 270; cat. no. 164

boxes. *See* covered box; polygonal box

bracelet, *33*, 35, **274–75**, 275; fig. 31; cat. no. 147

brasswork, inlaid, *2*, 4, 47, 49, 124–25, *125*, 189, 205, *205*, 208, 210, 221–22, 277, 279, 280; figs. 46, 145, 246, 254; cat. nos. 158, 159, 165, 170, 171

candlesticks, 129, 189, 190–91, *190*, *191*,

halo, 187

Hamadan, 115; tomb of Esther and Mordecai, 115

Hamadan Koran (1313), 208; frontispiece, *207*, 208; fig. 251

Hamd Allah Mustaufi Qazvini, 44, 59, 84, 90, 121 and n. 56, 122n. 65

Hamza ibn Muhammad al-ʿAlawi, 133

handled cup, *18*, **275**; fig. 13; cat. no. 149

Han dynasty (206 B.C.–A.D 220), 19, 21, 283

Hanifi school, 122

Hanlin Academy, 19, 29

Hasan Buzurg, 222 and n. 76, 224

Hasan ibn ʿAli, 117, 118, *118*, *119*, 121, 245; figs. 136, 137; cat. no. 4

Hasan ibn ʿAli ibn Ahmad Babavaih, tile panel, *199*, **268**, 270; fig. 237; cat. no. 116

Hasan ibn Muhammad ibn ʿAli ibn Husain al-Mawsili, copied by, see *Shahnama* (Book of Kings) dedicated to the vizier al-Hasan Qavam al-Daula wa al-Din

Hasan ibn Muhammad ibn Muhammad ibn Mansur al-Quhadi, 121

al-Hasan ibn Qutlumak ibn Fakhr al-Din, Koran box, *130*, **281**; fig. 157; cat. no. 175

Hasan ibn Sulaiman al-Isfahani, Koran stand, *132*, **281**; fig. 159; cat. no. 176

al-Hasan Qavam al-Daula wa al-Din, *Shahnama* dedicated to. See *Shahnama* (Book of Kings), copy dedicated to al-Hasan Qavam al-Daula wa al-Din

Hasht-rud, 77

hazira, 126

headdress ornaments, 71, 284, **287**; fig. 73; cat. no. 201

hegira, xiv

Herat, 37, 51, 65, 172, 283

Hermes Trismegistos, 222n. 78

hexagonal tile panel (exterior tiles), *93*, **266**; fig. 96; cat. no. 105

hexagonal tiles, *92*, *93*, *95*, 177 and n. 31, *185*, 263, 264, 266; figs. 93, 95, 102, 218; cat. nos. 86–89, 103. *See also* tiles, fritware

hexagon pattern, 283

Hind, rajah of, 253

History of the World Conqueror. See Tarikh-i jahan-gusha

Hohhot, 285

Hongzhou, 63, 71

Hormuz, 45, 46

horse motif, *28*, *100*, *101*, 267, 268, 282; figs. 24, 115, 116; cat. nos. 110, 117, 177

horses, 46, 171n. 7

horse trappings, *17*, 171, 273, **273**; fig. 10; cat. no. 141. *See also* entries at saddle

huihui taishi, 24

huijiaotu faguan, 24

Hulan Mören, 77

Hülegü Khan (ca. 1217–1265; r. 1256–65), 3, 11, 16, 17, 31, 32, 33, 37, 38, 42, 44, 45–46, 47, 51, 52, 60, 75, 76, 79, 81, 82, 84, 88, 108–10, 112, 127, 172, 222n. 76, 244, 250

Hungary, 16

Huns, 17

hunting, 28, 49, 83

huntsman motif, *52*, *94*, *99*, *125*, *190*, *191*, *192*, *193*, *193*, *205*, 264, 265, 278, 279, 280; figs. 50, 98, 145, 227, 228, 230, 231, 233, 246; cat. nos. 94, 98, 163, 165, 166, 171

Husam al-Din, 37

Hu-san-wu-ding, 71

Husayn ibn ʿAli, 117, 118, *118*, *119*, 121 and n. 62, 245; figs. 136, 137; cat. no. 4

Ibn al-Bawwab (d. 1022), 205 and n. 27, 258

Ibn al-Kutbi, copied by, see *Kitab al-athar al-baqiya ʿan al qurun al-khaliya*

Ibn al-Muqaffaʿ, Arabic version of *Kalila va Dimna*, 244

Ibn al-Suhravardi al-Bakri, Ahmad (Shaikhzada) (d. ca. 1320), 132, 203 and n. 25, 205, 206, 258, 259; copied by, see Anonymous Baghdad Koran

Ibn Badis, 229n. 9

Ibn Badr al-Din Jajarmi, Muhammad, 246, 247; compiled and copied by, see *Muʾnis al-ahrar fi daqaʾiq al-ashʿar*

Ibn Bakhtishuʿ, 141; *On the Usefulness of Animals*, see *Manafiʿ-i hayavan*

Ibn Battuta, 59; *Travels*, 197

Ibn Bibi (active ca. 1285), 102

Ibn Mubadir, 209

Ibn Qalawun, al-Nasir, Mamluk sultan (r. 1293–1341), 206n. 36, 207, 260

Ibn Zaid al-Husaini ʿAli ibn Muhammad, 259; copied by, see Öljeitü's Mosul Koran

Ibrahim (singer), *213*, 248; figs. 259, 260; cat. no. 15

Ilka Noyan, 222n. 76

Ilkhan, title, 32, 42

Ilkhanate lands, 7, *8*, *10*

Ilkhanid dynasty (1256–1353), 7, 11, 16 conversion to Islam. *See under* Ghazan conversion to Shiʿism. *See under* Öljeitü courtly life, 75–103; activities, 81–84; enthronements, 81; seasonal camps and migrations, 45, 75–77, *76*; fig. 80; *see also* Takht-i Sulaiman early period, 50–56 and Mamluks, 206–7 and Mongol empire, 32–35

illumination, 5, 61, 132, 133, 135, 202, 205–16

illustrated manuscripts, 47, 57, 112–15, 133, 135–67, 173. *See also* book painting and illustration; *and entries for specific titles*

Imamzada Jaʿfar shrine of, Damghan, 262, 266 tomb of, Isfahan, 126

Imamzada Yahya, Veramin, 121, 122, 198, 262

Immortals in a Mountain Pavilion, leaf from the album *Louhui jijin*, *181*, 183; fig. 214

incense burner, *208*, 210, **280**; fig. 254; cat. no. 170

India, 13, 46, 61, 153, 246, 252, 253; Mughal, 194, 248

Indians, 115, 246

Indus River, 37, 61

Inju dynasty (1325–57), 47, 60, 126, 132–33, 154, 216–22, 278; painting, *154*, 216–19, *217*, 222, 244, 247; figs. 181, 264, 265; cat. nos. 11–13

Inner Mongolia, 29

inscriptions on box, *205*, 279; fig. 246; cat. no. 165 on cenotaph, *22*, 288; fig. 19; cat. no. 205 on metalwork, *209*, 280; fig. 255; cat. no. 168 on tiles, *31*, *101*, 268–69, 270; figs. 28, 116, 117; cat. nos. 117, 118, 127 on vessels, *209*, 280; fig. 255; cat. no. 168

See also Koranic inscriptions; *Shahnama*: inscriptions from

Institute of Muslim Astronomy, 26 and n. 2

Investiture of ʿAli at Ghadir Khumm, from the *Kitab al-athar al-baqiya ʿan al-qurun al-khaliya*, copied by Ibn al-Kutbi, 117, 118, *118*, **245**; fig. 137; cat. no. 4

Iran, xiv, 3, 7, 17, 24, 43, 135, 249, 253; Mongol conquest, 16, 37–61. *See also* Greater Iran

Iranshahr, 43

Iranzamin, 43, 44, 55

Iraq, 3, 7, 117, 139, 197, 202, 209 and n. 45, 210, 244, 258, 281n. 175:2. *See also* Baghdad; Mosul

iron-gall ink, 228

Isfahan, 24, 60, 115, 120, 139, 153, 215, 219, 246 Congregational (Friday) Mosque, stucco mihrab added to, 58, 118–20, *120*; fig. 138 manuscripts copied in, 252. *See also Muʾnis al-ahrar fi daqaʾiq al-ashʿar* palace, 81 scenes probably painted in, *153*, *153*, 219, 252; figs. 180, 267; cat. no. 32 tomb of Imamzada Jaʿfar, 126

Isfandiyar, 99, *107*, *152*, *161*, 254–55; figs. 123, 178, 179, 188; cat. nos. 41, 42

Isfandiyar's Funeral Procession, from the Great Mongol *Shahnama*, *107*, 227–28, 230–31, 251, **255**, 266; fig. 123; cat. no. 42

Isfarayin, 184

Iskandar (Alexander the Great), 40, *53*, 54, 128, *128*, *134*, *159*, *162*, *163*, 194, 229n. 15; figs. 36, 51, 153, 160, 186, 190, 191, 234; cat. nos. 46, 48–52

Iskandar Battling the Habash Monster, from the Great Mongol *Shahnama*, 193, *194*, 278, 279; fig. 234

Iskandar Building the Iron Rampart, from the Great Mongol *Shahnama*, *162*, *163*, **256**; fig. 191; cat. no. 52

Iskandar Emerging from the Gloom, from the Great Mongol *Shahnama*, *155*, *159*, **256**, 273; fig. 186; cat. no. 51

Iskandar Enthroned, from the Great Mongol *Shahnama*, *53*, 54, 173, 187, 198, 254, **255**, 273; fig. 51; cat. no. 46

Iskandar Killing Fur of Hind, from the Great Mongol *Shahnama*, 40, 54, 250, **256**, 273; fig. 36; cat. no. 49

Iskandar's Iron Cavalry, from the Great Mongol *Shahnama*, *134*, *160*, 166, **256**; fig. 160; cat. no. 48

Islam, 3, 32, 34, 37, 43, 52, 105, 245; Shiʿite form, *see* Shiʿism

Ismaʿil I, Safavid shah (r. 1501–24), 84

Ismaʿilis (Assassins), 16, 38, 250

Italianate gold belt plaques, 67

Italian city-states, 59

Italian painting, 112, 128, 150, 165

Italian textiles, 185, 186n. 53; design, 185, *185*; fig. 219

ivory covered box, 286

Ivory Office, 29

iwans, 6–7, 81, 89, 90–91, 115, 121, 123

ʿIzz al-Din Malik ibn Nasir Allah Muhammad, 281

ʿIzz al-Din Quhadi, 121 and n. 59

Photograph Credits

From T. W. Arnold and Grohmann 1929, pl. 35:
 fig. 256
Fotostudio Bartsch: figs. 75, 196, 199
Courtesy of Jonathan M. Bloom and Sheila S.
 Blair: figs. 132, 138, 139, 142, 147, 148
Stefano Carboni: figs. 127, 248
Ellwandt, Staatsbibliothek zu Berlin: figs. 24, 33,
 35, 39, 52, 68, 86, 87, 122, 133, 134, 161,
 168, 180, 220, 222

From Ettinghausen 1962, p. 98: fig. 253
From Flemming 1927, fig. 68: fig. 76
Matt Flynn: figs. 217, 249
From Gray 1961, p. 46: fig. 273
From James 1988, p. 50: fig. 252; p. 120:
 fig. 251
Pernille Klemp / Ole Woldbye, Copenhagen:
 figs. 3, 42, 53, 113–15, 146, 195, 254
Linda Komaroff: figs. 8, 41, 141
Los Angeles County Museum of Art: figs. 7, 40,
 93–96, 98, 102, 218, 278, 279
Photograph courtesy Museum of Fine Arts,
 Boston. Reproduced with permission © 2002
 Museum of Fine Arts, Boston: fig. 234
National Palace Museum, Taipei, Taiwan, Republic
 of China: figs. 14, 27, 214

G. Niedermeiser: fig. 4
Husain Razzaqi: fig. 88
Réunion des Musées Nationaux, Gérard Blot:
 fig. 219; Hervé Lewandowski: figs. 51, 194,
 239, 242, 246
Réunion des Musées Nationaux / Art Resource,
 New York: fig. 119; M. Beck-Coppola:
 fig. 120
Scala / Art Resource, New York: fig. 232
Photograph courtesy of Noriyuki Shiraishi, 2001:
 fig. 81
Yves Siza: fig. 215